AMERICAN COMICS

AMERICAN COMICS

A HISTORY

Jeremy Dauber

W. W. NORTON & COMPANY

Independent Publishers Since 1923

For information about permission to reproduce selections from this book, write to
Permissions, W. W. Norton & Company, Inc., 500 Fifth Avenue, New York, NY 10110

For information about special discounts for bulk purchases, please contact
W. W. Norton Special Sales at specialsales@wwnorton.com or 800-233-4830

Manufacturing by LSC Communications, Harrisonburg
Book design by Daniel Lagin
Production manager: Lauren Abbate

Library of Congress Cataloging-in-Publication Data

Names: Dauber, Jeremy Asher, author.
Title: American comics : a history / Jeremy Dauber.
Description: First edition. | New York : W. W. Norton & Company, [2022] |
 Includes bibliographical references and index.
Identifiers: LCCN 2021024166 | ISBN 9780393635607 (hardcover) |
 ISBN 9780393635614 (epub)
Subjects: LCSH: Comic books, strips, etc.—United States—History and criticism. |
 Graphic novels—United States—History and criticism. | Literature and society—
 United States—History—20th century. | LCGFT: Literary criticism.
Classification: LCC PN6725 .D197 2022 | DDC 741.5/973—dc23
LC record available at https://lccn.loc.gov/2021024166

W. W. Norton & Company, Inc., 500 Fifth Avenue, New York, N.Y. 10110
www.wwnorton.com

W. W. Norton & Company Ltd., 15 Carlisle Street, London W1D 3BS

1 2 3 4 5 6 7 8 9 0

To Talia
A marvelous miss, who I know will become a wondrous woman

CONTENTS

INTRODUCTION **Birth of a Medium** xi

CHAPTER 1 **The Rise and Rise of the Comic Strip** 1

CHAPTER 2 **Comic Books Explode (in Every Sense)** 39

CHAPTER 3 **Who's Afraid of the Comic Book?** 92

CHAPTER 4 **From Censorship to Camp** 138

CHAPTER 5 **Comics with an X** 182

CHAPTER 6 **Convergences and Contracts** 223

CHAPTER 7 **New Worlds** 256

CHAPTER 8 **Between Spandex and Seattle** 300

CHAPTER 9 **New Worlds (Reprise and Variation)** 357

CHAPTER 10 **Endings, Beginnings** 390

EPILOGUE 431

ACKNOWLEDGMENTS 447

NOTES 451

INDEX 539

BIRTH OF A MEDIUM

O ur story starts, appropriately enough, with a bang: the whizz of shells, the crack of gunfire. And an artist crouching beneath them, getting it all down. Thomas Nast may no longer be a household name; but during his lifetime, he shaped the course of a war and set fire to the American imagination, and the themes his story illuminates sound familiar to anyone appreciating comics. Humble origins leading to remarkable successes. Surprising leaps (if not in a single bound) of artistic ambition. And, yes, weaknesses: with great power, great responsibility— and Nast's precedents weren't all good ones.

Nast, like so many others in our story, was an immigrant. His father was forced to leave Germany in 1846 due to his socialist stances; Thomas was six, and his eye became attuned to politics early.[1] He got his first job at fifteen (another theme: autodidacts and early starters) from another recent, and recently successful, immigrant, Frank Leslie, who was creating a new, expanded role in America for drawn pictures with words— comics, for now and for short.

Making images that imparted a message is an impulse as old as human civilization; juxtaposing them sequentially, so that the mind put them together to tell a story, is almost as old. Proponents and propagandists have

dated sequential art making, and thus proto-comics, back to cave paintings; if that feels somewhat dubious, feel free, as some have, to substitute Egyptian tomb paintings, Greek book rolls, Roman tabulae, Mayan ceramic art, Mexican codices, Japanese woodblock booklets, or the eleventh-century Bayeux Tapestry depicting the Norman Conquest.[2]

That's a contentious, and narrative-oriented, definition: comics fans and scholars argue about where to draw the line, pun very much intended. Are comics *sequential*? That definition excludes all single-panel entrants, from political cartoons to *The Family Circus*. Are words necessary? Many great comics don't have them. Perhaps we ultimately define comics as, in one critic's words, "objects recognized by the comics world as comics," ostensibly tautological and also correct. (There's general consensus, for example, that children's picture books aren't comics, despite meeting the criteria set out in many of the definitions.)[3] But juxtaposition of text and image have been crucial, if not strictly *essential*, to the history of sequential comic storytelling.

Which took a sharp turn with the development of the printing press. "Broadsides," or "broadsheets," which reached their height in Western Europe and its colonies between 1450 and 1800, often featured an image or series of images with separated text above or below.[4] Printing allowed these images wide circulation; newly invented movable type created separability between word and image not necessarily available to the creators of illuminated manuscripts or woodcuts. Broadsheets could feature general religious instruction or more topical moral polemics: Martin Luther employed caricatures extensively in his campaign against Catholic authorities. (He particularly liked 1521's *The Passionale of Christ and Anti-Christ*, thirteen pairs of woodcuts juxtaposing episodes from Jesus's life with less admirable papal activity.)

The Catholics did the same, producing a strip during the Thirty Years' War entitled *Martin Luther, Doctor of Godlessness, Professor of Villainy, Shameful Apostate, God-Robbing Husband, and Author of the Augsburg Confession.* And no one forgot the Jews: early broadsheets featured anti-Semitic iconography and false charges of ritual murder. Salacious

crime reporting was popular early on, too: broadsheets were frequently hawked at early modern public executions. (That the sheets required advance preparation meant that artists' impressions were, well, inaccurate in detail.)[5] Sellers soon realized the value in producing material looking on the brighter side, however, and by the 1700s, when broadsheet printing adopted the technology of etching designs onto copper plates, the works were known as "comical cuts," a term shortened to "the comicals," then "the comics." By the 1820s, that technique gave way to lithography, a chemical process that allowed multiple reproductions without loss in quality;[6] the images now produced, often by anonymous toilers, ranged far and wide, high and low.

Representations of miracle plays jostled for popular attention with Mr. Punch and the commedia dell'arte. William Hogarth's eighteenth-century sequential copperplate engravings mixed caricature and human comedy with moral message; he claimed he "endeavoured to treat my subject as a dramatic writer; my picture is my stage, and men and women my players." Are his *Harlot's Progress* (1732) and *Marriage A-la-Mode* (1743–1745) comics?[7] Whether they precisely are or not, they were so popular and influential that poet Thomas Gray, of "Elegy Written in a Country Churchyard" fame, wrote in 1742 that "the wit of the times consists in satyrical prints." And no small part of their popularity stemmed from merchandising: cheap pirated copies, and their designs transferred onto objects ranging from fans to teacups. There were even media adaptations: ballad operas with imitative *tableaux vivants*. Hogarth would spur an act of Parliament in his name to protect his, and other engravers', artistic copyrights.[8]

Hogarth's successors spanned the Continent. Fellow Britons included James Gillray, whose *John Bull's Progress* took a similar route; in Spain, Goya cartooned. Nineteenth-century Frenchman Honoré Daumier's caricatures of King Louis Philippe earned him prison time and, later, the role of political cartooning's "patron saint."[9] Farther north, Flemish speakers produced *mannekensbladen*, moralizing children's prints that featured sequential art. And across the Atlantic, around a decade after *Marriage A-la-Mode*, Benjamin Franklin published a cartoon, *Join, or Die*,

picturing a snake cut into pieces, that achieved immortality.[10] Paul Revere took Franklin's lesson to heart: his 1770 cartoon of the Boston Massacre strongly influenced anti-British recruitment. Both remind us of colonial readers' visual vocabulary and facility, and of the fertile, if sometimes unconscious, ground for comics' reception in America.

Our focus now switches to a vision-impaired Swiss prep school teacher named Rodolphe Töpffer (1799–1846). Töpffer, the University of Geneva's chair of rhetoric and belles lettres, always dreamed of being a serious artist, but it was the "doodlings" and "little follies" done for his and his students' pleasure that assured him immortality.[11] A dying, bed-ridden Goethe, taking notice, probably confirmed Töpffer's own opinion: "He really sparkles with talent and wit. . . . If, for the future, he would choose a less frivolous subject and restrict himself a little . . . he would produce things beyond all conception." But Töpffer understood, deep down: his 1845 "Essay on Physiognomy" suggested "the picture-story, which critics disregard and scholars scarcely notice, has greater influence at all times, perhaps even more than written literature."[12] And *his* picture stories, published between 1827 and 1844 in albums up to one hundred pages long, are comic strips, with panel borders and integrated words and pictures, that phenomenon's first European appearance.[13]

Töpffer's comics arrived in America around the same time Nast was getting off the boat. The year 1842 saw New York's Wilson and Company, specialists in "popular paperback romances," produce *The Adventures of Obadiah Oldbuck*, reprinting a bootleg British translation of a Töpffer album. At forty pages, printed on both sides of the paper, measuring eight and a half inches by eleven, *Oldbuck* looked more like today's comic books than anything previously published.[14] But comics' momentum, at this pre-war moment, lay elsewhere. The engraving process had been refined to allow cheap mass printing, and improvements in binding technology meant bound-together broadsheets could be produced at reasonable cost—thus, magazines.[15] England, as in so much else in that first American century, was the model, and British immigrant Frank Leslie looked to his former homeland's illustrated magazines, particularly its humor magazines.

The Victorians were illustration bashers. They were seen as requiring too little effort, encouraging laziness and, ultimately, moral collapse. But this was a visceral response to the illustrated magazines' explosive success. The most famous, 1841's *Punch*, had developed a reputation almost as much for its illustrations as for its satire. (A leading contributor was the iconic *Alice in Wonderland* illustrator John Tenniel; Dickens's great illustrator George Cruikshank refused to join, finding the satire "too personal.")[16] Two years later, *Punch* helped give those illustrations a new name.

The Palace of Westminster, home of Parliament, had been destroyed in an 1834 fire; the new palace, the building we know today, was still under construction. Queen Victoria's newish consort, Prince Albert, president of the Royal Society of the Arts, sponsored a competition to elicit fresco designs for the new building. Some publicly exhibited entries were pasteboard sketches, referred to by the French term of *carton*. Many were, apparently, less than ideal; *Punch*'s parodies launched a series of similar satiric drawings, eventually known, after their origin, as cartoons.[17]

Leslie brought America the cartoon-heavy magazine model in the 1850s with *Frank Leslie's Budget of Fun* and the *Jolly Joker*. He wasn't the first: New York had had the pro-Whig *Yankee Doodle* in 1846; Philadelphia, 1848's *John Donkey*; and 1852 saw the improbably named comic weekly *Yankee Notion; or, Whittlings from Jonathan's Jack-Knife*. But Leslie's success far exceeded that of his predecessors. With photography in its infancy, magazines still used engravings to convey, accentuate, or explicate the news. (Leslie had previously served as engraver for another great showman, P. T. Barnum, and his *Illustrated News*.) Leslie, however, had pioneered an engraving quasi-assembly line, each section of an engraving job handled by a different individual.[18] This allowed him greater immediacy in presenting images of the day—and in the telegraph and railroad era, faster was unquestionably better. *Frank Leslie's Illustrated Newspaper* (also known as *Leslie's Weekly*) started in 1855; it ran until 1922.

The *Weekly* was fifteen-year-old Nast's first regular job. Leslie auditioned him by requesting a drawing of the crowd boarding the Christopher Street Ferry, an assignment he didn't expect Nast to carry off.

Pleasantly surprised, he hired him; within three years, he had almost doubled Nast's salary. Why? *Leslie's Weekly* had exposed the "swill milk" menace: cows fed toxic mash, resulting in diseased milk, causing an estimated eight thousand infant deaths in a single year. The *New York Times* praised Leslie for "reproduc[ing] pictures that are true to the life, and so shocking that the very word *milk*, or the sight of the dainties into which it enters as an important component, will turn the stomach."[19] Some of which pictures stemmed from the pen of one Th. Nast. The swill-milk companies had champions of their own, most notably a Tammany Hall alderman—not the last time Tammany would appear on Nast's radar.

Harper's Weekly put Nast on regular staff in the summer of 1862; he drew for them for almost thirty years.[20] Fletcher Harper transformed his namesake periodical into "the greatest picture paper in the field," in no small part thanks to his indulging of Nast's own creative ambition. Which meant allowing Nast leeway to render his reportage in a symbolic, iconic key—something closer to patriotic art than the contemporary equivalent of photojournalism. Shelled by Confederate forces at Carlisle, it was Nast's subjective vision, not his objective eye, that resonated.

Two Civil War cartoons illustrate Nast's influence. His 1864 drawing "Compromise with the South" features a profusion of moments in a single image: "The defiant Southerner clasping hands with the crippled Northern soldier over the grave of Union heroes fallen in a useless war," an early critic described it. "Columbia is bowed in sorrow, and in the background is a Negro family, again in chains." As the war dragged bloodily on, Northern "copperheads" were unsure if the price was worth the goal of union. Cartoons like "Compromise," circulating in the millions, the visual equivalent of *Uncle Tom's Cabin*, were crucial to the galvanization of political morale essential for the totalizing Civil War. Lincoln later insisted Nast "has been our best recruiting sergeant"; Grant claimed he "did as much as any one man to preserve the Union."[21]

Nast's second great Civil War cartoon is a compact lesson in iconography and symbolism in comics. Visual reading depends upon the power of symbolic shorthand. (When you see a picture of a big bag with "$"

on it, you don't wonder whether it's full of crawfish.) Words are visual icons, too: consider the difference in meaning between really and *really*. Cultures have established sets of these symbols and icons, which comics readily draw on. But they're not Platonic ideals: they circulate, mutate, evolve, and, in many cases, are hewed and crafted.

"Santa Claus in Camp," in the 1863 Christmas issue of *Harper's*, features the white-bearded gent, dressed in Stars and Stripes, distributing presents to Union soldiers. Tritely, overdeterminedly symbolic? Possibly; until we realize it was Nast who popularized the image of Santa Claus we all know. Along with Uncle Sam. And the Democratic donkey. And the Republican elephant. He didn't originate any of them. His Santa was possibly inspired by Germany's Santa, Pelze Nicol. Cartoons from the early 1830s show asses with Andrew Jackson's head. Uncle Sam's history wends through the early-nineteenth-century cartoon character Brother Jonathan, "a tall, lean, shrewd fellow from rural New England" who wore "a tall hat, a long-tailed blue coat, and red-and-white striped trousers," and "Uncle" Samuel Wilson, a New York State meat-packer and military contractor who stenciled *U.S.* on goods during the War of 1812.[22] All Nast did was make the images ineffable.

He used this iconic technique to take on Tammany Hall. Borrowing from the illustration on the fire engine of "Boss" Bill Tweed's company, Nast portrayed the political machine as rapacious, predatory tigers; Tweed himself was caricatured as a literal moneybags, a sack of cash for a head. "I don't care what the papers write about me," Tweed allegedly growled. "My constituents can't read. But they sure can see pictures. Stop them damned pictures." He offered Nast half a million dollars, close to $10 million in today's money, to go away. Nast turned it down; Tweed and crew were unceremoniously voted out. (Nast's cartoon "The Tammany Tiger Loose— What Are We Going to Do About It?," published two days before the 1871 municipal election, couldn't have helped.) Tweed would flee the country, to be arrested in Spain—identified, ironically, thanks to Nast's pictures.[23]

Nast also used the power of his pen to take on the Ku Klux Klan, advocate for Chinese immigration (then a distinctly unpopular position),

and decry racial segregation. But he also depicted Irish Americans as John Barleycorn-esque drunks and produced stereotyped caricatures of Black and Asian Americans. Nast is strong proof that an image's power is multidirectional. Employing visual shortcuts to send messages tacitly acknowledged as meaningful by society means the art in question deepens and reinforces stereotypes, even ones they seek to interrogate.

Snidely Whiplash's handlebar mustache wordlessly suggests its wearer is up to no good; straightened posture and a strong jaw purport to denote the moral analogue. But when we say things like "people with mustaches are generally the villainous sort" or "bad posture = bad virtue," the door's thrown wide open.[24] Comics, for much of their history, were drawn quickly and cheaply, without too much attention to detail, and so shortcuts—mental, visual, and otherwise—were the order of the day. Want to ensure readers knew someone couldn't *possibly* be a love interest? Make them fat. Want them to know the character couldn't *possibly* be the hero? Make them non-white. These terrible shortcuts reflected the American cultural matrix of their time; but they also, all too often, could shape, not just reflect, opinion. If hundreds of millions of Americans only saw Asians portrayed in comics for decades as inscrutable Orientals, faithful servants, or embodiments of the yellow peril, how did that shape their understanding of that group? Unfortunately, it's a question haunting comics to this day.

One final point: many of the "terse and telling" captions beneath Nast's cartoons were actually written by his wife, Sarah, who has remained generally uncredited and unheralded in discussions of his legacy.[25] The history of comics is one of multiple erasures. For decades, creators frequently remained anonymous, or subsumed under house names. But beyond that are the lost *voices*: individuals and groups, both creators and representations, erased and marginalized by institutional culture. And they don't just deserve to be part of the story; we *need* them to be, too.

Since Nast, American comics have shaped wars and inspired movements; they've provided ethical edification and moral scandal. And, bluntly, they've conquered pop culture.

In 2018, half of the ten highest domestic grossing movies were based

directly on comic books (in order of box-office receipts: *Black Panther, Avengers: Infinity War, Deadpool 2, Aquaman,* and *Ant-Man and the Wasp;* a sixth, *Venom,* missed making the top ten list by less than half a million dollars). Three others were either animated films, comics on the screen, or properties with significant lives in comic or animated form (*Incredibles 2, Dr. Seuss' The Grinch,* and *Solo: A Star Wars Story*). As for television: as of June 2017, seventy-one shows based on comics were either currently airing or in the works. *The Walking Dead,* based on Robert Kirkman's comic, is not only the most popular television show in cable history, but for years running, it was the most viewed show on television, period, among the eighteen-to-forty-nine-year-old demographic coveted by advertisers.[26] Comic conventions, once a sleepy backwater for hard-core collectors, are now sites of pop culture pilgrimage: 167,000 eager fans attended 2015's San Diego Comic-Con, a quarter of the population of Wyoming.

And comics' move to the center of the American popular imagination is occurring side by side with an explosion of graphic literature that has entered the American *literary* imagination, speaking to, and advancing, the central concerns of American literature. It's not just MacArthur "genius grants" and National Book Awards; journalists, memoirists, trauma survivors, theorists, surrealists, satirists, experimentalists, and self-confessed fanboys have produced masterpieces that stand toe to toe with the best work in any other medium: *Love and Rockets, Watchmen, Fun Home, Jimmy Corrigan, Sandman, March, Black Hole, Ghost World.* Though the one thing the comics community can agree on is vehement disagreement, there's near-unanimity that if you don't like these, you could put another eight in their stead, and then another eight, without diminishing the quality one iota.

These two stories are deeply intertwined. The explosion of creative virtuosity in the graphic novel would be impossible without a remarkable variety of often-unheralded innovators toiling in the vineyards of four-color cape-and-tights sagas. Conversely, the recent decades' envelope pushing in mainstream comics, where superheroes and their ilk have become vehicles for explicit discussions of personal identity, contempo-

rary politics, and even the medium's artistic and moral limits, would've been impossible without a wide, diverse, generally even *more* unheralded community of alternative and independent creators. The two groups resisted each other, eyed each other, learned from each other, stole from each other, worked together, and, now more than ever, have reached a coexistence resulting in nothing less than a graphic renaissance.[27]

This book tries to cover the whole shebang, from Nast's cartoons to the latest graphic memoirs and transmedia corporate productions. The story of American comics is the story of America's last 150 years: the development, growth, and transformation of cherished American institutions, cultures, and practices, and comics' frequently central role in their business and their appeal. It's a political story of how a long-marginalized, at times even despised medium helped shape American thought and action. It's the story of a changing American audience: of American immigrants and American fears, American ideals and American anxieties, all in word-and-image form, a perfect vehicle for addressing contemporary issues.

Questions of representation, literally laid out upon the page for exploration. Questions of authority (Who gets to tell whose story? Who gets to star?), played out through the stretch of spandex. Questions of aesthetic limits—what should literally be shown—experienced more viscerally than in almost any other medium, given comics' unlimited imaginative budget and (potentially) uncensored nature. Comics may expand our horizons to new corridors of myth, letting us witness in ways more intimate and personal than the most evocative prose memoirs or the most visceral photojournalism. But they can also be blinders, allowing readers to imagine worlds so deeply conceived, and yet so narrowly drawn, they threaten to block out the world as it is, or indeed should be.

And so their story should be told.

AMERICAN COMICS

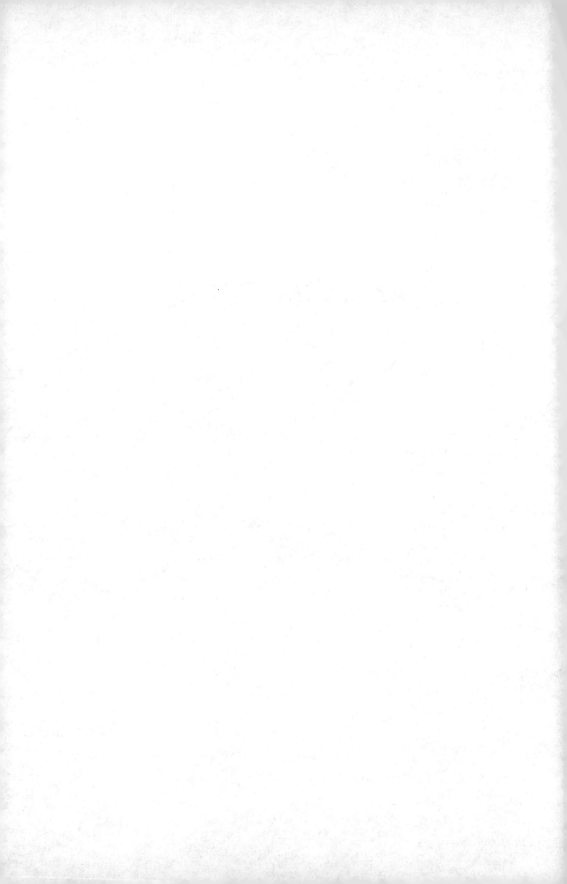

THE RISE AND RISE
OF THE COMIC STRIP

During Thomas Nast's career, the United States started resembling the nation we know today. So did comics.

America's population doubled between 1870 and 1900, thanks in no small part to immigration; accordingly, its urban population tripled, speeding America's transition from rural to urban nation. (By 1890, forty percent of New York's population was foreign born.) All those city dwellers clamored for the latest news, and weekly magazines like *Harper's* simply didn't satisfy. That same period saw the number of newspapers increase from 489 to 1,967; total circulation more than quintupled, from 2.6 million to 15 million. New high-speed presses pumped out multiple daily editions, trumpeting the latest news from across the land as reported via the newly invented telegraph. And all that competition between papers (New York City had nineteen English-language daily newspapers in the 1890s, to say nothing of weeklies or foreign-language papers) dropped prices, creating a golden age for readers.[1]

Immigrant readers were of particular interest to publishers; numerous and disproportionately urban, thus a more concentrated consumer base, their pennies and nickels were as good as anyone else's. Their non-native English, though, often rendered a product composed mostly of

English words a hard sell. One solution: take advantage of America's required public school education and develop features attractive to immigrants' children—native or near-native English speakers who would prevail upon their parents to buy a favored newspaper.

There'd been a few precursors in their own industry,[2] but the newspapers generally took their cue from American comic weeklies, with immigrant roots themselves. *Puck*, modeled heavily on *Punch*, began as a German-language magazine in St. Louis in 1876, aimed at immigrants like Thomas Nast's parents.[3] Its English version, begun the following year, soon reached almost six-figure circulation, inspiring some of its artists to form another magazine, *Judge*, in 1881. The eponymous Judge remarked on its first page, "I have started this paper for fun. Money is no object: let sordid souls seek that."

The Judge was a little blasé; both *Puck* and *Judge* were indispensable partners with Nast in establishing the American cartoon as a political force. *Puck* was avowedly Democratic; Grover Cleveland credited its editorials and cartoons above all else in his 1884 presidential victory.[4] Benjamin Harrison made similar claims about *Judge*'s role in Cleveland's defeat four years later; *Judge* even took money from the Republican Party. *Life*, the era's third great comic weekly, was more apolitical,[5] but H. L. Mencken's reported quip, "Give me a good cartoonist, and I can fire half the editorial staff,"[6] was apposite nonetheless.

The weeklies' cartoons generally consisted of a single picture accompanied by a two-line joke, a pun, or explanatory soliloquy or caption, modeled on then-popular vaudeville, where relatively static straight men and gagsters traded lines. Vaudeville was known for minstrelsy and ethnic humor, and the weeklies borrowed that, too: *Puck* was well known for racist, anti-Semitic, and anti-Irish cartoons, regularly depicting Black people via Zip Coon, Tambo, and Bones stereotypes.[7] But the cartoons' successes were carefully noted by an immigrant Midwestern newspaperman who became an industry titan thanks in no small part to comics.

Joseph Pulitzer was born in 1847 to a Hungarian Jewish family, emi-

grated to the States at seventeen, settled in St. Louis after an unexceptional stint fighting for the Union, and got into the newspaper business. By the age of twenty-five, he'd left behind the German-language paper he'd started with and merged the *Post* and *Dispatch* into the paper still around today. A little over a decade later, in 1883, he bought the distressed *New York World* from robber baron Jay Gould for $346,000 (nearly $10 million in today's money). Two years later, it was selling two hundred thousand copies,[8] thanks to methods surprising to those familiar only with the august name behind journalism's highest award: his focus on scandal and human-interest stories was more akin to today's tabloids. But he embraced the visual, not just the visceral.

Before 1841, American newspapers had refrained from publishing on Sunday, the Sabbath day. The *New York Herald* had broken the ban, but few papers were willing to risk the public umbrage, until Pulitzer. In 1885, two years after buying the *World*, he expanded its Sunday supplement fivefold, to twenty pages; it would be doubled, and more, within the next decade. Most importantly, he followed *Puck's* and *Judge's* example and introduced a comic supplement in 1889. This had the intended effect of driving a regional competitor, the *New York Daily Graphic*, out of business,[9] and the possibly less-intended effect of encouraging other papers to launch Sunday editions; by 1890, there were 250.

Pulitzer's progress was aided by another technological innovation: the high-speed rotary color press. The *Chicago Inter-Ocean* had gotten there first, in 1892; Pulitzer bought one the following year. He'd planned to use the press's bright reds and blues to reprint Western art masterpieces, but his Sunday editor, Morrill Goddard, had another idea. *Kids* loved bright colors, after all. And the comic weeklies for adults weren't using color very much. Perhaps tickled by the suggestion's aristocratic source (Goddard's maternal grandfather had been governor of Maine), Pulitzer agreed. The first color comic supplement appeared in the *World* on May 21, 1893, available on newsprint for a nickel, half the price of the fancy weeklies.[10]

Pulitzer hired away supplement art director Charles W. Saalburg

from the *Inter-Ocean*. Saalburg had created *The Ting Ling Kids*,[11] a cartoon about a group of Chinese gamins, a year before the first widely known American comics character was created. Their general omission from all but the scholarly record speaks volumes about how ethnic "others" fare in the American cultural memory. Saalburg's place in comics history ended up behind the scenes, working with the artist inextricably linked to American comics' origin.

Richard Felton Outcault's previous career had included a stint as a full-time employee of Thomas Edison, providing scientific illustrations for the inventor's *Electrical World* magazine. (Outcault once accidentally whacked the inventor in the behind with a ruler, believing him to be someone else. When Edison later reciprocated, Outcault considered framing the seat of his pants, but "they were his sole pair of trousers at the time.")[12] In 1890, Outcault began selling freelance cartoons to the weeklies, including scenes of slum and tenement life. His work caught Goddard's eye, who hired him for the *World* full time in 1894.[13]

Outcault wasn't the only chronicler of how the other half lived. But there was something in Outcault's cartoons of poor American children at play that was absent in the photographs of, say, noted muckraker Jacob Riis. Maybe it was the long exposure times contemporary photography required, necessarily imputing greater solemnity; maybe it was the progressives' view of their subjects as objects of pity and charity rather than action and autonomy. Whatever the reason, Outcault's character—Mickey Dugan, the Yellow Kid—and his comic strip, *Hogan's Alley*, were delightfully, shockingly, dangerously different.

"I always loved the Kid," Outcault later said. "He had a sweet character and a sunny disposition and was generous to a fault." Creators often have a lopsidedly affectionate view of their creations; Dugan comes across as the spirit of the streets, an energetic, crude, beady-eyed, carnivalesque symbol of a raw and wild urban America. (He was also bald; not uncommon then, when childrens' heads were shaved to prevent lice.) And his friends' bodies cavort and clamber with abandon, full of agency, full of voice. As Dugan himself put it, describing the supplement more gener-

ally, "It's a rainbow of color, a dream of beauty, a wild bust of lafter, and regular hot stuff."[14]

Dugan wasn't originally yellow: first appearing in the *World* in black and white in early 1895, then in color, first in a blue nightshirt, only yellow as of early 1896. Outcault, for his part, claimed he never knew who colored the Kid that fateful Sunday, or why.[15] But by the time he did, the color *meant* something in fin de siècle American culture, thanks to works like Charlotte Perkins Gilman's 1892 short story "The Yellow Wallpaper" (which is "smouldering unclean . . . dull yet lurid") and Robert Chambers's 1895 *The King in Yellow* (in which reading a play of that title causes insanity): something vaguely disreputable and somewhat dangerous, a perfect accompaniment to the Kid. (That said, the oft-made claim that his famed disrepute made him the source of the phrase "yellow journalism" is historically incorrect.)[16] Soon, no one called the champion of *Hogan's Alley* Mickey Dugan. To friends, readers, and critics alike, he was the Yellow Kid.

The dynamism of Outcault's art notwithstanding, his full-page cartoons are remarkably text-heavy by modern standards. That last clause matters: everything—political handbills, advertising circulars, humor magazines—was much wordier then. The Kid's nightshirt proved a prime spot for Outcault text, sometimes innocuous, sometimes opining on matters as weighty (and dated) as the gold standard.[17] But *Alley*'s text soon spread from nightshirts to word balloons, popularizing another comics feature.

Speech balloons appeared in fourteenth-century woodcuts; Paul Revere and Ben Franklin used them. They'd appeared in the comic weeklies, too, though more infrequently than captions, along with occasional multi-panel, sequential comics. But Outcault's combination of speech balloons and multiple panels for the first time, in October 25, 1896's "The Yellow Kid and His New Phonograph" (word balloon emerging from the latter), helped cement comics' look and feel. So substantial were these contributions, combined with *Alley*'s existence as a continuing series with consistent title, theme, and character, they have given rise to the

"Yellow Kid Thesis," which suggests that Outcault created a new art form. This seems overstated; each of these features predated Outcault, sometimes by centuries, sometimes by a few years. (Besides *The Ting Ling Kids*, James Swinnerton's *Little Bears*, appearing in the *San Francisco Examiner* in 1892, were also continuing newspaper strip characters.)[18] What made Outcault so foundational was his megaphone.

The Yellow Kid was the first national comic character, his likeness appearing on, among others, cigar boxes, cigarette packs, whiskey bottles, buttons, paperweights, ladies' fans, and fancy soap. Late-nineteenth-century America saw a new culture of consumption, one of chain stores, brand-name items, identification through product choice; not a week after that phonograph comic, *Ev'ry Month* magazine wrote that the " 'Yellow Kid' is familiar to a vast and applausive metropolis . . . at the music halls in Broadway you can see a travesty . . . called *Hogan's Alley*. There is a *Hogan's Alley* comedy on the road, and there are *Hogan's Alley* songs on the market."[19] Others had already explored the lucrative relationship between comics and merchandising. In 1883, Palmer Cox had illustrated his poem "The Brownie's Ride," featuring several fairy creatures, for *St. Nicholas Magazine*; the Brownies appeared in dozens of stories, received their own comic strip, and were featured in advertisements ranging from Ivory soap to an Eastman Kodak camera that could be "operated by any school boy or girl" (it eventually took their name: the Brownie camera).[20] They were so influential, Mickey Dugan's first appearance was entitled "The Fourth Ward Brownies."[21] Just a few years later, Rose O'Neill's "helpful, jolly little cupids," a byword thanks to their namesake Kewpie dolls, sweetened the atmosphere alongside Grace Drayton's Campbell Soup Kids,[22] but the less conventionally cute Yellow Kid became the most prominent illustration of how suited comic characters were to such promotion.[23]

Outcault claimed to weary of the phenomenon, writing, in 1898, with "but one request to make": "when I die, don't wear yellow crepe, don't let them put a Yellow Kid on my tombstone and don't allow the Yellow Kid himself to come to my funeral. Make him stay on the East Side, where he belongs." But Outcault certainly wasn't dissuaded from mixing comics

and merchandising: his second iconic character, 1902's Buster Brown, was selling shoes named after him for the next century (for boys *and* girls: Mary Janes are named after Buster's girlfriend). And not just shoes: Buster Brown merchandise was so varied, it once filled a museum in midtown Manhattan. Outcault managed the licensing himself; the merchandising money let him retire and devote his life to painting.[24]

Buster, whose name's etymology was "a guy with a shrewd, regular feller's soul, a hard business sense," was everything the Yellow Kid wasn't—the flip side of fin de siècle American childhood. Bourgeois, well-dressed (that blouse! those shoes!), out in nature (well, then-semirural Long Island), gamboling with animals as neat and well fed as he was. If the Kid was what newspaper-buying parents feared and their children loved—anarchy, all id—Buster was superego apotheosized, regretful for the pranks he pulled, penning little moral homilies, emblematic of Outcault's love for Emerson and Thoreau, at every comic's end.[25] But both sold tons of newspapers.

The older weeklies tried to beat the upstart back. *Life* regularly attacked Pulitzer and the *World* on grounds ranging from sniffy elitism ("It used to be so that one could tell a man by the newspaper he read, but now it is by the newspaper that he doesn't read") to ugly anti-Semitism (for doing "his worst work on Sunday"). The fact that many immigrants and new paper buyers were non-Christian wasn't entirely unrelated.[26] But to no avail. If the weeklies couldn't compete, though, other newspapermen could.

William Randolph Hearst, Orson Welles's model for *Citizen Kane*, used his father's mining fortune to build a newspaper empire. Within five years of his father's death, Hearst was a player in New York City journalism, buying the *Morning Journal* (previously owned by Pulitzer's brother Albert) in 1895. Within four months, he'd octupled the newspaper's subscription to 150,000; within the year, he'd practically tripled *that*. Thanks, in part, to loss-leading—Hearst dropped the daily's price to a penny, forcing Pulitzer's *World* to follow suit; but also through talent, which he accumulated the same way Pulitzer had, by buying it. Not least

from Pulitzer himself: Hearst snapped up Morrill Goddard and another eleven staff members of the *World*'s Sunday supplement in January 1896 (Welles memorably dramatized the moment in *Kane*), and, later in the year, acquired Outcault. Armed with the Yellow Kid's creator, Hearst produced a *Journal* eight-page Sunday supplement, *American Humorist*, which, as he bragged in print the day before its October 18 premiere, was "EIGHT FULL PAGES OF COLOR THAT MAKE THE KALEIDOSCOPE PALE WITH ENVY." He then proceeded to jack up the Sunday paper's price from three cents to five and sell loads of copies.[27]

The Yellow Kid was famous; creator Outcault wasn't nearly so. So, Pulitzer simply, unsentimentally, hired someone else to do the job: George Luks, later to become well known as a painter. The strategy relied on an extremely nebulous determination of copyright and led, almost inevitably, to *both* newspaper titans running versions of the Yellow Kid in 1896.[28] The upshot: Pulitzer's *World* got to keep the title *Hogan's Alley*, but using the characters and likenesses wasn't considered copyright infringement as long as Outcault (and Hearst) didn't use actual, previously copyrighted *material*, like the name. (No relevant court cases seem to exist, but possibly there was an unrecorded out-of-court settlement.)[29] And thus *The Yellow Kid in McFadden's Flats* was born. The whole thing happened again a decade later with *Buster Brown*, the *Herald* continuing to publish other artists' *Buster Brown* while Outcault did it for Hearst. Which all led to what was possibly the first crossover in comics, initiating the in-jokery and inside knowledge[30] now endemic to the medium: in 1907, Outcault has Buster Brown meet the Yellow Kid, who remarks, "There's another fellow who is being imitated like I was." More crucially, it was an early salvo in the ongoing fight over who owned what in comics: a debate eventually encompassing creators and corporations alike.

Hearst's most personal contribution to comics stemmed from childhood memories. Touring in Europe as a boy, he'd read Wilhelm Busch's illustrated German children's books featuring troublemaking pair Max and Moritz. The duo subsequently appeared in England, under the unlikely sobriquets of Tootle and Bootle, and more promi-

nently in pirated versions in the 1870s American *Puck*. (The 1886 Convention on International Copyright failed to specify whether cartoons or comic strips were "literary and artistic works," covered by the law, or " 'ephemeral' and 'miscellaneous' "; in a remarkable act of chutzpah, *Puck* claimed copyright on the materials it had stolen.) Apparently looking for an original analogue for his paper, and undoubtedly hoping to broaden the paper's appeal to German immigrants, Hearst tapped *Judge* and *Life* contributor (and German immigrant) Rudolph Dirks; the *Katzenjammer Kids* debuted in 1897.[31]

The word *katzenjammer* (literally, "cat yowling"; idiomatically, "hangover") certainly describes the effect of the kids' never-ending hijinks on their Mama, the Captain, and the Inspector, the essence of the strip. *Katzenjammer* apparently pioneered some of comics' most iconic shorthand: lines and dust clouds suggesting speed, dotted lines implying eye contact, beads of sweat conveying fear or nerves. But most importantly, *Katzenjammer*—like the Yellow Kid, *Buster Brown*, Inez T. Tribit's *Snooks and Snicks*, *The Mischievous Twins*, and Kate Carew's 1902 *The Angel Child*, who actually wasn't—reflected the centrality of kids, and their behavior, at the heart of comics' early days. And, even more than the others, it brought questions of moral consequence to the fore.[32]

If the Kid was never punished for his anarchic doings, and Buster Brown needed only mild correction, the Katzenjammers not only constantly required, but were provided, control and discipline: order always restored by the final panel, the Kids always getting their comeuppance. This was buttressed by that newly vital use of *sequential* narrative, the multi-panel structure required to display the workings of cause and effect necessary for moral instruction. That said, how moral *is* the strip, really? True, vice (or, more precisely, mischief) is punished; but *Katzenjammer's* ongoing publication meant, as readers understood, that the Kids would be up to more trouble in the next installment, slate wiped clean, as if last week never happened. Which, perhaps, put a more subversive spin on the question of consequences.

Kid readers got that message. But so did their parents—and the

backlash against comics is part of their story from the start. Given the domestic milieu of early-twentieth-century newspaper reading—families reading the Sunday "funnies," as the kids called them, those big, colorful newspaper pages spread all over the floor, parents reading to kids and vice versa—the comics were family, or could be. Which is why the bad behavior within them felt like such a violation. And it was an increasingly urgent concern, because newspapers were selling, and comics were selling newspapers: after 1898, the *World* and the *Journal* each passed one million in circulation.[33] And it wasn't just New York papers. In 1900, 915 American cities had dailies; a decade later, over 1,200. Around 60 percent of those cities had competing papers, and a main differentiating factor was which paper carried which comics. Which led to the next business innovation.

American newspaper syndication precedes the United States; in 1768, the column "The Journal of Occurrences," produced by pro-rebellion Boston patriots, was syndicated in Philadelphia, New York, and elsewhere. But the practice expanded drastically during the Civil War, supplying "evergreen" material, features, and illustrations to local papers hit by the wartime manpower shortage, and hit its stride postwar thanks to the railroad, which allowed easy distribution not just of printed material but of stereotyped plates you could place right on the presses—no need for resetting type or re-engraving. By the 1890s, it had become the norm; thanks to the dropping newsprint prices, big-city papers were producing fifty-to-sixty-page editions, not to mention Sunday sections (and Sunday comic supplements). They needed the raw material syndicates could provide; it came with a promise not to offer the material to competing papers in the same market. Pulitzer's *Herald* had started selling features to other papers by 1895; Hearst, who owned multiple newspapers himself, was publishing the same comics in the *World* and the *St. Louis Post-Dispatch* by 1897. By 1908, 75 percent of American Sunday papers were publishing comics, and 75 percent of that market was served by three syndicates: Hearst (later under the title King Features Syndicate), McClure, and

World Color. And no longer just on Sundays: the *World* and *Journal* both started printing comic strip series on a daily basis in mid-1902.

The holdouts from the big syndicates, primarily small-town newspapers that ran their own comics, often functioned as talent laboratories, giving cartoonists the chance to hone their craft in a smaller venue before jumping to the big time. That last phrase comes from vaudeville, whose influence on comics went beyond content: given their mass audiences, both tackled similar questions of family-friendliness. With shows (or strips) on Sunday, the acts had to be clean. "Characters should not smoke and must not drink," went one syndicate's version of the rules. "All references to divorce, Deity, racial characteristics, religion, and foreign words are banned. No mention may be made of social matters of a controversial nature, such as farm relief, chain stores, or politics." Individual newspapers went even beyond *that*: The *Deseret News* in Salt Lake City, a Mormon paper, deleted smoke, cigarettes, and pipes from cartoons before publishing them.[34] Such rules and syndicate pressures would often be internalized by cartoonists before external enforcement became necessary.

Not everyone was persuaded of comics' moral appropriateness, nonetheless. A 1906 essay in the *Atlantic* castigated comics for teaching "no high ambition, but devot[ing] itself to 'mischief made easy.'" The piece encapsulated two main objections to comics. First, their encouragement of moral laxity; a concerned citizen, in a September 1908 address to the Playground Association of America, said strips taught kids "it is cunning to throw water from an upper window upon an old person." But second, and less frequently appreciated, was their curtailment of capacity for aesthetic appreciation; that same year, the president of the National Association of Newspaper Circulation Managers wrote, "The crude coloring, slap-dash drawing, and very cheap and obvious funniness of the comic supplement cannot fail to debase the taste of readers and render them to a certain extent incapable of appreciating the finer forms of art." By 1908, the *Saturday Evening Post* fulminated that comics were "clownish, vulgar, idiotic"; such discourtesy generally extended to their creators, regarded

by the courts as "'draughtsmen' or similarly skilled laborers with little creative input or control."[35]

And, additionally, concerns were raised that comics were physically pernicious. In 1907, *Outlook* wrote that doctors claimed an increase in the frequency of night terrors on Sunday and Monday nights because "poring over the colored supplement of the Sunday supplement has been one of the absorbing occupations of the day of rest." The *Ladies' Home Journal*, flaying its audience with a scalpel of guilt wrapped in a call for responsible parenting, wrote, "Are we parents criminally negligent of our children? . . . [W]e are permitting to go on under our very noses and in our own homes an extraordinary stupidity, and an influence for repulsive and often depraving vulgarity so colossal that it is rapidly taking on the dimensions of nothing short of a national crime against our children." The *Boston Herald*, accordingly, dropped its entire comics section in 1908, claiming, "the comic supplement has had its day. The funnies are not funny any more and they have become vulgar in design and tawdry in color. . . . Most discerning persons throw them aside without inspection, experience having taught them that there is no hope for improvement in these gaudy sheets."[36]

There were objectors to the objectors. Some argued for a mend-it-don't-end-it approach, leading by 1911 to the League for the Improvement of the Children's Comic Supplement. Which reflected the newspapers' bottom line: the children's comic supplement was simply too big a business to abandon. (The *Herald* sheepishly reinstated its comics section before long.) But another line of argument suggested that much of the kid-centered criticism was in bad faith, given comics' actual, expansive audience. A tongue-in-cheek response from the popular *Everybody's Magazine* in 1905: "The comic supplement has come to stay, undoubtedly. . . . And it is blamed upon the children! . . . Yes, it certainly is the children who like the supplement—*the children of all ages*, of a larger as well as of a smaller growth. . . . Oh, yes, blame it on the children."[37]

Carl "Bunny" Schultze's *Foxy Grandpa* (1900) ran for over eighteen years in the *Herald*: a *Katzenjammer* in reverse, where Grandpa outwits

two mischievous kids, it nonetheless underscores the shift in emphasis from children to adults, both as protagonists and as readers. Frank Leslie and *Puck* alumnus Frederick Opper's *Happy Hooligan* began the same year, and it stakes out analogous territory; but *Hooligan*, written by an immigrant's son, has a more questionable stance on moral consequence. Happy, an Irish immigrant, always tries to do right, and always gets it in the neck as a result. Did Happy's travails resonate with immigrant adults who subscribed to the American dream but, not knowing the code, never quite saw it materialize? Opper also created Alphonse and Gaston, whose hyperbolic politeness ("After you!" "No, after you!") became a byword and spoke to the failure of mastered codes of civility. In his *And Her Name Was Maud*, a mule's constant delivery of mighty kicks to those turning their back on her illustrated the world's capacity to inflict violence on the unwary.[38] These, to put it mildly, were adult concerns.

That said, Happy Hooligan's bloody but unbowed nature (notably, Opper gave him a more pessimistic brother, one Gloomy Gus) is reminiscent of a certain bowler-hatted, mustachioed, cane-toting live-action cartoon character; and it's unsurprising that the strip ran during the height of Chaplin mania, which appealed to adults and children alike. Chaplin himself appeared in comics as early as 1915,[39] offering the opportunity to examine, not for the last time, the overlap between movies and comics.

The first large-screen motion picture projection took place in 1896, the same year the Yellow Kid made his bow. Short films based on *Happy Hooligan* appeared by 1900; between 1901 and 1903, fifteen features starred, among others, Alphonse and Gaston, Foxy Grandpa, and the Katzenjammers; the output increased to about 250 comics-based serials between 1913 and 1930. Gus Mager's strip *Sherlocko the Monk*, featuring a Holmesian protagonist solving mysteries involving characters like Tightwaddo or Boneheado, created a fad for appending -*o* to people's names: thus, Groucho, Harpo, Chico, Gummo, and Zeppo.

Certainly, comics' comical component owed much to Chaplin, Mack Sennett, and Harold Lloyd, among others. Many have noted the multipanel comic strip's resemblance to unspooling film frames, and described

its evolution as echoing cinematic development. Comics first featured, panel by panel, an almost static presentation, "as if a stationary camera had been aimed on the scene," then shifted to "continuous and ongoing" action. And its similarly varied content, especially in cinema-inflected strips like *Hairbreadth Harry* or, more famously, Ed Wheelan's *Minute Movies*, encouraged comics readers to see strips' inhabitants as living, breathing, familiar things.⁴⁰

Minute Movies' intriguing premise was that its cast of characters were movie company members—including "actors," a "director" (Art Hokum), and a "cameraman" (Otto Focus). The strip depicted the company's "slate of movies," running over multiple installments of the strip, which included thrillers, Westerns, gag reels, baseball movies, and even circus flicks (*Terrors of the Big Top*);⁴¹ installments labeled "Station WMMS" provided coming attractions via "radio announcement" and "interviews" with troupe members. Some children, perhaps not recognizing the nomenclatural puns, thought the Wheelan characters were real and wrote in for autographed pictures.⁴² But if comics like *Minute Movies*, *Hogan's Alley*, and *The Katzenjammer Kids* had some relationship to realism capturable via the camera's lens, even consciously rendered in a vaudevillian or melodramatic key, others engaged in surrealism avant la lettre. And no one more than Winsor McCay.

Little Nemo in Slumberland wasn't McCay's first attempt to use comics' expansive canvas to bring the dream world to life.⁴³ His *Dream of the Rarebit Fiend* had a standard frame: protagonist eats Welsh rarebit (a toasted cheese dish) before bedtime; protagonist therefore has vivid dreams, incorporating McCay's remarkable imagination; dream ends with protagonist falling out of bed; repeat. But Nemo, modeled on McCay's son, meets a different fate. Maybe it was McCay's continued artistic growth, maybe Nemo's pre-bedtime dietary choices, but Nemo's trips to fantastical Slumberland, Sundays in the *Herald* from 1905 until 1911 (until McCay *also* moved to a Hearst paper), were ongoing. Each strip ended with Nemo falling out of bed and waking up; but the next night (next week, for readers), the dreams took up where they'd left off, with clown

antagonist turned sidekick turned leading character Flip and a cast of thousands. There was no reason Nemo's dreams couldn't last as long as childhood itself, and *Nemo* was, as one scholar writes carefully, "the first strip to offer consistent characters in an ongoing, open-ended serial narrative." Yes, Happy Hooligan had taken a months-long European trip; and a year after *Nemo* bowed, in 1906, German-American cartoonist Lyonel Feininger (later a famed cubist painter) told of the Kin-Der-Kids' world tour in a bathtub. But *Nemo* was grander; its ultimate legacy lay in image, not narrative.

The *Herald*'s presses were perhaps the best in the business, and McCay took advantage, providing eye-popping color, stretching and condensing the page like the then-popular saltwater taffy. McCay's drawing professor had been a stained-glass craftsman, and there's something of the cathedral in many Slumberland venues; McCay himself had produced publicity posters for traveling circuses, and the big top was there, too.[44]

Nemo spawned many imitators, now long since forgotten: *The Naps of Polly Sleepyhead, Danny the Dreamer, Nibsy the Newsboy in Funny Fairlyland,* and *Wee Willie Winkie's World,* among others. But *The Kin-Der-Kids* and *Little Nemo* never quite found their readership. Was it the week readers had to wait between installments? Or did the dreamlike, nonnarrative, dare we say adult-dressed-in-kids'-trappings appeal not widely resonate? It was said *The Kin-der-Kids'* "to-be-continued storyline" confused not only *Tribune* readers but editors, who dropped it mid-story.[45] And character identification, crucial to kid appeal, is largely absent in *Nemo,* about whom we know almost nothing beyond the look of his bedclothes.[46]

A further argument for *Nemo*'s adult orientation is to see its dreamwork as visualized psychoanalysis. Freud's theories were just spreading as *Nemo* reached its heights, and its world of fantastic delights simultaneously reveals our subconscious anxieties.[47] Nemo's early visits to the dreamworld almost uniformly resolve into nightmare: a meeting with Santa Claus ends with out-of-control reindeer; Father Time turns him into a doddering, terrified old man; "Red Indians" fill him full of arrows.

Arrival at Slumberland proper, though, changes things, Nemo now insist-
ing, "I don't want to get up, I don't want to get up!"[48] Does this desire to lie
in *Slumberland*'s arms enact a kind of therapy, then? Too heavy for readers
and editors, perhaps; comic strips' transformation to an adult medium
with mass grown-up appeal was thanks to far lighter fare, in the form of
a chinless racetrack junkie.

———

MR. A. MUTT SAGELY NOTED, "I'm a rum for working for $10 a week. I see
here where a guy copped a million on the track."[49] His 1907 adventures ran
on the *San Francisco Chronicle*'s sports pages, largely because the horses
Mutt mentioned were actually running that day, often at the Emeryville
Track across the bay. Since Mutt (and cartoonist Bud Fisher) didn't know
who'd win, the strip was a natural cliffhanger; readers, mostly male com-
muters, tuned in day after day to see Mutt's reaction to the turns of for-
tune and horseflesh.[50] Six months later, the rangy Mutt, convicted for
petty theft and committed to an asylum, rescues Jeffries, his name later
shortened, perhaps to match his tiny stature. The duo, in a strip renamed
Mutt and Jeff in 1916, remained a transplanted vaudeville double act, mug-
ging and slapsticking, for almost seven decades.[51]

The strip was quadruply groundbreaking. It made legal history: lured
away by Hearst, as so many were, Fisher copyrighted the strip on his last
day at the *Chronicle*, sneaking into the engraving room after the strip's
editorial approval and writing "Copyright 1907, H. C. Fisher" on it before
the plate was made. Eight years later, when he left Hearst for another
syndicate, the publisher inevitably tried to imitate the strip; but a court
order restrained him from doing so, making Fisher the first cartoonist to
successfully manage the trick. Formal innovation: *Mutt and Jeff*, unlike its
predecessors, was laid out horizontally. Fisher thought it would be easier
to read that way. He was right.[52] Frequency and regularity: it ran six days
a week. Daily comics had appeared since 1902, true, but the *same* strip
almost never appeared more than biweekly. Strips running on a daily
basis didn't begin until the mid-1910s, and even comics-loving Hearst

only introduced the first daily comics *page*, in the *New York American*, on January 31, 1912.[53] And finally: it marked that pronounced shift toward strips focusing on adults, as protagonist, subject, and audience.

George McManus had explored the terrain early, with 1904's *The Newlyweds*, whose "interminable cooing . . . drove most of their friends and relatives to distraction."[54] But his later strip, depicting life after the honeymoon wore off, both matrimonially and as an American metaphor, was far more successful. *Bringing Up Father*, almost universally known as "Jiggs and Maggie," debuted in 1912 and featured an Irish immigrant suddenly made good (precisely how is never specified); in contrast to his socially aspiring wife, former pickle factory employee Maggie, Jiggs just wants to play cards and eat the corned beef and cabbage of his youth. McManus was inspired by a play performed at the St. Louis theater his father managed. "The Rising Generation," notable for its onstage, ad-libbed, real-stakes twenty-minute poker game, featured "a little Irish laborer" who'd struck it rich and snuck out of his Fifth Avenue apartment to the game despite wife and daughter's snobbish disapproval. McManus had always seen "a knockout strip" in the situation, and he was right: on *Father*'s twenty-fifth anniversary, McManus received a congressional dinner and telegrams from Supreme Court justices and cabinet members. Ironic, perhaps, that the strip celebrated as quintessentially American was built on questioning the American dream's ostensibly successful result.[55]

Several other defining domestic strips of the era were also about, well, losers, albeit losers championed by an unquestioned winner, a product of privilege.

Joseph Medill Patterson was far more than his rarefied background. A product of Groton and Yale (class of 1901), he covered the Boxer Rebellion for Hearst's *New York American* rather than his own family paper, the *Chicago Tribune*.[56] He resigned his seat in the Illinois House of Representatives after learning that his father and Republican Party bosses had fixed the election in his favor, following *that* up by becoming the campaign manager for socialist Eugene V. Debs's 1908 presidential campaign.[57]

Patterson's father died in 1910; disillusioned with socialism, Patterson took over the *Tribune* in partnership with his cousin, Robert McCormick (ideologically divergent, the two alternated editorial responsibility every month). Fighting in France in the Great War, he worked his way from buck private up to captain, a title he'd use throughout his life, earning the nickname "Aunt Josie" for the care he took for his men.

Patterson's variegated biography gave him familiarity with a wide constituency; it unquestionably honed his populist instinct. After the war, he launched the *New York Daily News*, filled with sex, scandal, and reader contests (such as providing the fifth line to a four-line limerick). Patterson famously looked over *News* buyers' shoulders on the subway to see which features they were reading; it was even rumored he dressed like a bum to mingle with Bowery readers. Understanding that adults bought the papers, Patterson wanted a strip about "real people . . . an average lower middle class family" whose desires and ambitions echoed those of his readers. That said, one clue as to how he perceived those readers might be his name for that family: a childhood term he and his sister had used for loudmouthed adults.[58]

When Sidney Smith's *Gumps* premiered in 1917, it *did* begin realistically, as a chronicle of the difficulties of raising a family with modest means. But the following year, the mysterious Uncle Bim was introduced, along with his even more mysterious rumored fortune, which upped the ante considerably. Patterson had learned early on that continuity was addictive: in 1914, he'd published a written version of each week's installment of the early movie serial *The Adventures of Kathlyn*, offering prizes for readers' guesses about subsequent installments. The *Tribune*'s circulation increased each of the twenty-six weeks the serial ran. A contemporary comics editor put it well: "You've got to remember you're not selling today's newspaper. They already *have* today's newspaper. You're selling *tomorrow*'s paper."[59] And so, *The Gumps*, for the first time in comics, ended with the words *To Be Continued* and opened with summaries of the story so far.

This wasn't just continuity. *Nemo* had continuity. This was suspense.

Yes, some readers complained that Smith drew things out. But even that annoyance implied something significant: increasing emotional engagement. Clubs adopted resolutions and sent telegrams regarding favorite characters. When beloved Mary Gold died, readers deluged the *Tribune* with inquiries about where to send flowers. Others demanded that Gold be brought back to life, questioning Smith's "right" to do this to them: this type of fan behavior would recur.

"The *Gump* paper"—which is how people asked for the *Daily News*—went from the lowest circulation of New York's eighteen daily papers to the top in under five years, forming the backbone of a new Patterson syndicate. By 1922, *The Gumps* had forty million readers.[60] This mass audience also came with substantial material compensation: although some cartoonists got a straight salary, some got salary plus 50 percent of gross income. Smith signed the first million-dollar contract in the business, $100,000 a year for ten years, and plopped a bronze statue of Andy Gump in his Wisconsin summer place that cost $35,000 in early-'20s money (well over ten times that today). *Mutt and Jeff*'s Fisher made a quarter million dollars a year by 1921; he bought a stable of racehorses, squired showgirls around town in a Rolls-Royce, and "purchased rooms from historic European houses and had them dismantled and installed" in his magnificent Park Avenue apartment.

Not that it was easy money. Syndication set a grueling pace, as cartoonists had to stay at least several weeks ahead of print date. George McManus, who lived in California and air-mailed his work to New York, wired King Features every time a plane crashed, claiming his strips had been on the downed plane; the syndicate would then rerun a week's worth of strips and McManus would get a respite. He tried it one time too many, though, and the syndicate wired back: "DEAR GEORGE NO WONDER YOUR WORK IS ALWAYS LATE. THAT PLANE WAS TRAVELING WEST. YOU'VE BEEN SENDING THEM THE WRONG WAY." Sometimes, all that money even seemed cursed. Fisher grew alienated from old friends, dying solitary and sad in that Park Avenue apartment; Sidney Smith died driving home after signing a new five-year, $150,000-a-year

contract in 1935.[61] And those creators proved, if not forgotten, replaceable: the idea of abandoning such lucrative properties seemed inconceivable, and indeed was. Strips went on, with new figures at the board drawing old ones. The tension between creative individuality and corporate property would remain at the heart of comics.

One contemporary comic bucked the trend, pushing the form's limits. George Herriman's *Krazy Kat* premiered a year after *Bringing Up Father*, in 1913, and can be described much as *Ulysses*, serialized just five years later, could be summarized as "a long walk around Dublin": accurate, but wholly insufficient. Installment after installment, year after year, Krazy Kat loves Ignatz Mouse, unrequitedly. Ignatz throws a brick at Krazy's head. Offissa Bull Pupp, himself in love with Krazy, hauls Ignatz off to jail. That's it. Well, no, that's not even *close* to it. The constant repetition plays out on a surreal Western landscape whose backdrop shifts abruptly from panel to panel; houses become trees, churches mushrooms. Krazy or Ignatz are of indeterminate gender, shifting in reference from episode to episode. The dialogue is "full of absurdities and Joycean fantasies." (Joyce himself, though, was apparently a *Mutt and Jeff* fan.)[62] All this spoke to the combination of optimism and resignation, shifting norms and wavering identities, characterizing the Great War and its aftermath.

Maybe it's not a coincidence that Woodrow Wilson was said to be one of the strip's biggest fans: his private secretary reported he read it before cabinet meetings. Other fans included E. E. Cummings and cultural critic Gilbert Seldes, who famously wrote in his influential *Seven Lively Arts* (1926) that "with those who hold that a comic strip cannot be a work of art I shall not traffic. . . . Mr. Herriman, working in a despised medium, is day after day producing something essentially fine." John Alden Carpenter, turning the strip into a 1922 ballet, compared Krazy to Don Quixote and Parsifal; Parisian Dadaists purportedly accepted Krazy as American Dada. Confronted with these analyses, Herriman apparently replied that he "merely drew a comic about a cat and mouse." Take that as you will.[63]

This enigmaticism extended to a contemporary puzzlement about Herriman: he "steadfastly refused to pose without his hat! . . . But he did

remove the gray fedora for a moment 'just to prove I have hair.' . . . As a matter of fact, Herriman has never been photographed minus the hat."[64] A reason for Herriman's seeming fixation on hattedness, as the critic perhaps understood upon seeing the hair beneath, was that it might have marked Herriman as Black, while his public profile most certainly didn't. It would be difficult to imagine Wilson, one of the most racist presidents in American history, enjoying *Krazy Kat* quite so much had he known its creator was Black. Some critics have suggested we take *Kat* as an allegory of Blackness in America, or of Herriman's Blackness (though it's certainly not *only* that), or, more broadly, as a question of ambivalence, a struggle to find identity's purchase. Relevantly, an earlier Herriman strip, 1902's *Musical Mose*, concerned a Black musician who supported himself by performing in disguise; when his true ethnic identity was revealed— and it always was—he was chased away. There may be subtext there.[65]

Like *Nemo*, *Krazy* wasn't popular; but unlike *Nemo*, it had a powerful champion. Hearst liked it so much he gave Herriman total creative control and a lifetime contract, and when Herriman died in 1944, King Features made sure no one replaced him on the strip.[66] Hearst's fannish patronage had a flip side: while he insisted on paying favorite cartoonists top dollar, his syndicate carried more strips than his own papers could print, and "since his charge to other papers for use of his strips was higher than that of competing syndicates—logically, Hearst felt quality should cost—his excess strips found few berths elsewhere." The future belonged not to Hearst's financially unviable model, but to Patterson's populist approach: his syndicate, with *The Gumps* at its heart, was ground zero for many of the era's defining serial strips. Symbolically, by contrast, Hearst's *World* changed its name during World War I, thanks to previous pro-German sentiment, becoming the unimpeachable *American*; its *Katzenjammer Kids* were now *The Shenanigan Kids*.[67]

═══

THE GREAT WAR had more important ramifications for comics. Expanded wartime production, supercharged by developing mass-production

techniques, kick-started the economy, resulting in prosperity and con-
sumption that was heralded by advertising, some of it through cartoons.
Between 1915 and 1920, America definitively shifted from majority-rural
to majority-urban country, solidifying its image as more urbane as well
as more urban. The automobile's arrival provided additional liberation.
Women were more present in public spaces and discourse than ever
before, thanks to labor-saving household devices, new occupational pros-
pects, and suffrage. (A 1920s *Life* cartoon features a man leaning over a
woman on a divan, who smiles enigmatically at the reader. The caption:
"THE 1920s GIRL: I wonder if he is after me or my vote?")[68] In 1913, a
woman needed nineteen and a half yards of material for an outfit; in 1928,
just seven. Women hadn't gotten appreciably shorter; flapperdom had
arrived, popularized by John Held Jr.'s iconic cartoons, "pored over like
a Paris fashion plate." Held's female counterpart, Nell Brinkley, created
the Brinkley Girl based on her drawings of the celebrated Evelyn Nesbit,
inspiring legions of women to curl their hair. Hearst syndicated Brinkley,
but many similar cartoons were distributed by the smaller Newspaper
Enterprises Association, among them Annette Bradshaw's *Feminisms*, a
gag cartoon panel, and Ethel Hays's *Flapper Fanny*.[69]

 Not everyone was as open to women's expanded role. In one emblem-
atic cartoon, a group of boys swimming naked beneath a bridge sense a
figure above them. Unable to tell it's a woman, they assure themselves,
"It's all right, fellers—it's a man. He just threw his cigarette away." Hearst
hired John Held Jr. to produce *Merely Margy* for King Features, and the
title's patronizing adjective speaks volumes. Syndicated comics often
expressed, and perpetuated, contemporary stereotypes; so-called "girl
strip" protagonists like Beautiful Babs and Dumb Dora frequently took
on a "French doll" appearance, suggesting they "were just helpless babies
to be rescued from the hard practical world around them." Simultane-
ously, though, the strips' *content* sometimes belied the illusion, present-
ing women as realistic, capable, and hardheaded, reflecting ambivalence
about women's changing role. *Dumb Dora* was subtitled "She's Not So
Dumb as She Looks"; the title character of Patterson's *Winnie Winkle the*

Breadwinner, introduced in September 1920, less than a month after the Nineteenth Amendment gave women the vote, worked hard to support her parents and little brother. Still, even Winnie was about display; she wore all the "contemporary working-girl fashions," while the eponymous Tillie the Toiler actually toiled in a fashion salon. King Features' strip *The Kid Sister* had cutouts with outfits you could put on.[70] Edwina Dumm, creator of 1918's gag strip *Cap Stubbs and Tippie*, published under her middle name. "When her identity is revealed to anyone who has been studying her work, the usual comment is: 'Impossible—a girl couldn't draw so convincingly about boys and dogs!'"[71]

Moral anxieties were, perhaps, even more pronounced. The *Baltimore Sun* dropped *Winnie Winkle* when Winnie became pregnant.[72] Cliff Sterrett, creator of the first successful "girl strip," *Polly and Her Pals*,[73] recalled, "We couldn't show a girl's leg above the top of her shoe . . . a comic strip kiss was unheard of, and all action had to take place and be completed before nine o'clock." After the war, he still received "many letters of condemnation . . . all I did was show a girl's ankle." *Polly* received equal alarm then, and critical attention now, for combining its domestic hijinks with the fractured modernist backgrounds and dreamlike transitions associated with McCay, Herriman, or Feininger. So radical were those settings that his syndicate, fearing reader abandonment, "ordered him to restore some measure of comprehensive normality."[74]

Another radical character emerged from Fleischer Studios, whose street-scene, jazz-infused immigrant sensibility produced Betty Boop, a unique combination of sexual knowingness and naivete, where with-it girl meets Hollywood ingenue (in one strip, she leads a leering mob to the set to help populate a movie scene).[75] But perhaps the most influential girl strip was Ernie Bushmiller's *Fritzi Ritz*—once the cartoonist realized flapper Fritzi's niece, Nancy, was the real star.[76] In a mid-1940s strip, Nancy suggests to friend/foil Sluggo that they should start a vaudeville theater. When he creates a sign ascribing all the credit to himself, she agrees with his statement "I believe in makin' a big splash"—by splashing paint all over the sign.[77] Her notably loud voice and ingenious optimism

match those of her most notable predecessor: a girl with similarly unrealistic eyeballs.

She had originally been a little orphan boy named Ottor. But Patterson, in the kind of decision that made him the dominant force in comics in the interwar years, reportedly told Harold Gray, "The kid looks like a pansy to me. Put a skirt on him and we'll call it *Little Orphan Annie.*" Immortality resulted. Gray and Patterson, both Midwesterners, probably knew the then-famous nineteenth-century poem "Little Orphant Annie," by "Hoosier poet" James Whitcomb Riley.[78] The curls came from "America's Sweetheart," Mary Pickford, specialist in portraying plucky orphans. Where the eyes came from is less certain, but their unforgettable blank look allows us to read multitudes into them. What comes out of her mouth, though, is less ambiguous. Annie is one of comics' great soliloquizers, perhaps *the* greatest, and the action often stops to let her speak her piece—or, more accurately, Harold Gray's. Gray, who'd assisted Sidney Smith on *The Gumps* before striking out on his own, spent his first twenty-three years on a farm (with a Great War stint as a bayonet instructor),[79] and Annie's heartfelt, plainspoken style was highly effective for expressing Middle American values.

Early on, Annie's an exemplar of pluck and grit who partners with self-made man "Daddy" Warbucks to fend off no-gooders posing as European nobility, contrasting American energy with Continental decadence and fakery. In a 1925 strip, when (fake) Count de Tour challenges Warbucks to a duel by slapping his face with a glove, Warbucks gives him an old-school beatdown in return.[80] But this munitions manufacturer's violence (consider that last name) suggests something pugnacious about Gray's championing of capitalism, rather than the benevolence his Daddy-ing implies. (Mrs. Warbucks first adopts Annie on trial, like a new washing machine. Warbucks himself has none of that, sternly correcting Annie on his first appearance: "You call me DADDY—see?")[81] Put another way, you could say *Little Orphan Annie* fought for capitalism against the quasi-socialist specter of That Man in the White House.

During the Depression, Daddy Warbucks went broke, got evicted

from his mansion, then worked his way back up to success again, befitting Gray's bootstraps philosophy. (The process took most of a year's worth of strips, illustrating how strong comics' continuity concept had become.) In a 1932 run, Annie takes a job from a striker, noting, "If he doesn't want to work for decent wages, o.k.—but he's got no right to keep anyone else from takin' th' job." Unsurprisingly, Gray advocated for the abolition of unions.[82] Henry Ford cabled his enthusiasm for the strip in 1933, and Gray, notoriously, not only advocated Franklin Delano Roosevelt's impeachment, but even had Warbucks symbolically "die" with Roosevelt's final election, reviving him once the president passed away. "You were sayin' that maybe it was the *climate* here that made you sick before?" asks a wide-eyed Annie. Warbucks, happily puffing away on a cigar, says, "Somehow I feel that the *climate* has *changed* since I went away."[83]

Patterson, it should be said, was a staunch New Dealer—at least until FDR's lend-lease policy, the breaking point for the committed isolationist. And not all strip writers were conservative, by any stretch. Liberals had *Joe Palooka*, and the *Daily Worker*'s *Lefty Louie*. Ernest Riebe's *Mr. Block* ran in the *Industrial Worker* from 1912 through the early '20s, the story of a (literal) working-class blockhead who identifies with the bosses and consequently suffers. (His misadventures, recounted in Joe Hill's song, became a popular entry in the *Little Red Songbook*.) But many strip artists, especially nationally syndicated ones, resisted the temptation to be explicitly political. Jabs at local politicians would be incomprehensible to a national audience; national political satire ran the risk of alienating local editors.[84]

Some of Patterson's most transformative strips didn't take an explicitly ideological stance at all, but held up a mirror reflecting different parts of the culture and, in so doing, shaped that culture's image of itself. In 1919, Carl Ed asked his high-school daughter about the "drugstore truth," the latest slang, the hottest craze. *Harold Teen* incorporated her answers: bell-bottomed trousers, autographed sweatshirts, slicker raincoats, and sundaes. In 1923, Patterson requested a "roughneck, low life sort of strip"

never before seen; *Moon Mullins* would become the template for genera-
tions of comics antiheroes. (In one 1928 strip, Mullins's landlady brings
him flowers in jail. "Whaddya mean flowers, Emmy? These is seeds!"
Mullins bellows. "They'll be flowers before you get out," she replies.)[85]
And Patterson featured the American landscape's newest addition, the
automobile, in *Gasoline Alley.*

Frank King's strip first targeted a very particular demographic, fea-
turing, as it did, a group of men who hung out on Sundays and talked cars.
Concerned about the strip's limited appeal, Patterson suggested adding
a baby to protagonist Walt Wallet's life. King pointed out that Walt was a
bachelor (out with a young woman in an earlier strip, he "proposed"—that
she buy his car); but Patterson was in a hurry, and so, on Valentine's Day
1921, a foundling arrived on Walt's doorstep. "I know you are kind hearted.
Please care for and give baby a good home," read the note on the bassinet;
he was, he did, and Skeezix (contemporary slang meaning, roughly, "little
shaver"—his real name was Allison) was adored by a nation. Thanks in no
small part to a remarkable innovation of King's: Skeezix, Walt, and all the
Alley's characters aged, just like their audiences. Over decades, Skeezix
would grow to have a family of his own. King's work was also remarkable
for its composition, particularly his Sunday pages, which treated the page
as one large canvas, allowing him to set an overall visual tone that was, at
times, quite experimental, even poetic.[86]

Patterson creator Chester Gould explained *his* strip's appeal thus:
"When gangland . . . was in full bloom during the scarlet days of prohi-
bition, the remark was often made by a good citizen . . . 'Why can't they
get those birds? Why, say, if I were a cop, I'd shoot them right down on
the spot. I wouldn't give them a chance.' "[87] Gould, graduate of the $20
mail-order W. L. Evans School of Cartooning course, originally submitted
his strip as *Plainclothes Tracy.* Patterson, remembering the artist who'd
fruitlessly submitted a daily political cartoon via express train, costing
$50 a month,[88] saw possibilities in *this* effort, but changed the name.
Dick Tracy both maintained the police reference ("private dick" lacking
the sniggering connotation the phrase has today) and stressed the law-

and-order cop's Everyman quality, presumably appealing to every Tom, Harry, and Dick.

The first of *Dick Tracy*'s three consequential innovations was a marked ramp-up of comics' violence quotient. There'd been significant bloodshed in the mid-'20s strips *Out Our Way* and *Phil Hardy*, but neither had *Tracy*'s reach or resonance. (In the first strips Gould submitted to Patterson, an Al Capone-esque character used a blowtorch on someone's feet.)[89] The bad guys got it bad, via Tracy's bullet, or baroquely—scalded to death in a steambath or doused with cleaning fluid and ignited. And not just the bad guys. Officers were "frozen alive in refrigerator trucks"; Tracy himself faced death via dynamite, exploding furnace, icebox, and, of course, hot lead. Tracy's girlfriend (later wife) Tess Trueheart was often a victim, at times of implied sexual violence; it was an attack on her, along with her father's murder, that drove Tracy to his extremes.[90] The abuse of women—often, as here, as narrative catalyst for male action—would recur. As would the tension between Tracy's conservative heroism, upholding social order by punishing legal violators, and his radical, lone-wolf disregard of process. Though the strip preceded Miranda warnings, Tracy was definitely not a "read 'em their rights" guy.

Tracy's violence had its detractors. The *Salt Lake Tribune* pulled the strip in 1934 on those grounds; Patterson's paper, the *New York Daily News*, struck back, editorializing, "We'll stand by Dick. . . . We don't think comic strips influence children much, anyway, one way or another. . . . If Dick Tracy influences children at all, he influences them to follow our noble example and fight crime and crooks. . . . This is a tough enough world at best. The sooner a child finds out what kind of world it is, the better he or she is equipped to get along in it."[91]

Hearst's syndicate, for its part, featured Will Gould's *Red Barry*, "a former college football star turned undercover man for the police." *Barry*'s slashing lines, dramatic captions, rough street slang, and powerfully violent imagery put it a cut above the rest. (Gould, no relation to Chester, knew from whence he drew: he had numerous gangster aquaintances who "woke up dead, one encased in cement.") But in contrast to Patterson,

Hearst (or perhaps his mistress, Marion Davies) disliked the strip. "I will not tolerate such disgusting violence on my comics page!" came a note,[92] and the strip was duly demoted, never reaching Tracyesque heights despite a Buster Crabbe movie serialization.

And heights they were. *Tracy* reached a hundred million readers in its heyday; FDR was so engrossed that when he couldn't stand the suspense, he called the syndicate for advance word on what happened next. J. Edgar Hoover was sufficiently inspired to propose a strip about the FBI—*War on Crime* premiered in 1936. It failed to last the year, possibly due to Hoover's command that the agents remain anonymous, preventing the audience from identifying with a hero. But it might also have been his insistence that the strip feature not "lurid tales of a fictitious underworld, but actual case histories."

Which leads to *Tracy*'s second consequential innovation: the entrance of "scientific romance" to comics. And the contemporary term fit. Yes, Gould loved to *claim* the realism Hoover aspired to; many of his ideas, he said, were "gleaned from actual news stories. . . . We try to show authentic scientific facts and methods used today by our police." He even hired a retired Chicago cop to consult. But Tracy's square chin and hook nose were direct lifts from Sherlock Holmes, and his crime-fighting gadgets (that two-way wrist communicator!) were more in line with the feverish dreams being propagated in the pulp magazines of Hugo Gernsback, John Campbell, and other stalwarts of American science fiction's golden age—not least on their lavishly, garishly, fantastically, astoundingly illustrated covers, complete with bug-eyed monsters and threatened ladies in dishabille.

The pulp periodicals were hitting their peak in the early '30s. Up to 250 different magazines on the newsstands at any given time—twenty million words of prose fiction of every conceivable sort every month (with a few pictures here and there), offering 128 pages for a dime.[93] (Accounting in no small part for their popularity: although the word *pulp* has now become almost solely associated with content, the cash-strapped Depression-era consumer would have focused on the connotation of

cheapness.) "Hero pulps" featured characters with abilities just at the outer range of normal, thanks to odd biographies (Tarzan), obsessive training from profound motivation (Zorro), or almost sociopathic devotion to right and wrong (the Shadow).

Such heroes required antagonists—*Tracy*'s final, crucial innovation. Sure, those Jimmy Cagney and Edward G. Robinson movies featured guys who'd walk over everyone but their mothers, and who boasted, at least in the case of Scarface, a very specific physical feature. But *Tracy* had a whole gallery of supervillains (although back then, they were known as "the Grotesques"). It started fairly mellow in the '30s, displaying Gould's predilection for spelling maleficent activities backward (1937's Frank Redrum, 1939's Professor Emirc). But in the next decade, they blossomed into full, glorious weirdness: the Mole, Pruneface, Flattop, Shoulders, and Mumbles. Many were inspired by gangland types: Big Boy was Al Capone, while Flattop's background echoed Pretty Boy Floyd's. But even those real-life gangsters, whom Assistant Attorney General Joseph Keenan in 1934 called "super-criminals. . . . roam[ing] the length and breadth of the land, leaving bloodshed and terror in their wake,"[94] were small potatoes compared to their fictional counterparts. Thus the demand for someone larger than life to stand against them. A hero to rise, so to speak.

═══

TRACY'S QUASI-FANTASTIC EXPLOITS reflected a widespread Depression-era escapist impulse. Not *every* strip was escapist: Martha Orr's 1932 *Apple Mary*, about a street-corner apple seller, was "an instant success" that "embod[ied] the very essence of the Depression." (It became even better known as *Mary Worth*.) But many of the most influential strips were. Two powerful locales for escape, the exoticized past and idealized future, coincidentally made auspicious debuts the same day: Harold Foster's *Tarzan* and Philip Nowlan and Dick Calkins's *Buck Rogers* both saw print on January 7, 1929. They had antecedents; some, like 1926's *Oliver's Adventures* and *Swiss Family Robinson*, 1927's *Jack Lockwill's Adventures*, and 1928's *Tailspin Tommy* and *Frank Merriwell's School Days*, haven't stood the test

of time. Some had adventure thrust upon them: Roy Crane's *Washington Tubbs II* started as a girl-crazy comedy featuring a "pint-sized Romeo," but soon transformed into a series of exotic adventures—and in May 1929, the arrival of soldier of fortune Captain Easy[95] marked the strip's transformation into one of the first great adventure strips. But Tarzan and Buck Rogers had gotten there a few months before.[96]

Tarzan of the Apes made his debut in the pulp magazine the *All-Story* (later the *Argosy All-Story Weekly*) in 1912; his first movie premiered in 1917.[97] Despite those successes, previous efforts at comics adaptation had never gotten traction; and this arrival, expectations curbed accordingly, was heralded by just a few small ads stating, "The Apes Are Coming." But he made a big splash, thanks largely to Hal Foster's and, subsequently, Burne Hogarth's remarkable art. Much of comics revolves around the representation of the body in motion; Foster and Hogarth were committed to action grounded in physical reality. Their panels are snapshots of kinetic motion, stages of a posed Tarzan as he goes through his paces resembling nothing so much as scientific drawing from before the photographic age. Foster eschewed word balloons, preferring to create tableaux with accompanying blocks of text, expanding—or exploding—what some people thought comics should be.[98]

Foster's and Hogarth's realism extended to their fantastic, escapist settings. *Tarzan*'s combinations of "a dream Africa, a mythical jungle, warlike tribes, [and] lost cities" were so attentive to visual detail, so intense and lush in illustration, that the strip *felt* realistic, though it certainly wasn't.[99] *Tarzan* managed the neat trick of providing the exoticism American audiences craved while simultaneously satisfying yearnings for a simpler, nostalgic past. The fact that said past wasn't nearly so simple, that Tarzan's backstory is the story of British colonialism, drawing on and reinforcing pernicious stereotypes of Africa and its inhabitants, is illustrated by its criticism, in later decades, by African UN delegates.

Buck Rogers brought similar escapist, supremacist thinking into the future. It was also a product of the pulps, featured in *Amazing Stories*, and it assured you the future was exciting! (Every sentence in the strip

ended in an exclamation point.)[100] *Rogers* was a useful pastiche of popular trends: the hero, originally "Anthony Rogers," became Buck, a good cowboy name, for the comics version; movie cowboys were the rage back then, along with Western pulps. The 1920s marked the widespread use of manufactured rather than homemade toys, and *Rogers* ray guns spread through the market with alacrity. They were just six-shooters in futuristic disguise, but a good disguise, paralleling *Tracy*'s love of scientific romance.[101] John Flint Dille, head of the strip's syndicate, wanted "the theories in the test tubes and laboratories of the scientists [to] be garnished up with a bit of imagination and treated as realities." And that's what you got—the imagination dolloped rather than garnished, admittedly.

Unlike *Tarzan*, as noted SF writer and *Rogers* fan Ray Bradbury put it, "it was not so much how the episodes were drawn but what was *happening* in them." Put less diplomatically, critics felt Dick Calkins's spaceships looked "more like the pipe fittings that might have resulted had Salvador Dali taken up the plumbing trade."[102] But like *Tarzan*, the strip's dramatic tensions were grounded in fear and stereotype. *Rogers*'s premise is that the hero, preserved in a mine by a strange gas for five hundred years, awakens into a dystopian society. America is in ruins, thanks to the ruling "Mongol Reds . . . 'cruel, greedy, and unbelievably ruthless.'" All that can save America from foreigners and strangers (read: non-white people), warns the strip, is a white man with the power of technology. Sadly, the other prominent contemporary SF strip, Alex Raymond's *Flash Gordon* (1934), took the same approach, with its Orientalist villain Ming the Merciless of Mongo fighting the polo-playing, Yale-graduating hero.[103]

The Orientalism wasn't limited to science fiction. In another nomenclatural masterstroke, Patterson transformed *Tommy Tucker*, the tale of a boy dropped into a world of intrigue, into 1934's *Terry and the Pirates*, one of the most influential adventure strips of the '30s. Creator Milton Caniff described another Patterson idea: "the last outpost of adventure is the Orient, so why not a screwy Chinese who can act as valet, interpreter and purveyor of the bams and zowies?" Caniff tried to do his homework

via the *Encyclopaedia Britannica* and regular New York Public Library visits. "By now I am an armchair Marco Polo and tipping my hat to every Chinese laundryman in New York."[104] Following in Roy Crane's footsteps, Caniff combined attention to realism with a rip-roaring sense of motion and adventure torn from the cinema serial, a hypnotic combination. Nonetheless, today's readers encounter a vivid array of stereotypes, most famously the Eurasian Dragon Lady, first introduced in 1934 and conflating "alluring, terrifying woman" and "inscrutable Oriental" tropes and combining, per Caniff, "all the best features of past mustache twirlers with the lure of a handsome wench." When you consider that the strip, at its peak, reached thirty million readers in three hundred newspapers, you can make a fair case that *Terry* had a significant effect on Americans' view of Asia on the cusp of the Second World War.[105]

Some stereotypes, like the comic strip version of Earl Derr Biggers's Charlie Chan novels, or *Annie*'s Punjab and the Asp (introduced in 1935 and 1937, respectively), may have been designed without rancor, even if they resulted from an exoticized imagining of the other. But others, emphatically, weren't. The Dragon Lady spoke in dialect only early on, but Red Barry's pal Hong Kong Cholly had lines like "He in glave danger— even ignolamus like Cholly see him fake Chinyman! . . . Wow is me!! We get killed up!" Racism can take diametrically opposite positions simultaneously, of course: while figures like Hong Kong Cholly displayed ignorance and cowardice, the strip version of Sax Rohmer's "insidious Oriental villain" Fu Manchu focused on "how the yellow hordes of the East plot to destroy Western civilization."[106]

Racist tropes had been in comics from the start, of course, published and perpetuated by an overwhelmingly white, male body of cartoonists. Outcault had strips called *The Gallus Coon* and *Pore Lil Mose*, whose letters to his mother were in exaggerated dialect. Swinnerton's 1905 *And Sam Laughed* showed Sam, who is Black, kicked out of a new job each week due to inappropriate laughter (often, notably, at the "hypocritical social attitudes and customs of his white employers"). Racist stereotypes worked their way into *Little Nemo, Moon Mullins, Hairbreadth Harry, Gasoline*

Alley, *Mandrake the Magician*, and *Minute Movies* (list not exhaustive). Funny animal comics, like Otto Messmer's *Felix the Cat* and, yes, Mickey Mouse mirrored and picked up on blackface stereotypes.[107] A 1928 work by E. C. Matthews, *How to Draw Funny Pictures*, "helpfully" noted "the wide nose, heavy lips, and fuzzy hair are all as important to a colored cartoon character as the dark complexion. . . . The cartoonist usually plays on the colored man's love of loud clothes, watermelon, chicken, crapshooting, fear of ghosts, etc."[108]

Endemic racism relegated the Black experience in comics to the margins. Black newspapers, an estimated 2,700 of them by 1900, boasted their own syndicate, featuring strips with Black protagonists leading three-dimensional lives. (Pullman porters helped smuggle them across the Mason-Dixon Line, since early distributors refused to circulate them in the South.) Strips included 1911's *The Jolly Bean Eaters*, a *Mutt and Jeff*–type piece; the decades-long *Bungleton Green*, about a ne'er-do-well turned adventurer; gag strip *Amos Hokum*; *Ol' Hot*, a humorous look at the contemporary Black bourgeoisie; and romance feature *Milady Sepia*, among others. Ollie Harrington's *Dark Laughter*, premiering in 1935 in the Black paper the *Amsterdam News*, had gags, often with a bitter twist. (A later Harrington cartoon featured a bandaged man saying, "Well, naturally I believe in nonviolence but the cops don't seem to know that!") The most famous Afro-American Continental Features Syndicate strip, from 1937 on, was Jackie Ormes's *Torchy Brown*, "an intelligent, self-reliant black career woman whose stories showed her fighting racism [and] sex discrimination" (and whose Patty-Jo doll, based on a different strip, was a "landmark" in postwar Black households).

But in the main syndicates, non-white characters, if they appeared at all, did so as stereotypes by writers often reliant on lazy, racist shorthand. A rare exception was Gus Arriola's *Gordo* (1941), about a "portly south-of-the border bean farmer, Gordo, his nephew Pepito, their menagerie," and their friends. Drawing on his own heritage, Arriola used his venue to educate readers about Mexico, introducing terms then uncommon, like burritos and piñatas; and, over the years, he dialed back on the "stereo-

typed lingo his characters spoke." "I realized," he said, "I was depicting a people—my people . . . so I started to use jokes other than ethnic."[109]

Stereotypes could be regional as well as racial. Al Capp's *Li'l Abner*, "fashioned after southern mountain folk," featured the Yokums, a portmanteau word combining *hokum* and *yokel*. Born Alfred Caplin in 1909, Capp took up cartooning after hearing that "Bud Fisher got $3,000 a week and was constantly marrying French countesses. I decided that was for me."[110] He'd assisted Ham Fisher on *Joe Palooka*, and the parting was rancorous: Fisher was so convinced Capp, who had met "mountain folk" after staying with a Memphis rabbi uncle, had swiped his hillbilly characters, he took to claiming the latter was slipping pornographic material into his work, even trying to convince the New York State attorney general. The allegations didn't take, but left the feeling among some that "there *were* hidden sex meanings in cartoons."[111]

Whatever the circumstances of *Abner*'s origin, its cultural influence was enormous. Sadie Hawkins Day, begun in 1937 and named after the *Abner* character, had over 350 towns and higher learning institutions celebrating the day of reversal of gender hierarchies within three years. Part of *Abner*'s appeal lay in its combination of innocence and sexuality: Abner himself, always on the brink of adult lust for Daisy Mae, never acknowledges it, even to himself. (When Li'l Abner and Daisy Mae finally *did* tie the knot, in 1952, *Life* magazine featured the happy couple on its cover.) That impersonation of male maturity by someone who is really an overgrown little boy, especially with regard to women, was a stereotype and truth that resonated through much of comics history.[112]

A second man-child costarred in one of the most successful strips of the '30s—and, indeed, ever. Murat "Chic" Young had done "girl strips" like *Beautiful Babs* and *Dumb Dora*, but his 1930 *Blondie* turned the type on its head. It started conventionally enough, albeit with an unconventional, perhaps unmatched, promotional gag: newspaper editors across America received a suitcase of lingerie bearing Blondie Boopadoop's name tag, followed by an explanatory telegram about the "mix-up." But Young's tale of a millionaire playboy and (presumably) bubbleheaded flapper turned

into something quite different, more like the then-prevalent Hollywood screwball comedies. When the two married in February 1933, in the teeth of the Depression, Dagwood was disinherited, following a twenty-eight-day "hunger strike" covered in news columns. He became the cheerful, suburban, eponymous sandwich–eating goofus dad many of us grew up with over the decades; she, an avatar of beautiful, understanding domesticity. So successful was the transformation—a 1941 contest to name the Bumsteads' second child drew 431,275 suggestions—those first traces seem like a strange dream.[113]

What if the stereotyping comes from within? Consider two useful case studies from early portrayals of Jews in mainstream—meaning English-language—comics. The active contemporary Yiddish-language press had its share of comics, too, notably *Der Groyser Kundes* (*The Big Stick*, 1907–1926), which took on daily politics and fellow Yiddish periodicals with caustic wit; the communist *Varhayt*'s strip about frantic matchmaker Gimpel Benish; and the *Tsayt's Charlie, What Are You Up To?*, whose Chaplinesque protagonist, modeled on creator Zuni Maud, was an early stab at comics autobiography.[114] This frantic, assimilative ethnic energy became available to English readers in Harry Hershfield's 1914 *Abie the Agent*.

Abie Kabibble had a curious, and emblematic, history. Hershfield, an Iowa-born son of immigrants, was a prodigy: his first strip, *Homeless Hector*, appeared in the *Chicago Daily News* before his fifteenth birthday. A second strip, 1910's cinematic melodrama takeoff *Desperate Desmond*, included cannibal chief Gomgatz, who used several Yiddish words as part of his "outlandish language," largely for Hershfield's own amusement.[115] At a friend's suggestion (or his editor's; accounts differ), he created a strip centered on a similarly-speaking character, "an up-to-date business man" constantly trying to sell the 1914 Complex automobile, bemoaning his failures to Reba, "mine gold." Hershfield's editor called *Abie* America's first adult comic; he was referring primarily to its concerns of middle-class commerce and marriage, but it was also profoundly American in its concerns about becoming, and being, part of America.

In one strip, Abie meets "Jennie Grossman who used to live up stairs by us on DeKoven Street"; when she cuts him and introduces herself as "Jennette Beverley Grossman," he fumes, then returns, "Abram BUCK-INGHAM Kabibble!"[116]

Hershfield told a Chicago women's club in 1916 Abie was intended as "a clean-cut, well-dressed specimen of Jewish humor [in contrast to] the big-nosed banker so often seen in films and sometimes other comic strips, too." The line betrays the anxiety of representation, of whether Hershfield's work was "good for the Jews"—a question posed even more sharply a decade later in judging Milt Gross. Gross, who numbered the great and good among the fans of the dozen-ish strips he simultaneously drew or scripted, was renowned for his use of Jewish dialect. Gross insisted it was a heartwarming reflection of his beloved Jewish immigrant community's foibles and trials; other Jews saw an impediment to Americanization. The Anti-Defamation League, founded during Hershfield and Gross's tenure, was first known as the "Anti-Caricatural Committees"; by the 1930s, Abie had dropped the Yiddishisms.[117]

This conversation *mattered*, because the comic strip's influence on American language was profound. Bud Fisher, of *Mutt and Jeff* fame, invented *piker* and the phrases *fall guy* and *got his goat*. Tad Dorgan came up with *applesauce, ball and chain*, and *cat's pajamas*, among others. *Barney Google* contributed *heebie-jeebies*. *Harold Teen* gave the world expressions like *sheiks and shebas* (boys and girls), along with *yowza, pantywaist*, and "Yeh, man, he's the nertz!" (Not all of these caught on to quite the same extent.) And Harold T. Webster's *Timid Soul* added a whole new character type to the lexicon—or, at least, named it: one Caspar Milquetoast. Comics even gave the world knock-knock jokes (through Bob Dunn's best seller of the same name)[118] and Rube Goldberg machines, those incomparable satires of the modernized, mechanized condition.[119]

That said, we'll end this chapter not with the machine, but the ghost. Lee Falk was a University of Mexico student when he sold *Mandrake the Magician* to King Features. None of Falk's wide range of interests—

stage magicians like Houdini, fictional detectives like Poe's C. Auguste Dupin, great explorers, gods, heroes of antiquity—were unfamiliar to those immersed in turn-of-the-century popular culture. Nor were colonial adventure, mythicized pasts, exoticized Orientalism, and exaggerated masculinity. In *Mandrake*, Falk simply mashed them all together, albeit beautifully. But for all his magic, Mandrake was still a man, like Dick Tracy or Captain Easy.

The hero of Falk's *next* strip, *The Phantom*, though, boasted something new: a "secret identity." Jimmy Wells dressed in purple tights and a black mask to go about his exploits. True, the Phantom had no powers unavailable to mortal men. What gave him the sobriquet "The Ghost Who Walks" or "The Man Who Cannot Die" was the Phantom identity's father-to-son passage. (Thanks to a centuries-old "oath of the skull" taken by an ancestor, the lone survivor of a pirate attack, to "devote my life to the destruction of piracy, cruelty, and greed, and my sons will follow me!")[120] The suit was just there to provide the anonymity people *mistook* for immortality. But the costume mattered. In just a few years, they wouldn't call them "superheroes," like now; the term of art would be "costumed characters."[121]

The only true challenger to the Phantom's crown as comics' first superhero was a spinach-eating, superstrong, English-mangling sailor.[122] Elzie Crisler Segar's Popeye first appeared in *Thimble Theatre* in October 1929, the same month as the stock market crash, and in some ways embodied '30s complexities and contradictions. Like his creation, Segar boasted an arm tattoo—his read "MPO," for "motion picture operator," a job he held for five years as a kid. Segar worked on *Charlie Chaplin's Comic Capers* before *Thimble Theatre*,[123] and the staggeringly popular Popeye—syndicated in over six hundred newspapers in twenty-five countries by the early '40s, along with movies, radio, over a hundred product endorsements, and a statue in Crystal City, Texas, "the Spinach Capital of the World"—shared '30s movie stars' appeal. He was both a dreamer and a realist, somewhere between common man and uncommon hero. It

wasn't just, or even primarily, his invulnerability (following an encounter with the magical Whiffle Hen), but his ability to keep striving, even after taking a licking, that spoke to Depression-era sensibilities.[124]

The age of heroes was in the air. And if in more literary fiction they took the form of Hemingway or Steinbeck's rugged, put-it-all-out-there masculinity, and in pulp fiction the mysterious manhood of the Shadow, who knew what evil lurked in the heart of men, the comic book business recognized, consciously or not, the appeal of combining these contradictions in a single individual behind a mask (even if said mask was just a pair of glasses and the strategic positioning of a spit curl). In short, the end of the Depression would mark the birth of the superhero.

COMIC BOOKS EXPLODE (IN EVERY SENSE)

We all think we know what a comic book is. For some, it's knowledge born of long familiarity: the weight, the paper, the staples, the way it flies across the room with the right flick of the wrist (this, of course, before "discovering" they're *commodities*, to be properly preserved and sheathed in Mylar). For others, they're simply part of the cultural landscape, appearing, depending on when you came of age, on newsstands, drugstore spinner racks, or in specialized stores. But where did they come from? And why call them books, when they're clearly magazines?

The answer, partly, is that they *started* as books. In March 1897, Dillingham's American Authors Library issued a bound edition of *The Yellow Kid in McFadden's Flats*, twenty-fourth in its series. Previous cartoon collections had focused on *Punch* or *Puck*; this marked a turn from glossy, high-culture weeklies to the populist rabble of newspaper strips. Perhaps attendant social anxiety was what led to the decision to bowdlerize the strips: redrawing and reconfiguring them, adding text to fit a theme. Or the difficulties in finding original art, or turning Sunday color art black and white, or concern that a book demanded the narrative momentum a concatenation of stand-alone strips lacked. Whatever the reason, "De Story of Me Sweet Young Life," as per the Kid's nightshirt message on the book's

cover, immersed "the brightly hued bomb of the *Kid* in a defusing bucket of . . . narrative." It worked: the book, priced at fifty cents (around $15 in today's money), sold thirty thousand copies, spawning dozens of other hardcover strip collections in those first years of the century.[1]

But perhaps that anxiety over narrative lingered: for book publication, the strip world's turn toward narrative serials couldn't come soon enough. Unsurprisingly, the first pure book collection of comics (with no interpolated text, unlike that *Yellow Kid* volume), was of that breakthrough serial strip *Mutt and Jeff.* In 1911, as a circulation booster, the *Chicago American* offered the book as a coupon return: six coupons clipped from the paper plus postage, and you got the book. They had to print forty-five thousand copies. And thus began the deluge: over a thousand strip-reprint books between 1897 and 1932. The dominant form, introduced by Cupples & Leon, was the black-and-white reprint book, nine and a half inches square with a flexible cardboard cover, sold on newsstands and passenger trains for twenty-five cents (a little over $3.50 today). Commercial considerations prevailed in determining who was reprinted, and thus canonized: *Foxy Grandpa* and *Buster Brown*, yes; higher-brow Feininger and Herriman, no. Another commercial technique Cupples & Leon adopted that would resonate in comics was to number the books, alerting readers to other volumes in the series for purchase. Early-twentieth-century readers, in other words, were used to walking around with books full of comics—just not what we think of as comic books.[2]

These collections, priced like books, weren't necessarily accessible to the working-class audience that had gravitated to daily papers over glossy weeklies in the first place; so companies looked for cheaper solutions. In 1922, *Bringing Up Father* cartoonist George McManus partnered with Rudolph Block Jr., the son of Hearst's comics editor, to create the Embee Distributing Company (note the initials) and produced the first regular newsstand comic, *Comic Monthly*, full of previous years' selections of *Polly and Her Pals, Tillie the Toiler, Barney Google*, and *Little Jimmy*, aimed at the widest possible audience. ("Great for children and even greater for grown-ups!" read an ad.) It only lasted a year, but its innovations—eight-and-

a-half-by-ten-inch dimensions, a soft paper cover, and cheaper interior paper, all of which allowed for a ten-cent price tag, about $1.50 in today's money—were crucial to the comic book's development.[3]

Those paper covers and interiors matter: the story of comic books is also the story of paper, and its next chapter developed in no small part from the need to keep an expensive printing press running during a shop's generally idle third shift. The press in question belonged to the Eastern Color Printing Company in New York; George Delacorte and his Dell Publishing Company used it to print *The Funnies* in 1929. *The Funnies*, essentially a Sunday comics supplement without the rest of the paper, was sixteen pages, in tabloid format, printed on newsprint, and came out on Saturdays. It started at ten cents, like *Comic Monthly*, but went to half that. Despite the price shift, it didn't last long; maybe people felt it looked so much like a newspaper supplement, it should've come free with papers they'd already bought—despite, in an important development, containing original material.[4] But Eastern Color sales manager Harry Wildenberg, looking to keep those presses running, went corporate.

Given comics characters' significant role as commercial pitchmen from the Yellow Kid onward, combining comic books and companies was a natural development. Wildenberg, contemplating the automobile generation, convinced Gulf Oil to give away comics with every gas station fill-up. The *Gulf Comic Weekly* ran for thirteen weeks in 1933. Encouraged, Wildenberg and one of his salesmen, Maxwell Charles (M. C.) Gaines, approached Procter & Gamble about ordering a million copies of the strip-reprint collection *Funnies on Parade*. Recent experience had taught them they could reduce, fold, and bind full-color Sunday comic pages to produce "an economical, eight-by-eleven inch, full-color book of comics" on their presses—that is, a comic book.[5]

Gaines had previously made ties reading "We Want Beer!" during Prohibition, among other novelties. Now he evangelized about comics, and their associated profits, getting brands like Wheatena, Canada Dry, Kinney Shoes, Milko-Malt, and John Wanamaker into the sponsored comic book business. *Skippy* radio show listeners and Phillips' Tooth Paste fans

got half a million comics.[6] Nobody considered these anything but colorful, potentially profit-generating fish wrappers, but they made history. One, 1933's *Famous Funnies: A Carnival of Comics*, can be credibly called the beginning of the comic book—its size and its look providing the template for billions of issues to come.

Their spread would also prove historic: these premium giveaways didn't come close to the most popular syndicated strips' reach, but many print runs exceeded a hundred thousand, some over a million. And so would their economic model—thanks, as the story goes, to an impulsive experiment by Gaines. Spotting extra copies of a free giveaway in the warehouse, he put a ten-cent price sticker on a few dozen and asked some news vendors to put them out for sale over the weekend. The comics sold, the vendors wanted more, and suddenly there was a new distribution channel and profit source all at once, lucrative enough to get Gaines and family their own Brooklyn house.[7]

Once Dell backed out of the business (they'd tried selling *Famous Funnies* to Woolworth's, which felt sixty-four pages of reprints weren't worth the dime), newsstand distribution was Eastern Color's main play. Back then, in May 1934, the corner newsstand wasn't just a marketplace; it was a social hub, a place to hang around and explore new material— news of the day, pulp fiction, or, yes, comics. Anyone, kids included, could browse—and, of course, buy. But newsstands expected, required, regularly scheduled publication, and thus was born the first monthly, normal-sized comic magazine. Eastern Color's next series of *Famous Funnies* lost money at first. But it was in the black within six months and never looked back.[8]

Seeing Eastern Color's success, Major Malcolm Wheeler-Nicholson founded National Allied Publications (later National Periodical Publications) in 1935. Wheeler-Nicholson, in his own telling, "chased bandits on the Mexican border, led a battalion of infantry against the Bolsheviki in Siberia, helped straighten up the affairs of the army in France, commanded the headquarters of the American force in the Rhine, and left the army with a select assortment of racing and polo cups, a sabre and

a battered typewriter."[9] The Major's colorful, sometimes controversial, military career[10] was matched by his equally colorful wardrobe, favoring a cloak, beaver hat, and walking stick. Drawing on his background, he produced military and swashbuckler adventures for the pulp magazines *Argosy* and *Adventure*. Coming from the pulp, rather than the newspaper, world, the Major and his ilk contributed different emphases to the comic book's structure and grammar.

That year, an average well-stocked newsdealer carried 150 different pulps. They had colorful bad guys with names like Robot Master and the Masked Headsman, colorful story titles like "City of Doom" and "The Crime Ray," and colorful covers that would look a lot like comics splash pages. And the heroes were equally remarkable. The Phantom was, in the end, only human; by contrast, Doc Savage, premiering in a 1933 pulp story entitled "The Man of Bronze," "could speak any language, sidestep a bullet, follow a trail by his sense of smell, outrun a car, scale a sheer wall by gripping the tiniest cracks and a profusion of other mental and physical accomplishments." That same year, readers met the Phantom Detective, an "idler, playboy millionaire . . . [who,] as the Phantom Detective . . . battled crime and criminals" via his "secret crime laboratory . . . equipped with every known device." The savage Spider did less battling, more executing: "Once, when he needed a human head, he simply decapitated the first felon who crossed his path." The most famous pulp creation of them all, though, was unquestionably 1931's Shadow. Creator Walter Brown Gibson wrote over a million and a half words—per year—of Shadow fiction in the early '30s, renting a triplex off Central Park off the royalties from his 283 (!) Shadow novels.

Ironically, the Shadow's appearance in the pulps at all was largely to preserve his copyright: his fame came primarily from the radio, as the announcer for *Street & Smith's Detective Story Hour* (voiced, at one point, by a young Orson Welles).[11] Radio was unquestionably *the* home entertainment medium of the '30s and '40s; radio households jumped from 60,000 in 1922 to 13.75 million in 1930.[12] It was the perfect Depression entertainment: comparatively cheap, available in every house, a domes-

tic, child-friendly complement to the newspaper. Families gathered around the electronic hearth to listen to favorite strip characters like Little Orphan Annie brought to life. (Three different actors played Sandy: a barker, a growler, and a whiner.) Radio was highly visually evocative, inviting listeners to use their imaginations to depict the sounds effected. By their nature, fantastic adventure stories—and so, pulp heroes like the Shadow—flourished there; many early comic books, in no small way, were radio serials brought to visual life.[13]

Wheeler-Nicholson undoubtedly noticed something else about pulps, besides their vast audience: the number of people clamoring to write about them. Pulps like Hugo Gernsback's *Astounding Stories* featured letters sections where like-minded individuals could find each other, even meet up. Early science-fiction fan networks, like New York City's Futurians, would disproportionately constitute the field's writers, editors, and agents; some would become hugely important in comics, too.

Wheeler-Nicholson figured fans like these were an ideal source for original comics content. No more negotiating with syndicates for costly reprints; new material might even—who knows?—sell better than the stuff consumers had already encountered in the then-omnipresent daily newspaper. Sure, creators would try snagging a lucrative syndicate deal first. But vanishingly few would succeed, and, given the economic climate, they'd happily take whatever they could get at what was, let's face it, still only a step up from a cut-and-paste chop-shop operation. Desperate, wet behind the ears, they'd beg to sign whatever contracts the Major put in front of them.

National launched *New Fun* comics in 1935, so titled because the contents were all new material. The thirty-six-page, black-and-white tabloid seemed in search of its audience; *Oswald the Rabbit* and cowboy stories for kids, but adult advertising—the first modern comic to feature it—pitching Gem razors and a Coyne Electrical School booklet explaining "how to get in on the ground floor of television." It wasn't a huge success. Changing its title to *More Fun* and adding another title hitting that same note, *New Comics*, didn't help; more significantly, neither did Wheeler-

Nicholson's decision to shrink the oversized pages to a format closer to today's, while using the savings to add color.[14]

For one thing, he had competition. Gaines and Eastern Color had parted ways that same year (family legend relates that Gaines came to work one day to find his office locked). Gaines promptly went to the McClure syndicate, which had two color presses from the defunct *New York Graphic* sitting idle. He offered to keep them running in return for 50 percent of the resulting business, raising his end by partnering with George Delacorte and Dell. Thus was born *Popular Comics*, reprinting the top strips: *Dick Tracy, Little Orphan Annie, Terry and the Pirates,* and *Gasoline Alley,* among others. Longtime editor and production chief Shelly Mayer called it "a schlock operation," peeling original art off cardboard and cutting it to fit comic book proportions.[15] The syndicates themselves soon jumped in: United Features published *Tip Top Comics* in 1936; Hearst's King Features had *King Comics*; even Walt Disney gingerly got into the fray, publishing comics in 1935's *Mickey Mouse Magazine.*

For the smaller publishers, this was a distribution game—grinding it out, negotiating with syndicates for reprint rights. It had more unsavory elements, too. Dirty money from Prohibition profits, much of it mob-related, was looking for safe businesses to be laundered through; early comics occasionally provided that haven. Also unsavory were the "spicy," often pornographic "Tijuana bibles" then reaching their height. The bibles were arguably the first original comic books, preceding the Major's by several years.[16] While some were of the tamer, "She was only a farmer's daughter, but oh, how she harvested me" variety,[17] on a continuum with magazines like Chicago's late-'30s *Lulu: The Life of the Party* ("Umph on Every Page"), the bibles were generally far more explicit. As one called *Iva Crustycrotch Presents Betty Boop in Flesh* suggests, the bibles, also known as "Eight-Pagers, Two-by-Fours, Gray-backs, Bluesies, Jo-Jo Books . . . or simply Fuck Books,"[18] frequently presented iconic comic strip characters like J. Wellington Wimpy, Donald Duck, and Minnie Mouse in remarkably indecent activities.[19]

The Major, eschewing these more lucrative routes, tried keeping

afloat by using such devices as paying his writers unreliably, but was nonetheless soon in debt to his printer and distributor. Independent News had been formed in 1932 by Harry Donenfeld and Jack Liebowitz, veterans of the men's pulps—that is, they were involved, via various companies and relatives, in girlie magazines like *Juicy Tales*, *Spicy Stories*, and *Artists and Models Magazine*. The New York Society for the Suppression of Vice discovered full-frontal photos in one of Donenfeld's magazines; Donenfeld got editor Herbie Siegel to take the rap and spend a few months in prison in return for a lifetime job.[20]

So, perhaps it wasn't surprising that Independent was willing to capitalize on the Major's troubles. The company had started primarily as a distributor, but Donenfeld and Liebowitz saw production as a way to diversify and get in on the ground floor of a newly growing industry. When the Major developed a new idea in early 1937—focusing all of a comic's stories thematically; in this case, detectives and crime fighting—he was forced to do it in partnership with Independent. A new company was created to acknowledge that reality: *Detective Comics* was published neither by National Allied nor Independent, but by Detective Comics Inc. In later years, the company became known by its initials: DC.[21]

Any newsstand browser knew how popular the word *detective* was. Pulp titles then on sale included *Detective Action*, *Action Detective*, *Fast Action Detective*, *Double Action Detective*, *Crack Detective*, *Smashing Detective*, *Hollywood Detective*, *Double Detective*, *Triple Detective*, and *Famous Detective*.[22] The Comics Magazine Company, formed by defectors from the Major's stables, had published *Detective Picture Stories* in 1936. But *Detective Comics* differed from all its predecessor comics, and not just thematically: the others, either strip reprints or slavish knockoffs, replicated the now-standard newspaper strip layout. *Detective* stories were designed to take advantage of the comic book's particular shape: more down than across; larger panels that could even splash across the whole page.

The detectives featured in the first issue were largely forgettable: Speed Saunders, who, "in contrast to the methodical Sherlock Holmes type of sleuth . . . relies on nerve and an uncanny sense of hunches!";

Brad Nelson, "crack amateur sleuth"; Cosmo, the Phantom of Disguise; and Slam Bradley, "ace freelance sleuth, fighter, and adventurer."[23] None even made the cover, which instead featured a stereotypical Asian figure, either to evoke an Orientalist sense of mystery or capitalize on the popularity of Charlie Chan. (The Cosmo story contained the line "Me have fliend, he have nice loom for lent.")[24] There was commercial reticence to risk valuable cover real estate on an unknown ace detective who looked just like an ordinary guy. Readers, everyone knew, bought comics off the newsstands not from allegiance to a continuing serial narrative, as with many of the strips, but a one-shot experience based on, yes, the cover.

Which is why the first issue of DC's *next* magazine (June 1938) made such a splash. The title, *Action Comics*, promised exploits of all sorts. (It was almost called *Action Funnies*; thankfully, wiser heads prevailed.)[25] And the cover delivered. A man in colorful garb holds a car above his head, smashing it into a rock outcropping. Other men flee the scene. One, in the foreground, clutches hands to head in apparent disbelief; in the background, another's hands are raised fearfully. Critics frequently note it's hard to tell from the cover whether Superman is a hero or a villain: less surprising, considering the character's development.

Jerry Siegel and Joe Shuster, two Jewish kids from Cleveland—a futuristic-feeling city then, the nation's first with public electricity—had grown up on pulps and comic strips. Superman owed a lot to Doc Savage; even more to Philip Wylie's 1930 novel *Gladiator*, which featured an observation concerning insects' proportional strength that Siegel and Shuster used to explain Superman's power in that first story.[26] Siegel, who'd created the early SF fanzine *Cosmic Stories*, reviewed *Gladiator* in his second fanzine, *Science Fiction*. Its third issue, dated January 1933, featured "The Reign of the Superman," a story written by Siegel (under a pseudonym) and illustrated by Shuster. In it, a man taken off a Depression breadline by bald, villainous Professor Smalley is given a secret drug that transforms him into a "mental giant, able to tell the future, assimilate all the world's knowledge, read and control people's minds, and transport himself at will to anywhere in the galaxy." The Superman plans to conquer the world:

"I am a veritable God!" he thinks. But he loses his powers and returns to the breadline.[27]

Siegel wrote in his fanzine that same year that he was "working upon a scientific fiction cartoon strip with an artist of great renown." He later described the eureka moment to the *Saturday Evening Post*:

> I am lying in bed counting sheep when all of a sudden it hits me. I conceive a character like Samson, Hercules, and all the strong men I ever heard tell of rolled into one. Only more so. I hop right out of bed and write this down, and then I go back and think some more for about two hours and get up again and write that down. This goes on all night at two-hour intervals, until in the morning I have a complete script.[28]

By 1936, Shuster had made sketches. The costume was based on a trapeze outfit: the tights from standard pulp SF illustration, the cape added for a sense of motion. In bright primary colors meant to pop off the Sunday comics pages they hoped he'd appear in—since, naturally, their goal was to make the newspapers, achieving social status and, more importantly, lucrative syndication fees.[29] But perhaps Superman's most important aspect wasn't his superness, but his humanity, embodied in ordinary Clark Kent, who, though named after Clark Gable, certainly didn't share the actor's élan. Siegel explained:

> As a high school student . . . I had crushes on several attractive girls who either didn't know I existed or didn't care I existed. It occurred to me: What if I was real terrific? What if I had something special going for me, like jumping over buildings or throwing cars around, or something like that? Then maybe they would notice me.[30]

That distilled voice of adolescence, particularly *male* adolescence ("What if I was real terrific? Then maybe they would notice me"), would be, in

many ways, the key to the superhero's success. Accompanied, arguably, by a substrate of loss: Kal-El's orphanhood and desire to fight crime has echoes of Siegel's early loss of his father, who'd suffered a heart attack during a holdup.

But syndicate editors didn't see Superman's potential. Siegel and Shuster racked up seventeen rejection letters (the Bell Syndicate: "We are in the market only for strips likely to have the most extraordinary appeal, and we do not feel Superman gets into that category"; United Features: "a rather immature piece of work"; Esquire Features: "Pay a little attention to actual drawing . . . yours seems crude and harried"). Their first ambitions thwarted, they turned to comic books. They weren't strangers there; they'd done several features for the Major's *More Fun* and *New Comics*, mostly following the hot trends with "Federal Men," "Calling All Cars" (later "Radio Squad"), "Dr. Occult" (DC's first costumed hero), and, for *Detective*, "Slam Bradley." (Bradley, it's worth noting, would turn out to be quite a success by any standards but Superman's; running for 152 issues, he was comic books' "first enduring character.")[31]

Nonetheless, the Major had passed on Superman, as had Gaines, who had been alerted to it back in 1937 by his editor, Shelly Mayer, who'd snagged it off the McClure syndicate's slush pile. But by 1938, the Major was no longer in charge: he'd gone into receivership in March, and new boss Donenfeld was publishing a newly expanding stable of comics through DC. So, Mayer passed the comic over to Vincent Sullivan, an editor presiding over a DC title in the works. Sullivan thought Superman would be a perfect fit for *Action Comics*, and he bought the thirteen-page, ninety-eight-panel story for $130, around $2,500 in today's money.[32]

And in return for that, he also got the rights. To Superman.

When it came to comic books then, the ownership question was, or at least seemed, pretty cut and dry. If they were reprints, they belonged to either cartoonist or syndicate; if they were original, you signed away your rights or you didn't get published. Or paid: your output was work for hire, generally paid for at a page rate. And almost nobody thought much

about it. If the strip market wasn't biting, you pretty much took what you could get: there were a lot of super-fish in the sea. A useful metaphor: that first Superman story was literally cut up and rearranged from panel layouts designed for strips, every action signaling the book's second-choice status. (The Major himself called comics "more or less . . . brochures to interest the newspaper syndicates in an idea.")[33]

And besides, after all those rejections, Superman was hardly considered a slam dunk. The big boss, Donenfeld, was even notoriously cool to the cover that would define a movement. "We're going to die with this," Mayer remembered him saying. "Who the hell can hold a car up in the air?"—not realizing that, for the kids, that was precisely the point. Superman didn't even feature on the next few covers: *Action*'s ninth issue spotlighted a race car smashing through a fence. But kids were asking for "that magazine with Superman in it"—and there were lots of kids. In 1939, the American population under the age of eighteen was a record-setting level of more than forty-five million. And Donenfeld was pragmatic enough to recognize when he was wrong. By issue ten, a chastened *Action* featured Superman bashing a (presumably enemy) plane, with a notice proclaiming, "Superman! Appearing in this issue and every issue."[34]

Pretty soon, *Action* and spin-off title *Superman* were each selling over a million copies an issue, a good 10 percent of the entire comic book market. And Siegel and Shuster got their wish after all: the *Superman* strip started a little over six months after the character's debut, in sixty papers; within two years, over three hundred carried it, with twenty million readers. That figure was matched by the number of listeners to the *Superman* radio show, which premiered in 1940 and aired for fifteen minutes on Mondays, Wednesdays, and Fridays, during the children's hour between 5 and 6 p.m. "I'll give you a fortune if you'll star in the movies!" a movie producer says when Superman saves him from kidnappers in a 1940 comic. "Sorry . . . not interested!" Superman says, departing. A year later, the Fleischer Brothers' Paramount cartoons arrived in theaters; their painstaking effort, requiring twice the production time and costing

three to four times as much as the average cartoon, got the first one nominated for an Oscar.[35]

Perhaps the most omnipresent Superman was the merchandising Superman. Besides those Buck Rogers ray guns, consumers could buy Flash Gordon wedgie shoes, Gasoline Alley fix-it kits, Prince Valiant swords, and Daisy Mae's "Dogpatch denims";[36] why should comic *book* characters be any different? A clever early Siegel plot revolved around a Superman impersonator pitching gasoline, bathing suits, and "development exercisers" for personal gain: "I've even made provisions for him to appear in the comics!" the faux-Superman's manager boasts.[37] In 1941, Superman created a Krypto-Raygun, "with which [he] can snap pictures—they are developed right in the gun—and can be flashed upon a wall!" Ads for the invention (well, an identically named flashlight/projector) soon appeared in *Superman*.

Siegel and Shuster began to see just how much money their creation was worth, and how little flowed to them. After protesting, the pair got more money, making well over six figures in 1941, but it was still work for hire.[38] Which hardly dissuaded others from entering the business. When Bob Kane heard in 1939 that Siegel and Shuster were each making $80 a week, twice what he was, and that Donenfeld was looking for another costumed hero, it stimulated his imagination. Kane put his head together with Bill Finger and, later, seventeen-year-old Jerry Robinson (Kane and Finger were grand old men of twenty-three), stirred together generous helpings of the Shadow, Zorro, Dick Tracy, the Sandman, and Avery Hopwood and Mary Roberts Rinehart's Broadway play (and later movie) *The Bat*, not to mention the acrobatic Douglas Fairbanks, and came up with a millionaire playboy who fought crime by dressing up as a giant bat.[39] And the floodgates opened.

═══

BY 1939, fourteen new costumed heroes had appeared in various companies' publications; in 1940, another twenty-two. Few other than antiquarians recall the Crimson Avenger, the Masked Marvel, the Flame,

the Clock, the Green Mask, Amazing Man, or the Gay Ghost. (Or 1940's Red Bee, whose belt buckle concealed "a trained bumblebee, who came buzzing out on cue to sting criminals.")[40] Perhaps the strangest was 1941's Plastic Man; petty criminal Eel O'Brian fell into some acid and became, well, rubbery, then rehabilitated. He stood out thanks to creator Jack Cole's Daliesque combination of visual dexterity and absurdist comedy, making him superherodom's response to Rudolph Dirks and Winsor McCay. Though he can take any shape, for example, he maintains the same colorful uniform; his powers of disguise should be somewhat limited, but people don't seem to notice. "I never knew fighting for the law could be so much fun!" O'Brian says, finishing his first adventure. Readers felt the same way.[41]

Plastic Man was part of Everett "Busy" Arnold's Quality Comics line, which featured other bizarreries. Kid Eternity could summon any historical figure by shouting, "Eternity!" Alerted by Rembrandt that someone is replacing great artworks with forgeries, the Kid calls on Inspector Javert from *Les Misérables* to help. Javert's too obsessive: the Kid sends him back in favor of Nostradamus, whose oracular statements are too confusing.[42] And the Kid wasn't nearly as idiosyncratic (or brutal) as Fletcher Hanks's heroes, who brought criminals to bloodily creative ends.[43] Stardust the Super Wizard's secret ray displays murder victims' skeletons before their assailants; Fantomah, "Mystery Woman of the Jungle," defends the secret of the elephants' graveyard with a skull face that appears beneath her skin. "You are partners!" she intones to the poachers. "Partners in death!"[44]

At least one early hero was lost to litigation. Donenfeld's accountant, Vincent Fox, seeing the Superman dollar signs, left to create his own company, tapping a young artist named Will Eisner and his partner, Jerry Iger, to create their own Superman knockoff. Wonder Man appeared in May 1939; DC promptly sued for copyright infringement. Judge August Hand ruled for the plaintiff in the U.S. Second Circuit Court, asserting that Fox couldn't publish any stories in which Wonder Man did Superman-ish things. *Wonder Comics'* first issue was its last.[45] But many characters created in those first, febrile years of the superhero

explosion are still around today. Space prohibits us from detailing all their origin stories, powers, weaknesses, designated supervillains, etc., but a few general points need elaboration.

First, perhaps foremost: the costume. The first Green Lantern, Alan Scott, says it all when he soliloquizes, "I must make myself a costume so bizarre that once I am seen I will never be forgotten!"[46] Granting a somewhat different usage of *bizarre* in 1940, the industry's collective decision to employ costumes—eye-catching to the kids, but with attendant psychological, even fetishistic subtexts—stands out. But no less important was writers' intensive reliance on contemporary cultural touchstones in creating their heroes: immediately available, clearly comprehensible, emotionally resonant. What strikes a reader so powerfully now is these pastiche artists' frenetic energy, as they dove high and low through movie houses and public libraries to mine nuggets they could dress up in bright costumes.

Ancient Egypt, hot off the discovery of King Tut's tomb (and Boris Karloff's *Mummy*, flavored with H. P. Lovecraft)? Dr. Fate's helmet it is. The Arabian Nights (and the Thief of Baghdad)? Borrow a magic lantern, paint it green, and you have Green Lantern (inflected with an Orientalist tinge: the green flame powering the lantern comes from a meteor falling in "Old China").[47] The SF pulps and strips, where everything's "atomic"? (Buck Rogers mentioned the atomic bomb early as 1938.)[48] "The Atom" sounds nice. It's small; let's make him a battling hero of diminutive stature. Greek mythology? Put the Flash in a winged helmet, recalling Mercury and *his* winged hat. And so on. Even the oddest of the crew, the Spectre, drew on penny-dreadful traditions of the avenging ghost, happily committing gruesome murders to punish criminals.[49] (Incongruously, he headlined *More Fun Comics*.)

Much of this could be laid at Gaines's feet. He'd been contracted to produce an extra line of comics, since DC couldn't come up with material fast enough,[50] and his All-American line, edited by Shelly Mayer, came up with a vast stable of heroes. How vast became apparent when, in 1940, Mayer and the *All Star Comics* writers had a new idea: bring a bunch of

them together. They seated the Justice Society of America's original eight members—the Atom, the Sandman, the Spectre, the Flash, Hawkman, Dr. Fate, Green Lantern, and Hourman—at their very own round table. "Gathered in the Justice Society club rooms for their first meeting are the mightiest champions of right and justice in the world!" they trumpeted, justifiably proud.[51]

Something immediately resonated about the team-up—thanks, perhaps, to its primary reading audience: little kids who not only identified with the characters in play ("I'm Superman!") but realized their imaginations required room for more than one hero ("We can't *all* be Superman"). Of course, team-ups not only accommodated narrative fancy but commercial cross-promotion—allowing new characters to be tried out, launching their own titles if they appealed, or giving a faltering hero a boost, strategies companies employ to this day. (*All Star*'s first issue explained that its heroes came from other monthly magazines: "Turn to the center spread . . . and familiarize yourself with these six titles.") But the Justice Society showcased an even more important innovation. Several months into their meetings, they acquired a secretary to record their exploits: Wonder Woman.

This may seem a tokenistic, demeaning way of introducing one of comics' icons. And so it is, purposefully: to illustrate comics' echo of wider trends, the circumscription of those liberated '20s women into '30s and '40s settings that betrayed their potential, power, and talent. Although there were female protagonists in the strips, and several female cartoonists, the first spate of superheroing was almost universally male. The stories had female *characters*, of course, some of whom breathed life into simple girlfriend/wife/assistant stereotypes. Most famous was *Superman*'s Lois Lane, in her original outings a fierce professional competitor to Clark Kent in the Rosalind Russell/Katharine Hepburn mold. (The most *direct* inspiration was apparently a less-well-known film journalist from Warner Brothers' B-pictures named Torchy Blane; note the rhyme.)[52]

In her first appearance, Lane refuses a man who is insistent on danc-

ing with her. When he doesn't take no for an answer, she slaps him in the face, to which Clark says, sotto voce, "Good for you, Lois!" A whip-smart journalist who doesn't hesitate to endanger her life for the story—in a memorable early tale, she crosses from one tall building to the next via a grappling hook—she got her own backup strip, *Lois Lane, Girl Reporter*, in the '40s, with no Superman. "I *do* get some stories on my own!" she insists in that first solo appearance, and indeed she does; at story's end, someone tells her, "You're terrific even without Superman!," and indeed she is.[53] As of 1940, Batman had the Cat, later Catwoman, an accomplished burglar who sets Batman's moral compass somewhat adrift: after he trips up Robin so that she can escape their first meeting, Batman ponders, "Lovely girl! What eyes! Say . . . mustn't forget I've got a girl named Julie! Oh well . . . she still had lovely eyes! Maybe I'll bump into her again sometime. . ."[54] But overall, the makeup was rather . . . unbalanced; DC worried enough to put a psychologist on the case.

William Moulton Marston's idiosyncratic career prior to 1940 was matched only by his even more idiosyncratic personal life: his wife, lover, and their various children all lived happily under one roof. In an interview with that lover for *Family Circle* magazine in 1940, Marston criticized *Dick Tracy* and praised *Superman*, alluding to its potential for educational and civic improvement. Gaines took note, maybe because Marston praised him specifically for his "insight into fundamental emotional appeals which other publishers had lacked." Following a Harvard Club dinner between the two, Marston was hired first as an advisor, then a writer. Deeply influenced by early-twentieth-century feminism, Marston, at the strong encouragement of his wife, Elizabeth, developed a suitably feminist idea for a superhero. As he wrote later, Wonder Woman opposed what comics had been doing to women all along: "It's smart to be strong. . . . But it's sissified, according to exclusively masculine rules, to be tender, loving, affectionate, and alluring. . . . The obvious remedy is to create a feminine character with all the strength of a Superman plus all the allure of a good and beautiful woman."[55]

Wonder Woman first appeared in 1941, in an extremely unusual

bonus nine-page insert in *All Star Comics*' eighth issue. "At last, in a world torn by the hatreds and wars of men, appears a *woman* to whom the problems and feats of men are mere child's play!" Marston trumpets in the first panel of "Introducing Wonder Woman." The original Amazons had supposedly fought in the Trojan War; in Marston's imagining, they'd taken a page from Charlotte Perkins Gilman's *Herland*, living in isolated splendor on Paradise Island after, in Diana's mother's words, "our submission to men became unbearable." And now, the daughter would come to Man's world to improve it as a remarkable (if sometimes reluctant) ambassador.

What Wonder Woman *really* evangelized was women's positive thinking. Returning home to address self-defeating young Amazons ("They think they *cannot* perform the tasks required and so, of course, they fail," Queen Hippolyte confides to her daughter), Wonder Woman shows them the power of self-actualization, lifting a twenty-five-ton boulder with the words, "You see, girls, there's nothing to it—all you have to do is *to have confidence in your own strength!*" What's more, each early Wonder Woman issue included a feature called "Wonder Women of History," a cartoon biography of a "real-life hero" like Florence Nightingale, Sojourner Truth, or Susan B. Anthony.[56]

Which did not really explain why Wonder Woman got tied up so much. On that same return trip, she bids the girls tie her to a tree: "Bind me as tight as you can, girls, with the biggest ropes and chains you can find!" she says, smiling. In another story, she becomes the slave of Baroness von Gunther; fetters welded to her wristbands, she's conducted through her captor's "school," where girls are whipped to get them to "Step higher! Point toes out! Backs straight!" And then there are those "bracelets of submission," which, if a man binds them together, force obedience until another man breaks the chains. They were modeled on those of Marston's lover, Olive Byrne; Marston's own fetishistic tendencies probably sold more books than editor Shelly Mayer realized at the time.[57] The comic certainly influenced, and was influenced by, Tarpé Mills's 1941 newspaper strip *Miss Fury*, the only '40s adventure comic drawn by a

woman, in which socialite Marla Drake fought crime in black leopard skin: battles incorporated "whips, branding irons, spike-heel shoes, men beating women, women tearing each other's clothes off, and a handsome selection of frilly lingerie."[58]

Wonder Woman was only an honorary Justice Society member, despite editorial acknowledgment that "most of you" readers wanted Wonder Woman granted full membership: clearly, the character resonated strongly right away. Her disqualification was partly technical; an oddly self-aware clause in the Society's charter stated no hero with their own comic book could be a member, and given her popularity, she was receiving her own book "in record time." But it was all handled as patronizingly as possible. One ad claimed "a few of the [fictional] members felt that a woman should not be permitted to become a member," and so, unlike Superman and Batman, honorary associates with their own books, she was offered the secretaryship. "Why—that's quite an honor!" she responded. "I don't think I was so thrilled in my life!"[59] Sounding little like Wonder Woman's Marston-written stance in her solo adventures, reminding us these characters are as malleable as authorial styles and editorial currents permit.

The pulp companies, noting comics' explosive popularity and the fact that six cents of every comic book dime was publisher profit, started adapting their genre fiction to the medium. (Contributing to the profit: a bewildering, delightful variety of ads, promising to "make YOU a new man, too, in only 15 minutes a day!" and offering "amazing simulated duplicates" of wedding and engagement rings "imported from Europe," insurance policies, "Toy Gas Masks—War Surplus—Just Released by U.S. Govt," and SO MUCH MORE!)[60] In 1940, Fiction House and Street & Smith published the first SF comic (Fiction's *Planet Comics*), the biggest jungle comic (Fiction's *Jungle Comics*), and, um, sports comics (Street & Smith's *Sport Comics*); that same year, Dell produced the first war comic book (*War Comics*). Fiction House would be a leader in what later became known as "good girl art" and, more colloquially at the time, "headlight comics": books featuring pretty girls, dressed in little, aimed

at an audience old enough for this to tantalize. Not to mention enough fur, leather, and bondage to make William Moulton Marston wriggle with glee.[61]

First among equals in this regard were the jungle comics, all derived from Tarzan's DNA. Fiction House's *Jumbo Comics*[62] featured Will Eisner's Sheena, Queen of the Jungle, then almost as influential a figure as Wonder Woman. A dominant figure, both in her environment and in her relationship with tag-along mate Bob, *she* was the jungle's protector, largely against what we'd now call colonialist exploitation of indigenous people and natural resources. Most jungle comics relied on racist "white savior" narratives, fruit of the poisoned Tarzan tree: "superstitious, gullible, morally weak" Africans, incapable of governing themselves due to "diminished physical and intellectual capacities," needed a visiting white hero (or, in Sheena's case, a permanent resident) to get them out of trouble.[63]

Good girls went to space, too. *Planet Comics* featured consciously silly stories like "Norge Benson," "a teenage boy in a vaguely arctic situation, aided by a pet polar bear, a reindeer, and some friendly penguins," who fought "a group of villainous penguins, led by Slug, who wore a slouch hat and smoked a pipe"; but Gale Allen and her Girl Squadron and Mysta of the Moon, who "wore a different costume from issue to issue [which all] seemed constructed of vulcanized rubber," offered a different kind of attraction. SF comics allowed pulp genre writers to make extra cash, sometimes more than from their prose: classic SF writers who wrote comics included Otto Binder, Ed Hamilton, Henry Kuttner, Manly Wade Wellman, Alfred Bester, and Theodore Sturgeon.[64]

Closer to home, *Pep Comics* 22 introduced a more wholesome image of womanhood, or, at least, teenage girlhood, in December 1941. Betty Cooper arrived in Riverdale, and was soon joined by Veronica Lodge, bedazzling young Archibald "Chick" Andrews and bemusing pal Jughead in a town based on co-creator Bob Montana's Haverhill, Massachusetts, with a large dollop of *Harold Teen*. The publisher of *Pep Comics*, MLJ Comics, *had* been doing superheroes, but these characters' success, paving the way for the image of postwar teenagerhood, led MLJ to go all

in, changing its name to *Archie Comics*.[65] Imitators followed; some, like *Topsy-Turvy Comics*' Cookie O'Toole (along with "best friend/hipster Jitterbuck, heartthrob Angelpuss, sharp-dressed rival Zoot, and egghead pal 'The Brain'"), were arguably rivals in quality, if not in legacy.[66]

Demand for original material was furious, and those pages—sixty-four of them in color for a dime—wouldn't fill themselves. Creators and publishers simply couldn't keep up. As early as 1936, Harry "A" Chesler (his middle initial in quotation marks because he liked how it looked) stepped into the gap, establishing a "shop" to provide material for publishers like the Major, among others. And the next year, Will Eisner of the Wonder Man case, who'd turned down a lucrative gig doing Tijuana bibles (calling it "one of the most difficult moral decisions of my life"), got into the business, too.

Eisner was born in 1917 in Brooklyn, a city kid to the core. He was also a Depression product, making money wherever he could, scrabbling for any angle, and developing a sensibility to match: hard-boiled and idealistic, empathetic and tough-guy all at once. At nineteen, in 1937, he partnered with Jerry Iger to shop "package comics," first for foreign market syndication, then for new publishers Quality and Fiction House (founded in 1937 and 1938). Eisner and Iger would deliver the whole comic book, the "package" full of original material. "I think I was the first to sort of mass-produce comic magazines," he said three decades later. "We made comic book features pretty much the way Ford turned out cars." Looking back at the shop in an autobiographical graphic novel, an Eisner character says, "Hmmm . . . looks more like an Egyptian slave galley . . . than a comic book studio!"[67] And many of the resulting comics indeed had an assembly-line flavor. Eisner's shop, for example, created pre-printed pages, panels already laid out for the artist to fill in, saving time at the expense of formal creativity.

Joe Simon, then editor in chief for Fox's comics company, described the comics boom this way: "The art work was bad enough, but the best one could say about the stories was they were illiterate." In a kinder moment, he clarified: "Complicated plotting wasn't necessary. Few publishers read

the copy. They were interested in exciting graphics and action." (In a harsh note to Eisner, Busy Arnold once complained, " 'Lady Luck' for the past few months has been awful—not even comic book quality.")[68] The graphics and action took their cue from the strips, of course. Artists— at editors' encouragement, so they said—swiped occasionally, or more, from Alex Raymond and Milton Caniff, so young *Flash Gordon* or *Terry and the Pirates* fans felt on solid footing. Strips like *Minute Movies* and *Mutt and Jeff* actually appeared in DC comics.

But the direction of influence between comic strips and books now, sometimes, flowed the other way. Bob Kane credited *Dick Tracy* with inspiring "an equally weird set of villains for Batman." And what a (literal) Murderers' Row: Jerry Robinson's Joker, created as a proposed Columbia creative writing assignment when Robinson was seventeen, was supposed to die in his first appearance, but editor Whit Ellsworth convinced Finger to rewrite, understanding the character's potential; Catwoman; the Penguin, "[t]he strange, almost ludicrous . . . umbrella man"; Two-Face, inspired by a 1938 *Shadow* tale, appropriately introduced in a two-parter, the closest to a tragic character in Batman's rogues' gallery. ("I gave orders not to have any mirrors in my house. Who put this mirror up?" he shouts in his first appearance.)[69] That said, many of Tracy's most outré villains were created *after* Batman's. Jack Burnley, famous for his Superman and Batman, came to DC following ten years as a syndicated sports cartoonist: "After drawing the muscle men of sports, I was well qualified to portray the muscled super-heroes of comics," he said.[70] Seeing which way the wind was blowing, Ovaltine dropped its sponsorship of *Annie* in 1940, replacing her with *Captain Midnight*.

Other shops soon formed, most notably by Lloyd Jacquet and Jack Binder, but there were a dozen others. Some were run by the most famous names in the business: an ad placed in writers' and artists' magazines in 1938 read, "Help wanted. Artist with ability to draw action-adventure strips; assist on nationally established features. Send samples. Joseph E. Shuster."[71] Siegel and Shuster parodied the process, and themselves, in a 1943 issue of *Superman*. Clark Kent interviews the creator of the highly

popular superhero Geezer (contrary to modern usage, he's a young, vibrant type). Kent, wondering "how you manage to turn out such a terrific amount of material," is shown "Artists—stacks of them—figure men, background specialists, inkers, letterers—all plugging away on the adventures of GEEZER!"

"But a comic character's continued popularity is governed by the amount of care a creator puts into his conception," objects Superman. "Why should a genius work when there are always talented assistants available to do his work for him?" comes the response. By story's end, Superman inspires the creator to recommit time and creativity to the task. But it wasn't *just* a joke: quite a few early Superman stories were drawn by other artists under Shuster's byline.[72]

In other shops, conversely, "house names" often disguised just how much work was done by so few people. The men in those shops (and they were men, with rare exceptions) worked and lived together in apartments with walls papered with comic covers (to help cover dart holes, a favored pastime). In a legendary bachelor episode, Jerry Robinson and friends could only come up with six raw eggs and a can of beans during a blizzard; lacking a stove, hot plate, or utensils, they cooked off tiles peeled from bathroom walls. But it was the work that mattered: they were constantly experimenting, innovating, figuring out what a comic book *was*. As one of those shop workers, Jack Kirby, put it, "None of us had a school, so we became each other's school."[73] They watched artists like Lou Fine, who shone brightly in a brief career, and Mort Meskin, who would work for decades, seeing page layouts stretch and flex, panels varying in size and taking in new angles and perspectives, figures like the Ray and Black Condor striking poses heroes never had before. They developed more complex storytelling structures. Those team-ups, at first serial single adventures united by a narrative frame ("I know!" says a hero at a Society meeting. "Suppose you each tell the most exciting experience you ever had. . . . That'll entertain EVERYBODY!"),[74] soon progressed into truly united adventures.

The characters evolved, too. The first *Batman* storyline came straight

from a *Shadow* adventure, Bruce Wayne just another playboy detective, a "young socialite" friend of Commissioner Gordon's. It's only several issues later, in a two-page "legend" preceding Batman's war against the Dirigible of Doom, that we learn of "The Batman and How He Came to Be"—the primal trauma that shaped his every future moment. There was still the occasional false note: almost immediately after his creation, he abandons Gotham to fight vampires in Europe, and on one occasion, he uses a gun. Readers, already understanding the character in some ways better than the writers, objected strenuously: writer Bill Finger was called on the carpet, and Batman's loathing of guns became canonical. The contretemps led to an in-house code, sent to all DC writers and artists and soon a template for other companies: "No whippings, no hangings, no knifings, no sexual references. Even the word *FLICK* was forbidden because the lettering might run together."[75] These warnings were predicated, in no small part, on the understanding that the comic books were aimed at—and consumed by—kids.

What made them so appealing? A bio page in *Superman*'s first issue informed the reader that Joe Shuster liked the hero "because he really believes in the principles which prompt SUPERMAN's startling accomplishments on behalf of law and justice!" Justice, maybe. Siegel cited Roosevelt's fireside chats and Hollywood's '30s social-consciousness films as influences, and Superman's early targets—mining officials skimping on safety, embezzling orphanage managers—amply illustrate the first epithet given him on the very first page of his adventures: "Champion of the Oppressed." But law? On the eve of the war for democracy, the superheroes' extralegal activities, albeit in the name of good-guyism, were certainly noticed. Perhaps Gershon Legman put it overly strongly in declaring that *Superman* "is really peddling a philosophy of 'hooded justice' in no way distinguishable from that of Hitler and the Ku Klux Klan," but it was harder to argue with his assertion that "legal process is completely discounted and contemptuously by-passed."[76]

Commissioner Gordon begged to differ. Speaking to the district attorney about Batman, Gotham's top cop said, "Yes, he works 'outside

the law,' as you call it, but the legal devices that hamper us are hurdled by this crimefighter so that he may bring these men of evil to justice."[77] For his audience, Gordon was right on point. Kids care deeply about justice, when it comes to snack time, bedtime, parental promises, as *fairness*. The Flash refuses to try out for the Olympics, explaining, "It wouldn't be fair to those fellows for me to race against them. . . . To ask them to race against my scientific freak gift would be unsportsmanlike, and un-American!" Golden Age character Mr. Terrific literally had the words "Fair Play" on his chest.[78] Superman wasn't really a force for law. But he *was* a champion of justice, a grown-up kid fighting against villainy and hypocritical authority all at once.

———

IF SUPERMAN'S APPEAL was that he embodied a kid's sense of fair play all grown up, Captain Marvel furthered the metaphor by literally turning a kid into a superhero. Newsboy Billy Batson becomes the Captain by shouting the magic word *Shazam*—shouting, the way playground magic of transformation is always achieved. And then he . . . enjoys. "Aren't you going to wait for the police, Captain Marvel?" a character asks. "I never wait for the police—that's part of the fun," Marvel replies.[79] C. C. Beck had started out drawing Harold Teen and Tillie the Toiler on lampshades. He worked for "Captain Billy" Fawcett, a Great War veteran who'd published a magazine "full of corny gags and pictures of pretty young women" to keep up troop morale in France; back stateside, *Captain Billy's Whiz-Bang* (whiz-bang being First World War slang for an artillery shell) was joined by dozens of other pulp and true confession magazines under the Fawcett Publications umbrella.

Moving into comics, Beck and Bill Parker created a hero with a face modeled on Fred MacMurray and the outfit of "a typical light-opera soldier" called Captain Thunder, changing the name after DC came out with a similarly titled hero. The 1940 origin story is moody, atmospheric, with the orphaned Batson encountering a wizard who, upon granting Batson his powers, is crushed beneath a granite block, his job completed.[80] Like

Wonder Woman, Captain Marvel draws deeply on classical myth: Shazam is an acronym for Solomon, Hercules, Atlas, Zeus, Achilles, and Mercury. (The premise originally featured a team, each of whose members possessed a mythological god's power, but this was rejected as confusing.)

But Beck wasn't afraid to meld the epic with the childlike. Captain Marvel comics featured a talking telepathic worm (bad guy) and talking tiger (good guy), along with a lovable fraud who dressed up as one of the Marvel family—there ended up being a whole family—but with no actual powers. (Feeling badly for him, everyone else used *their* powers to cover for him.) And Beck's hero *was* a kid, playing out kid fantasies, not adult situations serving as metaphors. Captain Marvel beats up a guy picking on little kids; Billy, facing a spanking, says his magic word, and Captain Marvel is now the one bent over the man's knee: "I'm a big boy now," he says. Beck saw Captain Marvel as physically twenty-two, but mentally twelve, Batson's age—expressed most famously in his awkwardness around the women who were naturally attracted to his adult form. When one proposes, he responds, "I'm not in the marrying mood, Beautia . . . not as long as crime runs rampant. But maybe we'll meet again some day . . . so long!"[81]

Perhaps Captain Marvel's dual selves also appealed by focusing on something else Superman lacked: vulnerability. Batman had it, inherited from Dick Tracy; the Caped Crusader bleeds, bruises, breaks, even faints. (And yet, as a doctor treating him says early on, "I don't know how he kept going the way he did."[82] No man of steel, true, but a will of iron.) That schizoid core, supermasculinity and its opposite, reached its high (or low) point with the much-lesser-known Starman, who was so committed to preserving his secret identity, he presented himself in his playboy alter ego as a near-invalid. "I'd rather not go swimming, Doris—the water's too cold—besides, I might get a cramp and drown!"; "I wish they'd slow down the tempo—this fast dancing is bad for my heart!"; "Doris, you know I can't stand a picture with bandits and gun play! It upsets my nerves terribly!" To which last, Doris responds, "Bosh! Don't be a sissy, Ted!"[83] Masculine presentation, anxiety about gayness: other themes that would recur.

Captain Marvel Adventures' peak circulation, after World War II, was well over a million. Naturally, DC sued for copyright infringement, taking a page from the *Wonder Man* playbook. They may have had a point: similarities between Superman and Captain Marvel included specific superpowers, physical appearance, alter egos working in journalism, and mad scientists as central villains. But this was now a well-established genre, and you could argue with equal justification that DC was just trying to eliminate competition. After a stint in Learned Hand's court, where it was decided that Fawcett had indeed infringed on DC's copyright, the battle of Earth's mightiest mortals ended in the '50s with the whimper of an out-of-court settlement: $400,000 and an agreement to cease Captain Marvel's publication.[84]

The creator of the era's most unusual hero, though, didn't want him to be a hero at all. The year the Justice Society debuted, Will Eisner got an offer to create a sixteen-page comic book supplement as a nationwide Sunday newspaper insert: more robust and varied than a syndicated strip, but, given its wider and higher-status circulation, not quite a comic book, either. Eisner dissolved his partnership with Iger and leaped at the chance. It was technically called the *Weekly Comic Book*,[85] but nobody ever called it that. Its *real* name came from one of its three Eisner-invented features (two appearing pseudonymously). Lady Luck never caught fire, and neither did Mr. Mystic, whose backstory was just a mess (after crash-landing in the Himalayas, seven lamas branded him with their sign, endowing him "with unlimited powers to combat the forces of evil"). But the third was the charm, the reason one and all called it "the *Spirit* section." The backstory is prosaic: Denny Colt, law enforcement officer left for dead by bad guys, uses his resulting anonymity to fight crime. If this "ghost who walks" approach reminds you of the Phantom, you're not wrong; but everything else about the Spirit was relentlessly original. The words *Action Mystery Adventure* appeared in a small yellow square atop the section. But perhaps three better phrases to describe the Spirit were *Formal Innovation Humor Sex Appeal*. (Five words, I know.)

Eisner, who "grew up on the movies—that was my thing," made a

connection while watching Man Ray's experimental films at the New School: "these films were nothing but frames on a piece of celluloid, which is really no different than frames on a piece of paper."[86] Eisner was hardly the only comic book man at the movies. He adored German Expressionism and Fritz Lang's work, but so did Siegel and Shuster, who swiped the filmmaker's futuristic Metropolis for the Man of Tomorrow's home. Eisner was heavily influenced by *Citizen Kane*, but so was Jerry Robinson, who saw it so often, he "could recite much of the dialogue verbatim."[87] But the difference between Eisner and others hailed for "cinematic" usage of the medium is instructive. Caniff swipes from the movies in *Terry and the Pirates*, but Eisner's borrowings stemmed from self-proclaimed aesthetic ambition. Eisner said:

> By 1939 I had long been convinced that I was involved with a medium that had "literary potential" . . . but I was trapped in what to me was a comic-book ghetto where I would be turning out the same sort of adventure stories for the same level of reader indefinitely. Newspaper syndication would give me an adult audience . . . to expand this medium beyond the existing parameters.[88]

His most notable expansions, formally speaking, were *The Spirit*'s "splash pages"—full-page illustrations necessary here because of the section's stand-alone format. The term's etymology presumably stems from the big splash the full-page ilustrations make, but in Eisner's case, the name was particularly appropriate. It always seemed to be pouring in Central City: cinematic, noirish, practically announcing its seriousness with artful compositions reminiscent of a staged tableau. (Eisner's father was a stage set painter, and the background came through.) It made you wonder how everyone wasn't constantly nursing a hacking cough.[89]

This mixture of seriousness and irreverence isn't just me; Eisner perfected the approach. If he saw comic panels as film frames, he also employed another metaphor, calling *The Spirit* (and comic books more

generally) "nothing but a series of short stories." He often cited Ambrose Bierce and O. Henry, skilled and popular writers whose engrossing stories often featured famously surprising twists (the former's "Occurrence at Owl Creek Bridge" and the latter's "Gift of the Magi" arguably American literature's two most famous examples). Both frequently combined pathos and melodrama with wicked humor; both mined everyday life for near-metaphysical investigations. So, too, Eisner's *Spirit*; Jules Feiffer, who apprenticed with Eisner, described his most powerful stories "as documentary fables—seemingly authentic when one reads them, but impossible after the fact."[90] A nobody named Gerhard Shnobble believes he can fly, and, though no one else sees him, actually does; in the end, he takes a stray bullet meant for the Spirit and dies, still unrecognized. Here, as in many other stories, ostensible star Spirit hardly appears, a shocking deviation from developing norms. (He also wore the closest thing to street clothes in the business; his mask and gloves came at the publisher's insistence.)

When the Spirit *did* appear, it was often in the company of cinematic femmes fatales, with whom he interacted unabashedly erotically. (The commissioner's daughter provided a contrasting, more innocent love interest.)[91] A femme fatale introduces herself on one of Eisner's most famous splash pages in 1946, looking like Lauren Bacall on a particularly sultry day: "I am P'Gell—and this is *not* a story for little boys!!"[92] Indeed not; unsurprisingly, *The Spirit* attracted an older audience than many other comics. A contemporary researcher reported it "placed high in the preferences of [high school] seniors. This strip is hard to comprehend in that the language is filled with railleries and innuendoes, the drawings are made from exaggerated angles, and the characters are bombastic in nature. Its popularity seems to lie in its perverted form of humor and its unexpected twists of adventure."[93] Eisner was reaching the adult newspaper audience, but was bridging the gap with the costumed-heroes audience, believed to be kids. Once again, he was ahead of the curve.

In arguably Eisner's most powerful Spirit story, published the day the German army invaded the Soviet Union, an undercover Adolf Hitler

visits America, the land he loathes. He grows to cherish it—its diversity, its love of freedom, its commitment to personal happiness—and resolves to return to his own country to reform it. Tragically, Nazi Germany's rot is deeper than any one individual, even its leader; the powers that be simply assassinate him, replace him with his double, and continue on their destructive path.[94] Hitler's appearance in a Spirit story raises another aspect of Eisner's biography, then largely unmentioned, that would loom far larger in his later career.

Feiffer described the Spirit as "reek[ing] of lower middle-class: his nose may have turned up, but we all knew he was Jewish." Did we? Did Eisner? Put otherwise: Did the fact Eisner was Jewish—along with almost the entire original generation of comic book publishers, writers, and artists—make any difference to their work? Eisner's later description of the Spirit's provenance—"I suppose he was Jewish, insofar as the fact that he was the product of my experience, and I put a little of myself in him"—is hardly a ringing affirmation. (Stan Lee, on himself and his cohort: "We never thought about it, talked about it, never even seemed to be aware of it.")

In recent years, a veritable cottage industry has debated the broader proposition: *Is Superman Jewish?* reads one title.[95] Superman's story seems, on third or fourth exegetical glance, to *reek* of Jewishness. He's of the house of El—a Hebrew word for "God." His is a story of diaspora, and parents sending him away in an ark like Moses's in the bulrushes. And disguising oneself to get along with a majority unlike him? Isn't that *the* Jewish story? In his Pulitzer-winning novel about these early comic book days, *The Amazing Adventures of Kavalier & Clay*, Michael Chabon put it best. "They're all Jewish, superheroes," Clay tells Kavalier. "Superman, you don't think he's Jewish? Coming over from the old country, changing his name like that. Clark Kent, only a Jew would pick a name like that for himself."[96] Actually, that isn't quite accurate: *Klayman* says that to Kavalier, then changes *his* name. It's too Jewish.

It's not quite so clear. Yes, these creators mostly came from immigrant backgrounds with stronger connection to Jewish culture and com-

munity than many Jews have today; and significant numbers explored those connections in later life. But as young men, they simply were far more interested in, and influenced by, pulps, movies, and comic strips (and, less so, other American and Western culture). Jewishness was a small part of them, often left behind at parents' Sabbath tables. Even the slam-dunk evidence often evaporates: Jor-El, Siegel said, was simply short for "Jerome Siegel."[97] Eisner explained the Jewish prevalence simply and brutally: "There were Jews in this medium because it was a crap medium. And in a marketplace that still had racial overtones, it was an easy medium to get into."[98] In his later autobiographical account, one creator asks another why he changed his name. "Goin' to have my own daily strip one day!!" the other replies. "Y'need a classy name to get ahead!"[99] If anything, "getting ahead," creating something *American*—that is, ethnically homogenous and uniform—while deeply Jewish in sensibility, produced an outcome necessarily, carefully, un-Jewish. Now, you can say *that's* what makes it Jewish, but such arguments are finicky at best.

This said, influence may be apparent in two specific areas. The first relates to those "racial overtones" in Eisner's comment. Growing up in the Depression, these first-generation American Jews inevitably encountered anti-Semitism in streets, hotels, and job markets.[100] Did these encounters render them more sensitive to the plight of the discriminated, the downtrodden?

Whether it did or not, it didn't make them particularly more sensitive to the representation of *other* minorities. Eisner gave the Spirit a sidekick, Ebony White, who was the epitome of minstrelsy: dialect speech, exaggerated features, exaggerated cowardice.[101] Over the decades, Eisner was defensive and self-justifying: "Ebony was done with a great deal of love and affection. . . . To me, Ebony was a very human character, and he was very believable." "I *did* Ebony, I'm *glad* I did Ebony, I'm not *ashamed* of having done Ebony, I *don't* think I was racist, I *know* I wasn't racist, I was *not* doing Ebony in the same spirit that a Nazi propagandist might have drawn hook nosed fellows. . . . I drew Ebony as he was because he was a creature or a pattern of the *time*." Sadly, that last claim is true. Billy Batson

"disguises himself with the aid of a piece of burnt cork" in one story, then speaks in dialect: "Is yo' sho' we is gonna be all right, Mistuh Boss Man? Ah is gonna see ma mammy in Alabamy sho' nuff?"[102] In 1949, four years after a youth delegation convinced Fawcett to drop Batson's stereotyped valet, Steamboat Bill, from Captain Marvel comics, Eisner dropped Ebony entirely—to be replaced by a white boy named Sammy.[103]

But besides personally perceived discrimination, Jewish creators, as first-generation Americans, frequently had close European relatives, and Hitler's rise loomed for them not just as Americans, but as Jews as well. This is the story Chabon's *Kavalier & Clay* tells: an American Jew and a European refugee partnering to produce works that are, if not pugnaciously Jewish, at least avowedly anti-fascist. And some, though by no means all, comic books took this tone well before Pearl Harbor, despite isolationism still running strong in American society. (Comic strip publisher Patterson, by contrast, had transcended isolationism to become "a leading Third Reich apologist" before Pearl Harbor; FDR "once personally sent him a German Iron Cross, observing that no man in America deserved it more than he.")[104] This anti-fascist impulse was best summed up in the immediately iconic image of Captain America delivering a good solid right to Hitler's jaw.

━━━

IF SIEGEL AND SHUSTER'S SUPERMAN fulfilled one childhood vision of omnipotence—born this way, never knowing anything but power— Joe Simon and Jack Kirby's Cap was the diametric opposite: weakness granted power for specific purpose. Steve Rogers was the classic ninety-seven-pound weakling from the Charles Atlas ads (Atlas's "Dynamic Tension" program was then at its height, its ads appearing first in comics),[105] but instead of wanting strength for juvenile fantasies like beating up bullies and getting girls to like him (as in Siegel's early imaginings), Rogers wants to act in the service of liberty and country.

Kirby was a self-proclaimed street kid, born on the Lower East Side, dodging ice wagons and kid gangs early, brawling when he had to. ("The

punches were real . . . we'd chase each other up and down fire escapes, over rooftops, and we'd climb across clothes lines.")[106] He read voraciously, "on the sly, in hallways and under porches," as "book readers weren't recognized as a high type"; sold papers at a newsstand, his "school . . . Alex Raymond and Miton Caniff"; watched movies ("I was brought up by Harry Warner"); got thrown out of the Educational Alliance for "drawing too fast with charcoal"; did animation for Fleischer as a teenaged in-betweener; worked for Eisner and Iger (where he "really got serious about comics . . . because *they* were serious. They felt it was a valuable medium").

Kirby's partner, Joe Simon, was a more middle-class guy. At an early working lunch, Kirby recoiled from a raisin-packed dessert; they reminded him of the bugs "that infested the Lower East Side tenements." Kirby wrote and penciled; Joe wrote, inked, lettered, and dealt with the publishers. "Joe and I manufactured products worth selling. And they sold . . . a lot." Given overwhelming production pressure, Kirby drew faster, and faster, and "the figures began to show it. Arms got longer, legs bent to the action, torsos twisted with exaggerated speed. . . . I discovered the figures had to be extreme to have impact, the kind of impact I saw in my head."[107]

Much of their early material is forgettable: standard Buck Rogers fare (*Blue Bolt*); a Lone Ranger strip, except the horse wasn't white; a stint for *Captain Marvel Adventures*. But a sense of historical moment (to engage in some Kirbyesque drama) yielded a quantum leap. "Everyone knew [the war] was coming," said Kirby. "That's why Captain America was born; America needed a superpatriot." "The opponents to the war were all quite well organized. We wanted to have our say, too," Simon said. The opponents didn't like it. The German-American Bund flooded the duo's offices with threatening calls and hate mail; New York mayor Fiorello LaGuardia put on a police guard.[108]

The usual four-color narrative applies to Cap's origin: FDR, stymied as to how to prosecute the war, asks, "What would you suggest, gentlemen? A character out of the comic books?" And indeed they do, thanks to Professor Reinstein's (that's Einstein with an *R*) super-soldier serum.

Unfortunately, a witness to the serum's demonstration "is in the pay of Hitler's Gestapo," and Reinstein is assassinated, but not before Rogers undergoes his remarkable transformation.

Sabotage was on everyone's mind in the years leading up to Cap's debut. The FBI had uncovered an extensive New York–centered Nazi spy ring in 1938, German agents planted in the army and defense industries. The Rumrich case became the basis of the movie *Confessions of a Nazi Spy*. Two dozen other movies dealt with espionage between 1939 and 1941; the following year, seventy.[109] In January 1940, MLJ's first issue of *Pep Comics* (later *Archie*) had introduced the Shield, the first superpatriotic hero, working "to shield the U.S. Government from all enemies." Between April and July 1940, fifth columnists tried kidnapping Little Orphan Annie. Eisner's Spirit enlisted in October 1940, under the proviso he keep his identity secret; *he* went into counterespionage. Wonder Woman's first adventure, in 1941, found her battling German spies. As one *Superman* story breathlessly put it, "At this tense period when the United States is striving to rearm itself in an all-out defense effort, sabotage of defense production and military objectives is of stunning effect."

In a *Look* magazine two-pager on February 27, 1940, Siegel and Shuster answered "What If Superman Won the War?" with a fantasy of, well, blitzkrieg: Superman smashes Germany's Siegfried Line, busts through the ceiling of Hitler's retreat ("I'd like to land a strictly non-Aryan sock on your jaw," he tells him), plucks Stalin from his Moscow perch from which he's reviewing troops, and hauls them both before the League of Nations.[110] In the regular comic, Siegel and Shuster were only slightly more circumspect. In a March 1940 issue, "Toran" invades "Galonia," and Clark Kent says, "The democracies are definitely opposed to aggressor nations—any more questions?" The next year, Superman helps the small country of Numark, attacked "by its large militaristic neighbor" Oxnalia, whose "beloved dictator" looks exactly like Hitler.[111] Perhaps this was in (slight) deference to the strong (pre–Pearl Harbor) isolationist sentiment in Gaines's All-American line;[112] *USA Is Ready* to fight, a 1941 Dell comic's title read, but not all of it was, not even in the comic book world.

Captain America's company, though, seemed particularly so. Martin Goodman, Brooklyn-born in 1910, had a colorful youth (traveling the country, hanging out in hobo camps), getting into the pulp business in 1932. By 1937, he had published a dozen titles in various genres—one, in 1938, called *Marvel Science Stories*. According to legend, Frank Torpey, sales manager for the comics packaging outfit Funnies Inc., convinced Goodman to get into comics; a grateful Goodman gave him a $25-a-week stipend for years afterward. *Marvel Comics'* first issue appeared in 1939,[113] an anthology title, like *Action* or *Detective*, for Goodman's company, Timely Publications—jungle heroes like Ka-Zar and cowboys like the Masked Raider appeared alongside flyboys, magicians, and detectives like the Ferret (who had a pet ferret). There was even a gag page or two. And costumed heroes—some, like the Angel and the Vision, with famous later incarnations; some, like the Fiery Mask and the Fin, without.

But two of Goodman's pre–Captain America heroes seemed particularly invested in larger concerns. The Human Torch, name notwithstanding, was an android. (Faulty construction meant he burst into flames when exposed to oxygen.) Inspired by *Julius Caesar* ("A common slave . . . / held up his left hand, which did flame and burn . . . / and yet his hand, / Not sensible of fire, remained unscorch'd"),[114] Carl Burgos (né Max Finkelstein) took a page from Mary Shelley to sketch an uneasy relationship between creator and creation: "Horton, destroy that man, before some madman can grasp its principles and hurl it against our civilization!" says another scientist. Horton refuses, and by story's end, the Torch refuses any control whatsoever. This narrative of alienation and rebellion would become central to the entire Timely, later Marvel, line.[115]

It's matched only by the second great Timely creation: the water to Torch's fire. Bill Everett, Funnies Inc.'s art director (whose great-grandfather had been the president of Harvard and the secretary of state of the United States), took the Sub-Mariner's title from Coleridge's *Rime of the Ancient Mariner* and his proper name, Namor, from spelling *Roman* backward (and, possibly, his face from Fred Astaire). Was he hero or menace? The product of a mixed human–underwater denizen marriage, at

home in neither world, Namor felt deep hostility toward humanity for what it had done to both him and the undersea kingdom. "The white earth-men were blasting us out of existence with their infernal 'scientific investigations,'" Namor's mother tells him, simultaneously infusing the story with racial metaphor and environmentalist sentiment. The Sub-Mariner was even given the chair for murders ostensibly committed while terrorizing New York; thanks to moral ambiguity and commercial desirability, the electrocution didn't take.[116]

Just after those Justice Society members congregated around that table, these two alienated antiheroes got together—and, perhaps naturally, hit each other rather than hitting it off. "The Battle of the Comic Century! Fire vs. Water! A Fight to the Finish! Read about the most famous fight in action-picture magazines—the Human Torch and the Sub-Mariner—22 pages of sizzling action!!!" read the teaser for *Marvel Mystery*'s eighth issue (June 1940), which featured the first instance of that future comic book staple, the crossover. But circumstances soon brought them together for a very different reason.

"The Human Torch and the Sub-Mariner are together again . . . not to destroy each other but to form an alliance that will stop the gigantic plans for an invasion of these United States," reads the first page of "The Human Torch and Sub-Mariner Fighting Side by Side." "I came to New York just to find you!" Sub-Mariner tells the Torch. "But first . . . are you ready to fight for Uncle Sam under any conditions?" "You know I am!" is the reply. After foiling an attempted Nazi invasion via a tunnel under the Bering Strait, thanked by a grateful governor, a surprisingly cheerful Sub-Mariner says, "Forget it! We had a lot of fun doing it!" The Torch chimes in, "At least America is not in danger now! It's still the Land of the Free!"[117]

And then Simon and Kirby came up with the Captain. Premiering in his own magazine—then unheard of; characters routinely got tryouts in other books—*Captain America Comics* reached sales of close to a million. Three months later, Cap, angrily brandishing his shield, put malefactors on notice: "IMITATORS BEWARE! Now that Captain America has attained such a vast following, many comic books are attempting to copy

his costume and deeds. The publishers of *Captain America* hereby serve notice that they will prosecute to the full extent of the law any and all such acts of infringement. THERE IS ONLY ONE CAPTAIN AMERICA!" Someone should have informed the earlier MLJ character the Shield—or, for that matter, Goodman's own publishing company, which was busily pumping out *The Patriot, The Defender, Major Liberty, American Avenger,* and *Miss America.* Goodman had always hired family members; now he hired another, his wife's seventeen-year-old cousin Stanley Lieber, just fired from his low-paying job in trouser manufacturing.[118] Gofer turned writer Lieber, wanting to save his real name for his Great American Novel, would sign his first work, a two-page text piece in *Captain America Comics'* third issue, as Stan Lee.

But Captain America wasn't wrong: there were lots of patriotic long-johnnies out there, and more of them after Pearl Harbor: Uncle Sam, who'd premiered back in 1940; Liberty Belle, who got superstrength when someone struck the Liberty Bell; Fighting Yank, with powers derived from a Revolutionary War–era ancestor; and the Star-Spangled Kid and Stripesy, a variation on the recent vogue for youthful sidekicks (Stripesy was the adult).[119]

Looking to "humanize Batman," who'd failed to resonate as powerfully as his Kryptonian colleague, DC took inspiration from Robin Hood, who in Errol Flynn's 1938 film incarnation combined acrobatics with cheeky comic energy. (Robin's first appearance, jumping through a paper drum Batman is holding on the cover of a 1940 issue of *Detective Comics,* renders his name in a font reminiscent of Merrie Sherwood Forest days.) Robin's bright colors and youthful sensibility presented an odd contrast with the Dark Knight: these amounted to a feature, not a bug. Superman, for his part, never technically had a kid sidekick, but Siegel and Shuster elevated Jimmy Olsen, a kid at the *Daily Planet,* to a speaking role around the same time.[120]

By contrast, Bucky is created simultaneously with Captain America; he's an essential part of the product. (In a note accompanying the very first Captain America sketch, Simon writes Goodman, "Martin—

Here's the character. I think he should have a kid buddy or he'll be talking to himself all the time. . . . Regards, Joe.") Bucky transcended the kid's dream of going to work with your parent, speaking directly to kids' fantasies of participating in the good fight when too young to enlist. Or, as *Captain America Comics* 1 put it, "Bucky's dream is fulfilled as he fights side by side with Captain America against the vicious elements who seek to overthrow the U.S. government!"[121]

Bucky wouldn't just backstop the grown-ups. Alongside Toro, the Torch's teen sidekick, he headed up 1941's Young Allies, the subjects of the first "kid gang" comic. Simon and Kirby introduced the Newsboy Legion and Boy Commandos, whom Batman and Robin personally welcomed to *Detective Comics*' cover.[122] Inspired by Dead End Kids and Bowery Boys movies as well as war pictures, kid gangs threw together one of each stereotype: the Young Allies included Knuckles (pugnacious, Brooklynese), Jefferson Worthington Sandervilt (user of five-dollar words), and Whitewash Jones, a Black caricature. The more continental Boy Commandos had Brooklyn (toting a tommy gun in a violin case) alongside Alfie Twidgett (England), Jan Haasan (Holland), and André Chavard (France). An adult version appeared in Eisner's *Military Comics*, launched several months before Pearl Harbor; he cocreated the multinational Blackhawks, known largely now for the stunning art of Reed Crandall and for Chop Chop, the "Chinese cook and comic-relief man," who followed earlier trends of Asian caricature in look, behavior, and dialect.[123]

And these were the *good guy* stereotypes. Alex Schomburg, who produced almost all Timely's wartime covers, said, "They bought sight unseen—just as long as the Japs showed their ugly teeth and glasses and the Nazis looked like bums." The Japanese were pictured as subhuman, sporting long, animalistic buckteeth, fingernails verging on claws, and greenish-yellow skin. The rhetoric, with titles like "The Terror of the Slimy Japs" and "The Slant Eye of Satan,"[124] was just as bad. (Future novelist Patricia Highsmith, before writing *Strangers on a Train* and *The Talented Mr. Ripley*, cut her teeth on U.S.A. Comics' *Jap-Buster Johnson*.)[125] Nazis—or "Ratzis," in common parlance—being white, were subject to

less physical caricature (though some artists indulged in a brutal Hun-nishness) but almost always spoke in their best Colonel Klink accents. A line taken almost at random from 1943, all spelling intact, read: "Gute!—Ve will go ahead mit de plan! . . . Und den—! Ha! Ha! Ha!" Notably, Germans were demonized as soldiers or Nazi party members; the non-white Japanese, by contrast, were tarred as an entire nation.[126]

Comic book Nazis, not unrepresentatively, exhibited monstrous behavior. Captain Marvel's creators found a terrifying way of joining the sidekick craze in 1941. A villain, Captain Nazi, is knocked by Captain Marvel into a bay. He then boasts to Hitler about how he has treated the duo who pulled him out: "Herr Hitler, I haff killed an old man and crippled a little boy. . . . It iss so eassy beating these Yankee pigs."[127] But Captain Marvel takes the boy to the place where he got *his* powers, and though "the poor boy is destined to carry a cripple [sic] leg as a souvenir of his encounter with Capt. Nazi," he becomes Captain Marvel Jr. Given the enemy's monstrosity and subhumanity, it was fine both to kill them and not feel too badly about it. The Sub-Mariner opens a Nazi subma-rine hatch thinking, as the water rushes in, "This'll fix any of those poor dopes who happen to have their helmets off!" We see one drowning in the next panel, clutching at his throat; another, struggling to get his helmet on, shouts, "*Donnerwetter!*"—a standard comic book Nazi exclamation. Namor, watching them writhe, laughs, "Ho! Ho! That's right, lads! Don-nerwetter! And wetter! And WETTER!"[128]

Sometimes, though, ridicule and laughter seemed to be the best response. Plastic Man bumfuzzles an "American Fuhrer" by rearrang-ing his India rubber features to look like Hitler, then Roosevelt. An admittedly uncharacteristic *Superman* story, "Meet the Squiffles!," has him fighting the titular "evil elves who are subsidized by the Axis." Cap-tain America, after defeating (yes) Bowery bums-cum-zombies placed in Hitler's service by (yes) the Lord of Death, ends with Bucky trium-phantly answering the Fuhrer's call to the bad guy with a raspberry. The Human Torch singes the mustache off "Hitler's" face.[129] Perhaps the most irreverent—and certainly the dirtiest—appeared in the Tijuana

bible *Hyme Putz Presents You Nazi Man*, which, among other things, replaces Hitler's nose with a phallus.[130]

But, generally, the tone was high-hearted patriotism. Following a bit of comic business, in which each member doesn't know how to tell the others they plan to enlist, the Justice Society becomes the "Justice Battalion"—"in answer to their country's call . . . for America and Democracy!"[131] Various heroes rattling around DC's stable were corralled into the Seven Soldiers of Victory, giving the Crimson Avenger and Shining Knight higher purpose, and, perhaps more relevantly, second chances at audience purchase. Wonder Woman is sent to Man's world (the only immigrant in the great heroic explosion, Superman being a refugee) specifically to help "America, the last citadel of democracy, and of equal rights for women"; thus her outfit's resemblance to the American flag, later explanations notwithstanding. She is also the most active presence in the war effort (her lasso of truth coming in handy as a counterespionage tool), standing in, in some ways, for women's extensive participation in the war effort: "If a woman can do this to us—what can the men do?" a Japanese soldier asks. "I'm not staying to find out," says another.[132]

There were explicitly militarily oriented strips, of course, some predating the war. *Don Winslow of the Navy* was created in 1934 with the support of Frank Knox, *Chicago Daily News* publisher and, as of 1940, secretary of the navy; its writer, Lieutenant Commander Frank V. Martinek, thought of it after hearing of the navy's recruitment difficulties. As a Bureau of Naval Intelligence employee, he ensured that no one in the military-approved strip acted contrary to the navy way. There was a distinct subgenre of aviation strips: one, *Ace Drummond*, was written by the Great War's great ace Eddie Rickenbacker; another, Russell Keaton's *Flyin' Jenny*, about an aviatrix, had gorgeous art that was matched, and surpassed, in artistic heights by Noel Sickles's chiaroscuro magnificence in the pilot-for-hire strip *Scorchy Smith*. Sickles, who managed to blend dark, shadowy impressionism with realistic depiction of people and technology, bringing the depths and perspectives of cinema onto the newspaper page, would prove a major influence on Caniff, and thus on the entire

school of adventure strips and comics, with his manifesto, as he put it in 1973, "to get the punch of a poster into every panel."[133]

Perhaps given their narrative bias toward conflict, many such strips supported America's entrance into the war early on. Two of the aviation strip *Barney Baxter*'s main characters joined the Royal Air Force several months before Pearl Harbor. Terry of *Terry and the Pirates* entered the war before America did, as a special investigator for the Chinese government; after Pearl Harbor, he served as Flight Officer Terry Lee. Loy Byrnes's *Spunkie*, first published in December 1940, focused on a refugee's arrival in America in a bid to create sympathy for refugees. In September of 1942, an editorial in pre–Pearl Harbor interventionist *Wings Comics* assured readers it "will continue to glorify the freedom-loving, devil-may-care Yank spirit that sparks America's swift-growing air fleets across five oceans and as many continents."

Other strips, particularly the serials, incorporated the war into their characters' lives. Barney Google and Snuffy Smith joined the navy and army, respectively; Dick Tracy was commissioned as a lieutenant, senior grade, in navy intelligence; Daddy Warbucks became a three-star general. *Gasoline Alley*'s Skeezix, the foundling now grown into a young man, joined up; his war story, told during 1942 and 1943, was emblematic of Greatest Generation ordinary heroism. Bombed by a German plane in North Africa, he commands his own small-ordnance recon mission, takes a German POW, and weathers a sandstorm and a shell wound (ensuring that his more seriously wounded colleague is seen to first). As the strip's novelization puts it, his fiancée, Nina, "was proud of Skeezix, of his fighting this war to make the world a better place to live in, of his taking his wounds so lightly, of his eagerness to get back into the fight again." Terry, for his part, eventually received his pilot's wings: the "Creed of the Pilot" speech read to him on Sunday, October 17, 1943, was entered into the *Congressional Record*, and Caniff considered it a pinnacle of his career. Not all characters were so heroic; George Baker's *Sad Sack* premiered in 1942, and Bill Mauldin's *Willie and Joe* (the latter originating as a Native American, though many ethnic identifiers would be dropped along the

way) showed soldiers and civilians alike the weary struggles and anxieties of infantry dogfaces: "I'm beginnin' to feel like a fugitive from th' law of averages," Willie said in a foxhole in November 1944.[134]

Many comics creators were involved in military service themselves, some as combatants. Kirby was an infantryman in Patton's Third Army, landing at Omaha Beach ten days after D-Day, his feet becoming infected from "stringing barbed wire on Europe's freezing fields." (In hospital, he was "put to work painting clinical watercolors of patients' frostbitten feet . . . a useful tool for the army doctors at a time when color photography wasn't available or effective in a battlefield setting.") Will Elder, later of *Mad*, was at the Battle of the Bulge; Charles Schulz was outside Dachau as the Americans liberated it. Some were involved in more congruent activities. Future *New Yorker* cartoonist Saul Steinberg used comics to teach demolition techniques to Chinese guerrillas. In April 1941, Walt Disney made *Four Methods of Flush Riveting*, a training film for Lockheed Aircraft. North American governments, preparing for war, noticed. Canada wanted an instructional film on antitank guns; the U.S. Treasury enlisted Donald Duck to make the case to Americans that higher taxes were necessary to support the war effort. Once the war started, Disney joined forces with another purveyor of first-class Americana, director Frank Capra, to provide animation for his *Why We Fight* films.[135]

═══

SOLDIERS READ COMICS at the front in massive numbers. It was perfect reading material: cheap, suitable for a wide range of literacy, easily portable. (The paperback book was only beginning development: the army was responsible for jump-starting that industry, too.) The Special Services Division distributed "features supplied by syndicates without cost"; 1945's *G.I. Comics* combined King Syndicate strips like *Blondie* with News Syndicate Company's *Terry and the Pirates* and Walt Disney's *Donald Duck*.[136] The war went unmentioned in many of those strips—thanks, in part, to the requests of soldiers, who wanted "to relax with their comic strip heroes [and] to forget about the war for a few minutes." By 1944, DC

editors Jack Schiff and Whitney Ellsworth had made a similar decision for *Superman*. That said, the military, seeing comics' popularity, began commissioning them for instructional purposes, too. Eisner, drafted in 1942, created comics about equipment maintenance for the Ordnance Department.[137]

Given the need for release valves, it's unsurprising the war years saw a substantial increase in "funny animal" comics. The most influential, far and away, was *Walt Disney's Comics and Stories*, which began in 1940 and ran for twenty-two years. Mickey Mouse (who'd started off life in animation as Mortimer the Mouse, losing the definite article and gaining a new name thanks to Disney's wife Lillian) had appeared in daily syndication as early as 1930. That was the Mickey of *Steamboat Willie*: tougher and less childlike than later on.[138] Slowly but surely, the strips took over 1935's *Mickey Mouse Magazine*, which, in the wake of the comic book boom, was replaced in 1941 by the all-strip reprint *Walt Disney's Comics*. The reprints continued for several years while Disney was all in on the war effort, but Disney original comics material would soon achieve new heights. The year 1941 also saw the first issues of *Looney Tunes and Merrie Melodies* and *Whitman-Dell Animal Comics*; in a licensing deal with Warner Brothers, individual Porky Pig and Bugs Bunny comics followed in 1942. That year also marked the debut of George Carlson's surreal, whimsical Krazy Kat–esque *Jingle Jangle Comics*; Goodman's Timely had *Krazy Komics* and *Joker Comics*. The former featured Stan Lee trying his hand at comedy, but it was the latter that shone, showcasing Al Jaffee ("Squat Car Squad") and, even more notably, Basil Wolverton's Powerhouse Pepper.[139]

In the next few years, Wolverton's freakish, goony figures—it's as if he went looking for artist's models in a museum of medical curiosities—would influence a generation of sickos and satirists. (His big break came via a contest to depict a never-before-seen Al Capp character, Lower Slobbovia's ugliest woman, Lena the Hyena; his winning drawing adorned a 1946 *Life* feature.) But the comparatively sedate Powerhouse Pepper was important for another reason: as an early parody of the comic book superhero, bald, "combat[ing] evil wearing a striped turtleneck sweater, slacks,

and heavy work shoes." Making fun of superheroes was a thing in 1942. Fawcett had Hoppy the Marvel Bunny; DC had its Flash parody, McSnurtle the Turtle (even wearing a Flash outfit); future *Mad* stalwart Al Jaffee had Inferior Man. Koppy McFad, boy hero of Ed Gruskin's *Supersnipe*, had the "most comic books in America," kept a red flannel costume and cape under his clothes, jumped off roofs, and was "spanked for butting into people's affairs [and] laughed at for the lumpy appearance his hidden costume gave him."[140]

Wartime paper shortages affected both strips and books: by order of the War Production Board, newsprint production dropped by over 20 percent between 1941 and 1944, resulting in deleted features, higher prices, inferior paper quality, and, most relevant, reduced strip size, often by as much as 25 percent for weekdays, twice that for Sundays. Some creators were happy to oblige what they felt was patriotic duty, but found when wartime ended that the offered-up space, frequently put to use selling ads, didn't come back. This was a particular blow for the adventure strips, whose appeal was predicated on detailed, realistic pictures. It would be a long, slow decline, with high points along the way, but they never really recovered.[141]

As for comic books, paper shortages dropped their page count by war's end, from sixty-four to fifty-two; the military's need for metal afforded each book only a single staple. That was a lot of staples saved: between 1940 and 1944, sales of comic books went from 3.7 million to 28.7 million copies a month; by summer 1941, *Superman*, *Captain Marvel*, and *Walt Disney's Comics and Stories* were each selling over a million copies, three of 150 different monthly titles produced by at least twenty-nine comics publishers. And not all those readers were kids, by any means: recall those *Blondie*-reading soldiers. By the end of 1942, comic books constituted over 30 percent of material mailed to military bases; at post exchanges, comic books outsold *Life*, *Reader's Digest*, and the *Saturday Evening Post*—combined—by ten to one. Fiction House and its "good girls" like Sheena were particularly popular, naturally;[142] perhaps ironically, the company was the closest thing to a home for comics' Rosie the Riveters, a prolific

wartime employer of female creative talent like Frances Hopper and Lily Renée during the massive shortage of male labor caused by enlistment. (DC, notably, employed Dorothy Woolfolk as a writer and editor; she was partially responsible for kryptonite.)[143]

A surprising number of the new superheroes joined them on that home front. Superman, of course, *should* have won the war single-handedly, as Siegel and Shuster had predicted, but he didn't. Naturally, Clark Kent, "eager to strike back at the enemies of decency and democracy," signed up to fight the bad guys right away. But, distracted by thoughts of bayoneting an American enemy in the behind, he "inadvertently glanced through the wall by means of his X-ray vision, and read the lettering on an eye chart in the adjoining room!" and flunked out as 4-F. Superman's subsequent strategy, as he noted when he addressed a joint session of Congress on March 10, 1942, was to return to prewar activity: "I believe I can best serve the nation on the home front, battling our most insidious foes . . . the hidden maggots—the traitors, the fifth columnists, the potential quislings." But then he adds something more: "I will be on the alert for the old totalitarian trick of creating unity by spreading race hatreds." Or, as Hitler put it in *All Star Comics*, accurately if somewhat ungrammatically, "We will make them to hate each other! We are hate experts!"[144]

This approach encouraged readers' identification of superheroes with a progressive, race-blind American civic liberalism. Dr. Mid-Nite, told that neighborhood kids have been bullying Jews, "Polish, Chinese, and Slovaks," saying they're not Americans, responds, "You certainly are Americans! We must make the boys around here realize that the United States is a great melting pot, into which other races are poured—a pot which converts all of us into one big, healthy nation!" Hawkman agrees: "Hitler fears nothing more than a nation strong in its collective, unified strength! No more racial, religious or class hatreds or intolerance."[145] This cheerleading for American ideals was matched by cheerleading for American soldiers, a DC policy decision to show that "America's fighting men were the real Supermen of the world." In an iconic cover, Superman

(labeled with a new epithet: "Defender of Democracy") happily strides arm in arm with an American soldier and sailor; three years later, Lois Lane is the one striding arm in arm with three soldiers, telling them, "You're *my* Supermen!" as a large background image of Superman looks down happily. "America's fighting men don't *need* Superman to defeat the nation's enemies—on land, on sea, and in the air!" Clark Kent says in 1945, and thankfully that was true.[146]

But comics didn't just support the troops with messages. Batman puts together a march of Revolutionary War reenactors to raise money for war bonds. ("Fellow Americans! Which is it to be—bondage, or war bonds?")[147] A 1943 *World's Finest* issue shows Superman, Batman, and Robin tending a victory garden; Wonder Woman explains waste paper salvage to her mother, who has watched American women in her "magic sphere . . . using their own shopping bags instead of having their purchases wrapped for them." Thanks to the stoppage of new car production to use the materials for the war effort, even Bruce Wayne had to look for a used car. Slogans ran across the bottom of various DC comics: "Tin Cans in the Garbage Pile Are Just a Way of Saying 'Heil!' "; "If You Have an Extra Quarter, Buy a Stamp to Make War Shorter!"; "You Can Walk to School and Store! Saving Gas Helps Win the War!"[148]

These civic efforts weren't just being encouraged in the comics; comics were initiating and facilitating them, too. Little Orphan Annie's Junior Commandos, numbering close to twenty thousand in the metropolitan Boston area alone in 1942, went "scrambling through junkpiles and knocking on doors to round up newspapers, scrap metal, old tires, kitchen grease" for the war effort. Al Capp's 1942 feature *Small Fry* (later retitled *Small Change*), about a kid, too young to enlist, who bought and pitched war bonds, helped eighty-five million Americans buy $185 billion worth of them by war's end. (Capp, Caniff, and others entertained wounded vets with chalk talks; they decided to continue their good works after the war, in no small part the organizing basis for the National Cartoonists Society.)[149] Kids were encouraged to turn in their comic books for paper drives, helping create those early issues' subsequent rarity. (To say

nothing of suggestions in comic books themselves that they were meant to be discarded or torn apart, with coupons designed for clipping. An early *Action* advertised a *Superman* issue "with a big full color picture of Superman suitable for framing";[150] in other words, feel free to tear it out.)

The Junior Justice Society, which before the war had provided readers with coded messages containing information about the next issue,[151] now provided new members, upon receipt of fifteen cents, with a certificate stating they'd been elected to keep the country united "in the face of enemy attempts to make us think we Americans are all different, because we are rich or poor; employer or worker; native or foreign-born; Gentile or Jew; Protestant or Catholic . . . knowing full well that we are *ALL* AMERICANS believing in DEMOCRACY!" Clark Kent's kids, "the Supermen of America," received similarly patriotic messages.[152] Ten cents got you membership in Captain America's Sentinels of Liberty: "Join Captain America in his war against the spies and enemies in our midst who threaten our very independence," read the half-page house ad beneath Captain America's first story.

The Sentinels actually appeared in the comic, helping Captain America defeat the Camera Fiend (who turned out to be their schoolroom teacher; talk about reader wish fulfillment!),[153] which simultaneously highlighted youth mobilization's potentially creepier side. The Justice Society are told they're "needed as patriotic Americans" because "our colleges are overrun with alien [i.e., "foreign"] teachers and students, preaching hatred for democratic ideals! . . . Soapbox orators stir up class and race hatreds! . . . This must stop!! America is a land of freedom and must remain so!" To which the Atom responds, "I'd love taking a poke at a couple of those dictator-minded professors!" Stirring up class and race hatred is pretty inarguably bad, but in the land of freedom, one might suggest some free-speech concerns. Fletcher Hanks's comics insisted that "in every American city and town, National Defense columns form" called "the Stardust Sixth Column"; Stardust gives them "thought-recorders" so that they can telepathically tell who's a fifth columnist.[154] Scholars have noted the war period's transformation of Superman from his earlier,

more anti-authoritarian incarnation into an institutionalist, a backer of the state order. It was reflected in his new epithet: the idealistic Man of Tomorrow now became the more militaristic Man of Steel.[155]

How much did all this relate to full-throated commitment to the war effort, and how much to countering contemporary criticism? Educational authorities, parental groups, and cultural critics had certainly noticed the comic book explosion and weighed in on this new technological development, this weaponizing of the comic strip many had made their peace with. A small selection of article titles from the war years: "Are Comics Bad for Children?"; "Need to Combat the Comics"; "How Much of a Menace Are Comics?"; "Comics Menace"; "The Case Against Comics"; "Are the Comics Harmful Reading for Children?"[156] The criticisms were similar to those first anti–newspaper strip broadsides. In 1940, Sterling North thundered in the *Chicago Daily News* that comic books were aesthetically, physically, and morally poisonous: "Badly drawn, badly written, and badly printed . . . the effect of these pulp-paper nightmares is that of a violent stimulant. Their crude blacks and reds spoil the child's natural sense of color; their hypodermic injection of sex and murder makes the child impatient with better, though quieter, stories." The *News* reportedly received *twenty-five million* requests for reprints of the editorial to distribute in churches and schools nationwide. In 1943, the Children's Book Committee of the Child Study Association criticized comic books for "violence of subject matter, the crudity and cheapness of format, the strain of young eyes, and the spoiling of taste for better reading." The fact that in 1941, comics had grossed four to six times what traditional children's book publishing had might have been relevant to their objections.[157]

The teachers were on the battlements. Chicago high school teacher Harriet E. Lee, after noting "neither I.Q. nor home environment is proof against [comics'] allure," concluded in 1942 that comic books "discourage the realistic facing of problems. . . . They fail to induce the spiritual lift that comes only through the appreciation of fine writing. . . . Much fine thinking is lost in the present tendency to indulge in pictograms." More rigorous studies of comics' effect on reading skills, language, or social

adjustment provided little evidence of much effect one way or the other. Perhaps ironically, perhaps in response, comics publishers encouraged literacy efforts. The *Superman Workbook*, published on the heels of Superman's success, trained students in reading. In March 1940, the children's department of Baltimore's Enoch Pratt Free Library experimented with a Superman poster recommending books; the increase in circulation resulted in a monthly bulletin distributed by numerous libraries. Scholars noted, additionally, that strips often contained fairly advanced vocabulary, sometimes at the junior high reading level, despite being consumed by much younger individuals.[158]

All this fed into a "mend it, don't end it" approach. As early as 1928, another high school teacher suggested "it is but a short step from the recognition of the universality of the appeal of cartoons to their use as a means of instruction in the history classroom,"[159] and many agreed; an issue of the *Journal of Educational Sociology* dedicated to comic books argued that "somewhere between vituperation and complacency must be found a road to the understanding and use of this great new medium of communication and social influence. For the comics are here to stay."[160] In 1941, the publishers of *Parents' Magazine* started *True Comics*, its advisory board including Shirley Temple and Mickey Rooney alongside seminal pollster George H. Gallup. The idea, said the publisher, was for parents and teachers to "offer this new comic, made up of stories from history and current events, as a substitute for the less desirable comics. Psychologically, such substitution is better than a prohibition of all comics while they are so very popular." The first issue, featuring "real life heroes" Winston Churchill and Simón Bolívar, sold three hundred thousand copies in ten days: testament, perhaps, to popular anxiety about those *other* comics. The company then added *Real Heroes*, *Negro Heroes*, and *Calling All Girls* ("published exclusively for girls and sub-debs," with "up-to-the-minute departments on good looks, good manners, 'date' fashions, recommended movies, beginner's cooking, articles . . ."). Other companies followed suit: Ned Pines's *Real Life Comics* and *It Really Happened*, Street & Smith's *Pioneer Picture Stories* and *Trail Blazers*, DC's *Real Fact*.[161]

In fact, the early '40s saw an explosion of educational comics: J. Carroll Mansfield's *Highlights of American History*, a *Texas History Movies* comic book by Dallas's Magnolia Petroleum Company, and so on. Strips joined in "safety crusades" concerning careless driving (*Gasoline Alley*) and offered scientific knowledge (naval/oceanic information in *Don Winslow*, for example). Many *Superman* issues contained full- or half-page "tips for Super-health" counseling regular exercise, rest, fresh air, and "cereals, milk, and fruit to give you that Superman energy!"[162] That said, even a sympathetic contemporary advocate concluded if "reliable facts are present in the comics . . . it sometimes takes a critical reader to discover them." More pungently, Robert Vigus, of Nashville's George Peabody College for Teachers, wrote in 1942, "The substitution of true stories in the comic magazines for the prevailing sagas of super-electromagnetic morons is only substituting cigarettes for chewing tobacco."[163]

The most famous contemporary "elevated" comic, though, contained no real facts at all. *Classics Illustrated* was founded by another child of Jewish immigrants, Albert Kanter, who became a traveling salesman at sixteen, reportedly reading literature, biography, and history while peddling products. In 1940, seeing his kids "reading comic books and neglecting the rich literature on the shelves," he came up with "a line of comics devoted to making great literature accessible to the young," starting with *The Three Musketeers*—in part, as he later said, to loosen "the hold of video and Superman on countless youthful minds." Adults read them, too, the Red Cross shipping forty million copies overseas during the war, but they really took off when kids discovered they could base book reports on them. Which resulted, starting in 1950, in the slightly wishful sign-off: "Now that you have read the *Classics Illustrated* edition, don't miss the added enjoyment of reading the original, obtainable at your school or library." (Perhaps somewhat disingenuous, considering *Classics Illustrated* chose titles to adapt based on public schools' required-reading lists.)[164]

The most prominent, and troubling, critique was on moral grounds. Almost all critics in the '30s and '40s accepted the strip-era argument of comics' potential moral influence. But the nature of that influence

was greatly disputed. Scholars tried to quantify: a 1941 study of ten lead-
ing comic strips drew such conclusions as "In no instance was a good
deed left unrewarded or a misdeed left unpunished, but whereas sixty-
three good deeds were rewarded, 192 misdeeds were punished."[165] Such
scholarship didn't resonate; polemics did. The Catholic Church, long a
veteran of weighing in on the content of printed material, soon began
campaigning against comics in major Catholic publications. "Like it or
not," Reverend Thomas F. Doyle said in *Catholic World* in 1943, "there
are plenty of American children who know more about this man-wonder
Superman than they do about Christ or any of the great characters of the
Bible." Another priest, Walter Ong, later one of the century's most influ-
ential media theorists, wrote an article in 1945 suggesting the superhero
comic, "with its concentration on a single leader-hero (Superman or *Uber-
mensch*), purveys 'herdism,' conformity to a mechanistic norm, clouded
in a haze of metapolitical dreams and provided with a strong-arm phi-
losophy as a receipt for government."[166] That fascism argument, in other
words. (The fascists didn't agree. Mussolini banned all American comics,
except for personal favorite *Mickey Mouse*; the Third Reich, in a 1940 arti-
cle, called Superman a "Jew"; the Japanese created a Greater Asia Comic
Strip Study Society "to bolster fighting spirit and thus spark 'a large drive
to bring the enemy, the United States and Britain, to their knees.'")[167]

 Some Catholics tried adopting the substitutional approach: the Cat-
echetical Guild's 1942 *Topix Comics* "featured stories of saints and Cath-
olic heroes, along with Bible tales and wholesome morality lessons." But
the most influential moral crusader in the business proper was Max
Gaines, he of the ten-cent sticker. In 1941, he produced *Picture Stories
from the Bible*, a fifty-cent, 232-page collection that, as a contemporary
put it, was "strictly in the comic-book technique, yet with sensationalism
left out." Although the title first met a rocky reception, religious leaders,
including Norman Vincent Peale, eventually endorsed it. Eight hundred
thousand copies of the book were sold in two years, and it was read in
over two thousand Sunday schools.[168] Gaines may not have been as saintly
as the figures his books portrayed ("I don't care how long it took Moses

to cross the desert; I want it in three panels," he reportedly shouted),[169] but he *was* interested in improving the medium. His Educational Comics Inc., so incorporated after he sold his DC interests (largely his paper ration) in 1944,[170] also produced *Picture Stories from Science*, *Picture Stories from World History*, and *Picture Stories from American History*.[171]

Everyone understood the war was a hinge point in history. One of the period's most fascinating comics was an "alternate history" Batman story, years before the subgenre's more famous treatments by SF authors C. M. Kornbluth and Philip K. Dick. "The Two Futures" (1943) showed dual possibilities of "what will happen to our democratic life when this war is over": in one, crushed under Nazi jackboots, a resisting Batman and Robin meet a defiant end before a firing squad. ("If the people are indifferent—if they do not do their full share in this total war—IT COULD HAPPEN HERE!" a character says, driving the point home.) The other possibility: a literal shining city upon a hill.[172]

Another time-travel tale: in spring 1945, the Justice Society voyaged through Germany's history. The tale simultaneously ended with a "formula for a lasting peace," a world organization dedicated to the cause, and the insistence that Germany was "a degenerate nation whose people throughout the centuries have always been willing to follow their military leaders into endless, bloody, but futile warfare!" Perhaps the story's mixed messaging resulted from a rush to publication: it was printed a few months before originally planned because the war's end seemed imminent.[173] But it also spoke to the fact that postwar life would require some readjustment. Sometimes physically: an early 1945 comic book cover showed the Society saluting a soldier who'd lost an arm, a trope similar to that soon explored in the celebrated film *The Best Years of Our Lives*. Coulton Waugh, who wrote one of the first histories of the comic strip, produced 1945's *Hank*, a strip about a one-legged veteran's return to civilian life.[174]

But comics themselves were more integrated into American culture than ever. In 1948, British anthropologist Geoffrey Gorer wrote up his findings about the architects of the new postwar world order for fellow

countrymen. "As one travels about the country," he wrote, "one may be unable to learn what is happening in Congress or at the United Nations meetings: but there is no excuse for ignorance of the latest adventures of Li'l Abner, Joe Palooka, Skeezix Wallet. . . . They are one of the few important bonds (the films being another and the presidential elections a third) uniting all Americans in a common experience." Comic *books*, for their part, were "the most widely consumed reading material in the United States," selling by 1945 at a rate of *102 percent*, meaning even damaged copies were being bought up.[175]

But not everything in Comic Book Land was untouched. Consider Alan Armstrong; better known, though largely now unremembered, as Spy Smasher, "mysterious enemy of fifth columnists," as *Whiz Comics* put it in 1941. Once the war ended, Armstrong traded costume for trench coat and turned his attentions to domestic affairs as a private detective called Crime Smasher, part of a radical decline of superheroes: in 1946, only a single new such character was introduced (Timely's Blonde Phantom).[176] Was that because the Greatest Generation's own democratic, decidedly non-superpowered superheroing took some of that wish fulfillment away?

Or was it because the anxieties went elsewhere?

WHO'S AFRAID OF THE COMIC BOOK?

Though *Crime Smasher* didn't last long, Fawcett had the right idea. In a postwar America yearning for calm domesticity after its sacrifices in blood and treasure, what loomed large—even larger, at least in everyday life, than the specter of the Cold War—was the fear of its potential disruption. The dynamic played out in two new comic book genres of the immediate postwar era, neither related to superheroes: romance and crime/horror comics were both hugely popular and incalculably influential.

Both were also predicated on adult readership. People who grew up on comic books, well, grew up; they were almost a decade older than they were when *Action Comics* premiered. Some stopped reading, but many—who, after all, still inhaled the daily newspaper strips—didn't. In 1947, a scholar noted that while comic books were near-universal components of six-to-eleven-year-old kids' reading—read by 95 percent of boys and 91 percent of girls—comics reading declined after that. The question, though, was how much. "Between twelve and seventeen," he wrote, "the figure falls to 87 percent of boys and 81 percent of girls. Between eighteen and thirty, the figure is 41 percent of men and 28 percent of women; after thirty, it is down to 16 and 12. But remember, these are steady readers. To

estimate the occasionals, add another 13 percent of men and 10 percent of women."[1] Imagine having over 50 percent of twentysomething men and over a third of similarly aged women reading *anything* now, even occasionally; we'd certainly hesitate to call it simply for kids. Note, too, the broad female participation, which partly explains, and is partly due to, the first great new genre.

Joe Simon and Jack Kirby, of *Captain America* fame, were looking for the next big thing. They'd left Timely in 1942: Goodman had screwed them on promised *Captain America* royalties via accounting shenanigans, counting far broader company costs against the comic's earnings. They then moonlighted for the competition and were ratted out, perhaps by Stan Lee, perhaps not. (Lee was given Simon's editorial job—temporarily, at first.) In an effort to attract and hold an older female audience (recall that two-thirds drop-off for women between adolescence and ages eighteen to thirty), they turned their attentions to romance. Love had flourished in comics in various flavors, from Maggie and Jiggs to Blondie and Dagwood; given the genre's current success among the illustrated romance magazine–buying crowd, a comic book version seemed plausible.

After a brief, four-issue run of *My Date*, a 1947 series still very much in the *Archie* mold for second-rate comics publisher Hillman, Simon and Kirby published *Young Romance*, "designed," as the cover banner said, "for the more adult readers of comics," meaning teenaged girls. (And they did it with a new publisher, Crestwood, negotiating a back-end deal in the process.) *Young Romance*'s first issue sold 92 percent of its print run, tripling that run by its third issue; it told first-person stories of girls and women who were (in their titles' words) "Boy Crazy," "Old Enough to Marry," "Lovesick," "Old-Fashioned Girl[s]," even "Fraulein Sweetheart[s]." This last presented a unique spin on star-crossed love: a potential German war bride is discovered by her Allied lover to be a Nazi, dissolving the romance. Her road to regret, symbolized by foiling an attack on American troops, nonetheless doesn't result in reconciliation; the story's bittersweet conclusion indicates the knowing nuance of some of the stories.[2]

Imitators and knockoffs followed in the hundreds. Of forty-nine monthly comics Timely published in 1948, twenty-seven were aimed at girls; in the second half of 1949, 118 different romance titles appeared, in over 250 issues. By 1950, at the height of the short-lived "Love Glut" (most new titles shuttered that year; most of the rest by mid-decade), *Newsdealer* magazine said females aged seventeen to twenty-five were reading more comics than males.[3] Titles included *Revealing Romances; Daring Confessions; Forbidden Love; Modern Love; For a Night of Love; Love and Romance; It's Love; I Love You; Sweethearts; My Love Story; Exciting Romances;* and *My Private Life.* Some were crossovers with another popular genre: *Cowboy Love; Romance Trail; Love Trails; Rangeland Love;* and *Saddle Romances.* ("If this young woman from the East wanted war, I would oblige her. Oh, not with tomahawk and war cry, but with smiles and bright challenging eyes!")[4]

There had been Western strips by the '30s, following in the Western pulps' footsteps: *Red Ryder, Lone Ranger, White Boy, Skull Valley,* and *Big Chief Wahoo.* After getting their Superman fix, *Action Comics* fans could read *Vigilante,* created by Morts Weisinger and Meskin, about a rodeo showman who headed east and took up gun-toting, lasso-roping crime-fighting, carrying on the legacy of his murdered sheriff father. Even Batman and Robin rode horses in 1944's "The Streamlined Rustlers." But Western comics really took off in the late '40s, featuring both original creations (Kid Colt, the Two-Gun Kid), and movie cowboys. Gene Autry's comic ran for eighteen years, Roy Rogers's for seventeen, the Lone Ranger's for fourteen. Dale Evans's series debuted under the DC banner in 1948; Autry's and Rogers's *horses,* Champion and Trigger, got their own books, as did the Lone Ranger's Silver. They sold: in 1951, a Roy Rogers promotional movie claimed twenty-five million Roy Rogers comics were bought each year. DC converted the Justice Society's *All Star Comics* into *All Star Western* (featuring art by a young future icon, Alex Toth); Batman was backed up in *Detective Comics* with Pow-Wow Smith, Indian Detective. In 1950, Pittsburgh's Black weekly, the *Courier,* featured *The Chisholm Kid,* a Black cowboy hero.[5]

The late-'40s appeal of the Western isn't surprising. In times of social anxiety, cowboys like John Wayne, then doing some of his best work, appeared as rocks of morality, stability, and masculinity, teaching values to the kids, who were clearly (as they always are) in deep trouble. Many Western comics were set in contemporary times, allowing Roy Rogers to help the FBI break up narcotics rings, smash subversive communist plots—or both simultaneously.[6] That said, anxiety was strongly present, too, most prominently expressed by a pervasive fear of the other, attempting to define America through who didn't belong. Native Americans, all too often dubbed "Injuns," almost always speaking broken English, were generally depicted as lacking white Americans' moral rectitude, as were the Asian characters dotting the comics.

Some women were more complexly portrayed. Several late-'40s creations ran ranches, foiled enemies, and generally administered whuppings of various sorts in the absence of strong male figures in comics presumably aimed primarily at young boys. There was Buffalo Belle, "maverick deputy to colorless, square-jawed sheriff Luke Hanley"; Rhoda Trail, "trigger-tempered editor of the *Sundog Sentinel*"; and rancher K-Bar Kate, who'd attended drama school in New York and thus employed "impeccable Eastern grammar and diction" rather than typical comic book Westernese. Were they reflections of ambivalence about a post–Rosie the Riveter return to an image of domesticity? It may be no surprise, then, that these strong female protagonists were the exception rather than the rule.[7]

One of the most prominent romance publishers was M. C. Gaines's son. In August 1947, Gaines died in a Lake Placid boating accident (another boat plowed into theirs; he died pushing a kid to safety), and son Bill was handed the business with very little experience. He'd had a complex relationship with his father: Bill was, in his own words, "a behavior problem, a nonconformist, a difficult child," and Max let him know how much he failed to live up to expectations. At the time of the accident, twenty-five-year-old Bill was completing his final year as an education student at New York University and his wife had just left him; his mother convinced him

to move in with her and go into the family business instead of becoming a chemistry teacher.[8]

The family was well-off; it wasn't about the money. Shelly Mayer thought "Bill went into the business as a joke, to see if he could screw up things, change them for his private amusement, and still manage to make money doing it."[9] Maybe it was more than that, psychologically speaking; Bill's sense of being beholden to none resulted in a vastly different perspective than his father's, symbolized by his change of the company's title. To keep things simple, he kept the initials it was often known by, but EC went from Educational Comics to *Entertaining* Comics.

Gaines started by scudding along with the trends, publishing Western comics like 1948's *Gunfighter* and *Saddle Justice*, which, again following the market, became the aforementioned *Saddle Romances*. Originating a whole new comic book meant giving the post office a hefty deposit until a much cheaper second-class postage status could be obtained; if you simply changed the title, but kept the previous incarnation's numbering, you could get around that requirement—unless, of course, someone noticed.[10] (Those mail privileges required the inclusion of two-page text pieces. The resulting stories were the subject of a bargain between publishers and readers: the publishers agreed not to care about them, the readers not to read them.) In addition, newsstand distributors might take an existing title at higher numbers than an untried one. Thus comics' odd issue numbering, which bemuses readers and bedevils comics historians. For example, EC's *A Moon, a Girl . . . Romance* (subtitled *True Stories of Young Love*), started as *Moon Girl and the Prince* (a space adventure), became *Moon Girl*, which became *Moon Girl Fights Crime* (space *and* crime), which became *A Moon, a Girl. . . . Romance.*

Gaines satirized the nomenclatural, and genre, whiplash in "The Love Story to End All Love Stories": *Modern Love*, another EC title, is so successful that an executive announces, "Gentlemen! . . . Change all the titles! T. Tot Publishing Company is dropping its crime!" A shocked junior exec, looking eerily like Gaines, asks, "No more 'Crime Might Pay?' No more 'Crime Could Pay?' No more 'Crime Should Pay?' No more

'Crime Used to Pay?' No more 'Crime Does So Pay?' No more crime, T. T.?" To which T. T. replies, "I want . . . 'Love Might Pay,' 'Love Could Pay,' 'Love Ought to Pay,' 'Love Should Pay,' 'Love Used to Pay,' and 'Love Does So Pay'! It will pay!"[11]

Gaines collaborated on "Love Story" with Al Feldstein, who'd come to EC for a job drawing an *Archie* knockoff; *Going Steady with Peggy* never saw the light of day, but Gaines liked Feldstein and kept him on the payroll.[12] A 1952 EC bio explained what happened next: "It became apparent that he was not only a talented artist but could write better script than the professional comic script writers! Slowly the balance between art work and script shifted until Al found himself working almost exclusively on script and doing no art work but occasional covers!"

And those scripts! A single issue of *A Moon, a Girl . . . Romance* featured titles like "I Was Jilted and Had No Desire to Live," "I Was a Flirt," and "I Was a . . . Heart Pirate."[13] Here's a tale from a later issue: "I suffered through three years of desperate, aching loneliness. . . . Then Jerry came into my life and I almost forgot I was a. . . . PRISON WIDOW." If *that* feels overwrought, imagine the gyrations required for *Saddle Romances* stories: "When my eyes first looked into those of Gordon Feathers, my heart seemed to burst with—AN INDIAN LOVE CALL!"[14] A 1949 story ("Promises of a glamorous stage career by a handsome theatrical producer brought me to New York. . . . But after I arrived, I became . . . SUSPICIOUS OF HIS INTENTIONS!") informs us, inside a small heart, the story is "as told to the editors by Lucy Harper.*" The asterisk caveats that "all names in this true love story have been altered to conceal the identities of those involved." If you're suspicious as to Lucy Harper's existence, you may also appreciate knowing the "Indian Love Call" story above was reportedly "told to the editors by Little Firefly,* Osage Indian Princess." Insiders have, in fact, reliably informed us that most, if not all, stories were figments of Gaines and Feldstein's fertile imaginations, as was their agony-aunt column "Advice from Adrienne."[15] (They weren't the only fakers; Simon and Kirby alternated answering *Young Romance*'s letters under the pseudonym Nancy Hale.)[16]

Gaines and Feldstein may have been fibbing when claiming to be "deluged by requests for advice and counsel on problems relating to dates, social activities, married life," though the following issue's caveat, "We reserve the right to edit and shorten all letters for publication," suggests at least some correspondence. That said, tantalizing responses to queries from unprinted letters ("Dear J. C.: Surely you must be joking! I am unable to advise you in this matter!") are, at the very least, a good act. But if there's any truth to the claim they "selected those problems which seem to affect the majority of our readers," those readers were contemplating accepting an engagement offer at fourteen (answer: no); debating staying away from Sis's boyfriend, despite knowing "my feeling for him is more than just a passing fancy" (answer: yes); or "I am 14 and I have been going with this boy since he left his wife. He is getting a divorce soon. Should I continue to go with him?" (answer: definitely no).[17]

Two of those three questions concern marriage; the romance comic was wrapped up in the creation of domestic bliss, meaning, of course, *Father Knows Best*–style heterosexual marriage. Which clearly reflected tensions about that selfsame family: the divorce rate had skyrocketed in 1946, and the 1948 Kinsey Report stated that over a third of American males had had homosexual experiences, and half had cheated on their wives. Significant pressures existed to return, post–Rosie the Riveter, to a gendered hierarchy (even as total female employment grew in the '50s by over a third, to one-third of the total workforce). Romance comics frequently used (or mimicked, or ventriloquized) female agency in order to subvert it. A story in *Saddle Romances* began, "I could ride like a broncobuster, shoot and herd steer like Buffalo Bill . . . but what I didn't know until I met Cliff Scott, was that ROMANCE ISN'T FOR TOMBOYS"; it literally ends with the woman handing her man her whip. And some, like those known as "treat her rough" stories, seem particularly ethically repulsive now. There were exceptions, primarily by Dana Dutch, but they were few.[18]

And there were almost no non-white characters whatsoever, echoing a postwar trend of addressing Black stereotypes through the expe-

dient of removing Black characters more generally, a way of coping with the betrayal of the liberal ideal of inclusive equality the Justice Society, and American society, had suggested during wartime.[19] Although the St. John romance comics had a "correspondence club" for soldiers that explicitly included Black members, this occurred off the comic book page itself. *All-Negro Comics*, created in 1947 by Philadelphia journalist Orrin Cromwell Evans, "jam-packed with fast action, African adventure, good clean humor and fantasy" and proudly stating that "every brush stroke and pen line in the drawings on these pages is by Negro artists," only lasted a single issue, in part because newsprint vendors wouldn't sell their wares to Evans. In the early '50s, Fawcett, then Charlton, published *Negro Romance*, featuring Black protagonists; it only lasted a few issues.[20]

In these matters, of course, romance comics were no worse, and no better, than contemporary film and television. Or other comics. Miss America was a female Cap, first appearing in Timely's 1943 *Marvel Mystery Comics*, soon acquiring her own title. In 1945, though, teen Patsy Walker takes over *Miss America Comics* for romantic adventures; after the war, Timely's female characters included Millie the Model, Nellie the Nurse, and Tessie the Typist. Millie the Model, in fact, substantially outsold Timely's superhero comics. Walker soon appeared in a half dozen titles of her own, including *A Date with Patsy* and *Patsy Walker's Fashion Parade*. (She even ostensibly edited a magazine herself, *Girls' Life*.) A comic adaptation of radio and TV show *My Friend Irma*, launched in 1950, "survived for five years on the simple premise of her dim bulb" and the heroine said, "Golly!" a lot. All these were edited, and often written, by Stan Lee, who'd kept that editorial chair permanently. As the war ended, MLJ, which changed its name to Archie Comics the following year, created model turned Hollywood starlet Katy Keene; readers were asked to send in designs for her outfits, and successful contributors—one named Calvin Klein—were credited by name and hometown. Keene got her own title in 1949, which grew to eight by the mid-'50s, including *Katy Keene Glamour* and *Katy Keene 3-D*.[21]

The only comic book character in the postwar decade who "seemed

consistently and assertively feminist" was approximately three feet tall. Little Lulu was created by Marjorie Henderson Buell for the *Saturday Evening Post* in 1935 as a one-panel strip. It was a commercial success; book collections and toy dolls appeared as early as 1939, animated cartoons from 1943. The comic book premiered in 1945; written by John Stanley for fourteen years, it presented Lulu as strong, brassy, smarter than everyone around her, *especially* the boys. Since Buell owned the rights, Stanley's stories were published as "Marge's Little Lulu," perhaps also inspirationally suggesting to young readers they were *written* by a woman, too.[22]

Sexism wasn't only on the page, but behind the scenes. Lois Lane's newspaper-strip equivalent was Dale Messick's *Brenda Starr*. Dale was a pen name for Dalia; finding a cool reception under her real name, she changed it to something more ambiguous. Patterson never agreed to publish *Brenda* in his *Daily News*; it only appeared there after his death.[23] Hilda Terry created *Teena*, a popular postwar teen girl strip. In 1949, she sent a protest letter to the all-male National Cartoonists Society in the name of the Committee for Women Cartoonists: "The cost of your stag privilege is stagnation for us, professionally." The membership was "overwhelmingly in favor of admitting" women; however, proposed members could be blackballed, and Terry fell victim in 1950, possibly because several men felt they wouldn't be able to talk dirty around her. Milton Caniff made an angry speech in response; Al Capp walked out and wouldn't return for years. Eventually, the blackball was eliminated, and members (including women) were allowed to join on a two-thirds vote.[24]

Some postwar strips *were* characterized by a lighter touch, like Crockett Johnson's *Barnaby*, but the period's most significant comedy, complete with a dollop of postwar swagger, appeared in *Walt Disney's Comics*. While various Disney characters took turns in the spotlight—Bucky Bug, Li'l Bad Wolf, Mickey Mouse, and Grandma Duck, among others—the character who spoke most profoundly to early postwar America was an expostulating waterfowl who wore a shirt but no pants.

This was, in almost sole part, due to the genius who wrote and drew Donald Duck's adventures. An *uncredited* genius, at the time: Disney

never acknowledged any writer or artist other than Walt himself, ostensibly to avoid ruining children's belief he was personally doing it all. Thus, Carl Barks became known merely as "The Good Artist" or, sometimes, "The Duck Man." He'd been at Disney in various capacities since 1935, but it was his ten-page Donald stories, month after month for two decades, that earned him immortality. Barks sent Donald, his adventurous and highly capable nephews, and his miserly Uncle Scrooge to real sites all over the world—places he brought to brilliant life, intensively researched from *National Geographic* and the *Encyclopaedia Britannica*, populated by colorfully named characters like Argus McFiendy, Professor Artefact McArchives, Gladstone Gander, and Gyro Gearloose.[25] Were Donald's incredible adventures colored by the fact Barks hadn't traveled internationally himself?[26] Was it Barks's varied stints as "a cowboy, a logger, a printing press feeder, a steelworker, a carpenter, an animator . . . and a barfly," only starting comic book work at forty-one?[27] Or were they echoes of a newly global America?

Barks was certainly mindful that his work was read by millions in many countries;[28] famously, leftist critics saw Donald and his parent company as fronts for an imperialist enterprise. "It is the manner in which the U.S. dreams and redeems itself, and then imposes that dream upon others for its own salvation. . . . It forces us . . . to see ourselves as they see us," they said, talking about Latin America but willing to apply their point more broadly.[29] The global spread of American comics wasn't *just* Disney: as of 1939, King Features had fifteen foreign bureaus, supplying eighty-five countries with comics in twenty-nine different languages. And you can argue that, since different cultures "read" visually, teaching to read American comics is like teaching to read in an American, or Western, way.[30]

But if we *are* to engage in Groucho Marxism, we should note how obsessively money features in Barks's stories: personified, of course, by the duck who has bajillions and just wants more. Scrooge McDuck, inspired by both Ebenezer and Andy Gump's rich uncle, first appears in 1947 as a stereotypical miser. By 1949, with Americans having more pur-

chasing power than ever (the gross national product of the United States more than quadrupled from 1940 to the mid-1950s), Scrooge's monetary obsessions—working hard for it, neurotically keeping it—drive many of Donald's greatest adventures. (Although, as Barks himself frequently noted, Scrooge would have cratered a capitalist economy, hoarding all the money as he did and not letting it circulate.)[31]

But Donald wasn't only a nephew: he *had* nephews. And they were more adult than the adults: Boy Scouts (well, Junior Woodchucks); sane, levelheaded; displaying the virtues every white-picket-fenced, suburban-lawned American wanted for their child. The past was tough but good, inculcating virtue; the future was full of safe adventure.[32] Maybe that's why Disney would be spared from industry ravages to come: in its view, the kids were all right—a sense of safety hardly provided by the period's second great comic genre, which, in the public's imagination, often stood in for comics as a whole.

"THE MOST SENSATIONAL COMIC IDEA ever is sweeping the country!" ads teased. In 1942, Lev Gleason Publications had changed one of its comics titles from *Silver Streak Comics* to *Crime Does Not Pay*. Gleason, an Andover graduate and Harvard dropout (to fight the Germans in World War I),[33] had originally worked with Wildenberg at Eastern Color; his company's presiding genius, Charles Biro, had bounced around the industry, creating comics like *Crimebuster* and *Airboy*, though he was possibly best known for the pet monkey that sat on his shoulder while he drew. But then, a brainstorm: a comic book version of '20s true-crime pulps, with a title borrowed from a '30s MGM documentary series and subsequent radio drama about real-life officers solving crimes.[34] It "is more than just a magazine," Gleason wrote on the new comic's inside front cover. "It is dedicated to the youth of America with the hope it will help make better, cleaner young citizens."[35]

People didn't need *Crime Does Not Pay* to let them know crime didn't pay. Dick Tracy, the Shadow, Batman, and J. Edgar Hoover had reminded them of it for years. But there was something different about the crime comics. Unlike Tracy, these were taken from the newspapers and history

books: true-life accounts, full of realistic, grim, and lurid—if not necessarily gory, and not too fastidiously accurate—details. (Truman Capote's *In Cold Blood*, often hailed as the birth of the true-life crime account, was published almost a generation later.) Gleason and Biro may have been premature in their hype, but they weren't wrong. Circulation started small but shot up quickly; the company was selling a million copies a month by 1947, and Gleason and Biro accurately, or self-servingly, estimated each copy was passed around to five or six other readers.[36] Batman and Robin literally skywrote "Crime Does Not Pay" from their new jet Batplane in 1946—a simultaneous attempt at appropriation and acknowledgment of the new, more powerful force on the horizon.[37]

In 1947, three crime comics accounted for about 1.5 percent of all comics titles published; a year later, the number had increased twelvefold. As one critic from abroad bluntly put it, "In 1948, out of 800 million books published in the USA, 700 million were comic-books, and of these, nearly half were crime-comics." Titles from that year alone included *Crime Must Pay the Penalty, Crimes by Women, Crime Detective Cases, Authentic Police Cases,* and *All-True Crime Cases.* Simon and Kirby, never slow to jump on a bandwagon, turned *Headline Comics,* "until then chock-full of clean-cut boy heroes," into a crime comic in 1947; the duo occasionally posed for cover photos as cops and robbers, another gesture toward realism.[38] Each cover of *Wanted Comics* had a wanted poster with a dangerous criminal's profile; if you identified the public enemy on the street, you got a hundred dollars. Biro, for his part, wanted "literal realism" when it came to the look of machine guns, cars, and so forth. "I don't want art—I want detail!" he used to say. "That's what people look for." The least truthful part of *Crime Does Not Pay* was Biro's authorship: David Hajdu discovered that many, if not most, of Biro's scripts were actually written by Virginia Hubbell, a woman he'd met at an earlier job. *Crime Does Not Pay*'s most pronounced feature premiered in its third issue: a spectral narrator, Mr. Crime, who Dionysiacally rejoiced in the mayhem and gunplay and added a kind of horror-show element to the proceedings beyond any simple documentary-style presentation.

(More prosaically, he was the reworking of a 1930s ad character called Mr. Coffee Nerves created by Sickles and Caniff.)[39] Mr. Crime's prurient observations reminded readers of the capering pleasure—mixed with horror?—they took in the reading. It's widely noted that the comic's title, with CRIME in big letters and "does not pay" in much smaller ones, marked the real location of reader interest.[40]

In 1947, Gleason ex-partner Arthur Bernhard asked *Plastic Man's* Jack Cole to create a crime comic, and *True Crime Comics* is the wildest, most terrifying example of the lot: its "Murder, Morphine and Me," done in confessional style, features an infamous shot of a syringe about to plunge into poor Mary Kennedy's eye. The same issue had a speeding car dragging men along a gravel road—"Ya gotta admit, there's nothing like them for erasing faces!" a criminal says.[41] Think, though, about that wide-open eye, about to be stabbed with addictive and deadly content, a reminder of the notion that behavior can be influenced by outside forces—forces, perhaps, like comic books. Crime comics weren't necessarily aimed *directly* at kids: an ad for *Crime* reading, "Show it to Dad, he'll love it!" suggests both an expansive audience *and* a sense of who'd do the showing. But a 1948 survey finding that 57 percent of the comic's readers were over twenty-one means that 43 percent weren't; and Victor Fox's 1948 comic *Murder, Incorporated* sticking "For Adults Only" on the cover can be interpreted as come-on as as much as keep-away.[42]

Never one to ignore a trend, Bill Gaines jumped into the crime comics fray as well. In another retitling frenzy, 1947's *International Comics* soon became *International Crime Patrol*, and then just *Crime Patrol*. Aping *Crime Does Not Pay's* most distinctive feature, Gaines introduced his own bizarre narrator: wizened cackler the Crypt-Keeper, presenting "an illustrated Terror-Tale from the Crypt of Terror." Soon enough, the comic transmogrified again, from *Crime Patrol* to *Crypt of Terror*, and finally to *Tales from the Crypt*.[43] Other titles in Gaines's company participated in this "New Trend": *War Against Crime* became *The Vault of Horror*; *Gunfighter* the *Haunt of Fear*. Each featured its own host: the Vault-Keeper and Old Witch, respectively.

Gaines and Feldstein hadn't invented the horror comic. *The Hunchback of Notre Dame* and *Frankenstein* had been adapted for comics in the '30s; in the '40s, Classic Comics' *Frankenstein* was translated into twenty-two languages and distributed in thirty countries. The trend only grew. *Jumbo Comics'* jumbo-ness included ghost-hunting detective Drew Murdoch's "Ghost Gallery";[44] *Front Page* (1945) and *Strange Story* (1946) featured Bob Powell's Man in Black, "who narrated unusual and spooky yarns"; 1948's ongoing series *Adventures into the Unknown* featured ghosts, werewolves, vampires, zombies, and haunted houses. Timely, taking notice, changed *Marvel Mystery Comics* into the horror title *Marvel Tales. Captain America Comics* had always had a tinge of the weird about it, with story titles in '40s issues like "Captain America and the Wax Statue That Struck Death" and "Horror Hospital"; after the war, though, the title became *Captain America's Weird Tales*, and Cap even went to hell to fight archenemy Red Skull, whom he'd killed at the war's end. Classic literary influences notwithstanding, many of these comics took their influences from pulps like *Weird Tales, Terror Tales, Ghost Stories*, and *Horror Stories*, along with the flood of '30s horror pictures, ranging from Universal features like *Son of Frankenstein* to the wide variety of less-remembered Poverty Row movies like *The Devil Bat, Valley of the Zombies*, and *The Vampire's Ghost*.[45]

But it was EC that put the horror comic front and center with the crime mags, thanks in no small part to those hosts. They owed a *lot* to the spooky old radio-show hosts on programs like *Inner Sanctum, Lights Out*, and *The Whistler*.[46] Gaines and Feldstein, sitting in their "dingy and cluttered" offices that, "except for some cubicles with drafting tables . . . might have belonged to a shirt manufacturer or shoe company," borrowed, with great relish, from the atmosphere of words radio created of necessity. Here's the Vault-Keeper, introducing a story with typical alliterative brio: "Venture into the vault, vultures. This is your host in howls, the Vault-Keeper, ready to narrate another nauseating novelette from my crawly collection."[47]

The three GhouLunatics, as they became affectionately known,

appeared in each others' books and palled around in house ads and let-
ters pages—which, unlike in the romance comics, contained seemingly
real letters from actual readers. "Be sure you have the correct address,"
the Crypt-Keeper chided, "so that your correspondence doesn't end up in
the DEAD-LETTER office!" Yes, the puns. There's the distinct impression
stories were often brought into being for the sake of a title joke or climac-
tic punchline; a particularly ramshackle construction concerning a vam-
pire cabbie was "Fare Tonight, Followed by Increasing Clottyness." Fans
chimed in with their own ghoulish parodies of the American songbook:
readers provided titles like "I'm Slicing You a Big Bouquet of Noses" and
"It Breaks Two to Mangle"; or, to the tune of "I'm Looking Over a Four
Leaf Clover":

> *I'm running you over*
> *With a sharp lawn mower*
> *That I never used before.*
> *The first blade's for chopping*
> *The second will hack*
> *The third will disjoin*
> *Your head from your neck.*[48]

EC ranked stories by fan mail, as had early SF mags and contemporary
comics. Fiction House comics readers divided up the dime they'd paid
for their comic based on the relative value derived from individual sto-
ries therein: a top favorite might have been worth five cents, while the
text pieces, always the least favorite, weighed in at half a penny, if that.
And other comics hawked plenty of merchandise, though arguably only
EC offered a five-by-seven-inch "actual photographic reproduction . . . to
proudly hang on the wall of your TOMB." But the fan club was something
else: nine thousand charter members in November 1953, ultimately ris-
ing to nearly twenty-five thousand, received a card, shoulder patch, "stun-
ning antique bronze-finish bas-relief pin," and sense of a community
aborning.[49] And only EC would have dared explain its choice of name so:

"As one reader wrote a while back, 'E.C. Magazines are habit-forming.' "[50] The EC Fan-Addict Club and its correspondence, in short, confirmed the moral authorities' worst fears.

In fact, you could say EC comics were so troubling partly because they suggested a certain moral commonality with the monstrous. Some of EC's most outrage-eliciting horror comics had no ghosts or vampires anywhere: they were crime stories, simply put. Or doubly put, since they were generally tales of crime, and then gruesome counter-crime in the name of punishment, that grue generally coming in the final panel for impact. The abusive stepfather run through the meat grinder ("Grounds . . . for Horror!"). Or the tainted-meat seller hacked into prime cuts by his wife and displayed in his own butcher's case ("'Taint the Meat, It's the Humanity!"). As Stephen King, as grand an inheritor of the EC Comics tradition as ever there was, has suggested, it's an ultimately conservative narrative: rotters are punished, over and over again, by the rotting. Crime does not, as it were, pay.

Admittedly, at times it seemed disproportionate. Murder for murder may be one thing, but terrible as bigamy might be, you probably don't advocate two-timed wives using the cad's head as a bowling ball and gouged-out eyes as golf balls ("How Green Was My Alley"). But you can be forgiven, as with the crime comics, for thinking that wasn't the point. The point was that human nature was criminal to begin with. Scratch a suburban husband behind that white picket fence and find a bigamist; look past the neighborhood butcher's clean white apron to discover the sociopathic poisoner underneath. The Vault-Keeper puts it nicely in his introduction to "Roped In!": "They seem nice and respectable, eh? . . . Well, come on in and listen! You'll be shocked!"[51] The supernatural horror stories, as always, were allegory: *we* were the ghouls and vampires all along.

The sentiment imbued EC's supernatural horror, too. Selections from 1951 include a man's hearing replaced with a bat's—a vampire bat's—with predictable consequences ("Bats in My Belfry!"), and a man who dissolves when a painter accidentally drops turpentine on his "voodoo" self-portrait ("Drawn and Quartered!"). And the many returning, moldering corpses

that walked among us ("Zombies! I've married into a family of zombies!" says the narrator of "Cold War"). But the tales' most striking feature is the frequent corralling of the reader into the story—as the monster. "THIS chilling ordeal . . . is about to happen to YOU! YOU are the main character!" says the Crypt-Keeper; "you" turn out to be a rotten, decomposed corpse. (In a similar story several years later, "you" are a Frankenstein-type monster.) EC wasn't the first to use the trick—it's borrowed from Lovecraft[52]—but when combined with the cheerful letter-page identification and the addict fan club, clearly something's happening.

"We were writing for teenagers and young adults, we were writing for the guys reading it in the army," Feldstein said in 1972. "We were writing for ourselves at our age level, and I think perhaps that was responsible for the level we reached." That, and feverish intensity: Feldstein generally scripted from plots either brainstormed in story sessions or "springboards" dreamed up by Gaines after diet pill–fueled all-nighters spent reading SF or horror. " 'If we didn't have an idea by two o'clock,' recalls Bill, 'we knew we were in trouble.' By four o'clock the story was finished . . . a story a day. For five years." Plus, Gaines and Feldstein designed the stories around individual EC artists' talents, ensuring a creative match between writer and artist for almost the first time in the comic book era. And it was a real (heh, heh) murderers' row of artists: Jack Davis, "Ghastly" Graham Ingels, Johnny Craig, Jack Kamen. Colorist Marie Severin, the story went, "made her feelings known by coloring dark blue any panel she thought was in bad taste."[53]

EC readers knew them all: and the reason they did was because EC ran creative-team pictures and biographies on full-page spreads. DC and Timely had done it occasionally, as had Charles Biro and Bob Wood; but these were generally press-release pieces that smelled of the puff, rather than the sense of personality, community, and sheer silliness EC encouraged. Even the GhouLunatics gave the staff an affectionately hard time: "Stick to the script, you slime-slinger!" one note reads.[54] The *truth*, revealed in *Weird Science*'s story "EC Confidential," was that the whole staff were Venusians, sent to warn Earth of the dangers of Martian conquest.

That origin story fit Gaines and Feldstein's general orientation. Though to many of their critics EC would become synonymous with horror comics, EC considered itself "proudest of our science fiction magazines," as ads for *Weird Science* and *Weird Fantasy* proclaimed. The proof was in the budgeting: Gaines kept publishing the titles even though they lost money, covering the hole with profits from the horror titles. Given their shared authorship, a similar sensibility was unsurprisingly at work in both genres: echoing new cynical and satirical trends in '50s SF, EC suggested human nature was pretty lousy even in the far future. The comics contemplated questions of atomic anxiety, civil rights, changing gender roles, and much else through fantastic metaphor.

"If we ever answered a letter that we were not trying to teach anything with our science fiction stories, we were lying," Gaines would say. "On the contrary, science fiction traditionally has been a great vehicle for an author to try to teach a moral or ethical lesson, and we certainly were doing that." A favorite source of material was Ray Bradbury, whom they touted on covers as "America's Top Horror Writer!"[55] (They owed him, having swiped his stories without paying royalties until he caught them; but, as a Buck Rogers fan from way back, he was mellow about it, even letting them use other stories at low cost.) Bradbury famously mixed his SF with his horror, or vice versa; his lyrical stories of Mars and rocket ships frequently juxtaposed hearts of darkness with gleaming metal. And moral nihilism never looked so good, with art by geniuses like Joe Orlando and Wallace (aka Woody or Wally) Wood, who'd started out assisting Eisner.

Except maybe in Harvey Kurtzman's war comics.

Kurtzman's first job for EC had been to illustrate a comic about VD, but he soon started working on two new titles, *Two-Fisted Tales* and *Frontline Combat*. Much of the fanfare came from the books' incredible attention to detail: Kurtzman provided copious notes and instructions to present armaments, uniforms, and military terminology with previously, and perhaps still, unsurpassed accuracy. An EC Christmas card showed a combat-helmeted Kurtzman demanding, "Now I want you guys to get

out there and make them stories real! REAL YA HEAR!"; in one famous case, he sent assistant Jerry De Fuccio down in a submarine to garner appropriate sound effects, despite, as De Fuccio later wrote, "Kurtzman kn[owing] I had a five-foot shelf" of reference on submarines.[56]

But in the midst of the Korean War, whose rationale for engagement was far less clear-cut than that of World War II, and whose resolution was equally—if not more—murky, Kurtzman adopted the same iconoclastic perspective as the other EC comics in tales like "The Big If" and "Corpse on the Imjin": an unwillingness to glamorize combat, in sharp contrast to previous, and contemporary, war comics and films. The year 1952 alone, for example, saw Marvel's *War Adventures* and *War Action*, DC's *Star Spangled War Stories* and *Our Army at War*, and others, like *War Heroes*, *War Fury*, *Battle Cry*, and *Fighting Leathernecks*. *G.I. Joe*, cheerfully and savagely jingoistic, also premiered during Korea. "I was absolutely appalled by the lies in the war books," Kurtzman said. "'Americans are good guys and anybody against us is the bad guys. We're human. They're not. And God is always on our side.' This trash had nothing to do with the reality of life." Younger readers complained many of *Two-Fisted Tales'* stories had "sad endings"; Kurtzman's reply was that they were realistic.[57]

Kurtzman, Gaines, and Feldstein reasonably saw themselves possessing a strong, if admittedly unconventional, moral sensibility: question received wisdom and authority; leaven, in some cases, with humor, particularly wordplay and satire; don't flinch, in an age of sanitized newsreels, post–Hays Code film, and careful early television, from the visceral power of the visual. A sensibility as responsible as anything for launching the '50s undercurrents that fully flowered in the countercultural '60s.

And so, of course, they made enemies.

———

AN AMUSING, BUT SYMPTOMATIC, expression of Gaines's emergence from his father's shadow was his somewhat idiosyncratic response to a small *New Yorker* squib of March 24, 1951, which simply took note of Educational

Comics Inc.'s publication of New Trend titles like *Tales from the Crypt* and *Crime SuspenStories*. Four days later, in the first of two identically dated letters, Gaines took this as "a personal insult": "as vice-president of Educational Comics Inc., I would have absolutely nothing to do with magazines dealing with such shocking and distasteful subject matter as those which you list." In the second letter, he insisted, "Having worked hard to build up a reputation for the very finest entertaining comic magazines in the field . . . as Vice President of the E-C group, I would have absolutely nothing to do with magazines dealing with such dry, unentertaining and obviously educational material as Educational Comics Inc., publishes."[58]

The New Yorker published both letters under "Department of Correction (Jekyll and Hyde Division)."[59] The comparison was somewhat inaccurate, as well as facetious: Robert Louis Stevenson's character was genuinely interested both in proffering medicine *and* indulging monstrosity, while Gaines was far more interested in one than the other. He wasn't alone: between 1950 and 1954, the industry saw no fewer than one hundred new horror titles; by 1954, more than forty horror comics came out each month, sometimes ten appearing on a single day.

EC got the attention, and the lion's share of profits; but even Fawcett (*This Magazine Is Haunted*) and Harvey (*Chamber of Chills*) were part of the mix. Some boasted EC-like hosts, such as Dr. Death, Mr. Mystery, and the Mummy; some had the bad guys win after all. Cannibalism, necrophilia, and other taboo breakers abounded. Some are buried treasures only now emerging from EC's long shadow, like Bob Powell's work; and some just seem, well, stupid, like the 1953 cover where all a monster can think of to do with a woman's boyfriend's skull is go bowling with it. A similarly inclined artist, under standing instructions to up the spooky quotient, just "added skulls to any pages that weren't already scary enough." But it was a free country, and if the horror comics were outselling *Superman* and *Batman* four to one, well, as Gaines shrugged in an early-'50s interview, "Our magazines are written for adults. It isn't our fault if the kids read 'em, too."[60] Maybe not; but there definitely *were* a lot of kids reading 'em, horror and crime comics alike. There had to be, with

comic book sales as high as one hundred million a month. And it wasn't unreasonable to ask what they were taking from them.

Gershon Legman, who would write two massive volumes on the dirty joke, turned his attention to comic books in 1949. Perhaps surprisingly, given his later interests, Legman was fairly uninterested in comics' sexual aspects, dismissing "the accusation that certain comic-books might excite young children sexually" as "wrong," that critics "have not the slightest recollection of what does excite children sexually. . . . The really surprising thing is the hypocrisy that can examine all these thousands of pictures in comic-books showing half-naked women being tortured to death, and complain only that they're half-naked." Violence—in no small part, violence against women—was Legman's concern; he suggested comic books presented impressionable youth with a world saturated with, indeed predicated on, criminality. "Instead of being brave and fearless," he writes, "Superman lives really in a continuous guilty terror, projecting outward in every direction his readers' paranoid hostility. Every city in America is in the grip of fiends." And the "rehabilitate comics" approach wasn't better; in some ways, it was worse: "Hypocritically or not, the crime-comic does tell the child that murder is the act of a criminal, and will be punished. The educational comic tells him the opposite. It gives murder prestige. . . . Movie stars do it, duchesses do it, men of distinction do it—why don't you? . . . In the educational comic, murder is rewarded. Murder is heroic."[61]

Legman was following a trail blazed in the popular press. In 1948, drama critic John Mason Brown had termed comics "the marijuana of the nursery . . . the lowest, most despicable, and most harmful form of trash." Other negative articles appeared that year in *Collier's* and *Reader's Digest*; a radio debate between Brown and Al Capp on ABC Radio's *Town Meeting of the Air* generated a record six thousand letters. Comic book defenders like Josette Frank suggested literature was full of similar material. (Frank, the staff advisor for the Child Study Association of America, wasn't entirely unbiased: a member of DC's largely toothless editorial advisory board, her "Books Worth Reading" picks appeared in *Superman*

comics for millions of kids to ignore.)[62] But with the rise of crime and horror comics, the case became even more pointed.

The war years *had* witnessed a significant increase in juvenile crime (thanks in part to social stresses caused by the war, such as widespread familial disruption), leading to greater press attention; thus, greater law enforcement, which, alongside broadening definitions of delinquency, generated higher statistics. Add teen culture's greater visibility: postwar teens' "speech, fashion, music, and mores puzzled and distressed Americans, who searched for ways to interpret this behavior." Mass culture was an easy scapegoat, coming from "outside" (New York and Hollywood), penetrating the home, affecting all classes of children, and seemingly promoting horrific values. Plus, opponents could point to grisly individual episodes and extrapolate to the whole. In 1947, a kid's hanging death was blamed on comics, his mother claiming he was reenacting a scene from one; the following year, a minister's son was tortured by boys "inspired" by comics. The year after that, juvenile murderer Howard Lang claimed he'd killed a playmate under the influence of comic books and sensational movies. The judge bought it.[63]

Comics tried defending themselves; the Justice Society took on juvenile delinquency in 1948. A teen gang, the Crimson Claws, are menacing the neighborhood; a social worker the JSA consults explains that the causes of delinquency include "lack of proper home life [and] fundamental principles of religion,"[64] substandard academic performance, unsympathetic judges, badly supervised municipal spaces, racial and religious hatred—in short, everything *but* mass cultural product. By no coincidence, it's a group brought together by comics, the Junior Justice Society, that helps bring the Claws down. Conversely, when *Crime Does Not Pay* focused on kids' criminalization, they blamed individual character rather than environment: "It is [the child's] will-power and moral stuff that is challenged," Biro and Wood wrote on their letters pages. "If he is good and clean inside, so he will be outside." Another way of avoiding blame, even letting them argue, in their words, that they were "A Force for Good in the Community"![65]

It didn't move the needle. That same year, 1948, the National Institute of Municipal Law Officers, concerned about the sale of comic books "which tend to incite juvenile delinquency," an effect "becoming more evident every day," approvingly cited book dealers' and newsstand owners' voluntary efforts to remove offending material in cities like Indianapolis and Hillsdale, Michigan. Such activity was encouraged by community decency campaigns organized by church groups, women's clubs, and parent-teacher associations, who often visited those dealers and newsstands to apply a little moral suasion. (They relied on review groups like the Catholic Church–affiliated National Office of Decent Literature.) Other cities went further: in April 1948, Detroit police seized comics off the newsstands, in support of an ordinance banning thirty-six different titles from being sold. Ann Arbor, Mount Prospect, Illinois, and Indianapolis all followed by the end of May.[66]

The problem, though, was that the Supreme Court had just addressed the matter. On March 29, 1948, in *Winters v. New York*, the court overturned a nineteenth-century statute prohibiting the distribution of publications "composed principally of criminal news or stories of bloodshed or lust" on constitutional grounds. The court's reasoning, occasioned not by a comic, but by the tabloid *Headquarters Detective: True Cases from the Police Blotter*, was that the statute was "so 'vague' and 'indefinite' as to infringe on freedom of speech and press."[67] The statute, (im)properly viewed, could apply to reports by, say, war correspondents, clearly no one's intent. Los Angeles County Counsel Harold W. Kennedy thus concluded that "[t]otal elimination of this type of literature, though possibly desirable, is fraught with both constitutional and practical difficulties." That said, he believed "an ordinance can be drawn which will eliminate the sale of such literature to children, and which will be supportable legally."

The county promptly prohibited selling "any book or magazine, or other publication, in which there is prominently featured an account of crime, and which depicts by the use of drawings or photographs the commission or attempted commission of certain crimes of force, violence,

or bloodshed" to anyone under eighteen. Given the New York statute, the LA ordinance specified those "certain crimes": "arson, assault with caustic chemicals, assault with a deadly weapon, burglary, kidnapping, mayhem, murder, rape, robbery, theft, or voluntary manslaughter."[68] It specifically excepted news accounts, and charged a misdemeanor with penalty of not more than six months or a $500 fine. Other cities passed similar codes. Such codes *did* let comics publishers off the hook slightly, unless authorities could prove intent for sale or distribution to minors. Which still raised the problem of uncertainty: What company wanted to spend time and money producing material that would be confiscated or potentially even land them in jail? Municipal authorities had a work-around: providing publishers the option to *voluntarily* present material to designated city officials prior to publication. If approval was obtained, they wouldn't face conviction under ordinances forbidding, say, the sale of obscene, indecent, or immoral literature.

A similar movie-related ordinance had been upheld by the Supreme Court in *Block v. City of Chicago.* In a long-standing dynamic, most concerns about film censorship revolved around sexual, rather than violence-related taboos (thus the emphasis on obscenity and indecency), so it was important for critics to craft an argument connecting crime comics' violence to sexuality—one reason why comics-related legal opinions said things like "accompanying these accounts [of crimes] will often appear illustrations of women in varying stages of undress, which are highly suggestive of the coarser aspects of sex in connection with the criminal activities being described." This, though, was somewhat weak sauce; though lawyers had noted that statutes could legally expand "indecency" to include crime literature, recognizing "the importance . . . to minimize all incentives to crime, particularly in the field of sanguinary or salacious publications with their stimulation of juvenile delinquency,"[69] they really needed to tie up all the threads, combining crime comics, obscenity, indecency, and delinquency all in one.

Dr. Fredric Wertham was just the man to do it.

Given the arch-supervillainous role Wertham played in comics his-

tory, it should be said that he wasn't just a talking head making a name as a moral scold. Wertham was an extremely interesting character: a German Jew who had emigrated to America in the '20s, had corresponded with Freud (who told him not to write on psychiatry for the press), had worked with Clarence Darrow as one of the first psychiatrists to testify on behalf of impoverished Black defendants. His wife was a distinguished sculptor who exhibited at the Whitney, he was praised by Thomas Mann and Arthur Miller for his psychological acuity, and his clinical work to help Black youth in Harlem earned him the nickname "Dr. Quarter" (he insisted patients pay that small sum to encourage ownership and responsibility). His research was used in *Brown v. Board of Education* and appreciated by Thurgood Marshall, and he was one of the few who "constantly publicized the Nazi sympathies of physicians who supported Nazi racist policies" post-Nuremberg.[70]

As Bill Gaines, who would arguably become Wertham's greatest victim, put it, not entirely unsympathetically, a generation later, "Well, you've got to understand that . . . he was trying to defend the kids. . . . I think the man was relatively sincere in what he did. It's just that when someone is making a living at doing something you've got to be very suspicious of what exactly is the motivation."[71] Wertham *did* have a yearning for the limelight. Long before his involvement in comics, he chased celebrity by publishing lurid accounts of murder cases; and as a psychologist at the precise moment the field began to attain status in highbrow culture, he had an attentive audience. In July 1948, he presided over a medical symposium on the so-called "psychopathology of comic books," providing an air of medical and scientific respectability to legal authorities' possibly unconstitutional instincts. He'd shown his willingness to use the power of medical language two months earlier in the *Saturday Review of Literature*, writing, "You cannot understand present day juvenile delinquency if you do not take into account the pathogenic and pathoplastic influence of comic books, that is, the way in which they cause trouble or determine the form that trouble takes."[72] Comics, in other words, were essentially, and at heart, trouble.

Charles Biro and Harvey Kurtzman attended the symposium. Wertham didn't give them much chance to speak, but they *did* respond. A dozen publishers (out of thirty-five) formed the Association of Comics Magazine Publishers in 1948, complete with a code of standards and a seal of approval based on reviewers reading the comics pre-publication. The code, based in no small part on in-house DC and Fawcett codes, stipulated "crime should not be presented in such a way as to throw sympathy aganst law and justice, or to inspire others with the desire for imitation," and outlawed "scenes of sadistic torture," "vulgar and obscene language," and "ridicule or attack on any religious or racial group." Gaines was involved; the inside cover of a 1950 *Crypt of Terror* explains the star-shaped seal on the cover: "The Association does not believe in censorship . . . it believes in self-regulation . . . always look for the Association seal on the front cover. It is your guarantee of quality and entertainment." Lev Gleason, of *Crime Does Not Pay* (who'd been convicted of contempt of Congress in '47 when he refused to name names before the House Un-American Activities Committee) served as the ACMP's president. [73]

However, the code had no teeth, no penalty for violation, and even those displaying it quickly ignored it. By 1950, Gaines had left; by 1954, membership had dropped to three publishers and a handful of distributors and printers. Which meant the local, state, and national objections continued unabated: one particularly colorful grassroots technique against supermarkets stocking comics involved parents filling shopping carts with groceries, then demanding to speak to the manager; if the manager refused to remove offending items, "they walked out, leaving a cart full of groceries for the store personnel to put back before the frozen fish thawed."[74]

The movement picked up steam. Harry Wildenberg, so important in comics' early days, told a 1949 interviewer, "I don't feel proud that I started the comic books. . . . [I]f I had an inkling of the harm they would do, I would never have gone through with the idea." Schools arranged comic book burnings—in Binghamton, New York, in 1948, and in Runson,

New Jersey, in 1949. At the Peter and Paul Parochial School in Auburn, New York, they gave awards to whoever brought the most comics to the fire. In 1951, Canada passed a law "calling for two years' imprisonment for anyone making, publishing, printing, or selling crime comics. Crime comics were then smuggled across the border"—ironically, a crime. In 1952, New York lawmakers, assisted by Wertham, passed a bill making the publishing or selling of "comic books dealing with fictional crime, bloodshed, or lust that might incite minors to violence or immorality" illegal. Governor Thomas Dewey vetoed it on constitutional grounds.[75]

Wertham, despite the frustration of his New York efforts, kept at it, producing speeches and articles, culminating in his 1954 book *Seduction of the Innocent*. An early historian of the moral panic over comics put his argument particularly well, that crime comics:

> were literally seducing young people . . . caught by the magnetic attraction of the covers, the big grabbing words, the drawings, the colours, the heroic swashbuckling characters, the sexual titillation. Not all, he conceded, would become delinquents—but some would. The comics were a factor, a weighty influence among others, in tipping some children over into crime. Or, if not that, into nightmares, into anxieties, into moral confusion. The influence, however, great or small, was *never* a good one.[76]

That last sentence particularly important because it blocks any statistical refutation: it didn't matter if comics only turned a vanishingly small percentage of kids to crime, or if its baneful psychological influence was only one factor among many others, which Wertham certainly believed to be the case.[77] Wertham combined earlier criticisms (the format invites illiteracy; it illustrates how to actualize delinquent impulses) with newer ones about stimulating unwholesome sexual fantasies and abnormal ideas. Not just stimulating: normalizing them, too, given the power of visual concreteness.

Wertham's faults are manifold. He misrepresents the comics he

discusses, taking individual panels out of narrative contexts that might lessen their impact for his case—symptomatic of his worst flaw, assuming an image's particular effect without engaging in complex thinking about it. Thus, any image that, say, *had* a crime in it was not only automatically *about* crime, but, in some fundamental sense, *pro*-crime.[78] This becomes even more pressing with regard to Wertham's particular bête noire: not violence, but sex.

Psychoanalysis, famously, reads sex into everything, and we may be excused for thinking that sometimes a hurtling Kryptonian rocket ship is just a Kryptonian rocket ship. But some of Wertham's points here hit. He spoke openly of some comics' bondage and sadomasochistic aspects when such concepts were hardly common topics of discussion, but *Wonder Woman* and "good girl" comics may stand mute under the charge. Even more virtuously, the clinic founder who worked tirelessly to help Black youth called out the racism of many of those jungle comics.[79] His comments on other aspects of sexuality in comics, though, are at best wildly overstated, and at worst total nonsense.

His most famous charge concerned those sidekicks. Wertham took the admittedly bizarre phenomenon and charged that all this palling around of grown men with young males was a sign of comics' homoerotic and pedophilic tendencies: "Only someone ignorant of the fundamentals of psychology and the psychopathology of sex can fail to realize a subtle atmosphere of homoeroticism which pervades the adventures of the mature 'Batman' and his young friend 'Robin.' "[80] In a *Ladies' Home Journal* article, "What Parents Don't Know About Comic Books," Wertham claimed some comic panels contained hidden pictures of genitalia, which you could see if you squinted.[81] And if Wertham misunderstood the boys of comics, he was even farther off base with girls. To Wertham, Wonder Woman wasn't a symbol of female empowerment, but precisely the opposite. Not because she was tied up so much, an argument with potential merit, but simply because she was strong, and thus "an undesirable ideal for girls": "To be strong is to be unwomanly,

and to have strong close associates who are female is automatically les-
bian *and* horrific."[82]

Part of Wertham's appeal was that his argument's first part, comics'
seductiveness, was universally acknowledged. Even industry contributor
Josette Frank's sympathetic 1949 pamphlet *Comics, Radio, Movies—and
Children* stated, "A child reading a comic is lost to all else. He hears not,
neither does he see." But parental anxiety, though understandable given
"scare headlines," was "unfortunate. . . . [A]nxious parents may do more
damage to their children than comics reading!" She suggested that par-
ents and publishers involve themselves in improving the medium: "Com-
ics can be inspired and imaginative, interesting and funny, informative
and meaningful. There is no reason not to make more of them so."[83] Some
comics creators struck similar notes, sometimes in unlikely places. In
the caveman-meets-dinosaurs comic *Tor*, Joe Kubert and Norm Maurer,
who had the unusual habit of drawing themselves directly addressing
the audience, spoke "about something in the newspapers that affects us
directly . . . these attacks on comic books." Kubert pleads, in arguments
repeated over coming decades, "Comics, as such, have gone far beyond
their original 'comic' conception. Adults, as well as younger people,
find enjoyment and relaxation in comics. Show our magazines to your
parents—then decide if our efforts are of good or evil intent. OUR TRUE
AIM IS TO PRODUCE THE VERY BEST THE MEDIUM OF COMIC
BOOKS HAS TO OFFER!!!"[84]

All these figures understood the war would be won or lost on the
parental battlefront. But while Frank offers counsel, and Kubert pleads for
sympathy, Wertham offers the solace of forgiving authority. In *Seduction
of the Innocent*, he depicts a parent saying to him, "Tell me again that it
isn't my fault." And he does: "The influence of a good home is frustrated
if it is not supported by the other influences children are exposed to—the
comic books, the crime programs and all that." Obviously, parents were
happier to take this exculpatory approach than to accept responsibility for
reading and contextualizing.[85] *Seduction of the Innocent* just missed being
a Book of the Month Club selection, and was excerpted in *Reader's Digest*.

And then the Senate got involved.

The Senate Subcommittee on Juvenile Delinquency was chaired by Robert Hendrickson of New Jersey, but the impetus for hearings came from Estes Kefauver of Tennessee. Kefauver had actively participated in very well-received 1950 hearings on organized crime, which had helped support an ultimately unsuccessful bid for the 1952 Democratic presidential nomination; he was searching for something similar as he looked to 1956. Kefauver had worked with Wertham back in 1950 on a questionnaire sent to juvenile and family court judges and probation officers. Asked, "Do you believe that there is any relationship between reading crime comic books and juvenile delinquency?" almost 60 percent answered no; "Do you believe that juvenile delinquency would decrease if crime comic books were not readily available to children?" elicited a no from almost 70 percent. So no action was taken.[86]

But the climate had changed in the intervening years. And so had the market. By September 1953, there were five hundred titles with an average monthly circulation of sixty-eight million; in the first three quarters of 1954, an all-time high of 650 titles, with 150 million individual issues published every month. A 1955 report noted that comic book sales averaged "1 billion copies per year, or an expenditure of about $100 million—more than is spent for the entire book supply for elementary and secondary schools, and four times that of the combined book purchasing budgets of all public libraries." Prosaically, some of this success was clearly connected to the fact that comics' pricing had failed to keep pace with inflation, remaining at ten cents in the early '50s when pulps, for example, had increased to a quarter. But that wasn't why Kefauver arranged for hearings on the subject.

In his opening statement, Hendrickson stressed most comics were "as harmless as soda pop"; the committee was focused only on crime and horror comics. Nor did they intend to become "blue-nosed censors"; this wasn't a freedom of the press issue (in no small part because, as Hendrickson and Kefauver knew well, such censorship had recently failed

Supreme Court scrutiny). Their job was simply to determine whether crime and horror comics produced juvenile delinquency.[87] Wertham was among the witnesses for the prosecution. Though he followed Hendrickson's lead in decrying censorship ("I detest censorship. . . . I believe adults should be allowed to write for adults. I believe what is necessary for children is supervision"[88]), far more unforgettable was his statement "I think Hitler was a beginner compared to the comic book industry," part of an argument that comics incited racial hatred. His case study, illustrative of his decontextualizing approach, was an EC comic in which racist positions are indeed articulated—by *racists*, who, in a typical EC twist ending, are horribly punished.[89]

The defense wasn't holding up. Witnesses were revealed as paid industry consultants, generating headlines like "Senators Charge Deceit on Comics—Experts Were in Pay of Publishers." Cartoonists who testified, including Walt Kelly and Milt Caniff, were invested in staking out middle ground, maintaining an anti-censorship stance while firmly distinguishing between the all-American comic strip and the problematic comic book.[90] The lines were slightly blurrier than they'd have liked: *The New Yorker* then hosted Charles Addams's suave macabreness alongside James Thurber's light wittiness; and *Dennis the Menace*, which had premiered just three years before, was in hundreds of newspapers. (That said, though Dennis's delinquency was in the strip's name, creator Hank Ketcham made him mischievious rather than menacing, trying to make amends with bedtime prayers.) Caniff himself had gotten heat for a few particularly curvaceous illustrations in the Sunday papers in the fall of 1947. But Kelly and Caniff's charm offensive worked: after their testimony, they even hung around to draw sketches for committee members.[91]

And then Bill Gaines volunteered himself as a witness for the defense.

Accounts vary on precisely what happened on April 21, 1954, at the federal courthouse on Foley Square. Gaines had stayed up most of the previous night working on his introductory remarks. He was also taking Dexedrine for his diet—at the time, legal, even normal, but speed has

highs and lows. He'd taken it that morning, calibrating its effects and duration, but the hearing was delayed, and in the middle of his testimony, the drug had worn off and he was crashing.[92]

Gaines started his opening statement pugnaciously, if puckishly, stating proudly that he was "the first publisher in the United States to publish horror comics," even making a play for the moral, civic, and educational high ground: "Are we afraid of our own children? Do we forget that they are citizens, too, and entitled to select what to read or to do? Do we think our children are so evil, simple-minded, that it takes a story of murder to set them to murder, a story of robbery to set them to robbery?" But then, as he later recalled, "I could feel myself fading away. I was like a punch-drunk fighter. They were pelting me with questions and I couldn't locate the answers."[93] Gaines was repeatedly asked if various comic images were in good taste; his reply, that it depended on genre and convention, led to unquestionably the most famous comics-related exchange ever read into the federal record.

> **Herbert Beaser, Committee Investigator:** There would be no limit actually to what you'd put in the magazine?

> **Gaines:** Only within the bounds of good taste.

> **Sen. Estes Kefauver, D-Tenn:** Here is your May issue. This seems to be a man with a bloody ax holding a woman's head up which has been severed from her body. Do you think that's in good taste?

> **Gaines:** Yes, sir, I do—for the cover of a horror comic. A cover in bad taste, for example, might be defined as holding the head a little higher so that the blood could be seen dripping from it, and moving the body over a little further so that the neck of the body could be seen to be bloody.

> **Kefauver:** You've got blood coming out of her mouth.

> **Gaines:** A little.

Kefauver: And here's blood on the ax. I think most adults are shocked by that. Now here's a man with a woman in a boat and he's choking her to death with a crowbar. Is that in good taste?

Gaines: I think so.[94]

Gaines could have argued that not only *could* it have been worse, it actually *had* been: he had directed the artist to redraw the original, gorier cover art. But it probably wouldn't have cut much ice with the senatorial committee or the press. Aptly, Gaines described the last half hour of his testimony "like whacking a corpse"; *Newsday*, perhaps imbibing some EC sensibility itself, suggested Gaines displayed "the detached manner of a surgeon after a hard day at the autopsy table." The *New York Times* headlined its story "No Harm in Horror, Comics Issuer Says."[95] A previous Gaines attempt at a satirical rejoinder hadn't helped, either. An EC house ad published during the committee's investigation read, "ARE YOU A RED DUPE? . . . After much searching of newspaper files, we've made an astounding discovery: THE GROUP MOST ANXIOUS TO DESTROY COMICS ARE THE COMMUNISTS!" The weakly satirical piece then "quoted" the communist *Daily Worker* to that effect. Gaines later admitted he'd "made up the ad out of devilishness" and it was "all pretty dopey," but the Senate didn't take to being associated with communists, even satirically.[96]

Gaines was aware his back was increasingly against the wall. That fall, EC comics carried "an appeal for action."[97] Asserting that the claim "that comics are bad for children . . . is *nonsense*" and that "a large portion of our total readership of horror and crime comics is made up of adults," they argued the hysteria was caused by a "small minority": "The voice of the *majority* . . . you who buy comics, read them, enjoy them, and are not harmed by them . . . has not been heard!" They begged readers to write to the Senate subcommittee and tell them "you agree that comics are harmless entertainment": "Make it a nice, polite letter! In the case of you younger readers, it would be more effective if you could get your

parents to write for you, or perhaps add a P.S. to your letter, as the Senate Subcommittee may not have much respect for the opinions of minors." That last, if not the shock ending favored by so many EC stories, at least savored of similar irony.

The appeal generated several hundred letters, no more. The subcommittee's report finally appeared following discussion with Congress's Joint Committee on Printing about whether it should break new ground by including illustrations in a report. It didn't, and the report was distinctly non-revolutionary in other respects, too. Resolutely taking a middle ground, it refused to make the clear causal connection between comics and delinquency that comics' opponents hoped for, while simultaneously suggesting publishers had a "responsibility to the nation's youth [not] by merely discontinuing the publication of a few individual titles . . . [but by] insuring that the industry's product permanently measures up to its standards of morality and decency which American parents have the right to expect."[98]

This was jawboning: the subcommittee knew that, legally, its hands were tied. There was a reason it didn't end its work by recommending legislation. But it hoped to scare the industry into solving its problem for it via *self*-regulation. And as the furor reached international proportions— that summer, an exhibit of horror and crime comics called *Made in the U.S.A.* toured Great Britain; Winston Churchill, seeing the exhibit in the House of Commons, asked to read some—and other countries began mounting their own campaigns against crime and horror comics,[99] the industry understood it needed to make a change. On October 25, 1954, publishers, via the newly constituted Comics Magazine Association of America (CMAA), produced the Code for the Comics Magazine Industry. Newsstands hung posters picturing a huge Code stamp of approval, trumpeting the standards of comic book decency the new Code would ensure. (As for comic *strips*, the Newspaper Comics Council, founded in 1955 to increase "the prestige of newspaper comics and interests therein among the reading public,"[100] didn't need to tell anyone why that prestige was endangered. The council maintained the anti-censorship position it

had adopted in the hearings, but only in terms of legislative action. Other than that, silence.)

The Code relied heavily on earlier comics codes and the Motion Picture Production Code, with consultation from Catholic, Protestant, and Jewish leaders.[101] At a time when the Catholic League had significant influence over films' content and release, the nexus between religious leadership and artistic censorship wouldn't have raised eyebrows. Nor would the rhetoric resulting from the collaboration. "The comic book medium, having come of age on the American cultural scene, must measure up to its responsibilities," began the Code in a preamble, and one can almost taste the crow it was eating: the CMAA was confident, though, that the Code would "become a landmark in the history of self-regulation for the entire communications industry."

The Code took Wertham's argument about comics' formative influence for granted, at least rhetorically, forbidding crimes to be presented "as to create sympathy for the criminal, to promote distrust of the forces of law and justice, or to inspire others with a desire to imitate criminals," instead to be depicted as "a sordid and unpleasant activity." Concomitantly, "policemen, judges, government officials and respected institutions" would never be represented "in such a way as to create disrespect for established authority." The Code toned everything down, prohibiting "scenes of excessive violence," asking for "restraint" in using the word *crime* in comics titles, and outright prohibiting the words *horror* or *terror* there. "All scenes of horror, excessive bloodshed, gory or gruesome crimes, depravity, lust, sadism, [and] masochism" were forbidden; along with "all lurid, unsavory, gruesome illustrations" or "scenes dealing with, or instruments associated with walking dead, torture, vampires and vampirism, ghouls, cannibalism and werewolfism." So were "profanity, obscenity, smut, vulgarity, or words or symbols which have acquired undesirable meanings." "Slang and colloquialisms are acceptable," the Code allowed, but "excessive use should be discouraged and wherever possible good grammar should be employed." Elementary school teachers nationwide might have cheered, but did anyone else?

Other kinds of moral engineering were built into the Code, some ringing more comfortably to our ears than others. Many might sympathize with the statement that "females shall be drawn realistically without exaggeration of any physical qualities," if many an artist, or adolescent male reader, didn't. "Ridicule and attack on any religious or racial group is never permissible" might raise quibbles as to implementation (what about in the mouths of villains?), but seems a considered response to the racism Wertham identified in jungle comics. And few probably remember that the Code also outlawed liquor and tobacco advertising (along with ads for "sex or sex instruction books," "knives or realistic gun facsimiles," fireworks, and gambling equipment).

But other moral engineering strove to create (not restore—that would be historically inaccurate) the white-picket-fence, nuclear, heterosexual family model we've grown to associate with the '50s. "Respect for parents, the moral code, and for honorable behavior shall be fostered," the Code said. "The treatment of love-romance stories shall emphasize the value of the home and the sanctity of marriage. Passion or romantic interest shall never be treated in such a way as to stimulate the lower and baser emotions. Sex perversion or any inference to same is strictly forbidden." And, just to be sure, anything not explicitly prohibited but "contrary to the spirit and intent of the Code, and are considered violations of good taste or decency," could be prohibited nonetheless.[102]

How did it work in practice? Several months before publication, publishers submitted "boards," black-and-white drawings and lettering, along with text material and advertising, scripts or printer's proofs, to the Comics Code Authority, established in 1955. A whole story could be junked as contrary to the "overall principle and spirit of the Code," if so decided, or individual details could be singled out. The story would then either be returned to the publisher for the mandated changes, or the artist could come to the Authority to make "on the spot" changes. Each page then received a stamp of approval.[103]

In its first two months, the Authority—New York City magistrate Charles F. Murphy and five women who worked under him, includ-

ing a former Department of Agriculture publicist and a former MGM story department editor—reviewed 440 different issues. They rejected 126 stories as unsuitable, and "5,656 individual drawings blue-penciled and replaced with panels to conform to the code." Murphy described his job that first year as "time consuming, back-breaking, ulcer-producing, artery-hardening," and it only got worse. Between 1954 and 1969, the Authority reviewed 18,125 comics; in 1969, it asked for changes in 309 of 1,000 reviewed books, although most changes were minor; by then, "most comic book companies had their own editorial review in anticipation of code requirements." Bizarenesses occurred. A *Plastic Man* reprint that, pre-Code, featured "twins with bottomless gullets," now had one glutton eat a candy bar instead of a can of peas (complete with can)—but didn't change the text, where he still ate the can. A man stuffing a loaf of (phallically offensive?) French bread in his mouth simply has it disappeared in the censored version, leaving him pointing at nothing.[104]

Sure, the American Civil Liberties Union objected, noting "divergent—even contrary—opinions" as to whether comics made kids commit crimes; J. Edgar Hoover himself had told the Senate he doubted "an appreciable decrease in juvenile delinquency would result if crime comic books of all types were not readily available to children." And given the absence of proof of such connection, the ACLU argued, "there is no justification for cutting into a basic right guaranteed by the U.S. Constitution." Besides, there was "ample evidence" of significant adult readership, and they believed the First Amendment flatly prohibited "prior censorship of reading material for adults, even if children may obtain access to such material."[105] But wasn't the Code voluntary? Their response: "Collective adherence to a single set of principles in a code has the effect of limiting different points of view. . . . The variety of ideas is the lifeblood of a free society." They called for parental control; like Wertham, who certainly understood some kids lacked potentially watchful parents, they also noted schools, churches, and community organizations could step in if kids lived in "an unwholesome environment."

But the writing was on the wall. Twenty-four of twenty-seven comics

publishers joined the CMAA right away. Dell, one of the holdouts, had its own internal code; that, along with 40 percent of total market share and the cool leadership of Helen Honig Meyer—the first woman to run an American comics company, or, for that matter, an American publishing company generally—allowed it to shrug off any pressure. (Meyer testified before the Senate subcommittee, saying, "Dell Comics are good comics," a slogan that subsequently appeared on all Dell's comic books.)[106] Gilberton's *Classics Illustrated*, though attacked by Wertham for illustrating violence, held out, too, wrapping itself in the mantle of high culture and claiming its works weren't "comic books." While there was some merit to the charge besides the content, particularly the way they stayed in print, ironically, the claim was a death knell: if a product *wasn't* a comic book, it wouldn't qualify for magazines' second-class postal rates, raising costs tremendously. A second irony: between 1955 and 1958, Gilberton and Dell were each winners of the Thomas Edison Award, designed in 1955 to "encourage publishers to exert an influence toward the elimination of juvenile delinquency," even receiving a "joint citation for consistent efforts to provide wholesome comic books for youth"![107]

The third holdout, at first, was EC. Issues published after Gaines's impassioned appeal opened with a black-bordered "In Memoriam" for the five EC titles. "You may never read this magazine," it said.

> As the result of the hysterical, injudicious, and unfounded charges leveled at crime and horror comics, many retailers and wholesalers throughout the country have been intimidated into refusing to handle this type of magazine. . . . There's no point going into a defense of this kind of literature at the present time. Economically our situation is acute. Magazines that do not get onto the newsstands do not sell. We are forced to capitulate. *We give up.* WE'VE HAD IT!

Gaines couldn't quite keep his sense of irony at bay, though, adding, "Naturally, with comic magazine censorship now a fact, we at E.C. look

forward to an immediate drop in the crime and juvenile delinquency rate in the United States."[108] And *The Haunt of Fear*'s final issue contained "The Prude," featuring a "self-appointed guardian of public morals" named Warren Forbisher (note the initials—Wertham's reversed), who is revealed to have a skeleton or two in his closet—or, at least, a walking corpse to remind him of past hypocrisies.[109] But Gaines knew when he was beaten, announcing that his titles would be replaced with something he called the "New New Trend." "They won't be horror magazines . . . they won't be crime magazines! They'll be utterly new and different—but in the old reliable E.C. tradition!" the notice teased.

IF THE FIRST IMAGE on one of the new titles' first page—a terrified, misshapen, drooling head—could have come from any *Tales from the Crypt*, its caption was quite different. "This is the face of mankind in the days before modern medicine," it began; "humanity . . . crucified by its own ignorance . . . waiting, since the dawn of civilization, for *the doctor* to appear on earth." *M.D.* was dedicated to "the man who fights that neverending battle day after day after day . . . your family doctor." And *M.D.* wasn't the only sign of a 180-degree shift in perspective from man's essential rottenness to a humanistic optimism. The old EC would've gagged at *Valor*, "a magazine devoted to stories of Chivalry, Mortal Combat, Deeds of Daring, Action, and Adventure" (often set in ancient Rome, the Crusades, or the French Revolution). Or *Psychoanalysis*, apparently aimed at mollifying the precise people who'd attacked them![110]

Okay, *Piracy* and *Aces High* had the tinge of old-EC adventurism, and there were some structural similarities, too. Gaines eulogized the old EC at the new titles' start: "We respected your tastes, your judgment, your standards, and above all, your intelligence. . . . And, because we ourselves had always liked it, we tried, wherever possible, to include a 'surprise' or 'snap' ending to each story." A point made most clearly in the new *Impact*, "devoted to the unexpected outcome, the twist, the snap windup," along with "another tradition at E.C. . . . EMOTION. We hope to stir

your deepest feelings with these stories of pathos, tragedy, comedy, love and hate."[111] Some of *Impact*'s stories relied on traditional literary twist authors: Guy de Maupassant's "The Diamond Pendant," generally known as "The Necklace," a former high school English staple, appeared in its first issue. But that issue's standout story, a comics milestone, was "Master Race."

The story features a man stalked through an American city by a shadowy, menacing figure he recognizes from Europe's charnel houses; the twist—keeping with *Impact*'s philosophy, there is, of course, a twist—is that the constantly addressed "you," that EC trope, ends up not being the Jewish survivor of Belsen,[112] but the Nazi commandant who's sought refuge in the New World and whose guilt drives him to destruction and to justice.

American culture hadn't addressed the Holocaust much in 1955. There were notable exceptions: Margaret Bourke-White's *Life* concentration camp photos; John Hersey's 1950 best-selling novel *The Wall*, about the Warsaw ghetto; and, most notably, *The Diary of Anne Frank*, published in English in 1952 to remarkable reception. But Feldstein, Gaines, and artist Bernie Krigstein were all Jews, acutely aware of anti-Semitism and its particular role in the Second World War; Feldstein recalled "several episodes of anti-Semitism" while stationed in Arkansas during the war, and remembered well receiving a piece of army propaganda entitled *This Is Your Enemy*, with pictures of the concentration camps and the "bulldozing [of] piles of bodies."[113]

Other EC stories had treated anti-Semitism. In *Shock SuspenStories*' "Hate," an anti-Semite discovers he's adopted and his biological parents are Jewish, and then becomes the target of anti-Semitic activity himself; "The Lonely One," in a later *Impact*, features a bullied soldier, clearly Jewish, whose name, Miller, was almost certainly changed by the Code from something more explicitly Jewish. But "Master Race," written by Feldstein, went far beyond those. The editors, recognizing the story's significance and seeing Krigstein's revolutionary art, agreed to expand the story's length from six to eight pages.[114]

"Master Race" is remarkable both in its movement between past and present, memory and current moment, and Krigstein's blunt, shocking expressionist presentation of anti-Jewish violence, including two unforgettable panels of burial in mass graves: bodies hauntingly flying in motion.[115] Sidney Lumet's movie *The Pawnbroker*, adapted from Edward Lewis Wallant's 1961 novel, would bring this kind of traumatic intercutting to high-culture audiences, but Krigstein got there almost a decade earlier, with emotional keenness even the master novelist and filmmaker might not have matched. But the story doesn't just shift time period: it shifts our identification from victim to perpetrator—uncomfortably, if thankfully, only momentarily—placing its American readers in complicity with the murderers of European Jewry. (Remember the EC dogma: readers are monsters.) It also reminds them how seemingly distant traumas resonate on local shores, with notable effect on an attentive reader: in college, Art Spiegelman would write a paper on "The Graphic Story as an Art Form: An Analysis of Bernard Krigstein's 'Master Race,'" and would later describe reading it as "like being struck by lightning. . . . [H]ere was a singular demonstration that the Nazi death camp could seriously be contemplated in comic books."

However, if, in the wake of message pictures like 1947's *Gentleman's Agreement*, the country had come to a spoken, if not always upheld, consensus against Jew-hatred by the mid-'50s, other bigotries were far less controversial, and one of these ended EC comics entirely. Gaines and Feldstein couldn't bear to leave their beloved SF titles behind. Despite the plentiful horrors within their pages, they hadn't been nearly as central a focus as the crime and horror comics; and besides, America was beginning to go science crazy, which suggested the possibility for saving them. The two SF titles were combined into *Weird Science-Fantasy*, which, post-Code, changed titles to *Incredible Science Fiction*. Soon after, Gaines, short several pages for an issue (the Code had spiked a story), decided to reprint a pre-Code *Weird Fantasy* story.[116] In Feldstein and Joe Orlando's "Judgment Day!," an astronaut in classic space gear—full suit, mysterious blank helmet—visits a planet to determine its readiness to join the

Galactic Federation. The planet is populated by robots, some orange, some blue; observing the orange robots discriminating against the blues, the astronaut deems the planet unready. The classic EC twist comes when the spaceman removes his helmet in the final panel: he's Black. Not the subtlest of messages, but in Jim Crow America, when most depictions of Blacks in comics were still caricatures, a powerful moral chastisement. To say nothing of the cynical observation that someone who looked like that representing institutional judgment and authority only existed, as of then, in the realm of science fiction.

But "Judgment Day!" discomfited one reader in particular. Murphy, the Code's chief censor, evaluated each EC title personally.[117] Despite the fact "Judgment Day!" had run two years earlier to almost no objection, even during the height of the comic book panic, Murphy insisted the story couldn't be reprinted unless the astronaut was redrawn as white. Was it simple racism? Was it craven acquiescence, concern the piece might anger racist Southern readers and endanger the Code's authority—racism by another name? (Less morally consequentially, the change also rendered the story incomprehensible.) Gaines had had it. He told the members of the Authority they were bigots and threatened to make their objections public knowledge. The officials tried a pusillanimous counteroffer, perhaps to maintain a shred of dominance: he can be Black, but remove the beaded sweat on his face. Gaines told them to go screw themselves, printed the story, and canceled the entire comic book line.[118]

Commending Gaines for his morals is certainly appropriate; that said, his shuttering the comics wasn't only a matter of principle. Wholesalers, singling out EC for the industry panic, were returning many EC comics without ever putting them on newsstands; Gaines' titles were selling 25 percent of their print run, compared to most comics' 80 percent.[119] All these headaches gave Gaines the impetus to turn to magazines, which weren't subject to the Code. He experimented for several years with "Adult Picto-Fiction," prose illustrated by black-and-white art; critically and financially abysmal, *Terror Illustrated*, *Shock Illustrated*, *Crime Illus-*

trated, and *Confessions Illustrated* had eaten up all EC's horror profits by early 1956. Luckily, Gaines had another card up his sleeve: a joker.

Back in 1952, Kurtzman had asked for more money, closer to Feldstein's compensation. This despite producing two books to Feldstein's seven; and Gaines, not unreasonably, paid proportionately. Gaines responded, also not unreasonably, that a third comic would raise his income by 50 percent, and even had a thought about what kind of comic it should be. Back in the '40s, Kurtzman had done gag comics for Stan Lee; even his VD comic, *Lucky Fights It Through*, had featured doggerel:

A ranch on the range isn't likely to find
Much use for a cowboy who's dead, lame or blind
So if you've known Katey, please listen to this:
Only a doctor can cure syphilis!

Gaines, who'd found Kurtzman's "Hey Look!" pages for Lee hilarious, suggested Kurtzman's comic sensibilities were being underutilized with his war books; he should do a humor comic. Kurtzman agreed; taking their cue from office and letter column slang, they settled on *EC's Mad Mag* as the title.[120] Thankfully, someone pointed out the first and third words were extraneous, and *Mad*, featuring its first, less-iconic idiot frontman Melvin, was loosed upon the world.

"Of all the nauseating things, this new mag is actually FUNNY . . . choke!" the Crypt-Keeper said. "Imagine a 'comic' being COMIC!" But of course, it was, and it shaped American culture in the process. *Mad* was early to capitalize on a phenomenon increasingly central to postwar American identity: audiences' deep immersion in mass popular culture—comics, both books and strips, among them.

Sid Caesar and *his* team of geniuses were parodying movies, television shows, and Broadway musicals on television every Saturday night; in far smaller clubs, so was Lenny Bruce. (Bruce's *Lone Ranger* parody appeared almost simultaneously with *Mad*'s "Lone Stranger!")[121] But no one did it better than *Mad*, with its attention to and affection for the

source material, combined with a keen nose for logical weaknesses and characterological incongruities.

Gaines had never taken himself entirely seriously; *Mad*'s first issue is accordingly full of EC parodies, all Kurtzman-scripted—he wrote every one of *Mad*'s twenty-three comic book issues—and drawn by various EC artists. But it hit its stride when it parodied the first iconic comic book. "Superduperman" presents its titular hero as a product of '50s neuroses: a little sex-crazed "creep" constantly lusting after Lois, whose battles with a Captain Marvel figure, a nod to a lawsuit most readers would know little about, are about selling out—there's space for rent on Superduperman's chest in place of the big red S. Sex and capital are behind comics, "Superduperman" suggests, not virtue or grand ideals. (DC wasn't crazy about the suggestion, and threatened legal action; Gaines promised not to do it again . . . at least until four issues later, when "Bat Boy and Rubin" came out.)

Kurtzman and Wally Wood used their visual medium to its fullest extent: following Wolverton, who "cluttered almost every inch of wall (and often floor and ceiling)," with signs and posters,[122] they crammed panels and margins full of jokes, ensuring you couldn't just quickly take in the art and move forward with the words: you had to study them, pore over them, return to them, as if they were . . . well, as if they were art.[123]

But *Mad* elevated such parody to a way of life. Literally: it regularly lampooned comic characters by placing them in the "regular world"— being psychoanalyzed, answering self-improvement ads, discussing current events, and so on. A very inexhaustive list of such parodies includes "Little Orphan Melvin," "G.I. Shmoe," "Prince Violent," "Starchie," "Poopeye," and "Bringing Back Father" (in which Jiggs, furious with Maggie, "hired a gang of thugs to re-establish himself as the head of the family").[124] This normalizing trend would permeate mainstream superhero comics in decades to come, but premiered here, farce before tragedy.

Mad sparked a wide variety of imitators, including *Cracked, Crazy, Eh!, Whack, Bughouse, Flip, Get Lost, Madhouse, Nuts!, Riot, Wild, Leer, Unsane, Frenzy, Loco,* and *Zany*. Stan Lee got into the act with *Snafu,*

canceled unceremoniously after three issues; it's remembered largely for its Alfred E. Neuman–like mascot, Irving Forbush, who entered Marvel lore. *Archie's Madhouse* began in 1959; its brightest legacy, Sabrina the Teenage Witch, appeared in 1962. ("We modern witches believe life should be a ball!" she says, lounging on a fashionable couch.) Simon and Kirby produced 1960's comparatively successful *Sick*, even developing a relationship with Lenny Bruce. *Mad* made fun of all the imitators; then, wondering why *they* should have all the fun, produced its own in-house knockoff. *Panic* ("Humor in a Varicose Vein") premiered in December 1953; in the spirit of the season, Will Elder illustrated "The Night Before Christmas." The sedate nineteenth-century poem had gotten the comic treatment before—a quarter century earlier, Milt Gross's "De Night in de Front from Chreesmas" rendered it in Yiddishy dialect—but Elder's version came out when, facing godless communism, America was doubling down on Judeo-Christian religious symbolism ("under God" was added to the Pledge of Allegiance the following year). And so, Elder's Santa, riding a sled with a "Just Divorced" sign hanging off it, raised hackles.[125]

New York City police booked EC business manager Lyle Stuart on the charge of "selling disgusting literature." The case was thrown out in magistrate court, but the Massachusetts Governor's Council suggested banning the book, and state attorney general George Fingold tried to shut down its distribution. Gaines's attorney Martin Scheiman told the *New York Times* the action was "a gross insult to the intelligence of the Massachusetts people"; censors were coming "to the rescue of a wholly imaginary, mythological creature rarely believed to exist by children more than a few years old."[126] That didn't work, so they tried dudgeon: Gaines yanked his company's *Picture Stories from the Bible* out of Massachusetts as retaliation (a largely symbolic gesture; it hadn't been sold there in five years).

So, the magazine world offered freedom from a *lot* of headaches. But ultimately, according to Gaines himself, the decision was financial. "We did not change *Mad* from a comic to its present format to avoid the Code," he said in 1982. "We changed it . . . to retain Harvey Kurtzman, who had gotten a very good offer from *Pageant* magazine, and the only way I could

keep Harvey was to agree that he could change the magazine to its pres-
ent format. It had the wonderful side effect of eliminating the Code from
Mad, but I didn't do it for that reason."[127] The '50s were a golden age of
leisure and humor magazines, which had far higher status than comics;
becoming a twenty-five-cent magazine, with slicker paper and production
values, certainly appealed (and *Pageant* had run a very laudatory article
about *Mad*, and Kurtzman, part of their lure). The *Mad* comic's twenty-
third issue, accordingly, contained an "important announcement": "Excit-
ing plans are now underway to turn *Mad* into a regular large-sized adult
magazine. For the past two years now, Mad has been dulling the senses of
the nation's youth. Now we get to work on the adults." Subscribers to the
comic *Mad* received the following insert soon after: "Dear Reader: This,
alas and alack, will be the last issue of *Mad* as a 10¢ comic magazine. So
be careful of the accompanying magazine. Treat it gently. Make it last."[128]

It was, after all, the end of an era.

FROM CENSORSHIP TO CAMP

The traditional '50s narrative foregrounds a bland *Ozzie and Harriet* wasteland, suffocating beneath gray flannel, waiting for the '60s to burst out in glorious Aquarian hues; the triumph of Authority, Comic Book and otherwise. But the '50s were the world of the Beats, jazz, and rock and roll (Elvis modeled his hairstyle on Captain Marvel Jr., later wearing similar capes);[1] they invented modern comedy. They had Hitchcock and Brando and, for better and worse, the Playboy Philosophy, which ushered in conversations about sex, fundamentally shaping '60s counterculture. And '50s comics, both inside and outside the Code, were packed with creative developments, if you knew where to look.

Not at the comic book companies, admittedly, who were busy doing damage control. In March 1955's *Better Homes and Gardens*, DC editor Mort Weisinger, insisting that, "in many respects, the new comics code has sterner moral standards than any other comics medium," included this illustrative exchange between Code administrator Murphy and an editor adapting *Treasure Island*:

Murphy: I won't pass this sequence. It's too violent.

Editor: But we're sticking to the actual Stevenson story. Why, the book is even more bloodthirsty.

Murphy: Sorry, but that's no defense. There's a great deal of material in the classics—and even in fairy tales—which we won't allow. In 'Hansel and Gretel' the witch gets stuffed into a blazing oven.[2]

A decade later, John L. Goldwater, president of the Comics Magazine Association and *Archie* publisher, insisted "it is not an over-statement to say . . . the program has had considerable social significance," and that the Code and its administrators had challenged writers to "create magazines and stories that are interesting, exciting, colorful" within its framework. But both claims were debatable. Goldwater himself admitted sales were precipitously down from pre-Code days: newsstand titles had dropped from about 650 in 1953–54 to 250 in 1956, the first year in which there were no new publishers since 1934. In 1952, the top-selling comic, *Walt Disney's Comics and Stories*, sold over five million copies; in 1962, it sold 350,000.[3] And not everyone had been mollified, Goldwater's claims notwithstanding. "It's Still Murder," Wertham insisted in the April 1955 *Saturday Review of Literature*. (That said, he kept a framed copy of a 1957 *Mad* parody, "Baseball Is Ruining Our Children," by "Frederick Werthless, M.D.," in his office.)[4]

Other factors were certainly more important than the Code, though its censorship would loom larger in comicdom's imagination. The comics market had generally overheated and oversaturated, a bubble popped by inflation and rising prices. The leading comic distributor, American News, went out of business, the target of a 1952 antitrust suit brought by the Justice Department relating to an alleged conspiracy to monopolize magazine distribution. Suburbanization may have played a role; it was

harder to walk to the newsstand and check out comics in the new communities being built across the country. But a lot simply had to do with another recent "menace" to children's morals and reading habits. In 1946, eight thousand TV sets were in use in America; by 1955, there were 37.4 million. Through the '50s, the percentage of American homes with television rose from ten to ninety. The 1955 final issue of *Famous Funnies*, the comic that started it all, had a television set on its cover.[5]

The new medium's rise did lead to a new subgenre: TV show–based comics, some still based on the Western, a breakout genre on the little screen. *Gunsmoke, Maverick, Bat Masterson*, and *Rawhide* all received four-color equivalents between 1956 and 1959, mostly from Dell. Comedy worked, too: *The Adventures of Bob Hope* ran from 1950 until 1968, and *The Adventures of Dean Martin and Jerry Lewis* ran from 1952 until 1972 (renamed just for Lewis after 1957, when the influential twosome split up). Abbott and Costello had a comic in the '50s; so did Milton Berle ("Uncle Miltie"), the Three Stooges, and Pinky Lee.

Children's comics continued to flourish: Dell, with Disney characters, Little Lulu, and Tom and Jerry, sold nine million comics monthly in 1956, compared to Timely's four million and DC's 6.2 million; by 1958, Dell had reached fourteen million. Harvey had *Sad Sack, Spooky the Tuff Little Ghost, Little Lotta*, and *Richie Rich*. There was a brief 3D comics craze in 1952, first revolving around an issue of *Mighty Mouse*; it sold 1.25 million copies, but the whole thing collapsed inside six months.[6]

And there was *Mad* magazine.

Its first issue sold out and required reprinting, something that "just didn't happen in the magazine industry"; by 1960, it boasted a circulation of 1.4 million and was read by 43 percent of high school students and 58 percent of college students.[7] At school, those students were learning comics could be the source of high art: Jasper Johns painted *Alley Oop* in 1958; Ed Ruscha produced *Jiggs* in 1961. Andy Warhol was painting canvases of Dick Tracy, Superman, and Popeye. Roy Lichtenstein was adapting stills from war comics (with no credit or cash going to original artists Irv Novick or Russ Heath, it should be noted). In the 1956 Mel-

lon Lectures, E. H. Gombrich, in discussing caricature, talked about Al Capp's Shmoo.[8]

But in *Mad*, they saw that it could also be not-so-low parody. *Mad*'s production values, spurred on by Kurtzman's obsessive attention to detail, Gaines's willingness to go far for a good joke, and the creative team's immense talent, succeeded in that regard. The EC gang (soon to become *Mad*'s "usual gang of idiots") hit all the right notes: Will Elder, whose pages and panels were crowded thick with gags, as if Outcault had taken a huge hit of laughing gas; Jack Davis, whose action sequences brought the energy of *Looney Tunes* animation to the page; and the breathtaking figures of Wally Wood. *Mad* itself refused to take advertising from almost the beginning until the late '90s—almost unheard of—which let the parodies shine so bright, editors received furious parental letters about cigarette "ads" in their kids' magazines, not realizing they were jokes.[9]

And in contrast to *Playboy*, the other world-shaping '50s magazine, they endowed it all with a relentless sense of their own stupidity. (And insanity: as a novelty item, *Mad* literally sold straitjackets in 1959 and 1960, bearing Alfred E. Neuman's face and slogan—"What, me worry?"—on the back.) If EC's readers were monsters, *Mad*'s weren't just alienated grotesques (though Wolverton's "weird portraits of typical *Mad* readers" did appear early on). They were also foolishly, fondly, idiots. Staffers accordingly referred to their new, post-Melvin mascot—taking his name from Henry Morgan's old radio show, his face and slogan from various venues over a half century—as "the idiot kid."[10] (One reader chafed: after nine-year-old Prince Charles's 1958 American visit, many remarked on his eerie resemblance to Neuman. One of the roughly two thousand weekly letters arriving at *Mad*'s offices shortly afterward was on the Duke of Edinburgh's stationery and read, "Dear Sirs, NO it isn't a bit—not the least little bit like me, so jolly well stow it! See! Charles P[rinceps]." Decades later, Buckingham Palace refused comment.)[11]

A more seriously unamused constituency were composers, notably Irving Berlin, who sued *Mad* over its popular song parodies. In 1964,

Judge Irving R. Kaufman of the United States Court of Appeals for the Second Circuit ruled for *Mad*, in a victory that would resonate: "While the social interest in encouraging the broad-gauged burlesques of *Mad* magazine is admittedly not readily apparent, we believe that parody and satire are deserving of substantial freedom—both as entertainment and as a form of social and literary criticism."

If Kaufman nonetheless sneered at *Mad*'s broad humor, *Spirit* alum Jules Feiffer's mid-'50s *Village Voice* strips[12] played the neurotic, intellectual smart-ass to *Mad*'s middlebrow, back-of-the-classroom spitballs. Feiffer was *there* in the coffeehouses and hook-up joints, reporting dialogue twisted only ever so slightly:

He: Allright! Is it a crime?

She: It's just so *hard* to believe.

He: It's not like I did something *wrong*, is it?

She: It's just so *hard* to believe.

He: You wanted me to confide in you. Are you *sorry* now?

She: No. It's just that it's so *hard* to believe.

(Pause.)

She: Tell me again.

He: I've never been to Europe.

All this in six panels, the bohemian conversants writhing over and around their java, made less of bone and muscle than id and superego. Freudianism, civil rights, rebellion and its commodification: Feiffer's *Munro* (1959),[13] the tale of a four-year-old boy drafted into the military ("unseen" by the military-industrial complex and therefore subjected to terrors and indignities), won an Oscar the following year in Gene Deitch's animated adaptation.

Feiffer wasn't the only comic strip artist speaking mature truth to political power. The strip was an important platform as newspaper circulation reached its all-time peak: a 1962 survey indicated newspaper comics were read by over a hundred million Americans every day, ninety million regularly—three times the number reading the daily news. And someone whose platform had vastly greater reach than Feiffer was Walt Kelly. A Disney alum who'd worked on *Snow White, Fantasia,* and *Pinocchio,* he'd gotten into trouble with Republicans as far back as 1948 in his iconic strip, *Pogo,* for presenting their candidate, Thomas Dewey, as a mechanical doll. In later years, he would portray President Richard Nixon as a spider and Vice President Spiro Agnew as a hyena. His greatest profile in political courage, though, was calling out Joe McCarthy ("Simple J. Malarkey") a year before Edward R. Murrow's 1954 famed *See It Now* program, when the Wisconsin senator was still popular and the stakes high and the syndicates could've dropped him like a hot potato.[14] But the strip most deeply and deftly in tune with the personal and cultural trends of the moment was (superficially) politics-free.

An astute early critic characterized *Peanuts* this way: "We are, in a sense, part of the strip . . . not only the audience but also the 'straight-men.' [Schulz,] Mort Sahl, Lenny Bruce, and Shelley Berman expect—in fact, *count* on—the shock of recognition." If comic strips model contemporarily popular comedy, from vaudeville and ethnic humor to slapstick to the autobiographical turn of the '50s, *Peanuts'* resonance may have more in common with Lenny Bruce than generally realized. Schulz's original title for the strip, *Li'l Folks,* makes the connection clearer: folks like us, only little.[15] (What Schulz often called "the worst title ever thought up for a comic strip" was a syndicate concoction, in the apparent belief little kids were called "peanuts," thanks to *The Howdy Doody Show*'s "peanut gallery.") As with Bruce, as with life, the comedy was mixed with darker streaks: *Doonesbury*'s Garry Trudeau, a Feiffer disciple from the beginning, also felt *Peanuts* "vibrated with '50s alienation, making it, I always thought, the first Beat strip." Ostensibly a kid strip featuring, as another critic succinctly put it, "tiny cute kids [who] were mean to each other," it

was full of adult talk, rain, and failure; and Charlie Brown, who never gets
to kick the football and whose baseball career is a (pitch-black) joke, is in
his own way as philosophically indelible as the figures in contemporary
works by Camus and Sartre.[16]

But Charlie Brown is also an ode to persistence, and the '50s marked
comics' community, not just alienation. There had been a brief publica-
tion in 1947 called *The Comic Collector's News*; in 1952, Ted White had pub-
lished *The Story of Superman* ("The Facts Behind Superman—World's
Greatest Adventure Character"). That same year also saw one dedicated to
SF comics (confusingly called *Fantasy Comics*). Active SF fans created *EC
Fan Bulletin*, the first EC fanzine, employing "some of the slang and leg-
endry of general fandom."[17] Fanzines, EC-related and otherwise, began
to be circulated and swapped: Robert Crumb and his brother Charles
produced an homage to EC's horror and satire comics—*Foo*—in 1958,
trading it with others like Marty Pahls's *Fanfare* or Fred von Bernewitz's
The Complete EC Checklist, and forging friendships and relationships in
the process. "Discovering comic fandom . . . changed our lives," Crumb
later said, speaking for many future comics icons, including Art Spiegel-
man (whose fanzine was called *Blasé*).[18] The process was aided immea-
surably in the early 1960s by the development of cheap offset printing,
which narrowed the quality gap between amateur and professional work.

Mad's outsized success had allowed Bill Gaines to exercise his already
outsized eccentricities. "One of the least probable men in the world," he
had a skull on his desk next to his father's picture; he often told visitors it
was his father's skull. (It wasn't.) Gaines inserted into his contracts that
his "right to withhold consent shall be absolute and shall not be subject to
any criterion of reasonableness," expounding, "God forbid that anybody
should ever expect me to be reasonable." Which explained, in part, one
of comics' most famous and consequential falling-outs.

Harvey Kurtzman had always felt underappreciated at EC, and even
more so at *Mad*, where he felt, justifiably, that he was carrying a remarkable
load and deserved a large share of the credit for the enterprise's success.
"I wanted control of the editorial package," he'd say. "I tried experiments

with new kinds of material and talent, but the rates I wanted to pay were more" than Gaines did. Given Kurtzman's obsessive drive for quality, it's certainly a plausible account of the disagreement; but it's also undeniable that when Gaines offered him 10 percent of the company, Kurtzman countered by asking for 51 percent—an offer he should have known was unreasonable. And no one ever expected Gaines to be reasonable, much less unreasonable. "Goodbye, Harvey," was his response.[19]

Or was that Kurtzman's plan all along, to present unreasonable terms? (Asked later if his demand was unreasonable, Kurtzman said, "Probably, yeah. I don't want to go into it because it's a very sensitive business.") After all, there was another player in the wings all along: a failed cartoonist turned rather-well-known Chicago publisher and man about town named Hugh Hefner. Hefner had encouraged Kurtzman to push for an equity stake in *Mad*, but was also engaging in some old-fashioned pot stirring, interested both in snapping up Kurtzman for his aspirational magazine empire and, perhaps, shanking a competitor (*Mad* and *Playboy* were then competing not just for influence, but for teenage and college dollars). When Kurtzman left *Mad*, Hef was there to scoop him up, along with Will Elder, Jack Davis, Al Jaffee, and others, for his new humor magazine *Trump*.[20]

Gaines was devastated at the defections, though somewhat mollified when *Trump* lasted only two issues. After the first issue premiered toward the end of 1956, he wrote Kurtzman, "Dear old Harv—Some very nice art. Beautiful print job. I wish you success. But frankly, I doubt it! Not at half a buck!" He knew the magazine trade well: after *Trump* folded, a *Playboy* executive suggested that, given high production costs, it would've had to sell over 100 percent of its print run to profit. Gaines was even more mollified when Al Feldstein, replacing Kurtzman, made *Mad* even more generally accessible and commercial and started raking in pots of money that would accumulate for decades. Kurtzman, conversely, floundered. He and some of the other artists joined together to publish another magazine, *Humbug*, in late 1957. In its first issue, he wrote, "We won't write for morons. We won't do just anything to get laughs. . . . [W]e won't

sell any magazines." Which turned out to be correct: as an independent enterprise, it had distribution problems (its distributor, in fact, wanted Kurtzman to work for his other enterprises, generating a conflict of interest), and its unique size made it hard for retailers to display. Still, it had a devoted following, and limped on for eleven issues before finally stopping production in October 1958.[21]

And then there came a surprising opportunity, from, ironically, a different *Mad* decampment. Ballantine Books had previously published highly profitable *Mad* paperbacks, but Gaines had taken those to Signet. Hoping to profit from Kurtzman magic, Ballantine published his original paperback, *Harvey Kurtzman's Jungle Book*, in 1959.[22] Which allows us to consider the question of the *book* of comics, and thus, the graphic novel: the first time, though obviously not the last, we'll encounter this vexed phrase.

Scholars and fans alike wonder what should legitimately fall under its rubric. (The phrase's actual genealogy probably dates to the mid-'60s and the fan writing of Richard Kyle.)[23] Some, emphasizing the phrase's first word, might consider its definition largely a matter of scope and page number. Others, emphasizing the second, might require a certain literary sensibility, or, perhaps, structure. Historically, the first plausible candidates for the term extend Hogarth's concept to tell stories of social woe. Otto Nückel's 1926 "wordless novel" *Destiny* pictured the descent of a young woman, mistreated by society and the men around her, into prostitution, murder, and eventual death. Nückel himself was greatly influenced by Belgian woodcut artist Frans Masereel, generally credited with introducing the "novel without words." His 1919 *Book of Hours* had gotten Thomas Mann's attention; "Look and enjoy, and let your joy in contemplation be deepened by brotherly confidence," he wrote in the German edition's introduction. *The Book of Hours* was translated into English from its original French as *Passionate Journey* in 1922.[24] But it was Nückel's naturalist work, in a 1930 English translation, that caught American Lynd Ward's attention, and Ward's own wordless novels might reasonably be claimed the first American graphic novels.

Studying at Germany's Leipzig Academy in the '20s, Ward found his linguistic foreignness a kind of boon, forcing him to "develop enough fluency in the graphic language to be able to make a convincing statement." Ward imagined his wordless novels, including *Gods' Man* (1929), *Prelude to a Million Years* (1933), and *Song Without Words* (1936), with no sound connected to their contents at all, possibly because he "grew up with the silent motion picture." But that silence also resonated with his theme of the artist's difficulties in an uncaring modern world. *Gods' Man* was published the week of the 1929 stock market crash; *Song Without Words* was a "prose poem" in part about having children in a world threatened by rising fascism. But if Masereel, Nückel, and Ward took serious cues from high art and culture, another early progenitor came from the world of gag strips: Milt Gross, that Yiddishy dialect cartoonist, and his 1930 *He Done Her Wrong*.[25]

As its title suggests, Gross's work partook of the silent melodramas, but rendered them in comic key, packed with sight gags and slapsticks. (He'd worked with Chaplin on *The Circus*.) With typical Grossian faux grandeur, *He Done Her Wrong* was subtitled "The Great American Novel." A Strapping Young Man of the Klondike and his Best Girl fall into Bad Company, separate, undergo travail, and are reunited, victorious over the Evil Snooty Mustachioed Gentleman, and live happily ever after thanks to a Hastily Discovered Birthmark revealing the Young Man to be Heir to a Great Fortune. This classic wish-fulfillment Depression product came out the same year as William Gropper's *Alay-Oop*,[26] a wordless ninety-two-plate depiction of acrobatic adventure doubling as a tale of female empowerment. A female acrobat pursues her dreams of erotic and athletic liberation through bad men and bad circumstance; the work ends with her triumphant, in a family act with twin girls and no men. "This is no book to give your grandmother for Christmas," a contemporary review said, "but it will provide unhallowed joy to the younger generation."[27]

A decade later, Italian-American artist and *San Francisco Chronicle* contributor Giacomo Giuseppe Patri produced his own political wordless novel in linocuts. (Linocuts: attach linoleum to wood, make images by

gouging out pieces with chisels, ink with a roller, and press paper onto it.) Patri was deeply involved with union causes in the '30s, and 1940's *White Collar* is about blue-collar workers' difficult life and the comparative ease of their middle-class counterparts.[28] Though Patri vocally opposed the Communist Party's insistence that socialist realism was the sole valid means of artistic expression, the work employs a similar tone to illustrate the tightening of one artist's family's financial noose and the possible hope of union, in both the political and human sense. (The story was at least partially autobiographical.) As with other wartime comics, there were escapist novels, too. In 1943, former Fleischer head animator Myron Waldman created the "pictorial love story" *Eve*, about a matrimonially inclined romantic whose man of her dreams was in front of her all along (although his features were always obscured, delivering towels to her office as he did). Not nuanced, not complex, never less than charming, *Eve*'s gag-laden narrative was Preston Sturges very lite.

Leslie Waller and Arnold Drake, at school on the G.I. Bill after the war, had noticed the ten million comics a month read by GIs, the twenty-five-cent paperbacks cutting into comics' profits (probably also partially responsible for the '50s readership decline),[29] and thought, "With most of the soldiers now at college . . . we guessed that most would never read more than their textbooks. Then why not a bridge between comic books and book-books, stories illustrated as comics but with more mature plots, characters, and dialogue? We called them 'Picture Novels.'" Drake and Waller brought the idea to St. John Publications, where they met Matt Baker. Baker, one of the few Black artists then in comics, had been a top "good girl art" talent for Fiction House and was a perfect match for their contemporary Western romance. Under the portmanteau name Drake Waller, the duo published *It Rhymes with Lust* in 1949. Drake later humbly suggested they might have been the first graphic novelists, discounting earlier works like Gross's on the grounds of lack of dialogue: "The things characters say and think (thought balloons, take a bow!) go to the core of their story." Of course, as a writer, he *would* say that.[30]

This mini-history suggests, if nothing else, that the graphic novel

has many fathers (all, at this point, indeed male). But one commonality exists: all dealt in adult themes, even if comically caricatured, for an adult audience. Kurtzman's *Jungle Book*, a decade after *Lust*, went even further: following in Hefner's rather than *Mad*'s footsteps, he harnessed it to a performatively sophisticated, knowingly "adult" sensibility. If Hefner's "What Sort of Man Reads Playboy?" house ads seem a little . . . overcompensating today, portraying/flattering the reader as urbane, mature, and grown-up, they're nonetheless drawing a bright line between adolescence and adulthood. Kurtzman's *Jungle Book* behaved similarly.[31]

Kurtzman's parody of late-'50s gumshoe TV series *Peter Gunn* (known best now, if at all, for its insanely catchy musical theme) mixed hard-boiled shamus talk with hipster jazz argot: "This kat was laying there. He was cool. Like gone, I mean. Dead, like. . . . I was suspicious of the daddio with the slide trombone." "Compulsion on the Range" merged the newly omnipresent language of psychoanalysis with the laconic verbal rhythms of the Western. ("In the Nebraska territories, a man riding herd months on end in the saddle can get a powerful yearning ta t'ar loose when he gits ta town. To put it in plain, everyday talk, neighbors . . . he develops tensions that can lead to neurosis . . . or even psychosis, unless an outlet . . . often as not a violent one . . . is found for repressed, subconscious emotions.") But *Jungle Book*'s most important creation, young Goodman Beaver, starred in "The Organization Man in the Grey Flannel Executive Suite," a tale of idealism and innocence coming to terms with mid-century American capitalism. (Beaver, descendant of Hawthorne's Goodman Brown and Timely's Martin Goodman, while high-minded at the tale's beginning, ends up absconding with all his company's earnings.)

Ballantine's high commercial hopes for *Jungle Book* went unfulfilled; Kurtzman was, perhaps, too far ahead of his time. (Goodman Beaver would have later adventures,[32] some remarkably transformed: a pitch to Hefner resulted in the character's transformation into *Playboy*'s *Little Annie Fanny* in late 1962, parodying not only *Little Orphan Annie* but whatever topical targets Kurtzman and Will Elder fancied, all accompanied by generous

proportions of pulchritudinous female flesh.)[33] But while Kurtzman was pushing the boundaries of both satire for adults and adult satire, he was working on something . . . scruffier. And more consequential.

James Warren, publisher of *Famous Monsters of Filmland*, had expanded his empire to other screen entertainment magazines—*Spacemen, Wildest Western, Screen Thrills Illustrated*—and brought Kurtzman on to create a similar format magazine. *Help!: For Tired Minds* was born in 1960. Like *Famous Monsters of Filmland, Help!* looked to the past to create a history and genealogy of comics, reprinting work by McCay, Eisner, and Caniff, among others. But it also was firmly of the present, attempting to reach a more mature audience by printing some new Goodman Beaver stories and including photographs, some featuring partial nudity. One actor in those photo arrays was John Cleese, who, in meeting *Help!* art director Terry Gilliam, shaped Monty Python. Rising stand-up comedian Woody Allen also appeared there, not uncharacteristically leaping into a girl's lap. The girl in question wasn't Wonder Woman superfan Gloria Steinem, but she was there, too, an assistant editor.[34]

It shaped comics' future, too. Kurtzman was dedicated to showcasing work from up-and-comers, some from that obscure fanzine world. Crumb and Spiegelman, among others, got their first national exposure in *Help!*'s "Public Gallery." But one of Kurtzman's main sources for material was the campus quad, and the humor magazines that flourished there. College students have always mixed the aesthetically ambitious and the deeply sophomoric, and the '60s were no different. In November 1962, *Help!* readers encountered a Superman-esque figure who ushered in a trend in American comics as significant in its own way as his *Action Comics* predecessor had a quarter century earlier.

But before we meet Wonder Wart-Hog, let's spend some time with the Man of Steel and his companions.

———

SUPERMAN, BATMAN, AND WONDER WOMAN were the only superheroes surviving the early-'50s retrenchment. In late 1953, as the comics controversy

heated up, Timely briefly revived the Human Torch, Sub-Mariner, and Captain America, recasting them as anti-communists nonpareil. "Next issue: Captain America again plows into the commie nests and smokes them out!" one blurb reads; although Namor mistrusts all land dwellers, "the ones he trusts the *least* and hates the *most* are . . . the Reds!" (Simon and Kirby parodied the phenomenon with Cap imitation turned superhero satire *Fighting American*, who faced communist baddies Hotsky Trotski and Poison Ivan. "Don't laugh—they're not funny!" the cover warns, tongue in cheek.)[35] But even this minimal superhero revival petered out by 1955.

Comics professionals, asked to take reduced page rates, left the field; those who remained were embarrassed, post-panic, to say what they did for a living. Artist John Romita called himself a commercial illustrator; Joe Simon explained his odd hours by letting it be known he was a bookie. Stan Lee, if pressed, called himself a writer of illustrated children's books.[36] *Children's* books: of course comics had generally aimed at a juvenile audience, but any occasional tremors of adult ambition had been largely crushed by the Code. So, editors and writers embraced the juvenile with a vengeance.

Superman had no fewer than three villains dedicated to childlike mischief: the Toyman, the Prankster, and Mr. Mxyzptlk. *Batman's* villains also changed accordingly: the Joker was now a clown prince who committed crimes based on an acrostic of his name ("Acrostic of Crime!"), in reverse ("I spell my name REKOJ now!"), using radio hits ("Sing a Song of Villainy!"), or basic rebuses ("The Rebus Crimes!").[37] The Riddler played charades: holding up a ham, mewing, looking, and humming, to suggest his next crime's location: "Got-Ham-Mew-See-Hum." And through much of the '50s, Superman also took on surprisingly ordinary criminals—for reasons of what we'd now call transmedia synergy, connecting the hero across multiple media platforms.

Those 1940s Fleischer Superman cartoons started a trend. When Wonder Woman first arrives in America, "the scantily clad girl . . . attracts attention": "Aw . . . I bet it's some sort o' publicity stunt for a new

movin' picture!" a kid says.[38] In 1941, a Republic serial ad in *Captain Marvel Adventures* read, "Gangway! Here comes Captain Marvel in the movies. Yes sir!" A Captain America Republic serial followed in 1944 (with Steve Rogers now Grant Gardner, and a female assistant replacing Bucky). Superman had starred in a '40s serial, too, but now it was TV's turn. The syndicated *Adventures of Superman*, running through most of the '50s, probably saved the character; but the medium's technical limits meant he had to face fairly limited and mundane opponents.[39]

By decade's end, though, the comics had embraced Superman's cosmic aspects. SF was built into the character's DNA, yes, but the shift in emphasis came in no small part from a shift in personnel. Like '50s SF, the decade's mainstream comics were an editor's medium: just as the main magazines publishing SF—*Astounding, Galaxy,* and *Fantasy and Science Fiction*—each boasted a distinct editorial sensibility, so, too, at DC. Mort Weisinger had arrived in 1941 after editing SF pulps *Thrilling Wonder Stories* and *Startling Stories,* where he'd cocreated Captain Future, bought Arthur C. Clarke's first American story, and publicized Alfred Bester's and Ray Bradbury's work. He'd also partnered with another future comics legend, Julius Schwartz, to form Solar Sales Service, a literary agency representing H. P. Lovecraft and Robert Bloch. And Weisinger and Schwartz, along with superfan Forrest Ackerman, had partnered on a fanzine, *Time Traveller,* around the same time as Jerry Siegel's; the two contemplated swapping ads. Once at DC, besides creating Green Arrow and Aquaman, Weisinger turned to his network for material, and thus *Superman* began being written by classic SF writers like Bester, Edmond Hamilton, and Otto Binder.[40] Given those SF roots (he's an invader from outer space, after all, albeit a friendly one), they comfortably engaged Superman in the genre's central conceits: time travel, returning to Krypton before it exploded; future war, battling Brainiac; and alternative history, or imaginary story.

"Imaginary story"? As Alan Moore put it famously, "Aren't they all?" Maybe some more than others. By the '50s, Superman was a generation old, and he'd evolved as multiple creators, companies, and platforms fea-

turing him continually produced commercial and artistic innovations. Superman didn't fly when he debuted. He leaped, as in "tall buildings in a single bound." He lacked X-ray, heat, and telescopic vision. The paper he joined was called the *Daily Star*. His adopted mother was named Mary (or Sarah; it depended), only definitively and canonically becoming Martha in 1952. Some such developments stemmed from other media's needs: the Fleischers had Superman fly in their cartoons because the animated leaping made him resemble a kangaroo; radio listeners couldn't tell when he was flying, so the writers developed the phrase "Up, up, and away"; because he needed weaknesses, they developed kryptonite.[41]

But there were strict parameters nonetheless, understood as scripture by '50s writers, editors, and readers alike. Lois Lane would never discover Superman's secret identity. Superman would never marry. Krypton would remain a dead planet. And so on. But SF "sidewise in time" models appealed to comics readers wanting to *see* those possibilities played out in four colors without "damaging" the "real" story, allowing them to have their canonical cake and eat it, too. And so, "Mr. and Mrs. Clark (Superman) Kent!," an "imaginary series," appeared just as the '60s began, the flip side of a powerful mythos. (Although, in a typical '50s perspective, Lois is miserable because she can't let her girlfriends know her husband's incredible secret.)[42] At their best, these tales generated great pathos; some, like when Superman is stranded on a pre-explosion Krypton, befriending his parents, falling in love, all without revealing his, or Krypton's, secret, reach toward tragic consciousness.

There was another early postwar case of glimmerings of personhood peeking out from under the cape, this one "less imaginary": Batman finds his parents' murderer, a thug named Joe Chill, and does the unthinkable—reveals his secret identity to him—to convince him to confess. (It works: Chill is conveniently rubbed out by other villains before sharing the secret.)[43] But such expanded, expansive storytelling had the potential to contradict what would later be called "continuity," the heroes' canonical historical narrative. Take Superboy, who premiered as the war ended, receiving his own comic in 1949. Perfect for the new

juvenile emphasis? Check. A clear contradiction to the original Super-man narrative, where Clark Kent only donned the costume as an adult? Also check. Writers' using him to explain Superman–Luthor enmity by the latter thinking the former caused his hair to fall out in childhood? Check (groan). The twin problems of tracking rapidly expanding material and explaining apparent contradictions only grew in decades to come.[44]

But the SF emphasis stayed. And it wasn't just Superman. Although SF comics had boomed and busted with the industry at large, in the age of *Sputnik*, the space race, along with what we'd now call a STEM sensi-bility, was omnipresent in DC more generally, especially books edited by Julius Schwartz.[45] Schwartz, who'd had a letter in Siegel's fanzine issue containing "Reign of the Superman," was, at least conceptually, a New Frontiersman, looking to space and science. He and Murphy Anderson created Adam Strange, an explorer type accidentally beamed trillions of miles away to planet Rann. There, along with a literally star-crossed romance, Strange faced a man-eating vacuum cleaner, a sentient giant atom, and a huge floating magnifying glass, thanks to Schwartz's use of a classic SF magazine technique: first commissioning the eye-catching cover, *then* getting the story for it. Far more memorable, though, was the hero who was generally acknowledged as kicking off what fans and his-torians sometimes call comic books' "Silver Age" (looking back on that first wave of activity as the "Golden Age"): a police scientist named Barry Allen who'd had some chemicals spilled on him two years before.

The Flash's new incarnation appeared in the fourth issue of *Show-case* in 1956, Jet Age in all the right ways: even his Carmine Infantino–penciled crew cut radiated test pilot savoir-faire. Hal Jordan, the Silver Age Green Lantern, was a *literal* test pilot, whose Gil Kane–drawn look was fresh, clean, Kennedyesque. If the first Flash hearkened back to winged Mercury, and the original Green Lantern to Aladdin's lamp, these new iterations were living better through chemicals (Allen was a police *sci-entist*) and alien intervention. Similar transformations were worked on other DC heroes. The Atom went from diminutive brawler to a physicist who shrunk to subatomic level, clearly inspired by Richard Matheson's

The Incredible Shrinking Man; Hawkman from a historical-weapon-using crime fighter to an interplanetary policeman, whose adventures thus allowed for SF-type sociological speculation. ("Wonder what our earth friends would say . . . if they knew we never personally handle money on Thanagar—but 'pay' for everything with our Identi-Cards!")[46]

Ten years before, a British critic could write of American comics that one needed "to admit at once that, without quibble, in varying degrees of intensity, these heroes all have one thing in common—they hate brains." These new comics begged to differ, frequently putting scientist types in top positions. Jack Kirby's *Challengers of the Unknown* were "Right Stuff" adventurer-scientists who feel like they're living on borrowed time after surviving a jet crash. ("The unknown has a million doors, men!" says the professor. "We've opened just a few. Now, let's get to the others!")[47] A series set in a museum, a *Space Museum*: in each installment, a father and son share a story about an item therein. The *Flash Gordon*-and-Heinlein juvenile-ish *Space Ranger*, where Rick Starr, girlfriend Myra, and pink alien Cryll patrol the solar system. And a group of future superpowered teenagers, 1958's *Legion of Super-Heroes*, scripted by SF writer Edmond "World Wrecker" Hamilton (so known for his space opera approach).[48] And it all worked: a 1960 poll showed Green Lantern to be DC's most popular hero, beating out Superman, Flash, and Batman. So, Schwartz, taking a page from the old JSA playbook, teamed them all up along with Aquaman, Wonder Woman, and the Martian Manhunter, and *Justice League of America*, written by old-timer Gardner Fox, was a monster hit. (*League*, rather than *Society*, not only for anti-aristocratic purpose but because young readers recognized the term from baseball.) In the 1962 fan poll awards, eight of the top ten titles were Schwartz's.[49]

Modern readers can't help but notice the number of science factoids included, sometimes central to the plot. Fox and Schwartz regularly inserted footnotes like "Editor's note: Petrified wood is caused by minerals replacing the woody structure of trees or sawdust with quartz!"[50] (The Schwartz title *Strange Adventures* was actually going to be called *Project: Science*, until someone realized that was taking the educational

dimension a bit too far.)[51] Metamorpho, the Element Man, was literally a "walking chemistry set," teaching about the periodic table through his adventures.[52] The Atom's "Time Pool" stories had him encounter historical figures like the telescope's inventor.[53] Similar materials featured in Schwartz's comics as far back as the late '40s, with "JSA Laboratory Notes" in which heroes "explained a simple scientific experiment," probably by Schwartz himself. And Fox is described in a "meet the author and artist" page as "a verifiable fount of information on queer scientific facts and prehistoric phenomena."[54] But the didacticism got even more pervasive. "You walking encyclopedia!" a bad guy tells Batman in 1950, as he foils him via the application of another factoid. "You know everything." At least, writer Bill Finger did, famous for his "gimmick file" providing story material. But gimmicks and factoids pointed to a new direction for the character, befitting the industry's sense of audience, which, as Eisner put it, "commonly accepted the profile of the average comic book reader as that of 'a ten-year-old from Iowa.'"[55]

Ever since Robin's introduction, Batman had been at war with himself: grim terror of the night versus colorful gadgeteer. Post-Code, under editor Jack Schiff, the tilt was clear. True, '40s Batman had his Batmobile, Batplane, and Batcave, but now readers encountered Ace the Bat-Hound (1955), Bat-Ape (thankfully, very briefly, in 1958), and Bat-Mite (1959). "I'm not an elf!" Bat-Mite helpfully explains in his first appearance. "I come from another dimension, where all men are my size!"[56] Batman would transform into, variously, a merman, an invisible man, a zebra Batman, a robot, a negative Batman, an alien, a baby, a colossus, a mummy, and a genie. "The Strange Costumes of Batman!" gave readers a "camouflage costume," a "luminous uniform," an "interplanetary suit," and "golden garb." "Look who's comin'! Batman . . . fitted out in the weirdest outfit I ever saw!" says one thug, seeing a frogman Bat-suit.[57] Timely's heroes similarly battled vampire bats, space aliens, and octopus-men; the Blackhawks fought an eight-limbed Octi-Ape; the Spirit went to outer space.[58] And at DC, there were *so many gorillas.*

That ten-year-old from Iowa was, almost inevitably, thought to be

a boy. Attempts to pitch comics to girls led to spin-off female charac-
ters like 1961's Bat-Girl and, most notably, Supergirl. Some young female
readers *were* inspired: Diana Schutz, later a senior comics editor, wrote,
"Supergirl was everything we weren't, and yet she was close enough in
age to be everything we could aspire to." But these exceptions proved
the rule; many of DC's earlier heroines were drained of former energy.
Golden Age crime-buster Black Canary went into semi-retirement;[59] Lois
Lane became a husband-seeking busybody. Lana Lang, Superboy's love
interest, wasn't any better: when *she* gained superpowers, she became
Insect Queen, appearing in varying insectile forms.

Other love interests were slightly more interesting, but still clearly
secondary characters. Jean Loring keeps refusing Ray Palmer/Atom's
proposals with the mixed message "I'm determined to prove I can be a
success as a lawyer, before I give up my career and settle down!" "Hal,
when Carol here was born I was down-hearted—I was hoping for a son
to take over the business!" says Ferris Aircraft's owner to Hal Jordan/
Green Lantern. "But as things have turned out—Carol has proven herself
to be as good as any son!" Carol: "I've got to satisfy his faith in me—and
that means that during the next two years I'll have absolutely no time for
romance! I'm your boss, Mr. Jordan—and that's orders!" Naturally, a love
triangle results between Ferris, Jordan, and Green Lantern. When Ferris
is kidnapped by alien Amazonian types called the Zamarons and given
superpowers as Star Sapphire, she says, "I seem to be two people—one
wanting to conquer Green Lantern—the other at the same time wanting
him to defeat me!!" Losing in the end, she says, "I'm defeated! How terri-
ble. . . . No! How wonderful!" The Zamarons leave in disgust, and, really,
who can blame them?[60]

DC's greatest female character, if anything, fared even worse. Given
the spotlight shined on its fetishistic and sadomasochistic aspects, sig-
nificant components of Marston's *Wonder Woman* unquestionably had
to go. (Marston had died in 1947, so wasn't around to object.) But author
Robert Kanigher "also bled it of the mythological and political themes
that had made it unique," leading to a long decline in quality. In a sym-

bolic transformation, "Wonder Women of History" was replaced in 1950 with "Marriage à la Mode," detailing international wedding customs. The comic only stayed in print because of the unique rights structure Marston had negotiated; DC would lose the property if it stopped publication.[61]

These sexist attitudes pervaded many other comics, too. Just one example: 1952's "It's a Woman's World," published in *Mystery in Space*, featured a thirty-third-century society dominated in every respect by women, while "to men passed the role of domestics and housekeepers." ("But mother—why *can't* I go to rocket cadet school like you did?" asks a plaintive youth holding a futuristic vacuum cleaner. "Because you're a *man*, Greg—that's why!") This state of affairs is "corrected" through one man's effortful struggle ("I've learned a man never knows what he can do—til he has to do it!"), but rather than equality, his military success results in reversion to what the story, sighing in relief, posits as the natural order. "We women ran things long enough, Greg! It's time you men took over again!" says fellow soldier turned love interest Stella in the story's final words.[62]

While late-'50s and early-'60s DC was optimistic, idealistic, and, yes, chauvinistic, Timely (which frequently went by Atlas in the early '50s) was encountering problems. It had tried, post-Code, to follow the trends: like EC's *Valor*, it had *Black Knight*; like *Rawhide,* it had the *Rawhide Kid*. Both, like much else from Atlas, were scripted by a thirtysomething Stan Lee: "Ere the venison had been served, a cry was heard from the sentry at the watchtower!" went a typical 1955 line. Lee enjoyed the forced versatility: "I always felt that if you're a writer, you can write anything. Instead of saying, 'Follow that car,' you say, 'Follow that stagecoach,'" he said.[63] In early 1957, though, when Martin Goodman's distributor, ANC, shut down its periodical division in the wake of former client Dell's antitrust suit, he was forced to work through DC, which dropped him to eight titles a month from over sixty. (DC may have been less interested in constricting a competitor than avoiding looming antitrust action as a distributor.)[64] This "Atlas Implosion" was a bloodbath for the company and its freelancers. Goodman was down to a single employee—Lee, his wife's

relative, who only issued previously commissioned, stockpiled inventory in 1957, no new stories, and would describe himself as "a human pilot light, left burning in the hope we would reactivate our production at a future date."[65]

When they did, the standouts were on the SF and "mystery" side. (Horror comics carrying the Code seal, given the opposition to the word, were dubbed "mystery comics"; DC had *House of Mystery*; Atlas, *Journey into Mystery*.) In no small part due to two artists working on them, an old hand and a newer name. Jack Kirby, who never quite stopped thinking of Lee as "a pest," "sitting on my desk and playing the flute, interfering with my work,"[66] had returned, joined by Steve Ditko, who'd done powerful horror work for Charlton. To explain their appeal, and the distinction from DC, think atomics.

At the end of 1945, Superman faced the Atom Man on his radio show—a Nazi scientist's creation seeking revenge for Germany's loss. It was a weeks-long battle, "embellished by the sounds of humming radiation, incessant explosions, and threats shouted over howling winds." But Superman won, of course, and many post-Hiroshima comics, including DC's, projected the impression that atomic power was American, a force for good, and controllable. *Atom-Age Combat*, appearing in 1952–53, had Buck Vinson in all-out worldwide atomic war with communists, employing atomic artillery, atomic grenades, and atomic rifles firing atomic bullets that somehow spared "Americans, their allies, and assorted fauna from any serious atomic consequences."[67]

Even the apocalypse was controllable. The Atomic Knights are post–nuclear war inhabitants of "an Earth in ruins!" but, like their chivalric predecessors, fight for truth, justice, and more: "Someone's got to start putting the pieces together of what used to be our American way of life— and it might as well be us!" They soon participate in a Boston Thanksgiving feast and watch a car roll off the factory ramp in Detroit.[68] Perhaps DC was interested in projecting calm for its young audience. They weren't the only ones. *Atomic War!* (1952) took a sharp turn toward normalcy within two sentences: "This magazine was meant to shock you—to wake

up Amercans to the angers, the horror and utter futility of WAR! Write us—tell us how well we've succeeded, and the best letters will win valuable cash prizes!"[69]

But Timely/Atlas was happier to let the monstrous flourish. The late '50s were the era of shock theater; Screen Gems offered fifty-two Universal movies as a syndicated TV package. This led not only to audiences' new engagement with classic horror (as did Warren's *Famous Monsters of Filmland*) but a new wave of horror pictures, like *Invasion of the Saucer Men* and *Creature from the Black Lagoon*. Many of these monster pictures took the same tack as the mystery comics (or, really, vice versa); thanks to the Code, most of the usual monster suspects—vampires, Frankensteins, the walking dead—were verboten, so new ones had to be generated, either from the vast and empty reaches of outer space or the stew of atomic fallout. Simply combine a near-random group of consonants and bright colors, and monsters like (I swear this is real) Pildorr, the Plunderer from Outer Space[70] destroyed stuff, then bided their time until next issue, when they could destroy again.

These monsters expressed the dark anxieties of the Atomic Age, and, perhaps, Timely's own fiscal anxiety, appearing in comics whose names are now so associated by fans with the superheroes who later appeared in them as tryouts (remember those postal regulations; no one wanted to change titles) that just reading them reminds us of the importance of decontextualizing: *Strange Tales*; *Tales of Suspense*; *Journey into Mystery*; *Tales to Astonish*; *Amazing Fantasy*. Like the EC comics, many of the tales had twist endings; unlike them, many of the leading males found redemption in defeating the monster. And even the monsters themselves—Kirby's, at least—had this human touch. "I couldn't draw anything too outlandish or horrible. There was something about that monster you could live with," he would say. "My monsters were lovable monsters."[71] These were not superhero books. And yet they birthed superhero comics' next revolution.

The most famous version of the story has Martin Goodman on the golf course with DC publisher Jack Liebowitz, who was talking up *Justice*

League's sales. Goodman, commercially envious, asked Lee to come up with a superhero team of their own. (Liebowitz would deny the story: "I'm sure I didn't discuss anything with him about that, but everybody knew what the sales were." More cynical voices suggested Goodman spies at the distributor.) Lee turned to Kirby. Almost none of the resulting pieces were totally new. The superpowers? A mélange of Plastic Man, the Invisible Kid, the original Human Torch, and any of the superstrong invulnerable types. The origin story? Test pilots out of Green Lantern, crash landing à la Kirby's own Challengers of the Unknown. The villains? At least at first, retreads from the monster comics. (The bad guy on that first-issue cover in 1961 could have been cut and pasted from Kirby's earlier works.) Even "cosmic rays" were in the air, so to speak, having appeared in a Green Lantern story just a few months before.[72] But the Fantastic Four felt new.

One seemingly superficial but deeply resonant change was to set the stories in a world more recognizably our own. The FF, and the characters who followed them, lived in New York, not Metropolis or Gotham. (In later decades, occasional DC/Marvel crossovers would suggest, in a manner that borders on the ludicrous, that Superman had never bothered visiting New York, or that Peter Parker had never seen Gotham City.) But that sense of realness was amplified by Lee's attention to character. In his frequent retelling of the tale, Lee relates a conversation with beloved wife, Joan, when he was thirty-eight. She wanted him to "make something of myself in the comic book field": "I had always thought of my comic book work as a temporary job—even after all those years—and her little dissertation made me suddenly realize that it was time to start concentrating on what I was doing—to carve a real career for myself in the nowhere world of comic books."[73]

Lee's own novelistic temperament and focus on character ("the kind of characters I could personally relate to . . . inside their colorful, costumed booties they'd have feet of clay"),[74] as opposed to a more mythically oriented DC, was important; but what was equally important was the nature of that clay. The Fantastic Four were constantly alienating,

and alienated from, each other—*arguing*, bringing '50s teenagerdom into comics. And not the *Beach Blanket Bingo* side; the Holden Caulfield/ James Dean/Marlon Brando side. That sensibility, wrapped in a kind of Lower East Side streetwise tone that feels very Kirby, is embodied in the Thing, always the quartet's soul over its decades-long history.

This second, far more important invention, taking off from Kirby's "friendly monster" perspective, would resound through the incredible run of works Lee and Kirby (and Lee and Ditko) created in the first part of the '60s, a run that for resonance and impact may only be contemporaneously matched by the Beatles, just beginning to play Hamburg then. It's always fun to make Beatles comparisons, but here, I think, it fits: Kirby the Lennonesque genius, pugnacious, spiky, out-there imaginative, of a vaguely mystic bent, matched and complemented by Lee's McCartneyesque, extroverted Organization Man genius, keeping the verities and the structures moving.[75] Lee and his partners employed a technique sometimes used in comics since the '40s, but which would become known as the Marvel Method,[76] in which, put broadly, Lee and his cocreator/artist would have story conferences in which a rough plot was developed; the artist would pencil the story, essentially creating the full plot and its development as he went; only *then* would Lee (and his successors) actually write dialogue and captions, followed by whatever corrections and changes were needed, usually before the comic was set in ink.

This broad characterization requires some commentary, though, because behind it lies much of the discord roiling through comics history ever since: that is, the question of who created what. That phrase "story conferences" may give a false sense of Lee's original input. By the mid-'60s, for example, in Lee's own words, "Kirby would often build a complete story from no more than a few suggestions over the phone." Another '60s Marvel artist, Don Heck, said, "Stan would call me up and he'd give me the first couple of pages over the phone, and the last page. I'd say, 'What about the stuff in between?' and he'd say, 'Fill it in.' "[77] So, Kirby must be treated with some justification when he said, "Stan Lee wouldn't let me fill in the balloons. Stan Lee wouldn't let me put in the dialogue. But I wrote

the entire story under the panels . . . so that when he wrote that dialogue, the story was already there. . . . From a professional point of view, I was writing them, I was drawing them."[78]

Assuredly, the Marvel Method was partially structured to allow Lee space to write and edit the vast number of titles he worked on. And the only reason it could work was that he was matched in energy, speed, and prolificacy by Kirby, whose ability to produce great work quickly was unequaled by perhaps any other artist.

Introducing a silent nine-panel fight sequence in an early story, Lee's caption reads, "The wise man knoweth when to speak, and when to shuteth up! Sly Stan knows that no words of his can do justice to Jolly Jack's great action scenes." In fact, Kirby—who would, as one historian put it, be "the primary force when it came to designing characters and pacing stories"—served as not just the animator, but in deep ways, the architect, of the Marvel revolution, a point later obscured by many, not least a self- and company-promoting Lee.[79]

So, when it came to plot, structure, layout, visual design, Kirby could justifiably say, "Stan Lee was not writing. I was doing the writing." But when he said, "I began to define characters," it's more complicated. Because those characters were formed in no small part by their talk (and talk, and talk).[80] And that talk, that explaining, huckstering, joking, shpritzing, dancing dialogue and captions, the great majority of that—at *least*—was Lee's.[81] The Method truly generated, almost by necessity, a real partnership, words and images truly blending together in a way previously rare outside the strips, where one person generally both wrote and drew.

In 1953, Lee's story "Your Name Is Frankenstein" had the monster find "the humans he tried to save as uncaring as always, and preferred to return to the Earth." In 1960, he'd written a story about a gray, heavily muscled Thing he liked so much, he brought it back for another issue.[82] But in partnership with Kirby, who "never felt the Hulk was a monster because I felt the Hulk was me," he produced a green-skinned monster (gray at first; printers' problems keeping the gray consistent turned him

green)[83] who transcended his classical literary origins, a Frankenstein–
Jekyll and Hyde mash-up, to become a parable of alienation, the atomic
age, and adolescence simultaneously. Before quitting the Avengers in
their second issue, the Hulk tells them, "I never suspected how much
each of you *hates* me, deep down"; his bellows are the natural scream
of a fourteen-year-old whose body betrays him on a regular basis. And
then he retreats to his room; only here, the room was the wide expanses
of Kirby's southwest, and the stern parent who doesn't get it is General
Thunderbolt Ross.

Changing bodies also characterized Lee and Kirby's third great cre-
ation. The X-Men, children of the atom (Lee's term, but also a contem-
porary SF novel's title), were hated and feared for what they were. Lee's
original title was "The Mutants"; the X, as the first story tells us, comes
from the "EX-tra power" mutants possess. "Preposterous!" a character
says of one mutant's power. "Pure science fiction balderdash!"[84] But muta-
tion was on everyone's mind, amidst fears of fallout and thalidomide, and
the creators had probably read Richard Matheson's heavily anthologized
"Born of Man and Woman," about a mutant whose monstrous appearance
terrifies and infuriates its parents. In *X-Men*, by contrast, the characters
looked camera ready, which only increased readers' ability to read their
individual experiences of marginalization into it, whether ethnic, reli-
gious, sexual, or bodily.[85]

DC's *Doom Patrol*, first appearing less than three months earlier, trav-
eled in similar waters. (Comics' production schedules make it clear it was
less plagiarism than parallel thinking.) Cocreator Arnold Drake (with Bob
Haney) characterized the Patrol as "very angry super-beings. Why should
they give a hoot-in-hell about a world that treats them as freaks?"[86] But the
Patrol's alienated, resentful mien, decidedly uncharacteristic for DC, was
less reader-friendly than the teenage X-Men, struggling with problems of
body, identity, and acceptance. This bodily alienation spoke to how prom-
inently disability figured in Lee's (co)creations then. Three others, Thor,
Iron Man, and Daredevil, were disabled in their "secret identities": Don
Blake had a bad leg, Tony Stark was wounded by shrapnel, and Matt Mur-

dock had been blinded via radioactive waste; all three were "cured," or better than cured, by superheroic transformation—a model of wish fulfillment at a time when perspectives on disability were more negative than now.[87]

But arguably, early Marvel's most iconic creation was *not* a Lee/Kirby invention. For his part, Steve Ditko says he came up with almost everything except the name, that he lived with his aunt and uncle, and that he was a teenager.[88] But that last was so unusual that when Lee brought it to Goodman, he relegated it to the fifteenth and final issue of the already canceled *Amazing Adult Fantasy* ("The Magazine That Respects Your Intelligence"), reverting for that issue to its earlier title, *Amazing Fantasy*.[89] When Goodman got the sales figures, Spider-Man immediately got his own title.

Spider-Man wove together many previously mentioned strands. (Sorry.) He, too, was a product of radioactivity; onlookers were often unclear if he was hero or menace; he wasn't even sure himself. Not just because of why he decided to fight crime—his letting a criminal go resulted in his beloved uncle's death—but more importantly, he didn't feel like, succeed like, or even *look* like a hero: thin, sweaty, and bespectacled. (As a matter of fact, Kirby had gotten first crack at the character, but his sketches were too heroic.) Peter Parker actually looks a lot like Steve Ditko's high school photo, and Ditko's decision to put him in full face mask, almost unheard of then, gave the sense he was hiding something.[90]

Parker was poor. He lived in an outer borough, not glamorous Manhattan. He had trouble with girls. After suffering a combination romantic/commercial/superheroic deflation, he sits on a street corner, head in hand, thinking, "Boy! When I used to read comic mag adventures of super heroes, I always dreamed about how *great* it would be if *I* could become one! It's *great*, alright—for everyone except Spider-Man! Aw, nuts!" As he sits, a street sweeper sweeps dust in his direction, saying, "Move it, bub! You're blockin' progress!"[91] But this *was* progress—a great deal of progress. Ditko's moody drawing, reflecting Parker's churning, doubting life, allowed Lee not to overwrite and to let the readers in. He was, in Lee's words, "The Hero Who Could Be You."[92]

As for Lee's female characters, well, there were pluses and minuses. Take the FF's Sue Storm. Defined from the first in terms of others (Reed's girlfriend, Johnny's sister), granted an allegorically dubious power (on the verge of women's liberation, turning invisible isn't exactly on brand),[93] she still showed the then-revolutionary possibility of balancing domestic responsibilities with career. (For the FF, superheroing was a career, another difference from the work-by-day/fight-crime-by-night binary of so many comics.) And Sue was at least half a generation older than Mary Jane Watson, who bursts into Peter Parker's doorway announcing he had just hit the jackpot, tiger. So had we all: Mary Jane was no '50s Lois Lane; she was empowered, autonomous. But all too often, Lee's *Patsy Walker* background was too painfully evident, as when the Wasp complains, "I'm all right as *any* girl could be who had all her makeup smudged by a silly ol' collapsing ant hill!"[94]

Lee's innovations weren't limited to the characters themselves. In 1958, Julius Schwartz, taking a page from EC, had introduced one of the first letter pages in superhero comics; he and Weisinger used the letters as market research. (Supergirl came as a result of reader demand.)[95] Letter columns were also a useful way of meeting those postal-service text-page regulations; and starting in 1961, Schwartz included fans' mailing addresses, allowing them to write one another and create a community. The pages also became a forum for readers' questioning "facts" in the book, ambiguities, or errors of logic or continuity. And, from the evidence, these were being asked by an increasingly older audience. A year later, a Justice League story killed off all the team's members, in what turned out to be an imaginary story sent in to the team by "one of our greatest fans—Jerry Thomas!" (named after fans Jerry Bails and Roy Thomas). The team is seen discussing the letter eagerly—the Flash, clapping his hands: "I never appreciated what writers and editors have to go through to come up with a story solution before!"[96]

In Lee's very first letters page of the new era, printing letters responding to the FF's first issue, he includes a final postscript: "We've just noticed something . . . unlike many other collections of letters in different mags,

our fans all seem to write well, and intelligently. We assume this denotes that our readers are a cut above average, and that's the way we like 'em!" True or not, Lee's comments, then and subsequently, made readers feel part of a special, elite community; Lee wanted them "to feel that we were all part of an 'in' thing that the outside world wasn't even aware of."[97]

EC's development of its audience as a community, along with its fan club, was clearly an inspiration for Marvel, a name the company officially adopted in early 1963. In 1964, it introduced the MMMS (Merry Marvel Marching Society, for the uninitiated, later to be replaced by FOOM, Friends of Ol' Marvel). Fifty thousand readers paid a dollar each to join. There were ranks of Marvel fandom, with abbreviations reminiscent of the British honors system: an RFO (Real Frantic One) bought at least three Marvel comics a month, while a KOF (Keeper of the Flame) got someone else interested in Marvel.[98] People who caught Lee et al. in a contradiction received a No-Prize; combining community, continuity, and comedy all in one, its envelope stated, "Congratulations! This envelope contains a genuine Marvel Comics No-Prize which you have just won!" (Of course, there was nothing inside the envelope.) And when Lee spoke to readers from "Stan's Soapbox," as it became known as of 1967, he was both preaching Marvel's gospel and gently mocking the idea it was a sermon.

Lee considered humor, along with more humanized characterization, as the feature distinguishing early Marvel from its counterparts. Far more than DC's editors, he'd developed a warmly ironic persona and voice that transcended official writer/editordom. The closest comparisons were EC's GhouLunatics (though Lee was less devoted to puns). He favored a kind of baroque tone with notes of subterranean self-mockery. A caption, picked almost at random, hawking a next issue featuring Dr. Strange: "As surely as the twelve moons of Munnopor gleam with their eternal mystic light, your startled senses will reel in wonderment, when you behold our next chapter. . . . Till then, may thine amulet never tarnish!" (As a kid, Lee had loved Shakespeare's rhythms; it showed.) Sometimes, you got the sense he believed his hype: the third *FF* issue, the one with that first let-

ters page, bore the slogan "The Greatest Comic Magazine in the World!!"
Sometimes, as with startled senses ostensibly reeling in wonderment,
you didn't, quite.[99]

Lee's rising tide of egoism lifted a variety of creators' boats: he gave
credit to his entire creative staff, including previously totally unsung prac-
titioners like letterists and colorists, along with jazzy nicknames (others
must also reflexively append "Joltin'" to the name of Marvel mainstay
Joe Sinnott). Lee, of course, placed himself first among not-quite-equals:
Smilin' Stan, ace pitcher and manager of the Marvel Bullpen, a gang not
of idiots, but hip geniuses who understood what all their readers did, that
superheroes were actually cool. What the readers didn't know—that the
literal Bullpen had existed earlier in Marvel's history, but disappeared
when everyone was kicked off salary in 1950—didn't hurt them.[100] EC
had done this, too, on occasion,[101] but Lee's cheerleading was of a far dif-
ferent magnitude.

Not everyone thrilled to the self-promotion: "a lacklustre humor book
from DC, *Angel and the Ape*, included a comic book editor named Stan
Bragg." And Kirby, particularly, and particularly justifiably, chafed at his
presentation in the press as the mere conduit for Lee's creative genius,
when mentioned at all. But it was Marvel's brand and sensibility as much
as its characters that made it so popular among teen and college readers.
(Kirby didn't realize they *had* college readers until some Columbia stu-
dents came to Marvel and told him the Hulk was their dormitory's mas-
cot.) By 1964, Marvel was sweeping the fan awards the Schwartz titles
used to lock up, and selling almost twenty-eight million copies a year,
nine million more than in 1960; DC's sales, by contrast, were beginning
to decline. By 1968, Marvel was selling fifty million copies annually, and
rearranging its distribution deal with DC—which had been achieving
similar sales with triple the titles—allowing lots more characters to get
their own solo mags.

Lee hit the college lecture circuit, where one student famously
remarked that "we think of Marvel Comics as the twentieth-century
mythology and [Lee] as this generation's Homer." (A mid-'60s ad appear-

ing in college papers agreed, citing similar quotes; Captain America and Spider-Man chime in: "Who says this isn't the Marvel Age of Comics?" "Not *these* pussycats!")[102] Peter Fonda would be Captain America in *Easy Rider*; Paul McCartney sang "Magneto and Titanium Man" (albeit with Wings).[103] But Marvel did more for the industry than putting creators up front and creating more human superheroes. It radically overhauled the concept of comic book continuity.

Superheroes had teamed up since the Justice Society; it was a team book that kick-started the Marvel revolution. But Lee's role as writer or cowriter of most of the line's books, and editor of them all, allowed him to weave together *all* the company's heroes to an extent never previously seen. There were constant drop-ins, appearances, contretemps, and consultations. Spider-Man appears at the FF's headquarters; Matt Murdock shows up at a circus Spider-Man is at. Much of this was undoubtedly commercial, "to draw the reader further into 'Marvelmania'"; Lee himself said he "really treated the whole line as a gigantic advertising campaign." But his earlier line about wanting readers to be part of an "in thing" shouldn't be discounted. And it was a whole Marvel Universe—as it had to be known, since outer space was part of it from the very start. (Anyway, Lee and Kirby's ambitions would hardly have been limited to a single planet, or even a galaxy.) A universe in which everyone was constantly in dynamic relationship to each other—friends, enemies, lovers, long-lost family, and so on. Its early apotheosis was Reed Richards and Sue Storm's 1965 wedding, which featured, in Lee's Technicolor prose, "the world's most colossal collection of costumed characters, crazily cavorting and capering in continual combat."[104]

In a slightly later memo, Lee wrote, "Always make sure the characters have some sort of extreme, exciting expression on covers. . . . We can never convince readers a story is exciting if the characters themselves don't look excited! . . . [I]t can't be mentioned too often. It's VITALLY important."[105] Lee was interested, almost fanboy-ishly, in doing things because they'd be cool; Marvel's first team-up book was basically this impulse in concrete form. Did Lee get the name Avengers from the Brit-

ish TV show? From the 1950 Fernando Lamas Western? Doesn't matter. Trying to find a team name, the Wasp says, "It should be something colorful, and dramatic, like . . . the *Avengers*, or . . ." Ant-Man: "Or *nothing*! That's *it*! *The Avengers!!*"[106] What Lee wanted was just the fans' favorites together, nothing more, or less, meaningful than that.

But Marvel's coherent, frenetic present also had a necessary past. Marvel heroes weren't the only ones not operating in an eternal Now. In the strips, *Gasoline Alley* proved the point daily; in 1942, Lois Lane paged through a scrapbook of previous Superman adventures to finally connect Superman and Clark Kent.[107] But Lee took it to a new level, with characters constantly referring to previous battles, or, indeed, personal insights, to explain the current situation, and often providing literal reference—an asterisked footnote—to allow readers to return to previous issues and review the events themselves. Which provided a new dimension to comics collecting: not just for individual enjoyment, but narrative cohesion. (Just as frequently, of course, the footnotes suggested adventures happening in another title, *still on sale!*)

Lee's increased willingness to tell stories ranging beyond single-issue installments made such references even more necessary. Again, not new; one of the Golden Age's greatest stories, deeply inspired by movie serials, was the twenty-six-part "Captain Marvel and the Monster Society of Evil," running from 1943 to 1945. But this was very rare: even the long stories, sometimes called "novels" in '50s DC argot, by SF-milieu creators accustomed to multipart stories ("The Last Days of Superman! Presenting a great three-part novel featuring the last mighty deeds that Superman must perform before he dies!"),[108] almost never ranged beyond the issue. How could they? Nobody assumed people would pick up the next issue; it was chance, the vicissitudes of newsstand visitation and cover attraction.

Lee started changing that in 1965, providing ongoing connective tissue in tales of Dr. Strange, the Hulk, and, most notably, Thor.[109] The inevitably increasing complexity—a necessary outcome of longer narratives and cross-stitching of multiple threads of a complex universe across different titles, hinted at by footnotes—allowed the increasingly older

readers to get a sense of something grand. If, before this, superheroes had offered flashes of mythic grandeur—sometimes, as in Superman's SF '50s, approaching a mythos—this was more. It was a world. Or, in DC's analogue, multiple worlds.

DC was simultaneously developing its own brand of continuity, premised on its much longer history. In 1961's "Flash of Two Worlds," Gardner Fox and Julius Schwartz neatly solved the problem vexing a certain kind of reader since Barry Allen sped onstage five years earlier—his relationship to the '40s Flash—via an ingeniously *different* adaptation of SF's "alternate worlds." Barry Allen knew the original Flash's adventures; that's why he *called* himself the Flash. But to him, Flash the first had been a comic book character. Turned out, though, there was actually an alternate world where he was real (dubbed Earth-2). Slipping through "vibratory shields" separating the worlds, Allen encountered his counterpart, and, after several well-received Flash/Flash team-ups, "it became inevitable that Green Lantern would meet Green Lantern, Hawkman would meet Hawkman, and so forth."[110] Then their two *teams*, Justice League and Society, teamed up to battle both Earths' bad guys; regular team-ups followed on a roughly annual basis, and the whole shebang became the basis for, well, an infinite number of DC Universe Earths. (You and I live on Earth-Prime. Basically. Earth-Prime also has a Krypton . . . it gets confusing.) This allowed DC heroes not only to participate in a larger narrative, but did something that was, by definition, then impossible for Marvel: it created a Before.

Obviously, Marvel had a corporate past. Lee and collaborators resurrected *tons* of character designs, names, ideas, and settings from Timely and Atlas days, ranging from the *Spider-Man* villain Electro (in his earlier iteration a red, yellow, and green robot) to the Vision and Angel (same names, otherwise very different), to the Human Torch (roughly the same powers, different person and backstory).[111] But perhaps the only Marvel figures who are *the same characters* from the Timely days are the Sub-Mariner and Captain America. The latter offered a special emotional attachment, as the announcement of his return explains: "Jack Kirby

drew the original Captain America during the Golden Age of Comics . . . and now he draws it again! Also, Stan Lee's first script during those fabled days was Captain America—and now he authors it again! Thus, the chronicle of comicdom turns full circle, reaching a new pinnacle of greatness!"

But Marvel fans didn't want Lee and Kirby looking back. A caption at the end of an early story teases, "Each following issue of *Suspense* will feature a new adventure of Cap and Bucky, based on their World War Two exploits! You'll see them as they were in the past . . . bringing the majesty of the Golden Age of comics into this—the new and Mighty *Marvel Age!*" But, a few issues later, Lee backtracked, citing "your requests for more stories of America's red-white-and-blue avenger in the *present!*"[112] Marvel readers weren't looking to the past. DC was sketching a Before with a capital B—a Golden Age, you could call it—and a Now. For Marvel, befitting its Boomer-oriented, '60s, forward-looking affect, there was only a Now. DC was creating fans; Marvel was looking for converts. Fans correctly point to Lee and Kirby's sixteen-issue *Fantastic Four* run between 1965 and 1967 as a high-water mark;[113] and two characters introduced there, Black Panther and the Silver Surfer, illustrate Marvel's foray into the complications of '60s politics.

———

COMICS TREATED THE DECADE'S first great political question, civil rights, rather gingerly at first; when the newspaper strip *On Stage* featured a Black character in a major role in 1961, four newspapers canceled it. Hal Foster told members of the National Cartoonists Society the following year of angry letters after *Prince Valiant* had included "Nubian Negro slaves, a Jewish merchant, and an Irishman." None of this applied to the Black papers, of course, where a wide variety of postwar characters, including a transformed Bungleton Green and a nuclear weapon–wielding Speed Jaxon, demanded the equality and democracy fought for in the war with strength and dignity.[114] But these characters, and others like them, went unnoticed by the wide majority of comic strip and book readers. *Martin Luther King and the Montgomery Story*, a late-'50s comic

book by Alfred Hassler, Benton Resnik, and Sy Barry, produced by Al
Capp's studios and distributed through the South by civil rights organi-
zations and church groups, was frequently destroyed; it was believed too
dangerous, too provocative to own.[115] A copy inspired future congressman
John Lewis, who would later cowrite a graphic novel of his own.

But in 1965, Morrie Turner, a former Oakland Police Department
clerk who'd served as a journalist with the Tuskegee Airmen and had
previously published almost exclusively in Black papers, was syndicated
more widely with *Wee Pals* and its integrated cast of kids. (Circulation
soared after Martin Luther King Jr.'s assassination, when "newspaper
editors were desperately seeking ways to give racial matters a human
face.")[116] Turner felt "by exposing readers to the sight of Negroes and
whites playing together in harmony . . . a useful, if subliminal, purpose
would be served, and ultimately have as great effect for good as all the
freedom marchers in Mississippi." That same year, John Saunders and
Alden Spurr McWilliams's strip *Dateline: Danger* featured two ncwspa-
pcr journalists of different races as leads, and DC war story "What's the
Color of Your Blood?" has a German fighter transfused by a Black soldier,
the racist determining, "I was wrong. *Wrong!* The color of your blood . . .
is . . . *red!*" (It takes nothing away from the good intentions to observe
that Black cartoonists like Mel Tapley had been archly expressing the
sentiment since the war.)[117]

And Marvel noticed. Notably, if subtly, they introduced Blacks into
random street scenes as "policemen, reporters, or mere passers-by."[118]
But they went much bigger in 1966. The FF arc invited to the (fictional)
African nation of Wakanda. Those expecting a narrative out of earlier
decades' racist jungle comics were presented with the exact opposite.
Wakanda was no benighted region requiring white saviorhood; rather,
it was the most scientifically advanced nation in the world (brought to
life by Kirby's wizardlike techno-drawing).[119] White presence in Wakan-
da's history was hardly salvific; it was, instead, predatory colonialism, the
rapacious Klaw in pith helmet trying to strip-mine the nation for its pre-
cious vibranium. And, most importantly, its leader, T'Challa, was hardly

the weak and feckless stereotype of comics past: he was modeled instead on an iconic figure in contemporary race relations.

No, not Martin Luther King, or Malcolm X, or even the Black Panther Party. (The character was conceived slightly before the party was founded, and apparently first called Coal Tiger.)[120] To find his roots, one might look to Sidney Poitier, then one of America's biggest movie stars, whose lyrical press coverage was full of words apt for describing the Panther, such as *regal* and *leonine*. Poitier was the quintessential example of a certain kind of mainstream Northern civil rights liberalism—willing to welcome the "Negro" (only?) if he were extraordinary practically beyond human possibility, the kind of idealized character Poitier specialized in playing in films like *To Sir, with Love*, *Lilies of the Field*, and *Guess Who's Coming to Dinner*—a liberalism resonating with at least one section, perhaps particularly the college-educated, of Lee's audience.

That same *FF* run, however, hinted at other political currents. World-eater villain Galactus was cut from fairly standard alien invader cloth, albeit bigger (the original pitch was "The Fantastic Four Fight God"). But the humanized face of this cosmic menace, his herald . . . that was another matter: the Kirby-designed Silver Surfer, cobbled out of alliteration and Beach Boys songs, ended up resonating. Lee and Kirby probably hadn't seen Rick Griffin's *The Surfing Funnies* (1961) or *The Cartoon History of Surfing* (1963), formative texts for underground comix, but all three grasped the connection between the surfboard and a kind of transcendent, existentialist experience.[121] If, for Griffin, it was a kind of proto-hippiedom, Lee infused Kirby's Surfer with a much more explicit philosophical sensibility complete with tragic mien, articulated in some of his most soaring writing. Lee once said his characters "soliloquize enough to make Hamlet seem like a raging extrovert," and none soliloquized more than the Surfer.[122] And if some were attracted to the vistas the Surfer traversed, proto-hippies in the audience were even more tripped out by Dr. Strange, the Sorcerer Supreme. In Steve Ditko's hands, the doors of perception were opened ("If you are an ordinary human mortal, this scene your uncomprehending eyes are gazing upon is an

unfamiliar, startling sight! For it is not of our dimension—it is a seg-ment of the *dream dimension!*" Lee intoned over a Ditko specialty), and the mystical landscapes Strange encountered felt like those being viewed under the tutelage of then–Harvard professor Timothy Leary. (LSD was legal at the time.)[123]

From September to November 1965, Marvel Comics called itself Mar-vel Pop Art Productions; colors would bloom like the cover of *Sgt. Pepper's Lonely Hearts Club Band* (released two years later), Iron Man blossoming from gray to red and gold. Marvel would soon showcase an artist even farther out, in his own way. Jim Steranko had previously been an escape artist, sideshow performer, and author of two books on card magic. In a special issue of *Genii: The Conjurers' Magazine* dedicated to Steranko, he wrote about a routine of his: "We exercise a rather tight sense of balance in most of our compositions; that is, that each has a definite beginning, middle, and end." And Steranko, arguably the best composer in the busi-ness since Eisner, similarly used page, rather than panel, as his canvas: except *his* influences stemmed not only from film but the psychedelic rock posters beginning to flourish in San Francisco. Steranko—the only early Marvel Age creator Lee allowed to write, pencil, ink, and color his own work—engaged in "original narrative experiments" like nothing else in mainstream comics to date.[124] Most amazingly, the experiments were in the service not of an enlightenment-seeking mystic, or even a standard cape-and-tights man, but Marvel's war hero, Nick Fury.

Fury's adventures had begun several years earlier, in 1963, in *Sgt. Fury and His Howling Commandos*, a World War II–set series billed as "The War Mag for People Who Hate War Mags." But then came the cult of James Bond, recommended by beloved, departed President Kennedy and pop culture imitators like *The Man from U.N.C.L.E.*, and in 1965 Lee and Marvel did something they'd continue to do for decades: revamped a major contemporary character to generate luster and buzz. Sgt. Fury became *Nick Fury, Agent of S.H.I.E.L.D.*, with techno-gadgets straight out of Q Branch and an agenda to bring a smile to any cold warrior. The message may have been pure '50s, but the medium was something else:

when a robot bombards Fury with gamma rays, Steranko X-rays the panels, swapping four-color for black and white and showing a skeletal Fury; "the fantastic HALLUCINATION CUBE!" he encounters "discharges an incredibly potent MIND-BENDING VAPOR!"[125]

Following in Bond's footsteps, Steranko made Fury a sexual being, something Reed and Sue Richards never quite managed, even with the benefit of wedlock. Countess Valentina Allegra de Fontaine ("Val") is introduced by knocking Fury flat on his ass in response to his sexist statement that "the spy game ain't no place for women"; Steranko then gives us three silent panels of Fury sheepishly regretting his stupidity. Later, Steranko provides a suggestive variety of discontinuous images indicating that Val and Nick Fury are about to make love, shifting from a smoldering cigar, to a flower juxtaposed in front of Val's face, to a telephone ringing unanswered: a quieter but no less revolutionary transition than his psychedelic backgrounds.[126]

Fury's extracurricular activities were unique, but his politics weren't: if one cared to look, Marvel's anti-communist bona fides permeated every aspect of their publications.[127] "The commies would give their eyeteeth to know what he's working on now!" reads the very first panel of the very first Iron Man story; defense contractor Tony Stark becomes Iron Man in South Vietnam and fights ideological opponents like the Red Barbarian, the Crimson Dynamo, and the Mandarin (importing the "yellow peril" stereotype into the Marvel Age of Comics).[128] The reason the FF were in that rocket ship that gave them their powers in the first place was to beat the communists to space. (The issue hit newsstands the same week East Germans started building the Berlin Wall.)[129] But the winner had to be the man dressed in red, white, and blue. Mid-'60s Captain America spoke unashamedly of American values, transplanted, explicitly, from the war against the Nazis.

Lee would say in 1978 that these comics were published because "during World War II, we were told that we were the good guys, and the Nazis were the bad guys. I believed it, and I still believed it. . . . A few years later, when the word came down from D.C. that the commies are the

bad guys, I just acted like one of Pavlov's dogs." An interesting wrinkle, though, comes via Lee and Kirby's explanation for Cap's continued youth. Turns out he'd been in suspended animation, frozen in ice for decades. The device managed to instill the early Marvel ethos of alienation even into the heart of patriotism, presenting these values as somehow those of a man out of time. Some of Cap's melancholy could be attributed to the "veil of sadness" resulting from the death of sidekick Bucky Barnes. ("I didn't care if I lived or died" after that, he said, something you'd never hear from Superman.) Some was certainly attributable to Kirby, who had weekly nightmares about his wartime experiences into the '70s, as Captain America does in these early stories.[130] And some, maybe, was a metaphor for Lee himself, a Greatest Generation guy presiding over a Boomer youthquake phenomenon.

Not everything was so serious, even in fighting the Cold War. Wally Wood's *T.H.U.N.D.E.R. Agents* tied anti-communist superheroics to prosaic bureaucracy: an android keeps getting reamed out for ruining expensive bodies, for example. *Mad*'s iconic "Spy vs. Spy," itself the creation of a Cuban refugee cartoonist, Antonio Prohías, forced to flee because of his anti-Castro cartoons, made you think the whole espionage thing was ridiculously futile.[131] And arguably, the most bizarre and sublime contemporary comic figure was small, fat, lollipop-loving Herbie Popnecker, who possessed seemingly infinite power—Presidents Kennedy and Johnson had him on speed-dial—but whose father constantly dismissed him as a "fat little nothing"—far more subversively surreal and, at times, politically deconstructive even than Kurtzman and Elder's overarching mania.[132] But all this comic politics, even *Esquire*'s dutiful 1965 report that Spider-Man was as popular in the radical sector of the academy as Che Guevara, was entirely overshadowed by the result of a brainstorm on a 1965 airplane flight.

William Dozier, best known in the entertainment industry for being married to actress Joan Fontaine (and executive-producing the TV show *Rod Brown of the Rocket Rangers*), picked up a Batman comic in mid-flight and thought it might make good TV. Dozier maintained he was reading

it because ABC had already acquired the rights; somewhat salaciously, a network executive had been at Chicago's Playboy Mansion when they'd screened fifteen chapters of the old *Batman* serial. "The bunnies and Hugh and his friends were laughing and screaming and hissing the villains. It was all very campy."[133]

Camp was the word. *Batman* premiered in January 1966 (one of the first shows ever launched outside the traditional September season), replete with guest stars, flashy cartoon-panel sound effects, and the twisted camera angles known in the industry as "Dutch tilts." As star Adam West put it, "*Batman* the television show captured a late-'60s audience in the same fashion as had Bond and the Beatles." Bond, the Beatles, Batman: it's not implausible to argue that *Batman* brought the swinging '60s to television no less powerfully (and two years earlier) than *Rowan & Martin's Laugh-In*. Only one other contemporary prime-time show was scheduled twice a week. But *Batman*, unlike *Peyton Place*, was in color.

It became a monumental hit, a veritable craze, airing Wednesdays and then Thursdays—same Bat-Time, same Bat-Channel. Batman was the first superhero to appear on the cover of *Life*. There was even a Bay Area nightclub, Wayne Manor, "where guests could buy their tickets from Batman at the front door, be seated by a Joker maître d', and enjoy drinks served by Wonder Woman while girls dressed like Robin (!) . . . led revelers in the Batusi."[134] (*Peyton Place*, watching the competition, went to color a few months later.) ABC went all in on *Batman* as a Pop Art phenomenon, scheduling a "cocktail and frug" premiere party at the iconic New York discotheque Harlow's. Attendees included Andy Warhol and Harold Prince. (Jackie Kennedy turned down her invite.) *Mad* flayed ABC's pitch with its usual stiletto-like precision: "For years TV tried to reach the sophisticates with 'Playhouse 90,' 'The Defenders,' etc. But they wouldn't even turn on their sets. Then along came 'Bats-man' and the industry made a revolutionary discovery. Give the 'in' group garbage—make the show bad enough and they'll call it 'camp' and stay glued to their sets!" The real camp habitués might not have been so sold, though: guests at the

premiere "were reportedly unexcited about the show, but in true Pop style, they cheered when a commercial for corn flakes came on the screen."[135]

DC had recently tried to make Batman a little cooler: Schwartz had taken over the line in 1964, removing the aliens and most of the Batman family. Introducing a new Batmobile, Bruce says to Dick, "The original Batmobile has had its day! The trend now is toward sports cars—small, maneuverable jobs!" But all this changed with the show's success, in what remains one of the most powerful examples of the media tail wagging the comic book dog. *Batman* sales skyrocketed to almost nine hundred thousand copies,[136] and the rising tide lifted all comics. Notably, at precisely the same time, a more conventional Broadway adaptation of Superman—*It's a Bird, It's a Plane, It's Superman*—was closing after 129 performances.[137] Schwartz, who didn't need a weatherman to know which way the wind blew, jettisoned the "New Look" and camped it up.

There had been attempts at hepcattedness throughout the Schwartz era: a book throwing together the various sidekicks, the *Teen Titans*, was replete with grating teenybopper slang, an adult's misguided idea of being with-it. ("Batman—you sound like an old square!" chides Robin on the first page of the Titans' adventures. "Dig this crazy teen scene!" another cover reads.)[138] Justice League sidekick Snapper Carr snapped his fingers to be cool and crazy, saying things like "The JLA! You're all back from the dimensional worlds! I'm rocking along on cloud nine!" But now it got worse. Black-and-white "go-go" checks streamed atop DC covers. "That 'negative' radiation is making me act like a camp-style Green Lantern!" the hero complains mid-battle. Visiting the war heroes the Blackhawks in 1967, Batman brings his campy tone along: "The Blackhawks are washed-up has-beens, out-of-date antiques . . . to put it bluntly, they just don't swing!" Even Archie Andrews got into the camp superhero act, donning a red suit to become Captain Pureheart in 1967.[139]

Ironically, another teen-centered book showed a different way forward. Even back when people started young, Jim Shooter debuted preposterously early: his first comic script for the *Legion of Super-Heroes* was delivered at age thirteen, within months of *Batman*'s 1966 premiere.

Reading their adventures, "I thought, 'I can write better than this,'" he said. "And so I did." Some of what he did was bring a Marvel sensibility to DC characters: a scene in his first story in which a character dodges autograph hounds on his way to a Legion meeting feels right out of early *Fantastic Four*; in another early issue, shape-shifter Chameleon Boy turns into a spider, then winks at the reader and references "a certain web-headed character." But Shooter was also profoundly shaped by the extreme poverty of his youth; his stories were more than just escapism, they helped support his family, issues millionaires Bruce Wayne and Oliver Queen didn't know from. (In "The Hapless Hero," a Legionnaire refuses to let people know his family survives on his wages.) Other tales, such as one in which Brainiac 5, in love with Supergirl, creates a robot version of her in his sleep, brought darker behaviors like obsession to previously cheery heroes.[140]

But Shooter's work was the exception at DC rather than the rule. The cover of the August 1966 issue of *Batman* showed the Caped Crusader relaxing in front of a TV showing *The Adventures of Batman*, Robin begging him to come out and fight crime. It showed who was in charge of what.[141] TV fan favorite Alfred the butler's odyssey was indicative. First appearing in 1943 as a rotund comedic foil, a thinner actor was cast in the Republic serials. The editors, worried readers would be confused, sent Alfred to a health resort to drop some weight and added the mustache sported by the movie actor. When there was some post-Wertham anxiety about two men and a boy living all alone in Wayne Manor, Alfred was killed off, replaced by an Aunt Harriet. But thanks to television, he was back, having cheated death in grand comic book style. DC was following the money, which wasn't just from TV revenues. The Licensing Company of America, with DC's approval, Bat-licensed "every type of clothing imaginable," and a lot else besides—$150 million worth of merchandise sold in 1966 alone, dwarfing anything done before, even with Superman. And you'd better believe people paid attention, with consequences felt right up to the present. (The next big comics merchandiser: Charles Schulz, with *Peanuts*-related endeavors grossing the same amount five years later.)[142]

It wasn't just camp craziness; part of the commercial appeal unques-tionably stemmed from nostalgia. Many of the *Batman* series' positively inclined critics praised its "deliberate evocation of juvenile fantasy." Some might even have recalled Jules Feiffer's noting what he considered a sur-prising phenomenon the previous year in the unexpectedly resonant book *The Great Comic Book Heroes* (excerpted in *Playboy*):[143] "old comic book fans . . . men in their thirties and early forties wearing school ties and tweeds, teaching in universities, writing ad copy, writing for chic magazines, writing novels—who continue to be addicts, who save old comic books, buy them, trade them . . . who publish and mail to each other mimeographed 'fanzines'—strange little publications deifying what is looked back on as 'the golden age of comic books.' Ruined by Wertham. Ruined by growing up."[144] Ivory tower readers, old EC fans, *Mad* Maniacs, Wertham-haters, fanzine swappers . . .

Three years before Feiffer wrote those lines, one ivory tower cartoon-ist had ushered in the next movement in comics. With that warthog.

COMICS WITH AN X

G ilbert Shelton's *Wonder Wart-Hog* first appeared in the *Texas Ranger*, the University of Texas at Austin's humor magazine. Unfettered by commercial limitations (only legal ones), aiming at an older audience of collegians, Shelton epitomized comics' new vanguard: emerging from a more middle-class setting, and with higher formal education.[1] Many were also those EC fans and *Mad* maniacs Feiffer had mentioned. Some Shelton jokes about "the Hog of Steel" feel like familiar riffs from *Mad*'s "Superduperman":

> Is he possibly the lone survivor of a gigantic explosion on some distant planet, come to Earth in a miniature rocket-ship? Did he turn crime fighter in his youth when fiends murdered his old and kindly parents? Bosh, no! What do you think you're reading, *Action Comics*? This is 1962, Mac, and this is a 1962-type comic character, a home-grown, more-intelligent-than-most warthog who fights crime for the only sensible reason . . .

Wonder Wart-Hog then says, "There's money in it, Dad! . . . And if you're famous, you get lotsa dates with well-carved American girls! Which ain't bad for a wart-hog, Dad!"[2]

And a later encounter with an archenemy, the "merciless menacing Masked Meanie," becomes a *Mad* and Kurtzman–inspired Freudfest as the Meanie becomes the Psuper-Psychiatrist ("Why do you refer to everyone as your ARCH-enemy? Do you think everybody is out to get you? Are you some sort of paranoid nut?").[3] But soon, Shelton, and a small circle of other UT alumni, began gathering artistic and satiric momentum.

Frank Stack, the *Texas Ranger*'s late-'50s editor in chief, had decamped to New York post-graduation to try selling gag cartoons to *The New Yorker*. Joined there by fellow alum Shelton, Stack shared his new creation with him: *The Adventures of Jesus*. From a contemporary perspective, *Adventures* shares ground with Lenny Bruce's and Mel Brooks's routines: Jesus as Jew, complete with Jewish mother. "My boy's popular wherever he goes!" she brags proudly to another woman attending the wedding at Cana, as guests, sloshed on water turned to wine, sing, "What a friend we have in Jesus."[4] Tame now, but fairly hot stuff at the time. Recall Bruce's legal travails over obscenity in his act, or, more relevantly, what happened to Kurtzman and company after they published *The First Golden Book of God* in *Help!* in 1964: subscriptions fell off significantly, undoubtedly contributing to its cancellation.

Stack had similar concerns about the *Adventures*, having Shelton print fifty copies "clandestinely on the Xerox machine at the University of Texas Law School (a Xerox was still a rare and exotic piece of equipment in those days)." Stack was—justifiably—concerned that publishing it under his own name might endanger his tenure-track job in the University of Missouri fine arts department, and thus the work often considered the first underground comic was circulated under the title of *The Adventures of Jesus* by F. S. Even several years later, when it was published slightly more formally, Stack expanded on the initials but adopted the pseudonym

Foolbert Sturgeon, in no small part to throw off suspicions of Stack's authorship by the name's similar sound to "Gilbert Shelton."[5]

The third Texan central to the new movement, Jack Jackson, who generally went by Jaxon, began his career working the same satiric-religious vein as Stack. *God Nose (Snot Reel)* first appeared in 1964, featuring a pun-addicted divinity with thick glasses and, yes, a tremendous honker: after divine correction to a stuffy nose, he exults, "Yes friends, modern sinus triumphs again!!" (The nasal emphasis, Jackson later explained, stemmed not from God's stereotypical Jewishness, but from drippiness stemming from regular peyote ingestion.)[6] Jackson, who once felt called to be a preacher and briefly worked as an encyclopedia salesman, found his quasi-religious idealism tempered by comedic cynicism, sending Jesus to earth as a folk singer, singing parodies à la Allan Sherman: another link between Jewish comedy and early underground sensibility. But Jackson's perspective was more pointed, presenting the angel Gabriel's answer to the civil rights question—in the form of a blank word balloon. (Asterisked material reads, "Yes, friends and neighbors . . . now at least *you* can solve the race problem and win valuable prizes for yourself!!") Its 1,000 printed copies sold out within weeks.[7]

Jackson, Shelton, and another former *Ranger* cartoonist, Dave Crossley—fired from the *Ranger* for sneaking obscenities onto the cover—all appeared in Kurtzman's *Help!*, joined there by a young cartoonist named Robert Crumb, who had moved from Cleveland and a job at the American Greeting Card Company to work there just as it was folding in 1965. "I walked into the *Help!* office," he later remembered. "Kurtzman's standing there against a wall looking real forlorn, and guys are taking out the furniture!" Feeling badly, Kurtzman got Crumb some work and critiqued his sketches: "You can't simply do a drawing or an observation," he told him. "This is a humor magazine. It has to have a punch line of some kind. It has to have a humorous element."

Crumb would go on to become one of the most influential, and controversial, comics artists of the twentieth century, and his comic sensibility—which would infuse almost all his work, if not always

appositely—would juxtapose Kurtzman and greeting cards. "It's irrevocable. It's just ingrained. I was trained to be cute, and I never lost that," he later lamented, although the cuteness, along with the technical training he received, unquestionably contributed to his influence, and, indeed, his later crossover appeal. But at the time, moving back to Cleveland and the greeting card company, he felt stagnant. At a 1966 show of his work in Peoria, a "Margaret Dumont–type matron in a fur stole" asked him, "Why do you hate us so much?" Crumb "wanted to march her to the wall and squash her smug, rosy face against one of my psychotic drawings."[8] And then a blast of flower power jolted him from black and white into glorious tie-dye Technicolor.

On a "cold dreary evening" at a Cleveland bar, in January 1967:

> These two guys, both certified lunatics, told me they were on their way to San Francisco that very night. They said something exciting was happening out there . . . a gathering together of people of like mind . . . acid-heads, drop-outs, hipsters. . . . I asked if they might have room for one more . . . [and] told another friend I was with to call my wife and inform her that I went to San Francisco. *No way* was I going to confront her myself. Are you kidding? She would've thrown a snot-slinging fit! Was I afraid of her? I was terrified of her![9]

Crumb's self-presentation as a weirdo weakling terrified of powerful and dominating women, and the kinds of misogynistic cruelties that generates, are themes that recur throughout his long career. (It started early on: a book-length comic he gave his future first wife, a "sophomoric-romantic work . . . done in the throes of horny passion," features a gigantic nude woman threatening to eat the froggy protagonist whole, over and over again.)[10] But some of Crumb's strongest work of the period was about running off to join the hippie circus, albeit ambivalently.

And the circus was in town—*towns*, actually. After *Help!* folded, many of the Texan cartoonists had gotten involved with what *Time* would dub

the "underground newspapers." The *East Village Other*, or *EVO*, started in 1965; by spring 1966, it was joined by the *Berkeley Barb*, the *Los Angeles Free Press*, Detroit's *Fifth Estate*, and the *Michigan Paper*, among others. By 1967, the cartoonists, following in their strip predecessors' footsteps, had formed the Underground Press Syndicate to sell cartoons to these local papers. And by then, many of them had gone west, heading for the Bay.

Mario Savio's Free Speech Movement had taken hold at Berkeley in 1965 and 1966; as early as 1965, Joel Beck published the cartoons "Marching Marvin," "Lenny of Laredo," and "The Profit" as part of the student movement, directly affiliating comics with the emerging counterculture; underground cartoonists took as credo the movement's implication that nothing was off limits. Hippies lined up outside the *Barb* publisher's home in 1967 to buy wholesale copies, complete with underground cartoons, at fifteen cents; they resold them downtown for a quarter, making enough in a day to support themselves for a week. Everyone, including Crumb, gawked at the New Age rock posters by future partners Rick Griffin and Victor Moscoso, visual landmarks clearly reflecting new inspiration, cultural and, yes, pharmacological.[11] A 1965 psychedelic rock happening in Haight-Ashbury titled "A Tribute to Dr. Strange" suggested that Ditko's vistas, along with counterculture hero the Silver Surfer and Kirby's cosmic colors, weren't lost on some of the Marvel college fans who'd turned on and dropped out: some of them had certainly visited Gary Arlington's San Francisco Comic Book Company, arguably ground zero for the new West Coast movement.[12] The seventh issue of the *EVO*'s monthly comic supplement, the *Gothic Blimp Works*, featured Willy Mendes's full-page "Leaving New York at Last." "So long, Badlungland!!!" Mendes shouted, ditching the Big Apple, "Tombstone City," full of polluting traffic and mouth-breathing assholes: "There's lots more joyous hippies, I hear tell, in that 'golden' place, California." (In 1971, *East Village Other* stalwart Dean Latimer wrote, "In 1969 all those fuckers split for the Coast, and we've been broke ever since.")

"There's a lot of weird shit in everybody's head," Crumb told the *Barb* in 1968. "The whole value of a cartoonist is to be able to bring it out in

the open."[13] Crumb published in the underground papers, but wanted to make a statement, a kind of comic manifesto. He considered a number of titles for his comic book: *Crud*, *Trip Comics*, *Where It's At*, *Psycho Comics*, *Wow*, *Funk*, *Okay*, *Bang*, and *Yes*. But none did the trick—until he found the precise word to express the electric excitement of the era while simultaneously channeling the essence of comics.

"The Comic That Plugs You In!!" announced the electrified/electrocuted figure on the cover of *Zap Comix*'s inaugural issue, plug and wire entering his navel from a wall socket. On the inside front cover, Mr. Sketchum promised, "'Zap' comics. . . . Audacious! Irreverent! Provocative! You bet! . . . Every page will be jampacked with thrills and laffs!" But *Zap*'s comedy was less showbizzy than suggested (and, simultaneously, mocked); between its covers, readers found the surreal "Meatball!," where the eponymous object, striking people on the head, generated "rioting and looting and dancing in the streets and a lot of giggling!"—a symbol for both the Age of Aquarius's merry pranksterhood and its darker underbelly.[14]

Crumb, at his best, made only a qualified ambassador for total liberation, resonating so broadly precisely because of how powerfully he expressed his ambivalences and psychologically self-imposed restraints. A small five-panel strip from the summer of 1967 illustrates this neatly. A box strains under effort from within, until, with a panel-filling *"Foont!"* a man bursts out. "Free!" he exclaims in the fourth panel—until we pull back to discover, in the final panel, he's inside yet another box. *Zap*'s "Whiteman"[15] features the eponymous white man "on the verge of a nervous breakdown": "It's such an effort being polite anymore! But if I stop, they'll see . . . they'll find out . . . my real self deep down inside . . . the raging lustful beast that craves only one thing! SEX!" (Later, stuck in traffic, Whiteman also suggests he wants to "KILL.") Heading home, he hears parade music, and he's pantsed by a set of Black minstrels. "Hey! C'mon! We's all joining the parade!" "Will Whiteman join the parade?" the text ends. "Oh, eventually!"

But would he? One of Crumb's best-known creations, Mr. Natural, is essentially a rejoinder to the peace-and-love crowd; sought for wisdom

constantly, he has little to provide. "Come here, I'll let ya in on a secret! The whole universe is completely insane!" he tells young Flakey Foont on one occasion; on another, he simply tells Foont to go fuck himself. Even vouchsafed a visit to heaven, Mr. Natural describes it as "a little corny if you ask me. . . . The whole concept is a little outdated . . . it's just not my scene."[16] Crumb just can't fully get behind anything or anyone. Except, perhaps, for the medium of comics itself. On the back cover of that first *Zap* issue, Crumb wrote, "Were you given lectures about how comics were CHEAP TRASH put out by evil men? Do you feel a spark of GUILT every time you pick up a comic book? . . . Let ZAP comics wisk [*sic*] away all such foolish notions!" The cover of the *Zap* issue[17] famously sold out of a baby carriage during a February 1968 Haight Street block party by a very pregnant Dana Crumb has a parody of the Code stamp reading, "Approved by the ghost writers in the sky" (along with a "fair warning": "For adult intellectuals only!"). For Crumb, and among underground artists generally, there was a special place in hell for the Authority that had done in their beloved EC.

An early *Zap* inside cover features a figure with copies of *Mad* and *Humbug*. "I don't like editorial meddling in my work. That's why I stick with the 'underground' still," Crumb said, twenty years later. "I learned this lesson from seeing what happened to my hero Harvey Kurtzman when he got tangled up with Hugh Hefner." Another EC alum, Wally Wood, had learned the same lesson, self-publishing *witzend* because "I got tired of seeing my work turned to shit." *Witzend* started in 1966, a bit before *Zap*, and was an underground precursor: a prozine—a fanzine in distribution and production, professional in content. Creatively, it was an "open forum. Each feature was unique, without relevance to the other contents, put directly into print without editing." Wood's first-issue "Statement of NO Policy" read, "Our theory is that an artist is his own best editor, and left to his own devices, will turn out his best work." Art Spiegelman published one of his earliest longer pieces, "Little Harold Sunshine," in *witzend*'s third issue; that same issue saw Ditko premiering the polar ideological opposite, Mr. A, an antihero speaking up for a quasi-

objectivist moral absolutism, a creator-owned version of the Question, a Charlton character he'd worked on. (In a later issue, he savaged moral relativism via his character the Neutralist, whose idea was: "To be right is to be a loser!")[18]

But the commercial terms were as interesting as the creative freedom: while not paid for one-time printing, *witzend* contributors got the copyrights to their original material and the return of their original art, and could sell their work and the characters they'd created anywhere else. When *Zap* came out, contributors Griffin and Moscoso not only brought name recognition, thanks to their reputation from those rock posters, but business experience: connections to distribution and the savvy to insist on artists owning their own copyrights and receiving royalties. Moscoso got the original *Zap* artists to form a legal partnership, register *Zap* as a trademark, and ensure it remained artist-owned.[19]

As *Zap*, *Feds 'n' Heads*, *Yellow Dog*, and *Bijou Funnies* were "passed around in communes, crash pads, and college dormitories across North America and Western Europe" during that summer of 1968, other regional enterpreneurs were inspired. Jay Lynch and Skip Williamson met through the fanzines. Williamson moved to Chicago to join Lynch in 1967; after seeing *Zap*, they turned their underground magazine the *Chicago Mirror* ("somewhere between *The Realist* and *Mad*") into a comic. *Bijou* began at the time of the bloody Chicago Democratic Convention; Lynch's *Nard n' Pat*, the comic's signature strip about a bickering "bourgeois man and a radical cat," spoke to the times, albeit, perhaps, in a slightly lower-key Midwestern tenor. Another Midwesterner, Denis Kitchen, took a similar approach, busting out of Milwaukee with *Mom's Homemade Comics* ("Straight from the Kitchen to You!!"). Although his comic's cover promised "bold, blustering tales of stark passion," Kitchen's work itself, as Spiegelman put it, "radiated a general good-naturedness, a *liberal*—rather than a radical—vision of what comix might be"; by issue 2, the cover read, "America's Most Wholesome Underground Comic!"[20]

A Kitchen piece in one of his other titles, *Snarf,* suggested that while most cartoonists "succumb to the harsh demands of capitalist economics

and are swallowed up by the giant maw of faceless industry . . . others, through superior genetic chains (or perhaps divine guidance) choose the smaller path and become Underground Cartoonists. . . . It falls primarily on their shoulders to lead the masses against the corrupt bourgeois institutions that oppress all mankind." And yet, living in a corrupt and fallen world as they did, they still needed to engage capitalism. Kitchen treated the subject ironically in a one-pager about heading an underground publishing company. (He would soon agree to publish *Bijou*, and took a quantum leap forward entrepreneurially when he began publishing some of Crumb's work.) He changes from suit to bell bottoms to greet a new cartoonist, whom he advances $20, then rides a limo to meet Hefner and wires sums to his Swiss bank account.[21] But commercial questions—involving production, circulation, and compensation—were real.

In January 1969, Shelton, Jack Jackson, Dave Moriaty, and Fred Todd bought a Davidson printing press, set it up in the upstairs of Mowry's Opera House, and created the Rip Off Press. (Sometimes, the staff's long hair got caught up in the press's rollers.) To their best recollections, the name came from discussions about "who got ripped off on the way to work"; it wasn't a safe neighborhood.[22] But it also savored of a certain irony, since they were highly mindful of how artists being ripped off had been central to comics' business model for decades.

In 1947, Siegel and Shuster had sued in New York Supreme Court to regain the rights to *Superman* and recover about $5 million they believed they were owed from the past nine years. They didn't get the outcome they'd hoped for. They *were* paid for *Superboy*, which DC debuted under Siegel's byline despite his claim he had neither authorized nor been paid for it. But the court ruled that DC owned Superman; then Donenfeld fired them. They suffered serious financial reversals: Shuster was picked up as a vagrant in Central Park; treated to a sandwich by a kind cop, he tried convincing comic-reading kids in the diner he'd created Superman by drawing them a picture. He became a printer's deliveryman (on one infamous occasion, delivering to DC's offices). In the mid-'50s, he illustrated "kinky tales of adventure, bondage, and torture" for a series called

Nights of Horror; several of the characters' features are identical to those of Superman, Lois, Jimmy, and Luthor. In 1971, a 386-page book DC published called *Superman from the '30s to the '70s* didn't even mention Siegel's and Shuster's names.[23] By contrast, in the same year Siegel and Shuster sued, Milton Caniff negotiated with a new syndicate for ownership of his new strip; leaving *Terry and the Pirates* behind for *Steve Canyon* put him on the cover of *Time* and made him a fortune.[24]

These lessons weren't lost on the underground artists, who looked backward to the syndicate model. Rip Off Press's Comix Syndicate reached some fifty newspapers at its peak; a far cry from King Features, but enough to create a national reading community. The syndicates were also a much better example of profit sharing than comic books. Kitchen broke down how *their* book business worked in 1972: "We have the highest royalty setup for any publisher today, which is 12%. . . . So out of a 50¢ book, 6¢ goes to the artist. Another 7–8¢ goes to the printer, and most of the rest goes to the distributor, who buys in volume, and gets between 40–60% off. Between the artist, printer, and distributor, that leaves about 6¢ a copy for us."[25] The numbers differed from one operation to the next, but the principle was the same, much different from the mainstream companies: publisher and creator shared windfalls.

It should be said that royalties, and the all-important assignment of rights, were made much easier by the fact there was usually a single creator to assign those rights and royalties to. The underground, similar to the strip world, was a world of writer-artists. The assembly-line shop/bullpen model of corporate comics meant creative contributions were divided, and theoretically unequally, among many possible claimants. (What's the percentage breakdown for the creation of a character between writer, penciler, and inker, for example?) All this was organically sidestepped, allowing for the re-creation of the cult of individual genius omnipresent in the comic strip world, but largely absent, except for perhaps Stan Lee and a few of his cocreators, in the mainstream.

To *sell* the comics, the underground seeded an alternative distribution system through alternative bookstores, record stores, head shops,

military bases, gift stores, political bookstores, mail-order houses, and considerable overseas exports. (An original distributor: *Rolling Stone*, which brought these underground "comix" along on its distribution routes to head shops and record stores.) And, for the first time, comics were "printed and sold on a demand basis," unlike mainstream newsstand distribution, where publishers printed at least twice as many issues as sold, and any remainders were returned and destroyed. The undergrounds, by contrast, were printed in batches of (often) ten thousand, sold nonreturnably, then reprinted as needed. This system would prove important later on.[26]

And it worked. The first fifty thousand copies of *Zap* sold out within several months. Kitchen's company was put on the map in 1971 when Crumb's *Home Grown Funnies* sold 160,000 copies; Crumb's second comic for them, *XYZ* ("the last word in comix") had a print run of fifty thousand the following year. By 1973, the first issue of Shelton's Fabulous Furry Freak Brothers adventures had sold four hundred thousand copies; the series as a whole sold into the millions. Between 1968 and 1978, Print Mint sold over five million creator-owned comics. With numbers like these, comix may have been countercultural, but they were certainly part of the culture; if movies like *Easy Rider* were making an impression, so were Crumb and Shelton. Creators, since they were in on the finances, started making money, especially from Print Mint. And there was an additional revenue stream: merchandising. Kitchen's company hawked T-shirts, for example.[27] Arguably, these advances in printing and distribution strategy, profit sharing, and creators' rights would be even more revolutionary than the underground's content.

———

THAT CONTENT DEMONSTRATED CONTINUNITY, not just revolution, starting with homage to its chosen ancestor. "E.C. Comics for Moral Support!" says editor Gary Arlington explicitly in the back of the first issue of 1969's *Bogeyman Comics* ("Horror in the Blood Vein"), where the great primitivist Rory Hayes depicts Winnie-the-Pooh-meets-Lovecraft in "The Thing

in the Room."[28] *Skull Comics* (1970) began: "Hi kids! Ever wonder what happened to those great old *horror* comix that used to scare the shit out of ya way back in the 50's? Remember? Well, they all disappeared, an' it wasn't *black magic* what done 'em in, either! . . . Things bein' as they are these days, a few of us ol' characters decided it was time to revive th' *horror* comix . . . in keepin' with th' *times*, y' understand!"[29] And in a third comic, Code enforcer "Dr. Lester Prong,"[30] who crows, "What a relief it was to drive *Tales from the Crypt* off the stands" and recalls "how insidiously young minds were exposed to carnal knowledge disguised as Batman's armpit in reality a blatant female vagina," is torn to shreds by EC-esque fiends.

What appealed most, in other words, was EC's mixture of horror and comedy. The cover of the first issue of Roger Brand's *Tales of Sex and Death* (1971) has a naked woman fleeing from rotting skeletons: running across the top, the message "Clean—Wholesome—Mellow—Affectionate." Rick and Tom Veitch's 1972 *Two-Fisted Zombies* was a mash-up parody of EC's war and horror comics. Parodic iterations of the GhouLunatics abounded: Richard Corben's eponymous Fantagor (actually, he's two-headed: the other head's named Uk) invites his readers to "come outta that radioactive rain an' I'll tell ya some stories"; his *Grim Wit* (claiming on *its* cover to have "100% Gore" and be "For Adults Only") had a big-bosomed, skeletal-faced hostess, Horrilor, a mash-up of Vampirella and the Crypt-Keeper.[31]

EC had published the first EC parody, of course, in that original issue of *Mad*. And *Mad* was a natural touchstone for the undergrounders. "If you were growing up lonely and isolated in a small town, *Mad* was a revelation," Crumb said, and many other creators expressed similar sentiments.[32] That same sensibility applied to underground artists' take on EC's (and others') romance comics, too; but the content was something else again. Rebelling, they were inevitably drawn to material then absolutely verboten under the Code, like graphic sex, extreme violence, unfettered use of language, and offensive stereotype. And so, while Bill Griffith and Jay Kinney's cover to *Young Lust* 1 portrayed the archetypal tear-stained young woman thinking rueful thoughts, the thoughts them-

selves—"Two weeks ago he was dry-humping me in the elevator! And now . . . and now I'm lucky if he remembers my goddamn name!"— would have given the Code administrators fits.

Tongue firmly in (whose?) cheek, *Young Lust* not only parodied the genre dead-on (Nancy Griffith contributed text pieces parodying both contemporary *Penthouse* Forums and those boring mid-century two-page comic book prose stories)[33] but demonstrated the ethos of countercultural sexual exploration. *Young Lust*'s second cover stated it "pulls no punches in its frank treatment of formerly taboo romance comic topics!" Nor did it: "I answered a 'personal' ad in the paper—and our home soon became a . . . Love-Nest for Three!" was, in its own way, an introduction to the jolt of sexual self-discovery expressed in mainstream novels like *Fear of Flying*, published two years later. (Here, an "uptight" woman agrees to bring home another woman to spice up a dull marriage; it turns out that the two women spark sexually much better than anything hetero. "Was Ted mad!" her voice-over says.)[34]

The back cover of *Young Lust*'s first issue advertised similar fake mags: *Just Laid, Mutant Love, Rape Fantasies, Lib Love, Queer Diary, Galactic Romance*. But there were non-fake imitators, too. *Bizarre Sex*'s first issue, put together by Kitchen, led off with Richard "Grass" Green's extremely X-rated "memoir" of brother-and-sister incest;[35] its fourth came with a plain white outside cover reading, "Retailer: Remove this outer cover at your own risk!" Given that the inner cover featured a gigantic space vagina straddling a skyscraper, that was almost certainly true.

But the Code wasn't the only institution the undergrounders were taking on. Their other essential inspiration—the other comics dominating their youth[36] in the early '50s, when the superheroes were in decline— were Disney publications, and the funny animal genre more generally. Papa Walt stood for everything sweet and light about the culture they felt needed to be toppled.

Underground comix are full of cartoon animals doing horrible things to each other. (*The Simpsons*' Itchy and Scratchy owe a great debt to the underground.) The most famous example is Fritz the Cat,[37] appearing

in 1969's *R. Crumb's Comics and Stories*, the name a clear nod to *Walt Disney's Comics and Stories*. Crumb, who later confessed to "becoming heavily sexually attracted to Bugs Bunny" at age five and that Carl Barks's duck stories "sustained me and my brother Charles throughout our childhoods," created "a sophisticated, up-to-the-minute young feline college student" who talks a good '60s hippie game, luring three young things into his bathtub for a frolicsome foursome, only to be joined by a wide variety of others: in a typical Crumb eros-to-farce move, it becomes the stateroom scene from *A Night at the Opera*, X-rated. Fritz was part of a sex-crazed cat tradition going all the way back to James Swinnerton's *Mr. Jack*, whose showgirl-chasing so outraged Hearst, he moved it from the child-friendly Sunday supplement to the daily sports pages, and Otto Mesmer's '20s Felix the Cat, who catted around behind his girlfriend's back.[38] But Fritz went much further; it's implied he seduces his younger sister after returning from a joint midnight swim.

And others went further than *that*. When Walt Disney died, Paul Krassner's *Realist* magazine published a centerfold by EC/*Mad* artist Wally Wood of Disney's beloved characters in a memorial orgy, engaging in drugs, sex, and scatology. (Krassner once spoke to Gaines, at a time when *Mad* was doing over a million in circulation, about going more adult. Krassner: "I guess you don't want to switch horses in midstream." Gaines: "Not when the horse has a rocket up its ass.")[39] Dan O'Neill took that Wood orgy poster, turned it into a narrative in 1971's *Air Pirate Funnies*, and was found guilty of copyright and trademark infringement and trade disparagement, earning an injunction prohibiting republication and a $190,000 fine; the Supreme Court refused to hear the appeal, that old Irving Berlin vs. *Mad* case notwithstanding. (It's still very hard to find the original.)[40] In the later *Dan O'Neill's Comics and Stories*, the "author" recounts his motives in language resonant of those Barks critics: "The Mouse fascinated me now . . . he was symbolically a monster . . . all the world knew him . . . he represented America!! The worst of our national vices . . . materialism and flag worship!" Others followed: in Robert Armstrong's *Mickey Rat*, Mickey turns a pile of bird shit into a "Magik Kingdom" ride that Disney-goers,

trained to accept anything as a ride, pay him fifty cents a pop to go on.[41] But for *total* engagement with taboo, one looked elsewhere.

If Hieronymus Bosch had come to the Haight at the apex of flower power, he'd have looked like S. Clay Wilson. Savage, offensive, uncompromising, Wilson was arguably the most formative underground artist of the era, the one influencing the influencers. As Crumb said of Wilson:

> The drawings were rough, crazy, lurid, coarse, deeply American, a taint of white-trash degeneracy . . . mayhem, violence, dismemberment, naked women, loose body parts, huge, obscene, sex organs, a nightmare vision of hell-on-earth never so graphically illustrated before in the history of art. After the breakthrough that Wilson had somehow made, I no longer saw any reason to hold back my own depraved id in my work.[42]

Unsurprisingly, Wilson grew up a huge EC fan; more surprisingly, his favorite was a post-Code title, *Piracy*, which proved deeply influential. In an early Wilson comic, a pirate, holding a naked woman beneath her breasts, says, "One more step, mate, and this lassie gets my dirk [*sic*] in her, 'tween her tits, HILT DEEP!!" But this is an air kiss compared to the work he published in *Zap*, when Crumb opened it to the cartoonists who would become known as the "*Zap* Seven": the third issue featured Wilson's "Captain Pissgums and His Pervert Pirates," a case of sodomy and violence on the high seas culminating in an attack of "the dyke pirates off the larboard bow" from their ship, the *Quivering Thigh*.[43]

And that's just the pirates. In Wilson's work, humans and demons (most notably his impishly perverse Checkered Demon), evildoers and innocents, all mixed together in a violent profusion of limbs and genitalia, rendered in gory but intimate detail. Bodies had weight in Wilson's comix. They *sloshed*. Even fifty years later, little protects you from the density of Wilson's visual attack. As Wilson started out, he wrote a note to himself: "Don't water down your whiskey," which meant, to him, "One should push art as far as it can be pushed . . . the artist is only limited by

his imagination." Work for such comix as *Insect Fear*[44] was like *The Fly* on, well, acid, as giant insects assaulted and feasted on two young women, viscera and fluids everywhere.

Artists like Crumb and Wilson were staking out the front lines in what was shaping up to be a culture war. In the winter of 1967–68, *Wonder Wart-Hog*'s Gilbert Shelton produced *Feds 'n' Heads*, whose cover featured a menacing Fed threatening to bash in the Head's hairy skull: the bare-chested, peace-signed, frizzy-haired hippie (also long-nosed, a Shelton signature) threatens to "take this little blue pill and change into PSUPER PSYCHO!"[45] But pill popping wasn't the main bag of the figures featured inside, who, alongside Crumb's Mr. Natural, would become the counterculture's most indelible comics figures. And if drugs were one of the counterculture's central pillars, and pot was the main drug, then Shelton, also a later addition to *Zap*, was its poet laureate.

The Fabulous Furry Freak Brothers—Fat Freddy, Phineas, and Free-wheelin' Frank—first appeared on a flyer for a five-minute University of Texas student film *The Texas Hippies March on the Capitol*. And they were fab indeed, offering a light comic touch often missing in the caustically satiric underground sensibility. (They're sometimes called "the Marx Brothers of comix.") They engage, unusually for the time, in narratively coherent adventures heavy on the accoutrements of classic comedy, slapstick, mistaken identity, and so forth, weathering "The Legendary Dope Famine of '69," getting caught in their own Rube Goldbergesque contraptions to flush their stash, landing in a Mexican prison.[46] But what they do the most is smoke marijuana. As Freewheelin' Frank famously put it, "Grass will carry you through times of no money better than money will carry you through times of no grass." Undergrounder Skip Williamson explored similar territory, albeit in a more caricatured, baroque way, with Snappy Sammy Smoot, who, though not quite square himself, encounters freaks and heads with explosive results: mistaking the word *nark* to mean "friend" while attending a rock concert, the hippies he speaks to scatter, leaving him holding (in Smoot's words) their "medicine and cigarets." He's sentenced to three million years at hard labor.[47]

But to the actual narcs, such figures were *dangerous* (despite much of the joke being how these pathetic figures couldn't possibly pose any peril). The Brothers smoke, threaten to kill a little old lady and rape a young girl, then turn their orgiastic violence upon themselves: at story's end, we discover their murder/suicide is part of *The Truth About the Killer Weed Marijuana*, a cautionary film they've been paid $2,000 to act in.[48] In a mock ad, a nude young woman is postcoitally surrounded by the brothers and comic books. "Oh, wow!" she says. "That was far out! Let's read some more of those and do it again!!" This was the specter of the counterculture to straight America: their nubile young daughters being violated by freaks as a result of those comix—a scuzzy stereotype the underground delighted and indulged in. A 1969 photo of Art Spiegelman by Raeanne Rubenstein features the artist flashing open what the British call a "dirty mac," one hand opening his fly, the other clutching, on the inside of the coat, a page of original comic art—*he* got it.

But the Freak Brothers, drug ambassadors though they might have been, were barking up the wrong tree as far as the medium was concerned: LSD was probably the drug most suited to comics, its hallucinatory and visual effects stimulating creators' visual imagination. Crumb began taking LSD in November 1965 (it wouldn't be illegal until 1968), and though he claimed he never worked while actually on it, just during the "post-fog," it "really opened up the cosmos" to him: "It was the Road to Damascus for me!" Though he turned ambivalent about LSD, as about so much else,[49] his usage was deeply influential on the field.

The trips could lead to expressions of transcendence. A character marooned in space in Larry Welz's "Wyatt Winghead" (a nomenclatural play on a Fantastic Four supporting character) describes an experience clearly akin to tripping: "Faster and faster I streaked through the void . . . my eyes became clear—the cosmos appeared to me as a woman— beautiful and mysterious—she absorbed me into her mind and gave me a vision which I could not at that time comprehend."[50] But the acid mindset could also expand creators' imaginative horizons, and people's minds, on the level of form. Yale-trained *Zap* contributor Victor Moscoso produced

surreal, Escheresque landscapes of figures and shapes. (Though not, like Crumb, while on acid directly: "That's like drawing when you're tumbling down a flight of stairs," he said.)[51] Fellow contributor and surfer comic alum Rick Griffin featured flowing, liquid lines giving the impression of everything melting into waves. Both had been behind many of the psychedelic rock posters defining the era's visual culture: in 1967, Griffin had designed the poster for Pow-Wow: A Gathering of the Tribes for a Human Be-In, inaugurating the Summer of Love.[52] John Thompson's 1969 *Book of Raziel* and *Cyclops Comics* stirred hermetic mysticism, astrology, mythology and folklore, and Rossetti-like paintings into a stirring hippie mix in full-page illos suitable for any hippie pad.

Sometimes, this led to genuine political or cultural self-understanding. In 1971's "When Dreams Collide," a reverend and a hippie girl fall asleep across from each other on a bus; their dreams meld. The reverend has violent fantasies of destroying the counterculture; the hippie, of transcendence and self-empowerment. The two face off: the hippie wins, understanding her dreams can be made real.[53] But sometimes, it just led to addled argle-bargle, visually and verbally. Here's Thompson's word salad on his early-'70s interests: "the process of consciousness in terms of experiential phenomenological knowing. The Kundalini of Tibetan Tantic [sic], the qabbalistic linguistics of ancient hebrew, astrological and alchemal [sic] presentations, shamanistic science, einsteinian definitions of field, electromagnetic gravitation flow of Energy." Crumb's later assessment ("Looking back now at the underground comix of the late 1960s to mid-1970s period, most of them are more or less unreadable, incoherent. The artists were mostly stoned out of their minds")[54] is not entirely incorrect.

And sometimes the trips went south. Dave Sheridan began a story in 1971, "Scrawling out the most twisted of drawings . . . doors open out of nothing, strange visions of alien worlds flash before me and demons of indescribable horror wait in dark recesses for my eyes." The bad trip spoke to a kind of Crumbian skepticism about hippie utopianism, better living through chemistry, and California dreaming. Denis Kitchen's "I Was a

Teen-age . . . Hippie!" speaks of heading to California "to get my head together" after sexual and political awakening, drug taking, and communication breakdown with parents; but San Francisco, presented in the caption as "a groovy scene" with "beautiful people and good heads," is belied by the placid-looking characters' thought balloons, full of suicide, sexual assault, and heroin. Character Kitchen, amidst all this, innocuously says, "Peace!"; writer Kitchen is ironically bemused.[55] Seminal underground artist Kim Deitch got his start with *Sunshine Girl* for the *EVO*—"a nice clean psychedelic strip for the whole family" about a cosmic superhero who despairs of saving the world. Some of the sharpest critiques even dramatized the charge of comics (and drugs) as escapism from necessary political engagement. "Things getting a little HEAVY? Are you hung up? Strung out?" Greg Irons announced in 1969. "*Heavy Tragicomix* [sic] brings you 40 all new doom-ridden pages . . . each one a real bummer." "Feeling a little worse?" he asks at the end. "Well, you'd better get out there and do [something] then, 'cause if *you* don't, aint nobody gonna. Of course, there *is* an alternative. Just roll up another joint."

What lay in those forty pages was a critique of the dehumanization of the individual under rampant capitalism, along with, as one title put it, "The Rape of Mother Earth as Performed by Certain Sinister & Well Known Individuals."[56] Environmentalism was a major component of the undergrounders' politics, in no small part because it spoke to the essential toxicity of the whole system, the culture as poison. George Metzger's *Moondog* featured its title character wandering across the blasted landscape of an America destroyed by "satisfaction made of plastic";[57] Irons and Dave Sheridan's *Slow Death*, its name from "ecology and the slow death that's going on all over the world," featured many stories about "future aliens discovering the burnt out shell of a world once called Earth." *Compost Comics* (1973) even came up with a movement mascot, Larry Todd's Dr. Atomic. (Besides composting, Dr. Atomic devotes an entire comic to proper growing, care, maintenance, stashing techniques, and pipe architecture for something a little more, well, homegrown than LSD.)[58] Irons even prophetically suggested America would deal with

"pollution, disease, massive waste, overpopulation . . . economic, and political strife" by "the construction of a great wall around the entire continental United States. All that was red-white-and-blue (and clean) was to remain inside, and all that was black, brown, yellow (and unclean) would be put outside."[59]

One of the *Zap* Seven took an explicitly ideological stance. When he was twelve years old, Manuel Rodríguez heard neighborhood kids bragging about their Irish ancestry, said Spain was as good as Ireland, and a pen name was born. Like S. Clay Wilson, he was a biker. (Hot rod and dragster magazines, which ran Shelton's Wonder Wart-Hog and work by Griffin, were a superficially surprising home for the underground; although, as Brando's *Wild One* and *Easy Rider* illustrated, there were overlapping alienated sensibilities.)[60] But as a biker in the Road Vultures in Buffalo, Spain helped produce a leaflet, *Youth Against Legal Terrorism*, "about police hassling poor people in general and bikers in particular," and he established the United Cartoon Workers of America, which he tried to affiliate with the IWW.[61] This mixture of leftist sympathy and blue-collar bikerism was, to put it mildly, unusual.

Spain's *Trashman* strips first appeared in the *EVO* in 1967. One strip, depicting a man going down on a woman complete with sound effects, earned the paper its first police bust; quite a distance traveled by a former member of the Captain Marvel fan club.[62] *Trashman* is set in a post–nuclear war North America, "where the enslaver's hand is masked by the guise of law and order . . . thus it will be till men of reason can live together to build a world free of exploiter and exploited. But until that day Trashman must carry on the struggle to . . . FIGHT THE OPPRESSOR."[63] It was pretty clear who the oppressors were to Spain, particularly since another creation, Manning, was a hyper-violent and corrupt cop, a fascist authority cracking down on free spirits (including of the road).

But if Spain was explicit about his political affiliations, most of the undergrounders, like their EC predecessors, satirized and criticized rather than advocating programmatic social change. Dave Geiser's cover to 1971's *Demented Pervert Comix* 1 features a fleeing man in jacket and

tie on the cover, clutching his briefcase: "No never, I'm a responsible intelligent adult—this—this stuff is trash not art—it—it's not right—it's imm—immoral—give me Andrew Wyeth—quick—" But the last word goes to Pete Pervert, addressing the audience on the inside front cover: "But realistically, can anything be really as perverted and demented as the social, economic and political neglect that is present in our society today?"[64] Most underground politics, in other words, focused on the counter rather than the culture. As underground icon Trina Robbins put it, "There was no real politics. Politics was just 'off the pigs.' Most of the underground, I felt, had the political awareness of your average oyster."[65]

This was even true when it came to the ostensible issue of the underground's golden age, from the late '60s to 1974: Vietnam and its presidential architects. A realistic contender for the title of earliest underground comic alongside Griffin's surfing books and the UT Austin cohort was Vaughn Bodé's 1963 war parody *Das Kampf*, featuring strangely childlike cartooning infused with the Nazi military imagery not uncommon among the undergrounds. Bodé's disastrous 1957–58 stint in the military police (he had fainting fits, was sexually harassed by an officer, and deserted, before being declared psychologically unfit to serve) certainly helped generate the antipathy present in the self-published, hundred-copy first print run:[66]

> War is shooting lots of bullets and hand grenades at an enemy guy and finding out it's the company commander all the time. War is when a sniper shoots you in the head and you gots to lie down an' die an' forget about that card game you were gonna . . . have. . . . War is remembering it's some kind of enemy holiday but shooting them anyway. War is getting so scared you go wee-wee. War is selling your gun so you can buy comic books.[67]

The captions would have struck a familiar chord with almost everyone in 1963 America; Charles Schulz's *Happiness Is a Warm Puppy* had been on the best-seller list from December 1962 through October 1963.[68]

Happiness feels like a symbol of American innocence before Kennedy's assassination led to self-reckoning; but *Das Kampf* shows it's not so simple. Given its date of composition, it's unsurprising *Das Kampf* doesn't mention Vietnam; more surprisingly, it doesn't mention Korea, either.[69] Perhaps Bodé wanted to avoid the minimization of his points that topicality might have engendered.

This distancing from specificity was the path frequently taken by DC war comics like *Our Army at War*, *G.I. Combat*, *Our Fighting Forces*, and *Star Spangled War Stories* with regard to Vietnam. Many editors were deeply against the war, but expressed their opposition largely by ending stories with the phrase "Make War No More" and stressing in the letters pages, as Joe Kubert did, that "in the last analysis there are never any victors in war, only losers."[70] Perhaps the most interesting takes in mainstream comics were penned by DC writer Bob Kanigher, in tales of the stolid Sgt. Rock and Easy Company (so called because nothing ever came easy to them) and Enemy Ace. Ace was a World War I fighter pilot—a *German* fighter pilot, a fact arguably too controversial to put on the cover: only a blazing question mark appears, with the words, "Who is the blazing ENEMY we dared not show on the cover? Who? WHO? *WHO*? **WHO?**" By setting Ace stories a half century earlier, though, Kanigher could displace the heat of sentiments like "War is a one-sided game played by Death—a game in which that gaunt figure is the only winner!"[71]

It's true that, seven years after *Das Kampf*, Bodé showed two of his iconic alien lizards, dressed in American camo, standing carelessly over an eviscerated Vietnamese baby.[72] And Shelton's Jesus, in one of his later adventures, is picked up by military police for apparently being AWOL; rendered fit for military service by the doctor, he holds up his hands: "What about these holes?" "Everybody in Vietnam has them."[73] But overall, the underground tone was more general anger and frustration at a fascistic military-industrial-political-cultural complex, being fed a line about war and, indeed, America, rather than the specific war itself. "Raw War Comics," in 1970's *Hydrogen Bomb and Biochemical Warfare Funnies*, showcased their response, by presenting typical war-comic image

and dialogue, interrupted by the protagonist's repeated gory murder. "Jesus! That isn't what's supposed to happen!" the narrator stammers. "God! This isn't in the script at all!" "Shit! Can't even get through a little war story!" "What's this comic strip coming to! Things have gotten completely out of control!" It was that defacement of control, of the narrative, of conventional icons and images, that really turned the comix artists on.[74]

Take, for example, the visual transformations worked on the culture's central representative. Willy Murphy's "Bring Us Together" gives us a platitudinous, bushy-haired, jowly Richard Nixon, deploring the nickname "Tricky Dick," revealed, as successive panels pull back, to be a penis and scrotum. Ed Badajos was one of the president's most vicious visual chroniclers, rendering him as Pinocchio, a heroin junkie, Count Dracula, the end of a policeman's truncheon, and so on. And in the not-so-comic SF parody "Adolf Hitler Funnies," Steve Stiles has a time traveler equip Hitler in his bunker with "a plain old atomic ray cannon"; time shifts to reveal Nixon at the presidential podium, speaking German, behind him a flag with swastikas instead of stars. The final caption: "The more things change, the more they stay the same!"[75]

Certainly, those subscribing to more conventional narrative—say, the artists' Greatest Generation parents—frequently found this downright un-American. In Joel Beck's "Father and Son, 1972," the two generations *try* to bridge their divide, but end up picturing each other as, respectively, a patriotic, flag-waving robot with a swastika button and a caricatured Asian baby wearing a hammer and sickle.[76] But the underground cartoonists, at times with real justification, considered themselves part of a tradition of patriotic protest, challenging America's self-righteous self-image. And as artists, they issued those challenges through imagery. Irons's "Discover America" showed a tall ship sailing across the horizon—a horizon revealed to be a soldier in stars-and-stripes helmet and gas mask. Larry Welz's *Captain Guts: America's Savior!,* a clear Captain America parody, features Fillmore Grinchbottom, "lone defender of the vast silent majority," who ends up accidentally blowing up the Capitol

while attempting to "rid . . . the Earth of that revolutionary scum once and for all so that America may remain free!"

But the American value the undergrounders championed most was, unsurprisingly, freedom of expression. Spain, putting it pungently, said, "Liberty and justice for all should mean you can say what you want. Unless you can show some tangible harm I'm doing somebody, fuck off. That's the battle line I want to be on." What this did, though, was cover a lot of sins in the name of free speech. R. Crumb can answer for many of them. "I think the best way to define" underground comix, he once said, was to talk in terms of "the absolute freedom involved. . . . People forget that that was what it was all about. That was why we did it. We didn't have anybody standing over us saying, 'No, you can't draw this' or 'You can't show that.' We could do whatever we wanted."[77] Which reasonably allows us to judge what it was they wanted to show.

If you were already discomfited earlier in the chapter by the minstrelsy in "Whiteman," you'll be revolted by Crumb's "advertisement" on *Zap* 1's inside back cover, with two corn-fed, chubby white kids shouting, "Hey Mom! Let's have nigger hearts for lunch!" and another minstrel smilingly attesting, "Sho' nuff! Evvabody loves Wildman Sam's Pure Nigger Hearts!" The next issue introduces us to *Zap*'s "dream girl of the month," Angelfood McSpade, who "gots the biggest tits in town . . . an' fahn big laigs . . . an' yo' awt ta trah some mah sweet jellyroll!"[78] Here's one of Crumb's (many) attempts to justify his frequent use of racist imagery:

> Using racist stereotypes, it's boiling over out of my brain, and I just have to draw it! . . . Hey, in my own defense, I am *not* a racist! Come on! I don't consciously believe that any race is inferior to any other race . . . but all this stuff is deeply embedded in our culture and our collective subconscious, and you have to deal with it. It's in me. It's in everybody. It's there! . . . Some people say that the way I play around with it is too rough. It hurts people's feelings. I suppose it does. . . . A perverse part of me likes

to take the heat for all that stuff. Then people can hate me and feel righteously indignant about it, but meanwhile, I've brought it all out in the open.[79]

No one could argue there weren't perverse parts of Crumb. Nor that much of this doubtless feels therapeutic ("Especially when it comes to the really sick stuff, the really twisted stuff, I just have to [put it down in a comic]! If I don't, something gets all chokcd up inside of me," he has said). But is Crumb's decision to *publish* more shock for its own sake, in which case it feels offensively pointless? Or worse? In "Morbid Sense of Humor," Crumb writes, "Even now, as an adult and an eminently respected American cartoonist, I still sometimes find myself *fascinated* by . . . by . . . *psychological sadism* . . . with you, the reader, as victim!!"[80] What's a reader's moral response to—or responsibility for—a self-proclaimed sadistic assault?

It's true even when the satiric stakes are clearer. Dave Geiser's *Uncle Sham* cover shows two "pickaninnies," labeled "Huey and Eldridge," saying "yowser" and "sho-nuf." Inside, a children's book parody: "See the darkies dance and play, dance and play all day. . . . Darkies especially love watermelon. When they are not singing or dancing, darkies are eating watermelon." Yes, there's a twist ending—it's a white supremacist's book, being read to George [Wallace?], who calls it "jest the type of inspirational literature that Black folks children need to grow up to be good Americans," when the real Eldridge and Huey burst in with machine guns and put him up against the wall. But is the payoff worth the racism?[81] And not that it's a competition, but in many underground comics, women come off even worse: objectified to within an inch of their lives—and beyond.

A Freak Brother, at a college library,[82] shouts, "Hey! Where are the fuck books?" A librarian responds, frostily, "What did you say, young man? . . . The library of the state university does not contain any 'fuck books.' The state university will never contain any 'fuck books.'" This would prove untrue, as explicit sexual activity became increasingly present in contemporary cutting-edge literary and pop culture, and in comix,

too. It might have started as early as 1964 with the *Evergreen Review*, which, thanks to the reaction it got from reprinting *Barbarella*, produced an American counterpart, Michael O'Donoghue and Frank Springer's *Adventures of Phoebe Zeit-Geist*, "a socialite brunette who goes through all the kinky ordeals obligatory in a sixties 'girl strip': rape, flagellation, branding, degradation, fellatio, bestiality, and so on *ad nauseam*."[83]

But this was nothing compared to Crumb, Wilson, et al. In Apex Novelties' delicately named 1969 offering *Jiz Comics*,[84] Wilson contributes work under the pseudonym Howard Crankwood, and perhaps no wonder, because it's literal child pornography. In "You've Been Good All Day Fifi," Fifi's reward is to get "a ride before bed," being penetrated while sucking a lollipop.[85] Crumb, in *Ray Finch's 17th Annual Review of Turned On Cuties*, portrays Frannie Frightenedfaun, tearful, covering her genitalia, and "only fourteen years old and so tiny and painfully sensitive!! . . . She instinctively knows how terrible it would be for a big, fat, hard penis to force its way between her tiny petals! What fun! Wouldn't you like to be the first one?!" Grass Green, in *Good Jive Comix*, features a Hobo Hal who gets screwed by the whole family, including blown by a little girl.[86]

Like the earlier Tijuana bibles, the underground's pornographic impulse was frequently parodic; also like the bibles, many of their parodies came from comics. Shelton's Wonder Wart-Hog reappears in *Zap*, but now far more violent and sexually graphic: he not only pulls the head off "Robert Scum, king of the underground cartoonists" and "smut peddler," but nasally rapes Lois Lamebrain with his snout (his genitalia are tiny, it transpires) and discorporates her with a supersneeze. Justin Green's "Soupygoy" (alias Kent Lark, Boy Voyeur) is Superduperman's direct descendant, but the latent has become manifest: here, the superpowered character uses his X-ray vision to look under high school classmates' clothes, various sexual characteristics clearly revealed. "Flashlight Gordon," a parody of the SF strip, has the hero ending up inside a giant vulva.[87] In that *Ray Finch* special, "Miss Lulu Moppet" is an adult pulchritudinous Little Lulu all grown up: " 'Ban the bra!' is the battlecry of Miss

Lulu Moppet. . . . But we'd say this magnificently mammaried militant has her sister suffragettes outranked," the text reads.

Spain, addressing these kinds of images, took the free speech approach: "Some woman complained we had the wrong attitude. And she's right; we do have the wrong attitude. But that doesn't mean we shouldn't be out there and people shouldn't hear what we have to say, see what we have to show." But his 1990 story "The Sexist" is indicative. A woman confronts him: "We don't need your misogynistic rantings. . . . We're not just sex objects here for your pleasure." The sexist's response: "That's because a low life bitch like yourself is clearly unworthy of even touching my dick."[88] That threat of violence simmering beneath his comment isn't merely limited to a character whose titular epithet warns us up front he might be prone to it. This kind of violence toward women's bodies, played for "laughs," permeates the underground.

In Crumb's "Nutsboy" (1969), the character, bored by television, bloodily massacres a pretty girl. "I feel better now . . . got rid of my pent-up hostilities 'n' repressions! . . . An' it's only a comic book, so I can do anything I want!" he says, drooling, holding a severed breast.[89] Wilson's "Lester Gass, the Midnight Misogynist" (1970) features the stringy-looking psychotic fingering the "razor-sharp jack knife in his pocket" (three guesses what that represents), throwing "a whacked-off TIT" at his latest victim; a "rescue demon" simply kibitzes, "Mother of Christ! Didja catch the way that pervert opened her up like a can of beans!" Gass's own death in the end doesn't quite account for the luxuriating joy Wilson takes in the violence against women.

Some of this clearly resulted from anxieties about female power. Spain's Trashman met the violent and sexually rapacious "fighting She-Devils," who had "obviously reversed the whole sexual dominance relationship traditional to our civilization"; his *Mean Bitch Thrills* (1971) featured women soldiers with a mission "to worm out and exterminate the last remnants of that almost extinct species . . . MAN!" And fiction was how they tried to alleviate those anxieties. In 1969's "Lenore Goldberg and Her Girl Commandos," Crumb presented women "from out

of the depths of servitude and oppression, leading the militant wing of the female liberation front," but in his imagining, the action ends with Goldberg on her knees, fellating her partner, with him, hand raised in the air, grinning, "*Viva la revolucion!*" Or, as he put it in a face-front 1971 comic, "A Word to You Feminist Women," after admitting the "heck of a lot of negative feedback" women had given him "is a source of anxiety to me . . . it really is!": "Well, listen, you dumb-assed broads, I'm gonna draw what I fucking well please to draw, and if you don't like it FUCK YOU!!"[90]

These attitudes weren't limited to the *Zap* artists, of course, or the underground.[91] In a 1976 European comics convention booklet, *Beetle Bailey*'s Mort Walker wrote, "The rib that God took from Adam and donated to Eve must not have been a funny bone. From all outward appearances, women don't seem to have one." (Continued criticism of *Bailey*'s Miss Buxley led Walker to self-publish a 1982 book called *Miss Buxley: Sexism in Beetle Bailey?* His position: "I think it's a big tempest in a teapot.")[92] But similar trends of minimalization, marginalization, and exclusion were occurring in the proudly liberal and progressive underground. When many women objected, understandably, to the depictions they saw, they were informed they were unfunny, didn't get the joke, and were engaging in the same censorship that had always kept the comics down.

"I took great offense to that," said Trina Robbins. "It's very hard to be a woman and look at that stuff and not take it personally. In fact, I think it's impossible to not take it personally, and I don't see why we shouldn't take it personally." Robbins, an editor and contributing cartoonist at *EVO*, had moved west for good in 1969 with then-husband Kim Deitch. (She had previously made clothes for David Crosby, Joni Mitchell, and Mama Cass Elliot in LA, then ran a successful clothing boutique in New York called Broccoli.)[93] In San Francisco, Robbins joined the staff of *It Ain't Me Babe,* one of America's first women's liberation newspapers. (She'd met the staff at a Golden Gate Park be-in, wearing a self-designed T-shirt featuring a tough-looking superheroine and the words *Super Sister.*) She soon had a comic strip in the paper's back pages: *Belinda Berkeley*, the tale of "a typical pre-liberation 'Everywoman,'" a college graduate who worked

the second shift along with the first while husband Buzz tried to write the Great American (Sex) Novel, addressing topics like sexist TV advertising and New Left sexism along the way. From her various perches, she had a firsthand look at all the ways women were depicted by and excluded from the burgeoning comix movement.

Grumbling about the *Zap* Seven's unwillingness to allow others to participate in the flagship comic may or may not have been gender-related. But there was certainly merit more generally: notwithstanding the individualist ethos of particular comix, one of the movement's signature features was collective "jams," jointly produced comix, and women were almost never asked to participate.[94] As Robbins put it, "It was simply a club that I was not allowed into. . . . I was never told, never literally told, 'I'm sorry we don't want to consider you because you're a female.' I was simply ignored."[95] And so she and Barbara "Willy" Mendes produced a mag of their own.

＝＝＝

ROBBINS'S INSTANTLY ICONIC COVER for 1970's *It Ain't Me Babe*, the comic book, featured classic female comics characters in strong poses (Little Lulu and Olive Oyl holding up clenched fists), putting readers on notice for uncompromising, powerful stances predicated on female solidarity. "Any resemblance to chauvinist comic characters living or dead is strictly admitted," the copyright notice read. Inside, the book featured empowered "jungle women"[96] and magical sisterhoods. Michele Brand's "Tirade Funnies" was powerfully prosaic, dedicated to the difficulties of being a woman in the world undisturbed. ("Ever try to sit on a bench and read a book? And better just forget about walking in certain parts of town.") But the most gripping story, by the It Ain't Me Babe Basement Collective, has well-known comic characters walking out of their traditional homes (Little Lulu: "Fuck this shit!") and congregating, sharing "tales of outrage." (Petunia Pig: "Being married to Porky kept me isolated from other women. He was able to totally define my reality.") And the action begins: "Accredited women's groups raise money by selling *It Ain't Me*

Babe Comix," says "And Now for a Commercial Announcement" in the back.

The attempt to create their own sphere, limited as it was, started to work. The next year saw *All Girl Thrills,* complete with "God Paper Dolls": "God," a nude Black woman with an Afro and stigmata, could become Krishna; the Son (a more classic Jesus); or a contemporary American mom holding a kid emblazoned "Thou art God" (from Heinlein's *Stranger in a Strange Land*). After *It Ain't Me Babe Comix* had gone through three printings, its publisher, Last Gasp Ecofunnies' Ron Turner, wanted to put out another similar comic, and ten women formed a comix collective— among them Robbins; Lee Marrs, who'd written for *Hi and Lois*; Aline Kominsky; and Terry Richards. In 1972, *Wimmen's Comix* (its title from collective members' continual refrain, "What should we call this women's comic?") made history.[97]

"Inside this issue," suggested the first issue's cover, "Sex, Revelation, Psychotic Adventure, and More . . ." Stan Lee or R. Crumb might have used an exclamation point instead of ellipsis points, but the collective reserved theirs for the inside cover: "Wimmen's Comix are done by women for everyone!" it read. The very next page featured Aline Kominsky's "Goldie: A Neurotic Woman," the tale of a Jewish woman whose self-doubts and body image questions result in poor romantic and sexual choices and, eventually, self-rediscovery, newfound pride, and liberation: "Finally, after 22 years of trying to please other people, I set out to live in my own style!" That style, artistically speaking, was revolutionary both in its "primitive and self-deprecating" form (as Kominsky put it), and in its content, as one of the earliest autobiographical comics.[98] Kominsky's work was flanked by Robbins's brief but groundbreaking "true life comic" of her friend Sandy's coming-out story, based on former roommate Sandra Crumb, Robert's sister, and two Lee Marrs stories that told, with a twisted smile, of negotiating sexism and harassment in the contemporary workplace.[99]

Some feminists were angry with *Wimmen's Comix* because it lacked lesbian contributors at first; some felt it failed to live up to its promises

by maintaining the word *men* in the title spelling. (One piece of hate mail written by Moonbeam, Labyris, and Sparkling Star assumed the collective were actually FBI agents: "You don't even know that the point in respelling 'women' is to get the MEN out of it.") *Ms.* magazine, which had put Wonder Woman on its first cover and suggested she run for president, refused to carry ads for *Wimmen's Comix*. "We have no desire to be an exclusive, divisive, or female chauvinist group," the collective responded in its second issue. "We *do* hope that publication of high quality beginning work will give our wimmen artists a chance to be seen, and a foothold in the industry based on their talents of mind, hand, and eye, rather than the more traditionally requested parts of their anatomy, *and* provide good comic entertainment for *all*."[100]

There were other venues for visibility, too. Two months before *Wimmen's Comix* premiered, a little farther down the coastline, Joyce Farmer and Lyn Chevli had produced *Tits & Clits Comix* in response to similar concerns. As the title suggests, its sensibility is a little more raucously, raunchily comic, closer to complementing the male underground's bodily obsessions. Joyce Sutton's "The Menses Is the Massage!," for example, is a long, complaining, genuinely hilarious monologue about tampons: insufficiently large, too expensive, providing unclear directions in case of heavy flow. (She tries drying them out at a Laundromat, reading comics while doing so: "Hmm . . . does Wonder Woman work during her period?") Other stories are equally funny: a woman, absent a condom in the moment, calls to ask her friend about possibilities, getting so caught up in conversation the man self-gratifies and drifts off to sleep. A woman with vaginal drip navigates physical discomfort, anxiety about her pharmacist knowing her situation, and chafing—figuratively and literally—at medical restrictions on sexual activity.[101] This last was by Chevli, one of the underground's great comic talents.

Tits & Clits and its peers showcased a wide variety of comic sensibility, at times an explicit nod, or response, to the comics produced by their male peers. Teresa (Terry) Richards's *Manhunt!*, in the tradition of *Bizarre Sex*, boasted Richards's self-explanatory "A Hard Man Is Good

to Find . . . Why Did They Always *Wilt* When I Pulled Out My Peter-Meter?" and Lee Marrs's more nuanced "I Wuz a Teenage Intellekshul! or, What Good Are Brains If You Can't Boogie?" *Pandora's Box Comics* parodied Kim Casali and Charles Schulz ("Love is . . ." ". . . Dad fronting the money for your abortion" and ". . . not being criticized by a feminist for wearing blue eye shadow") and Shelton (the Perfectly Permeable Peters Sisters, having "acquired" tampons, dildos, face cream, and wine, toast each other with a slogan "acquired" from the Freaks: "Shoplifting Will Get You Thru Times of No Money Better than Being a Dope Will!"). A later Roberta Gregory story, "Crazy Bitches," had a more confrontational response, depicting women angrily reading R. Crumb; when a husband objects that it's "classic American culture," they bite off his dick, stuff it in his mouth, and then shit on his head. Gregory ends the story: "Don't be alarmed, fellas . . . this is just the ladies letting off steam . . . (heh-heh!)." There was also lighter fare: Marrs's *Pudge, Girl Blimp* focused on a full-figured woman who explored the relationship between sexuality and food and found her virginity to be an annoyance; the chaos rumbling in her wake was expressed in a *Mad*-like crowding of the visual field. "What portends for Pudge?" Marrs asked. "To have her face lifted or consciousness raised? Will she ever see herself as WHOLE PERSON FEMALE? Will she ever get laid?"[102]

Marrs had taken her work to Last Gasp publisher Ron Turner, who said, "Too bad, the women's book is filled." She said, "There's only one women's book?" and started *Pudge*. Several years later, Robbins edited a comic of women's erotic fantasies, *Wet Satin*; Kitchen's Midwestern printer refused to touch it, though he'd printed all the other Krupp Comics titles, including that issue of *Bizarre Sex* with the outer-space vagina cover. When asked the difference here, he said "the predominantly male sex comics were all satires, but that *Wet Satin* #1 was serious, and therefore pornographic."[103] He was wrong on every count but the seriousness: these artists *felt* the importance of using comics to help secure and save womens' bodies. The cover of Farmer and Chevli's 1973 *Abortion Eve* promised "a discussion about . . . the legality of abortion; what to expect

during an abortion; head trips, before and after—and more. . . ." Lead story "The Rap," a conversation on the subject among women from different backgrounds and different ages, opens up wide vistas of experience; "A-Day" takes the reader through that experience in close (yet supportive and comforting) detail.[104] These stories in the women's comics *resonated* in a way many others hadn't, most other underground comics very much included; they were more explicitly autobiographical, in combined confessional and political vein, than almost anything preceding them.

There were some stray exceptions: Sheldon Mayer, who'd discovered *Superman* in the reject pile, had created the semi-autobiographical character Scribbly Jibbet for Dell Comics several decades earlier, in 1936. Scribbly was the portrait of the artist as a young scamp, an embodiment of the necessity to draw even when it makes trouble. Particularly dangerous, it suggested, was putting figures from your life, like your teacher, into your work—reminding future artists, and readers, that autobiography also involves those around you.[105] Several Al Capp panels in a 1946 Red Cross–distributed comic "to boost the spirits of thousands of WWII amputees returning to the USA" told the story of the amputation of his leg.[106] There was an even *earlier* autobiographical comic: in 1931 San Francisco, Henry (Yoshitaka) Kiyama told a tale of four Japanese immigrant students, based, according to an early critique, "on the personal experience of the author, or of his friends." *The Four Students Comic*, requiring knowledge of both Japanese and English to read, describes the students' efforts to Americanize; asked by the store owner he works for to address her as Honorable Madam, "Japanese-style," Charlie replies, "I'll have you know, America is a *democratic* country! . . . I didn't travel 5,000 miles to America to address my equals as 'honorable' anything."[107] It was castigated for being too "journalistic" and too "realistic."

Several decades later, around 1970, WWII veteran Sam Glanzman produced a series of mostly four-page vignettes taken largely from sketchbooks and diaries chronicling his experiences on the destroyer USS *Stevens* between 1943 and 1945. One ends with the artist sketching just-occurred events, to which two of his shipmates react: "Nobody'll read

this stuff! Yeah! You've got to make up stuff . . . like a Superman story or sompin'! You'll never get that inna comics!" "Wanna bet?" the artist-character says, smiling at them, and us, from the last panel. (Perhaps accordingly attuned to human experience, Glanzman's were among the war comics most empathetic to stories of others: "Kamikaze" humanizes the Japanese pilot, who recalls not only the Bushido code but "the pungent smell of sea and wind" of his fishing village; "Color Me Brave!" depicts a Black naval hero prohibited from approaching his ship's guns; in "Toro," a clearly gay soldier—a shipmate says he "acts like a dame"; he's "going stateside for further treatment and perhaps a medical discharge"—dispatches a group of Japanese soldiers and plunges after one to his death, rather than, the story implies, facing the then-seemingly irreconcilable components of his self.)[108]

Glanzman's work appeared around the same time as *It Ain't Me Babe*, about two years before the publication of the most influential auto-biographical comic of the underground era. Justin Green had been an underground regular since the scene's beginning, his material as sex-ually explicit as anyone else's, only often with the, um, personal touch. "Self-Abuse" (1969) noted, "Often, while the dad is bowling or playing poker, puttering around the house or watching TV, the son is masturbat-ing"; a more explicitly autobiographical piece that year in *EVO* told of a sexually disturbing, disappointing, and awkward visit with friends to a burlesque show.[109] Three years later, Green, under the fairly transparent guise Binky Brown, appeared in a work that in many ways set the tone for autobiographical comics-making to the present day.

"O, my readers, the saga of Binky Brown is not intended solely for your entertainment," Green told us, "but also to purge myself of the com-pulsive neurosis which I have served since I officially left Catholicism on Halloween, 1958." Defining his work not just as commercial entertain-ment or collective countercultural happening, Green relocates his work as something for himself, in one of the most important manifestos by a comics creator ever.

Which is not to say he eschewed previous influences. Green described

his childhood self as "fixated on Superboy, as a budding neurotic" and having "a brief fling with Sgt. Rock . . . but it slowly dawned on me that I would never have these highly masculine characteristics."[110] He placed himself, albeit uncomfortably, in conversation with both the underground and the long history of "edifying" comics.

> I daresay many of you aspiring revolutionaries will conclude that instead of focusing on topics which would lend themselves to social issues, I have zeroed in on the petty conflict in my crotch! My justification for undertaking this task is that many others are slaves to their neuroses. Maybe if they read about one neurotic's dilemma in easy-to-understand comic-book format these tormented folks will no longer see themselves as mere food-tubes living in isolation.[111]

It's not just, or perhaps even primarily, the words, but the visuals: Green depicts himself-as-Brown uttering them while hanging upside down, legs bleeding from ankle shackles, wrists bound behind him, pen in mouth—clearly borrowing from the visual iconography of Catholic martyrdom,[112] reminding his readers that as secular as this confession may be, it's Green's religious past that shapes this present. The idea of the past shaping the present is, of course, a cliché, but a cliché that autobiography rests on more strongly than almost any other genre: particularly relevant given the countercultural movement's constantly emphasizing new experiences, revolutions, and ages.

A striking example of how present freedoms are rendered impossible by the constraining past: Binky Brown imagines everything in nature speaking to him. But this potential Aquarian pantheism merely reinforces his neuroses. "Sit on us so we won't get wet! You better protect us or something bad will happen!!" blades of grass shout at young Binky. Why is he so cursed? The comic provides reasons, and, in so doing, reinforces another autobiographical convention, that of causality itself. Here, the oak of personality grows from the acorn of trauma. And Binky has plenty of

acorns: his father showing his penis to young Binky, suggesting a "sword-fight"; nuns' "obsessive way of imposing order, uniformity, rigidity, and obedience"; the malformations of his parochial education ("Believe it or burn!" he recalls). Unsurprisingly—and, in the comic, necessarily—this results in obsessive-compulsive tendencies.[113]

A priest tells Binky in confession, "Ah, my son—stop tormenting yourself! Impure thoughts are not necessarily sinful in themselves. . . . Catholicism is not an exact system of weights and measures." But Binky senses rays of impurity extending from his crotch; his fingers transform into phalluses, as do, eventually, his feet. The phrase "No sin"—malformed, eventually, to "Novatin"—is "silently intoned all day long as a temporary release from guilt-pangs that accompany every other thought." This and other obsessive behaviors are eventually only defeated through a symbolic destruction of Madonna statuary, or, as Green pungently puts it, "turn[ing] off these crazy pecker rays forever [by] blow[ing] up the main power plant."[114] Autobiography is, almost inherently, about qualified victory over the past. Putting it into narrative is, in some way, controlling it; and yet the narrative also controls the artist, defining them in terms of whatever elements they foreground. ("Virtually every incident in the book is allegorical, even though some have a closer foothold in reality," Green said, having noted over one hundred "factual incidents or neurotic habits" on cards as "research.")[115] In some sense, Green is forevermore defined by his self-characterization as OCD sufferer and traumatized product of the Church.

But he has also been defined, by himself and others, as a figure not just turning trauma into autobiography, but personal stories into comics, and an identified brand of comics at that. In a 1973 follow-up, Green presents himself, unsurprisingly self-flagellatingly, surrounded by kids clamoring, "Tell us more stories! Tell us about your pa again! . . . Phil and me want a dirty story!" Comics were the problem, but they were also the solution—but they were also the problem. In 1976, Green wailed, "Damn it! . . . For the past 7 years, I've considered every waking moment and even my dreams as potentially viable cartoons—so my life has become a

relentless comic strip! I wanna get offa this merry-go-round!" And even-
tually he does, following advice to take up a career in sign painting. Of
course, we learn this from a comic: escape had proved impossible. And
not just from personal identity, but from the medium at large: put another
way, comics artists interested in writing their lives were writing lives pro-
foundly shaped by their medium.

Kominsky's early stories of sexual disillusionment, for example,
are often framed as subversions of romance comics' promises and, as
a result, strike a more serious tone than the juvenile pornographies of
romance comic parodies like *Young Lust*. In 1973's "Hard Work and No
Fun," Kominsky's Goldie sits at a drawing table and says, "Heh heh, I'll
just draw myself here with some cute man, sorta power of suggestion.
Then it'll probably happen. After all, life imitates art!" Spiegelman used
autobiographical persona Skeeter Grant to discuss a dream where he was
similar to Happy Hooligan. Spiegelman and Kominsky claimed Brown
as a significant influence; Spiegelman, aptly, moved into Green's San
Francisco apartment just as he was moving out.[116] Spiegelman, along with
several others, produced a "centerfold manifesto" in 1973's *Short Order
Comix*: "It is the Reader's responsibility to understand the Artist. . . . It is
also the Artist's responsibility to understand the Artist! . . . Fantasy must
point one back to reality. . . . Of course, one man's Reality is often another
man's Fantasy! . . . COMICS MUST BE PERSONAL!"[117]

Dave Geiser's 1973 *Saloon* has the author's self-portrait speak from
the inside front cover: "Well, it's all here, and it's all real . . . the story may
seem a little chaotic, and once in a while not make any sense, but . . . that's
life!" But representation of self and world becomes particularly complex
when that representation has been historically caricatured. One of the
very few underground Black artists, Grass Green (who had gotten his
start in fandom, the first prominent Black fan), illustrates the question's
complexities, practically vanishing under caricature in 1972's *Super Soul
Comix*. "I plans ta fix yaw dirty whiteys! Honky bigots, beware!" says Soul
Brother American on the splash page. "The blacks is done got a savior. . . .
ME! . . . 'Fye c'n ever get out f'm unda dis dam LOGO . . ." Inside lies a

more complicated story: "I—I just don't understand it," the protagonist says. "I go to Vietnam and fight for America . . . I come home as a highly decorated hero . . . yet, even with all my learning and qualifications, I can't get a decent job . . . I may's well join 'at gang I met on page 2 . . ."[118]

It says something, perhaps, that one of the underground's only other contemporary treatments of the Black experience, published in 1972 by an ex-con and addressing questions of "prison, black culture, ghetto life, the sex trade, and radical activism," actually lost Grass Green a bet: because, though he figured anyone who wrote so powerfully about Black culture must be Black, he was wrong. After sending back his draft card, Guy Colwell was sent to a minimum-security prison where, in his words, "there were no real harsh consequences for fraternization" between Blacks and whites. There, he was exposed to the *EVO*; one convict held the paper in clenched fist and screamed, "TRASHMAN!" down the row so everyone could hear. Released, he moved to the Bay Area, and *Inner City Romance* 1, featuring a returning con wondering if supporting his friend's drug-dealing plans meant betraying his community, sold fifty thousand copies.[119]

But who was buying? Green told of being "confronted by a disgruntled priest" who said *Binky* was "inappropriate material for kids to see"; when Green explained that "children were not the projected audience for my work, and that the comic form itself was open to experimentation," the priest replied that since comics "had been associated with children's literature for so long, all other motives for publishing my explicit tale should have been outweighed."[120]

The police and the courts were certainly sympathetic to that approach. Yes, avoiding newsstand distribution allowed the undergrounders to sidestep concerns about the Code. But that didn't mean communities were happy about the often pornographic and arguably obscene material on their streets. The public face of this movement, or, perhaps, its two faces, could've been Al Capp, who, feeling "the ground being pulled from under his feet, [went after] longhaired hippies and students." Joan Baez would become Joanie Phoanie, a member of SWINE ("Students Wildly Indignant

About Nearly Everything"). "It's the political spectrum that has shifted, not Al Capp," he said. "They left me, I didn't leave them." Whether true or not is irrelevant; it's hard to grant Capp any high ground, considering he was guilty of serial sexual predation of female college students, charged with indecent exposure and sodomy in 1971 after a visit to the University of Wisconsin–Eau Claire. (He pleaded guilty to "attempted adultery.")[121]

But Capp, stained ambassador as he was, was symptomatic of an attitude. The mid-'70s Supreme Court, in the wake of Kent State, Watts, and Detroit, was comfortable placing its thumb a little more firmly on the scale on the side of communities deciding—communities where all those members of the white "silent majority" lived. Many previous obscenity cases had focused on the display and circulation of problematic items in otherwise innocuous surroundings: the single copy of Ulysses in a neighborhood bookstore, the issue of Crime Does Not Pay on the corner newsstand. But the new comic distribution channel relied on a venue much of the neighborhood found problematic in its essence: the head shop, which to many minds not only sold obscene, blasphemous, defamatory material but (surely) served as a site for drug dealing, the gathering of unsavory characters, and the propagation of vice. Anything to knock it out, or deliver a blow, was desirable.[122]

An employee of Encino's Third Eye Bookstore was busted for selling Zap's second issue, but a county court judge ruled that the strip allegedly rendering the book illegal (an S. Clay Wilson story where one pirate cuts off another's huge penis) wasn't obscene "because it did not arouse one's prurient interests." Zap's fourth issue was something else again. Within a few pages, its Crumb story "Joe Blow" transforms, or descends, from '50s domestic tranquility into all-American incest. "Hey Joe!" says wife Lois. "Are you pretending to watch T.V. even though it's not on??" "Yep!" he replies. "'Cause I can think up better shows than the ones that are on! Ha ha!" And Crumb suggests he believes this is so, though his definition of "better" is . . . well . . .

"That's it! Pretend it's candy!" Joe tells daughter Sis, patting her on the head, to which she replies, engaged, "Yummy nums!"[123] It's that old

underground trick, poking the bear of the squares, taking on cherished myths of home, hearth, and *Father Knows Best*. But in this case, it was more than enough: the police raided Print Mint in September 1969. Owner Don Schenker had been tipped off and moved the stock elsewhere, but booksellers couldn't shift location so easily, and there were arrests for sale and possession nationwide.

In New York, clerks for the East Side Book Store and New Yorker Bookshop were aided by Steven Marks, who testified he would have taught S. Clay Wilson's visions of hell in his class on Dante in a Columbia humanities course had it been out then. Judge Joel Tyler, later to suppress *Deep Throat*, was less impressed: "Merely because the magazine in question does not appeal to the prurient interest of the sophisticated or other small group of intellectuals does not remove it from the prohibition [against obscenity]," he wrote in his opinion. "To do so would permit the substitution of the opinions of defendants' sophisticated and intellectual experts for those of the average person in the contemporary community. . . . The cartoon is ugly, cheap, and degrading. . . . It is a part of the underworld [sic] press . . . and it is not reality or honesty, as they often claim it to be."[124]

This notion of "community standards," as per the Supreme Court's *Miller v. California* decision, was sharpened via a New York State obscenity statute that "a person who promotes obscene material, or possesses the same with intent to promote it in the course of his business, is presumed to do so with knowledge of its content and character." Which meant that if others found it obscene, the vendor could retroactively be fined and jailed unless they could *prove* they didn't know it was obscene. Which affected the financial picture. Head shops, primarily selling "pipes and other marijuana paraphernalia under the guise of tobacco accessories" at higher profit margins than their sideline comic books, didn't want the twin hassles of police pressure and potentially ruinous legal bills for a low-profit item. To make matters worse, financially speaking, other comics creators had seen Print Mint's earnings and rushed into the market; by 1972, there were over three hundred titles in print, creating a glut. (The back cover of Doug Hansen's 1973 *Frezno Funnies* 1 shows a naked

woman firing a submachine gun out of a convertible against a backdrop of burning buildings. She: "Isn't this a bit over-dramatic?" He: "Sure, but it sells comics, don't it?") Thus began the "Crash of '73."[125]

In the end, one of the underground's first stories could have been its most prescient. Joel Beck's *Lenny of Laredo*, drawn in the early '60s and printed in 1965, tells the story of a (very) thinly disguised Lenny Bruce's rise to fame by saying dirty words (which, in the story's satiric vein, are rendered as *poo-poo, pee-pee*, and so forth). Beck envisions an entire world under Lenny's spell, where gray-haired librarians eventually find his shtick just a bit jejeune. Being naughty loses its power, and fades away into obscurity and despair. "WARNING!" the story blares in big letters. "KEEP CENSORSHIP ALIVE!"[126] Otherwise, Beck realized, the work loses its power.

This was the subject of one of Bruce's most famous routines, of course, where he repeated racial epithets over and over for that precise, weakening purpose. But this was to be the fate of the underground. The catalytic reason for its collapse was indeed censorship, not its lack. But its ultimate dissolution would lie in the seeds of its own success: the fact that much of its work—thanks in part to it, thanks in part to much else— could be done elsewhere.

CHAPTER 6

CONVERGENCES AND CONTRACTS

I n 1969, Stan Lee wrote underground publisher Denis Kitchen a letter. In it, the ringleader of the Marvel Universe praised the creator of *Mom's Homemade Comics*: "Dear Den: With a moniker like KITCHEN SINK ENTERPRISES you'd *better* be good—'cause no one's ever gonna forget you! Your mag was really funny—I enjoyed every page." Lee even told Kitchen he envied him, in a way: "It must be a blast to just let yourself go and do whatever tickles your funnybone."

By 1972, according to Kitchen, Lee's envy had turned to something closer to desperation, or, at least, co-optation. "As for the straight comics," he said in an interview, "as long as their circulation continues to decline, they're going to try desperate things, and they've already made attempts to make the books more hip and more relevant. . . . Just a short while ago, Stan Lee called and asked me to edit a book for him that would be semi-underground. . . . I turned it down, primarily because it's a lot more fun to call all the shots on a small scale than to be just another editor in a big operation."[1]

At the time, Lee characterized Kitchen's refusal as a "definite positive negative maybe," which grew closer to yes as the underground's reversals changed Kitchen's prospects substantially. With a second child

on the way, he reconsidered,[2] offering to create and curate a collection of underground-flavored material for Marvel. The reasons for Kitchen's acceptance may seem clear, but how did Lee come to make the offer in the first place? Yes, the decline in circulation Kitchen talked about was real; it had started in 1967, the result of both the *Batman* boom wearing off and comic prices' rise from twelve cents to fifteen, and continued on a downward trend, from thirty million monthly copies in 1971 to twenty-three million in 1974. But finding a solution, as Kitchen put it, in a turn to hipness and relevance? What was *that* about?

As we've seen, "straight comics" had always been political; when last we left the subject, comics were struggling with the nascent civil rights movement.[3] Lee and Kirby's *Black Panther* notwithstanding, the almost all-white status quo was best summed up by Sid Jacobson and Ernie Colón's *Black Comic Book*, which parodied iconic comic strips by simply "applying a gray tint" to characters' skin without changing anything else, resulting in *Superblack*, *Bronzie* (*Blondie*), and *Raisins* (*Peanuts*). But there were signs of change, and the strips led the way.

Charles Schulz had followed his protégé, *Wee Pals*' Morrie Turner, in integrating his own strip in 1968, adding Franklin to the gang in no small part thanks to an exchange of letters with a reader. Black cartoonist Ted Shearer followed Turner with 1970's *Quincy*, about mostly Black kids in an urban setting.[4] That same year, *Beetle Bailey* introduced Lieutenant Flap after being criticized at a meeting at *Ebony* "for having a 'dishonest' [all-white] army" that didn't reflect the contemporary military. (Decades later, Colin Powell reminisced fondly with Walker about the character's first appearance.)[5] *Friday Foster* became the first strip to feature a Black heroine, a globe-trotting fashion photographer. Reception wasn't smooth. *Beetle Bailey* was temporarily suspended not only from Southern papers but the Pacific edition of *Stars and Stripes*—Wisconsin senator William Proxmire had to persuade the paper to reinstate it. Dale Messick included a Black girl in *Brenda Starr*; "the syndicate had her removed in order not to 'offend' readers in the Southern States."[6]

Comic books' attempts at expanding Black representation on the

page were similarly fitful: the Black Owned Communications Alliance ran an early-'70s ad featuring "a young black boy striking a heroic pose in front of a bathroom mirror"—to see a white superhero looking back at him.[7] But there was some movement, especially at Marvel. In 1969, *Spider-Man* had introduced Hobie Brown, who, fired by a racist boss, becomes the supervillain the Prowler; Spider-Man catches him, but doesn't turn him in. (Maybe he was discomfited by how even this quasi-sympathetic portrait came wrapped up in stereotypes of criminality.) The next year, the Falcon, a Black hero, partnered with Captain America; and in 1972, in the wake of the burgeoning Blaxploitation phenomenon, Marvel introduced the first long-running Black lead character, Power Man (his name from the phrase "Just chalk it up to Black power, man"). Like Shaft's, his office was over a movie theater. Iron Fist, the white supporting character, was taken from John Saxon's and Chuck Norris's characters in Bruce Lee movies—but not, apparently, from Bruce Lee himself: an Asian hero displaying Asian martial artistry would appear only the next year, as Shang-Chi, son of Fu Manchu, became (as his comic's title asserted) *Master of Kung Fu.*[8]

In 1973, the year Kitchen finally agreed to work with Lee, Don McGregor, a (white) former military policeman in the national guard who'd been repulsed by the racism he saw on the job, began writing Black Panther stories in *Jungle Action*, a series known for reprinting racist '50s jungle comics. The first issue of his twelve-part "Panther's Rage" contained a map of Wakanda, giving it additional heft—a placeness—rather than simply comprising a collection of jungle clichés. The narrative matched: the Killmonger and "Panther's Rage" stories in *Jungle Action* (and, as of 1977, his own title) featured a Black Panther fascinated by (white) America, symbolized by his Avengers adventuring, while Wakanda, feeling abandoned by their leader, considered chieftain Erik Killmonger's claim to rule. (The 2018 *Black Panther* movie drew heavily on McGregor's work.)[9]

Not that expanding this representation was easy. When two young new DC writers, Marv Wolfman and Len Wein, tried to introduce a Black hero, Jericho, for the Teen Titans around 1969, the company "panicked,

went, 'Oh my God! We're doomed! We'll never sell our magazines in the South, anywhere south of Toledo!' [and] scrapped the issue."[10] But Wein, Wolfman, McGregor, *Legion* wunderkind Jim Shooter, and especially a former journalist named Dennis O'Neil represented a sea change: part of a late-'60s cohort of new arrivals to corporate comics—the first in a long time, since the post-Code '50s had been such a period of industry contraction. In addition, many of DC's first- and second-generation writers—Gardner Fox, Bill Finger, Otto Binder—had departed,[11] leaving a vacuum filled by a small, young group (at the end of 1972, the average age of Marvel's flagship superhero writers was twenty-three) in no small part responsible for innovations shaping comics' next two generations. And one of those innovations related directly to civil rights and political relevance—or "relevance," because the term would soon become a buzzword.

O'Neil had come to DC from a very brief stint at Marvel (Stan Lee asked him not to wear his Legalize Pot button around the office). In his first issue of the *Justice League*, the heroes squabble about taking a particular case, already striking a newly dissonant note. One line sticks: Green Arrow, Batman, and the Atom leave; Green Lantern, Wonder Woman, and Superman stay behind. "Whee-ee-w! What's got into them?!" asks Green Lantern. "I've often wondered if they don't feel a bit . . . well, inferior!" Wonder Woman replies. "I mean, we *do* overshadow them! They're only human and we're . . . *more* than human!"[12] The heroes had been seen as gods before. "There'll Always Be a Superman!" a 1943 comic proclaimed, showing the hero still around two hundred years in the future ("There's still plenty to do, even with wars and crimes out of fashion!").[13] But such *explicit* contemplation of mythic status would become a superhero staple in decades to come.

What attracted real notice, though, was O'Neil's revamp of a low-energy DC title, *Green Lantern*, transforming it into an investigation and indictment of contemporary injustice. "Could a comic book equivalent of the new journalism be possible?" O'Neil said. "What would happen if we put a superhero in a real-life setting dealing with a real-life problem?"

O'Neil, in collaboration with a remarkable new artistic talent named Neal Adams, started off on a low key, thinking, in Adams's words, "In case anybody questioned us, we could say we were trying to be competitive with Marvel."[14] O'Neil had already adopted Marvel's psychologizing of heroes' personal lives. In an earlier *Justice League* story, a doctor's "Id-Actualizer" brings out Green Arrow's evil side: "Underneath, you were always Oliver Queen—much, much more interested in wealth than heroism!" But in making over the book, in part by adding Green Arrow to interior and title, O'Neil and Adams took on contemporary political issues and the politics of heroism, getting to the heart of the iconism and patriotism underlying thirty previous years of comic bookery.

Their most famous example, unsurprisingly a reference to matters of race, marked a conscious move away from the '50s and '60s star-spanning SF. (And, in some ways, into comics' past: O'Neil said his "first glimmering of social consciousness was hearing—as maybe a 6-year old or a 7-year old—Superman on the radio telling me that the difference in skin color was only because of a chemical called melanin and people were all the same.")[15] In the April 1970 issue, an old Black man confronts Green Lantern: "I been readin' about you . . . how you work for the blue skins . . . and on a planet someplace you helped out the orange skins . . . and you done considerable for the purple skins! Only there's skins you never bothered with . . . the *black* skins! I want to know . . . how come?!" At issue's end, Green Arrow suggests, right out of *Easy Rider*,[16] "There's a fine country out there someplace—let's go find it!"[17]

Though rightly hailed as groundbreaking, not all of it worked. Green Lantern and Green Arrow constantly argued, and, as O'Neil later said, "Green Lantern was, in effect, a cop . . . with noble intentions, but still a cop, a crypto-fascist."[18] Green Arrow, on the other hand, was the spokesman for O'Neil's own greater radicalism, and thus always won the argument. One letter to the comic hit it on the head: "Just as I would not have William Buckley write Green Lantern, so too do I object to Mr. O'Neil's opinionated, fustian rhetoric." Sales never picked up, maybe for these aesthetic reasons . . . or maybe because the material rattled people. Like

Wolfman and Wein, O'Neil claimed he'd heard "some of our pro–civil rights stories of the '70s didn't get off the boxcar in certain Southern areas once the magazine wholesaler got wind of what their content was."

And the *nature* of that content, that representation, wasn't always optimal, even when undoubtedly well intended. Hal Jordan objects to potential replacement Green Lantern John Stewart, claiming the Black would-be hero "has a chip on his shoulder the size of the rock of Gibraltar." By issue's end, though, he learns Stewart's heart and mind are excellently suited to the task—but still, his "style turned me off." In 1976, new Legion member Tyroc became the focus of a somewhat muddled attempt at civil rights relevance; while Legion membership definitely displays tolerance bona fides, Tyroc's power, expressed through a series of screams, evokes uncomfortable images of African nativism and otherness.[19] The apotheosis (or nadir) of these well-intentioned attempts was 1970's Lois Lane story "I Am Curious (Black)." The title's reference to the contemporary adult film notwithstanding, it borrowed more from John Howard Griffin's 1961 nonfiction *Black Like Me*; Lane uses a Kryptonian "transformoflux pack" to journalistically investigate life as a Black woman. But, at story's end, she returns to whiteness, liberal bona fides reassured.[20] (Although DC had dodged a much worse bullet: in 1977, its first Black superhero in his own comic, Black Lightning, was introduced to lukewarm reception; but the original, never-published version, the Black Bomber, was a white bigot who turned into a Black hero under stress, thanks to Vietnam-era experiments performed on him.)[21] DC also published the romance story "Full Hands, Empty Heart," in which a doctor and nurse in an interracial relationship were too good for this world, so one had to die.

These explorations of civil rights via white characters of undoubted good intentions underline the fact that the creative talent on all the stories featured above, by both DC and Marvel, were white. There were *some* comics by Black creators. In 1976, an "inner-city, multicultural answer to the homogeneity of Archie comics" presented in Dan DeCarlo style, *Fast Willie Jackson*, appeared briefly; 1980 saw *Lookin' Fine*, a strip chronicling the "comical misadventures of a youth in a black inner-city neighbor-

hood."[22] And in 1981, Turtel Onli, taking a page from Stan Lee, attempted to usher in the "Black Age of Comics," with characters including Nog, the Protector of the Pyramides [sic], Future-Funk, Malcolm-10 (as opposed to X), and Sustah Girl; he created Onli Studios and organized a Black Age of Comics Convention in Chicago. In part due to less polished execution, his work got little purchase.[23] But these were exceptions that proved the rule.

And the problems of workforce diversity and contemporary political relevance were hardly limited to ethnicity. While many male underground artists responded to the feminist movement with depictions of brutal sexual violence, mainstream companies were attempting—awkwardly, gratingly, sometimes sincerely, and largely unsuccessfully—to grapple with the new movement.

Batgirl, originally introduced along with Batwoman to address Wertham's claims that Batman and Robin were gay, got a TV show–inspired update in 1967, complete with mod wardrobe ("her handbag reverses itself to form her specially designed weapons belt"). Fashion notwithstanding, Batman learned "to deal with her as an individual and an equal, rather than the appendage that the earlier incarnations of Bat-females were."[24] Other efforts were (even?) less successful. *Wonder Woman* writers tried situating her in the '60s, with dismal results: "Ha! The new me sure turns 'em on!" she thinks, reflecting corporate wish fulfillment. She loses her powers, then runs a boutique and learns kung fu from a man named (seriously) I Ching.[25] O'Neil's Black Canary was tougher than before, but still under Green Arrow's dominance. Even superpets demonstrated casual sexism. "We may be animals," thinks Streaky, "but we're too gentlemanly to battle girls!"

In 1970, Marvel introduced the Valkyrie, who, along with her "Lady Liberators," dedicated her life "to the downfall of male supremacy," leading female Avengers against the males ("Up against the wall, male chauvinist pigs!" she shouts), and, contemporaneously, an all-female version of S.H.I.E.L.D. called the Femme Force.[26] Still, in 1972, there was at least a brief effort to recruit women as creators; Lee—assuredly remembering a moment in the previous generation in which women had made up the

majority of comics readers—hoped to get a line of "women's comics" going. *Night Nurse*, *Shanna the She-Devil*, and *The Claws of the Cat*, all written by wives or partners of male comics professionals, were each canceled within five issues.[27] Universal Press Syndicate's *Cathy*, with its neurotic, unfulfilled protagonist, started in 1976, along with 1977's comic book nomenclatural feminist Ms. Marvel (tagline: "This Female Fights Back!") and 1978's Spider-Woman; in the latter cases, the characters were designed more to protect trademark claims on the names than out of genuine interest. Trina Robbins diagnosed the problem in 1980: "What [Marvel/DC] need, as far as I'm concerned, to spark up their line is a woman cartoonist doing their female strips. Or a woman writer doing their strips. I mean, that's obvious."[28] Still, thanks in no small part to the Code, the more overt racism and misogyny that characterized large swaths of the underground's output were absent.

If the mainstream lapped the underground with regard to race and gender (the bar wasn't so high), another "relevance" hot spot, the drug conversation, was handled far differently, though its limited contours had wide-ranging consequences. In 1971, Peter Parker's friend Harry Osborn becomes addicted to tranquilizers. Here's Parker on the subject: "Any drug strong enough to give you that kind of trip—can damage your brain—but bad! But how do you warn the kids? How do you reach them? . . . I'd rather face a hundred super-villains than toss it away by getting hooked on hard drugs!—'cause that's one fight you can't win!" If Spider-Man sounds straight (in all senses of the word) out of a PSA, there's a reason: Lee had been asked to publish the story by the National Institutes of Health, which understood comics' reach. The governmental support allowed Lee the comfort to explicitly buck the Code, the first time a major comics company had done it in fifteen years. And the gambit worked: 1971 saw the Code significantly revise its 1954 standards, giving the industry freedom to present nuanced portraits of crime and corrupt institutional authority as part of the medium's role in providing "social commentary and criticism of contemporary life."[29]

DC soon followed in Marvel's footsteps. Several years earlier, the

Legion's Timber Wolf had struggled with drug addiction, but metaphor-ically (via "the Oomarian lotus fruit"); soon after the *Spider-Man* story, though, Green Arrow's sidekick, Speedy, became a junkie, too. They'd apparently had the idea before the *Spider-Man* story came out, but shelved it because of the Code. Afterward, editor Julius Schwartz said, "Do the story, get it done. Goddamn Stan Lee, son of a bitch!" The (Code-approved) story received a letter of commendation from then–New York City mayor John Lindsay, in no small part because of the story's liberal social orien-tation: as Neal Adams, then chairing the board of a Bronx drug rehab center, put it, "Society has to solve these problems, because it's the society that puts people in the position to need drugs."[30]

Schwartz's turnabout showed it wasn't just young Turks willing to embrace "relevance": the old masters did produce some newly relevant works, or attempts. Several years earlier, DC had moved away from its model of editorial fiefdoms, concentrating oversight in a single individ-ual, artist Carmine Infantino. Infantino hired away inker Dick Giordano from Charlton, who brought Steve Ditko with him, among others. In 1968, Ditko created the Hawk and the Dove, two brothers on opposite sides of the culture—but with superpowers! Captain America cocreator Joe Simon had Brother Power, the Geek, described as "a living bundle of rags that purported to tell the truth about the underworld of hippies and 'flower power,'" and a few years later, the utopian Prez, about an eighteen-year-old who becomes president.[31] And in 1970, another icon joined them.

Jack Kirby had finally left Marvel, chafing at matters of credit and cre-ative control, for a multiyear DC contract. The terms: an incredible four titles a month—a suite, to create volume and continuity—one an ongo-ing series with some connection to the rest of DC's operations (*Jimmy Olsen*, until then frequently focused around the character's gimmicky sci-fi transformations, at the time lacking a regular creative team), the other three with then-unprecedented (for the mainstream) total creative control. Kirby, looking to Tolkien readers, who were often themselves counterculture types,[32] mixed that fantastic sensibility with his regular

SF trappings, yielding the so-called Fourth World, featuring the New Gods, Darkseid, Mr. Miracle, and the Forever People. As later comics icon Grant Morrison put it, "It's like someone slipped LSD into Johnny DC's Kool-Aid." That said, these comics were *so* epic, featuring an America turned cosmic flower power metaphor (the first issue of *New Gods* opens, "There came a time when the old gods died! . . . Silence closed upon what had happened. . . . It was this way for an age. . . . Then—there was new light!"), humanity was left behind, leaving many cold. The titles were canceled fairly quickly, and Kirby left DC when his contract ended in 1975. He duly returned to Marvel, where his similarly cosmic series *The Eternals* channeled the popularity of the book and film *Chariots of the Gods?*[33]

Other "relevant" treatments were similarly allegorical. The early '70s had seen a new horror comics boom, complementing the underground's fascination with EC tradition. Some, à la *Mad*, sidestepped the Code entirely by appearing in black-and-white magazine form. Warren Publications had been doing black-and-whites for a decade, using plenty of EC talent and borrowing from the Universal monster movie: 1964's *Creepy* magazine was hosted by Uncle Creepy; in *Eerie*, Cousin Eerie did the honors. (*Vampirella*, from 1969, featuring "a pleasantly healthy and tastefully underdressed vampire from the planet Drakulon" as hostess, spoke to other appetites.) Other publishers followed with titles like *Witches' Tales*, *Ghoul Tales*, *Terror Tales*, *Stark Terror*, and *Horror Tales*. By 1975, almost two dozen black-and-white horror magazines were on sale, many reprinting pre-Code stories. Marvel tried *its* hand at black-and-white horror in 1973–74: *Tales of the Zombie*, *Dracula Lives!*, *Monsters Unleashed*, *Vampire Tales*, and *Haunt of Horror*.[34]

But the 1971 Code revision didn't just impact crime stories: it allowed comic books, not just magazines, to "present once again stories handled in the literary tradition of Edgar Allan Poe, Mary Shelley, and Sir Arthur Conan Doyle whose works are read in schools all over the world." What exactly that meant, no one really knew; but it opened the door to return to that EC tradition, broadly speaking.[35] By 1974, half of Marvel's comics and magazines were monster- and horror-related. *Marvel Chillers* and

Chamber of Chills reprinted old monster stories; newer titles included 1972's *Werewolf by Night*, featuring a teenage werewolf named Jack Russell (ugh), along with the far more artistically successful *The Tomb of Dracula*, thanks to Marv Wolfman's strong characterizations and literary approach, influenced by Stoker's novel, and Gene Colan's shadowy atmospherics. (And, a year after Luke Cage, the title introduced another Black hero: Blade, the vampire hunter.)[36] DC stepped up its horror anthologies, with titles like *Secrets of Sinister House, House of Secrets,* and *House of Mystery* (which boasted strange and silly features on many issues' page 13).[37] At least one critic has argued these titles' quick rise and fall was related to Watergate-era moral ambiguity giving way to the comparatively sunny Gerald Ford; whether one sees 1973's *Son of Satan* or 1974's *Morbius, the Living Vampire* (or 1972's *Ghost Rider*, for that matter) as reflections of the recently resigned president, it's easy to sense a post–revised Code liberation in them, the ability to get out relevant aggressions and anxieties more generally, albeit allegorically.

A more explicit link to domestic politics appeared in two Marvel heroes' identity crises. In a 1970 story, Captain America wondered briefly, "In a world rife with injustice, greed, and endless war, who's to say the rebels are wrong?" but nonetheless ended his musings with: "So I belong to the establishment. I'm not going to knock it. It was the same establishment that gave them a Martin Luther King, a Tolkien, a McLuhan, and a couple of brothers named Kennedy." By 1974, though, the president was revealed to Cap as head of an evil secret empire; disillusionment caused him to give up the cowl temporarily and become the wandering Nomad (although he was his old self again by 1975). That same year, Tony Stark questioned the military's actions in Vietnam and his role in enabling them, turning munitions-making Stark Industries into "peace industries"–focused Stark International.[38]

The loosening of the Code had an additional consequence: combined with Tolkien's growing popularity, it allowed deeply built fantastic worlds to enter comics on a fundamentally new level. The "sword and sorcery" revolution of the '70s, looking back to Robert Howard and

Clark Ashton Smith's pulp work, was led by nostalgist Roy Thomas's 1970 *Conan the Barbarian*, a highly detailed, lyrical fantasy brought to life by Barry Windsor-Smith's artistic genius. Thomas also elevated the minor Howard character Red Sonja to leading-woman status.[39] But all these trends reflected one inescapable fact: the growing recognition of an increasingly mature audience for mainstream comics—mature in the physical, not just ideological, sense.

Iconic comic book characters' storylines were illustrative. Dick Grayson had left stately Wayne Manor for the ivied halls in 1969; Peter Parker was in college, too. Both arrived on campus to find "riots, sit-ins, demonstrations and protest meetings," and related stories torn from the headlines, like Peter Parker's high school frenemy Flash Thompson returning, disillusioned, from Vietnam.[40] But a different seriousness resulted from Grayson's matriculation, one that more subtly placed O'Neil's "relevance" in the service of a kind of comic-history conservatism. Robin's departure didn't only invite newly mature readers to see themselves in age-appropriate characters; it left Batman alone, absent the lightening influence he'd had for three decades, providing the opportunity for darker, grimmer, *adult* stories.

O'Neil had clearly bridled against the camp Batman. In a *Justice League* fight, his opponents actually repeatedly urge him to crack wise, confused and perturbed when he doesn't. Finally, he relents: "If you *insist* I behave like a cornball crime-fighter out of a comic mag. . . . 'Have a knuckle sandwich!'" The fact that it's basically not funny was O'Neil's point: he wanted "to reestablish Batman not only as the best detective in the world, and the best athlete, but also as a dark and frightening creature." O'Neil, such a pulp fan he would write a *Shadow* comic book, returned Batman to his noir and pulp roots, aided immeasurably by Neal Adams's iconic art. Adams's lush, shadowy, three-dimensional style, inspired in part by contemporary cartoon advertising, fit less well with the cartoonish plots of the SF '50s and camp '60s. He'd recently worked on *Deadman*, which mixed past (the Spectre) and present (the Hindu-inspired mysticism of Rama Kushna). But *Deadman* was less an ode to

'60s New Ageyness than an unsettling encounter with empathy and psy-
chology of the other: Deadman can leap into the bodies of others, living
their lives, a set of trial reincarnations, trying to determine his own path.[41]

Adams and others took advantage of a mainstream company cost-
saving device: shifting art board sizes from double the comic page to
150 percent allowed artists to consider the page as a whole more easily,
providing for more possibility to set a mood, a tone, and not just impart
individual image and illustrate narrative. Symptomatically, Adams once
asked to set a *Batman* daytime sequence at night ("Batman is supposed
to be a creature of the night. To have a guy in that outfit walking around
during the day, to me, seems silly"), allowing one of superherodom's
flagship titles to engage with more adult themes. Some of those themes
were also horror-inflected: it was here that the Joker returned to his hom-
icidal, psychotic origins, for example. But it was also where Batman was
(re)introduced as the product of primal trauma. In "No Hope in Crime
Alley," Batman becomes uncontrollably furious, in a four-panel sequence
drawn by Dick Giordano that pulls no punches, when someone pulls a
gun on him at the location of his parents' murder.[42]

This "back to the roots" movement was, in many ways, conservative,
inflected by fan-oriented nostalgia: a product, definitionally, of older fans.
In 1960, Dick Lupoff had published the first issue of the SF fanzine *Xero*,
with an article on Captain Marvel; throughout the '60s, "comics fans and
science fiction fans found more common ground," and one of those com-
monalities was creating increasing numbers of fanzines.[43] Jerry Bails,
one of comic fandom's first members, wrote in his 1972 "Introduction
to Fandom" that "collecting is only one of the main activities of comics
fans. . . . Many fans spend a great deal of time [producing fanzines, and]
new fans, upon seeing a fanzine for the first time, are often seized with
an almost uncontrollable urge to publish their own." In October 1966,
there had been slightly under two hundred fanzines; by October 1971,
over six hundred, some featuring pathbreaking comics scholarship and
almost all of them imparting adult contemplation and valuation to older,
more juvenile-oriented material.[44]

Bails also wrote that the "watermark" of true fandom was corresponding with other fans, and over the last decade, they'd begun congregating in real life. Perhaps the first comics convention was staged in July 1964 by Bernie Bubnis at a New York City union meeting hall, on 14th Street near Broadway, although there are other claimants to the crown; in 1968, Phil Seuling ran the "International Convention" at the Statler-Hilton, expecting a hundred people, getting three hundred. "The next convention drew 700, the next 1,200. The following year, I think it was 1,800—and nobody knew where it would end."[45] Meanwhile, the first "San Diego's Golden State Comic-Con" was held in the basement of the U. S. Grant Hotel in 1970, with three hundred attendees; Jack Kirby was the big guest, along with Ray Bradbury and A. E. van Vogt, befitting the links between SF and comics fandom. The next year, *Superman* actor Kirk Alyn joined eight hundred people; by 1973, it was officially called the San Diego Comic-Con.[46]

Those conventions became hubs for swapping and selling old comics, making markets for them in *monetary* currency. In December 1964, a *New York Times* article entitled "Old Comic Books Soar in Value" suggested World War II–era comics could bring as much as $7.50, sparking similar articles; by 1970, a critic could note that "No. 27 of *Detective Comics*, the issue in which [Batman] makes his first appearance, sells for around $125 if it comes on the market." That same year, Bob Overstreet issued the first edition of his soon-to-be-definitive *Comic Book Price Guide*, creating the very contours of the collectors market; by the late '70s, forty thousand copies of each new edition were being printed.

Perhaps the apotheosis of the early-'70s nostalgia movement took place on Memorial Day weekend 1972 in New York, when most of the EC staff attended the EC Fan Addict Convention (which boasted Kurtzman home movies from 1953).[47] EC was ground zero for the phenomenon: the prior year, Nostalgia Press (note the name) had published *Those Were the Terrible, Shocking, Sensational, Appalling, Forbidden . . . but Simply Wonderful Horror Comics of the 1950s*. That same year, DC licensed rights to Captain Marvel from Fawcett's successor, enabling his reintroduction

(although Marvel had trademarked that name, so he became Shazam). Street & Smith had given way to Condé Nast, and DC paid royalties to them; thus, O'Neil's revived Shadow in 1973 and 1974. Kept in his original setting, the hero was allowed not only to sidestep contemporarily "relevant" debates but give fans that thrill of the past (but new!). Other revivals soon followed: Doc Savage, Conan, Dracula, Plastic Man, and Tarzan.

Marvel, whose fans had skewed slightly older from their start, embraced the nostalgia born of that maturity early on. In an editor's note to Captain America's 1964 reintroduction, Lee wrote, "We sincerely suggest you save this issue! We feel you will treasure it in time to come!" A similar note is struck two issues later: "Caution!! Don't tear this magazine or wrinkle the pages or get food stains on it! We have a hunch you'll want to save it as a collector's item for a long, long time!" As early as 1965, Marvel had issued its first *Collector's Item Classics*; Jonathan Lethem perceptively notes that the '70s featured *many* Marvel reprint titles, along with the compendia of *Origins* and *Son of Origins*, creating a sense of nostalgia and inferred inferiority of contemporary work: "We '70s kids couldn't have been issued a clearer message: we'd missed the party."[48] Marvel, for its part, established early fan Roy Thomas as Marvel's editor in chief in 1972. Thomas, a huge Golden Age comics fan, would write the World War II–set series *The Invaders*, a "return to the past" that felt like a departure for Marvel: the Now had become the Then.

Paradoxical, perhaps: a mature audience making nostalgic turns inward, open to new creative possibility. But Lee saw opportunity. Business changes helped; not just the loosening of the Code, but corporate transitions. In the fall of 1968, Martin Goodman had sold Marvel to Perfect Film and Chemical Corporation, which changed its name to Cadence Industries. (DC, around the same time, was acquired by the Kinney Corporation, owner of parking lots and funeral parlors; it subsequently acquired Warner Brothers, whose name it took as its own.) Soon after, Goodman retired, and Lee became publisher in September 1972, providing him not only creative but greater business control, and therefore more room for experimentation.[49] And so, seeing his readership's increasing

age, doing his market research, and understanding the underground's sales reach, Lee decided to invite them back toward the mainstream.

═══

IN A 1974 KITCHEN COMIC, Lee appears as tiger-smiling J. Jonah Jameson, lighting money on fire with his cigar. "I want to try my hand at some of this 'underground' stuff," he says. "I have a script for a dope-fiend anti-hero & his bare-breasted side kick that I want you to have Crumb pencil and [Marvel Bullpen figure] Artie Simek ink." Lee himself claimed he wanted "a magazine that *looked* like an underground comic and even *read* somewhat like an underground comic—but wasn't as totally outrageous or sexy as an underground comic! . . . [I] felt I had a responsibility to our company and our younger readers."[50] He eventually appeared on the masthead only as "Instigator." But Lee's instigations mattered. His agreement to publish *Comix Book* in magazine format allowed it to circumvent the Code; his acquiescence to Kitchen's insistence that original art be returned to the artist was a first for Marvel; and most important, his agreement to grant artists the copyrights to their material was a huge symbol of underground business styles making their way toward the mainstream.[51] (Also, Kitchen was allowed to edit the book from Wisconsin, preserving his autonomy and serving as a very early harbinger of the decline of mainstream comics' New York base.)

Comix Book featured underground stalwarts like Deitch, Wilson, Marrs, and Robbins (whose "Wonder Person Gets Knocked Up" features Mary Marvel and Sheena forming their own child-care co-op). Justin Green's five-part "We Fellow Traveleers" was an allegorical *Pilgrim's Progress* about the character Neurosis encountering a Cuss-Cross on his way toward fulfillment. Kitchen also pushed to include Art Spiegelman's autobiographical "Prisoner of the Hell Planet," a brief reflection on Spiegelman's mother's suicide and his subsequent mental breakdown, urging Lee, "Although it is very serious, even depressing, in mood, it is a prime example of how effective a medium comic art can be." Despite worrying it was "too heavy" for the book,[52] which was marketed quite differently—

with the tagline "It's new! It's strange! It's subterranean!"—Lee agreed to keep it in.

Kitchen described *Comix Book* in 1974 as "an experiment to determine if there is a mass audience for underground cartoonists, or whether they are, by definition, limited to cult followings." Lee gave it an initial print run of two hundred thousand, larger than even the largest underground printings. It never quite took off; there was pushback from some undergrounders, most notably Bill Griffith, and Spiegelman stopped contributing after disliking some work he was appearing next to, particularly Howard Cruse's *Barefootz* strips. In 1973's "Mr. Toad and the Great Underground Comic Book Crisis," Griffith's character returns to San Francisco to find the artist collapsed over his drawing table. "Th' industry's on it's last legs!! People aren't buying—publishers aren't publishing . . . it's . . . the end . . . ," Griffith gasps. Toad grabs him painfully by the arm. "Don't gimme that crap! You guys just gotta pick up th' pieces yourselves an' start over! . . . The best is yet to come!!"

And so, Griffith and Spiegelman tried starting their own magazine, a quarterly for the newsstands—Spiegelman calling it "a lifeboat for the best of the San Francisco–based cartoonists." In *Arcade*'s first issue, in spring 1975, the duo depict themselves at a San Francisco carnival shooting gallery. Spiegelman says *Arcade* will be "a comics magazine for adults!" Both chorus: "We've got humor! Satire! Pulp adventure! Slices of life!! Experimentation! And irrational behavior!" *Arcade* boasted high production values, full copyright, a $50 page rate (half what Marvel offered, but still very good for the underground), and limited invitations. As Robbins put it, "There was the Clique . . . and then there was the Rest of Us. The only women they published were their girlfriends, to whom they magnanimously gave half a page. I was never invited into any of their books." (Spiegelman, for his part: "We were really eager to find women cartoonists whose work we could support, and we just generally didn't care for the work. I don't think it was motivated by male chauvinism, although it might have been on some level.")[53]

Spain and Crumb illustrated Paul Krassner pieces on Timothy Leary

and Lenny Bruce, Wilson illustrated William Burroughs, and Green adapted classic literature in "Classics Crucified," a not unreasonable characterization of what he did. Perhaps most notably, Diane Noomin published several stories about DiDi Glitz, "an exorcism of and a wallowing in my Canarsie roots," who originated as a 1973 Halloween costume and whose stories told of "life in the Bagel Belt." *Arcade* also indulged nostalgia, with deep dives into comics history, reprints of Tijuana funnies, and cartoons by Milt Gross and George McManus. It was a next-generation *Help!*, and, unsurprisingly, Kurtzman himself called the first issue "a knockout."[54] Like *Help!*, it was highly influential and never really took off, shuttering the next year.

Kurtzman, godfather to the revolutionary satirists but also product of mainstream corporate companies, was lionized by the undergrounders, and returned the favor: he'd written Kitchen, in the same issue of *Mom's Homemade Comics* Lee did, that "the underground comic book is becoming a phenomenon to be reckoned with." "I'm tortured by the same devils. I identify with them," he said, devoting considerable space to comix in his history of the medium. In June 1970, he even appeared with Shelton and Spiegelman at a Goddard College "comics seminar." Although *seminar* may not be the right word: *Saturday Mindfuckee Funnies* was more of a "two-hundred person discussion group [including] a multi-couple fuck-in in the center of the floor, a selection of moderately good dope being passed around, and the like."[55] In 1978, Spain, Shelton, and Wilson made a pilgrimage to see him at Comic-Con, one of the first times undergrounders attended: in a way Lee never managed, Kurtzman was able to serve as a very tentative symbol that could unite disparate corners of the medium.

As was Will Eisner. Eisner had capitalized on his wartime work, and the potential he'd seen in it, by forming the American Visuals Corporation to produce educational and corporate comics. Through 1972, he was a creature of the military-industrial complex, drawing and producing educational comics on "preventive maintenance" for the military; characters like Joe Dope (as in "giving the straight," not foolish) and the Eisner femme fatale repurposed as mechanic/pinup Connie Rodd appeared

in *P.S.* magazine, running 227 issues over two decades.[56] Artistic hero-worship prevailing over ideological purity, Eisner's interests in the underground, both commercial and aesthetic ("My God, I said to myself, they are using this new medium as a true literary/art form. So I got caught up in that"), were reciprocated. Kitchen reprinted *The Spirit*; Eisner not only did new covers and stories but produced a 1972 cover for Kitchen's *Snarf*, featuring the Spirit contemplating a bunch of comix longhairs name-checking Crumb. (He visited underground comics' first convention, in Berkeley in 1973, to promote it.)[57]

Mainstream comics creators were watching the underground, too, noting the economic possibilities. In 1972, Neal Adams said, "There's a lot of soul searching going on these days by artists whether or not they should plug along doing straight comics, or getting rich doing undergrounds. I don't know, undergrounds look pretty good, folks." (That same year, Adams's work appeared in the similar-sensibility *National Lampoon*; the lapsed Catholic illustrated the adventures of Son-O'-God, a thirty-year-old nebbish who, uttering the magic word *Jee-zuz*, becomes "a long-haired, rock-muscled superhero charged with defending all that is decent about white Protestant America.") By 1974, those creators were scrutinizing Lee's experiments in particular, and less the aesthetic ones than the economic ones. Before *Comix Book* was killed, Kitchen heard that Marvel employees were mindful of, and upset by, the difference between their deals and rights and the *Comix Book* contributors'.[58] And unsurprisingly, they tried some new experiments as a result.

Adams tried forming a guild to try to change working conditions at the Big Two; when it failed, he decided to form his own independent studio, which also sputtered. Comics writer Mike Friedrich took up Kitchen on his 1972 prophecy that "the underground comix are going to become more traditional and the straight comics are going to be more underground, and there's going to be some point in between where there isn't going to be much difference" by creating a mid-'70s company that described itself as "the unique synthesis of underground and overground . . . Ground Level Comics."[59] "Imagine if you were going to start a comics company

from scratch," an ad for Star*Reach read. "What would you do? First, I'll cut the artists and writers in on the action, and give them more creative freedom, so they'll be motivated to do their best work . . . then, I'll do comics for grown-ups; stories with insight and intelligence, art with excitement and sensitivity . . . I'll make comics fun again!"[60] Star*Reach's flagship title published a graphic adaptation of Michael Moorcock's *Elric*, following in *Conan*'s footsteps, and put out a funny animal magazine, *Quack!*, to use childhood conceits "in entertaining and perhaps enlightening grown-up stories."

But Marvel, letting its freak flag fly a bit, had already taken a significant web-footed step in this direction: Steve Gerber's *Howard the Duck*, a self-educated, philosophizing, universe-saving, um, duck from an alternate-dimensional reality, who ended up, as the comic put it, "Trapped in a World He Never Made!" (That world, by the way, centered around Cleveland.) The cigar-chomping duck gained a cult following; Howard even ran for president in 1976, his campaign covered by the *New York Times* and *Washington Post*. "In this bicentennial bummer of a year," Marvel stated, they backed the "candidate who has no vested interests, owes no favors, and believes all hairless apes were created equal!" (Various Marvel heroes provided testimonials: "Hulk likes little duck! Duck is Hulk's friend! Vote for duck or Hulk will smash your face!")[61]

Howard's impact was less notable for its delightful weirdness—although with a mad financial wizard antagonist named Pro Rata, the weirdness was indeed delightful—than for what it represented creatively. Gerber, sounding like an undergrounder—or, more, Will Eisner—characterized Howard as "that rarest of birds among mainstream comics: a personal creation" and a departure "from the standard form of comic book storytelling—of what can constitute a comic book, what it can do, what it can say, and what it can mean." The title's sixteenth issue, due to deadline pressure, is almost entirely a Gerber text piece about his comics writing in the form of a discussion between him and Howard, only much weirder than that.[62] But when all was said and done, Howard the Duck still belonged to, and was of, Marvel, a 1980 Gerber lawsuit notwithstand-

ing; and it turned out that the personal creation of another funny animal artist (and Star*Reach alumnus), and *its* formal departure from the medium's standards, would have a far more significant effect.

Dave Sim had produced stories for *Quack!* about beavers ruminating on Canadianness and comic books. ("I mean, the idea of a duck in the world of humans would kill me even if the story *wasn't* funny . . . but where's the empathy?") He began his own series poking fun at sword-and-sorcery comics' solemnities by a simple expedient that probably wouldn't have occurred to anyone else: creating a deadly, hyper-efficient, sword-wielding aardvark at his narrative's center. "An earth-pig born," as Cerebus often presented himself; the name came from misremembering the spelling of Hades's three-headed canine guardian.[63] Though hailed early on as "a true heir to Carl Barks's duck stories," Sim's parody would've quickly worn thin. But within a year or two, he'd changed his approach, thanks to a plan hatched during a hospital stint in 1979: to produce three hundred issues of a comic "as one continuous story documenting the ups and downs of a character's life." "Once I did that," he said, he felt he couldn't "just do single-issue stories." In 1980, after going monthly, he warned his fans, "I'm still trying to keep each issue as an entity unto itself, but I'm playing up the issue-to-issue plot threads as well since there's not as long a wait between books."[64]

This proved an understatement. Sim's long-running stories, often lasting a year or two, delved into his invented worlds, engaging so deeply with local politics or religious bureaucracies, you begin to forget these were not, actually, real places. Back in a 1972 university lecture, Jack Kirby had suggested the comic book was the wrong forum for relevance because of its length: "Because of the restrictive nature of its own format, a comic book cannot do a definitive analysis of a given issue. . . . They should have done a bigger *Green Lantern*, a book of say 200 to 250 pages. That would tell a really good story on any given issue, and it would have meant something." (Lee, on the same panel, disagreed.)[65] Sim's work over the next years served to buttress Kirby's arguments. The "High Society" narrative, for example, which runs to 512 pages, has its share

of the comic's original parodic sensibility: one main character is a clear double of Groucho Marx (his name, Lord Julius, further evidence), and the homage makes it clear Cerebus's Iest has elements of Freedonia mixed in with Conan's Cimmeria. The satire is deepened by Sim's ability to play out the complex machinations of high politics, where a prime ministership is largely for sale and to the victor belong the spoils of war. "High Society" took two years to play out, and if Cerebus ends mostly back where he's begun (as the Marx Brothers often do), it's not for lack of richness revealed along the way.[66]

Keeping the issues in print was a problem; but, as Sim said, it was "necessary to keep them in print to build up the readership." So, he began packaging his comics together in thick volumes (often dubbed "telephone books"), available through his company, Aardvark-Vanaheim, the latter a word for heaven in Norse mythology. "There's no question that reading a single issue of Cerebus is not likely to convince someone to buy the book regularly," he said. "But I figure let someone read ten issues in a row and I might as well be pushing heroin." Sim's efforts weathered distributor problems, cease-and-desist letters from other comics companies for his parodies of their characters, a public and bitter divorce with then–publisher and partner Deni Loubert, and, most notably, his outspoken and repeated misogynistic statements, both inside and outside *Cerebus*, to finish his tale in 2004.[67] But Sim's ambition, the maturity of his stories, his self-publishing, and his book packaging all helped set a trail the industry would follow.

The popular high-fantasy genre served as the jumping-off point for another milestone of converging methods, materials, and mores. Wendy and Richard Pini, who'd met via an exchange of letters in *Silver Surfer* 5, were extremely active in the developing fandom circles intersecting between high fantasy, SF, and comicdom. Wendy Pini had done illustrations for SF magazines, but was perhaps better known at the conventions for her cosplay, another SF-con innovation that went on to robust life in comicdom. (Her Red Sonja stainless-steel chain-mail bra and bikini bottom weighed ten pounds.)[68] The Pinis created a comic that infused

fantasy tropes with a warm, loving eros largely absent from Tolkien. Like the underground, there was sex (nothing graphic, but erotic), dreamberries, and occasional music. Also like the underground, it was invested with autobiographical energy, even if not always obviously so. *Elfquest*, about an elven band seeking a new home after exile, is about the search for connection in every sense, including the artistic. (Wendy said many of *Elfquest*'s incidents "are symbolic representations of things that have happened to me or me and Richard.") Like Sim, the Pinis created their own company to distribute *Elfquest*; creator-owned, it was answerable to no one. Or, as they put it, "We can do whatever we damn well please, but Marvel has a mythos to stick to."[69] *Elfquest*'s 1978 appearance was met with wonder and not a little condescension. "*This* from a young woman whose major claim to fame heretofore was going to comic conventions in a chain mail bikini?" said one critic, simultaneously referring to it as "the most gorgeous thing I've seen come out of comics fandom in the eleven years I've been here," its quality and level of detail of world-building particularly praised.[70]

Fantasy wasn't the only genre in which this new convergence flourished. Star*Reach had delved into space opera: *enfant terrible* Howard Chaykin's "Cody Starbuck" (1974) was a kind of male Barbarella meets Douglas Fairbanks. That same year, longtime comics professional Jack Katz (he'd worked in the Iger shop) started *The First Kingdom*, mixing the '30s adventure strips of his youth, particularly *Tarzan* and *Flash Gordon*, with more than a dash of H. G. Wells and Olaf Stapledon by way of Greek mythology. *Kingdom* is occasionally woolly, given to pontificating about life force, the human drive for adventure and purpose, and the eternal pattern of human endeavor via its premise of a postapocalyptic society stocked with gods and monsters. But it is, unquestionably, a planned, long-term endeavor, plots set in motion years in advance. Katz structured the work to comprise precisely twenty-four books, in emulation of Homer's epics.[71]

Mainstream creators followed these epic, cosmic turns, and were given increasing latitude to do so. In 1975, Jim Starlin's *Warlock* saga

featured a mighty purple-skinned alien, Thanos, would-be lover of a personified Death.[72] (A later Starlin *Warlock* treatment featured Thanos acquiring the Infinity Gauntlet to please Death by eliminating half the universe; this plot, altered, became the basis for Marvel's movie slate in the 2010s.) Around that time, *Howard the Duck* creator Steve Gerber further developed a bunch of misfits called the Guardians of the Galaxy; and at DC, Mike Grell, off a highly regarded stint drawing *Legion*, was allowed to write his own comic, an epic fantasy called *Warlord*, and was given rare leeway over the book's direction, in a manner similar to Sim and the Pinis. (Grell's wife, Sharon, handled a lot of the writing, uncredited, in later years.)

But when mainstream and ground-level creators looked at the underground, they saw not only political relevance, or genre creation as personal statement, or even the creator-owned business model. They also saw the medium's capacity for autobiographical expression plainly put. And at that time and place, around the Bicentennial, that meant going back to where the superhero revolution began: Superman's birthplace, Cleveland. This time, to a file clerk in a veterans' hospital.

IF SAM GLANZMAN'S Greatest Generation soldier stories bore personal witness to extraordinary times, and Green's and Kominsky's suggested the artist's extraordinary (neurotic) character, Harvey Pekar was firmly dedicated to the idea that extraordinariness, of any sort, wasn't his bag. He didn't think he was special—or, at least, he didn't claim to be ("More Depressing Stories from Harvey Pekar's Hum-Drum Life," read the cover of his comic's second issue). He didn't think his life circumstances were anything much. But they were his, and he wanted to record them. "I think that the so-called average person exhibits a great deal of heroism getting through an ordinary day," he said, "and yet the reading public takes this heroism for granted."[73] Thus, the ironically titled *American Splendor*, debuting in a year when America was both celebrating its history and plagued with self-doubt about its future.[74]

Since Pekar couldn't draw, he *hondled* artists into drawing for him. (Pekar was a hustler, too, in a certain aggrieved, Americanist way.)[75] Pekar chose his artists carefully for visual styles befitting particular stories, storyboarded them, and reviewed roughs and pencil versions. It would've failed, but for two things. The first, which attracted the most notice initially, was that one of his earliest artists was old acquaintance/1962–1966 neighbor/friend/fellow jazz obsessive/fellow Clevelander Robert Crumb, then near the height of his influence and fame. (Although, as Pekar says, he "wasn't doing much work" at the time, since undergrounds had lost much of their popularity.)[76]

But the second was that, despite his protestations, Pekar *was* an extraordinary voice. "All you get from Pekar is . . . real life," Crumb says in an introduction to their collaborations. (Pekar himself wrote: "As a kid I used to read the kind of escapist comics and science fiction books that most comic fans devour. However, after a while I tired of them. They contained the clichés of genre writing and did not relate to my life.")[77] His pacing, structure, the flow of his words, the exquisitely observed characters—particularly himself—meshed not only with the new Hollywood's increased interest in anti–leading man protagonists but with the anti-comic comedy sensibility championed most notably by David Letterman, on whose show Pekar appeared multiple times. Among a certain set of cognoscenti who hadn't read comics since they were kids, Pekar was probably the most famous cartoonist they knew of. Not, as he frequently reminded Letterman in increasingly acid exchanges, that it paid the bills.

Other characters recur in *American Splendor*: his Black friend and colleague Rollins, and Doctor Gesundheit, who sometimes tells Harvey stories about Jewish life and folklore. (An ambivalent but strong affiliation with Jewishness recurred throughout Pekar's career.)[78] Later, he even turned the comic over to other voices. But his aim, in the end, is self-understanding: in his book-length depiction of unsympathetic character Michael Malice, Pekar notes that to "compare [his history] to one's own can lead to incidents of self-discovery." "I don't think I make myself out to

be more of a shit in these stories than most people actually are," he said, "although I guess I look like more of a shit than they'll admit to being."[79]

Pekar wasn't the only figure discussing life, work, and sex from an adult, personal perspective. Some were directly or quasi-autobiographical: *Wimmen's Comix* was still publishing, and creators like Melinda Gebbie, Debbie Holland, and Simone Bressler were telling stories of sex, relationships, and reproductive rights. Some were not: in 1974, *Doonesbury* character Joanie Caucus matriculated at Berkeley's law school; in 1977, Trudeau gave her "graduation's" actual commencement address (facing an empty seat for her up front, complete with mortarboard). Some were even something close to novelistic, in ambit at least. In 1973, *National Lampoon*, of all places, ran a strip by Byron Preiss and Ralph Reese: "Just 52 weeks from today, the characters introduced here will TERMINATE their relationship. . . . This, then, is the ignominious beginning of a . . . ONE YEAR AFFAIR," it began. Given publishing's propensities, this "microcosm of the state of romance among young adults in the early seventies" took three years to tell, but the story was told, from meet-cute beginning (Steve picks up Jill's dropped box of Tampax), to their friendship becoming something more (the comic pulls the bedroom shutters down, literally), to the strains that cracked the relationship (a pregnancy scare, a mother's drinking problem), to reconciliations and, most importantly, a conclusion that seems, given the strip's title, only appropriate.[80]

Preiss, one of comics' great entrepreneurial experimentalists, was also a prolific SF book packager, and in 1976, he produced a volume of his *Fiction Illustrated* line called *Starfawn*, featuring "a starship named Destiny . . . a fantastic multi-national crew . . . and the woman known as—Starfawn!" Preiss wanted it known that *Starfawn* was "*not* a *Star Trek* ripoff" (though he may not have informed his cover, which describes it as "in the *Star Trek* tradition"). But Preiss, trying to prove his point, cites three upcoming movies in his introduction: *Logan's Run*, *Dune*, and something he calls *The Space Wars*. That last underwent a name change; and, when released the following year under new title *Star Wars*, transformed both the film industry and the world of comics. George Lucas

said he owed a debt to the "fantasies of Alex Raymond," which showed "remarkable cinematic dimension"; he'd also loved EC comics, especially Al Williamson's SF work. (Many saw similarities to Kirby's Fourth World stories, too, which featured Mark Moonrider, Darkseid, and the Source.) The comic book adaptation, while perhaps overly faithful at the expense of dynamism, was a commercial bonanza: the first comic to sell a million copies in thirty years, it helped keep Marvel afloat during late-'70s aesthetic and commercial doldrums. (Howard Chaykin, who drew many of the early issues, got page rate.) It sparked a *Star Wars* newspaper strip (art by Williamson), a *Howard the Duck* parody ("Star Waaugh"), a Will Eisner gag paperback (*Star Jaws*, also lampooning the era's other big movie). Even S. Clay Wilson's Checkered Demon headed off to space for a series of obscene adventures in 1978.[81]

Other SF movie adaptations would follow toward the end of the decade.[82] *Alien*, by Archie Goodwin and Walter Simonson, has strikingly adult aspects, given the R-rated original material; it was the first comic to appear on the *New York Times* best-seller list. And, in 1978, Superman fought Muhammad Ali to save the world from aliens. (Neal Adams's artwork needed approval not only by Ali's people but also Elijah Muhammad, Ali's guide at the time.) Although excoriated for its plot and rank commercialism (the *Star Wars* adaptation was mentioned), Adams pointed out that at seventy-two coherent pages, it felt more like a short novel, rather than "a series of incidents. . . . I feel that the industry has not done short novels or stories for a long time in most cases."[83]

Paradoxically, Adams may have been feeling that most keenly *precisely because* the idea was increasingly in the air. A decade earlier, Gil Kane and writer Archie Goodwin had taken the Sterankoesque James Bond–type comic into new, pulpily violent territory, formally creating something more than an illustrated novel, a little less than full integration of text and image. But 1968's *His Name Is . . . Savage* had distribution problems, and Kane's Bantam follow-up, the postapocalyptic SF-fantasy hybrid *Blackmark*, had its plug pulled in 1971 after the first of eight projected volumes. The successful volumes of comics on mid- to late-'70s

bookshelves were, say, 1977's Pocket Books collections of early *Spider-Man* and *Fantastic Four* issues, or Lee-edited anthologies like *Son of Origins* and *Bring on the Bad Guys*—more of the same. Looking back and around in 1977, Kane said, "I think . . . comics [have to] go on appealing to people as they grow up with them, instead of stopping at a certain point and having people grow out of comics."[84]

Preiss was doing his part. In 1976, he'd worked with Steranko on *Chandler*, which he called a "visual novel" and "film on paper—the graphic story's answer to the classic private eye films of the 40s." Then he teamed with iconic SF writer Samuel R. Delany and artist Howard Chaykin to create another. *Empire*, while lacking both the visual richness of Delany's best prose and the dynamism of Chaykin's later creations, was nonetheless, as Preiss claimed, "another step forward in the evolution of the graphic story as an intelligent medium for the development of fiction about our world." Other classic SF adaptations followed, though critics argued Preiss butchered the editing and never meshed the words and images, rendering them more illustrated novels than comics.[85] Whatever arguments one could make about the genre's juvenility, these works, like *Cerebus* and *Elfquest*, were unquestionably aimed at adult readership, once more translating genre staples into new genre forms.

And then this, alongside a discussion of Preiss's forthcoming *Illustrated Harlan Ellison*: "*A Covenant with God and Other Tenement Stories* is a project Will Eisner has been working on for two years now; it is printed in sepia tone and contains four stories concerning life in the New York tenements in the 1930s."[86]

In 1969, Eisner, contemplating Gil Kane's failure, noted, "I believe he's got the right idea. . . . But I suspect . . . that people haven't the patience to read that long. . . . Now the idea in doing a novel in comic form is not new and it's not novel, but it's how you do it. . . . There's nothing wrong with words; except the words aren't used properly here." Eisner had long been familiar with Lynd Ward's "wordless novels"; and in the years since the interview, though he wasn't following mainstream comics closely, he'd had contact with the underground, and its autobiographi-

cal sensibility, writ personal and national. Kominsky's confessionals, the old neighborhood meets O'Neillesque dreamers and searchers of Dave Geiser's *Saloon*: maybe he knew these, maybe not. Maybe he'd seen Phil Yeh's stand-alone book adventures of Tibetan hippie Cazco, created in 1972 while at Cal State Long Beach, referred to by the author as "novels" and explicitly *not* comic books.[87] Jack Katz regularly sent Eisner install- ments of *The First Kingdom* as part of an ongoing correspondence as early as 1974.[88] But in 1978, Michael T. Gilbert received a letter of comment concerning his story of Jewishness on a foreign planet after a second Holocaust, an Israel nuked and sixty million dead. "Congratulations!" the letter read. "Your story [is] an example of the kind of innovation and strive [*sic*] that is moving sequential art (or graphic literature) out of the primordial swamps in which comic books have so long wallowed. It is most reassuring to know that there are people like you and Art Spiegel- man who are also laboring to deal with themes beyond cops and robbers. More important you are giving credibility to the belief that this art form is capable of so much more than any of us have ever attempted." It was signed Will Eisner.[89]

Although the term *graphic novel* was coined earlier, Eisner later— rightfully—took some credit for popularizing the phrase; ironically, for a work, released in 1978 under the revised title *A Contract with God*, that was actually a series of short stories. (Perhaps he'd taken his concern about people's reading attention span to heart.) The stories encompassed fable, satire, wry recollection, in their own way of a piece with other Amer- ican Jewish classics like Henry Roth's *Call It Sleep*, Abraham Cahan's *The Rise of David Levinsky*, and (in a different key) Herman Wouk's *Marjorie Morningstar*. His coloring and lettering evoked the Jewish past: his car- toonish style, which ebbed and flowed in detail and abstraction with the moment, reminded readers of his *Spirit* past and the divergence from it here. His theme was memory and its power. "Over 90% of the artwork . . . was done from memory. . . . My perspective was learned looking out the window of a five story tenement building. . . . Every one of the people in those stories is either me or someone I knew or parts of them and me."[90]

Some of the work's most profound autobiographical elements are submerged. Even close acquaintances only learned decades later that *Contract*'s title tale, about a man trying to come to terms with God after his daughter's death, was influenced by the death of Eisner's own daughter Alice from leukemia. It made Dennis O'Neil's contemporary review even more prescient in considering it an "adult's attempts to make whole his childhood recollections, to fill in the gaps, a process akin to psychoanalysis"—which, of course, is a way of discussing trauma, too. O'Neil added that Eisner's caricaturic style worked well because he drew forth childhood memories "as archetypes—as caricatures, almost." (Eisner said that learning that "memory is impressionistic . . . began to make [his] work more impressionistic.")[91]

Though *A Contract with God* was not a commercial success at the time (Eisner hoped it would do significant business in bookstores; bookstores had no idea what to do with it), it would be a significant component of new rumblings about taking comics seriously, of a different degree than the early-'70s "relevance" debates. Both the *Covenant with God* announcement and the O'Neil review appeared in a newly robust forum: in 1976, a young comics fan, Gary Groth, had taken over the fanzine *Nostalgia Journal*, soon changing its name to the *Comics Journal*. There was a shift not only in emphasis, from focusing on the past to covering the current landscape, but in tone and ambition of coverage as well.[92] While spending significant time on Stars Trek and Wars ("The movie! The comic! The photos!" a 1977 issue cover shouted), the venue soon became an essential source for substantive comics writing, recording—and critiquing—these multiplying experiments in convergence and ambition. In 1979, future DC president Paul Levitz, then a young writer-editor, issued "A Call for Higher Criticism" there, asking for "a frame of reference, and a sustained level of introspection," calling for historical perspective and agreed-upon aesthetic criteria. While not all of the eleven critics who responded in the next issue agreed on his principles or terms,[93] it was a watershed moment—as was the special section the academic *Journal of Popular Culture* devoted to comic books that same year, and the panel at the Modern

Language Association on "What's So Funny About the Comics?" the year before, featuring Eisner and Spiegelman as speakers.

As always, comic *strips* were slightly ahead on the high-culture valuation curve: witness the release, and imprimatur, of the *Smithsonian Collection of Newspaper Comics* in 1977; and thanks to the indefatigable salvage efforts of Bill Blackbeard, one of the collection's editors, the volumes of strip reprints in the same year's Library of Classic American Comic Strips, the name announcing—reinforcing—canonical resonance.[94] If anyone in *New Yorker*–reading circles was talking about book-length comics, they probably weren't mentioning Eisner, but his former apprentice, known for strips. Jules Feiffer's novel in cartoons *Tantrum* came out in 1979, the year after *Contract*; its *Munro*-in-reverse plot featured a fortysomething man retreating from the weight of everyday bourgeois life by howling himself into the form of a two-year-old.[95]

Which, all these convergences and rumblings of relevance notwithstanding, was still probably what most Americans thought was approximately the right age for a comic book reader. Comic books' juvenile aspects were probably more blatant than ever, thanks to superheroes' media presence in the past decade. *Batman*'s 1966 success had led to Batman animated cartoons in 1968 and 1969. The year 1966 had also seen *The Marvel Superheroes*, featuring filmed, strung-together comic panels; it was as good as it sounded. In 1974, PBS's *The Electric Company* did "Spidey Super Stories," a Spider-Man comic tie-in. DC's *Super Friends* had been on Saturday morning TV starting in 1973; the cover to the 1976 *Super Friends* comic book read, "Smashing out of the TV screen— your Saturday morning favorites!" The heroes obediently did so, showing which medium was boss.[96]

There were plenty of other kid-oriented synergies. Bill Mantlo developed the new series *Micronauts* after seeing the Christmas toys his son got in 1977; in 1979, Parker Brothers approached Marvel with a toy they wanted adapted as a comic; *Rom the Spaceknight* duly premiered. DC and Marvel employed one of comics' oldest strategies, the free giveaway, for Radio Shack, Aim toothpaste, and Campbell Soup (Captain America part-

nered with the Campbell Kids in "The Battle of the Energy Drainers," distributed to schools as an educational aid). Licensing paid the bills; by 1981, Marvel, according to its corporate ads, reached 77 percent of all kids in America between six and seventeen, and that sold a lot of underpants and lunch boxes.[97]

The adult media fare wasn't much more mature. Wonder Woman was a super-powerless spy in a 1974 ABC made-for-TV movie; successor TV movies were called (I swear) *Fausta the Nazi Wonder Woman* and *Wonder Woman Meets Baroness von Gunther.* Lynda Carter's weekly hour-long series, in which her incredible leaps were achieved via "springboards, reverse photography, and an oversized pendulum called a Russian swing," began in the end of 1976, adding Debra Winger as Drusilla, Wonder Girl the following year; 1977 also saw the Bill Bixby–Lou Ferrigno Hulk TV pilot, now perhaps best known for its "Lonely Man" piano theme (as opposed to producer Kenneth Johnson's belief he was "retell[ing] the *Les Misérables* story for a modern audience," with Ol' Greenskin as the hunted Valjean). Spider-Man, Dr. Strange, and Captain America TV films premiered between 1977 and 1979. The only real bright spot, the exception that proved the rule, was 1978's *Superman* movie (original, unfilmed script by Mario Puzo), which, thanks to improved special effects—"You'll believe a man can fly!" was the tagline, and it wasn't wrong; it broke the record for largest production budget in film history—Christopher Reeve's natural, believable performance as both Clark Kent and Superman, and a genuinely mature byplay between Reeve and Margot Kidder's Lois Lane, was one of the few enjoyably adult media moments of the late '70s as far as comics were concerned. The box-office take was substantial ($300 million), and the merchandising was groundbreaking: a thousand different products.[98]

But that didn't make a difference. In the late '70s, scholars pegged the reading level of twenty popular comic book titles as ranging from grade 1.8 to 6.4.[99] Comics, in other words, were for kids, and increasingly few of them. By 1979, monthly comic book circulation was at its lowest since the early '40s. Things didn't look good. The kids weren't buying

off the newsstands anymore, the head shops had closed, and whatever the artistic virtue of these new innovations was, it hadn't helped in the bookstores.

Thank heaven for the mutants, then, and the ninjas, and the new stores they built. But before we turn to them, a quick journey abroad.

NEW WORLDS

The dramatic changes that now came to American comics demand some understanding of comics' international scene, and three markets in particular: continental Europe, particularly France and Belgium; Japan; and the United Kingdom.

Europe had hardly slept, comics-wise, since the days of Swiss schoolmaster Rodolphe Töpffer. Parisians imitated his example, most famously Gustave Doré, in historical and cultural satires in the mid-nineteenth-century *Journal Pour Rire*, published albums,[1] and Honoré Daumier. But Continental comics really took off in the interwar period. In 1936, in Marcinelle, a suburb of the French-speaking Belgian town of Charleroi, French-language publisher Jean Dupuis decided to publish a kids' magazine and put his nineteen-year-old son Charles in charge. The incalculably influential *Spirou* appeared two years later, especially noted for Jijé's adventures of a young bellhop turned journalist. Its only real competitor was the work of Georges Remi, better known as Hergé, whose clean and clear lines, bold colors, and rip-roaring adventure stories of a young reporter, his faithful dog, and his adult friends enchanted multiple generations of Europeans, and, in translation, many Americans. (Less enchantingly, his work includes colonialist and racist materials, and his

personal life, marked by an unsavory Nazi association and long-term anti-Semitism, has certainly sullied his legacy.)[2]

The influence went in both directions. For sixty years, American comics—newspaper strips, Disney comics, some superheroes—had dominated the world comic book market. *Buck Rogers* was translated into eighteen languages and published in forty countries. *The Phantom* was syndicated abroad by King Features, with staggering success, helping spark comics industries in India, Sweden, and Australia. Disney comics, often local versions, were produced everywhere from Italy to Egypt, still often dominating the children's market. *Le Journal de Mickey* premiered in 1934; *Spirou* featured Tarzan and Superman; Hergé learned to use word balloons, not in popular use in Europe at the time, from reading *Krazy Kat*. Anne Frank makes a Popeye joke in her diary.[3]

This cultural invasion wasn't always positively received, as we've seen. *Tarzan* had been denounced in Europe for "Americanism" and "immorality" as far back as 1941. There were Werthamesque campaigns against crime and horror comics. And politicians and social critics in various countries viewed American comics as an imperialist effort to spread American ideology. To argue that this was simply a manifestation of the capitalist impulse, simply the search for new markets, was to precisely concede the argument—but you didn't need to go that far. Not when the Associated Press was reporting in 1949 that the State Department had ordered 260,000 copies of "a picture story series on great Americans" sent to South Korea, Thailand, Vietnam and Indonesia. "The hope is that through hand-to-hand circulation information about the history and background of the United States will be spread widely in areas under strong Communist pressure."[4]

These questions of empire, expanding and retrenching, were not unfamiliar to French and Belgians. *Pilote*, created by French cartoonists in 1959, was aimed at "the growing number of bande dessinée [aka BD, literally "drawn strip"] enthusiasts," an older crowd that favored weekly *magazines* in a semi-slick format. Its most famous product was *Astérix*, about happy-go-lucky Gaulish barbarians who gained Popeye-like strength via a

magic potion and bedeviled the Romans who were trying to control their territory.[5] (René Goscinny, *Astérix*'s writer, had spent time in America with Harvey Kurtzman, who featured a "Major Goscinny" in an EC war story.) *Astérix* was a resonant, if historically inaccurate, inward look at the winding down of colonial empires: though in real life the Romans "pacified the region fairly easily," their travails against these Gauls gave readers a more positive self-image at a time of "retreat from empire, waning global influence and growing US dominance."[6] And it was a lot of fun to boot. An estimated one out of every fifty people in '60s France had purchased at least one *Astérix* work; the country's first satellite, in 1965, was named Astérix—undoubtedly a factor in Sorbonne professor Claude Beylie's 1964 insistence that *bande dessinée* should be considered "the ninth art"; a 1967 BD show at the Louvre followed.[7]

French comic energy went underground in the late '60s; *Pilote* artists, chafing under what they considered Goscinny's too-conservative editorial policy, broke away in May 1968 to form *L'Echo des savanes*, which featured more scatological, personal, and political materials (and reprinted Kurtzman and Crumb). But it was a *Pilote* contributor who dominated French comics' next decade and deeply influenced American comics. (As well known as *Astérix* was in the late '70s, with worldwide sales of roughly a hundred million, it was only beginning its American breakthrough; a daily strip was only widely carried starting in late 1977.)[8] Jean Giraud, better known by pseudonym Moebius,[9] produced, singly and in collaboration, comics that did for the medium what the spaghetti Western did for movies: delineate the contours of American culture's deep international influence.

Moebius worked primarily in two of the great postwar comics genres: SF and the Western. He'd drawn Westerns as early as 1956; in 1963, he began the adventures of Lieutenant Blueberry, whom he'd revisit for decades. Moebius took not only his wide vistas from John Ford and Howard Hawks movies but also the moral ambiguities of the best of those works—ambiguity largely absent from most mainstream contemporary American comic material. But his SF comics were even more influential,

themselves often Westerns of a sort, landscape portraiture infusing pulp SF covers with an almost insectile, organic roundness, suggesting a kinder *Alien* (for which Moebius codesigned the costumes).[10]

Much of Moebius's most influential SF work was wordless, symbolic journeys within those landscapes not easily interpretable, with narrative sublimated to image and symbol. (Moebius was a fan of Griffin and Moscoso.) According to some American critics, that, or perusing the works without benefit of English translation, may have been for the best. Gil Kane suspected, "If I [actually could] read them, the material would be tenth rate." Or, put even more pungently, "In *Arzach* Moebius manages to be long-winded without saying a word."[11] But creators and fans were thus influenced on a purely visual level, any narrative focus gaining its force from the sequential images themselves.

Much of this influence came via the magazine Giraud was instrumental in cofounding in 1975, *Métal Hurlant* ("screaming metal"), though it's better known to Americans in its English incarnation, *Heavy Metal*, which started in 1977. *Heavy Metal* published Moebius, Enki Bilal, Guido Crepax, Philippe Druillet, and Milo Manara. Entering its fifth year of publication, an editorial summarized, "The European legacy remains. Fantasy. Science fiction. The absurd. The surreal. And a quality that descends from bandes dessinees, a French term that means maturity in a graphic, narrative form." John Workman, *Heavy Metal*'s art director, said, "We've got a hold on all the people who've outgrown comics," a readership, according to "tests," between eighteen and twenty-eight.[12]

If *Heavy Metal* focused on bringing a European re-creation of an American genre back to the States for older readers, that same late-'70s period saw another comics revolution land on America's shores; one also indebted to America, but in a far more tragic manner. Keiji Nakazawa's *Barefoot Gen* is based on the atomic bombing of the author's hometown, Hiroshima, when he was seven.[13] First serialized in Japan in 1973, "the first Japanese comic book series to be reprinted in the United States" was published by Leonard Rifas's Educomics, whose *All-Atomic Energy* made his concerns about atomic power clear. The then-titled *Gen of Hiroshima*

was neither a critical or commercial success. Rifas stopped publishing it after two issues due to poor sales. An early review suggested "it should be understood as a story told from a second-grader's simplistic point of view." Some of this response clearly stemmed from difficulty with the form. *Gen* combined historical trauma and autobiography in a way familiar to later American readers of *Maus* (Art Spiegelman would read *Gen* in the late 1970s),[14] but the cartoony, almost childlike style it used to tell its tale would have shocked anyone unfamiliar with Japanese manga.[15] Which was, at the time, pretty much everybody involved with American comics.

The word *manga* itself, coined by Hokusai in 1814, originally meant something like "whimsical sketches"; it began referring to comics only in the twentieth century. Contemporary Japanese manga was in some ways itself the result of an encounter with American comics. The "god of manga," Osamu Tezuka, was a huge Disney fan, particularly loving the characters' "stylized big eyes." An early manga of his was a *Pinocchio* adaptation; he's probably most famous for *Astro Boy*, another *Pinocchio*-style tale of an inventor who builds a robot boy to take his dead son's place; considered an inadequate replacement, Astro Boy determines to foster peace between humans and robots. *Astro Boy* became Japan's first animated show in 1963, forging a powerful link between comics and the screen in Japan.[16]

Tezuka, like Will Eisner and many before him, tried to bring something of the cinema to the comic-reading experience. But he did so in a way that Americans, for reasons of commercial possibility and artistic tradition, rarely if ever did. He attempted to replicate the *rhythms* of unspooling film on the page, adding silent panels to indicate time stretching, or panels of fast and kinetic action that gave the effect of being inside an action sequence, rather than, like almost all American comics of the day, a series of still shots of impactful moments, like newspaper photos of a boxing match. All this took time—which is to say, space—and Tezuka's comics ballooned from the standard American comic's thirty-odd pages to several-hundred-page volumes. Tezuka also found that "a Caucasian look, with dewy, saucer-shaped eyes, was extremely popular among young read-

ers," leading to the widespread manga convention, surprising to Americans, of depicting Japanese people with such features.[17] The demand proved massive. By the late 1960s, a manga like *Weekly Boys' Jump* could reach 428 pages and sell five to six million copies; creators could make enough money to eventually rank among the ten richest people in Japan.[18] Manga readers exist in every age and social group; as of 1995, two billion comic books and magazines were sold in Japan every year, amounting to approximately *40 percent* of all publications in the country.[19]

Kazuo Koike became involved with manga in 1968; two years later, he and Goseki Kojima created an epic that became a new benchmark for manga. *Lone Wolf and Cub* concerned the rōnin (masterless samurai) Itto Ogami and infant son Daigoro "as they follow the assassin's path down the road to Hell, seeking revenge for their clan's massacre."[20] The quest, which combined hyper-violence, fairly regular nudity, and a strong, noble moral code, took six years and over eight thousand pages to unspool. As an American champion, Frank Miller, put it in 1982, "It takes you to another time, and to a frightening, alien land. . . . Its authors took the time and space to tell their tale in its every moment, often devoting many pages to scenes that wouldn't last three panels in a monthly American comic book." Miller, more than almost anyone else, would be responsible for bringing manga's rhythms to American mainstream comicdom, aided, narratively and thematically, by Chris Claremont. They applied them, separately and jointly, to two surprising choices.

Daredevil had never been Marvel's most exciting superhero, never generating much in the way of readership or heat. In a dynamic that occurred over and over again, the fact that his title was sputtering was what permitted greater experimentation. Miller started as a penciler on the title, fresh out of Vermont, brimming with innovative style: the credits to *Daredevil* 158 read, "From time to time a truly great new artist will explode upon the Marvel Scene like a bombshell!" By 1981, he'd also taken on the writing responsibilities; Jim Shooter, now Marvel's editor in chief, predicted he was "going to be a biggie," a rare case of understatement. As a mid-'70s teenager, Miller had had a fanzine called *Overkill*,[21] and he

pervaded *Daredevil* with a simultaneously gritty and stylized violence that combined auteurist cinema like Sam Peckinpah's with the down-and-dirty bare-knuckledness of Blaxploitation films. Miller even suggested "violence is actually the theme of the book"; critics complained in turn that "the book isn't *about* violence at all, it's just violent," appealing to base populist instincts through trivialization. Such reactions only intensified when Miller brutally killed off Elektra, whom he'd introduced in his first script, at the hands of a psychotic supervillain in 1982.

Miller, unlike many creators, was critical of EC, calling them "illustrated texts . . . movies with a narrator who wouldn't shut up." He gravitated instead to Eisner's expressionist New York and Japanese manga, " 'read'[ing] a hundred pages of one . . . without ever becoming confused. And it was written in Japanese! They rely totally on the visuals. They approach comics as a pure form more than American comics artists do."[22] There was an emerging wave of American talent inspired by Japanese visuals, not least via Japanese animation and ninja movies, whose choreography fascinated late-'70s American artists.[23] More prosaically, Manhattan's biggest Japanese bookstore was then just three blocks from DC's offices; future comics giant Scott McCloud and, assuredly, others made the trek to peruse then-untranslated manga, a word that, as of 1984, still needed translation for readers of sophisticated comics criticism.[24] But Miller brought it all together, populating *Daredevil* with ninjas and eros. And it was just a matter of time until Miller teamed up with the other great contemporary Marvel creator, similarly "getting involved in Japanese culture."

The X-Men were essentially dead in the mid-'70s. The title was moribund, doing reprints; Marvel's editorial staff decided to reboot it with an entirely new group of heroes. The idea was bandied about, in Roy Thomas's words, that "if we could come up with a group book that had characters from several different countries . . . we could sell the book abroad,"[25] and though the marketing aspect largely disappeared, under Len Wein and Dave Cockrum, the lineaments for something new emerged: the all-new, all-different *X-Men* marked a newly internationalist approach.

It didn't always work. Nightcrawler's[26] Europeanness, for example, was largely predicated on his occasional use of *"Wunderbar!"* and other Deutschisms. But other X-Men developed more fully under Chris Claremont's pen. Colossus's Russianness was used to defamiliarize, and occasionally critique, American ways amidst the Cold War. Storm's Africanness had similarities to Black Panther's, but at its best, it spoke to the complexities of race within a more domestic environment. Kitty Pryde's Jewishness rarely surfaced (a favorite moment was her failed attempt to combat Dracula by wielding a cross), but resonated powerfully when readers learned of her Holocaust survivor relatives and, even more, that archvillain Magneto's ideological hatred of humanity was rooted in *his* identity as a survivor.[27]

Pryde's youth, though, enabled Claremont to write her as as a blossoming romantic interest for Colossus, and under his pen (aided inestimably by John Byrne and Terry Austin's art), these characters were a quantum leap from the romance comic–inflected early Marvel love triangles or male comix artists' pornographies. Claremont's X-Men gave the impression that, off-camera, they behaved like young adults when it was time to engage in young adult behavior. An early Claremont issue illustrates this changing of the guard quite explicitly. Scott Summers and Jean Grey are on a date; after a bout of typical Scott soul-searching, Jean asks, "Can't you just this once give it a rest . . . and kiss me?" She brings him in for a passionate clinch ("Jean, I . . . I . . . mmmmm"), and we spy a bemused Lee and Kirby in the background. Kirby: "Hey, Stan . . . I tell ya, they never used to do *that* when *we* had the book." Stan: "Ah, Jack, you know these *young kids*—they got no respect."[28] Of course, within four panels, the Sentinels attack, interrupting a perfect evening—the kind of thing Stan and Jack *would* have done.

It's Jean who initiates the kiss; this empowered female image, which the late-'70s Marvel offices called the "Claremont woman" (in Claremont's description, a "woman who, at the drop of a hat, will machine-gun the hell out of anyone in their way"), not only culminated in Grey's transformation into the ultra-powerful Phoenix but resulted in a significant

female audience for *X-Men*, vanishingly rare among contemporary super-hero comics. The empowerment was not uncomplicated: Phoenix further transformed into Dark Phoenix, sacrificing herself in 1980 to prevent her destructive nature from taking over. This pattern, where writers "who bothered to create strong female characters seemed to believe that either a strong woman becomes strong only through incredible trauma, or being strong and being a woman causes her to have terrible traumas," would continue to plague the industry; but one set of consequences of Phoenix's death (a moral reckoning demanded by Jim Shooter after she'd destroyed a planet inhabited by five billion sentient beings) were emotional stakes, emerging from narrative ones: death was meaningful because it was, or then seemed, permanent.[29] The proof that people took the stakes seri-ously: Claremont got death threats.[30] But female characters' power, par-ticularly to indulge darkness, was constrained.

Compare the license given to the other character central to the X-Men's popularity: Wolverine, a hyper-violent gentleman with a healing factor and adamantium claws who was, counterintuitively, Canadian. Claremont hadn't originated the character, Len Wein had, but little was known about him when Claremont took him over, not even his name. (Logan, it turned out; "the tallest mountain in Canada for the shortest X-Man.") Asked to explain Wolverine's popularity on a conference panel, Claremont's flippant response was: "We're a nation of psychopaths." His fellow panelist and new creative partner, Frank Miller, added, "It's wish fulfillment. Any time one of us gets his toes stepped on, we would like to kill him. It's nice to have a character who does it."[31]

Wolverine was a metaphor for the series' central question: If he was socially assimilable, could the unruliness of mutantcy—and whatever it stood for allegorically—be, too? With hints at a long espionage career, and thus wide international travel, in his long past (thanks to a healing factor–augmented long life), Wolverine allowed Claremont to incorporate his new ambitions and explorations into the popular series. Claremont's X-Men had already visited Japan back in 1978;[32] now Claremont and Miller partnered to infuse Marvel's most popular character with that cultural

sensibility. Creating backstory was hardly new to comics: whenever an "old enemy" or "old flame" appeared, a million minds scribbled over what they thought they knew about the character (this before Wikipedia pages existed to be re-edited). But there'd rarely been a reimagining as powerful as Wolverine's: the barely restrained psychopath reinvented as a tragic, long-lived samurai who loved out of *Le Morte d'Arthur* and suffered in scenes out of Kurosawa and manga.

Miller and Claremont's successes paid all sorts of deepening creative dividends for mainstream heroes. In late 1979, writer David Michelinie suggested that Tony Stark descend into alcohol abuse; instead of blocking it, Marvel gave "only one proviso: 'Do it well.'" Michelinie and co-plotter Bob Layton did it well enough to receive an award for their portrayal. Trying to capture *X-Men* lightning, Marv Wolfman and George Pérez's *New Teen Titans* had enough erotic appeal to power a small city, Wolfman's cosmopolitan scripting matched by Pérez's pinup art presenting young adults in varying degrees of dishabille. (The creators, not incidentally, called it "DC's first Marvel book.") The Code Authority of a decade ago would've had fits. But, as DC's managing editor put it in 1982, "the Code has, just as all of us do, continually grown."[33] *Shang-Chi*'s Doug Moench, along with a new artist named Bill Sienkiewicz, was taking the character of Moon Knight into new dimensions of psychic instability, illustrated by expressionist artwork hard to find outside the underground. But arguably the most important outcome was the mushrooming of name-brand talent, aided by sophisticated and committed fans who now had a new type of venue to make their voices heard.

Phil Seuling, a fan who'd been central to those first late-'60s conventions thanks to his big mail-order back-issue business, started questioning comics publishers in the early '70s about the wisdom of the old distribution system, in which the distributor returned unsold copies to be pulped for a refund. (The inefficiencies were enormous, to say nothing of the paper wastage; a Marvel VP at the time estimated only 35 percent of printed copies were sold, and that was the highest rate in the business.)[34] He suggested selling them directly instead, and not taking returns. "That

was considered so far out, so ludicrous, that it was greeted with laughter . . . but comic books started doing so badly that, by 1973, I was called into the [DC] offices."[35] DC administration helped Seuling refine the concept; Seuling started reaching out to various buyers and sellers he knew, along with magazine and convenience stores who might agree to the plan.

In 1973, charitably, maybe two hundred stores fit the bill. A decade later, there were almost fifteen times as many, and they'd transformed into comic shops. There were some early snags—some dealers tried gaming the system, buying books on a nonreturnable basis and returning them to another wholesaler for reimbursement[36]—but it took off. In the first full year of the model, Marvel's "direct sales" totaled three hundred thousand; by 1979, six million. In 1980, X-Men alone was selling over a hundred thousand "direct market" issues every month. Meanwhile, the newsstand business was tanking, due to a glut of DC and Marvel comics (more than eighty-five new titles between 1975 and 1978, most of which didn't last a year); inflation (in 1978, comics cost between forty and fifty cents); and the recalcitrance of drugstores, newsstands, and supermarkets to give these low-profit items shelf space. It all resulted in "the DC Implosion," in which the company canceled seventeen titles in a sixteen-month period between January 1977 and April 1978.[37]

That decision was undertaken and overseen by Warner Communications' new choice to head the company, wunderkind Jenette Kahn, who'd created kids' magazines Dynamite and Smash and who arrived in 1976. Kahn turned the company's attention toward direct sales, where, as of 1980, Marvel had a "crushing advantage"; DC rarely had more than one of the top twenty titles sold there. By the early '80s, both DC and Marvel had created positions to focus specifically on the direct and specialty sales markets. And, unsurprisingly, product designed primarily, or exclusively, for the direct sales market followed. Not all of it was of the highest caliber: in 1980, Dazzler, the tale of a disco mutant, sold four hundred thousand copies exclusive to direct sales. But sometimes, as with Moon Knight, the process allowed more idiosyncratic comics to flourish at print runs far smaller than the newsstand allowed, since the sales were guaranteed.[38]

Perhaps most interesting of all was that while *X-Men* was selling a hundred thousand copies monthly, *Elfquest* was selling thirty thousand to the same direct market; these shops, and this model, could host a variety of material. *Star*Reach* may have been the first product "specifically directed toward the comics store market"; but *Elfquest*, *Cerebus*, and others found their audience there. Early-'80s companies like Pacific Comics, First Comics, Red Circle, and Capital Comics focused entirely on the direct market. A lot of the material was second-rate superhero stuff, "ambitious fan projects masquerading as professional comics lines," or revivals and adaptations of '40s and '50s material, but not all of it. Dave Stevens's 1982 *The Rocketeer* revived good girl art (the hero's girlfriend was modeled on Bettie Page, leading to revived interest in her work), its 1930s aerialist adventure combining innocence, naughtiness, and bold action. Capital's in-house mad genius Mike Baron provided way-out ideas with *Badger*, with its genuinely mentally disturbed protagonist ("Put on a costume and fight crime in the streets. . . . You'd have to be crazy," one ad went), and Nexus, an SF vigilante who targeted mass murderers. Eclipse Comics boasted Max Allan Collins's Ms. Tree, a hyper-violent private detective whose vigilantism was sometimes disproportionately decried because of her gender. (Collins would write *Dick Tracy* after Chester Gould's death.) First Comics had Grell's *Jon Sable, Freelance*, about a ex-mercenary who by day is a bland children's writer.[39] *Sable*, praised at the time for psychological depth, holds up less well than another work First produced, Howard Chaykin's *American Flagg!*

Reviewing one of Chaykin's illustrated SF works, one critic wrote, "Sooner or later Those Who Make Such Decisions are going to realize that Chaykin is his own best writer." Chaykin proved them right with a tale of postapocalyptic Chicago, Martian corporations, and a TV cop replaced by a holograph who becomes an actual policeman. But as dizzying as the political and cultural satire was, ideas piled on ideas, the art was even more so. Kineticism taken from Kirby, Toth, the new MTV, and *Miami Vice*, the whooshing visual dynamism was the most pronounced in decades; that, along with the layouts, the remarkably integrated sound

effects (Ken Bruzenak's lettering was the only thing Chaykin didn't do), and the adult sexuality dripping off the page,[40] meant the 1984 fan awards were dominated by an independent after years of *X-Men* and Miller dominance. What's more, Chaykin's stories were nominated for the Nebula, SF's professional award, in 1985, the first time ever for a comic. But it was another set of SF-influenced artists who seismically reshaped comics in those same years.

THE HERNANDEZ BROTHERS grew up thirty miles south of LA, reading widely across comic genres (their mother was a collector); influences included Kirby, *Mad*'s Mort Drucker, and R. Crumb; *Dennis the Menace, Peanuts*, and Steve Ditko's monster comics; *Archie*'s Dan DeCarlo and many others. Both Jaime and Gilbert ("Beto") loved the "bizarre double bills" at the Vogue, like *Dr. Strangelove* and *The Incredible Mr. Limpet*, which led to incongruous strategies of mixture; Jaime was particularly interested in his mother's tales of their hometown Oxnard and its past.[41] Oxnard was "filled with low-rider and punk culture . . . a fascinating world where punk and *cholo* came together and that most of the world didn't know about," Jaime would say.

Punk's DIY ethos led to their self-publication efforts, Jaime's images of "these little punk girls who I just fell in love with," the depiction of fluid sexuality ("There's a lot of women who are lovers in this world. . . . That's another thing that came from my 'punk background'—that anything was possible"), certainly their iconic comic cover with its lineup of different women (borrowed from the back of Black Flag's *Nervous Breakdown* EP). And, perhaps most importantly, the personal emphasis: "When I was young, all my characters were still white. . . . Around the punk days, we just started thinking, 'What are we doing? We should be doing stories about ourselves.' "[42]

California's Hispanic culture had yielded comics before the Hernandez brothers. In 1980, Rojelio del Fuego, along with other artists, self-published one-page drawings by Bay Area artists in *The Mission District*;

del Fuego's contributions whipsawed between realist portraiture and scenes aping (and parodying) Hispanics' presentation within American culture.[43] But it was Jamie, Beto, and their brother Mario's *Love and Rockets* that made it to the comic shop racks, and that made history.

Its first issues featured a much higher rockets-to-love ratio than subsequent eras, but even then, it was the women's voices that struck, and stuck.[44] Two of the brothers soon developed specific milieus: Jaime's "Hoppers" was set in a thinly disguised Oxnard, mixing "naturalism with caricatural abstraction . . . a sliding scale of realism," while Beto's was set in the Latin American town of Palomar. But both derive their power from forceful characters (like Hopey, who, responding to a comic's title, "Hey Hopey!," looks back from her bubble bath and says, "Hey's for horses, ass bite!"). Stories like "100 Rooms" show the range of love, connection, disconnection, and alienation that ebb and flow through the characters' relationships; "The Death of Speedy Ortiz" took a sharp and considered look at the wages of machismo. The brothers would follow their characters for over a quarter century; their creations would age, organically and not always graciously, and the storytelling would deepen correspondingly.[45]

Originally self-published, then rereleased and serialized by Fantagraphics, a company founded by the editors of the *Comics Journal*,[46] *Love and Rockets* deepened another channel in the comic shops' sales racks, one predicated on more individual artistic statements, sitting there alongside the Big Two's direct market exclusives, fan-favorite superhero titles, smaller companies' knockoffs and occasional home runs, *Cerebus*'s phone books, and, every so often, well-respected new works like William Messner-Loebs's *Journey*. First published in 1983, *Journey* owed a lot to *Cerebus* and Eisner and a little something to comic book Texas histories, weaving together strands of folk legend, colonial and postcolonial American history, and Native American encounter to produce something that complexly explored language, belief, and identity—tribal and otherwise—shot through with the sensibility of a tall tale become solid and real.[47]

Most of the time, though, comic store patrons were in search of creators turned brands. Fans didn't want Daredevil; they wanted *Frank*

Miller's Daredevil. They knew who George Pérez was, and wanted to see *his* Starfire drawings. The success of Walter Simonson's early-'80s *Thor*, which drew prominently on Norse mythology, was taken as sign of "the Daredevil effect": "in today's fan-dominated market, changes in personnel can make a drastic difference." As Eisner, always the businessman, put it in 1983, "The minute a retailer, a distributor, or fans communicate that they'd like—*want*—to see a Neal Adams cover on here, or a story by him, that is the end of the argument."[48]

Which got to the financial question. All those new companies were built on creator-ownership and royalty-sharing models of the underground, which actually led comics talent who had worked for the Big Two for decades to publish with them. Jack Kirby created *Silver Star* for Pacific; Roy Thomas adapted Moorcock's *Elric* for them. Marshall Rogers and Steve Englehart, who'd made a splash working on *Batman*, created *Coyote* for Eclipse, prominently featuring Native American iconography. Don McGregor's *Sabre* sold out its five-thousand-copy print run for Eclipse and went to a second printing. Very occasionally, they went the other way: Sergio Aragonés's barbarian parody *Groo the Wanderer* jumped from Pacific to Marvel in 1984 after a months-long negotiation that, according to Marvel, made him the highest-paid artist in comics.[49]

The main companies were trying to hold the line: especially in light of Steve Gerber's 1980 lawsuit against Marvel for ownership of Howard the Duck. Gerber, unlike his predecessors, could go to the independents, where he told the tale of Destroyer Duck, in which a Little Guy is literally murdered by Godcorp. Destroyer Duck was memorably drawn by none other than Kirby, himself embroiled in a public and increasingly bitter fight with Marvel over credit and the return of his original art. Kirby, who'd fumed at the stream of '70s Marvel press releases giving Stan Lee sole credit for the Marvel Age, had refused to re-up at Marvel in late 1978 because it would've involved signing a "work made for hire" contract relinquishing his ownership rights. New copyright legislation that radically revised the nature of work for hire and threw many old arrangements into confusion meant some clarification from the fuzzy old days was probably

necessary, but Kirby was clearly being given very short shrift. "I feel like I've contributed a lot when people really needed me, and there's a hell of a lot of ingratitude," Kirby said. "It smells like garbage."

Complicating the negotiations was the possible theft of many of the pages from improperly secured storage. Until around the early 1970s, DC, among other companies, "routinely burned all original art once it had been printed" to ensure no one would resell it for other publication; Marvel's warehouse full of unreturned art, located on Manhattan's West 22nd Street, was literally next to a matchbook factory. The neighborhood was so bad, the woman employed to organize the warehouse answered the door holding a knife. Gaines famously never returned art, and kept copyright. But the artists mostly accepted, even internalized, the situation. EC artist Al Williamson said in the '50s, "I'm sure [comics company] ACG would have given me back my originals if I'd asked for them. I just didn't bother. I don't know." Frank Frazetta, another famed artist, agreed: "[W]ho could imagine [the rise in value of original artwork]? We used to give that stuff away to each other. If somebody asked for a whole page, he'd get it and we'd autograph it." And so the original art was slow to be returned, and when it was, it was a trickle.[50]

Nonetheless, the companies *were* changing. By the mid-'70s, DC began committing to return original artwork and to reimburse artists if artwork got mutilated or stolen; it created a new royalties system for freelancers in 1981—Marvel following in its footsteps before the end of the year—and, by 1983, raised its rates for reprints. Lee Marrs noted lessons learned from the undergrounds: "Marvel and DC have yet to cross the final border into creators' ownership. But it's only a matter of time." Steps in that direction were made via addressing the ur-crime of comic book credit: Siegel and Shuster's creator credits had been restored in 1975 as part of a press offensive leading up to the release of the *Superman* movie, part of a negotiation by Adams and others to restore their place in history, complementing an anguished public nine-page letter by Siegel ("SUPERMAN, who in the comics and films fights for 'truth, justice, and the American way,' has for Joe and me become an American Night-

mare. . . . I, Jerry Siegel, the co-originator of Superman, put a curse on the SUPERMAN movie! I hope it super-bombs. I hope loyal Superman fans stay away from it in droves"). Siegel and Shuster eventually attended the premiere, in a limo; in a revised 1983 version of that official Superman history, Kahn thanked the duo publicly.[51]

Focusing on creators as individuals (and brands), complemented by a new type of venue to house their creations, led to other innovations. Some felt more like rehashes at first: Marvel announced plans in the late '70s for a "*Heavy Metal*-type magazine" in which they'd only buy first publication rights, rather than own the material: "I think that'll allow a lot of people to work for us who otherwise might not be interested and allow a lot of our own people to get . . . a piece of the action," new editor in chief Shooter said, articulating Lee's similar *Comix Book* principle of several years earlier, but opening the door to mainstream creators for similar deals. While not going "as far in terms of sex and violence" as *Heavy Metal* (nudity and "'hells' and 'damns' but no 'fucks'—'shit' I'm not so sure about," said managing editor Richard Marschall), the stories "would not, as opposed to those appearing [in *Heavy Metal*], be incomprehensible." Eventually named *Epic Illustrated*, the first issue had work by Starlin, Lee and Buscema, and Wendy Pini, among others. (There was even a contest by Lee, "Epic Epidemic," to try to find a word rhyming with *epic*; nobody succeeded.)[52]

But there were more formal innovations, too. A 1980 analysis announced that the direct market would be "the sole recipient of some of Marvel's upcoming collector's albums (in particular those fan-favorite . . . characters such as the X-Men)." Shooter envisioned the works "in the format of European albums, with cardboard covers, full-color, slick pages," and not under Code approval. Marvel's first "graphic album"—or, as it was starting to be called, "graphic novel"—was published in 1982. In it, Captain Marvel dies of cancer—inspired, perhaps, by what creator Jim Starlin's father was going through at the time. One critic called it "as stridently dreadful as anything Marvel has published of late, with added points for pretentiousness"; others thought it typical

Marvel fare in luxurious wrappings; but it was a commercial success, selling fifty thousand copies by August.[53] DC, not to be outmatched, came out with its own first graphic novel, *Star Raiders*, in 1983.

Over the next three years, several dozen Marvel and DC graphic novels appeared on the comic shop shelves. Many were basically extended comic book adventures with an arguably greater degree of aesthetic ambition: the examination of religious bigotry in *X-Men: God Loves, Man Kills*; Charles Vess's painterly beauty in *The Raven Banner: A Tale of Asgard*. Some were superficially controversial, and/or fix-ups. Greg Potter and Ron Randall's *Me & Joe Priest*, years before *Preacher* and *Y: The Last Man*, featured a randy preacher in a postapocalyptic landscape who grants "communion" to women in the face of nationwide male sterility. Rick Veitch's *Heartburst* (1984) has "For Mature Readers" on its promotional material; it's your fairly standard interspecies alien love story, with frontal female alien nudity and graphic violence. *Heartburst* was originally to appear in installments in *Epic Illustrated*: it was then repurposed, doing some violence to the artistic structure. DC's *Star Raiders* was supposed to be a four-issue miniseries run in conjunction with a video game, but the game cratered, and the discontinued partnership turned into a graphic novel. But others were breaking thematic and formal ground. Jon J. Muth's *Dracula: A Symphony in Moonlight and Nightmares* (1986), an original text story based on Stoker's characters accompanied by dazzling paintings, brings out the original's eros and menace; that same year, J. M. DeMatteis's *Greenberg the Vampire* took a one-note joke from Roman Polanski's *The Fearless Vampire Killers*—a Jewish vampire—and turned it into a meta-take on the writing process, vampiric death a metaphor for creative sterility.[54]

But as those graphic albums appeared, yet another direct market revolution: DC, luring away white-hot fan favorite Frank Miller, made a groundbreaking offer on many levels. A 1983 announcement read:

Frank Miller's *Rōnin*, which will premiere in April from DC comics as a miniseries, will introduce a new format to comics. It will run for six 48-page issues, released at six-week intervals. Each

issue will be printed on white paper (a higher grade than Baxter) and will sell for $2.50. The series will also feature full-color separation rather than traditional four-color comic book color, setting a new production standard for color comics in America. *Rōnin* will also be the first DC comic book to be owned entirely by its creator—in this case, Frank Miller.[55]

The paper first. A symbol of the change in comics, on many levels, was the shift away from newsprint. By summer 1983, many comics had shifted to white paper (be it Baxter or higher stock), which held inks better than newsprint, allowing for crisper images and sharper colors. DC direct sales readers had come to appreciate the change with *Camelot 3000*, DC's first book "for mature readers"—that is, outside the Code. True, much of the series was classic DC fare, with some Malory thrown in: Arthur awakens to defend a Britain under alien invasion in the year 3000; his Round Table has been reincarnated, souls reborn into other bodies.[56] But Tristan's reincarnation into a woman's body, and the resulting identity conflicts, particularly after encountering mythic love Isolde, herself reincarnated as a woman, broke new ground. Tristan's journey from denial to acceptance was not only narratively significant, it led to the first same-sex kiss in mainstream comics, several years before network television allowed it; and Tristan's acceptance of her body and her love for Isolde yielded discreet but definite evidence of same-sex sexual activity in the series' last pages, genuinely unheard of in mid-'80s mainstream comics.[57]

That "last pages" is important, too. *Camelot 3000* was designed to be twelve issues, no more, no less, providing the opportunity for a shaped narrative: "A beginning, a middle, and an end, with room for subplots and character development. In other words, it was the equivalent of a twelve-chapter novel." There'd been "miniseries" as early as 1979's three-issue *World of Krypton*, leading, ineluctably, to the death of "tryout" titles like *Showcase*.[58] And now "maxi-series," which included Miller's *Rōnin*.

Several decades after its publication, *Rōnin* feels both intensely individual and like a muddled pastiche: the cyberpunk juxtaposition of future,

Moebiusesque technology and Japanese culture with corporate, black-ops skulduggery, part of an increasing post-Watergate interest in telling stories focusing on behind-the-scenes structures rather than smash-and-grab plots. (Several years later, Miller wrote a *Daredevil* run where the Kingpin nearly destroys him by the "simple" expedients of disbarring him, ruining his credit, getting him audited by the IRS, and turning off his utilities for nonpayment—a horror story we can all relate to.)[59] But *Rōnin*, its name taken from the Japanese word for "masterless samurai," was a powerful metaphor for characters displaced, in time and sensibility, from any bonds of control.

Like their author. Though DC published *Rōnin*, Miller acted largely independently, performing almost all creative duties himself (except for future wife Lynn Varley's remarkable, technically revolutionary, colors). Miller had clashed with the Code before: a *Daredevil* issue he'd penciled, "Child's Play," was shelved for showing a child using PCP, a clear and explicit violation. (Ironically, Miller was sufficiently ignorant of drug culture that Dennis O'Neil had to show him a pipe at a head shop so he could draw it correctly.) Though the story was eventually published with only minor changes, the controversy had its effect on a young Miller, who called the Code "destructive." And when the Code administrator, asked to defend his decisions, replied, "I don't know that I can be a judge of that. . . . I'm not an authority on story content," that mechanistic attitude, so anathema to creative sensibility, had Miller (and not *just* Miller) champing at the bit for creative freedom. Which DC provided, by offering to release the book without Code approval to the new direct market comic shops.[60] Which was, in turn, possible because of Miller's name-brand appeal. And it worked: by the mid-'80s, thanks to direct sales, despite newsstand drop-offs and kids' disposable dollars increasingly going to arcade games, comics were earning their own keep, rather than relying on top characters' licensing. But these comic shops weren't attracting kids—little kids, at least—so much as teenagers and even young adults, a more lucrative audience, to be sure.

Both *Camelot 3000* and *Rōnin*'s SF dystopias were, at least in part,

reflections of the omnipresent early-'80s view that the future looked grim. Nuclear anxiety was everywhere in those early Reagan years: played for laughs by the anthropomorphic missile protagonist of Bert Dodson's strip *Nuke*, a kind of *Doonesbury* manqué; a set piece in Jim Starlin's space opera *Dreadstar*, whose protagonist walks through a ground zero site: "All dead . . . it's just that some haven't realized it yet." Archie Goodwin and Pepe Moreno's 1983 *Generation Zero* told the story of a post-nuclear apocalyptic struggle for civilization. Even Booster Gold, that largely forgettable corporate satire of an '80s hero, had dark corners: coming from the twenty-fifth century, he occasionally matter-of-factly "remembered," thus "reminding" readers, of the devastating nuclear war between our time and his.[61]

During the 1979 Tehran hostage crisis, Peter Kuper said to Seth Tobocman, "Looks like there's going to be a war, so I guess we should do an anti-war magazine." Kuper and Tobocman, childhood friends, comic fans, and Cleveland transplants (as a kid, Kuper showed up at Harvey Pekar's door when a neighbor kid told him Pekar had some comics), created an avowedly political comic that drank deep of both youthful idealism and punk nihilism. *World War 3 Illustrated*'s first cover, in 1980, displayed a twenty-megaton ICBM adorned with a Coca-Cola logo (slightly adapted, one imagines, for legal purposes) aimed directly at Moscow; the stories within place urban anomie and nightmare side by side with tales of nuclear devastation.[62]

WW3's early issues featured some traditionally structured satire. Kuper's 1981 "When Dinosaurs Ruled the Earth" presents Reagan as an old, mad, movie-obsessed cowpoke whose suggestion for post-nuclear survival is a gigantic robot dinosaur called Americanis Rex; in Peter Bagge's "Old Pals," two radicals turned Reaganites murder their old friend for living in sin with "a Negro." The take-no-prisoners punk ethos is at play; "Pals" caricatures the rightward drift of old lefties while simultaneously castigating the toxic right-wing combination of moral righteousness and nationalism. (The murderers announce their affiliation with the "Pure America Party" before shooting.) But the more powerful impression the

anthology left was the paranoiac, maddening, nightmarish atmosphere of '80s America, exemplified by the comics' often fractured, expressionist stylings, tipping its hat to German expressionism and contemporary urban graffiti. In 1986, Kuper set a transcript of a Jerry Falwell radio sermon on the rapture occurring before the certain coming nuclear war to terrifying artistic accompaniment.[63]

Gary Panter, one of the early '80s major talents, produced *Jimbo* (named after a childhood acquaintance), featuring a brutish and crude punk kid continually and increasingly tormented by fears of nuclear annihiliation. Panter's rough style and curt writing, with forays into near-geometrical abstraction, spoke to the matchstick nothingness of the individual, the sheer impotence in the face of possible oblivion. As Panter put it, "Jimbo never starts a fight or anything, but still faces disaster. He just lives in a calamitous world."[64] Panter was deeply enmeshed in the punk ethos. Punk was about not giving a fuck—about technique, about anything. Or, in Panter's case, posing as if you didn't: his sketches, though superficially naive, were (to use a seminal punk title) raw power, wrapped in politics.

Mark Beyer's 1982 *Dead Stories* stemmed from a similar ethos, but was even *more* unclassifiable, odd caricatured figures against abstracted landscapes: if *Little Nemo* characters had taken LSD and read *The Tibetan Book of the Dead* before bedtime, this was what their dreams might look like. Amy, a Beyer character from later in the decade, says, "I dreamt that our lives were an endless series of mishaps and disasters without any point or meaning. I'm so glad it isn't true!" But of course it was. Her partner, Jordan, remarks that the "exterior devastation reflects our inner turmoil," a manifesto for Beyer's characters, existentially aware of their lot and thus constantly despairing. (When Amy returns home and finds Jordan smiling, it's only because he's put glue on his face to fix it there.)[65]

Both Panter's and Beyer's work came to wider attention in a new comics anthology, probably the medium's most important venue for experimentation since *Zap*, one of its two prime movers a notable underground figure. Art Spiegelman had also been profoundly struck in the late '70s

by European comics, thanks to trips to the Continent with his new wife, Françoise Mouly, a French architecture student who had moved to New York and become involved in the avant-garde scene. "She showed me comics on a myriad of styles, in hardcovers, on good paper, in every bookstore," he'd say. "It was a higher level of mediocrity than I had ever seen before."[66] Inspired, he revisited some of his early work: 1977's collection *Breakdowns* contained work demonstrating both formal experimentation and personal introspection. Spiegelman's *Arcade* partner, Bill Griffith, had published a story in 1976 entitled "Conceptual Art: Bargain Rates," and Griffith—who would describe the approach of his best-known character, Zippy the Pinhead, as "opening up to and simultaneously letting in th' rich cultural stew all around us—without judgment or filtering . . . th' line between 'high' and 'low' culture is erased! It's all just one heady admixture of random input!"—was a key figure in keeping cracked surrealism going in the '70s. There was often, if you squinted, a method to the madness, but the goal was to experience what Griffith's characters seemed to: the constant immediacy of now and impulse.[67]

In 1978's *Mondo Snarfo: Surrealistic Comix*, Griffith's entry, "Situation Comedy," juxtaposes a fairly innocuous conversation, a typical white-picket-fence family at breakfast talking about Sister's date last night, with each panel switching context, from beatnik coffee house to operating theater to medieval times to chorus line, and so forth; his "The Plot Thickens" is an exercise in which each line has one more panel than its predecessor. Contemporaries like Crumb created "abstract comics," panels of images strung together without "a narrative excuse";[68] Columbia professor and poet (and, believe it or not, Stan Lee collaborator) Kenneth Koch made students in his "imaginative writing" course take a comic, paper over all the captions and balloons, and create their own—*without* having read the comic first. The idea: images can produce countless texts, infinite interpretations.[69]

Such structural play, focusing on comics' *form*, fascinates one side of Spiegelman: consider again *Breakdowns'* dual-edged title, whose primary meaning (to a comics practitioner) is about the structuring of a

visual narrative. Spiegelman's "Don't Get Around Much Anymore," in which the captions refer to the preceding panel's pictures; "Day at the Circuits," featuring a dizzying series of instructions on panel order; and Chandler-meets-Picasso-meets-McCay "Ace Hole, Midget Detective," are master classes in the formation and deformation of structure. As Spiegelman put it, their "narrative was almost as much a matter of indifference to me on one level as a coat hanger or the armature for a sculpture. You just had to have something to drape all these things on. So there is *a* story of some kind in *Ace Hole*, but I'm not sure I even know what it is."[70]

The other resonant sense of the word *breakdown*, of course, is represented by "Prisoner on the Hell Planet," that expressionist autobiographical tale. In the comic, Spiegelman's mental breakdown is clearly tied to his identity as the child of Holocaust survivors (he appears in a concentration camp uniform), and it appeared in *Breakdowns* along with "Maus," a story first published six years earlier in the first and only issue of *Funny Aminals* [*sic*]. Its setting mattered. "Most children hear *Winnie the Pooh* and such animal stories at bedtime," said an early critic. "Spiegelman heard another type of tale; and he's visualized it here in bedtime story terms." Spiegelman had come up with the notion after attending a film class where filmmaker Ken Jacobs (who had introduced Spiegelman and Mouly) connected cartoons and depictions of minstrelsy; he'd considered using that juxtaposition to reflect on race and America for his *Aminals* contribution, but, determining "I know *bupkis* about being black in America!" he moved closer to home. His 1977 sketchbooks detail various explorations with rats alongside sober ethnographic drawings of prewar Polish Jews, the product of increasingly extensive research; a late-1978 news item noted he was "planning on expanding his 'Maus' story to a 150–200 page volume chronicling life in Europe under the Nazi occupation, visualized in funny animal terms." The venue for publication would be the new anthology he and Mouly were coediting, which premiered in 1980. Mouly, recoiling at printing problems with *Breakdowns*, had started her own publishing company, Raw Books and Graphics, producing comics

works and brilliantly designed *objets de comics* by Griffith, among others; the title of their comics magazine flowed naturally.[71]

Raw's stationery called it "The Graphix Magazine That Changes Its Subtitle Every Issue." (Examples included "For Damned Intellectuals," "Of Abstract Depressionism," and "That Overestimates the Taste of the American Public.") It certainly didn't talk down. Hipper-than-thou, arty, sometimes almost willfully discomfiting and/or baffling, Kurtzman described it as "either a comic book masquerading as a magazine or the reverse—I'm not sure."[72] Mouly and Spiegelman combined international perspective with New York focus, bringing Europeans like Jacques Tardi and his encounter with America, specifically New York, to wider attention. "I was in AMERICA. I'd left FRANCE, my beloved mother-land, which I didn't give a shit about," Tardi's sweaty, smoking protagonist thinks. "I had a fever of at least 102. [My Miller] was luke-warm, the dog-piss of bottled beers. Yes, it was good, it was beautiful, I was in the movies, I was in the USA!"[73]

There's an old line about the Velvet Underground that their first album only sold a thousand copies on first release, but everyone who bought it started a band. *Raw* did a little better than that; its first issue sold out its initial five-thousand-copy print run; the second issue's print run increased to 6,500, the third to ten thousand—but the whole comics business, both in and out of the mainstream, was aware of *Raw* and what it was trying to do, even if many were turned off by its formalist and sur-realist experiments. Different issues would appear complete with trading cards, flexi discs, even individually torn-off corners, the close attention to design and production values heavily influenced by Mouly; this was bespoke comics, and either you got it or you didn't.[74]

Raw wasn't the only new appearance by an older stalwart. In 1977's "High Times Interviews R. Crumb," Crumb presents himself beneath an interviewer's unflinching, mocking gaze: "Don't you think you've become somewhat repetitious, grinding the same old axes, pushing your little pet obsessions, year after year, since, say, 1972?" the interviewer persists. (Crumb, goaded, finally attacks the interviewer, to be dispensed

with a quick karate chop and left on the floor.) The story appeared in the first issue of Crumb's new editorial endeavor, 1981's *Weirdo*, which seemed to gesture at that exhaustion: "another new magazine, another *Mad* imitation, anther small-time commercial venture with high hopes obviously doomed to failure."[75] And the magazine's most notorious early feature—captioned photographs frequently involving Crumb maltreating and being maltreated by female models (spanking them over his knee, being lifted by them at the beach in a Charles Atlas parody, being dumped by them in a trash can)—were long, thematically familiar exercises in objectification.[76] It's a testament to the complexities of individual psychology that Crumb could objectify women and champion them under the same cover simultaneously. *Weirdo*'s second issue cover read "Male Backlash Issue: Hey Guys! This Magazine Degrades Women!"; contributors included Aline Kominsky, signing herself "Mrs. R. Crumb."

At about the same time, in a 1982 *Zap*, Crumb produced "My Troubles with Women," described as "Another 'True Confession' by your favorite neurotic cartoonist," in which he admits to "something unsavory about my personality" from early on: but now, post-marriage, "I've more or less settled down." In that panel, Kominsky says, in his embrace, "You've always been able to get it up with me, Bob!" To which Crumb replies, "Isn't she cute, folks? She draws comics, too!"[77] And they drew them together, sometimes, Aline worrying that "my drawing looks too crude and ugly next to yours." But to take this as mere vulnerability obscures Kominsky (now Kominsky-Crumb's) sense of performance, subversiveness, eros, and mischief. In one joint comic, Crumb pushes her face into the enchiladas she serves him, then takes her from behind. Kominsky-Crumb shows herself, food on her face, saying, "Oh well I guess I deserved that right?" but *thinking*, "Confidentially speaking I enjoyed that quite a bit. I like it ruff, know what I mean?" An '80s self-flagellating autobiographical comic, "Of What Use Is a Bunch?" has the double effect of presenting a kind of compelling, magnetic, charismatic individual, an antihero in the manner of Erica Jong, accentuated by her chameleonlike approach to her own appearance: showing herself as a man in one panel, referring to her-

self as another of the "Legion of Bunchs," or explaining another image by saying she "decided to make myself cute for a change."[78]

Regular *Weirdo* contributor Dori Seda, on the other hand, was very much a singular self. The performative, showy, drag- and gay-friendly Seda was the "vampire bookkeeper" of Last Gasp, best known for her wild tales of personal disintegration (in 1982's "Cycle of an Artist," she looks in the mirror: "Cough! Hack! . . . I really *have* allowed myself to become a bit disgusting. . . . Maybe I should lay off the booze and cocaine for a while and get my health back!").[79] Her tale of a nude model's revenge on her leering, exploitative photographer, throwing him out the window and taking pictures as he falls and splats, may well be a response to other *Weirdo* material.[80]

Seda's success at *Weirdo* had something to do with Crumb's editorial ethos: in rejection letters to applicants, he'd write, "Do something more personal, spend more time on it and try to tell something about yourself or about something that's really going on." And people complied, with individual visions: most prominently Peter Bagge, who became *Weirdo*'s managing editor in late 1983. (He ended the photo-funnies when he took over.) Bagge was a punk product, albeit with polished linework: his characters had shouting, rip-roaring mouths that tended to dominate the rest of their heads, eyes often shrouded by hair, like the Ramones, raw anger spilled out onto the page. Soon, he was producing his own "one-man anthology." *Neat Stuff* displayed the . . . well, neat stuff Bagge had acquired in his mental attic, most notably Crumb, *Mad*, Basil Wolverton, and Norman Lear, whose "*All in the Family* accurately reflected the way people in my own family communicated." A first-issue parody ad read, "It's time for all you beautiful people to realize that—Ugly Is In!"[81] and the Bradleys, the Brady Bunch on meth and from Bizarro World, flexed and churned and jelloed their way across the panels, rippling with anger and aggression.

Seda also appeared in the newly returned *Wimmen's Comix*, which emerged from a seven-year hiatus in 1983. Other notable artists also appeared: Phoebe Gloeckner produced a harrowing tale of sexual assault,

the panels compartmentalizing—echoing a necessary detachment from herself—her background as a medical illustrator employing clinicality to achieve even more excruciating effect.[82] Kominsky-Crumb, now a mother, began considering maternity through the prism of her own dysfunctional upbringing. In 1984, she wrote, "I found myself possessed by 'the demon' . . . my own mother Blabette"; "I'm trying hard not to repeat this destructive relationship . . . but if yur [sic] weird . . . + not quite the perfect suburban housewife . . . what can ya do?" Other not-quite-the-perfect-suburban-housewives produced comics with titles like "Multiple Choice," "The Young and the Professional: The Life of the Lonesome Feminist Capitalist," and "Barbie at 30+." The work felt vital, a counterpoint to the usual representation: a study of *New Yorker* cartoons comparing female depiction in the periods from 1940 to 1950 and 1975 to 1985 showed that women were "still portrayed less frequently than men and were rarely portrayed in career roles, despite the increase in two-income families."[83]

But other undergrounder work, like Jay Kinney's 1978 *Anarchy Comics*, felt creaky and outdated to a new post-Vietnam, post-Watergate generation too young to have been drafted to fight in Southeast Asia and raised on a decline in American self-exceptionalism and a cynical historical perspective on American foreign policy malfeasance and domestic liberal failure. By the mid-'80s, the Print Mint had become "the Reprint Mint," "a Berkeley poster and print outlet."[84] The moment belonged to the new anthologies, with new concerns.

None of which were aiming at the comic shop crowd. *WW3* got commercial viability via an alternative music distributor who got it into Tower Records and alternative bookshops; *Raw* was produced in a large format to sit next to the "new wave zines" appearing in those bookshops. Some of those zines were vanguards in a new movement that cartoonist Matt Groening, pre-*Simpsons*, described in 1984 as offering "a humanistic reaction to media slickness . . . portraying in their crude markings the clumsiness of everyday life and all its little lumps."[85] It was exemplified by self-published features, usually eight-page mini-comics, sold and traded via mail, facilitated by figures like Clay Geerdes of Berkeley's

Comix World and his attendant newsletter. Geerdes, who'd seen cliqu-
ishness and "assholism" in the underground as well as the "overground,"
was committed to avoiding the nepotism he'd observed. "No one was
rejected. Ideas were accepted and put out there for others to deal with."[86]
The movement's name was nebulous: "mail art" and "newave comics"
never caught on; other terms, like "alternative press" or "small press,"
would become more enduring.

But it turned out many of them shared similar concerns, ones related
more and more to Groening's "everyday life": a life that seemed touched
by fear, drama, and urban decay. *Raw* had been on the New York beat for
years, ever since Tardi's piss-stained opening shot. In 1984, Tobocman
produced a piece that opened, "Once I saw a man bleed to death. That
night people walked to the movies over his blood. . . . I was full of the
things I saw on the street and could not control myself." Kuper and Tob-
ocman decided to do a "city issue" of *WW3* that year because, as Kuper
said, the things outside their door "were not only more pertinent, but
they were a more perceivable reflection of what was going on in the big
picture." "[T]his issue is not about El Salvador or Lebanon," they wrote.
"We didn't have to look that far this year. We are opposed to anything that
makes our city into a battlefield." The comics inside are raw, hallucina-
tory, animalistic, filled with anger, violence, and chaos. Animals merge
with buildings and backdrops and yearn to break free.[87]

There were other treatments of the city. Ben Katchor, in his brilliant
idiosyncrasy, presented a unique picture of urban decay, a disappearing
city deeply flavored by Jewish immigrant energy, ambition, and Borscht
Belt comedy, illuminated by the flashbulbs of "Julius Knipl, Real Estate
Photographer." Katchor's awnings and stores advertising products that
never were and jobs that could only exist in a creative fever dream had
some vague kinship to Kuper and Tobocman's provocations, but it was a
nostalgic, pathos-filled, powerful territory all its own.[88]

But, Katchor notwithstanding, the lessons were clear. The city has
gone to hell. The kids are *not* all right—at least, most aren't. America has
become a sick joke, a rotted version of its former self, thanks, in no small

part, to the doddering idiot in the White House. Nuclear armageddon is around the corner. Potential saviors? Sidelined. Out of action. Indulging their own obsessions. And it may be too late for them to return.

These were, in brief, the concerns animating the two most important works of superhero comicdom to emerge since the start of the Marvel Age.

———

THE DARK KNIGHT RETURNS and *Watchmen* came out in the same milieu as *Raw*, *WW3 Illustrated*, and *Jimbo*. With the Cold War heating up once again and New Yorkers wondering, in the face of sky-high crime rates, if their city was indeed ungovernable; as *The Day After* flooded American television screens with images of nuclear attack on American homes; as the lessons of Vietnam and Carter-era malaise and Iran-Contra gave rise to concerns that America's best days were truly behind it. And with them came a new and searching analysis of a symbol of America's exceptionalism: the American superhero.

People rejoiced when the word got out that Frank Miller was taking on one of DC's iconic superheroes: "a three-issue series detailing 'Batman's last case.'" That way, Miller explained, "it will give me the opportunity to do the character the way I want, free of present continuity."[89] *The Dark Knight Returns*, like most works of genius, presented its innovations within a familiar framework: here, the imaginary superhero story. We've noted that subgenre's pleasures before, but in *Dark Knight*, the imagination curved instead in the direction of psychological realism. "Superheroes have lost their human context. That's precisely why the comics have gotten so weak, and the stories seem so pointless and so irrelevant," Miller said in 1985.[90] And he didn't shy from the almost necessary corollary, anathema to previous generations of readers and writers: these characters are almost always psychologically unstable *by definition*, deciding, as they have, to become costumed crime fighters. And facing off against the same criminals, the same challenges, again and again, without any particular change? Another warning sign. Bruce Wayne (or

Batman? Which is real, which the disguise? A question increasingly fore-grounded post-Miller) can't move on. Traumatized as a child by his parents' death, he is stuck, constantly reliving that trauma and its cost. This is not, to put it mildly, a well man.

Add to that the urban nightmare that is New York (Gotham) City. During the decade Miller had spent there, he'd been mugged twice: illuminating his perspective on "subway vigilante" Bernie Goetz, who was arrested, tried, and essentially acquitted for shooting four prospective muggers on the subway in December 1984. (Miller cited Goetz in interviews.) The question of vigilantism had infused criticism of superhero comics from the start, and played itself out post-Vietnam most prominently, perhaps surprisingly, in Spider-Man's adventures. There, Frank Castle, a Vietnam veteran who lost his wife and children as innocent bystanders in a mob hit, declared deadly war on organized crime. Taking a page from the then-popular Executioner novels, the Punisher's commitment to murder put him in a curious moral position vis-à-vis the heroes he dealt with, and, indeed, his readers. And not only his: at the end of one 1983 story featuring DC's answer to the Punisher, Marv Wolfman and George Pérez's Vigilante, a TV reporter asks, "Who does America's youth look up to today? Who are the symbols for the future?" The panel shows us Vigilante and his assistants, looking straight out at us.[91]

But all this preceded Bernie Goetz, whose actions put the question simply and powerfully to the silent majority: What would they do in the face of what seemed like the collapse of law and order? It's hardly coincidence that Batman and Gotham's testing in *Dark Knight* comes after the detonation of a nuclear weapon, when the city must rely on citizens taking the law into their own hands. (The concept of "nuclear winter" was then first percolating in the news.) Miller, asked if *Dark Knight* was "fascistic," objected: "It has become de rigueur for any story where the lead character is not impotent to be regarded as fascistic. . . . This isn't Dirty Harry . . . Batman follows what I believe to be a very, very moral code of behavior." But Miller also has Batman snarl, "You've got rights. Lots of rights. Sometimes I count them just to make myself feel crazy."[92] Nonetheless,

the grand narratives still apply. The citizens (mostly) rise to the occasion. Batman will not, in the face of all possible provocation, take the step of killing the Joker. Even the evil youth gang the Mutants (symbolic representatives of the moral panic about children reading comic books, plus a joke aimed at the then-dominant superheroes in the market) become Batman's descendants and heirs in good.

In that last sense, as prodigal sons, the Mutants also highlight Miller's other great contribution to the genre: his seemingly effortless weaving of his psychological realism with an unabashed dive into the myth pool to create something simultaneously grand *and* grounded. Batman as Dracula. Batman as Western hero (actually riding a horse at one point). Batman as Christ figure, noting at one point, "Rain on my chest is a baptism—I'm born again," a metaphor that becomes near-literal when Batman "dies" and is secretly reborn toward the work's end, and a religious motif Miller also used to title a powerful *Daredevil* run.[93]

The first issue's initial print run was sold out before the books hit the West Coast, despite DC having set it at 40 percent over advance orders; it went back for a second printing within seventy-two hours, and *that* printing sold out within three weeks. Retailers sold out their stock within hours. A deluxe hardcover edition for bookstores—actual bookstores—sold eighty-five thousand copies at $12.95. DC started advertising outside the fan market, placing an ad in general interest magazines: "You outgrew comics—now they've caught up with you!"[94]

Dark Knight was thus seen, in its own way, as a product of superhero exhaustion—which illuminated another major trend. Comics professionals in the '70s, increasingly former fans (at least in the amateur, but also often the organized sense), were frequently interested in writing stories "filling out" the "holes" in earlier narratives; holes frequently generated by earlier eras' more laissez-faire approach to canonical consistency.[95] This necessarily created ever more complex, interlinking narrative that threatened to derail readership as well as cement it, buckling the DC and Marvel Universes beneath their own weight. By the beginning of the '80s, a critic could write, "Continuity may be attempted out of the most pas-

sionate affection for the comics, but however loving, the kiss is the kiss of death: it plunges stories into lifeless expository persiflage."[96]

Continuity exhaustion was exacerbated by brand expansionism. "Second X-Men Book Suggested," read a 1981 *Comics Journal* headline, and 1982's *The New Mutants* wouldn't be the last one. By 1985, there were four Spider-Man books, and another X-Men book: *X-Factor*. That last featured a resurrected Jean Grey—a sign, to those who were looking, that deaths *weren't* real, and lacked stakes: resurrection was not only possible, but inevitable—narrative kudzu.[97] During all this, Marvel produced *The Official Handbook of the Marvel Universe*, giving its characters (and Marvel had, then, about two thousand different characters) the solidity and fixity of entries in the *Dictionary of National Biography*.

Naturally, the various Spider-Man and X-titles had crossovers, the better to sell more comics, but horizontal continuity soon took a great leap forward. "All Major Marvel Characters to Engage in Year-Long 'Secret War' in 1984," the headline read. The maxi-series, Shooter explained, was being produced because "the essence of what Marvel does is all of our characters existing in the same universe, but there hasn't been any continuity across the line in any large, significant manner." It was also to sell toys. Mattel had lost its DC toys to Kenner; Masters of the Universe toys were succeeding, but Mattel wanted a hedge if He-Man lost his appeal. So the toy manufacturer approached Marvel, with conditions: a big event to launch the toys, some costume changes for unique design . . . oh, and the event had to be called "Secret Wars," two words they'd found tested well with adolescent boys. *Marvel Super Heroes Secret Wars* sold close to 750,000 copies per issue, spawned a 1985 sequel, and scattered crossovers through many Marvel titles, meaning completists had to buy them all.[98]

One product of all these new spin-offs and series: collector speculation. In comics' early days, anniversaries or special numbered issues went largely unheralded, temporal markers in a medium unconcerned with history or posterity: in the '50s, deciding how to number the Flash series restart, Donenfeld insisted they begin where the old one left off, at 104, reasoning that a kid choosing between that and a number one

would obviously go with the former: "Any comic that has gone that long is worth reading." Reading, not speculating. As Len Wein put it in 1985: "Unfortunately, too often we are [now] dealing with a collector's market rather than a readers' market. . . . I think if we canceled *Batman* tomorrow and started with the exact same book the month afterward, *The New Adventures of Batman* #1, it would sell 50,000 copies a month more."[99] Wein's suggestion would be taken up, in different ways. In 1986, on the occasion of the Marvel Age's twenty-fifth anniversary, Marvel created an entire New Universe, in no small part, critics charged, to give completist collectors "the opportunity not just to have the complete run of a title, but of a complete, discrete line."[100] The magic wasn't there; collectors ignored it entirely, and the line limped along until cancellation three years later.

But there was another, more radical way to cut through some of the accretion, the "little bit of rust on the Man of Steel." DC president Jenette Kahn appeared on *NBC Nightly News* in late 1985, talking up the radical revision of *Superman* (complete with new number ones), written and drawn by *X-Men* fan favorite John Byrne. Several years earlier, Kahn had brought in a professional designer to update Lois Lane's wardrobe; Byrne did the same for other aspects of the story, making Lex Luthor, for example, more businessman than scientist.[101] This reboot had come out of an equally radical DC attempt to achieve simplicity. The title of 1985's *Crisis on Infinite Earths*, released during DC's fiftieth-anniversary year, alluded to many earlier comics; its hodgepodge of a narrative reflected its mission's immensity, "the excision of countless timelines and storylines"[102] to create one simple, linear DC Universe. The result would be holy writ, its dogma canonized in narrative linear form in an official text (1986's *History of the DC Universe*), heresy forbidden: a memo from then–executive editor Dick Giordano after the series ended listed twenty-four characters who had died or been expunged, including Supergirl and Barry Allen's Flash: "they should never be seen again, nor should they be referred to in story."[103]

The *Crisis* also yielded a George Pérez reboot of Wonder Woman, reaccentuating her mythological aspect and her role as an ambassador

of peace, and infusing her with a largely joyful youth,[104] serving as an important counterpoint to the darkness around Batman in Miller's *Dark Knight* and, less flashy but perhaps equally important, in his *Batman: Year One*, published the year after *Crisis*. Its biggest narrative innovation is arguably presenting Catwoman as the fully sexualized being always hinted at previously but never quite shown. But thematically, crucially, it reaccentuated that even, perhaps particularly, in the new linearity, there were always moments in the heroes' historical past to be mined, presented, and entered into retroactive continuity—retconned, for short. Unsurprisingly, it was soon followed by *Batman: Year Two*, and many other *Year Ones* would follow.

Formally, *Year One* showcased another innovation. Miller and David Mazzucchelli had produced the story not as a limited series or graphic novel, but as a self-contained narrative within a regular, ongoing comic— suitable for breakout book publication nonetheless. The year after that, in 1988, regular *Batman* creative team Jim Starlin and Jim Aparo would further develop what was then called the "miniseries-within-a-series," but soon became known, as it is now, as the "story arc," which involved titling the arc, telling the readers which part they were on, and, most important, allowing the regular team room to produce longer runs collectible in trade paperback form.[105]

But while these massive changes had significant commercial ramifications, actually allowing DC to briefly overtake Marvel in direct-market share for the first time,[106] they paled in ambition, accomplishment, and influence compared to a superhero comic the company published that came from creators simultaneously deeply enmeshed in and structurally alienated by American comics. It was produced in America, for an American company, set in America, using iterations of American heroes, and employing American tropes to address archetypally American political situations—and neither of its two creators were American. Which leads to our final international excursion.

American comic books made their way into young British hands in the mid-twentieth century thanks to ships that used them as ballast, or

via American troops who, like practically everyone else, didn't save their comics, and so gave them away to local youth off base.[107] American comics wouldn't be officially distributed in Britain until 1959; the mid-to-late '60s saw reprints of *Hulk* and *Batman* Sunday strips. A fan base built; fanzines sprang up through the '70s; specialist shops focusing on American SF and comics followed. There was even a British underground scene along American comix lines: 1970's *Cyclops* reprinted Shelton and Bodé as well as featuring British artists; 1971's *Nasty Tales* was raided (over a Crumb image), but the courts found its publishers not guilty of obscenity in 1973.[108]

All this as prologue to 2000—or, rather, *2000 AD*, an SF-oriented comic whose first breakout star mixed late-'70s British views of America and domestic concerns. Judge Dredd's home, Mega City One, was located somewhere on twenty-second-century America's East Coast. Population topping one hundred million, afflicted with rampant crime and unemployment, Mega City birthed a figure dressed in old EC and Moebius trappings, but straight out of Spain Rodríguez and *Dirty Harry*. Dredd's draconian perspective on law and order, addressing British late-'70s anxieties about crime, took on greater resonance with Margaret Thatcher's 1979 victory and her early response to inner-city civil unrest. By the early '80s, *2000 AD* was selling 120,000 copies an issue.[109] Many of its contributors became totemic names in comics, but first among equals was unquestionably Alan Moore.

Self-described as "the only person that I knew who'd ever read an American comic," Moore grew up amid the working class in Northampton reading lots of them: Weisinger-period DC, Eisner, *Mad*, Marvel, Kirby-era DC, and the undergrounds, especially S. Clay Wilson, alongside British New Wave SF authors like J. G. Ballard and, more recently, *American Flagg!* and *Love and Rockets*. Thrown out of school at seventeen for dealing acid, which "hammered home . . . that reality was not a fixed thing," Moore did a little strip under the name Curt Vile, *Roscoe Moscow*, "that owed more than a little to Art Spiegelman's *Ace Hole*,"[110] and went on to write not only for *2000 AD*, cutting his teeth on a wide variety of

SF pastiches, but former fanzine publisher and Marvel UK editor Dez Skinn's[111] *Warrior*, a short-lived but hugely influential franchise. And then Len Wein came calling.

About fifteen years earlier, Wein had had the idea for a horror creature with EC bones: murdered man whose body rots in the swamp comes back. He'd referred to it as "that swamp thing I'm working on," and the title stuck. (Marvel had a similar Man-Thing; both owed significant debt to wartime character the Heap, the remnants of a Great War flyer who crashed into a Polish swamp; in comics history, like the Swamp Thing, everything that exists eventually comes back, albeit in altered form.) Praised both for Wein's writing and Berni Wrightson's atmospheric art, it had lain dormant after their departures; but a Swamp Thing film had been announced (to be written and directed by Wes Craven), and a comic was ordered up to capitalize on the hype. Wein, now editor, had been following Moore's British work (*Judge Dredd* was also coming out in American editions), and, encouraged by DC executives, called him up. Moore thought it was a prank call from a mate and hung up; but once he took the job, he, along with artists Steve Bissette and John Totleben, started a revolution.[112]

It was the application of Moore's fierce intelligence, and, no less important, almost (but not in conventional terms) religiously inclined eye, to the character's mythos. Treating the narrative as holy writ while applying the skeptic's tools, he came up with ingenious narrative twists and developments that provided the sense of something far deeper and more profound beneath the original.[113] Or, as Moore put it:

> The continuity-expert's nightmare of a thousand different super-powered characters co-existing in the same continuum can, with the application of a sensitive and sympathetic eye, become a rich and fertile mythic background with fascinating archetypal characters hanging around, waiting to be picked like grapes on a vine.[114]

A powerful example of Moore's gifts: as the old Superman titles concluded before the reboot, he wrote "the last Superman story": "Whatever Happened to the Man of Tomorrow?"[115] Penciled largely by iconic *Superman* artist Curt Swan, it wove together all the Superman universe's friendly elements in dark and tragic ways, for stakes. Bizarro becomes a killer; the Legion of Super-Villains electrocutes Lana Lang and Jimmy Olsen; Krypto dies of kryptonite poisoning. Ultimately, the villain behind it all is revealed as a homicidal Mr. Mxyzptlk—killed by Superman, who, having broken his oath, exposes himself to gold kryptonite, permanently removing his powers. And thus endeth Superman. It may sound silly. It doesn't feel that way. Buoyed by the pathos earned by decades of mythos-building stories, it felt more like a Götterdämmerung.

But Moore reached even greater heights with *Swamp Thing*, where, given the property's far more marginal nature, he had greater liberty. Moore had a character point out that the Swamp Thing's story, even by comic book conventions, makes no biological sense. But this was not to destroy Swamp Thing; rather, to save it. "We were wrong," a character says. "We thought that the Swamp Thing was Alec Holland, somehow transformed into a plant. It wasn't. It was a plant that *thought* it was Alec Holland." "He was just a ghost. A ghost dressed in weeds," Moore writes, the phrase illustrating both style and erudition (the play on *weeds'* more archaic meaning as "garment" a case in point).[116]

Moore, particularly proud of "how relentlessly experimental" *Swamp Thing* was, tried something new in "nearly every issue." Perhaps the most infamous example was the "vegetable sex" issue—in Neil Gaiman's words, "a prose poem: an hallucinogenic consummation between a seven-foot-high mound of vegetation and an expatriate Balkan," who says about this consummation, "It's impossible, it's bizarre, it probably isn't even legal." Which might have felt true, except Moore's *Swamp Thing* 29, five issues earlier, cover-dated October 1984, had been the first DC comic appearing on newsstands without the Code seal. The Code rejected the issue thanks to (first) a double-page spread of festering corpses and (second) an incest

motif; DC, faced with the option of releasing the issue only to direct sales, decided not to forgo high newsstand sales and simply bucked the Code. The seal returned next issue, then never again.[117]

"You have to keep finding new, untouched spots to jab a needle into," said Moore,[118] another way of saying he put horror back in the driver's seat of comics progress in a way it hadn't been since the EC days. But writing a monthly horror comic—a monthly comic—was frustrating for Moore. "The stories here don't end—not in the way a movie ends or a book ends. Oh, the current menace may be averted or triumphed over, but there'll be something else along in a month's time, sure as eggs is eggs. The character will continue indefinitely until poor sales or some other factor dictate his comic book's cancellation."[119] To end, definitively: that was the dream. Recent format innovations had made it possible. All Moore needed was the opportunity.

Which arrived when DC asked him what he'd do with a recent corporate acquisition: Charlton Comics' stable of heroes, which included characters like Blue Beetle, Captain Atom, and the Question. Moore submitted a brilliant, sweeping proposal that involved killing the vast majority of the characters at series' end. DC demurred on immediately wasting this potentially valuable property, but, as Moore put it, "Dick [Giordano] loved the stuff, but having a paternal affection for these characters from his time at Charlton, he really didn't want to give his babies to the butchers, and make no mistake about it, that's what it would have been. He said, 'Can you change the characters around and come up with some new ones?' "[120] And thus Nite Owl and Rorschach were born, and the world got *Watchmen*.

Watchmen is a superhero story in much the same way *Moby-Dick* is a treatise on the New England whaling industry: a woefully inadequate description. *Dark Knight*, for all its groundbreaking moves, still necessarily occurs in Superheroland, Batman ending up exactly where he ought to be: in a cave, training heroes to fight the good fight. Marvel's *Squadron Supreme*, "the first full-scale treatment of superheroes as fascists," features its heroes supplanting the government and becoming a kind of thought police; even so, the essential verities are observed.[121] *Watchmen*,

its title from the old Roman tag "Who watches the watchmen,"[122] still traffics in the currency of superheroes, but lets us know from the beginning its characters, and certainly their creators, think they're funny money.

Bleak, dark jokes are at *Watchmen*'s heart, from its opening catalyst, the death of crime fighter turned CIA agent turned boozehound the Comedian, to the final black joke that killed him more surely than his fall out his picture window. (I won't spoil it here.) The visual icon that became the series' central symbol was, accordingly, a yellow smiley-face button with a streak of blood running down it. But the series' biggest joke is the idea that what matters in life is the derring-do of superheroing. Those who live by the code die in ignominy: of cancer, at the hands of muggers, by getting their cape caught in a revolving door; and though one of the lessons of the mystery Moore and Dave Gibbons weave over twelve issues of one of the most intentionally crafted, highly structured comics works ever created[123] is that many things that *seem* not to be connected actually are, an equally important lesson is that so much of what we derive meaning and beauty from are the products of randomness and chance.

Whether the universe ticks like a watch or is the product of quantum uncertainty is the question animating one of the story's most powerful strands, featuring near-divine hero Dr. Manhattan. Manhattan was based on Charlton superhero Captain Atom, whose nuclear accident–derived powers made him a perfect symbol of the postwar American order. (At his debut's end, President Eisenhower tells him, "With your help, perhaps all of us can live in a world at peace!")[124] But Dr. Manhattan becomes increasingly alienated from his country, indeed, from humanity; and a useful metaphor the series employs—"God exists, and he's American," one character says—starts a cascade of questions: How fare other countries in the face of an imperial superpower? (*Watchmen* is, among much else, a Cold War story, occurring in the shadow of nuclear apocalypse: notably, the original comics' back covers had replicas of the nuclear "doomsday clock," ticking toward midnight, eventually covered by a sea of blood.) What place the American dream in the cold '80s? ("What's happened to the American dream?" Nite Owl asks the Comedian as they face rioters.

"It came true," he replies. "You're lookin' at it.")[125] What place for regular people in a world of superheroes?

Exploring this last would become a comics cottage industry. But *Watchmen* was early to explore that vein, and did so profoundly, often via superficiality. As Moore put it, "Our intention was to show how superheroes could deform the world just by being there, not that they'd have to take it over, just their presence there would make the difference." Gibbons suggested that, "Since masked heroes weren't special in this world, comic books might feature stories about pirates."[126] The resulting pirate comic-within-the-comic, rendered lavishly and at length, also revealed *Watchmen* as a treatise on comics history: Moore and Gibbons threw in motifs ranging from Tijuana bibles to EC science fiction horrors to '40s superhero team-ups and beyond, colliding them all together to say, *This comes from that. But is something beyond it.*

Watchmen joined with other newly mature material. Moore's *Marvelman*, a realist '80s reinterpretation of a '50s British hero, himself clearly modeled on Captain Marvel,[127] contained explicit scenes of childbirth in its ninth issue. J. M. DeMatteis and Jon J Muth's 1985 *Moonshadow*, a picaresque, dreamy tale about a boy raised in unutterably alien circumstances, included captions about the character's "shooting semen high and low once puberty came knocking" and "yanking on my swollen penis."[128] Reed Waller and Kate Worley created *Omaha the Cat Dancer* in 1981.[129] Worley's loving, genuine, emotional (albeit somewhat melodramatic) narrative included explicit portrayals of sexual activity by its anthropomorphic animal characters. *Omaha*'s readership, much of which was female, found it sexy, real, grounded, and *not* pornographic.

Some authorities disagreed. *Omaha* was one of the titles behind the 1986 arrest of the manager of Friendly Frank's, a comic shop in Lansing, Illinois. (The year before, customs agents had seized the entire run of French publisher Albin Michel's *Squeak the Mouse*, featuring explicit sexual activity between cat-hero and willing kittens; a jury almost immediately ruled it not obscene, based on *Miller v. California* criteria. *Squeak* was another work that partially inspired *The Simpsons*' Itchy and Scratchy.)

The legal machinations ground on, catalyzing Kitchen to start a fund-raising drive that led to the creation of the Comic Book Legal Defense Fund, and the manager's guilty conviction would be reversed on appeal (although the store closed in the interim).

Distributors, particularly Diamond's Steve Geppi, began wondering if there should be ratings on even direct sales comics—or, at least, better information about content in these nonreturnable books.[130] DC, seeing the trend, floated the idea of a labeling system toward the end of 1986, along with suggested editorial guidelines, angering creative talent who felt they hadn't been consulted. Moore and Miller announced they'd leave DC after their current contracts completed, feeling that all this stemmed from pressure from, in Miller's words, "moral fringe groups" (such as ordained minister and president of the "Conservatory of Arts for Christians," Bob Maddux, who despaired of current comics' "pervading sense of gloom [and] sense of hopelessness and cynicism"). Miller also noted, "It's interesting that all this trouble is starting just when comics are starting to become worth an adult's attention."[131] And that year also saw the comic that has, to this day, made that argument most significantly.

Art Spiegelman had been serializing *Maus* in *Raw* through the early '80s, generally produced as a separate insert, as if to announce its own status. And people were recognizing it, with each installment, as something big. "If Spiegelman ever completes the entire work—what a loss if he doesn't!—'Maus' could well end up a masterwork," wrote one contemporary critic.[132] But even when enough had been completed to warrant publication between hard covers, Spiegelman racked up the rejection letters. Publishers didn't know what to make of it or how to categorize it; as a comic, it was thought to be trivial; as Holocaust literature, it was considered trivializing. Finally, Pantheon took a shot.

Spiegelman's tale of his father, Vladek, bleeding history, in the words of the book's first subtitle, wasn't just a work of Holocaust testimony at a time when America was newly considering the event. (*Maus*'s first publication in book form occurred almost exactly halfway between the influential 1978 television miniseries *Holocaust*—an episode of which

Spiegelman watched with a visiting Robert Crumb[133]—and 1993's *Schindler's List*.) It was just as much, if not more, about the effect this survivor's tale had on its primary listener and interpreter—the trauma done to Art (or "Art," since character and artist aren't precisely identical). *Maus*'s first volume ends with Art leveling the charge of "murderer"— knowingly, and powerfully in a book about the Nazi genocide, it's flung not at any German or Pole, but at Vladek, who has destroyed all of Art's mother's journals. He has not killed *her*—she committed suicide, something Art tries vainly to understand in the work—but he *has* killed the possibility of her story. And it is this that causes this artist-biographer such terrible pain.[134]

That said, the resulting, complicated dynamics of resistance and recovery mean Art betrays Vladek, too, incorporating material Vladek explicitly tells him not to include.[135] At times, Art practically bullies Vladek into keeping talking. *That* said, Art constantly questions his own actions and choices—artistic, personal, familial. ("I always am suspicious of my own take on anything," he told comics scholar Hillary Chute.)

All this is included in the work,[136] a work whose visual strategies are a haunting and unforgettable complement to the tale they illustrate: the expressionist cross-hatching frequently characterizing the memory parts, suggesting the impossibility of rendering the past in realistic manner; and, of course, the decision to abstract from human faces in favor of symbolically representing the characters as animals (with blank, expressive eyes borrowed from *Little Orphan Annie*).[137] Spiegelman wasn't the first creator to do so. A "cute and cuddly" version came out in France right after the war by Victor Dancette and Edmond-François Calvo, an English version following in 1946. Calvo's Germans, states the foreword, "are the blackest, most hypocritical, most treacherous Wolves you can imagine. . . . Walt Disney's Big Bad Wolf is nothing in comparison." The French are rabbits and squirrels, the Americans are buffalo, and so on. That same foreword notes, however, "Among the Wolves' atrocities, the persecution of the Jews is noticeably given very short treatment. This is probably because of the difficulties in dealing with a cast of animals.

For how could a Jew be portrayed? As a large-nosed Rabbit? Or as a big-beaked, greedy-eyed Magpie? Depicting them as Rabbits would be hard for the French to take, nor would the Magpie portrayal be really on."[138] With this the sentiment, the critic suggests when it comes to Jews, the problems of representation clearly aren't the only ones.

Nothing is given to us easily, however, and *Maus* constantly asks us to re-evaluate the ways we understand its aesthetic choices. Jews are mice, right? But what about Spiegelman's wife, Mouly, a French convert to Judaism? Should she be a mouse, too? What about when Jews are pretending to be non-Jews? And how to portray one Jew looking more "Jewish" than another—a very relevant visual difference in the Holocaust narrative, where "passing" for Aryan could be the key to survival? We feel Spiegelman struggling through these choices, key to *Maus*'s role not just as Holocaust discourse or comics autobiography, but as a crucial statement on a topic that would come to consume comics: representation and authenticity—who gets to tell whose story. Spiegelman noted his "metaphor is meant to be shucked like a snakeskin" (another animal image, as it happens, inappositely applied to human activity); "having hit upon the metaphor . . . I wanted it to become problematic, to have it confound and implicate the reader."[139]

As early as 1982, while *Maus* was still being serialized, one critic suggested to Spiegelman that "it stretches the boundaries of comics as art." Spiegelman agreed, based on both subject matter and length, "in doing something that's this long and this intense." "I liked the idea of reading a comic book you could put a bookmark into; a book which wasn't just a quick hit," he'd say. But it was also its care and craft, of course. *Maus* was also about Art's attempts to impose order and linearity on swooping memory—about telling this story in a way that combined history, memory, and imagination. "After *Maus*," a contemporary critic wrote, "nobody will ever be able to say that the graphic story medium isn't well-suited to convey the complexity and delicacy of human emotion. The goddamn thing is brilliant."[140]

BETWEEN SPANDEX AND SEATTLE

aus sold out its first two print runs (thirty-five thousand copies) within two months and received major national media attention. In May 1986, mystery novelist Janwillem van de Wetering and artist Paul Kirchner collaborated on "a mystery novel" in graphic form; in fact, *Murder by Remote Control* called itself that on its cover. The *Times Book Review* reviewed it, and, the next week, took on Harvey Pekar's *American Splendor* collection. That August, the *Atlantic*'s cover story was "Comic Books for Grown-Ups"; similar stories appeared earlier that summer in the *New York Review of Books* and the *LA Weekly*.[1]

In 1990, Spiegelman received a Guggenheim Fellowship to work on *Maus*'s second volume. Released in 1991, it received comics' first front-page *New York Times* book review, Michiko Kakutani crediting Spiegelman with "stretch[ing] the boundaries of the comic book form" and creating "one of the most powerful and original memoirs to come along in recent years." It received a special Pulitzer citation in 1992, in part because of the committee's difficulty in deeming *Maus* fiction or nonfiction. (The *New York Times* had originally categorized it as the former on its best-seller list; Spiegelman asked the paper to change it, raising the

specter of Holocaust denialism. The Gray Lady, albeit concerned about the mouse issue, agreed.)[2]

Spiegelman's achievement, and the press surrounding it, may have pressed the argument that comics could appeal to adults. But that wasn't telling comic shop owners anything they didn't know. By 1987, the *Times* reported the average comics reader to be around twenty years old and spending over ten dollars a week on comics, probably at one of about four thousand comic shops. Two years later, comic book store sales were 60 percent of total sales, estimated at $300 million annually, and the amount readers were spending had crept up to twenty dollars a month. By the mid-'90s, the average DC reader was twenty-five years old. And, overwhelmingly, male; the shops were, in Trina Robbins's words, "a boys' club all over again."[3] By 1996, writer Kurt Busiek could say, "It's been a generation since we started the direct market and we've run out of readers," the industry pushing, as artist Rob Liefeld put it a year later, "toward making comic books for the 40- and 30-year-old set."[4]

The comic shops stocked the independents, sometimes; and new anthologies like *Pictopia* and *Snake Eyes*, featuring artists "for whom the doors of perception exist only to be beaten down in a dark, dervish frenzy," put international artists in translation side by side with homegrown talent, just as *Raw* had, allowing widely diverse material to flourish. But as of 1989, most of these titles sold between three and five thousand copies, a few hitting a ceiling of about twenty thousand.[5] Which didn't bother the comic book stores one bit, because the direct market business was growing by 10 to 20 percent a year in the early '90s, Marvel selling almost three-quarters of its comics there. Comic book sales reached $850 million in 1993.

And by 1997, they were half that.[6]

It was a bubble, of course. They'd happened before—even recently. The first issue of Kevin Eastman and Peter Laird's 1984 *Teenage Mutant Ninja Turtles*, self-published for $1,200, transcended its gut appeal as a Miller-Claremont parody[7] by its genuine humor and heart, visual stylishness, and great action. By early 1990, the likenesses of the pizza-

loving testudines were licensed to nearly two hundred manufacturers; by 1993, an estimated 90 percent of American boys between three and eight owned at least one Turtles action figure, part of a $2 billion global industry (Eastman remembered people "fighting over them like Cabbage Patch Dolls"). *TMNT*'s massive success convinced readers, shops, and investors that there was money in speculating in black-and-white and alternative comics, leading to a "black-and-white" boom in 1986— and subsequent bust in 1987.[8] But *this* bubble was a different order of magnitude, focused, primarily, on marquee artists, taking the Adams/ Byrne/Miller brand-name model to dizzying new heights. In 1990, Todd McFarlane's first issue of a new Spider-Man title sold close to three million copies. A newly numbered *X-Men* 1 by Claremont and new superstar artist Jim Lee sold seven and a half million copies the next year; the first issue of a new X-title, *X-Force*, sold three and a half million. New royalty arrangements meant some artists made five to six figures on a single issue; there were rumors Lee made seven figures on that *X-Men*. In July 1994, X-Men comics accounted for 14.4 percent of the whole market. It was a speculative frenzy, and the companies egged it on with multiple covers—embossed, die-cut, glow-in-the-dark, holograms, gold and silver foil, polybagged, and so on.[9]

In 1992, McFarlane, Lee, and fellow white-hot artist Rob Liefeld left Marvel en masse to create Image Comics, which operated according to two main principles: creators owned their property, and the company wouldn't interfere with creative or financial decisions. In his introduction to that Spider-Man best seller, McFarlane encouraged artists to write their own books: "I don't profess to be a writer, but I do think I can tell a story . . . rely[ing] heavily on the artistic side." But the main impulse was financial. McFarlane, never shy, said, "Being the psychotic shit that I was—and I read all the interviews—I knew that Jack Kirby got *fucked*. That was the biggest revelation for me—if 'The King' can get fucked, *anybody* can get fucked!"

Image, as its name and cofounders implied, was less about story than cool pictures, and its "West Coast style" was about violence, big muscles

and bigger guns, and characters with names like Deathblow. (A rare surviving similarly named character from the period, largely because neither he nor his writers took themselves seriously, was Marvel's merc with a mouth Deadpool.) Other anatomical parts were also big, particularly on female characters, resulting in the so-called "bad girl phenomenon," featuring absurdly proportioned women in tight outfits and sexually suggestive poses. Readers could ogle Lady Death's "special lingerie edition"; "top secret covert combat force" Danger Girl had "the best female operatives in the world" wandering around in bikinis or skintight suits; if neither suited, there were Lady Rawhide, Razor, Avengelyne, Witchblade, Double Impact, Vogue, and Fatale. The exemplary group was Image's *Gen13*, whose female members constantly strained at their skimpy clothes and whose male members regularly ogled them. The series' knowing, self-aware tone (one special issue actually focuses around a character's attempt to obtain a special premium chromium-covered comic) doesn't excuse much.[10] Perhaps it's not surprising that, while there was essentially gender parity in the comics audience in the mid-'40s, girls constituted a minuscule percentage of readers in the mid-'90s.[11]

But Image's business model, boosted by speculation, seemed rocket-powered at the start, amplified by trade magazines like *Wizard*. Advance orders for Liefeld's *Youngblood*, Image's first issue, were 307,000, then the highest ever for a creator-owned book; the first issue of MacFarlane's *Spawn* sold 1.7 million copies; twenty-six thousand people waited in a line a mile and a half long to see Image creators in an infamous "tent show" outside Chicago Comicon.[12] But within a few years, Image contracted radically, and its chronic lateness in shipping its comics, anathema to a direct market model that bought up front and expected regular product for weekly retail display, was part of the perfect storm that led to the precipitous decline of the comic store.[13]

A substantial rise in paper prices in 1994–95, contributing to rising comic prices, didn't help, either; numerous companies closed in the mid-to-late '90s, unable to ride out the storm. There were some storied names among them: Denis Kitchen's Kitchen Sink Comics collapsed in 1999,

partly due to recession, partly to corporate overcleverness. "An ignomin-
ious end to a thirty-year run," Kitchen put it at the time.[14]

In 1996, a state-of-the-industry report noted, "With the price ceiling
for comic books hovering around $3, trade paperbacks look to be a viable
way to circumvent that limit and maximize returns in the face of the
increased ink and paper costs." "No one has a problem with paying $20
for a novel," another source said.[15] These collections had been around for
a decade. In 1987, Marvel had announced Marvel Masterworks, "deluxe
hardbound editions of selected comics," not only appealing to audiences
wanting canonical material but offering higher profit per unit: accord-
ingly, over 140 graphic novels and trade paperbacks were announced for
the first half of 1988. Marvel then forged ahead with Simesque phone
books full of Essential reprints, in black and white and on newsprint, in
1997; DC countered with high-quality Archive Editions of works from the
Gold and Silver Ages, then followed the newsprint model with Showcase
editions. Companies like Fantagraphics and NBM began producing runs
of classic newspaper strips in high-end editions.[16] All these gave rise to
what one critic dubbed the "*Cerebus* Effect": "A process whereby sales
on a serialized title drop over time as collected editions of the title are
increasingly available."[17]

And, crucially, they could be sold in bookstores.

In 1985, Marvel took a booth at the American Booksellers Associa-
tion conference; the May 1987 edition of *American Bookseller* magazine
observed that graphic novels "were fast becoming an industry buzz-word"
and predicted most bookstores would have a graphic novel section in the
next year. At Angoulême, the premiere European comics festival, the
1986 Prix Alfred, awarded to the year's best comic, went to the Franco-
American collaboration *The Magician's Wife*, a tale of eros and obses-
sion that blended psychological naturalism and folklike fantasy. Jerome
Charyn wrote in his 1987 English introduction, "There are signs that this
new French Revolution is beginning to reach the United States. . . . [T]he
graphic novel, which Americans have resisted for so long, now seems a
little less irregular or remote."[18] In 1989, a Waldenbooks ad trumpeted,

"Who says comics are just for kids? Certainly not Waldenbooks! . . . These adult-oriented cartoons have enjoyed years of success in Europe and are now available in our stores. Introducing . . . GRAPHIC NOVELS!"[19]

And then came the coup de grâce—from Marvel, whose dismal fortunes in the '90s were determined in the corporate boardroom and swamped the comic shops.

In 1989, Marvel's publishing division was purchased by Wall Street titan Ron Perelman. Perelman, who claimed he "didn't know how to read comics," had seen dollar signs in the success of that year's *Batman* movie—and the even more phenomenal success of its associated merchandise. He took the company public in 1991, and not only loaded it up with debt, but also tried pleasing shareholders by extending market share, largely by flooding the market. By the end of 1993, Marvel was publishing 150 issues a month, counting on so-called "Marvel zombies" to buy mindlessly, playing on collectors' completist tendencies with increasingly tenuous and wide-ranging crossovers—in a 1995 presentation, a Marvel VP said a quarter of Marvel readers spent over $100 on their titles every six months.[20]

At the same moment, in November 1992, DC had an even larger commercial success, with complementary consequences: Superman died.

He'd "died" before, but in one of those "imaginary" stories; this, at the hands of the appropriately named Doomsday, was for real (the issue consisted entirely of splash pages, providing a fitting sense of occasion). The sales were stratospheric—comic shops were doing $30 million of business *a day*—and the outpouring of genuine emotion among a broad swath of adults was a reminder of these tales' mythic hold.[21] After a while (a long while, admittedly, by comics time), Superman came back, as the commercially and cynically minded always knew he would. But a new lesson had been learned, and such stunt events continued, where the momentum rose and the stakes lowered and reader enthusiasm waned and resentment curdled.

Peter Parker and Mary Jane Watson had gotten married in 1987 (Stan Lee officiated a "real-life" wedding at Shea Stadium). In the mid-'90s, he

was revealed as a clone. In the years that followed, his girlfriend Gwen Stacy, whose death had arguably set even higher emotional stakes than Jean Grey's, was "revealed" to have been: (a) cloned; (b) in an affair with the Green Goblin; and (c) the mother of secret twins, causing outrage among fans.[22] And the continuity reaccreted, with DC and Marvel series and crossovers whose complexities were so labyrinthine, they bled into surrealistic mirrors. Two perfect summations: in 2002, French artist Gilles Barbier created the installation *Nursing Home*, comprising wax dummies of "aged superheroes slumped over, gurneyed, or otherwise sprawled before a television set declaiming advertisements"—his critique of mass culture aside, the piece showed the exhaustion radiating from the characters.[23] Several years later, Robert Kirkman's intensely popular series *Marvel Zombies* served, in one perceptive critic's eye, as "a perfect allegory for Marvel's aging superhero universe. Marvel's core of unkillable characters/properties can neither expire nor radically change; they can only endlessly recycle and cannibalize characters and situations that have succeeded in the past."[24]

Higher prices, bookstore competition, speculative frenzy, narrative exhaustion—and then, an eyebrow-raising and alarm-sounding move from Marvel in 1995, when it bought North America's third-largest comics distributor, Heroes World.[25] The acquisition meant stores would have no choice other than to deal with a single distributor at whatever terms it chose. When Heroes World collapsed and the dust settled, it was Steve Geppi's Diamond that emerged with a near-monopoly in the stores, controlling 90 percent of the market by 1998. All this vertical integration made things more difficult for shop owners and controversial comics artists, and smelled like illegal trade restraint to the Justice Department, which started investigating the industry in 1997. (The investigation would be closed, without presenting findings, three years later.)[26] But the damage was done: the number of American comic stores dropped from ten thousand in 1993 to about 3,500 in 2001.

Marvel suffered, too. One of its few champions, Toy Biz co-owner Avi Arad, had told potential investors in 1997, "What do you believe Spider-

Man is worth? . . . I think Spider-Man alone is a billion-dollar entity." Arad kept pushing for movies, good movies. But investors didn't believe in this "character equity" (the language used in a 1995 investor presentation),[27] or, at least, couldn't see the short-term profit in it. Perelman, locked in a corporate battle with investor Carl Icahn, watched Marvel's share price drop from $35 in 1993 all the way down to fifty cents; Perelman filed for bankruptcy protection in 1996, and the New York Stock Exchange moved to delist it in 1998. After a head-spinning series of corporate maneuvers, Marvel eventually came under the control of Toy Biz's Arad and, particularly, its key shareholder, Ike Perlmutter.

The smart money *did* seem to be in toys, and in licensing, something Perlmutter had known when he bought the company. In 1989, comics characters represented 18.5 percent, or $12 billion, of the international licensing business;[28] before its final collapse, Kitchen Sink had been making significant profits on candy bars, so much so that executives had hoped that income would cover losses on the company's comics. Image, like other companies, went in on toy-based licensed comics series like *G.I. Joe* and *Micronauts*;[29] Todd McFarlane, arguably its lead figure, was spending less time drawing comics than fundamentally transforming the toy business. "Our action figures are not really action figures," McFarlane's colleague said in 2000. "They're more collectible touchstones, conversation pieces."[30] Of Marvel's 1998 revenue, 81 percent came from toys and licensing, just 19 percent from comics. Unsurprisingly, new Marvel CEO Peter Cuneo said in 1999 that "the Marvel Characters Group will be running the characters as brands."

And nothing sold those brands like movies. Tim Burton's 1989 *Batman*, at the time the fastest-grossing movie ever,[31] transformed the industry—as much a licensing and tie-in phenomenon as a ticket seller. While Hollywood accounting could still consider the movie $36 million in the red as of 1991, screwing those with a claim to net profits, the *Advance Comics Special Batlist* "offered 214 items ranging from $576 to $2 in price." The *Batman* movie *soundtrack* sold 150,000 copies; J. C. Penney was selling twenty thousand Batman T-shirts a week.[32] Still, while

the industry moved to replicate *Batman*'s success, with over seventy movies based on comics in production or preproduction as of April 1992, few made a big splash in the next decade; arguably, 1998's *Blade* was the next important comic book film not a Bat-sequel, the comics origin of 1997's *Men in Black* notwithstanding.[33] Part of this was almost certainly that perennial question of special effects (1988's *Who Framed Roger Rabbit?*, generally considered an aesthetic high point, wasn't technically a comic book). Animation, which didn't have such limitations, entered a second Disney golden age in the '90s, and the small screen witnessed an animation revolution of its own (1989's *The Simpsons*, 1992's *Batman: The Animated Series* and *X-Men: The Animated Series*, 1994's *Spider-Man: The Animated Series*) along with, increasingly, live-action shows (1990's *The Flash*; 1993's *Lois and Clark*).

Lines between screen and page blurred accordingly.[34] The *Batman Adventures* comic book shared the animated series' look and style:[35] "Watch the hit series on WB Kids!" read the cover of the trade collection *The Batman Strikes! Duty Calls*.[36] The early-'90s Sam Kieth creation *The Maxx*, a sort of damaged superhero id, became a mid-'90s MTV show; a new company, Dark Horse, founded in 1986, did good business with movie tie-ins like *Aliens* (1988), *Predator* (1989), and *Terminator* (1990). All this led to increasing comfort with locating comic business in California: although in the '70s it had been an article of faith that to work in the industry you needed to live within commuting distance of midtown Manhattan, things changed with DC's awareness of the talent (and low cost) of Filipino artists, and then, later, the advent of Federal Express, which could move art quickly anywhere.[37] It was a shift that would facilitate an increasing convergence between comics, corporatism, and other media.

———

AS EARLY AS 1967, Gene Roddenberry had premiered the *Star Trek* episode "Amok Time" to 1,500 people at the World Science Fiction Convention; the response it received "marked the turning point of sf cons to media-oriented rather than predominantly literary events."[38] But the first *Star*

Wars public presentation, in 1976, took place not at WorldCon, but at San Diego Comic-Con; three years later, a preview of *The Empire Strikes Back* showed there to a huge audience. Those '70s convention-goers could never have imagined what Comic-Con would become: thirty-six thousand attendees in 1996; forty-five thousand in 2000. And its demographics were changing: in 2000, first aid personnel reported that the con's "worst and most common maladies . . . were blisters on the feet of women who had walked all day in high-heeled shoes," testament to increasing female attendance.[39]

The best-attended daytime program of 1998's Comic-Con focused on actors from *Buffy the Vampire Slayer*, series star Sarah Michelle Gellar's absence notwithstanding.[40] The next year, cartoonist Evan Dorkin noted, "What we've become is a really interesting artistic medium and a slightly large commercial medium, but no mass market. All we've become is a petri dish for mass media, and that's how we survive." The concern, as with television in the '50s, was other entertainments successfully competing for the comic book dollar, which, itself, bought less and less comic: as one comic shop owner put it in 1995, "$1.50 is a lot of money for a kid to put out for a comic. You're talking about 15 minutes of entertainment versus six rounds of Mortal Kombat. I think that Mortal Kombat is going to win every time."[41] But video games—at least, video *arcade* games—would go the way of another technological development, one that transformed every element of the comics business, along with every other business.

In 1984, science fiction story *Shatter* was the first full-fledged comic to be drawn on a computer; crude as the Macintosh art was, people saw its implications clearly. *Batman: Digital Justice* (1990) featured computer-generated art in a cyberpunk story in which the Joker is a virus in future Gotham City's net. CD-ROMs of *The Complete Maus* and *Will Eisner's The Spirit* appeared in the early to mid-'90s; so did undergrounder Robert Williams and Timothy Leary's graphic novel, set on the ConsciousNet, featuring trippy computer text against a backdrop of even trippier screensavers.[42] Digital technology was soon revolutionizing all aspects of the industry. Late-'70s DC colorists had 124 color combinations; by the mid-

2000s, there were millions (to say nothing of digital effects like blurring filters and the ability to blend drawn and photographic images almost seamlessly).[43] By the turn of the century, artists like Kyle Baker and Art Spiegelman had begun drawing directly on the computer.[44]

Scott McCloud evangelized at the Festival of Comic Art in the summer of 1995 that "the digital environment is here now." Many cartoonists laughed, or didn't get it. But inevitably and inexorably, comics adapted to the web. In 1996, DC started posting a 1940s *Superman* radio serial episode online each week.[45] By 1998, Marvel sold a "Zone Card" at comic shops allowing buyers thirty-day access to a Marvel Zone website, and *Swamp Thing* artist Rick Veitch designed Comicon.com, a self-publishing website for creators like Alan Moore and Dave Gibbons. That same year, Spain, Jason Green, and Paul Mavrides produced the interactive feature *Dark Hotel* for the online magazine *Salon*; clicking on a given room let you read that week's installment of an ongoing strip. That same year, Mile High Comics' proprietor claimed to have realized a million dollars in income from his website, and the next year, 1999, announced a partnership with Amazon.[46] These new technologies naturally yielded new legal questions (a CD-ROM of *Heavy Metal* comics was put on hold when contributors realized they weren't being compensated for their work)[47] and new communities.

The word *Trekkie* was coined at that same 1967 convention where Roddenberry showed "Amok Time," and much active fandom had coalesced around *Star Trek*—not simply expressed through collecting and merchandising, but also by creating amateur work.[48] *Trek* fan fiction is generally considered the original fan fiction ("fanfic"); "slash" fiction— erotically charged fanfic featuring encounters between canonically non-romantically involved characters, often in ways that challenge conventional norms—began then with Kirk-slash-Spock stories. Such work inevitably raised questions about what *was* canon and who controlled it, an early step in considering these characters less as corporate intellectual property than as shared myth.

Perhaps the earliest notable example of mass fan outrage linked to

new technological possibilities for fan involvement was 1988's infamous "telephone stunt." After Dick Grayson's departure, Batman acquired "new Robin" Jason Todd; unpopular with fans, DC decided to get rid of him. But how? They decided to put Todd in an explosion and give readers two call-in numbers: call one number to vote that Jason lived; the other to vote that he died. "Robin will die because the Joker wants revenge. But you can prevent it with a telephone call," read the ad (noting in the fine print that the call cost fifty cents, a little more than double that today). The vote: 5,343–5,271 for death. The backlash was profound. Editor Dennis O'Neil issued a mea culpa the following year, saying DC had failed to grasp how profoundly Robin and other such characters are "our post-industrial folklore . . . part of the psychic family." Which was the precise argument the eventual third Robin, Tim Drake, made to Batman to take him on: "Batman needs a Robin. No matter what he thinks he wants."[49] The fans, after all, would settle for nothing less than immutability.

Fan fiction reached new levels of pervasiveness: by 1999, websites like The Definitive X-Men Erotica Archive and Wonder Woman and Friends appeared, the latter featuring stories like "The Domination of Wonder Woman" and "Wonder Woman in Slave Training."[50] Although much fan fiction was written by women, the demographic mostly doing the objecting was by and large male, white, and of a certain age. (Industry slang for such types—FYOVs, for Forty-Year-Old Virgins—long preceded the movie of the same name.)[51] In 1999's *Fanboy*, Mark Evanier and Sergio Aragonés had title character Finster imagine himself in his beloved superhero universe. Forced by Wonder Woman's lasso to tell the truth ("Not to me," she says, "to yourself"), he breaks down: "The truth is that I'm scared . . . scared of real women. . . . the ones in comic books are so easy to understand! You can even read their thought balloons!"[52] This dissection of fandom wasn't limited to mainstream artists; alternative creators, frequently childhood fans themselves, sometimes envious over the attention paid to mainstream creators, got in on it, too.[53]

The mid-'90s saw the rise of the Comics and Animation Forum on CompuServe; an early observer characterized it as "an agglomeration of

people who see themselves as 'in the know' chatting and bitching and moaning about their petty beefs with the comics industry."[54] "Abolish the word 'I' on the Internet," one critic suggested; it "will at least keep the conversations directly aimed at comics, rather than on the people having the conversation. That would be a great start."[55] But this seemed like a false dichotomy, since, increasingly, people doing comics were using the word *I* a lot themselves in their work.

═══

IN 1997, Art Spiegelman suggested that "autobiography has become the primary mode of underground comics—like what superheroes are for the other branch of the comic family tree." Ten years later, Alison Bechdel said she always felt "there was something inherently autobiographical about cartooning . . . it almost demands people to write autobiographies." Pioneer Will Eisner certainly felt the demand, producing more autobiographical material following *Contract with God. The Dreamer*, originally appearing in 1986, grew in the telling from "a work of fiction" to "the shape of a historical account . . . from the yellowing memories of my experience."[56] Eisner's roman-à-clef history of his and comics' youth has a certain rosy-eyed retrospectiveness; but its portrait of an artist as, yes, a young dreamer fulfilled an aesthetic promise readers (especially mainstream-ish ones) had looked for.

But other very different portraits emerged, in tune with emotionally spikier currents. Like autobio pioneer Harvey Pekar, Dennis P. Eichhorn had a variety of prominent artists illustrate his life stories. But while Pekar mined the quotidian, Eichhorn showcased gonzo bizarrenesses, repressing little to nothing. Muggings, punching-punctuated sexual encounters, assisting dominatrixes, watching dogs engage in uncharacteristic sexual activity—neither an ordinary nor exemplary life, to be sure.[57] This approach to life, what we might call American Weird, was reflected in the work of one of the immediate post-*Maus* era's most important creators.

Daniel Clowes had cut his teeth on an early-'80s EC take-off, *Psycho*

Comics, but found his métier in the "late '50s to early '60s schlock" left around the house by a decade-older brother: Kurtzman parodies, old art directors' annuals, paperback covers, record sleeve art, and old *Superman* comics—his first important character Lloyd Llewellyn's name was inspired by those comics' double-L phenomenon.[58] His series *Eightball*, begun in October 1989, featured weirdos: not Crumbian pervert weirdos, but bizarre, alienated individuals seeking same. In the *Eightball* universe, everyone is sweaty, pimply, often overweight; they look like flounder under morgue lights. A lead story, *Like a Velvet Glove Cast in Iron*, is about a man's obsession with an extremely odd movie; trying to track down its kindred-spirit creators, he encounters a sad and bizarre coterie, including a fish-woman, herself the product of an encounter between a lonely woman and a quasi-merman. A later *Eightball* series, *Ghost World*, featured two teenage girls whose close bond constantly vacillated between contempt for less-sophisticated others and ironic self-knowledge about how much their own attempts at hipness were illusions (or, perhaps, ghosts).[59]

Hatred flows everywhere in *Eightball*. "Here are some more people I can't stand," begins a second-issue taxonomy. In issue 4, Gilbert Hernandez writes in praising the title, "PS. Please print this so people will know I don't really hate everything," he says. In issue 13, Clowes draws Peter Bagge's famous character Buddy Bradley opining on twentieth-century culture; at the time, Bagge was producing *Hate Comics*, which had relocated Bradley to Seattle just in time to manage a grunge band with members Kurt, Kurt, Greg, and Kurt. (The band's name continually changes, cheekily name-checking other independent comics.) Bagge castigates Buddy's laziness, entitled white-guyness, and general misanthropy: a review of his type by a former roommate, "Is There Any Hope for Generation X?," suggests that the proliferation of Buddies "represents not only a failure of our mass culture and educational system, but a failure by the more enlightened among us for even tolerating the likes of them."[60]

But the hatred flows most prominently inward: self-loathing everywhere you look. *Ghost World* protagonist Enid Coleslaw's odd name is

explained by its anagrammatic equivalent, Daniel Clowes; another continuing *Eightball* series, the self-castigating, quasi-autobiographical adventures of "Young Dan Pussey," a rising comic book artist, features the authorial stand-in, asked to draw from "personal experience" and "real life," staring vacantly at a blank sheet of paper. In a "masturbation fantasy" in the fourth issue, the character suffers intrusions by his mother and a muscleman flyer.[61]

Clowes was certainly building on the work of former self-lacerating comics artists. By 1994, Crumb referred to himself as an "old curmudgeon," and, like most curmudgeons, he hadn't changed much, if at all: a 1992 Mr. Natural and Flakey Foont story has the duo have sex with a woman without a head. ("The head was always a big problem," says Mr. Natural. "So I got ta thinkin' and figurin'—why not just get rid of th' head?!"[62]) The thinness of the line between satirical exaggeration and expression of hatred in Crumb's work came to the fore in 1994, when two controversial *Weirdo* contributions, "When the Niggers Take Over America" and "When the Goddamn Jews Take Over America," were reprinted in the white supremacist *Race & Reality* (without Crumb's permission); the artist told the *San Francisco Examiner* he'd been worried someone would take them literally. The weariness was palpable. In 1998, he concluded *Zap* for good, suggesting, "This is a medium for the young . . . there's a new generation . . . they're hot, they're blowing us old guys off the stage! Look at us . . . we're just a bunch of characters out of a Dan Clowes comic!"[63]

"Dear Stupid," Laura Bernard writes in the letters page to *Eightball*'s eleventh issue. "You're not as sorry as you always draw yourself. Why do artists always have such a skewed view of how they look?" But this kind of self-critique was not uncommon among contemporary comics artists, most notably a trio hailing from our northern neighbor. Chester Brown's '90s works *The Playboy* and *I Never Liked You*, the latter an aching tale of youthful love, awkwardness, and sublimation, presented the author, while not unhandsome, as incapable of making erotic and personal connection. In pseudoautobiography *It's a Good Life If You Don't Weaken*,

Gregory Gallant, better known as Seth, tracked down traces of an obscure (fictional) cartoonist, in the process contemplating his ("his"?) own spectral, ephemeral nature, incapable of forging lasting bonds with lovers or family—aided, in no small part, by the silent panels that permeate the work.[64] In *Fair Weather*, Joe Matt, who would take the phrase "self-flagellating" to new depths (his 1992 autobio comic was revealingly called *Peepshow*; he describes a later work, not inaccurately, as "masturbation in comic form . . . no payoff . . . no epiphany . . . no nothing"), unforgettably presents himself as a rotten little kid, and, yes, fair-weather friend, behaving monstrously toward family and friends for money and comic books.[65] Back in the lower forty-eight, Bob Fingerman presented a portrait of the young, hungry, and horny cartoonist grinding it out (often in both senses of the word) in the very funny and often very filthy *Minimum Wage*, a tale of late-'90s New York very different from that depicted in the sitcom *Friends*. Rob tends to mostly draw for porn mags, but has his elite standards: "They still rack *Maus* next to *Dilbert*," he tells his friend, mournfully.[66]

All these, of course, are personas, representation, and all very, very male. But not all the period's great autobiographers were focused on masculinity. Lynda Barry had started out in *Wimmen's Commix* in the early '80s; in her *One! Hundred! Demons!*, she writes about when "the shattering into pieces became a way of life" and summons individual scenes-as-demons, sketching them, controlling them, exorcising them, making them into art and "autobifictionalography." *The Fun House* (1987)[67] shows this malleable strength by constantly, dizzyingly, shifting readerly sympathies; Barry presents childhood teachers as figures of fun, then undercuts that satiric perspective with a powerful and deadly sense of humanity. In doing so, she presents her past as a wild place, full of regret, danger, and pathos, that emerges most prominently in its retrospective analysis.

The trauma this kind of work investigated took its most literal form in chronicling medical matters, whether Justin Green/Binky Brown's OCD or, in the words of this 1975 announcement by the publisher of *Amputee Love*:

What you have in your hands is a most exciting and liberating book. This is a graphic novella about a woman amputee and her friends. The authoress, a double amputee, is Rene and her husband Rich did the illustrations. . . . If you are an amputee or have had any interesting experiences with them we would like to hear from you.[68]

Given the nature of underground comix, the nature of protagonist Lyn's liberation—proof of recovery from the accident where she lost her leg—was unsurprisingly sexual ("Have you any idea what it's like to make the scene with a one-legged chick? . . . No? Are you willing to try it out? Yes?"). But here, rather than primarily pornographic, it was explicit: telling truths about bodies. Such an approach, combined with the central authenticity of autobiographical testimony, would explode in the late '80s and '90s and shape a new genre of comics.

Although there were other Anglo-American predecessors and contemporaries (Al Davison's late-'80s comics chronicling life with spina bifida; Harvey and Joyce Pekar's depiction of struggling with Harvey's cancer),[69] the autobiographical comic reached maturity in the age of AIDS, and many artists went "on record," so to speak, in the 1988 benefit anthology *Strip Aids U.S.A.*, following a similar British collection. (As did Archie Comics, which included an AIDS education message in its digests that same year.)[70] DC's mature line, Vertigo, then best known for *Sandman*, simultaneously published a very different tale of desire, despair, destruction, and, ultimately, death in the autobiographical reflections of David Wojnarowicz, a gay teen hustler who never got to fully grow up.[71] *Seven Miles a Second* deserves to stand with *Angels in America* as one of the formidable chronicles of America's AIDS epidemic, imbued with the passionate ring of authenticity: "I've been so fucking ill: constant nausea headpains unable to shit for weeks and having bone biopsy intestinal biopsy and blood work and doing all these drugs that don't do shit for me." James Romberger's street scenes are hell in low light, a lurid glow rendering everything sickly, dangerous, and, in its own way, compelling,

if not inviting. The work's ending—"I am waving. I am waving my hands. I am disappearing. I am disappearing but not fast enough"—is the pure distillation of the artistic condition in the face of personal trauma.[72]

Fledging cartoonist Judd Winick participated in MTV's 1994 hugely popular reality show *The Real World: San Diego*, rooming with Pedro Zamora, an AIDS educator and victim. In his account of his time in the house and after, Winick, who would become a well-known comics writer, gracefully and poignantly deals with questions of prejudice and representation, as when he pictures Pedro as a walking virus on two legs before actually meeting him.[73] But perhaps comics' most profound statement on transmitted disease, sexual or otherwise, never mentions it by name.

Charles Burns had earned notice with hard-boiled detective parodies that engaged his love of '50s science fiction, monsters, and mutations to accentuate his only vaguely classifiable interests in bodily metamorphosis. El Borbah, Burns's hyper-violent detective dressed like a Mexican wrestler, encounters people addicted to replacing body parts with robotic limbs, and cryonically frozen heads sewn onto babies' bodies; Burns's tales in the '90s featured an all-American boy with a Labrador retriever's heart and a Hollywood starlet mistakenly surgically "repaired" to resemble the GI whose dog tags were found on her after a bombing.[74] But Burns's "sex meets the invasion of the body snatchers" idea, which he'd worked on since the late '80s,[75] matured into a mid-'90s masterwork.

Black Hole is a distant descendant of those safe-sex comics; in Burns's telling, anyone having sex with someone with "the bug" contracts it and undergoes physical changes, everyone differently—usually, though not always, monstrously. But the "black hole" in question doesn't only conflate sex and death (a familiar late-'80s formulation, those plague years, those ACT UP signs), but desire and oblivion as well; recall that a black hole is where light goes to die, sucked in by enormous gravity. Burns said that, while "obviously the direct AIDS metaphor is there . . . I was just thinking about sex being this dangerous and frightening thing rather than what it's supposed to be."[76] Burns's novel is full of images of floating,

falling, succumbing to desire; fear and passion and self-destructive and suicidal tendencies all together at once. It's about that terrifying black hole up ahead called adulthood, and, particularly, puberty (which can be described similarly to the bug's effects—the yearbook photos that serve as the book's endpapers, depicting students before and after infection, are a study in metaphorical acne).

High school is all about social circulation, as is disease. (STDs were once called "social diseases," recall.) *Black Hole* addresses how diseases stem, at least sometimes, from choices, albeit choices clearly inflected by peer pressure. The bug's visual metaphorization is an effective public health announcement, but it's also a metaphor for how inside and outside don't always match up, a lesson taught by almost every high school movie. The bug makes major protagonist Chris Rhodes shed her own skin; facial disfigurements make many other victims look like they're wearing cheap Halloween masks.[77]

For some groups, there was an additional anxiety: the fear from inside the closet. The Code had stifled discussion of sexuality of almost any sort, especially non-heterosexual,[78] but even the underground, with its openness to sexual display, largely demurred. Notable exceptions included the first lesbian comic ever published, Mary Wings's *Come Out Comix*, printed on an offset press in the back room of a women's karate center, and Roberta Gregory's ironically nuanced 1974 "A Modern Romance," for *Wimmen's Comix*, which ended with a quote from Blake: "Children of the future age, reading this indignant page, know that, in a former time, love! Sweet love! Was thought a crime!" Gregory sold most of a ten-thousand-copy run of her *Dynamite Damsels* (1976), in which many stories "are based on true life experiences—of myself an' other women I've known," in women's bookstores.[79]

Simultaneously, Howard Cruse was producing tales of individuals struggling with their desire for self-truth and self-liberation but constrained by upbringing and social norms. Cruse's first memories of same-sex desire were fantasies of rescue by Superboy, who "would pick me up in his strong arms and carry me home"; growing up in the South,

closeted at work, deeply uncomfortable "with the sense of complicity that exists throughout the culture that everybody's straight" even in the underground scene, he decided by the early '70s that he "wanted to be 'out' professionally and do openly gay work," but, simultaneously, "did not want to rise to prominence on that basis. . . . I wanted people to know my name before they knew I was gay."[80]

Cruse was then known primarily for *Barefootz*, a strangely philosophically and theologically minded gag strip involving a barefoot protagonist and cockroaches given to Transcendental Meditation. Barefootz was heterosexual; and in a contemporary *Bizarre Sex* story where Cruse presents himself as helplessly sexually aroused by drawing comics (to very explicit premature ejaculation), his sexual/artistic experimentation is with a girl. But the experimentation fails; and when she leaves, angrily shouting, "Give me a call when you grow up, Mr. Cruse!!" Cruse says, "Eventually I did grow up—but I never called her!" combining maturity with embracing his own sexual identity as artist and gay man.

And so *Barefootz*'s second issue, in 1976, announced, "And now let's dip a toe into the gay subculture with Barefootz's good buddy Headrack!" (A customer Headrack comes out to concludes, "This guy's ok for a faggot . . . as long as he keeps his fuckin' hands off me, that is!")[81] In 1977, underground publisher Krupp produced Kruppcards for various occasions ("Congratulations on Your Big Dope Deal"); Cruse drew what "appears to be the first gay greeting card." And in 1980, Cruse began *Gay Comix*. His letter to potential contributors noted that "many gay artists have never included the gay facets of their lifestyle in their published work, whether from fear of ostracism on a personal level, possible negative reaction from fans, or the chance that homophobia among editors or publishers could result in long-range career damage." Juxtaposed against a controversial portrayal of gay men as "thugs and rapists" in a recent issue of *The Hulk*, as well as adverse reaction from some of the male undergrounders, it was more than high time.[82]

Cruse told stories like "Billy Goes Out," about a young man engaging with the sexual and personal freedom the world had to offer. But he

also wrote 1981's "Jerry Mack," whose protagonist envisions the life he could have lived if he'd lived his truth—instead, he's in a heterosexual marriage, tormented by his desires. And in *Gay Comix*'s fourth issue, he wrote "Safe Sex," the first time AIDS was addressed in comics, realizing that "if something called *Gay Comix* came out in the year 1983 and did not mention AIDS . . . then any claim the comic might have to relevancy would be a farce." Its first page features an anxious artist diving headfirst into word balloons containing snatches of dialogue that could have come from the mouths of many gay men then ("He started getting so thin"; "I just can't take another funeral this year"). In the story, a character named Billy is said to be dead; Cruse has said it's the Billy of "Billy Goes Out."[83]

For a gay audience not attuned to undergrounds, exposure to such comics came via the emerging network of gay and gay-friendly newspapers and periodicals. (For a non-gay audience, it was mostly just *Doonesbury*, where, on February 10 and 11, 1976, Joanie finds out her old boyfriend Andy is gay, the first openly gay character in mainstream comic strips. "Are they sure?" Joanie asks. "I'm sure, Joanie," Andy replies.)[84] *Gertrude's Follies*, about Gertrude Stein and Alice B. Toklas, premiered in 1978 in the *Soho Weekly News* and the *Advocate*; creator Tom Hachtman said, "A comic strip about a lesbian couple and all their artist friends . . . There weren't too many newspapers that were going to publish this."[85] Cruse had an ongoing strip in the *Advocate*, too, a quasi-bildungsroman about a young gay man named Wendel Trupstock, whose playful narrative turned more serious as homophobia, AIDS, and gay rights activism increasingly colored the comic. And Tim Barela's tales of happily partnered Leonard and Larry (well, happy as any long-term couple), struggling with a Jewish mother-in-law, the leather business, ex-wives, and early grandchildren, combined Trudeau-like satire with classic gag strip hijinks.[86]

The most prominent figure emerging from this milieu was Alison Bechdel, who "got out of college in 1981, and went into a gay-and-lesbian bookstore one day, and found an issue of *Gay Comix*—I think it was the first one, that Howard Cruse had edited—and that was pretty mind-blowing."[87] *Dykes to Watch Out For* started in 1983, first as single

panels, then strips appearing in feminist magazine *WomaNews*. As Bechdel put it:

> Imagine my sense of purpose when one day it occurred to me to harness the central organizing principle of my existence—my lesbianism—to my sole other interest—drawing silly pictures. Through my cartoons, I would prove to the world, or at least other lesbians—or, failing that, myself—that dykes were human. . . . I remained uncompromising in my insistence that lesbian stories were human stories, and if people didn't like it they could just read *The Family Circus*.[88]

The back of her 1986 *Dykes to Watch Out For* collection, consisting of cartoons that had appeared in *Chicago Gay Life*, *Common Lives/Lesbian Lives*, *Gay Community News*, *Hot Wire*, *Lesbian Contradiction*, and *Philadelphia Gay News*, called her "a graphic illustrator of dyke delights and foibles, well-versed in the mores and quirks of the lesbian community she celebrates."[89] Similar to Armistead Maupin's equally long-running *Tales of the City* (and, for that matter, to *Doonesbury*), Bechdel followed several members of that community in real time; by 1995, her books and calendars had sold over one hundred thousand copies.[90] The strips poked at the confining and comforting boundaries and stereotypes of sexual orientation. In 1990, Mo and Lois read the personals at Madwimmin Books. "Jeez!" Mo says, reading an ad that says, "No Dykes." "What's the lesbian nation coming to?" "Maybe in a way all this is a good sign," Lois responds. "Like, maybe we've grown enough as a community that it's safe now to speak out against lesbian-feminist monoculture. After all, lesbians AREN'T all androgynous, vegetarian radicals. Some of us LIKE dresses and makeup! Some of us even voted for Bush!" "NO!" Mo responds, genuinely shocked.[91]

"To be perfectly honest," Bechdel said of her characters, "they're more vehicles to me than characters. Vehicles to talk about things I want to talk about."[92] And the conversation spread. In the early '80s, former

manga bookstore browser and future internet evangelist Scott McCloud produced *Zot!*, about a boy who visited our world from, as McCloud put it, "a sprawling amalgamation of everything worth saving from our world," including bits from Silver Age, Japanese, and French comics. (It was raved about in *The New Yorker*'s "Talk of the Town.")[93] As the decade progressed, McCloud took the comic in a darker direction. Zot is beaten while trying to help a crime victim, as onlookers stand by doing nothing; and his utopian world began to dissolve into ours as he became stuck on our Earth.

The resulting "Earth Stories" focused on more minor characters, investing them with depth and dimensionality. Most notable was 1990's "Normal," about a high school character's deciding whether to out herself. "Look what they've done to you," Zot comforts her, wrapped in her closeted pain and grief, and his phrase resonated. As McCloud said, while Cruse and Bechdel had treated the subject earlier (as had *Tales of the Closet*, published a year after *Maus* by a nonprofit, aimed at gay and lesbian teenagers to "let you know that you are not alone and that there are answers"),[94] it was in work either "hidden behind an 'over 18' curtain or banished entirely" from mainstream comic readership; for many young readers, "*Zot!* 33 stood a decent chance of being their earliest encounter with such themes in a comic book."[95]

That began, slowly, to change. GLAAD praised a 1991 run featuring reformed *Flash* villain Pied Piper coming out, for illustrating "there are no obvious 'signals' to indicate who is or is not gay"; when Marvel superhero Northstar came out during combat, his opponent, Mapleleaf, chastised him for not doing so publicly. "Don't you realize the good you can do?" he says.[96] "Gay readings of the mutant subtext have been fairly common in the [X-Men] letter columns in recent years," a critic noted in 1992; the discussion only continued with later film adaptations. Lynn Johnston's popular and critically lauded strip *For Better or for Worse* showcased a gay character in 1993, earning her a Pulitzer nomination, three thousand letters (75 percent in favor), forty newspaper cancellations or replacements (and fifty-two new papers signing on), and several death threats.[97]

As the '90s went on, mainstream-oriented readers might also have picked up Paige Braddock's delightful *Jane's World*, chronicling the lesbian protagonist's adventures with a style mixing *For Better or for Worse* and *Love and Rockets*; or Terry Moore's *Strangers in Paradise*, whose appealing protagonists, while tangled up with mob killers, mostly illustrate the fluid complications of desire—how you can love and not connect, regardless of fixed orientation and identification.[98] In 1995, Marvel included a beefcake pinup of a Speedo-wearing Northstar and "gay supporting character/superhero" Hector in their *Marvel Swimsuit Special*.[99] More substantively, but no less surprisingly given mainstream comics' past history, DC published Cruse's *Stuck Rubber Baby*, a long-gestating, semi-autobiographical novel about a young gay man's coming of age in the civil rights–era South, in which the struggle to love your own identity is masterfully intertwined with the struggle to accept, support, and love those traditionally identified as other.[100]

There were less mainstream treatments, too, and self-satisfiedly so. Mid-'90s teenage graphic memoirist Ariel Schrag slangily uses *definition* (as in "Definition 16!"; "Beauty." "Definition.") to suggest artistic creation is about defining the world on her own terms, nobody else's. As she went through high school, *Definition* yielded to *Potential*,[101] and her exploration of a more realistic style alongside her more cartoony one spoke to attempts to realize her own artistic *and* erotic potential. Diane DiMassa's angry, hilarious Hothead Paisan stalked through '90s mini-comics emasculating, chainsawing, moralizing. Asked, "How does one become a homicidal lesbian terrorist?" her response is "How does one *not*, you asshole?!?! What fucking planet did *you* grow up on?!?" Expanding on Paisan's violent attacks on horrible men, her absolute refusal to take the barest minimum of male shit, she writes, "A lot of women need to vent their rage, and this works for them." Or, in the words of a character surveying the landscape of Terry Sapp's irony-saturated *Adventures of Baby Dyke*—about an alienated character seeking her community in San Francisco, largely unsuccessfully—"This ain't no Alison Bechdel strip."[102] But Bechdel, who in 1995 hinted that her family's story "is kind of torturous

and sordid in that way families are, and I'm going to write a long cartoon novella about it one day,"[103] would have the next, if not the last, word a decade later.

In her introduction to the first issue of 1990's *Real Girl*, editor Angela Bocage said, "If gender identities, the real-ness of girl and boy, are plastic, they can be melted down. Re-shaped. . . . Comics are well-suited to these explorations." ("Talk about 'to thine own self be true!'" says Hothead Paisan, uncharacteristically demure after talking to someone who's transitioned. "That's about the bravest goddamn thing I ever heard. Wow. Mumble Mumble.")[104] Stories by artists like Diane Noomin go to show, as Noomin puts it, that "asshole-ism is not gender specific," or situation specific;[105] but questions of gender, of fixity and fluidity, were increasingly complicating earlier discussions of comics and identity. That same year, Rebecka Wright, then the editor of *Wimmen's Comix*, noted:

> There are those who think that Wimmen's has served its purpose, and ought to lighten up and open up its pages to men. It's true that (in underground comix, anyway) the work being done by both genders gets ever more individualistic, and therefore less categorically 'girl art' or 'boy art.' So, is this 'woman's perspective' stuff a lot of hooey? . . . Is Wimmen's great the way it is, or are we holding up progress here?[106]

An implicit rejoinder came the following year, when Noomin and Kominsky produced an anthology collecting material published variously over the past fifteen years (including, it should be said, in *Wimmen's Comix*), created by, as Noomin put it, "a dozen other 'bad girl' cartoonists who [produced] work that is personal, cathartic, and funny . . . uncompromising vision reflecting a female perspective." "Aline and I were both interested in personal comics which were self-deprecating, ironic, crude, in-your-face, 'fuck you' stuff," Noomin would say. "Neither of us could stomach the idealized 'mother earth superwoman' stype the collective was encouraging."

Noomin also wanted "to show people there were *a lot* of very, very strong, competent women cartoonists," and that she did. Contributors to the influential *Twisted Sisters* included Carol Lay, whose confessional tones take on, and subvert, the tropes of '50s romance comics, as in her tale of a billionairess facing just one obstacle to romantic bliss: saved by an African tribe as a child when her parents died on safari, she now has a protruding lip plate several inches in diameter. "I used this woman with the bizarre face," Lay said, "because I think that most American women feel really weird. There's this expectation that we're all going to be like the girls in the beer commercials. I think many of us, though, feel flawed and imperfect."[107]

Phoebe Gloeckner presented specters of men as fairy-tale menaces in the woods who tell her terrible futures of life with them; her mother quiets her, saying, "You'll grow up and find a nice man and get married and have children and live happily ever after!" The same tragic territory, of terrible predation at the hands of masculinity, was explored by Debbie Drechsler, who would tell horrific tales of sexual abuse by her father. ("My dad said it's my fault he did it to me. . . . I wish I could figure out what I do so I could stop doing it," says the small, pitiful figure in a 1992 comic, shivering in a towel on the bathroom floor.)[108] Drechsler and Gloeckner both accentuated the complexities of the autobiographical approach. "That's what I love about the kind of autobiographical cartooning I do," Drechsler said. "You don't really have to have the facts down all that well. Which is good, when you don't speak to your parents . . . I don't really remember it in the way you normally think about remembering. I recognize that memory is a really tricky thing."[109]

All unforgettable; but perhaps the most remarkable was Julie Doucet, who, in the '90s series *Dirty Plotte*,[110] told of finding her artistic voice while being seduced (in all senses) by male objectification. But in extensively picturing animated genitalia and castration (in the age of Lorena Bobbitt), she was responding to S. Clay Wilson and others. Here was a woman interested in taking on that same territory, and defending it, at knifepont if necessary. As Sabrina Jones put it in 1992's "Abortion Rights,"[111] "I use

my abortion rights every day, just walking down the street. Men remind me that I am just a cunt and they could rape me."[112] Jones went on to coedit 1995's influential *Girltalk*, which included harrowing depictions of sexual assault, explaining, "I often had women pull me aside at meetings to look at their most vulnerable and intense pieces, which they weren't comfortable showing in mixed company. . . . we just think girltalk is when the real stuff comes out."[113]

This intense mid-'90s ferment overlapped with the Riot Grrrl movement, which saw a series of women's "self-published photocopied minimagazines with print runs ranging anywhere from thirty to five hundred copies."[114] Among the movement's most notable artists were *Paisan*'s DiMassa and Jessica Abel. The title of one of Abel's *Artbabe* collections, *Mirror, Window*, suggested the essential autobiographical tension: Interiority or exteriority? The world or yourself? In her detailed, psychologized realist tales, Abel inserted moments of individual artistic expressionism (a bolt of burning light emerging from a breast; a swimming woman in a style of waves and thick brushstrokes, one with the water) that allowed her representations of reality to give way to transcendent joy.[115]

Equality may have felt itself teetering on the page—in 1991, even Blondie got a job, opening her own catering business after working in the home for the previous sixty-one years[116]—but in the world of those who drew them, it was coming slow. As of the early '80s, the National Cartoonists Society had slightly under five hundred members; fewer than a dozen were women. The newer and more progressive Cartoonists Guild, started in 1967, had a seven-to-one male–female ratio. In 1993, Lance Tooks's *Danger Funnies* provided a nuanced, erotic account of an interracial romance,[117] but Tooks, who had worked occasionally for Marvel in the '80s, was the independent exception that embarrassed the rule.

The late '80s saw controversy over Barry Blair's hyper-violent, racist *Ripper*; in 1991, objections circulated about *Gasoline Alley* character Teeka Tok, a "childlike" Asian Pacific Islander "who wears a flower in her hair, mispronounces English words and expresses amazement about American

ways."[118] The year *Danger Funnies* was released, Dark Horse published *Floaters*, a miniseries co-written by Spike Lee's brother Cinqué. A fourth-issue editor's note took on the question of Blacks in comics:

> Although comics did not evolve from racism, they have done much to perpetuate it. . . . [I]t was rare that a non-white charac-ter was implemented without a purpose: to convey a moral mes-sage, or tackle a racial issue. Whites appeared in comics without any explanation because whites could appear on the damn moon without explanation. . . . For all their powers, even superheroes are not immune from tokenization by their own names. *Black Lightning, Black Panther, Black Falcon*, and *Black Goliath* were apparently considered not worthwhile (i.e., marketable) unless distinguished by color.[119]

The tension, the doubled consciousness of presenting and representing, held across the ideological line; *Bloom County* creator Berke Breathed, a lib-eral, felt he couldn't "put black characters in my strip that acted as negative or silly as Steve Dallas. They'd become icons for something much larger . . . than they're supposed to be."[120] In the wake of Superman's "death," DC presented several potential claimants to the Kryptonian's name, one an effort to create a Black hero known for brains as well as brawn. John Henry Irons's mother tells him, "John Henry used his muscles to beat one machine, an' your pa hopes you'll use your brains . . . and become the machine's master." But when Superman returned, Steel, burdened by that weight of representation, would be shunted to the margins.[121] Con-temporaneously, Todd McFarlane premiered one of the longest-running Black superheroes in comics, but the circumstances of Spawn's origin—a badly burned, resurrected, antiheroic Hellspawn in full mask—meant his representational role ebbed and flowed over the decades.

Simultaneously, though, DC was approached by Black comics profes-sionals Dwayne McDuffie and Denys Cowan with a four-hundred-page plan for a separate company producing a line of four comics, a new one

each week, allowing for a wide spectrum of Black figures, not just token heroes. ("Diversity's our story, and we're sticking with it," the first-issue editorial pages of Milestone's Dakota Universe stated.)[122] Notably, they'd also keep creative control and have final say over merchandising. Milestone titles included *Hardware*, about a technological genius who, realizing the corrupt white power structure would never let him flourish, takes matters into his own hands via a supersuit, and flagship title *Icon*, another retelling of the Superman origin myth. Here, though, the eponymous alien protagonist is found by a slave, mimics his Blackness—then undergoes Black history.

The revisionist story has its ironies: Icon is a George H. W. Bush, pull-yourself-up-by-your-bootstraps type, his sidekick, Rocket, saying, "I think I just figured out how a black man could be a conservative Republican—you're from outer space!"[123] But even the joke speaks to the kind of freedom from stereotype Milestone made possible, thanks to representational diversity. When Rocket becomes pregnant, Icon encourages her to have an abortion: she refuses, in an empathetic treatment of the subject where characters don't take the usual sides. That empathy applied to reflections on comics' history with race, too. *Icon* featured a blatant Luke Cage parody, Buck Wild, who speaks in Blaxploitationese; when Wild dies, however, Icon's eulogy is a sympathetic look at an older, white, liberal project:

> Years before I arrived, Buck Wild was already there, fighting the good fight. Although we may, from our current perspective, find him crude and ill-informed, we cannot deny his importance. Intentions count as much as actions. And Buck was nothing if not well-intentioned. . . . While we winced on occasion at his embarrassing speech and demeaning behavior, more often we cheered him on . . . because whatever else he was, he was always a hero. A hero for those of us who had no heroes.

"Were it not for him," Icon concludes, "we wouldn't be here today."[124]

Not everyone in the Black community got behind Milestone. Nabile

Hage, of the Black independent comics publisher consortium Ania (Swahili for "protect and defend")—who once climbed the Georgia state capitol building dressed as a Zulu warrior and threw down copies of his comics— called them "traitors to themselves . . . [coming] out with the same kind of stereotypes that are already on the market. . . . Icon—Republican superhero! I mean, *what the hell is that . . .* ? Are they trying to tell us that we have to assimilate and become Republican and put on a coat and tie?"[125] But perhaps Milestone's biggest problem was articulated by the Black creators of Big City Publishing's 1991 *Brotherman*: "The stories take place in Big City, U.S.A. That stands for Universal Social Apathy. Inside the comic, that's what he's fighting; outside the comic, that's what we're fighting."[126] Generally, people loved what Milestone was doing; they just didn't care enough to support it with cash. It limped to a close a few years later.[127]

As Milestone premiered, so did Richard Dominguez's *El Gato Negro*, featuring a Spanish-speaking, drug dealer/fighting hero in uneasy league with the Texas Rangers. Dominguez's wife, Olga, acknowledged the achievement in a letters page.

> A major milestone in comics for the 90s. El Gato Negro, a Hispanic superhero. Yes, a Hispanic superhero, not a white American acting and sounding like a Hispanic American. Not a former gang member turned good. Of the few Hispanic characters portrayed in comic books in the past and present, none have truly captured the positive values, background, and shown the "good" side of this community.[128]

Like Milestone, *El Gato Negro* was part of a production line, Azteca Productions, that produced *Team Tejas*; members of the contemporary PACAS (Professional Amigos of Comic Art Society) would create titles like *Burrito!*, *Aztec of the City*, *Somnambulo*, and *Pineapple*.[129] But many of these representations, of diverse identities, of orientations, of experiences, made their way into the mainstream slowly, if at all. *Its* preoccupations were shared less with *Maus* than the other triumphs of 1986.

DARK KNIGHT **HAD SOLIDIFIED** the Caped Crusader's image as grim and gritty, and the field followed. Published three years later, Grant Morrison and Dave McKean's graphic novel *Arkham Asylum* may remain the deepest dive into the difference, large or small, between Batman's sanity and that of his rogues' gallery. And post-*Watchmen*, the question was asked again and again: What if the gods go bad? In 1989, in Moore and John Totleben's *Miracleman* 15, Kid Miracleman violently and graphically destroys London, murdering thousands in minutes. Readers, perhaps for the first time, sensed what might happen if these superheroes, unrestrained by Code and artistic self-censorship, *really let go*—and what became known as the Dark Age truly began.

Warlord's Mike Grell reinvented Green Arrow as a man verging on middle age hoping to raise a family, with lover Dinah Lance/Black Canary unwilling because of the risks of their work. "I love you, Oliver, and I'd love to make babies with you," she tells him, as they lie naked together in bed. "But I won't make orphans."[130] Grell also depicted Black Canary as the victim of grotesque torture; and as the violence and darkness quotient ramped up, it seemed female characters were increasingly on the receiving end of it. Part of Dave Sim's 1987 darkening of Cerebus's character is his rape of another character, Astoria.[131] In Alan Moore's *Supreme*, a para-Superman narrative, an advice-giving Lois Lane type, Grim '80s Diana Dane, says, "H-he'll pay you more attention once you're raped, crucified, and hooked on heroin, s-so he can avenge you."[132]

The practice developed its own term, "fridging," after the website *Women in Refrigerators*, started in 1999 primarily by a beautician and active fan named Gail Simone. Simone named the website after a particularly nasty piece of work: the 1994 murder of Green Lantern's girlfriend Alexandra DeWitt, who was then stuffed into the appliance in question. The practice didn't stop in the '90s, of course (and alas): the catalyst for 2004's best-selling limited series *Identity Crisis* was the rape and murder of Sue Dibny, wife of Justice League member Elongated Man. The story answers a question unanswerable, unaskable, under the Code—

Why don't supervillains, all those times they discover the heroes' secret identities, ever target their families?—in a manner befitting a more morally ambiguous age: JLA members conduct magical lobotomies. Consequences ensue, including said rape—made manifest, as opposed to the veiled threat of sexual violence omnipresent since the first pulp days of scantily dressed, menaced women.

Toward the end of *Identity Crisis* (note the title), writer Brad Meltzer quotes Arthur Miller: "An era can be said to come to an end when its basic illusions are exhausted." But one basic illusion, the destruction of female characters as grist for male heroic action, had a lot of life in it yet.[133] The global scale of the issue is laid bare in a (much more self-conscious) narrative moment in Brian K. Vaughan and Pia Guerra's 2000s series *Y: The Last Man*, in which, following the "gendercide" of every human male on Earth but one, a character tells the eponymous last man: "My whole life, I've always been a . . . a supporting character in somebody else's story. Daughter, student, fuck buddy, first mate. Whatever. But when the plague went down, I finally saw a chance to change that. . . . And then the last man on Earth shows up. . . . It figures. An entire planet of women, and the one guy gets to be the lead."[134]

Simone's (and others') criticisms resonated, questioning how these narratives, consciously or not, reflected a certain kind of lack of storytelling diversity. But while earlier trailblazing women had little impact on the superhero mythos,[135] Simone's own career would take a different trajectory. DC's late-'90s all-female comic *Birds of Prey* was failing to fly, and failing the Bechdel test. (In an early arc, a main factor bringing Black Canary, Catwoman, and Huntress together was their seduction by the same man.) With Simone's arrival a few years later, *Birds of Prey* transformed. There was no less ass-kicking, and, in fact, the characters were no less sexualized. Simone, parodying herself in an online "Classic Condensed Comic Classics" [sic], provides this one-line description of her work: "BLACK CANARY: Does this outfit make my ass look empowered?"[136] But they *were* empowered, in a way few female superheroes had been before. And diverse: Simone remembered thinking while growing

up "that if I ever did write comics, I'd do everything I could to create some characters that I myself would want to read: more Asians and other non-god-damn Caucasians, and a lot more females. That's still on my mind all the time."[137]

Simone's *Birds of Prey* refocused a character representative in other ways. One of the first "gritty" and "consequential" Dark Age works was an Alan Moore–penned twist on the eternal Joker–Batman rivalry, 1988's *The Killing Joke*. Trying to persuade Commissioner Gordon that all it took was "one bad day" to lose your mind, the Joker shoots his daughter, Barbara Gordon/Batgirl, paralyzing her from the waist down. Simone tells the story that editor Len Wein reported he shouted, "Cripple the bitch!" down the office hall when he got permission for Moore to do the story.[138] Gordon had already been revamped into Oracle, an all-knowing hacker. (In her '60s incarnation, she'd been a librarian, so this was natural.) But Simone took the character through the conditions of living with disability unlike almost any prior mainstream treatment. DC's treatment of Oracle was itself complex: in a related phenomenon dubbed "defrosting," male heroes usually shrugged off these sort of traumas—Bane *broke Batman's back* in 1993, and he was back on Gotham's rooftops several issues later—while Gordon remained stubbornly wheelchair-bound for years. Whether this is more or less powerful may be a matter of opinion, but Simone's treatment of Oracle undeniably advanced comics' representation of disability profoundly.[139]

But the question remained: Was the superhero business inherently toxic? The reboot of a lesser-known series, *Dial H for Hero*, about a device granting users different powers with each use, posited heroing as addictive, solipsistic, and self-destructive; the device passes from one user to another like a bad penny. Another reboot, *Human Target*, explored the hero's "delusion" that his actions stemmed from "some impulse to do good. Instead, they're the symptoms of my very modern sickness."[140] Perhaps the strongest indictment came in Warren Ellis and John Cassaday's brilliant *Planetary*, which debuted in 1998. Archaeologists whose mission was to keep the world weird by exhuming traces of the strange,

the Planetary team found their nemesis in a quartet "withholding glory from the human race": a quartet very thinly modeled on the Fantastic Four. "Magic & Loss,"[141] one of *Planetary*'s most powerful stories, has the journeys of thinly disguised versions of Superman, Wonder Woman, and Green Lantern cut short by black ops agencies that incinerate, explode, and vivisect them before they can get started saving lives—and, more importantly, enchanting the world with their narratives. *That's* what Dark Age realism gets you.

There *were* efforts at re-enchantment.[142] New incarnations of "imaginary stories"—such as those in Marvel's *What If* series or DC's Elseworlds imprint, side projects that relied on knowledge of older narrative without getting lost in continuity thickets—exploded in the '90s[143] (along with some cash grabs, cross-company team-ups and the like, that occurred, using the lingo "in dimension Earth-$").[144] And several mid-'90s works evoked remembered childhood awe, providing and withdrawing nostalgia all at once. Alex Ross and Mark Waid's elegiac, contemplative *Kingdom Come* (1996), aided immeasurably by the stained-glass look of Ross's painting, had iconic DC heroes descend from on high to witness what their descendants have wrought: an allegory for mainstream comics history, asking questions of the descendants of those bright, optimistic earlier incarnations.

Ross had come to attention working with Kurt Busiek on 1994's *Marvels*, nostalgically and interpretively[145] retelling classic Marvel stories from the perspectives of witnesses and chroniclers. But even these briefs for classic superheroing grappled with the underlying charge inherent, if not always explicit, in Dark Age material, and certainly by non-mainstream comics: What place have superheroes, the stuff of childhood, in adult life? James Robinson's mid-'90s Starman chides the inventor father who created his gadgetry: "You *should* have been inventing cosmic-powered cars and heating and . . . ecologically safe devices for mankind. . . . [This is] all self-propagating kid stuff. A chance for grown men to put their underwear on outside their tights. You've wasted a lot of your life with all of that, Dad."[146] Busiek explicitly took up the challenge in his contemporary

Astro City, writing, "If a superhero can be such a powerful and effective metaphor for male adolescence, then what else can you do with them? Could you build a superhero story around a metaphor for female adolescence? Around midlife crisis? . . . Sure, why not? . . . If it can do one, it can do the others."[147] But no less a figure than Frank Miller felt this was self-deception, saying, in 1997, "You're not supposed to call it nostalgia. You're supposed to call it 'retro.' But call it what you want to, nostalgia is nostalgia, and 'retro' ain't nothing but nostalgia wearing a nose ring."[148]

The genuinely new energy that *did* reshape the mainstream came from a different kind of enchantment, stemming from a different marginality, whose diversity would center on genre and narrative structure rather than identity—though the former would, eventually, allow even more profound exploration of the latter. And it stemmed, again, from 1986.

An early critic wrote that *Watchmen* was "a brilliant doctoral dissertation on the super-hero comic. Only it isn't a dissertation; it's, perversely, a super-hero comic." This analytic sensibility came, in no small part, from Alan Moore's own personality, but also from his and Gibbons's overseas perspective. Miller said of *Watchmen*, "You can't help but see American icons reworked from a very European point of view. It's very hard to miss the whole British flavor." And no one wanted to.

DC began viewing the United Kingdom as a poaching ground for new talent, especially, given *Swamp Thing*'s success, in the horror field.[149] DC executives appointed Karen Berger, a twentysomething English literature major who'd worked her way up from assistant to editing horror titles like *House of Mystery* and, more notably, *Swamp Thing*, as their "British liaison" and sent her to London. Attending the 1986 United Kingdom Comic Art Convention, she met, on Moore's advice, with a young journalist named Neil Gaiman.

Gaiman, then best known for a book on *Hitchhiker's Guide to the Galaxy* author Douglas Adams, had grown up "a Jewish kid in a Church of England school. . . . [I]t made me view *everything* as myth." He'd caught the comics bug in the summer of 1967, when his father's friend gave him

a cardboard box of comics; one, an old *Justice League*, boasted gas-masked Golden Age crime fighter the Sandman. Meeting Moore, Gaiman asked him how to write comics, and produced a *Swamp Thing* script Moore passed to Berger. Several months after Gaiman and Berger's first meeting, they started discussing characters he and creative partner Dave McKean might dig out of DC's back catalogue. DC, concerned that "the well of creativity [was] going dry after the extraordinary rush of the mid-1980s," thought they might find solutions in their "great old names that could be updated, perhaps with new characters or new versions of old ones."[150]

Music to Gaiman's ears, who was always interested in retelling myths with a soon-to-be-trademark combination of erudition, knockabout sense of humor, deep humanity, and deconstructive impulse. He could narrate the Book of Judges as an EC-esque "Old Bible Keeper," or pass an American gangster tale through the scrim of narrative unreliability and family trauma (1987's *Violent Cases*, with McKean). Gaiman first suggested one of DC's most mythic, mystic characters, the Phantom Stranger, but he was spoken for, as were many of Gaiman's other suggestions. They settled on Black Orchid, a character so minor Berger herself didn't know her. (Given the vicissitudes of British accents, she first misunderstood Gaiman as asking about a nonexistent Black Hawk Kid.)[151]

Gaiman and McKean's *Black Orchid* bore structural and thematic similarities to Moore's *Swamp Thing*: the seemingly dead character (actually a plant, though not quite realizing it, coming to terms with its identity as a spirit of nature); a dissatisfaction with violence as culminating thematic, narrative, or structural solution; *in* the DC universe, but not quite *of* it, except on its own terms. That last became increasingly enticing to Gaiman: especially after he wrote a *Swamp Thing* annual in which one character was transformed into another right before publication due to continuity changes. So, he was delighted when, in his next project—revamping that Golden Age Sandman—Berger essentially freed him to jettison everything but the name. Which he did, writing the series outline after "a solid week of enforced, computerless contemplation in an electricity-deprived house" following England's Great Storm of 1987.[152]

Summarizing *Sandman* is largely useless; it may even make the series seem faintly ridiculous. But here goes: the Sandman (though he's almost never called that; usually Dream, or Lord Morpheus, if you're fancy), is one of seven personifications of essential aspects of the universe called the Endless. Their essentiality and endlessness notwithstanding, each of them—Death, Delirium, Despair, Desire, Destruction, Destiny, and, of course, Dream—can, in fact, change radically. (Delirium, for example, used to be Delight.) Insofar as the series is *about* anything on a narrative level, it's about Dream realizing he must either change or die; he can't change, so he doesn't, and consequences ensue. Seems ridiculous, perhaps, but so does that tale about the guy cursed to kill his father and marry his mother. I use that example advisedly, since Dream, in Gaiman's telling, is the father of Orpheus, a fact essential to the plot; and Gaiman wields the engines of classical tragedy to rise to a furious crux emotionally worthy of its mythological predecessors.[153]

Gaiman wasn't the only Brit to delve explicitly into the myth pool then,[154] but his range was much broader. Over seventy-five issues, *Sandman* told more *kinds* of stories (Dream is, after all, the Prince of Stories) than perhaps any comic before or since, all invested with Gaiman's fierce intelligence and fiercer empathy, setting the stage for a self-conscious self-presentation of the comics reader (and writer) as an intellectual.[155] Chinese folktales? A tale of Ramadan? A retelling of *A Midsummer Night's Dream*, complete with actual fairies?

Gaiman opened his *Sandman* proposal by saying the comic would be "walking territory touched on in places in Alan's stint on *Swamp Thing*," and followed Moore in reminding readers that dreams were also nightmares: the early *Sandman* story "24 Hours," in which a psychotic supervillain tortures and kills a diner's denizens within that time span, remains one of the most disturbing single comic book issues ever written. But *Sandman*'s world has a sunnier cast than Moore's, in no small part thanks to Gaiman's decision to portray Dream's sister Death as a constantly upbeat comfort. (Her description in his original proposal: "She's really sweet. Really nice. The kind of person you instantly want to

befriend.") The decision turned much of the grim '80s sensibility on its head and significantly influenced the goth movement. Women loved the Death character, and loved dressing like her;[156] her appeal probably helped shift comics' gender demographics in the '90s more than anything else. (In 2001, Gaiman said, "It used to be if a lady was [at his signings] over 40, she'd be somebody's mom. That's not necessarily true any longer.")[157]

By its second year, *Sandman* had garnered significant press attention and critical praise, and DC decided to release issues in trade paperback form. Its success in that format led to a major shift in thinking about monthly comics: largely speaking, as loss leaders for the eventual trade publication (which, not incidentally, could be far more easily sold in book-stores). Discussing *Sandman*'s last main story arc, which ran for thirteen months before being collected, Gaiman admitted "some monthly readers complained that they didn't feel the story was being done for them, that they were just being used to subsidize the book, and there's truth to that charge."[158] But Gaiman was interested in using that advance planning, unavailable to Moore in his monthly *Swamp Thing*, to fill the series with "Easter eggs"—hints and cues that paid off down the line for dedicated rereaders with the book(s) at their disposal to flip through once more. Monthly readers of that arc, "The Kindly Ones," thought it was the worst of the *Sandman* stories; those who read it as a book (a trade, a collection—the terminology becomes inconsequential) thought it the best.

Gaiman famously refused to script his stories until he knew the illustrator, but all *Sandman* covers featured collaborator Dave McKean's dreamy symbolist art. The duo won a fight with DC to keep the "hero" off the cover after the first issue, going against a standard set in those first *Action* and *Detective* days. "But how will readers know that it's a *Sandman* comic if he's not on the cover?" Gaiman recalled them asking. "Because it will say 'Sandman' in big letters at the top," he responded. Gaiman, influenced by Eisner's *Spirit*, also kept his main character offstage for significant parts of the story.[159] All this opened the door for greater formal experimentation in mainstream comics, harnessing artistic avant-garde and narrative postmodernism to commercial concerns.

Sandman's success also allowed for a shift in creative control. Movement toward creators' rights had slowly but surely been continuing through the '80s. *Cerebus*'s Dave Sim and *Zot!*'s Scott McCloud launched "creator summits" in 1987, culminating in "A Bill of Rights for Comics Creators." While that didn't necessarily go anywhere directly, Kirby and Adams finally got original art back from Marvel around the same time,[160] and in 1988, DC announced it would no longer acquire "wholly new properties" under a work-for-hire system—creators would get copyright.

Sandman wasn't a wholly new property, but Gaiman had certainly put his unique spin on it; he negotiated after about a year for a stake in what was, in many ways, his own creation (he obtained 15 percent equity, according to his testimony in an unrelated court proceeding).[161] Gaiman was also allowed to end *Sandman* on his own terms, something his mentor, Moore, had been unable to do with *Swamp Thing*, despite its popularity. When he raised the issue, Gaiman said, DC's executives "went pale," but eventually realized that "when I'm done with *Sandman*, that *Sandman* is done."[162]

Sandman would prove the beachhead in a second British Invasion, thanks to Berger and DC, who actively headhunted talent there. Many of the British creators had a dash of the wide-eyed about them. Using Alan Moore's "insouciant, somewhat amoral occult dabbler and 'psychic detective' with a British working-class background," John Constantine, as mouthpiece,[163] Gaiman wrote, "When I was a kid, I thought America was a magic land . . . then I came out to America, and I discovered it was just like every movie or TV show or cliché about America you've ever heard or imagined." Moore himself said, "America was like a huge playground—full of all these great, quaint old characters that were left lying around by the publishers. . . . It was like having practiced swimming in the local municipal baths, and then being suddenly given the entire Atlantic Ocean to play in."[164]

But as outsiders, the Brits looked at the American myth(s) from a different perspective.[165] Garth Ennis's *Preacher* came out of a childhood infused with Lee Marvin and John Wayne movies, whose Texas ran forever

and yet was capacious enough to include Irish vampires. (And isn't that a metaphor for a British self-conception of a toxic, parasitical hanger-on to the American hero? There's enough questionable self-loathing in certain Ennis comics to beat the band.) Ennis, whose *True Faith*, serialized in the British political anthology *Crisis* in 1989 when he was nineteen, was pulped by Christian fundamentalists, was interested in religion—as a crutch to deal with God's absence, in the problem of evil done in its name, leavening it all, or, better, *taking the piss*, with caustic humor that made *Preacher*, cocreated with Steve Dillon, unlike anything preceding it. (Except, arguably, for Quentin Tarantino movies, a comparison much made at the time.)[166]

Peter Milligan, who had told a hyper-violent, hallucinogenic tale of future war in *2000 AD*, calling into question the myths the British had told themselves about World War II,[167] used minor Ditko character Shade the Changing Man to investigate "The American Scream": "The subject is overdosed and overloaded with America, he's poisoned, diseased, infected by America . . . he's got a galloping cancer inside him called America . . . the American scream."[168] But Ennis's satire and Milligan's political critique were arguably overshadowed by the radical work of Grant Morrison.

Morrison took the Doom Patrol, dubbed "The World's Strangest Heroes" in their 1963 debut, and made them much, much stranger. "These were no clean-limbed, wish-fulfillment super-adolescents," he said. "This was a group of people with serious physical problems and, perhaps, one too many bats in the belfry."[169] Like Los Bros Hernandez, Morrison's influences included punk, but he also ran to so-called surrealist Czech filmmaker Jan Svankmajer and Maya Deren's *Meshes of the Afternoon*; he wrote damaged, mentally unstable characters who fought menaces who destabilized the nature of reality itself, bringing profound surrealism to the mainstream comics page. And his take on the almost-forgotten minor character Animal Man was more deconstructive than *that*.[170]

Yes, Morrison shared that British politicized engagement, committing the character, like his author, to animal rights activism. (Buddy

embraces vegetarianism and struggles with the morality of extrajudi-
cial action against animal experimenters and maritime predators.) But
he also allowed Animal Man to engage with the nature of mainstream
superheroing itself. Much of Morrison's final year on the book revolved
around characters written out of continuity in DC's *Crisis*, and around
the loss evinced by both readers and, metafictionally, by the characters
themselves. Buddy becomes increasingly aware he may be someone else's
creation,[171] and in Morrison's last issue, he finally confronts Grant Mor-
rison (or "Grant Morrison," anyway) in a comic book simulacrum of the
"real world" itself, challenging him for his cavalier disposal of his wife
and children at an assassin's hand.[172] At story's end, "Morrison" muses,
"We thought that by making your world more violent, we would make it
more 'realistic.' More 'adult.' God help us if that's what it means. Maybe,
for once we could try to be kind. . . . Go home, Buddy."[173] And Buddy does,
to discover wife and children returned to him, as if it was all a dream.
The figure of "Grant Morrison" looks like late-'80s Grant Morrison. But
with his dead-white skin and dark clothing that seems to very slightly blur
at the borders—and, of course, his power over readers' and characters'
dreams alike—he also suggests Gaiman's Sandman.

Moore had inspired Gaiman to place the narrative act itself at the
center of comics. "Everything is made of stories," says an early *Swamp
Thing* character of his.[174] Years later, in an alternate Marvel universe set
in Elizabethan times, Gaiman's version of Mr. Fantastic posits that they
"are in a universe which favours stories"; asked by the Thing to cure his
monstrosity, he demurs: "The laws of story would suggest that no cure
can last for very long, Benjamin. For in the end, alas, you are so much
more interesting and satisfying as you are."[175]

"Interesting and satisfying" became the touchstone of a post-*Sandman*
renaissance spearheaded by the titles in the Karen Berger–edited DC line
Vertigo, launched in 1992 (*Sandman* retroactively bundled in). Berger
gleefully explained, "We've always tried, editorially, to shake up the status
quo; now we have the freedom to take it even further . . . it's almost like
being rewarded for bad behavior." DC, more corporately, cited "reader

interest in more challenging and controversial stories."[176] Those revital-
izing stories occurred largely in non-superhero, mainstreamish genres
that, fundamentally, replicated those popular before the Code and televi-
sion took them down.[177] First among them: horror.

In a comic book funeral for "Jack Carter," a mourner deconstructed
the '80s British horror turn: "We [Americans] had a doddery old Pres-
ident who talked about the end of the world a little too often. . . . But
they had a prime minister who was genuinely mad. . . . She wanted con-
centration camps for AIDS victims, wanted to eradicate homosexuality
even as an abstract concept, made poor people choose between eating
and keeping their vote. . . . England was a scary place. No wonder it
produced a scary culture." Its poisoned flower was writer Clive Barker.
A man of the theater and artist of no mean repute, Barker often did
the visual designs and at times even directed his works' movie adapta-
tions. Comics adapations were therefore a natural, and comics versions
of *Books of Blood*, *Night Breed*, and *Tapping the Vein* appeared on the
shelves contemporaneously with *Dark Knight* and *Watchmen*, display-
ing an anthological imagination echoed by horror comic anthologies
like (*Swamp Thing*'s) Steve Bissette and John Totleben's *Taboo*. *Taboo*
featured Alan Moore and Eddie Campbell's serialized Jack the Ripper
tale *From Hell*, and work by Michael Diana, whose *Boiled Angel* (1991)
resulted in an obscenity trial for violating the community standards law
of Pinellas County, Florida.[178]

For its part, Vertigo knew its audience's tastes: ads in its 1994 *Godfa-
ther*-meets-demons series *Mobfire* included pitches for *Nativity in Black:
A Tribute to Black Sabbath*; the Billy Zane movie *Demon Knight* ("coming
January 13th to a Crypt-Plex near you," chuckles the Crypt-Keeper); and
two Clive Barker movies. And that funeral's "Jack Carter" was clearly a
stand-in for Vertigo's closest thing to a horror superhero, John Constan-
tine, slouching and smoking in *Hellblazer*. In the hands of later writers like
Garth Ennis, Mike Carey, and Andy Diggle, Constantine became among
the most self-destructive, toxic, lacerating addicts—to drama, to trauma,
to magic, to the game—to ever appear in comics, an antihero grappling

with the human flotsam and jetsam he inevitably left in his wake, wondering whether the good he did was worth it, or whether it was good at all.

A female acquaintance shouts to Constantine, as he flees, "You're like every stupid macho bastard I've known: you can't think with anything except your dick and or your fists! You think you know it all! You think you're trying to help! And all you're doing is making things worse!"[179] This down-to-earth portrait of toxic masculinity inflected with supernatural horror provided a useful counterpoint to the Lovecraftian cosmic horror of works like Dark Horse's '90s *Hellboy*, a triumph of horror pastiche (according to creator Mike Mignola, "taking all the stuff I like— spooky old buildings, creepy frog people, ghosts, statues, skeletons, mad scientists, Jack Kirby monsters, and giant Lovecraftian horrors—and cramming them into one thing") that became its own mythos.[180] But Vertigo, and others, went beyond horror, exploring those other grand genres championed by Gaines and Feldstein at EC four decades before.

EC's other fondly remembered stalwart was its science fiction, and Vertigo delivered here, too. If SF is a literature of ideas, modern pride of place belongs to Grant Morrison's surreal *The Invisibles*, at least some of which was written on acid, which presented innovative stagings of comic page and panel to play with perceptions of time, space, and reality. Or, alternatively, to Warren Ellis and Darick Robertson's febrile *Transmetropolitan*, matching prose writers John Varley and Thomas Disch for sheer number of ideas per page, both verbal and visual, and once more providing a British take on American urban morass and pop showbiz politics.[181]

The genre whose return was *most* dramatic—which came *Out of the Past*, to quote the 1947 Robert Mitchum movie that became a touchstone— was the crime comic, the most popular and infamous of the pre-Code era. Noir often features the past's heavy hand on the present; and that Mitchum movie's plot, along with a dose of *The Killers*, is the essential template for the breakthrough 1997 graphic novel *A History of Violence*, and, to a slightly lesser extent, the following year's *The Road to Perdition*. *Perdition*'s grand and mythic questions of sin and weight, set in deceptively simple

black and white, are played out across a canvas of America, tightly struc-
tured to approach the seemingly inevitable ending.[182]

Leading lights in neo-noir included Brian Michael Bendis, whose ear-
liest polished work, 1994's *Fire: A Spy Graphic Novel*, thrust a young man
into a post–Cold War upheaval of uncertainty and, perhaps, disposability, a
vulnerability and marginality taken further in his moody, cinematic *Gold-
fish*.[183] Ed Brubaker started his career with the independent title *Lowlife:
Seedy Existential Stories of Real Life*, but would develop a larger following
in crime comics featuring archetypal crime figures with unforgettable,
detailed personalities. Brian Azzarello's *100 Bullets*[184] had a slightly hokey
premise (mystery man offering untraceable bullets for revenge purposes),
but was rightly praised for Azzarello's strong voices of individuals strug-
gling through moral and narrative ambiguity, accentuated by Eduardo
Risso's somehow simultaneously expressionistic and grounded art. And
David Lapham's *Stray Bullets* focused in granular and telling detail on
the lives of losers and hangers-on caught up in crime and caught in the
crossfire.

Perhaps the most influential title, though, came out from under Bat-
man's cowl. Post–*Dark Knight*, Frank Miller went on to create a black-and-
white, highly stylized crime comic; it was set in Basin City, but its many
assorted vices gave it the name it went by. Sin City was hyper-violent and
dark as night. Owing more than a tip of the hat to Mickey Spillane, the tran-
scendent possibility of love by the damaged and the violent was swallowed
up in almost nihilistic sensibility.[185] *Sin City*, while often criticized for its
violence, treatment of women, plots, and dialogue, was nonetheless incal-
culably influential, especially in the "cinema-ization" of the genre, Miller
seeking "a middle ground between the really congested American pacing
of comics . . . and the almost flip-book quality of Japanese manga."[186]

After horror and science fiction, EC was best known for its war com-
ics, and those comics' questioning of militaristic and jingoistic narratives
recurred in the late '80s, with respect to a war EC shuttered too early
to address. Doug Murray, a Vietnam veteran who had served eighteen

months in-country, decided to make *The 'Nam* realistic, setting it in real time. It worked well enough to become one of Marvel's top five news-stand sellers.[187] As the '90s went on, ambivalence reigned, summed up in a rebooting of DC Vietnam-era mythic representation the Unknown Soldier. In Garth Ennis's hands, the Soldier became code for all America's dirty tricks, realizing, at tale's end, he "justif[ies] regimes and atrocities every bit as bad" as those he fights. "God damn me," he says.[188] And Steve Darnall and Alex Ross's re-creation of World War II–era hero Uncle Sam presented him as a wandering, addled metaphor, replaced by a corpora-tized version of himself, trying to regain his standing by understanding his past, warts and all; he's assisted by other spirits, including Britannia and the Soviet Bear, who've come to terms with the loss of their own self-image and empires.[189]

The British invasion writers' political activism resonated strongly in the post–Cold War period, where '60s Manichaeanism, '70s skepti-cism, and '80s paranoia were being replaced by questions of globalism, thanks to comics readers' and creators' increasing internationalization. Miller and Gibbons teamed up in the Reagan/Bush era for a frighten-ing near-future look of authoritarian power gone wild, urban decay, and man-made ecocatastrophe. Naming *Give Me Liberty*'s Black protagonist Martha Washington indicated its reliance on, and subversion of, Amer-ican iconography (a notable image pictured Washington as the Statue of Liberty), and marked its call for a corrective to "American values." (Admittedly, Miller's "American" values are, as he suggests elsewhere, Ayn Rand's.)[190] A '90s Justice League–like team, Stormwatch, began as an avatar of liberal neointernationalism—working for the UN, fighting threats transcending the ambit of any one nation-state—but later writers used its successor to contemplate the fascistic authority of hyper-power. After saving the world (well, a parallel Earth, but still) from alien overlord-ship, "spirit of the century" Jenny Sparks broadcasts simply this: "We're here to give you a second chance. Make a world worth living in. We are the Authority. *Behave*."[191]

More locally, *Justice Inc.* updated malleable-faced Street & Smith pulp

hero the Avenger into a CIA-backed antihero inserted into anti-American regimes to create more friendly governments via targeted assassination and replacement. Mark Verheiden, inspired by Ollie North, the Iran-Contra scandal, and how "Chuck Norris and Sly Stallone were rewriting the history of the Vietnam War," deconstructed Captain America in *The American* (1987–1992). And Howard Chaykin, whose *American Flagg!* had been an early cynic's look at the American dream, created 2001's *American Century*, in which Harry Block gets mixed up in American dirty work in Central America.[192] This historical approach spoke to another genre of comic that blossomed, although not under Vertigo's aegis: the nonfiction comic, whether educational, biographical, or journalistic.

The educational comic had come far since those grow-your-own-dope comix and sexual health guides. In 1975, Denis Kitchen got money from the Wisconsin Department of Justice to produce *Consumer Comix*, distributed free to state high school students, "expos[ing] the tactics that some devious businessmen use to rip-off unsuspecting customers"; Kitchen's assistant editor, Leonard Rifas, followed up in 1977 with *Corporate Crime Comics* ("We must *depend on* big corporations—but how can we *control* them?").[193] *Wimmen's Comix* offered a special bicentennial issue on women's history (including pieces on Pocahontas, Harriet Tubman, Queen Liliuokalani, and the "sisters of Salem"), and another issue that same year on "Outlaws" (tales ranging from the pirate Anne Bonny to female moonshiners to, um, women engaging in same-sex kissing in public). Gilbert Shelton's *Give Me Liberty! A Revised History of the American Revolution* (1976), though frequently playing it straight, at times expanded into full-fledged colonial slapstick,[194] as did the contemporary gold standard, Larry Gonick's *Cartoon History of the Universe*, which combined dad jokes with myriad facts and a sure sense of history and narrative.[195]

But others were increasingly confident in comics' narrative possibilities—and their own historianship—to tell a meaningful tale. Most prominent was *God Nose* satirist Jack Jackson, who in childhood had been deeply influenced by the *Texas History Movies* comic and its racist depictions of Mexicans. Unsurprisingly for a counterculture type,

he tried to present stories complicating or overturning standard histor-
ical narratives. His "Nits Make Lice" (1976) depicted the hideous Sand
Creek Massacre, an 1864 mass murder of Native Americans by the United
States Army (the title comes from army commander John Chivington's
infamous phrase while ordering the murder of children there), and con-
nected its atrocities there to those by Americans in Vietnam.[196] In his
'70s work *Comanche Moon*, Jackson chronicled the story of Cynthia Ann
Parker, "her twenty-five year Captivity Among the Comanche Indians,
and her son, Quanah Parker, the last chief of the Comanches," a tale of
complicated identity—of America, race, difference, and the possibilities
of coexistence. And did so through detailed composition, characteriza-
tion, and sober historical work, unafraid to make moral judgment when
earned, engaging in none of the cartoonish racism or jingoistic caricature
that so affected comics history.[197]

Jackson's seminal example encouraged others in the following
decades, both familiar faces and new stars. Alan Moore and Bill Sien-
kiewicz "trac[ed] the major players in the Iran/Contra scandal back
through covert action in Iran, the 1960s secret war in Laos, and the Bay
of Pigs fiasco," inventing, in the inside cover's words, "a new form—the
graphic docudrama."[198] In San Diego, *National Lampoon* cartoonist Rick
Geary meticulously reconstructed the evil men and women do, helped by
old Sears, Roebuck and Montgomery Ward catalogs;[199] Ho Che Anderson's
King, a decade-long project, featured Witnesses—talking heads who not
only tell the story but display diverse ethnic appearance and speech—and
showed, complementarily, varying aspects, dimensions, and incarnations
of King himself, from visually realistic to abstract, elevated to profane.[200]

And two other major figures used the backdrop of American history
as a canvas to produce allegories telling a larger truth. In James Sturm's
The Golem's Mighty Swing, about Jewish baseball barnstormers in the '20s,
the titular Golem speaks to the multiple complexities of American race,
disguise, and otherness. No kabbalistically created legendary homuncu-
lus he; rather, a Negro League player disguised as a Jew disguised as a
golem to drum up more ticket sales, ample display that monstrosity is as

available in the New World as in the Old.[201] James Vance's Depression-set
Kings in Disguise depicts that savage period in America, but its tale of a
boy out on the road, alone, then riding the rails with the so-called King
of Spain, is more about coming to manhood in a difficult world and the
lies/myths/stories/works of art we tell each other to survive in it.[202] Each
spoke to the medium's effort to defamiliarize reality. And then there was
Joe Sacco, who essentially created comics journalism for a new era.

Like numerous other comics creators, Sacco was obsessively inter-
ested in music; his experiences on the margins of a rock lifestyle honed
the presence figuring in his later journalism. In his earliest works, Sacco
turned his somewhat caricaturizing gaze on himself,[203] but combined it
with political consciousness, tying the urge to report with the desire to
prove himself capable of decisive action. Paradoxically, that action became
reporting the action, giving voice, and image, to real people caught in
dismal situations.

In works like *Palestine* and *Safe Area Gorazde*, Sacco is open about
the ambiguities—moral, epistemological, and representational—of
graphic reportage. In *Palestine*, he writes, "We've hitched a lift . . . a don-
key cart . . . another authentic refugee camp experience . . . good for the
comic, maybe a splash page." "I want real stories, he knows that, vivid
descriptions, the details, man, comics is a visual medium." His honest
assessment that "I wasn't objective going in . . . I definitely had an idea of
what I wanted to get. But I think that as far as what I saw, I tried to portray
it accurately" reflects the questions about objectivity and bias prevalent
in journalism generally, conjoined with admirable self-awareness.[204] He
attends to the gaps along with the witnessing, nowhere more evident
than in his tale of *The Fixer*, a Sarajevan named Neven who helps him
find interviewees and provides valuable context. As the narrative unfolds,
however, Sacco is increasingly unsure whether Neven is telling him the
truth, or simply what his client wants to hear. But Sacco is *there*, and his
personal immediacy in chronicling the Balkan conflict is complemented
by the approach taken in Joe Kubert's *Fax from Sarajevo*, transformed
from the titular faxes (and, later, photographs) into a living, breathing

narrative of the horrific conditions a Muslim family faced from Serb shell-
ing and snipers. Both Kubert and Sacco feel the necessity of testimony,
not just as reporters but, in their own ways, as witnesses.[205]

<center>═══</center>

THE INCREASING ATTENTION to the formal aspects of '90s mainstream
comics, whether in Image creations, *Sandman*'s artistic experiments, or
moody genre explorations, had more than one eye on the explosion of
experimental work in *Raw*'s wake, and the expansion of publishing com-
panies like Fantagraphics to circulate that work more widely.

There were the comics with the slipperiest of narrative *sense*, where
formal rules faded into surrealist dream. Though the word, invented in
1903, didn't come into common usage until after the Great War, surreal-
ism's sudden juxtapositions, dreamlike imagery, and non sequiturs are
perfect for a certain kind of comics. McCay's visions arguably came to first
great flower not in Moscoso or Griffin's untethered trippiness, but in the
visions of Kim Deitch, one of the first artists published in longer form by
Fantagraphics in 1988 (and to this day). Deitch came by his craft honestly
(father Gene was a well-regarded cartoonist who'd won that Oscar for the
adaptation of Feiffer's *Munro*),[206] but as a mid-'70s *Arcade* appreciation
put it, his "nightmare-filled unconscious . . . [and] hallucinatory fantasies
complement [his] bizarrely stylized drawings to produce a dream world of
comparative intensity to George Méliès or Winsor McCay."[207]

Deitch, who came to the field by way of a stint in a mental hospital (as
an aide), was inspired by *Little Nemo*, Kirby, Ditko, and, clearly, the phan-
tasmagoric horror and majesty of American carnival and vaudeville.[208]
His Flip was cartoon cat Waldo, avatar of comics days past and "badass
alter ego," whose stories, he claims, "have always come as if inspired
by something beyond myself." Perhaps this explains the surprisingly
haunting and effective early-'90s encounter between Waldo and Jesus
in which Waldo plays Judas: a shared sense of transcendence.[209] Epipha-
nies, appearances, visitations, images stubbornly, undeniably *there* on the
page: also the hallmark of '80s and '90s force Jim Woodring, whose work,

particularly his comics showcasing anthropomorphic feline Frank, feels
a lot like Mickey Mouse stepping into a Salvador Dalí landscape by way
of Lewis Carroll.[210] And while Chester Brown discounted the descriptor
"surrealist" that was often affixed to his work,[211] the dementedly, hilari-
ously, filthily violent adventures of Ed the Happy Clown in the ground-
breaking *Yummy Fur* from 1985 to 1992 involved, among other things, a
man whose bunghole shat out an alternate dimension's Ronald Reagan,
then attached to another man's penis (an old anti-Nixon underground
trick, used to more startling, sustained effect here). The seeming ran-
domness all added up, at the end, to a strangely serious, narratively struc-
tured absurdism, encompassing sin, nightmare, a dose of vampirism,
and the threatening nature of female eroticism.

Which raised the question of narrative resolution, best expressed in
the title of Dave McKean and Neil Gaiman's collaboration *Signal to Noise*.
What does the meaning-making mind do with such imagery?[212] Bill Sien-
kiewicz's late-'80s presentation of minds collapsing and dissociating in
Stray Toasters[213] is reflected in jarring juxtapositions of wildly different
lettering styles, panel compositions, and sharp and blurry tonal shifts,
rendering the reader, well, unstable. But the blurriness of dream, or the
sense of unconscious at work, was only one display of these formal inno-
vations. Others were formalist and process-oriented, continuing Spiegel-
man's theme of "breakdown" of comics to elemental aspects.

Richard McGuire's "Here," first published in *Raw* in the late '80s,
remains arguably the most dazzling deployment of the medium's poten-
tialities: overlapping panels, picturing sections of the same space as it
appeared over millennia, illustrated how comics' depiction of *hereness* can
radically explode our understanding of *now*.[214] Formalist game playing
melded aesthetics and philosophy: dozens of early-'90s artists played (an
eventually published) version of Narrative Corpse, a stick figure the only
thing linking their various panels;[215] Scott McCloud's more focused Five
Card Nancy is played using images taken only from Ernie Bushmiller
panels from the eponymous strip. McCloud also created the twenty-four-
hour comic in the summer of 1990; the resulting product usually boasts

stronger narrative focus, but its process of creation clearly influences the viewing.[216]

Another rising formalist trend appeared in wordless (thus, all-image) novels, many emerging from the *WW3* school and therefore naturalist and socially focused. Eric Drooker's 1992 *Flood!*, a woodcut novel in the tradition of Otto Nückel and Frans Masereel, stemmed partially from Drooker's sense of being stymied by language while growing up on a fantastically multilingual Lower East Side, while Peter Kuper's 1996 wordless *The System* expressed his politicized sensibility of New York's interconnectedness, its secret sharing of powerful and powerless.[217] But two emerging creators' formalist presentations were particularly eye-opening.

Mary Fleener's take on the human, particularly female, form broke down her characters into geometrically sharp angles, displaying, in Aline Kominsky-Crumb's words, a "fractured cubist style and just enough psychedelic brain damage."[218] Her slice-of-life comics, with their slashing nonrepresentational forms, powerfully reminded '90s readers how comics all too frequently lull us into accepting simulacra as reality.[219] But no one delivered this message more influentially in the '90s than Chris Ware, perhaps the decade's most honored comics creator.

Ware's strong sense of page and panel constantly breaks down images to almost fractally repeating verticals, horizontals, circles, and ovals. Ware suggests synesthetically that "comic strips are like music notes on paper . . . when you read them you 'hear' things in your mind"; his strong geometrical forces also evoke his Chicago-oriented architectural inflection.[220] His works frequently ask: Is there more than the quotidian in human life? What dreams, if any, can break free of the grid? *Jimmy Corrigan: The Smartest Kid on Earth* is hardly plotless; it's the quasi-autobiographical story of a man adrift, searching for grounding by connecting to a father absent all his life. Like many Ware works, it's also an ode to the spiraling internality a near-solitary life can create (the exception, for Corrigan, a demanding, vampiric mother). But form and theme are perfectly matched: the fragmented panels filled with silent

reactions and contemplation, constantly varying size and placement in strong, uncompromising lines and bold colors drawn, almost unimaginably, by hand, enable us to experience Corrigan's ache profoundly.[221] Through reference to older comics and allusion to earlier American visual culture like reading primers, cigarette boxes, and mail-order catalogs, any fantasies of transcendence Ware floats end up reinforcing loneliness.

Such visual allusion and reference functions, in the most technical of senses, as parody, and other '90s parodies produced images whose appeal stemmed as much from technical appreciation as, say, thematic message or narrative suspense (albeit throwing off comic, ironic, or pathetic shadings). Drew Friedman's oddly affecting but also often perversely scuzzified images of Hollywood royalty and proletariat, rendered in detailed, stippled style, give the sense of grainy Weegee photos. There's pathos there, though: Friedman's most oddly touching comics are of favored '50s horror staple Tor Johnson, engaging in such quotidian activities as querying his agent ("Work for Tor?") or riding the subway ("Tor havin' fun on subway"). And R. Sikoryak deftly wove his comic book erudition and uncanny stylistic chameleonism into cockeyed comic versions of classics: "Hester's Little Pearl," a mash-up of *Little Lulu* and *The Scarlet Letter*; "Raskol," where *Crime and Punishment* is retold with '50s Batman brio; and "The Crypt of Bronte," featuring House-Keeper, the Governess, and the Tenant in classic GhouLunatic style.[222]

The more steeped you were in comics history, the more you appreciated Sikoryak's work; and as aging readers had longer exposure to comics' history and continuity, plus more sophisticated capacity to recognize subversion, irony, and satire, this material continued to expand. The approach, best summed up back in 1947 by Bushmiller's Nancy, musing self-referentially while walking on a ceiling ("Anything can happen in a comic strip," she says),[223] was proved by the two very differently defining '80s comic strips: Gary Larson's *The Far Side*, which had sold forty-five million collected copies by 2006,[224] and Bill Watterson's *Calvin and Hobbes*. Larson's massive popularity stemmed entirely from incongruous visual juxtapositions that either spoke for themselves or were paired with

clever captions (under cigarette-puffing dinosaurs, a dry note: "The real reason dinosaurs became extinct"). Watterson's most stunning entries relied on the juxtaposition between Calvin's quotidian circumstances and the rich, textured imagery of his fantasies.[225]

Other gag-oriented strips partook of the latest anti-comedy comedy trends. The deconstructive *The Magic Whistle*'s jokes lay in explaining the joke; the vaguely anthropomorphic title characters of Evan Dorkin's *Fun with Milk and Cheese* are lewd, crude, and in the mood; Michael Kupperman absurdly toured through comic book tropes with a snake and a piece of talking bacon as guides.[226] The brilliant Tony Millionaire's *Sock Monkey* followed its odd protagonists into grand, old-fashioned settings (stately houses, Patrick O'Brian–inspired sailing ships), then violently destroyed them with a logic seemingly taken from chidhood play but infused with a mature draftsman's restraint. His *Maakies* strips revealed how puerility (and, in prominent character Drinky Crow, alcoholic oblivion) is a hard-earned defense against the world's nihilistic, surrealistic demons.[227]

The most unique of the comic *book* parodies, Bob Burden's *Flaming Carrot*, was Zippy as superhero, except instead of a pinhead, his head was—well, you can guess. (He got that way after reading five thousand comics in one sitting on a bet.)[228] Flaming Carrot's surrealist adventures, including chasing a flying, mail-stealing dead dog and clones of Hitler's feet, hit identical beats to typical superhero stories, with ridiculous results.[229] Fred Hembeck's '80s visual stylings (particularly those elbow and knee squiggles) and deep dives into the mainstream canon made his work iconic for a generation. Don Simpson's '80s *Megaton Man* was a loving look at Marvel (though it earned him a cease-and-desist notice): the Thing analogue, made of yarn, serves briefly as the Invisible Woman's bikini. Jim Valentino's *Normalman* featured Norm, rocketed to planet Levram (spell it backward), where every inhabitant is superpowered and self-conscious about living comic book clichés. "Look out!" one bystander cries. "He's striking a significant . . . Kirby pose!"[230] The Big Two sometimes went along with the act, introducing DC's absurdist Ambush Bug, whose enemies included longtime editor Julius Schwartz; Peter Porker,

the Spectacular Spider-Ham; and John Byrne's fourth-wall-breaking She-Hulk ("If you don't buy my book this time I'm going to come to your house and rip up all your X-Men," she glowers from an issue's cover).[231]

But these were largely adult pleasures: even the works that would later enchant a new generation of readers claimed an adult audience. Eighties comic *Neil the Horse*'s delightful dance and music sequences were inspired by Fred Astaire and its worldview from Louis-Ferdinand Céline and Albert Camus; author Katherine Collins (known by another name prior to 1994 gender reassignment surgery) articulated it this way: "I don't have a target audience in mind, I really don't. I write what I would be amused by. And I think that I'm enough of a kid that it works for kids." Larry Marder's almost entirely unclassifiable late-'80s *Tales of the Beanworld*, inspired by Native American mythology and Marcel Duchamp, had the look of kids' material but was highly appreciated by older audiences. And Jeff Smith's early-'90s saga *Bone* was worm's-eye high fantasy, as if Snoopy and the gang had wandered into Middle Earth. Funnier than Tolkien, arguably less profound than *Peanuts*,[232] Smith insisted he was "definitely writing this for adults. . . . The only reason it can be read by children is just because I'm staying true to the kind of comic I always wanted to read when I was a kid."[233] That said, the oddly shaped Fone Bone's puppy love for beauteous princess Thorn, and the nobility and heroism he exhibits, evoke the same mythic appeal for kids as Frodo and squire Arthur: that little people can play the biggest roles. *Bone* would become a children's classic: but later.

IN 2000, Jules Feiffer retired after forty years of *Village Voice* strips. His iconic dancer addressed him in the final installments: "Are you giving up your strip because real life has overtaken satire? . . . Or is it because you've run out of steam and are repeating yourself? . . . Or is it because all comic strips have their day and then it's over?"[234] Although the dancer presumably meant *each* comic strip has *its* day, the ambiguity isn't accidental. True, there'd been recent bright lights: Pat Brady's *Rose Is Rose*, investing

its gags with visual genius, and Aaron MacGruder's *The Boondocks*, with its plainspoken, outspoken, controversy-courting kid protagonists Riley and Huey, as in Newton. (The *Atlanta Journal-Constitution* actually moved it from the comics pages to the op-ed section.)[235] *The New Yorker*'s Cartoon Bank, "an online storage and retrieval marketplace for cartoons," even helped put the magazine in the black at the new century's beginning.[236]

But its backward-looking focus, albeit using new media technology, told the tale: in 1992, the top ten syndicated comics were (on average) 26.5 years old; the five most popular, over 33 years.[237] Sometimes they evolved: Blondie's catering business, Tess Tracy serving husband Dick with divorce papers, Little Orphan Annie getting a haircut and donning jeans, *Doonesbury*'s focus switching generations. But often they stagnated, offering largely nostalgic pleasure, and so, little place for children there, either.

But the strip world's stagnation and contraction contrasted sharply with the explosion within the alternative and independent world. New anthologies like 1990's *Drawn & Quarterly* were published to showcase this groundbreaking work; new communities formed, and not just between covers. The Pacific Northwest, especially Seattle, was a major '90s hub, featuring creators like Pete Bagge, Julie Doucet, and others, some of whom worked for Fantagraphics, located there. So was Providence, home to the mid-to-late-'90s Fort Thunder Collective, which largely focused on non-representational, naive-type comic art. And so, very prominently, albeit north of the border, was Montreal (in two languages).[238] The year 1994 saw the start of the annual Small Press Expo (SPX); the following year, it had 250 attendees; two years after that, over a thousand.[239] New publishers appeared, like Tom Devlin's Highwater Books and Chris Staros and Brett Warnock's Top Shelf.[240] By 2000, attendees at SPX noticed that DC was scouting; Batton Lash called it "a little offensive: the idea of the majors using the independents as a farm team."[241]

But scouting had worked for DC before, most notably with the British invasion. And the consequences of *that* were rolling on. While the World Fantasy Award committee changed its rules after a *Sandman* story won in

1991 to prevent the same thing from reoccurring, the Horror Writers of America allowed comics professionals active member status in 1993. And by then, the medium's successes had resounded in non-genre outlets as well: that same year, the *New York Times* published its first-ever ongoing comic strip, Peter Kuper's *Eye of the Beholder*, in the city section. While newspapers publishing comic strips, even the *Times*, could be considered a dog-bites-man story, it marked a trend.

Feiffer was elected to the American Academy of Arts and Letters in 1995, and had his work displayed at the Library of Congress the following year.[242] That same year, 1996, the Popular Culture Association and American Culture Association jointly dedicated a panel to Los Bros Hernandez, and Joe Sacco won an American Book Award for *Palestine*. Sacco, admitting he'd never heard of the award, added, "But I think it's just good for the comics medium as a whole if they start getting recognition—this is a book award, not a comics award, and that's got to be good for the medium as a whole."[243] And then the honors really started coming in.

In its own way, the year 2000 was almost as eventful as 1986. Upscale book publisher Pantheon released Chris Ware's *Jimmy Corrigan* and Daniel Clowes's *David Boring*; the American Book Awards recognized *Corrigan* for "outstanding literary achievement" the next year, as did the *Guardian*.[244] That same year, Ben Katchor received comics' first MacArthur "genius" grant. And, most notably, Michael Chabon's Pulitzer Prize–winning novel *The Amazing Adventures of Kavalier & Clay* was published.

Kavalier and Clay had a lot of Siegel and Shuster in them, mixed with some Lee and Kirby, and the novel focused in no small part on the screwing (most of) these creators took: in his author's note, Chabon writes, "Even more than Siegel and Shuster—who at least got credit lines and a stipend—Kirby is the poster boy for the mistreated comic book genius." *Kavalier & Clay* not only won the Pulitzer but also firmly established comics as a site for non-ironic high-culture meditation; Rick Moody's *The Ice Storm* and Jonathan Lethem's *Fortress of Solitude* would follow similarly. Chabon was not shy about showing off his geek cred, speaking in interviews about childhood dives into '70s Marvel comics like *Howard the Duck*

and *Omega the Unknown*; closing the circle, he and Lethem would both write comics.[245]

Other creators were more ambivalent about comics' increasing cachet. *Jimmy Corrigan*'s endpapers boast a fake newspaper article. Headlined "New Pictorial Language Makes Marks: Good for Showing Stuff, Leaving Out Big Words," it reads in part: "Certain publishing houses are experimenting with this new form . . . strategically aiming them at a less-educated and/or intellectually blunted segment of the consumer pool. The results, thus far, are encouraging. 'Dumb people are eating it up,' says our researcher. 'They love it. Especially people who buy a lot of stuff. This could be big."[246] Even more pointedly, Patricia Storms's online comic *The Adventures of Lethem & Chabon* features the "dynamic literary duo" responding to a woman's cri de coeur ("It's my boyfriend! He's lost all interest in reading fiction! . . . Nothing connects to his masculine sensibilities!"): "With us on your shelves you'll have action, drama, intrigue, male-bonding and self-discovery, and, of course, that most important element in contemporary fiction for the modern male intellectual—comics, dude!"[247]

But these were minority reports. The story's end seemed clear enough, dovetailing neatly with the century's. Some unsung heroes had received their curtain calls; genres fallen victim to the Code had returned once again; and if superheroes and strips had reached an exhaustion point, comics had begun fulfilling the promise of their medium.

And then, of course, everything changed.

NEW WORLDS
(REPRISE AND VARIATION)

The September 11 attacks had a seismic impact on comics, as they did on every other aspect of American life. First, there were the immediate charity anthologies, encompassing documentary/re-creation (Paul Chadwick's "Sacrifice," about Flight 93's heroes), stark imagery (Peter Kuper's grieving Empire State building, hunched over its twin brethren's remains), ironized slice-of-life (Trina Robbins's woman disgruntled by airplane security provisions silenced by a mourning co-conversationist), and symbolic juxtaposition (Paul Levitz and Joe Staton's yahrzeit candle next to a cell phone holding a victim's final message).

Memorialization continued for months: that December, B.D. of *Doonesbury*, working at Ground Zero, is visited by Zonker. B.D. interrupts his dialogue: "Quiet." Zonker replies, "What?"

B.D.: "Moment of silence down below. They just recovered another victim."

After a silent third panel, Zonker asks, "So how often does that . . ."
B.D.: "Quiet."[1]

The medium even attempted to put itself on trial, briefly if profoundly, flirting with rejecting the adolescent, triumphalist aspect of superheroic fantasies. Yes, fan fiction about Superman saving the day on 9/11 existed;

"officially," Superman looked on helplessly from the pages of a comic book. "Where were you?" a frontline worker asks Captain America. "I wasn't here," is his—the only—response. Even Dr. Doom cried.[2]

Other comics used the medium's features itself as a challenge. Rick Veitch's *Can't Get No* featured a tattooed man of late decadent capitalism seeking meaning, sense, and community in America after watching the towers fall, with poetic captions delinked from the visuals, symbolizing the inability of words to capture what was witnessed that day. R. Sikoryak re-created a New York tabloid comics page, analogues of *Peanuts* and *Cathy* speaking to the moment's churning emotions.[3] Art Spiegelman, creating the full-page newspaper pages that would constitute 2004's *Shadow of No Towers*, was trying "to pick up the pieces of brain that were in the rubble . . . to make some mosaic." Given Spiegelman's comics-saturated brain, the result, built on "spelunking" through old comics, was an attempt to discover comics' commensurability with the unimaginable, in a form tapping "into something deep in the DNA of the city."[4]

But even the unimaginable was normalized soon enough. Sometimes, via subservience to long-standing ideology and sensibility, whatever those happened to be: eighteen days after the towers fell, a character in Aaron McGruder's *Boondocks* strip says, "I realize that America is all about blind, unquestioning faith in our almost-elected leaders."[5] Conversely, when Marvel's *Combat Zone* asked, "How powerful are the bonds of affection, trust, humor, fear, and dedication that bind real soldiers as they fight for their country?"[6] it's no detraction from American soldiers' heroism to suggest that Marvel's answer—very—was utterly predictable. (Author Karl Zinsmeister was not only an embedded war reporter but would serve as the editor in chief of the *American Enterprise*, a publication of the conservative American Enterprise Institute.)

And sometimes, it would be subservience to genre. Marvel's *Call of Duty: The Brotherhood* and *Call of Duty: The Wagon*, while presenting firefighters as unquestionable heroes, subordinate that everyday heroism to a tale of time travel and a big, bad menace. Brian K. Vaughan's *Ex Machina*, blended, with some success, New York's post-9/11 civic politics

with superhero motifs; Mitchell Hundred's implanted alien tech allowed him to save one of the towers and become mayor. The work interests more when jet packs and derring-do are shelved for snowplow crises and controversial art installations.

At times, gung-ho jingoism shaded smoothly into xenophobia: Graig Waich's self-published comic *Civilian Justice* featured the hero "ramming an American flagpole, flag and all, through the guts of a swarthy, demonic Arab terrorist."[7] And sometimes it gave way to greater ambiguity, especially as the War on Terror spread to Iraq, as 9/11 became woven into the new normal. Stuart Moore's *Giant Robot Warriors*, written in the wake of 9/11, presented America as the good warrior, fighting for ideals. By the time it came out, though, it rang hollow to the creators, who now favored something more "nihilistic . . . creepier and nastier." Like Andy Diggle and Jock's *The Losers*, post-9/11 dirty war CIA types; or Nate Cosby and Ben McCool's *Pigs*, a spy tale illustrating how hegemonic fathers' sins are traumatically visited on the children. Brian K. Vaughan and Niko Henrichon employed the talking-animal fable to take on war, misplaced American power, and empire in *Pride of Baghdad*. Steven T. Seagle and Becky Cloonan's eponymous, evangelical *American Virgin* goes to Africa; his moral rectitude and certainty are shaken by tragedy and the broadening of experience, showing the ebb and flow of the American myth. Arguably comics' most influential treatment of post-9/11 patriotism and affiliation played out in Marvel's pages, framing the question of superhero registration/government identification as the central crux of 2007's *Civil War*. "It's not like we're banning 'em, man. Nobody's stopping them from doing their thing," says one (non-superpowered) officer to another. "But they don't get a buzz out of being legit."[8] Reminding us, once more, of those claims of fascism. *Civil War* notably ends with the death of Captain America—who, after 9/11, had uncomfortably begun questioning the United States' militarism and interventionism, and, in *Civil War*, had even taken up shield against the government, unimaginable to his first World War II–era readers.[9]

For every evocation of Kurtzman's fetishistic detailism,[10] there were

works adopting the lessons of Don Lomax's '80s *Vietnam Journal*, evoking "the grunt's eye view [who] didn't have any goddamned idea why they were there": the agonized, helpless, unknowing perspective of Danica Novgorodoff's *Refresh, Refresh*, title taken from a son's constant email check to discover if his far-off father has messaged him; the passionate ambivalence of Tom Waltz and Nathan St. John's *Finding Peace*, about the vividly and impressionistically rendered horrors faced by a peacekeeping mission in a nameless country; and Jason Aaron and Cameron Stewart's *The Other Side*, which confronts the medium directly—"I used to *love* these things," says one comic book–reading Vietnam GI. "Now, though, man, they're just part of the lie. Domino theories, communist insurgents, the glory of killing and dying . . . that's all bullshit they made up to sell comic books."[11] Kevin C. Pyle's *Blindspot* addresses comics' power to compel such understanding on the home front; a kid, struggling to find his footing and fascinated by military matters, has battlefront imaginings overwhelm his actual setting.

Ambiguity would also mark the post-9/11 personal comics. Henrik Rehr's *Tribeca Sunset: A Story of 9-11* chronicled the experiences of a Danish-born American who lived in the neighborhood; it depicted Rehr's terrifying search for his family, and his finding not only a new geopolitical understanding but new depths within himself, anger and fear in the face of something unimagined, if not unimaginable.[12] While not a memoir, the travails of *Doonesbury*'s B.D.—who would lose a leg in Iraq in 2005 and whose long road home was based on Trudeau's intensive research with wounded veterans—spoke the words and aches of many.[13]

Frequently, the autobiographers took the opposite road from Spiegelman and Rehr and went inward, tilling their patch of personal ground and turning over fine soil. Musician[14] and cartoonist James Kochalka puts it best: "[E]ach day I pick one of these little experiences . . . each individual strip might be close to meaningless, but . . . together they are becoming a fully realized portrait of my life. . . . I draw myself as a rather awkward looking elf because it reflects . . . the magic & mystery of life and my awkward grappling with it." There are risks: of a certain cutesiness,

an almost forced whimsy, the obsessive tendency to make everything into comics. Others, like Vanessa Davis and Liz Prince, struck similar notes: after Prince suggests she'll splash a glass of water on her boyfriend's face, her companion says, "That'll make a good comic." "I know," she responds.[15]

But Kochalka was right to note on the strip's tenth anniversary that "my strip . . . can even make the mundane magical and transformative."[16] This was true of several of Kochalka's talented peers, too. Jeffrey Brown is less rigorous about diaristic chronology, but his small snapshots of relationships combine man-boy fecklessness and whimsical artlessness. In works like 2002's *Clumsy*, 2003's remarkable *Unlikely*, and 2006's *Every Girl Is the End of the World for Me*,[17] Brown presents himself as a weepy, frequently sick, unshaven mess, buffeted by feelings out of his control, wafted about by the whims, needs, and demands of (particularly female) others. But, as always in autobiography, he ultimately manifests control; if the girl he loses his heart and virginity to in *Unlikely* stomps on his very being, he has portrayed her in his panels sympathetically, vengefully, indelibly. It must be said, though, that he's equally unsparing of himself, and that he gains empathy as he develops artistically: when, in 2007's *Any Easy Intimacy*, his girlfriend says, "This is one of those times where if you weren't here, I'd hurt myself," his only response is to draw her close.

By contrast, Erika Moen's comics are gleefully, uproariously sexual, telling tales of her attraction to girls and romance and marriage to a man, claiming the word *queer* in all its dimensions. Willing to explore life and consciousness in whatever directions they take her, "it's a challenge to find the middle ground between just *over* exposing myself and getting 'naked' in order *to relate* with my audience," she has said.[18] This sense of comics as presenting vulnerability, embracing their chronicler's imper-fections and stresses, produced powerful work.

Gabrielle Bell's attempts at juggling art and gainful employment in a gentrifying Brooklyn in *Lucky* are constantly shot through with millennial socioeconomic stress. Box Brown presented a comic with two identical images—"Box Brown, Cartoonist" and "Ben, Fictional

Character"—writing, "I created this character to hide my shame. I was depressed and painfully alone . . . booze soaked and anxiety ridden. Ben was in love and sober and slightly happier. A fantasy. And slowly I became him."[19] Cartoonists like Carrie McNinch stressed daily drawing as a therapeutic device (for McNinch, to embrace her sobriety, taking it one day at a time), an aspect foregrounded in a subgenre of autobio comics that exploded post-9/11: the medical memoir.

Take, for example, the brace of cancer memoirs published in the 2000s, illustrating the subgenre's representational variety.[20] Brian Fies's *Mom's Cancer*, winner of the first Eisner Award for a digital comic, plays it fairly straight, the author resolving to "tell it as squarely as I could," focusing on patient empowerment and education (admittedly, some superhero images pop up along the way). Fourth-grade teacher Tucky Fussell's *Mammoir*, as its punny title suggests, takes a more cartoon-oriented educational approach, using *Magic School Bus* children's book–type techniques to venture inside her own body, quizzing anthropomorphized body parts for information. Miriam Engelberg's *Cancer Made Me a Shallower Person* took a stand-up comic's tone, honed from years in theater and monologue, and a visual rhythm bespeaking the gag strip. (Engelberg succumbed to her cancer the year her memoir appeared.) Marisa Acocella Marchetto's *Cancer Vixen*, by contrast, while also depicting cycles of diagnosis, reaction, and treatment, spends equal if not greater time on Marchetto's relationship and upcoming marriage; and while there are gags ("Knock knock!" "Who's there?" "Cancer." "Cancer who?" "Cancer your wedding! Cancer your career! Cancer your life!"), the horror pervades, metastasizing to assault Marchetto's sense of her femininity and maternity.[21]

Two works in the new century's first decade stood as high-water marks of the memoir as therapeutic investigation—both recognized as towering achievements of the medium, each digging into the creator's past to illuminate their present.

In 2003's *Blankets*, Craig Thompson sensitively depicts his younger self's swirling doubts and desires; given his extremely religious upbringing, Thompson questions—and foregrounds—art's role in fulfilling

religious imperative. "Come on, Craig. How can you praise God with drawings?" a teacher asks; the book, written after Craig has left the church—but not God—behind, features an epiphany of girlfriend Raina with angelic wings and halo as he recites from the Song of Solomon.[22] (It hardly seems a coincidence that a reference to "page 151 of your hymnals" appears on page 151.) *Blankets* powerfully expresses that balance between alienation and transcendence: Raina, who tells Craig, "Sometimes you look at me with longing . . . even though I'm here with you," also makes him a blanket, a symbol both of shared intimacy and being wrapped apart. "How satisfying it is to leave a mark on a blank surface," Craig thinks as he walks through the snow, "to make a map of my movement—no matter how temporary."[23] They're the book's last lines: the artistic process as salvation—another balance, between ephemerality and permanence.

Three years later, Alison Bechdel published *her* memoir, *Fun Home*, which presented the memoir as mysterious (one critic's review was appropriately titled "Puzzle Palace").[24] Even the title is elusive, ironic, referring to something we don't understand until later—which helps us understand the book's carefully designed, essentially circular structure: we go around and around, revisiting moments, periods, characters, getting more insight each time.[25] But never the full answer. What precisely *is* the nature of her father's death, and how does that understanding (and discovery—the book is structured as a series of revelations) affect the shaping of who Bechdel is? And that's as it should—*must*—be, which is another way of saying the memoir can be an attempt to constitute the self, rather than presenting a well-rehearsed self in memoir form.

Or is it? Bechdel, like all accomplished creators, gives us what she wants us to know, not more. Her mother, we learn, was an actor—but so, it turns out, was everyone else. (Composing preparatory reference photographs, Bechdel acted out all the parts, including those of her parents.)[26] Performance is a frequently invoked concept in contemporary gender and queer theory, and the novel asks, powerfully, what precisely these performances are covering—not least, though not solely, questions of sexual identity. The visuals fit the story: the pale green wash of the palette, like

Eisner's sepia tones in *Contract*, may suggest faded memories (Bechdel herself calls it "sort of a sad color, sort of a grieving color . . . [there's] a bleak, elegiac quality to it that I liked"),[27] but also exudes a flatness, suggesting both the weirdness of the setting, the funeral home called a "fun home," and how everything was perceived, sublimated, performed, as normal. Bechdel presents herself as having suffered multiple traumas: her father's death; being unloved or loved "improperly"; being either misunderstood or understood too well. What does recovering from this, achieving "normalcy," even mean?

Sometimes the prospects of loss and personal history felt too dreadful to be faced full-on; one resulting strategy was exemplified by a twenty-first-century autobiographical turn by a twentieth-century mainstream icon. Joe Kubert's two "alternative autobiographies" each deal with familial loss: *Jew Gangster*, about rejecting your parents' sacrifices to choose danger, adventure, and eros, was simultaneously a metaphor for the creative life and the fantasy of power, Jewish and otherwise, that comic books expressed. Kubert, a kosher butcher's son too young to serve in World War II and who lost family in the Holocaust, suggested the latter even more powerfully in *Yossel, April 19, 1943*,[28] with an imagined version of himself (Yossel is Yiddish for Joe or Joseph) as a kid drawing cartoons in the Warsaw Ghetto. His uprising is as imaginatively powerful, and tragically evanescent, as the sheets of paper and cartoon heroes (including Hawkman) he draws.[29]

And so, inevitably, the question of escape, and survival, persisted. John Porcellino's *Diary of a Mosquito Abatement Man*, while chronicling ambivalence about an early job, showcased his developing empathy for the nature around him, and portrayed comics as a means for personal survival, an escape from depression.[30] Miss Lasko-Gross's *Escape from Special* offers a deeply intelligent and imaginative younger version of herself, socially alienated for that very reason. But the move from, in her words, "Nobody fucking gets me!" to "I really *don't* care what they think. How about that?" (the book's last line) puts the focus on a successful escape, though the time and effort she devotes to those traumatic cir-

cumstances may beg the question. Maybe the last word belongs to Alex Robinson's *Too Cool to Be Forgotten*:[31] a man returning to his high school body, revisiting old mistakes and making new ones, thinks, "TV and movies can make you forget how awkward [teenagers] are. Maybe a realistic portrayal would be too boring . . . or too painful." History—that realistic portrayal—needed grappling with, too. And comics were increasingly recognized as a suitable medium in which to do it.

—————

FITTINGLY, THE MOST POPULAR—as in *New York Times* best-seller popular— example of comics-as-history in the century's first decade was Sid Jacobson and Ernie Colón's graphic adaptation of the *9/11 Commission Report*, published the same year as *Fun Home* and considered a marvel of using the medium to put across deeply complex and interconnected narratives.[32] But examples abounded, from George O'Connor's illustration of a seventeenth-century Dutch explorer's diary[33] to a whimsical investigation of evolutionary biology, conducted by Charles Darwin's eyebrow mites, to "pre-chew the food [of instruction] for you," as author Hosler biologically puts it.[34]

In Hurricane Katrina's wake,[35] Josh Neufeld's *New Orleans A.D.* juxtaposed wide-screen depictions of nature's depredations with intimately reported stories; Mat Johnson's *Dark Rain*[36] wove unsettling quasi-biographical images into a cinematic caper tale suffused with racial and political dynamics. As the works made clear, explorations of the American present were, necessarily, explorations of the American past, some factual, some reaching into allegory. Kyle Baker's long introduction to *Nat Turner* is one voiceless scream against the obscenities of the Middle Passage, setting the stage and providing explanation, if perhaps not total justification, for Turner's actions. Jeremy Love's *Bayou* served as the sunken place in which America's sins toward Blacks are uneasily buried, seen through the lens of an uncannily perceptive young girl; *Bluesman* transposed traces of stories left behind in twelve-bar folk songs to a fictional narrative fraught with traces of America's racist his-

tory. In contrast, *Stagger Lee*'s careful historical work teased out the true story, or variants of it, behind the oft-adapted folk song, visual tropes and triggers reflecting the multiple emphases of historical interpretation. So, too, *Unknown Origins & Untimely Ends*,[37] an anthology of true-life horrific tales, provided regionalist twists on narrative unreliability in lurid, gothic tone. And Glenn Eichler and Nick Bertozzi's *Stuffed!*, about two white brothers who find a taxidermied African of indeterminate origin in their father's effects and attempt to do the right thing, was an occasionally blunt but surprisingly supple metaphor for America's unfinished business with the heritage of slavery, and of race in comics storytelling. "History has its hands full," Joe Sacco noted toward the end of the decade; it "chokes on fresh episodes and swallows whatever old ones it can . . . the ink never dries."[38]

Much comics historianship emerging in the century's first decade took a biographical role, providing historical corrective in presenting the details of lived lives and hidden figures. For a decade, *Binky Brown*'s Green produced page-long musical biographies of little-known artists for Tower Records' *Pulse!* magazine, until it folded in 2002; a graphic anthology about women scientists like Rosalind Franklin, the overshadowed partner of Francis Crick and James Watson, had been published several years earlier. Less sympathetic, but certainly empathetic, was the portrait of Lincoln's assassin in C. C. Colbert and Tanitoc's *Booth*.[39] There were composite biographies, like Ed Piskor's *Wizzywig*, which presented a hacker's coming of age from multiple angles,[40] and Jim Ottoviani and Leland Purvis's Niels Bohr biography, which not only clarified the physicist's discoveries and the attendant controversies for general audiences, but commented wryly on the medium while doing it: "Where is an electron while it's jumping?" Bohr is asked. He replies, "You might as well ask what happens between the pictures in those 'comic strips.' "[41] Comics also used the medium's particularities to slow down, focusing on moments within a life, rather than the life entire. Jason Lutes and Nick Bertozzi's *Houdini: The Handcuff King* consists of a deep dive into one of the magician's tricks (in two senses) to tell us everything that matters about the

man, his craft, and his world; a focus on a single flight of Amelia Earhart's allows us to see its formative influence on a female journalist, expanding to vistas of unrealized feminist ambition.[42]

And some biographers worked to capture voices of less historical import. Like Pekar, David Greenberger has other artists render his stories, but Greenberger interviews senior citizens—mostly residents of a single nursing home—and they reveal themselves through his pen in their most human and varied form, ranging back over the decades, both in and out of the moment. Jerry Moriarty's look at an irascible, contemplative, humorous, often silent Truman-era dad who died when Moriarty was fifteen is a paradigm of complex affection and identification, "a time machine painting," he concludes.[43]

Unknown figures can be unknown victims, and true crime remained a powerful lure to the graphic journalist. Kevin Colden's Fishtown, inspired by the true story of Philadelphia teen murderers, casts their milieu in a sickly yellow, suggesting jaundice—and jaundiced personalities who commit an act beyond explanation. G. Neri's Yummy, examining another teen killer, this one Black, on Chicago's South Side in the '90s, revealed a milieu in which tragic choices and circumstances yield tragic result. Jeff Jensen and Jonathan Case's protagonists in the cold-case story of Seattle's Green River Killer age decades between panels, pungently showing the weight of age and crime. And Derf Backderf's childhood association with killer Jeffrey Dahmer becomes the basis for an indictment of adults who should have seen and known better—but he doesn't spare himself, either: when his wife told him his class included a serial killer, Dahmer was his second guess.[44]

Americans abroad post-9/11 often emphasized the ironies of attempted self-discovery through travel, suggesting you learn more about yourself than those you encounter. (Traveling through Morocco to prepare for his Blankets follow-up, Craig Thompson wrote, "I'm a doofy tourist acting out Orientalist fantasies in a poverty-stricken land.") But the best of these trips of discovery end in ambiguity. Sarah Glidden attends Birthright Israel in part to accentuate preconceived ideologies, and opens

herself up to the knowledge of humility. In the last panel, asked, "What's the deal with that place, anyway?" her response, the only possible one, is "Well—" and then the book ends.[45]

Glidden's trip is premised on exploring her Jewish identity: how she sees it, how others expect her to see it, and how she struggles with that complex identification. Such investigations of religious, ethnic, gender, and sexual identity became even more pronounced in the twenty-first century, as these questions were increasingly foregrounded in a rapidly diversifying American cultural scene. Previous decades' comics, for example, were filled with Orientalist stereotypes almost entirely written and illustrated by non-Asians,[46] and Gene Luen Yang's 2006 *American Born Chinese* addressed the subject head-on.

Its narrative seems at first to toggle between multiple levels of fictionality: a realistic personal narrative of a Chinese-American kid, an epic Chinese folktale, and a TV-sitcomesque cultural clash featuring the worst of comic book Orientalist stereotyping ("Chin-kee" has huge buckteeth and exaggerated epicanthal folds and speaks in exaggerated dialect). But the levels soon blur, suggesting identity is also defined individually, not just (although also) by legislation or external cultural conditions.[47] If at times—including now, alas—certain ethnicities or groups are seen as somehow "incompletely American," how does that racist thinking manifest itself? How is it internalized, apparent in the verbal and visual rhetoric of "normalization" clearly devoutly wished for by Yang's main character, and powerfully trading on the visual and verbal transformations easily available in comics? How does one break free of such histories of representation and produce a personal and aesthetic model shaped by alternate visual histories and approaches?

Rina Ayuyang's story "Acacia" explores such tensions. The Pittsburgh-born Filipino American's family home sports wooden carvings she believes are "heirlooms passed on from my ancestors to future generations." Discovering that they came from a thrift store, but are common to other Filipino family households, she explores the connection between art making, originality, and community. "Their mystique disappeared,

but it didn't mean we stopped taking pride in them," she says, a line that can illuminate her work, and this genre, more generally.[48]

In 2006, *American Born Chinese* was nominated for a National Book Award in the Young People's Literature category, a first in the fifty-seven-year history of the awards. (Yang was a Catholic high school teacher and database manager in Oakland at the time; he missed the NBA executive director's nominating call because he was pulling a tech-related all-nighter.)[49] *American Born Chinese* would sell roughly a hundred thousand copies in two years, thanks, in no small part, to the support of librarians and educators.[50] That same year, Chris Ware got a solo show at Chicago's Museum for Contemporary Art; *Time* named *Fun Home* 2006's Book of the Year; and Houghton Mifflin added a volume of the best American comics of the year to its many similar anthologies.[51]

The status shift had been ongoing since *Maus* and *Kavalier & Clay*, but the period from 9/11 to Barack Obama's inauguration saw a rapid increase in momentum. In 2003, Elvis Mitchell wrote a tribute to Jack Kirby in the pages of the *New York Times*; the next year, a *Times* magazine cover story was headlined "How Cool Is Comics Lit?" and a *New Yorker* cartoon character complained, "Now I have to pretend to like graphic novels, too?"[52] Readers of the *Paris Review* were in the same boat, the journal publishing comics by Renée French that same year.[53] In 2005, Seth's *Wimbledon Green* was excerpted in *The New Yorker*, and the *Times* magazine began *The Funny Pages*, a section including comics by Chris Ware and Jaime Hernandez, among others, a small part of the medium's rapidly increasing coverage in America's paper of record.[54] That same year, *Time* named *Watchmen* one of the one hundred best English-language novels since 1922, and Art Spiegelman was elected to the American Academy of Arts and Sciences. (He also had a cameo on *The Simpsons* in 2007, alongside Daniel Clowes and Alan Moore.) Academia more generally was following suit: James Sturm began the National Association of Comics Art Educators because, as he said in 2003, "I think comic-art programs will eventually have a place in art departments at universities . . . it's just a signifier to academe that comics are a legitimate medium."[55] Comics-

related monographs, publication lines, and special issues of academic journals followed.[56]

But much of this flourishing wasn't in the traditional venues. Marvel and DC's direct market sales declined by double-digit percentages in the late '90s; by 2006, top-selling monthly comics sold around 130,000 copies an issue, a far cry from the circulation of days past, and most sold well under a quarter of that. In the mid-2000s, comics sold roughly twenty million copies a month, a quarter of 1954's totals, and the average comic book buyer was in their late twenties. Newer potential readers had fewer opportunities to come in contact with the material, and existing ones were getting exhausted. When Captain America died in 2007, one retailer blogged, "I was working comics retail when the Death of Superman hit. . . . I remember skyrocketing sales, brought down by a near-crash of the industry when people realized they'd essentially been scammed. And I worry that we're watching the whole thing repeat." Still, he was optimistic: "It's a pretty good time for a comic book retailer to snag casual customers. . . . I feel like this was the right time to buy a shop."[57]

And there *were* efforts and innovations in the direct market, perhaps the most notable being Free Comic Book Day. It started May 3, 2002, piggybacking on the release of the movie *Spider-Man*; May 3 of the following year was the day after the *X-Men* sequel came out, and publishers widely participated, mostly with comics aimed at seducing younger readers[58] (which led to a controversial free speech case the following year, when a comic store employee accidentally gave a minor a book containing nonsexual nudity and was charged with a felony carrying a penalty of one to three years in jail).[59] By 2005, the day had broken away from movie tie-ins (and thus, to an extent, with superheroes), and by 2011, over a million people showed up to stores to claim over three and a half million comics.[60] Less public-facing, but still important, were comics publishers' adjustments to direct market rules, providing retailers some time to see how an issue sold before ordering the following one;[61] new point-of-service technology allowing retailers to better see what was selling;[62] or Diamond adding a new forty-seven-thousand-square-foot storage facility

in 2005, in no small part due to increased ordering of backlist items like graphic novels.[63] Diamond remained essentially the sole distributor to the direct market; its decisions about what to carry could raise hackles, as when ambitious work published by a serious company like Picture-Box was turned down in advance (though Diamond would reverse its decision).[64]

But the direct market was no longer where the action was. By 2003, an observer at the BookExpo trade conference noted, "Most book buyers and librarians have caught up to the educative value, broad-based appeal, and literary merit" comics provided;[65] the next year, the Graphic Novel Pavilion at BookExpo was twice as big, and the *Comics Journal* limited its "best of" lists to graphic novels and "bound collections of comics [due to] a fundamental sea-change in the industry, as comics publishers take advantage of the potential in both increased audience size and acceptable subject matter offered by the bookstore market."[66]

Longer shelf life and better profit margins mattered. In 2001, graphic novel sales totaled $75 million; they more than tripled in five years, to $245 million.[67] Independent companies like Fantagraphics and Top Shelf focused almost exclusively on the format by the mid-2000s. By 2005, Drawn & Quarterly was suggesting that two-thirds of its sales were in bookstores; Fantagraphics, at least half.[68] Marvel announced to stockholders in 2005 it would expand from offering its products in fifty Barnes & Noble stores to three hundred;[69] the same year, DC reorganized its sales and marketing efforts to combine direct sales and bookstores. Long-time comics professional Diana Schutz put it this way the following year: "We're in this complete transition . . . the retailers' entire structure is still based in periodical publishing. The real market shift is toward perennials."[70] By 2006, the year graphic novel sales outgrossed comic books ($330 million to $310 million), there were an estimated 2,500 to 3,500 comic stores nationwide, roughly one for every 1,000 square miles, serving no more than 350,000 to 380,000 comics buyers nationwide.[71] Occasional events briefly arrested the trend—mega-selling series like Marvel's *Civil War* and DC's *52*—but the writing loomed on the comic shop wall. DC

Comics president Paul Levitz mused, "It smells to me like the number of human beings who are regularly reading graphic novel formats in this country is now larger, or about to be larger than the number of human beings regularly reading the periodical formats. I think that's a very interesting transition, because that has never been true before."[72]

And with comics' growing appearance in bookstores, their traditional suppliers, book publishers, were increasingly getting into the game. Doubleday introduced, then shelved, a line of graphic novels; Fantagraphics partnered with W. W. Norton to distribute its books in bookstores; a few years later, Drawn & Quarterly did the same with Farrar, Straus and Giroux, and Norton acquired Will Eisner's backlist from Dark Horse.[73] By 2005, over half a dozen lines existed at various publishers, including Penguin (Puffin Graphics), Scholastic (Graphix), and Henry Holt (First Second).[74] Scholastic sold half a million copies of *SpongeBob SquarePants: Bikini Bottom's Most Wanted* in 2004,[75] republished *Bone* to massive success, and produced adaptations of the Baby-Sitters Club books, by a young writer/artist named Raina Telgemeier, starting in 2006.

If the direct market had faltered in providing all-ages material, ceding the ground to the bookstores, then new, post-*Bone* talent exploded in that venue. Art Spiegelman and Françoise Mouly's *Big Fat Little Lit*[76] offered fractured, formally innovative, and "childishly" subversive fairy tales and folktales; Mouly went on to publish her own line, Toon Books, in 2008. Andy Runton's *Owly* stories tell beautifully of a friendship between an owl and a worm;[77] David Petersen's *Mouse Guard: Fall 1152*[78] reminds us of how small creatures (mice with swords) provide a ground-level view of larger stakes. In Jordan Crane's lushly colored *The Clouds Above*, a classic childhood desire, to be out of school, going on adventures, leads to a narrative out of Maurice Sendak's *In the Night Kitchen*. Matthew Forsythe's *Ojingogo*, a largely wordless set of Korean-inspired narratives about a girl, a squid, and the adventures they go on, are about tones and feelings, rather than themes and narratives.[79] Mostly for kids, not by kids—one exception was Denis Kitchen's nine-year-old daughter Alexa, whose *Drawing Is Easy! (Except When It's Hard)* was published in a five-

thousand-copy run in 2006, with admiring notice from R. Crumb and a profile in the *New York Times*.[80]

Not everything was so lighthearted; the subtitle of Ariel Schrag's middle school–set graphic anthology, *Seventeen Comics from an Unpleasant Age*, says it all. But even this demonstrated an expanding audience, now growing up with the visual proof (comics were in bookstores! Between nice hard covers!) that comics were *important* and *legitimate*.[81] Although there was that shelving question: Should bookstores put all comics-related content in a stand-alone section, incorporating both *American Splendor* and *Zippy*? Scattered within relevant subject headings in other sections?

A similar question obtained with libraries, where these works were increasingly present, particularly in children's sections. *Bone*'s Jeff Smith, invited by the American Library Association to their 2002 annual meeting, was "taken aback when the librarians professed that they already were in love with comics and wanted more . . . saying their books were teaching kids—especially boys—to read and getting them excited about literature. . . . [C]omics and their book-length cousins, graphic novels, were the only books for which circulation was up."[82] Toon Books' Mouly said, "The librarians are so far ahead of the curve because they see kids coming into the library for two reasons. One is to use the internet. The other is to read the comics."[83] By 2011, according to one "informal" study of responding libraries, 86.9 percent had children's graphic novel collections; 83.3 percent had young adult sections; and 64.2 percent had adult collections.[84] There would be occasional controversies, as when, that same year, Schrag's middle school anthology was pulled from a school library in Dixfield, Maine, but it, like the collections more generally, stayed in.[85]

If bookstores and libraries embraced all-ages comics, another aspect was epitomized, ironically, by direct market–era excess. Image Comics' *Gen13*, it of the bikinis and quests for variant covers, was notable for its successful incorporation of manga action and representation into mainstream comics. This story's roots were a generation old: *Akira* had been available as a Marvel comic from 1988; its anime version premiered in art houses in 1990.[86] By 1996, fans had undertaken major "scanlation"

projects—acts of digital piracy where scanned and translated versions of works like *Ranma ½*, *Dragon Ball*, and *Naruto* were hosted on hosting services like GeoCities and Angelfire.[87] The explosion of Pokémon, whose cards were staples of the comic shops at century's end, didn't hurt in exposing kids to the ethos, either.[88]

Mainstream companies noticed the enthusiasm. Marvel briefly experimented with a Mangaverse around 2000, president Bill Jemas noting the "major trend [of Japanese] girls around 13 or 14 years old" reading comics,[89] and hoping to echo that in America. DC hired manga artists to take on Batman and collaborate with Neil Gaiman. Erik Larsen incorporated these techniques into his long-running *Savage Dragon* at Image. And companies like Viz, Tokyopop, and Vertical presented either translated manga or original manga-format material to American readers.[90] By 2002, Tokyopop was saving labor by not "flipping" the material and having readers read it in the original right-to-left format; by 2004, it was shipping over four hundred titles annually; in 2006, it signed a distribution deal with HarperCollins, following in the footsteps of Del Rey's manga division.[91] And two original English-language manga titles, *Van Von Hunter* and *Peach Fuzz*, appeared in the Sunday comics pages of the *Los Angeles Times*, *Denver Post*, *Vancouver Sun*, *Seattle Post-Intelligencer*, and *Detroit News* at the start of 2006.[92]

As graphic novels pervaded the bookstores, manga pervaded the graphic novels. By October 2005, forty-seven of the top fifty graphic novel titles in bookstores were manga; industry estimates placed manga sales between 155 million and 180 million—out of a total graphic novel market of 250 million—headed by the totally dominant *Naruto*, which, according to some observers, accounted for almost 10 percent of all North American manga sales in 2006.[93] In late 2006, *Publishers Weekly* began a comics and graphic novels best-seller list; nine of its top ten titles were manga. (The sole exception: the adaptation of the 9/11 Commission Report.)[94] The bookstore locale was particularly notable given manga's failure to resonate in comic shops; a prominent retailer noted in 2005 that he could "barely give manga away."[95] Manga appealed in no small part precisely to

the audience the direct market had been failing to reach: women, girls, young people. Expanded exposure to manga's wide variety had made work aimed at girls and young women available.[96]

Trying to follow trends, Dark Horse introduced a Harlequin romance line; NBM put out Nancy Drew and Hardy Boys series;[97] and DC tried a Minx line aimed at girls aged thirteen to eighteen who were reading manga, but no other comics. Editor Karen Berger called it "specifically targeted for the young adult female teenager . . . real stories about real girls in the real world." Like manga, it was in bookstores and in book form; the line shuttered in 2008, in part because Random House, DC's distributor, couldn't get the titles placed in the young adult sections of bookstores.[98] Shelving was indeed a problem, thanks to a deluge of product: 3,314 graphic novels were released in North America in 2007, a 19 percent increase over the 2,785 published the year before; and manga, where most works appear in the form of multivolume series runs, took up lots of square footage.[99]

But brick-and-mortar bookstores weren't the direct market's only competitors for market share. Seeing Amazon's low prices for a high-end collection, a comic store owner from Pompano Beach, Florida, asked plaintively, "Why would anyone come in a comic book store?" He added, "Many times I hear a parent tell their kid 'lets [sic] go home and see how much it's online for' . . . great."[100]

———

AH, THE INTERNET. "Today, with the help of computers, anyone can be a publisher, not just a select few conglomerates. This includes you, my friend," read a book—a book!—speaking to the Web's glories in 1999. While webcomics had existed as early as the CompuServe days,[101] by 2001, the year the alt-comics Ignatz Awards inaugurated a prize for online comics, Rick Veitch was suggesting that "the daily strip format is well-suited to the way people use the Web right now. A three- or four-panel daily fits right into the browser window so it can be read without scrolling and it provides a bite-sized blast of thrills or humor." The proof was there:

Tristan A. Farnon's LeisureTown.com was getting over a million hits a month in 2001. "You just have to give them something worth the time it takes to download," he said.[102] Marvel put a hundred classic Silver Age comics on a CD-ROM in 2004, separately offering other comics as digital "mini-movies" with music and surround sound. Meanwhile, the Mobile Comics Network was bringing comic strips to mobile phones, allowing users to scroll through a panel at a time. In 2005, King Features began an online subscription service.[103] A host of blogs and related websites sprung up, offering varying levels of journalistic scrutiny of the industry and medium.[104]

In 2005, James Kochalka, who had moved his diary comics online in 2002, reported he was making more money from subscribers to AmericanElf.com at $1.95 a month than from his Top Shelf royalties.[105] That September, Carla Speed McNeil announced that "issue #38 of her long-running *Finder* would be the last in serial comic book publication, and that she would be shifting to an on-line followed by print trades model."[106] Phil and Kaja Foglio's *Girl Genius* went online the same year, four years after it started, and flourished there, garnering an audience and two Hugos. And Michael and Nicole Jantze took their strip *The Norm* out of newspaper syndication and relaunched it online. Offering subscriptions at $25 a year, they were able to raise over $60,000. Alison Bechdel mused on her blog in 2006 about doing the same: "The email version could be like HBO. I could leave all the swear words in, and perhaps even have occasional frontal nudity. Instead of the #@&*'s and artful drapery that I employ in the newspaper version."[107] Jerry Holkins and Mike Krahulik's *Penny Arcade*, which began in 1998, attracted three and a half million readers worldwide in 2005 (and a *New York Times* profile in 2004);[108] it even hosted its own Penny Arcade Expo (with nineteen thousand attendees in 2006). Chris Onstad's *Achewood* merchandising allowed him to eschew a day job by 2006, five years after the strip started. The same year, Rodney Caston and Fred Gallagher's *Megatokyo*, posting over a hundred thousand views a day, became one of the top American manga—on the internet.[109]

And there were gems in the online mines. Onstad's *Achewood: The Great Outdoor Fight*, an epic satire of American masculinity where men simply bash the crap out of each other until one's left standing—and they're all portrayed as teddy bears.[110] Ursula Vernon's *Digger*, which did for wombats what *Cerebus* did for aardvarks, an epic (and epically funny) journey that gains somber beauty from its woodcut-like approach. Christopher Sebela and Ibrahim Moustafa's *High Crimes*, a spellbinding tale of espionage, murder, and redemption played out on the upper slopes of Mount Everest. The surreal comedy of Jonathan Rosenberg's *Infinite Typewriters*,[111] which first appeared on Goats.com. David Malki's juxtapositions of old-time photographic and lithographic cutouts with absurdist humor on Wondermark.com.[112] Nicholas Gurewitch's blatantly ironically named *The Perry Bible Fellowship* and its surreal, hilarious, gut-punch comic juxtaposition. Randall Monroe's *xkcd*, the kind of nerd science humor the characters from *Dilbert* wish they could appreciate.[113] Kate Beaton's fractured, feminist-minded views of English and American literature, the sharpest misuse of a classical education since P. D. Q. Bach, followed close behind by Dave Kellett's musings at Sheldon.com—what he does to Emily Dickinson should really be a crime.[114] Fittingly, the Eisners would add a webcomic award in 2005; the Harveys would follow suit a year later.

The medium's digital capacities also allowed works to alter, and thus comment on, other comics, with occasionally remarkable results. Dan Walsh's *Garfield Minus Garfield* (2007) used Photoshop "to eliminate all the characters in the Jim Davis strip save for Garfield's owner Jon. The result was an absurd series of strips that portrayed its main character struggling with insanity and existential despair"; at its height, the Tumblr site received three hundred thousand hits a day.[115] (In 2011, another Tumblr site, *3anuts*, performed similar formal magic on Charles Schulz's strip: "*Peanuts* comics often conceal the existential despair of their world with a closing joke at the characters' expense. With the last panel omitted, despair pervades all.")[116] And there was *The Silent Penultimate Panel Watch*, a 2006–07 blog whose name spoke for itself.[117]

The internet also provided the opportunity for new expressions of community: artistic collectives,[118] expressions of immediate financial support for suddenly struggling companies,[119] venues for talented artists without connections or in-person opportunities to be seen and employed by gatekeepers.[120] But in many ways, the story of the period was still very much IRL. The biggest story of paper and pixels in comics went the reverse direction, when Jeff Kinney took his comics-prose hybrid *Diary of a Wimpy Kid* from FunBrain.com to Harry N. Abrams and spent most of 2007 on the *New York Times* best-seller list.[121] And in terms of community, the real stories were the explosive growth of conventions, and of the fans attending them.

By decade's end, comics conventions were blossoming all over the continent: Toronto's Comic Arts Festival, Portland's Stumptown, Seattle's Emerald City. Wizard World Chicago had 56,000 attendees in 2005; Wizard World New York drew 77,000 in 2009.[122] But San Diego remained King Con. Comic-Con International marked close to 75,000 attendees in 2002; two years later, there were 87,000; the six-figure barrier was broken for the first time in 2005, hitting between 120,000 and 130,000 in 2006 and 2007. In 2009, the fire marshals determined it was at capacity, even with a recent expansion.[123] In 2004, the convention used an exhibit hall, Hall H, as a programming space that could hold 6,500. The first program, on July 23, 2004, was for *Batman Begins* and *Constantine*, featuring Keanu Reeves, and drew a capacity crowd. By 2007, entertainment magazines, understanding that comics and movies were an increasingly intertwined business, had moved from sending a single reporter to five or six.[124]

Some of those movies, to be sure, came from the independent end of the street. Terry Zwigoff, who'd supported the undergrounders by distributing food stamps as a welfare case officer,[125] directed a well-received 1994 documentary on R. Crumb and adapted Clowes's *Ghost World* in 2001; two years later, Harvey Pekar arrived onscreen alongside Paul Giamatti's fictional counterpart in *American Splendor*, in one of the most formally innovative adaptations of a comic yet.[126] But it wasn't the

independents packing them into Hall H, or, indeed, the conventions in general—especially as an original reason for convention-going, "to find all the comics that your store might not carry, as well as to live in a world where these things were the primary order of business for everyone on hand," no longer applied, for technological and demographic reasons.[127]

Brian Michael Bendis, still drawing caricatures at Bar Mitzvahs the day after winning an Eisner for "Talent Deserving of Wider Recognition," created an entire graphic memoir in 2000 about his neo-noir adaptation, which was moldering in development hell.[128] By contrast, after the cinematic version of Frank Miller's Thermopylae, *300*, compounded the original's historical inaccuracies, while selling millions of movie tickets,[129] Miller went on to codirect his own *Sin City* film adaptation in 2005. The comic's trade paperback got a demonstrated boost from the DVD's arrival; the same thing happened the next year with Alan Moore and David Lloyd's *V for Vendetta*, when the movie version, starring Natalie Portman, came out—half a million trade copies were sold. DC reprinted over a million copies of *Watchmen* in 2008, the year *its* adaptation was released.[130]

And it seemed people were finally cracking the code of the apparent crown jewels of the comics-to-movie business: the Big Two's superheroes. In the late '90s, a shrewd observer could still say of Marvel and the movie business, "The properties that they had, had just failed, over and over again, to sell to Hollywood. . . . The idea that Captain America was frozen in ice for fifty years was laughable in Hollywood. They weren't getting anywhere with their core properties. Asking the Talmudic continuity scholars in Marvel editorial to throw away the holy litany of Stan and Jack to satisfy Hollywood was having no effect at all."[131] Lee, an early California transplant (for mainstream figures), had never found his footing in Hollywood; the new millennium's first years were particularly awful, as his internet company Stan Lee Media collapsed in recrimination and fraud in late 2000, leading to FBI charges of securities fraud (though not against Lee personally). "A hype machine with an Amazing Simulation in place of a concrete product," commented one contemporary observer.[132]

But his (and Kirby's, and Ditko's, and others') characters began doing better and better: first the X-Men and Spider-Man, in movie series starting in 2000 and 2002, the first Marvel movies to dominate the box office. *Spider-Man* would make well over ten times its $139 million budget in international box office and home video sales by 2003; the first two Spider-Man movies took in $3 billion from ticket sales, DVDs, and TV revenue.[133] But due to terrible previous deals, Marvel was making almost no money on them. Instead, thanks in no small part to turnaround specialist Peter Cuneo, they were earning money through character licensing (and not, primarily, publishing: in 2005, Cuneo told the *Motley Fool* that, "from a profitability point of view, about 15–20 percent of our earnings come from the comic book business").[134] Licensing generated cash, to be sure; in 2006, *License* magazine placed Marvel fourth in its list of 101 leading licensors, behind only Disney, Warner Brothers, and Nickelodeon/Viacom, with $5 billion in retail sales based on its brands.[135] But when it came to sharing in the smash hits' profits, the company was left out in the cold; industry analysts estimated that Marvel took home $62 million of that Spider-Man $3 billion. The X-Men movies made $2 billion; Marvel got $26 million.[136]

By the end of 2005, Marvel Studios, headed by COO and subsequent chairman David Maisel, took on over half a billion dollars in debt, putting up film rights to its characters as collateral, to produce ten movies, the first to appear in the summer of 2008. The deal let Marvel keep a greater share of revenue and maintain merchandising rights.[137] Soon enough, the first Marvel-produced movie was announced: *Iron Man*, the character a childhood favorite of executives Avi Arad and Isaac Perlmutter. Not everyone was bullish. "Shares of Marvel Entertainment . . . have climbed 50 percent in the past year, clobbering the 14 percent return of the S&P 500. But assuming investors follow the usual script on how to play the stock, it's now time to sell," said one analyst in 2007. "Lifting its share price in coming years may be too tall a feat even for its superheroes."[138]

But the inspired casting choice of Robert Downey Jr., "whose own well-publicized struggles with drugs and alcohol resonate strongly" with

the character, as one observer noted, and an assist from the publishing arm, foregrounding Iron Man in the popular *Civil War*, helped lift 2008's *Iron Man* to critical raves (a 94 percent Rotten Tomatoes rating in the first twenty-four hours, "the highest grade ever received by a superhero movie")[139] and, significantly, to huge box-office success. It outgrossed— and who would have believed it?—the new Indiana Jones movie. Trajectories were changing: that summer also saw the artistic and commercial triumph of *The Dark Knight*, featuring an Oscar-winning performance by Heath Ledger as the Joker. By September, a Seeking Alpha analyst was arguing Marvel stock, then trading in the mid-thirties, was severely *under*valued, and should've been selling for more than double that.[140]

The box-office smashes drove another form of speculation: sales of classic comic books. In October 2007, a copy of *Amazing Fantasy* 15, Spider-Man's debut, went for $227,000, a record for a Silver Age comic; in March 2009, a copy of *Action Comics* 1 went for $317,200.[141] For those with less (though still grown-up) money to spend, there were increasing opportunities to exhibit these enthusiasms: in pricing an 848-page Fantastic Four "Omnibus Volume" to tie in with the 2005 movie at $100, a Marvel senior vice president noted, "We'd buy it." It sold out in weeks. More than a dozen followed in the next years, frequently pegged to movie releases.[142] Scrutiny of comics reached new levels; novelist Walter Mosley participated in a 2005 coffee-table book that examined each panel of the Fantastic Four's first issue, considerately blown up one per page.[143] And that same year saw the first publication of *The Batman Chronicles*, an attempt to tell every single one of Batman's adventures in chronological order.

In the process, creators' rights to material became even more pressing as potential movie riches, real or imagined, loomed. In 1998, writer Marv Wolfman, the creator of Blade, sued Marvel, New Line Cinema, and New Line's parent company, Time Warner, for $35 million, claiming he owned the character. The following year saw a deluge of actual, threatened, and rumored litigation about Golden Age characters, as terms of copyright revised under '70s legislation became newly relevant. Superman, Green Lantern, Captain America: all seemed, for a moment, up for

grabs. ("I'm thinking that people think I'm a fool," Joe Simon said. "Like my kids! 'What do you mean you don't own it? You do! You created it!' . . . I'm not a lawyer. I don't have a legal mind. But that's what I feel like. An idiot. After all these years.")[144] Longtime Archie artist Dan DeCarlo, as the *Josie and the Pussycats* movie went into development, claimed ownership of the Josie character, leading to his unceremonious dismissal; his case would also be dismissed, on summary judgment, by New York's Southern District.[145] In 2007, Gary Friedrich filed suit, claiming ownership of Ghost Rider after the (relatively) successful movie.[146] Wolfman lost his suit. Simon would win some battles, but ultimately settled without him (or Kirby) gaining ownership, while the ur-case of comic creators' rights—Siegel and Shuster—dragged on in federal court, potentially complicating new Superman and Justice League movies.[147] Stan Lee, seeing the movies' business, sued Marvel in 2002, based on a clause in his contract giving him 10 percent of Marvel's movie and television profits (in whatever way contract details and Hollywood accounting would interpret them). The suit wended its way through the courts for years, and was eventually settled for what was widely rumored to be $10 million.[148]

As the movies generated buzz and fervor, the comics themselves got more raveled and knotty, the stakes galactically larger than ever—and therefore smaller and smaller.[149] DC's weekly *52*[150] would be followed by *Countdown* and *Final Crisis*, which no one believed was final. Cumulative "event fatigue" resulted, short-term sales spikes notwithstanding (which themselves played havoc with retailers' ordering systems and critics' nerves). "You Won't Need a PhD in DC Comics to Understand New Weekly," said a *Gizmodo* headline in 2008, implying that, in most cases, you did.[151] Grant Morrison's original pitch for a 2000 *X-Men* run read: "What was dynamic becomes static . . . nothing that happens really matters ultimately. . . . The comic has turned inward and gone septic like a toenail," and his take proved a hugely resonant countervailing force in the field over the next generation, "with its stripped-down speed and weird stylistic flourishes" and, notably, no thought balloons—interiority would be expressed through implication or visualization, or not at all.[152]

Spectacle was the order of the day, as cinematic-oriented "decompression" began to hold sway, cutting back words and spreading time over space.

Other attempts to infuse energy into the mainstream stemmed from the adrenaline of facing ideologically dated, even opprobrious, elements of comics continuity head-on. Darwyn Cooke's 2004 *DC: The New Frontier* retold the birth of the Silver Age heroes in one coherent narrative, ensuring that issues like racism and xenophobia were addressed, not elided: a Black hero's murder at the hands of white supremacists casts the postwar Jet Age gleam into more shadowy balance.[153] In 2002, the limited series *Truth* told a Tuskegee-inspired story of the deaths and injuries suffered by hundreds of black soldiers by injections of the super-soldier serum before white savior Captain America got it. (Steve Rogers had no idea . . . but it was too late.) And there were neoromantic approaches. Grant Morrison's *All-Star Superman* incorporated wide swaths of Superman mythology while delving, in the face of his "death," to get to the heart of the character's appeal; Jeph Loeb's *Superman for All Seasons* found its gentle beauty in a return to Smallville Americana.[154]

But many powerful moments came through engagement with previously marginalized or unmentioned constituencies and geographies. G. Willow Wilson and M. K. Perker's *Cairo* (2007)[155] saw a privileged young Orange County woman encounter characters rarely seen in American comics in and from the city, finding not just adventure or romance, but purpose. The work's magical MacGuffin is a box containing "a word . . . [meaning] whatever those in the box wish it to mean." Though the word in question, *east*, has "belonged to people . . . who judged it and bought and sold it from far away; who feared and diminished it," *Cairo*'s syncretistic lesson, "that holy books change depending on who reads them," is powerfully disseminated by a convert to Islam interested in the *creative* energy sparked by such encounters. Wilson herself had moved to Cairo after college graduation already "privately committed to Islam"; after returning to the United States, she became, in the words of a 2010 *Boston Globe* interviewer, "the only white American Muslim woman in comics."[156]

A new, early-twenty-first-century Batgirl, Cassandra Cain, is literally

trained by her assassin father to be speechless, to have no language to address her desires for connection and community. The series chronicles her gaining these things, becoming a profound metaphor for a woman gaining autonomy and voice.[157] Harleen Quinzel, better known as Harley Quinn, had an old-school origin (Arkham psychologist turned Joker girl-friend with a touch of gymnastic derring-do), but her lunatic energy, rare for DC's early-'90s female characters, propelled her from a small role in the *Batman Adventures* animated series to a central one in DC's universe. Marc Andreyko and Jesús Saiz's *Manhunter* featured a divorced, chain-smoking prosecutor turned vigilante interested in killing supervillains; Andreyko played up the double standard of "bad motherhood" and its pressures on his (super)heroine. Created by Brian Michael Bendis and Michael Gaydos, *Alias*'s Jessica Jones was a former superhero turned pri-vate detective; her traumatic mind control/rape at a supervillain's hands (a flashback depicted in standard comic book colors, markedly distinct from the series' generally darker tones) led to post-traumatic prowling around the edges of the Marvel Universe. Catwoman, always one of main-stream comics' more nuanced depictions of female sexuality, agency, and autonomy, was increasingly presented as a woman intimately acquainted with violence, not just as its deliverer, but also as its object, while lighter, more girl power–oriented approaches characterized new series featuring Wonder Girl and Supergirl. Terry Moore's *Echo* was among the best, fea-turing a woman caught beneath a liquid metal suit that responds to the world around her, a metaphor for the atmospheric conditions women in the world hazard daily.[158] But not only for that: for the constant shaping and flowing of the artist's pen as well, for echoing—and remaking—the world as you get it down on page and panel.

IN DECEMBER 2001, Marvel delivered issues with no dialogue in them at all (the phrase "Make Mime Marvel" was bandied about), accentuating, once again, the energetic playfulness and expansiveness of form and image. The apotheosis of formal play in superhero comics was *Plastic Man*, now

in Kyle Baker's hands, whose wild and woolly gags were an excuse to take a heroic body's plastic line for a walk ad absurdum. Other Baker works like *Why I Hate Saturn*[159] recall an earlier era, eliminating word balloons and placing captions beneath pictures that thus look particularly static—accentuating the question of characters' paralysis, a central trope in Baker's tale. Form freezing character was a marked characteristic of a towering work of the century's first decade. Asterios Polyp, the protagonist of David Mazzucchelli's eponymous graphic novel, is a "paper architect," building worlds on the page, and the work's use of bright, thematically oriented color and curve that leaps off the page provides an expressive counterpoint to the binaristic chill that emanates from the character within.[160]

It wasn't just Mazzucchelli and Baker; formal experimentation abounded. Paul Hornschemeier's *Sequential* featured an eighteen-page story, "The Devil's Lonely Day," whose publication was planned in three six-page installments—each containing out-of-order selections that, when supplemented by later installments, gave a continually differing construction of the entire narrative. (The way we understand life as we live it, it could be said.) Renée French challenged herself, in *Micrographica*,[161] to draw single-panel comics "roughly one centimeter square" (mostly about rodents and crap balls). Jason Shiga's *Meanwhile* is ingeniously constructed in the manner of a Choose Your Own Adventure book, but with visual guides to your choices: tubes, tabs, panel flows, coruscating next to each other on the page.[162]

Lynda Barry, in *What It Is: The Formless Thing Which Gives Things Form*, tried to grapple with the question "What is an image?" "What is the past made of?" she asked. "What is and where is your imagination?" The collage-like nature of her text partially suggested her answer, as did a later work's near-manifesto, significantly laid out as a design motif: "There is a state of mind / that comes about when we / let a line lead us along itself. / It can loosen the straight-away of thinking / and help us get where we are going."[163] Form and image countering narrative thinking, and *as* thinking, was a theme among other artists, too; Anders Nilsen's *Monologues*

for Calculating the Density of Black Holes was full of blank, faceless fig-
ures spouting furious verbiage that ultimately, and consciously, signified
little. (In the middle of the four-hundred-page volume, critics accuse the
protagonist of being "random and incoherent"; he responds, "Ah, good,
my audience is finally beginning to understand me.") Jesse Jacobs's *Even
the Giants*[164] has a recurring feature entitled "One Million Mouths," a
profusion of images and figures that give a sense of scale, immense and
insignificant all at once. Others, like the near-wordless *Gaylord Phoenix*,
provide more obscure, almost chthonic explorations of the press and
struggle for comfort with a sense of self (in this case, the sexual self).

Sometimes, that obscurity once again invoked comics' tradition of
surrealist dream. Jennifer Daydreamer's *Oliver* and Hope Larson's *Sal-
amander Dream*[165] provided powerful examples of the elision between
dream and reality via slippery, edge-of-consciousness visuals. In *Pic-
nic Ruined*, Roman Muradov delivers a character's Joycean wanderings,
memories, and word-pictures in cursive script that begins to curve and
loop, turning into pure design, pure image. Ron Regé Jr.'s *Skibber Bee Bye*,
whose quivering, vibrant figures owe a clear debt to Keith Haring, illus-
trates warm life pulsating pantheistically;[166] similarly, John Hankiewicz's
flowing and dancing figures engage in physical action of great mean-
ing, although blurry in understanding.[167] This anarchy of image *can* have
thematic resonance: the power of Ted Jouflas's *Filthy* comes less from
the strong poetic rhythm and form it displays than the surreal, some-
times collage-based, sometimes blunt black-and-white swirling drawings
of protagonists losing their minds (unless these are the clawing, rotted
minds they already possess). Carel Moiseiwitsch's politically oriented
material suggests *Guernica* portraiture coming apart at the seams. And
in Josh Simmons's wordless *House*, about three teenagers succumbing
to what they discover in an abandoned mansion, the surreal turns into
nightmare—using silence, the drawn-out pacing of panels, and the inter-
play of "light" and "darkness" to indicate the slow, lonely extinction that
occurs within.[168]

Many such works, though, actively sought their effect by investing

these fractured, surrealistic panels with strong narrative and theme. Chester Brown's *Underwater* tracked the development of language from children's point of view: the vaguely comprehensible noises they first hear are rendered as incomprehensible text, small islands of meaning swimming into view with greater comprehension. The required interplay between text and visual renders this a seemingly impossible task in almost any other medium.[169] Jay Stephens's *Oddville!* features a flying baby, zombie grunge bands, and giant radio-controlled robots, but follows its own humane logic about curiosity, the desire for connection, and the need, in life, for surprise and fun. Hans Rickheit's *Chloe* is a haunting tale of a lonely young woman; *her* desire for connection leads her into odd and disturbing territory envisioned via gas masks, an actual uterus, expanding and collapsing building horizons, and other images even harder to describe.[170]

Kevin Huizenga's character Glenn Ganges not infrequently steps into the blurred area between reality and fantasy: in 2003's "28th Street," Glenn and his wife struggle with infertility. "You got a curse on you. I'm pretty sure," his doctor says. "Your only choice is to pluck one of the ogre's feathers . . . he or she or it can only be seen when the moon is full and red, and you must be pantsless."[171] And Megan Kelso's stories of genuine, grounded pathos in *The Squirrel Mother*, of young girls on the edge of adulthood looking for connection and young mothers looking for liberation, are similarly near-surrealistically juxtaposed with the language and visuals of folktale.[172]

Folktale continued to become a toy box for creators to rummage, pillage, and pastiche as a generation raised on comics' higher status further integrated these canons, and their lessons, into their work. Sometimes blissfully, but sometimes subversively—the Bluebeard fable turned on its head to become a parable of feminine empowerment, the coiled, wolfen violence at the heart of every tale of a Prince Charming and his beloved.[173] Other adaptations focused on other genres: hard-boiled crime fiction, or genre horror work by authors like H. P. Lovecraft, Stephen King, or Thomas Ligotti.[174] And some focused strongly on the formal challenge

of adaptation itself, perhaps most notably Paul Karasik's version of Paul Auster's *City of Glass*. Working closely with Auster, editorial presence Art Spiegelman, and guiding figure David Mazzucchelli, Karasik created a fitting visual analogue for a detective story that not only turned in upon itself but worked fractally, segments part of a larger whole, by considering panels and pages as larger units, much as Spiegelman had in *Maus*.[175]

But comics also saw more ambitious effort at new realist work. Foundational here was Adrian Tomine's remarkable short fiction, which first appeared in his '90s comic *Optic Nerve*, often focusing on young people, portrayed with depth and roundness, unable to figure out how to enact their own escape. A short story about phone sex and failed attempts at intimacy is called "Long Distance"; a longer tale, "Hawaiian Getaway," features a character behaving as oddly as the protagonists of *Ghost World* but who, unlike them, seems entirely uncaricatured; the unlikely stakes to which her longing and loss drive her seem all too real.[176] As Tomine got older, his protagonists aged, too; tales of a failed "hortisculpture" artist or a man seeking redemption in a younger woman's arms without doing the work of self-reckoning transposed that impossibility of escape or transcendence to a new generation.[177]

Like so many literary fictions, such works often interrogated the artistic life. The protagonist of Tomine's *Shortcomings* could be the man Danny from *American Born Chinese* grows into, if he fails to learn the monkey god's lessons: obsessed with his own failure and inferiority, in part, perhaps, from internalizing stereotypes around Asian-American men that seemingly infuse his worldview.[178] Noah Van Sciver's *Fante Bukowski*[179] features an untalented writer who fancies himself the great American novelist, but instead ends up rewriting Milan Kundera and alienating everyone. Gabrielle Bell's "Felix" brilliantly shows how multiple aspects of the protagonist's being—teacher, student, substitute parent, muse, object of desire, young woman—clash and attempt to resolve themselves as she tutors a famous sculptor's twelve-year-old son.[180]

And finally, there were the novels of greater sweep, the contemporary graphic Zolas and Manns. Most notable, perhaps, was Jason Lutes's

Berlin, which follows regular lives within that city's vast tapestry with fascism looming.[181] Closer to home, Neil Kleid and Jake Allen's extensive historical research infused their tale of Jewish gangsters and their violent lives in *Brownsville*.[182] Adam Hines's slightly later *Duncan the Wonder Dog* combined impossible beasts (here, talking animals who have a bone to pick with humankind), Ware's complicated, fractured layouts, and Sienkiewicz's painterly expressionism—a wide variety of styles fitting for biodiversity, as the sense of a irrevocable turning point approached.[183] All shared the feeling of world-historical times: like the sentiment after the attack on the World Trade Center, and again, very differently, around the 2008 presidential election.

ENDINGS, BEGINNINGS

A round the time that Image's Erik Larsen endorsed Barack Obama's candidacy in his long-running *Savage Dragon*, a little after Barry Blitt depicted Muslim terrorist Obama giving revolutionary Michelle an Oval Office fist jab on a *New Yorker* cartoon cover,[1] the American economy entered the Great Recession. Consumer spending contracted; retail, including the comic market, slowed. Obama's appearance on the cover of *Amazing Spider-Man* 583 lifted sales to well over three hundred thousand copies;[2] but generally, prospects looked worrisome, especially for the format known variously as pamphlets, floppies, or good old comic books. Price was a big part of the reason: comic books went from $1.99 in 1999 to (in some cases) $3.99 in 2010.[3] Dark Horse Comics' Mike Richardson remarked a month before Obama's election:

> Comics cost a dime at one time, and now they're at $2.99. . . . Just a couple of years ago not a single book sold over 100,000 copies, and that's a number the big companies used to cancel at. I think when you start talking about $3.50, $4, or $4.50 for the traditional 32-page comic (with these days 22 pages of story, and some of them, the rest are ads), I just don't know if there's any perceived

value for that. I think that when somebody can buy a graphic
novel, they're much more willing to throw 10 to 20 bucks on a
graphic novel as opposed to $3 or $4 on 20 pages of story. And . . .
maybe there's not the nostalgic connection to the pamphlets that
some of us have . . . a lot of the kids that are coming into comics
these days have grown up with manga that does not come pre-
packaged in comic book format.[4]

This perhaps most powerfully affected serial independent or alterna-
tive comics. Diamond raised its minimum requirements for distribu-
tion, helping lead well-known independent creators Kevin Huizenga
and Sammy Harkham to cancel comic book releases in early 2009. "The
comic book is a weird holdover, like a coelacanth. I guess if I do this right
now I can always feel like it was my decision," Huizenga said, perhaps
half-persuasively. "It's a potential category killer," longtime comics jour-
nalist Tom Spurgeon put it more pungently, pointing out the resulting
increased competition between the direct market and bookstores or the
internet.[5] But trades or anthology volumes like *Mome, Kramer's Ergot,* or
The Ganzfeld, labors of love showcasing much of the new century's finest
craft, were only one alternative.[6] The other, as Spurgeon suggested, was
screens, particularly as digital options became more and more appealing.

In late August 2006, Tokyopop decided to make some product avail-
able exclusively online; in March 2007, Top Cow offered year-old com-
ics for downloading, saying, perhaps ominously, "Our goal is to support
the direct market print sales by offering only backlist items."[7] Obama's
first term saw more digital options by bigger companies, "trying to find
the right digital formula to appeal to a younger computer-savvy genera-
tion that doesn't mind reading comics online," as industry website ICv2
noted. Marvel had 2008's online-only *Marvels Channel: Monsters, Myths
and Marvels,* featuring Galactus, and *Fing Fang Four.*[8] DC's short-lived
2007 imprint Zuda was ostensibly something like an internet slush pile
for comics.[9] Both companies also actively started cracking down on digi-
tal piracy, taking on sites like Z-Cult FM.[10] The oldest popular American

comics form got into the act, too: the month Obama was elected, United Feature Syndicate, which distributed *Peanuts* and *Dilbert*, "made its full archives and portfolio available free on its Comics.com Web site . . . to attract more and, ideally, younger readers," the *New York Times* said. Nobody expected it to make up what a syndicate representative called "declines on the print side": it was, rather, "a platform for what comes next." Other syndicates behaved similarly, focusing on mobile (Andrews McMeel) or creator websites (Garfield.com and Dilbert.com).[11]

As new digital platforms kept developing, growth mushroomed.[12] In 2010, digital comics were a $6 million-to-$8 million business, the bulk of them sold via Apple's iTunes store;[13] by 2011, IDW, a company with comparatively small market share, had seen its reading app for iPad and iPhone downloaded a million times.[14] That summer, aided by new site ComiXology, both DC and Marvel announced that their comics would be digitally available the same day print copies went on sale, a potential dagger to the direct market. Though there were artistic concerns (ComiX-ology had placed fairly strict terms and conditions on content providers,[15] in part to comply with Apple's terms and conditions, leading to the cen-soring of some underground comix images for the iPhone)[16] and com-mercial questions (What was the best digital price point for Marvel and DC comics?),[17] none of that stopped digital sales from tripling that year, to twenty-five million.[18] By 2012, digital represented 10 percent of Dark Horse revenue, and "a double digit percentage" for Image.[19]

Diamond continued procedural tinkering to support comic shops, allowing greater returnability and supporting backlist product,[20] but in the same month it was trumpeting these innovations (October 2012), ComiXology announced its one-hundred-millionth download.[21] Two months later, it informed consumers and investors it was the iPad's third-highest-grossing app.[22] In 2013, when Marvel announced at South by Southwest that seven hundred number 1 issues were free for temporary download on ComiXology, it crashed all the servers;[23] that year, digital comics sales grew to $90 million, up 29 percent over 2012.[24] Yes, print comics (including graphic novels) had total sales of $715 million in 2012;[25]

but ComiXology hit its two-hundred-millionth download in September 2013, just a year after its hundred-millionth, making it the top-grossing non-game iPad app for the second year in a row. Unsurprisingly, Amazon acquired it the following year.[26]

It wasn't just the big companies benefiting. In 2009, PictureBox sent out what one observer called "the most curious press release in recent memory: an announcement for two forthcoming books combined with a plea for advance patronage in order to make the projects happen." The "plea" contained four "ordering options" or "levels," each offering an ascending degree of bonus items or benefits;[27] within two years, a website operating on the same principle, Kickstarter, had facilitated almost a million dollars in financing for comics projects.[28] The following year, one project to bring a comic back into print raised over $1.25 million, about twenty times its request.[29] While this was the exception, not the rule—as of early 2012, roughly half the projects got funded, many presumably just barely[30]—by 2013, a total of 1,401 comics, a separate Kickstarter category, had generated $12.5 million in pledges, its almost 50 percent success rate trailing only dance (70 percent), theater (64 percent), and music (55 percent).[31]

Even Archie Comics tried getting into the game, with a 2015 Kickstarter to support new titles to the tune of $350,000. Pushback was immediate and fierce; its CEO shut the campaign down and backpedaled: "While the response to these new titles has been amazing, the reaction to an established brand like Archie crowdfunding has not been." But more individual voices could flourish. The year 2013 may have been a turning point; in March, Brian K. Vaughan and Marcos Martin released *The Private Eye*'s first installment on a pay-what-you-like model on Panel Syndicate, with a suggested price of ninety-nine cents; it crashed the PayPal link temporarily.[32] And Paul Tobin and Colleen Coover's delightful tales of teenaged thief Bandette—her name, so similar to the "bande" in *bande dessinée*, showing her ancestry[33]—was nominated for the Best New Series Eisner that year, with no qualification due to its appearance on screen rather than page.[34]

Digital technologies also allowed supporting material like "podcasts, YouTube videos, archived hurricane tracking reports, and . . . mixed drink recipes" to supplement the stories, as in Neufeld's *A.D.*;[35] enabled the restoration of old, yellowed pages to crisp, four-color glory;[36] and, crucially, provided access to a wide variety of material previously unimaginable. Art Spiegelman said in 2009, "All of our history is available to us. This is like a new thing . . . that's part of what makes it, on some level, a golden age, because at this point we are getting our history back." Spiegelman also noted he'd "discovered I'm willing to give up certain things, like having an original"; and, in fact, some of the previous period's most essential questions, like the return of original art, were simply rendered moot by digital production, where the concept no longer quite applied.[37]

Not to say there weren't losers. *Bloom County*'s Berke Breathed said in 2009, "I'm going to be blunt. Newspapers have about five years left. Young readers of the newspaper comics simply don't exist anymore in numbers that count. Those eyeballs are elsewhere and will not come back. Online comics are terrific. But they will never have 1% of the readership any major comic had 20 years ago, by the nature of the technology."[38] Between 2011 and 2014, print ad revenues shrank 50 percent, to the lowest they'd been since 1950, when the economy was one-seventh the size.[39] Some comic strip icons, who'd weathered so much, symbolically expressed the passing of an era. In June 2010, *Little Orphan Annie* ended, after running for eighty-six years; two months later, *Cathy* announced its closure (thirty-four years); *Brenda Starr* ended its run of over seventy years on the second day of 2011. There were occasional bright spots, most notably Richard Thompson's *Cul de Sac*, the most imaginative, delightful strip about childhood mischief and imagination since *Calvin and Hobbes*,[40] but its tragically shortened life due to Thompson's Parkinson's disease seemed a part of the whole. And it wasn't just periodicals: the Borders bookstore chain went out of business during Obama's first term, and Barnes & Noble, the last bookstore chain left standing, contracted significantly.

But for many, newsprint and brick and mortar were the old world, not the brave new one; and that sense of uncharted, historic territory—a

new new frontier!—was accentuated, for and by some, by the election of the first Black president. Which also, inevitably, shone a light on questions of diversity and representation, with complex and uneasy lessons to derive from it.

On February 10, 2008, nine months before the election, several Black newspaper cartoonists published similar cartoons to spotlight their dearth of representation. Seventy-six percent of newspapers were then running strips without minority characters appearing in any way,[41] and when it came to gender diversity, matters were possibly even worse: as of 2005, three of the seventy-seven working editorial cartoonists were women—the same three who were there ten years before.[42] In 2007, comic book melodrama led to half the Fantastic Four being replaced by Black Panther and Storm, making 50 percent of Marvel's iconic team Black—thanks, in no small part, to the presence of Milestone alum Dwayne McDuffie, a reminder of diverse creative teams' centrality to telling diverse stories.[43] But Marvel's 2010 *Girl Comics*, an anthology intended to showcase talented female creators, simultaneously marginalized and patronized (that title!). Perhaps ironically, another set of characters with decades-long histories illuminated the path ahead: the folks from Riverdale.

In 2009 and 2010, Archie Andrews married his sweethearts. (In a nod to parallel-Earth thinking, the comics presented marriages to both Betty and Veronica, so you weren't disappointed, no matter whom you preferred.) Archie and friends' continued adventures, which included multiple marriages, deaths, and Moose becoming Riverdale's mayor, revolved around Mr. Lodge's plot to homogenize Riverdale into bland chain-storehood, versus organic change: a metaphor for the series', and the company's, aims and anxieties as a whole.[44]

Archie CEO Jon Goldwater, commenting on the marriage stories' success, said that as readers "grow older and get more indoctrinated as to what goes on in the world, we felt like we wanted to give them something so that they could stay with us as they got older. . . . [But] we'll never change the core of what we do."[45] But the core was, at heart, an idea and a sensibility that *did* change. A *Today* show poll had suggested Betty would

have prevailed, by a four-to-one margin; but Jughead came in a strong third. Perhaps noting those Jughead results, Archie Comics introduced a gay character in 2010, Kevin Keller, a typical all-American teen with a military dad who soon became class president. Archie also started an interracial relationship, with Valerie from Josie and the Pussycats. "We're trying to show that Riverdale is an accepting community, that everyone is welcome in Riverdale," Dan Parent, who wrote and drew the first Kevin Keller issue, said.[46] When the Christian conservative American Family Association tried pressuring Toys "R" Us to take Keller-related toys off its shelves, Goldwater responded, "As I've said before, Riverdale is a safe, welcoming place that does not judge anyone. It's an idealized version of America that will hopefully become reality someday."[47]

This moment also marked, on an appropriately anticlimactic note, the dissolution of the Comics Code Authority. Changing audiences, venues, and industry practices had meant the institution had been fighting a rearguard action since 1989, when it had first acknowledged "that comic books were not just for children," allowing members to publish comic books for adults (without newsstand distribution, and with appropriate retailer content warnings).[48] But Marvel had dropped the Comics Code by 2001,[49] and now, a decade later, DC, and even Archie—whose Goldwater family had been so instrumental in establishing it in the first place—had followed suit, ending it once and for all.[50] The point was, not only was all this good citizenship, it was clearly good business: the issue introducing Kevin Keller went to a second printing, "unprecedented in Archie history, and the Keller miniseries for 2011 sold out."[51] Which didn't go unnoticed.

Certainly, Marvel and DC had had characters of diverse ethnic backgrounds and different sexual orientations before, often new incarnations of earlier characters. White Tiger, one of the earliest mainstream Hispanic characters, changes gender (but not ethnicity) simply by a different character picking up the relevant magic necklace; a physicist from Asia takes over both the academic and superhero position of Ray Palmer's Atom by finding his gear. "Scrappy teen from Brooklyn" Anya Corazon becomes "Marvel's first Latina hero," Araña, "the butt-kicking Hunter of

the ancient and mystical Spider Society by night."[52] Hawkeye's protégée, Kate Bishop, became Hawkeye, with a notably millennial, even Generation Z, take on the whole superhero biz. Sometimes, reboots reworked old stories to showcase different representations and shift frames of reference. Brandon Perlow and Paul Mendoza kept 221B Baker Street, the Irregulars, the medical war veteran, and the consulting detective, but their Harlem-set *Watson and Holmes* played out the Black duo's adventures in a milieu that proves how well the great stories flourish in different frameworks.[53]

But progress in representation occurred in fits and starts. In 2002, Marvel had reintroduced the Rawhide Kid from the Atlas days and presented him as the first gay hero to feature in his own book, despite little if any depiction of same-sex romance or activity.[54] As late as 2006, Marvel's official unofficial policy was an "unwillingness to have a gay and lesbian lead character in a solo miniseries without an explicit content warning," thanks, supposedly, to the criticism the comic, and Marvel, received on CNN's *Crossfire*.[55] And most of those new incarnations were always considered temporary replacements, placeholders for the "real, authentic" (and white) originals to return, as in mainstream comics they inevitably did.[56]

And then, a robust breakthrough for representation, at least on the page. *Ultimate Spider-Man*'s Miles Morales, created by Brian Michael Bendis and Sara Pichelli, was the twenty-first-century-Brooklyn equivalent of outer-borough Queens kid Peter Parker a half century earlier.[57] Bendis had been thinking about a new, minority identity for Spider-Man in 2011, when he noticed Donald Glover's "semi-serious" internet campaign for the lead in the new Spider-Man movie, "and I went, 'Why couldn't he be Peter Parker? He'd be a great Peter Parker.' Then I realized I was working on that project already." Bendis, who is white, had also talked to "a black friend who told him that Spider-Man was the only superhero that other children would let him play when he was growing up. 'You couldn't see his skin color,' Mr. Bendis said the friend told him. 'He was any of us, when he was in costume.'"[58]

Morales's enormous popular and critical appeal not only saved him from that replacement fate, migrating from the alternate universe he originated in to the "main" Marvel universe,[59] but helped propel a new wave of diverse characters who were more frequently *living* their identities, not just *looking* them. In 2012, Northstar, one of the first mainstream superheroes to be identified as gay, had a same-sex wedding, marrying a Black non-superhero he'd met in Bryant Park.[60] (Kevin Keller had done it several months before.) Thor turned into a woman in 2015 and outsold her previous male incarnation by twenty thousand copies a month—a very significant number in the era's comparatively shrunken market. Thor's nemesis, Loki, starred in a new series in 2013; the series' writer revealed that the god of mischief's gender and sexuality would be fluid. "Yes, Loki is bi and I'll be touching on that," he wrote. "He'll shift between genders occasionally as well."[61]

Perhaps the most touching same-sex love story in mainstream comics—complete, as is so often the case, with alien DNA experiments and hyper-violent battle-computer implants—is the Authority's Apollo and Midnighter.[62] Thinly disguised variations of Superman and Batman, something that might have started as a minor jab at Werthamesque speculation has developed, over a decade, into a genuine portrait of a passionate, tender, and deeply devoted relationship in which the two people involved are superheroes.[63] "We're not going to have any shame or second-guessing about it," writer Steve Orlando said. "Anything we see, you could see a straight couple doing."[64] Recent comics like the *Young Avengers* and *Batwoman* include similar characters and narratives, sometimes with the character's sexuality central, sometimes simply as a fact.[65]

There were setbacks. Marvel was accused of "straightwashing" Hercules in its series, ignoring the mythical character's history of bisexuality,[66] and its editor in chief claimed he wasn't "looking for labels" when it came to characters in stories featuring one of Marvel's first trans characters.[67] And while the *number* of diverse characters was rapidly increasing, few headed solo books, as opposed to operating within Marvel's team structures.[68] Several of the rare exceptions would include titles

also showcasing diverse creators: *Ms. Marvel* (2014), with its Muslim-American heroine, incorporated Kamala Khan's religious and ethnic identity as an essential part of her personality, thanks in no small part to writer G. Willow Wilson; the Sina Grace–written series featuring Bobby Drake—the original X-Man known as Iceman—who had come out in 2015;[69] and *Black Panther*, written by one of America's leading intellectuals, Ta-Nehisi Coates.[70]

"Comic books are still—along with hip-hop, D&D, and my dad's collection of black books—my first literary inspiration," Coates wrote in 2008. "They gave me that sense of the fantastic and the magical that, as I've said before, I really believe all little black boys should have. . . . At any rate, I doubt I'll ever go back full speed. Retconning Spiderman's marriage was the end for me."[71] When Coates changed his mind and went back full speed, he immersed himself in a place suffused with the fantastic. Wakanda came into existence as a space under colonialist attack and visited by the Fantastic Four, and was therefore defined largely in its relationship to the outside (read: white) world. When Coates took over the creative chores, he flipped the script, creating a kingdom whose questions were largely internal, if riven.[72] Coates's activity spoke volumes about the relationship of elites to comics in the new century, but it also spoke to questions of creator diversity. Between 2004 and 2014, four Black writers were nominated for writing Eisners. Three of them were in 2014. As of May of that year, Marvel had one Black writer, as did Image; DC had none.[73]

And it wasn't just ethnic diversity: only 13 percent of comics published in November 2010 by DC, Marvel, Dark Horse, and Image credited female contributors.[74] At the 2011 Comic-Con, DC copublisher Dan DiDio, asked about the gender demographics of the creative teams behind the New 52, bristled: "Who should we be hiring? Tell me right now. Who should we be hiring right now? Tell me."[75] He penned a "we hear you" letter the next week,[76] but the diversity situation didn't appreciably improve at the majors. As of February 2013, no Black writers were working on any monthly Marvel or DC series.[77] Marvel did hip-hop-styled variant

covers in the summer of 2015—without a single Black writer or artist on announced new Marvel titles.[78] An infamous photo of the creative teams at the 2014 Image Expo reinforced the overwhelming impression of white dudeness.[79]

This mattered not just for its own sake but because of the stories that were, and weren't, told. One critic's 2011 cri de coeur summed it up, after decrying several central characters' rampant sexualization:

> But the problem isn't Star Sapphire. Or Catwoman. Or Starfire. Or Dr. Light raping Sue Dibny on the Justice League satellite or that stupid rape backstory Kevin Smith gave Black Cat or the time Green Lantern's girlfriend got murdered and stuffed in a refrigerator. The problem is all of it together, and how it becomes so pervasive both narratively and visually that each of these things stops existing as an individual instance to be analyzed in a vacuum and becomes a pattern of behavior whose net effect is totally repellent to me.[80]

There were efforts at spaces of their own, like 2011's Kickstarter-funded *Womanthology*;[81] community building online in spaces like *When Fangirls Attack* and *Girl-A-Matic*, in addition to a wide variety of blogs;[82] there was the Women of Marvel initiative, DC Women Kicking Ass,[83] and the Valkyries, started in 2012. ("A group of women who work in comic shops . . . babes on the front lines of the comic world. It's kind of a big deal. We're an army.")[84] The Carol Corps, named after Ms. Marvel's secret identity (one of the ones *before* Kamala Khan—comics continuity is a mess), showed "up at conventions en masse, dressed in so many different varieties of the iconic Captain Marvel costume it's hard to keep them all straight." They were even featured on the cover of a 2013 issue of *Captain Marvel*. ComiXology reported its percentage of female customers at 30 percent in 2014, up from 20 the year before, perhaps in part because the website, unlike the comic store owner, doesn't judge.[85]

But others would. Sometimes with consequences.

THE WORD *FANBOY* made it into the *Merriam-Webster Collegiate Dictionary* in 2008,[86] and comics' increasing presence in movies and television meant film and television takes and comics takes would overlap and amplify each other. Fandom was always invested in the casting of comics characters, and studios certainly wanted the warmest possible response from ticket-buying audiences. Controversy arose over Scarlett Johansson being chosen to play an Asian character in a manga-based movie, reprising earlier controversy over the casting of an *Akira* adaptation and the employment of non-Asian actors to represent Asians in the filmed version of *The Last Airbender*.[87] As it did when a Black actor was cast as orange-skinned alien Starfire (when no such objections were registered about Jennifer Lawrence playing a blue-skinned mutant in X-Men movies). These objections were frequently couched as fidelity to original material, or a sense of familarity[88]—which, of course, baked in the original issues of representation. Take, for example, the generally critically reviled *Catwoman: The Movie*: Oscar-winning actress Halle Berry's casting raised, for some fans, an issue (or "issue") not present (or "present") when Michelle Pfeiffer essayed the role in *Batman Returns* over a decade earlier.[89]

Sometimes fannishness was more benign: Tom Spurgeon designed a theory he called "Team Comics," which suggested, in one critic's words, "a solidarity of complacency" (particularly among industry folk) rather than "a healthy, ongoing debate about the aesthetics of the medium."[90] But often it was less healthy. Two notable portraits held fictionalized mirrors up to the uglier side of fandom's nature: Seth's *Wimbledon Green: The Greatest Comic Book Collector in the World* showed the drive to possess and the criminal lengths such obsession can lead to, while Mark Kalesniko's *Mail Order Bride*[91] featured the tribulations of the title character, brought to Canada by a comic book shop owner. In the book's crescendo, the wife finds her husband masturbating to Asian pornographic images; she is a fantasy to him, she realizes, just another representation.

"It is a poor critic who says that a lack of effect on *them* implies all

others are insincere in their love," a mythic pantheon's custodian says in Kieron Gillen and Jamie McKelvie's fan-favorite comic *The Wicked + the Divine*,[92] and in the internet age, everyone was a critic. Some few of them might be poor ones, but that would be enough, in an age of disproportionate polarization and response. Sometimes, as in the past, when fandom's attentions turned toxic, it stemmed "merely" from dislike of plot choices. At the end of 2012, *Amazing Spider-Man* writer Dan Slott revealed he was receiving death threats over the title's seven-hundredth issue and the associated arc. "If you think, because of something happening to a FICTIONAL character, that you need to type out a death threat and SEND it to someone: You. Need. Help," he wrote. "From now on, they ALL get reported. The End."[93]

With the slow but increasing emergence of (especially) gender diversity in comics, the toxicity took a particular direction and emphasis, threats of violence alongside a wide variety of sexist and creepy comment. In 2010, Kate Beaton of *Hark! A Vagrant!* wrote, "Dear internet . . . when you tell a female creator you like her work so much you want to marry her and have her babies, you're not doing anyone any favors . . . as cute as it sounds in your head, it's a shitty, disrespectful 'compliment.' No one makes comics looking for sexual attention."[94]

A "dickwolves" rape joke in a 2010 *Penny Arcade* strip metastasized into full-bore controversy when, instead of acknowledging distressed readers and rape survivors, creators mocked them in a series of posts, a non-apology, and even, temporarily, the sale of "Team Dickwolves" shirts and pennants, which were withdrawn only in response to sponsor concerns. *Arcade* artist Mike Krahulik even said he regretted the decision to pull the merchandise at a 2013 event. Numerous creators and gamers no longer felt comfortable attending PAX, *Penny Arcade*'s deeply influential expo, even as they felt the commercial necessity to do so—a horrible bind. Critics received rape and death threats. Even an early designer of *Penny Arcade*'s website cut ties with them after the 2013 incident.[95]

Depressing and enraging accounts increased, and increasingly became public, of inappropriate behavior and harassment at conventions

by established figures, targeting both fans and young women in the industry, unquestionably imposing a chilling effect on the latter's interest and prospects.[96] "I've been told to move on, I wasn't raped, it was no big deal . . . but it is a big deal to me," one victim said, speaking out in 2006. That same year, Katherine Keller had to write an article entitled "Sexual Harassment, Cons, and You" on the *Sequential Tart* blog site, giving clear advice on what to do when facing unwanted and unwarranted behavior from fans and pros.[97]

All this occurred against the backdrop of a still-exploding convention industry—particularly, though not solely, at San Diego. By 2008, you could no longer get tickets at Comic-Con the day of. By 2011, a hundred thousand badges sold out in February for the July convention within a single day; by 2014, within ninety minutes; by 2015, within the hour. That year, even convention parking had to use a lottery system.[98] Big business for San Diego—a study suggested the 2008 Comic-Con, directly and indirectly, was worth $163 million[99]—and nationally: by 2014, the online ticketing and events service Eventbrite estimated the value of the fandom events market at $600 million annually, and that was just ticket sales. "That represents about 80% of the comic publication market all-up (periodical, digital and graphic novel)," an analyst wrote. "The old joke about there being more people going to Cons than buying comics? Funny because it's true."[100]

Much of this had to do with the the continually increasing shift in convention emphasis, particularly in San Diego, toward more general Hollywood genre entertainment. In 2009, the cable channel G4 televised the first Comic-Con panel; it was about Lucasfilm.[101] That same year, the movie *District 9*, about aliens in South Africa, got raves at San Diego and opened (comparatively) huge, showing the Comic-Con touch.[102] By 2010, Tom Spurgeon could say, "For the first time at Comic-Con in 16 years, I felt surrounded by the film and television industries. I felt like I was attending the comics portion of *their* show."[103] In 2014, MTV brought the band Linkin Park to Comic-Con to help inaugurate its mtvU Fandom Awards;[104] Conan O'Brien booked a San Diego "residency" in July 2015, doing his show from the city.

In a May 2014 survey of Emerald City Comic Con attendees, 52 per-
cent identified themselves as female, and 2 percent as non-binary. Not
all of this was statistically significant (one identified as "Cthulhu" and
another as "a nebulous glow cloud"), but, as the iconic *We Are Comics*
Tumblr page stated that year,[105] "We are comics: professionals and fans;
creators, publishers, retailers, readers. And we are a hell of a lot more
diverse than you might think."[106] Which had consequences. Longtime
comics journalist Heidi MacDonald wrote that some con organizers
didn't understand that, "as more and more people attend these shows . . .
and the audience becomes more and more diverse, cons have become a
big, hot petri dish of social interaction, with all the potential for disaster
that entails. There have been rapes at conventions; there have been stalk-
ers; there have been all kinds of harassment, and this is not an imaginary
thing or crying wolf but real incidents."[107]

The year 2013 saw notable episodes of harassment at New York Comic-
Con,[108] and while industry members were increasingly willing to speak
out and name names, even of major creators in the industry,[109] those expe-
riences, as Spurgeon wrote, also represented "hundreds of uncomfortable
experiences you can see referenced on a lot of cartoonists' twitter feeds
and other accounts the week following every sizable show—and even
more that are never referenced at all."[110]

Back in 2008, one longtime comics observer had posted a long "seri-
ous note" on his blog about harassment, stalking, abuse, and assault
issues at San Diego. But perhaps even worse, he noted, was that in the
convention handbook he consulted, there was nothing about "attendee-
to-attendee personal behavior," though the convention policies addressed
"live animals, wheeled handcarts . . . [and] drawing or aiming your replica
weapon"; there were seemingly no procedures for reporting such abuse,
or how it would be handled. "As the leading event of the comics and pop
culture world," he ended, "Comic-Con should work to make everyone who
attends feel comfortable and safe."[111] Six years later, the situation hadn't
changed much. A 2014 survey reported "thirteen percent [of all respon-
dents] reported having unwanted comments of a sexual nature made

about them at conventions—and eight percent of people of all genders reported [being] groped, assaulted, or raped."[112]

In late March 2014, signs reading "Costumes Are Not Consent" were posted at Washington's Emerald City Comic Con. Over two thousand signatories to a petition circulated by a group calling itself Geeks for CONsent asked for a formal anti-harassment policy at San Diego Comic-Con, one that would particularly (though not solely) take note of behavior with regard to cosplayers, including an easily visible and accessible harassment-reporting mechanism, with relevant signage throughout the convention and volunteer training, as opposed to the general language available on the website.[113] While an official response pointed out the convention's general anti-harassment statement,[114] many felt it was insufficient. What was needed, clearly, was not just a policy, no matter how robust, but a change in the culture of comics.

The evidence of such change remained inconclusive. Licensed DC T-shirts bearing sexist messages (such as "Training to Be Batman's Wife")[115] continued to be sold, even as a Comic-Con committee member was dismissed for posting "offensive and threatening" comments on the internet.[116] Website and message board policies were changed in an attempt to cut down on the toxic behavior that had flourished there— and the doxing and rape and death threats toward those who called such behavior out.[117] There were calls to no longer turn a blind eye to longtime professional harassers—with the awareness that focusing on individual bad apples was insufficient to address the institutions that had protected them for so long.[118] Backward and forward steps seemed to come fast and furious, side by side.

Perhaps the best sign of how much had changed in comics in the Obama years, *and* how far was left to go, could be found in the fate of a graphic memoir that opens on the morning of the president's first inauguration. Congressman John Lewis had written a previous autobiography, 1998's *Walking with the Wind: A Memoir of the Movement*, but *March* was his first graphic novel—the first by any member of Congress—and it spent a year on the *New York Times* graphic novel best-seller list. Subse-

quent volumes were also best sellers—thanks, in no small part, to pre-
inaugural Twitter spats with Donald Trump—one of them receiving the
National Book Award.

March's framing device usefully blends realism and symbolism:
Lewis (aided by cowriter Andrew Aydin) relates his story, on that Inau-
guration Day morning, to two boys named Jacob and Esau, suggesting
narrative's role in reconciling enshrined opposites. It's an on-brand tac-
tic, given Lewis's early preacherly ambitions, to say nothing of the civil
rights movement's strong reliance on, and effective use of, biblical imag-
ery and rhetoric. But it also speaks to the book's view of history and time.
March implies moving forward, progress—the view of history the book
symbolically suggests, from Jim Crow to Obama. That said, memoir
moves backward by definition, and shifts between frame and recollec-
tion emphasize the *remembered* nature of Lewis's stories, allowing us
to consider how ironic retrospection or multiple retellings might affect
the narrative. *March* is rendered in black and white—fittingly, given the
subject, but also befitting shadowy memory more generally, especially in
a memoir of older age.

Lewis's personal recollections of such visually well-known events and
figures allow consideration of that central topic in graphic literature in
general: representation of the body. Particularly since the placement of
bodies, at lunch counters, in jails, on buses, was such a vital part of the
struggle—how those bodies occupied space with such dignity, and were
in turn treated with such indignity. (Such questions relating to the por-
trayal of Black bodies under violent assault, sadly, remain deeply relevant
today.) Nate Powell's images[119] are not naturalistic: his pliable positions
often evoke conventional hagiographic, Christian poses.

Lewis is obviously participant, observer, and witness to trauma. A
reader might ask: Is his act of memory also a narrative of recovery? Is,
or was, Lewis traumatized? And if so, what does it mean to teach this
material—or, indeed, any traumatic historical episode—to children who,
necessarily, don't know these facts? Such questions elide the fact that
childhood is suffused with trauma and anxiety, as every fairy tale will tell

you; and Lewis's work, taught widely in schools, was part of the increased expansion of all-ages material in the Obama era, dominated by one figure: Raina Telgemeier.

In 2003, Telgemeier published an autobiographical reflection about reading *Barefoot Gen* at age nine (her father gave it to her). Traumatized, she tells her mother, "I think that book ruined my life." "Maybe it actually made your life better," her mother responds. "You just haven't realized it yet." "I mean, Jeez, it was just a comic book," Raina says. "Raina, there's no such thing as 'just a comic book,'" her mother responds.[120] The following year, Michael Chabon gave a keynote speech at the Eisners, saying, "Children did not abandon comics; comics, in their drive to attain respect and artistic accomplishment, abandoned children. . . . Now, I think, we have simply lost the habit of telling stories to children. And how sad is that?"[121] Telgemeier would be instrumental in challenging that assessment in the following decade. After a Baby-Sitters Club graphic novel, *Kristy's Great Idea*, Telgemeier jumped to the more personal *Smile*. To say it was successful would be an understatement. In May 2014, *Smile* marked its one-hundredth week on the *New York Times* best-seller list and had a million copies in print; its follow-up, *Sisters*, got an initial print run of two hundred thousand copies.[122] By the end of the year, Telgemeier had 1.5 million copies of *Smile* in print, and 1.4 million of *Sisters*.[123]

Telgemeier's work checks all the all-ages boxes: the cartoony style, the bright colors, the strong and defined line drawings, the avoidance of "adult language" while explicating complicated terms and concepts. She's particularly masterful at explaining the numerous dental procedures her younger self is forced to undergo in *Smile*, words and pictures flowing in the complementarity of the very best comics. But she's also unmatched at dealing with the often unspoken core of children's literature: defining yourself as a individual, and understanding the community of adults, one of which you will become.

It's anthropological: every tribe, most especially that of Adult, is strange and foreign to the young. Sitting next to Scott McCloud at a convention led to a contract for Barry Deutsch, a Reform Jew whose 2010

Hereville tells stories of ultra-Orthodox kids whose adventures blur Jewish folktale, demographically appropriate contemporary concerns, and his own imagination; and *Hereville*'s explanation of Jewish custom differs little from *Smile*'s information about dentistry, or, for that matter, public school. Like *American Born Chinese*, both works frequently involve accepting, or changing, one's view of oneself, often regarding body image, a particularly resonant theme for a population undergoing noticeable bodily change. Body changes are social, we're reminded; Telgemeier's title *Smile* is also an imperative, asking someone to socialize in potentially discomfiting ways, to construct a public self. *Hereville*'s young female protagonists are constantly on display, and Mirka's imaginative life and her activities impact not only how she's viewed, but her, and her siblings', marital prospects. Mark Sable and Robbi Rodriguez's *Hazed*,[124] an R-rated cautionary tale about young women struggling to find their own identity and self in the pressure cooker of the Greek system, is on the other side of the universe and right next door to *Hereville*. But children's literature, graphic or not, would be sterile catechism without adventures on the way: boys' own adventures of pirates passed from father to son which double as lessons about "a moral code we make for ourselves," as in Chris Schweizer's tales of the family Crogan; or the Girl Scout camp–oriented adventures of the delightful and intrepid *Lumberjanes*, bringing myth down to snarky, perky size while subtly invoking the charms of friendship and community.[125]

Inflected by Harry Potter, some works tried to push adults out of the picture. Tom Siddell's *Gunnerkrigg Court* (originally a webcomic) has the "magic boarding school" vibe down (enchantingly) cold; Kazu Kibuishi's *Amulet* took the "orphaned children with familial gifts" side of the equation, complete with stunningly imaginative visuals; and Ted Naifeh's tales of Courtney Crumrin are packed with mysterious creatures in a gothic house and a down-to-earth kid. While Doug TenNapel's *Ghostopolis* is an epic journey that negotiates issues of death and afterlife without ever losing its charm, Vera Brosgol's *Anya's Ghost* covers the same territory in a more grounded setting that features questions of young immigrants'

acculturation.[126] But the literature often returned to family questions, either the benefits of connection or the dangers of alienation. The last panel of TenNapel's *Bad Island*[127] features a kid saying, "Cool vacation, Dad! Can we do something again next week, too?" The dad replies, "I'll go anywhere as long as we're together." Given the adventure they'd just had, you can see why the kids would love more family time.

Setting and protagonist aren't always telling, of course. The schoolkid protagonists of works like *Morning Glories* and *Deadly Class* are very much for adults only;[128] Charles Forsman's *The End of the Fucking World* may take its title from the overarching dramatic tone teenagers seem to imbue everything with, but then twists it to imbue the sparsely illustrated, deadpan narrative with the glacial terror of a genuinely dramatic series of events, featuring a teen sociopath who feels almost nothing and his romantic partner, who feels it all.

Forsman's protagonist might have felt at home in the adult, dark, and gritty worlds Marvel and DC had often become: which, to their credit, the companies understood to be a problem.[129] Thus, decisions like Marvel's *Ultimate Spider-Man*, placing rebooted classic heroes side by side with the ongoing soap operas, updating them to current conditions, allowing younger readers to share in adventures from the beginning (and allowing speculators another crack at the market). But, at least corporately speaking, Marvel and DC's attentions were increasingly captured elsewhere: Hollywood, with movies, while rarely R-rated, that were skewed toward older ticket buyers.

═══

IRON MAN'S SUCCESS marked the start of what became known as the Marvel Cinematic Universe, and Lee, Kirby, and Ditko's characters would dominate the box office even as their comic book equivalents were shadows of their former circulation. DC president Paul Levitz said in 2008, "I don't think we overdose easily on superhero films, assuming that the two major oil wells are managed properly . . . comics as a source of material for Hollywood will remain a very, very fertile field."[130] Writer Brian

K. Vaughan said, that same year, "[About ten years ago,] I would have an occasional meeting with some intern at a movie studio who would express interest in comics who would say, 'If only I could get my bosses interested, but they're just not.' And how over those past ten years, those interns have now become studio heads. Really the geeks have inherited the earth, but it's happened unbelievably quickly."[131]

Unsurprisingly, given the size of the financial pie, there were consequences. In August 2009, Disney bought Marvel for $4 billion, ten times its 2003 valuation—or, put another way, between double and triple the international gross of just one movie Marvel released three years later (2012's *The Avengers*), and less than 150 percent of the international gross of 2019's *Avengers: Endgame*.[132] The same year Marvel was sold, Warner-Media restructured DC as DC Entertainment, Paul Levitz's successor reporting to the president of the Warner Bros. Picture Group rather than Warner Bros. Entertainment. "DC has been a publishing company, but I think it has the potential to do more," Diane Nelson told the *Los Angeles Times*. "I come into this not as a comic-book fan per se but someone who knows Warner Bros. and how to bring value to the DC properties."[133] Perhaps inevitably, DC Entertainment announced plans to move to Burbank in late 2010, a "strategic business realignment allow[ing] us to fully integrate and expand the DC brand in feature films as well as across multiple distribution platforms of Warner Brothers and Time Warner," said Diane Nelson's boss, the Warner Bros. Pictures Group president. "We are creating a seamless, cohesive unit that will bring even more great characters and content to consumers everywhere."[134]

One victim: Vertigo comics, that hotbed of mainstream innovation with an enviable track record stretching back more than two decades. As the *New York Times* put it in 2013, "as DC has moved more aggressively to establish its characters as exploitable properties for its parent company, Time Warner, it has shifted some of its Vertigo characters back to its central DC universe. Vertigo contributors . . . believe that DC's hands-off approach to the imprint has come to an end." Karen Berger, seeing what was coming, had announced her departure the previous year: DC

and Disney-owned Marvel, she said, "are superhero companies owned by movie studios."[135]

As the money poured in—2012's *The Avengers* grossing over a billion dollars internationally; *Iron Man 3*, released in May 2013, returning an estimated $400 million in profit to Disney/Marvel *by June*[136]—it gave new urgency to the paucity of benefits to those who'd invented the characters, their abilities, their looks, their stories. (Even the policies DC had instituted in the early 2000s to provide some "creator equity participation" were significantly curtailed in the Burbank era.)[137] "The scale is different, and thus the stakes are, too," one observer summarized.[138]

Hopes that the movies would drive comics sales were, at best, only locally fulfilled. "We all wanted the movies to kick ass, and we all wanted to cross over into other media," cartoonist Dean Haspiel said in 2013. "Well, we're there and those media are taking over and I don't think it's driving people into comic book shops. The few that we have left."[139] As of February 2014, fewer than twenty-five books sold over fifty thousand copies in the direct market.[140] Contemporary creators, even most of those working in the commercial mainstream, were unable to make a living, as page rates had refused even to keep pace with inflation;[141] alternative or independent cartoonists even more so. Older creators, with no savings and, having freelanced all their lives, with no retirement funds or health care plans, were in even worse shape. Just one example: as the *Guardians of the Galaxy* movie opened in August 2014, cocreator Bill Mantlo's family needed to raise money for his ongoing medical expenses. The organization the Hero Initiative tried to crowdfund on creators' behalf, but this was hardly a structural solution.

Individual creators, or their estates, tried to find relief in the courts. But it was hard to find. Gary Friedrich lost his Ghost Rider case in 2011, a federal judge ruling he'd transferred his rights both in 1971 (having signed the back of a check) and 1978 (having signed a relevant contract to that effect).[142] In 2010, Kirby's estate sued Marvel for ownership of the Fantastic Four and X-Men, among others; they settled in 2014, a few days in advance of the Supreme Court deciding whether to take up the case.[143]

A few weeks later, the high court declined to hear a final appeal from the Shuster estate, following years of back and forth in the lower courts and drawn-out litigation.[144]

Adding insult to injury, creators saw their work, in the form of original art, changing hands at prices they could never possibly afford. A single page from *The Dark Knight Returns* sold for $448,125 in 2011, and Todd McFarlane's cover art for an issue of *The Amazing Spider-Man* went for $657,250 at auction in July 2012.[145] That November, the same auction house offered a similarly sized painting by Renoir with a high estimate of $700,000.[146] In something that felt like an overdetermined symbol, the original *check* for $130 made out to Siegel and Shuster for Superman, the site of the grandest battle between creator and corporation, netted $160,000 at auction in 2012.[147] Though *Wizard* had shuttered its print version in 2011,[148] with circulation about 20 percent of its '90s glory days, the speculative sense it had encouraged continued. In 2010, a copy of *Detective Comics* with Batman's first appearance sold for over a million dollars;[149] a "pristine" copy of *Action Comics* 1 sold for $3.2 million in the summer of 2014.[150]

But none of these qualms stopped film, television, and comics from growing ever closer; the outcomes, in fact, seemed to help facilitate the opposite. Marvel Comics started a formal "creative committee" that met with Marvel studio execs several times a year to discuss ongoing projects: Kevin Feige, then Marvel Studios' president of production, noted that "it's a hell of a lot less expensive to take a chance in a comic" than in a movie, and Marvel's former editor in chief, then chief creative officer, Joe Quesada said, "It's the cheapest R&D there is, but the best R&D there is."[151] Self-professed comics fans from film and television were drawn to the material: Kevin Smith had a very successful run in the early 2000s writing *Green Arrow*; Joss Whedon expanded his Buffyverse into comics later in the decade,[152] and, of course, went on to direct 2012's *The Avengers*. Damon Lindelof, writing an *Ultimate Wolverine vs. Hulk* miniseries, said, "I can honestly say without doubt that if it weren't for comic books, *Lost* would not exist." He said it on the first podcast Marvel ever offered.[153]

This backward-seeming business model—make the comics with a freer hand and hope the pickup comes—led to a remarkable expansion of genre-oriented work, the same types that had thrived at Vertigo a decade or two earlier. Here—perhaps ironically, given its origins—Image would take a leading role: as one company partner suggested "when accused of catering to superhero fans" in 2000, "Name a traditional superhero good-guy/bad-guy title that Image publishes. We don't have a title where a bunch of teen-age mutants dismember each other over a metropolitan street and we haven't for a long time." Instead, Image shifted its "mainstream" elements toward other widely resonant genres and modes.[154] That—along with, crucially, its commitment to creators not only owning their work but maintaining their media rights—made them, along with companies treading similar ground like Dark Horse, IDW,[155] Boom!, Dynamite, and Avatar, central clearinghouses for some of the era's most popular genre works.[156]

The first among Image equals—the company's first new partner after its original formation, and its first non-artist—was Robert Kirkman,[157] whose zombie comic *The Walking Dead* (with art by Tony Moore and Charlie Adlard), premised on George Romero's slow inexorables, was high up on the direct market charts well before its AMC television adaptation.[158] (Unusually for modern comics, the TV series made a huge difference: the comic's sales rose by almost 50 percent within a single month, April to May of 2012.)[159] Kirkman's thesis, valuable for a long-running horror serial, and precisely inverting Moore's *Swamp Thing* plaint, was that closed narrative isn't really the point. Life (or unlife) goes on—sometimes prosaically, sometimes horrifically, often existentially, certainly commercially.

Kirkman's series eventually did run its course; "survival horror" can only survive so long. But it left its traces: in the unclassifiable combination of cartoonish hyper-violence, self-awareness, and zombie mayhem in Eric Powell's *The Goon* (whose start preceded Kirkman's by several years); in the theologically influenced Atheist, dealing with Winnipeg teens possessed by returning dead; in the decline from horror into wild

absurdity in Ben Catmull's *Paper Theater*; or in the creeping naturalism
of Tim Seeley's *Revival* and Terry Moore's *Rachel Rising*.[160] Even Archie
got into the act. *Afterlife with Archie* (because, really, what else could you
call it?) started with a "legitimate" premise—Hot Dog dies in a car acci-
dent, Sabrina the Teenage Witch reanimates him—and goes from there
to plumb new depths of character and resolve in Riverdale's citizens (well,
the survivors).[161] And Nancy Drew and the Hardy Boys followed suit in
Papercutz's *New Case Files*.[162] But almost certainly the most extreme
was Garth Ennis and Jacen Burrows's *Crossed*, which took a zombiesque
premise—viral transformation into something monstrous—and pushed
it as far as it could go. There was "one abiding truth," says a character
of the pre-*Crossed* world in the series' second panel, "we were unshock-
able," and Ennis and Burrows went on to prove even jaded horror comics
readers wrong.[163]

Comics' ability to set visual pace lent itself to voyeurism, to the bated,
suspenseful anticipation that implicates viewers in the horrific experi-
ence. The fairly typical setting of Brian Ralph's *Daybreak* (postapocalyp-
tic ruin menaced by vampiric zombie monstrosity) belies the genuine
unease coming not from the hidden monster, but the hidden point-of-
view protagonist, who is us and who never speaks.[164] Joshua Williamson
and Mike Henderson's *Nailbiter*, set in a town that has birthed most of
America's serial killers,[165] investigated the dark side of Americana, and,
by extension, the age's terrifying question: What *is* our nature, after all?
American horror's regionalism, so central to its varied streams of identity,
pokes up its half-eaten head in works like Cullen Bunn and Tyler Crook's
Harrow County, set in the South of Faulkner and O'Connor's worst night-
mares: haints less the problem than family.[166]

And then there was more wide-ranging, cosmic horror. Joe Hill and
Gabriel Rodriguez's grand *Locke & Key* expands the haunted house myth
into something that encompasses (and yes, unlocks) the widest bounds
of the imagination.[167] The Luna Brothers' *Girls* starts with an egg-laying
naked girl from, well, beyond, who produces more naked girls, who lay
waste to a small town—or, more precisely, to the women of the small

town—and again we learn that true monstrosity is people's behavior to one another. In the end, the mystery remains: the monster is defeated, but its effects lurk.[168]

Like EC, the genre's greatest progenitor, some work incorporated comedy, on steroids—ranging from the deranged humor of Jhonen Vasquez's *Johnny the Homicidal Maniac* and the gag strips featuring hockey-masked killer Butch in Lee Adam Herold's *Always Remember to Bring the Scythe,* to the *Perils of Pauline*-meets-*Little Annie Fanny* go-girl vibe of Richard Sala's *Peculia.* The sharp assault of Joe Casey and Steve Parkhouse's *The Milkman Murders,* presenting the curdling, maggot-infested mirror image of the all-American family, owes as much to Bagge's Buddy Bradley as Stephen King; as do the wry, deconstructive efforts like Jessica Abel's *Life Sucks,* where the newly turned protagonist is forced by his master to eternally work his convenience store's night shift. ("Dave, Dave, Dave. . . . I give you geeft of eternal life, I promote you to assistant manager, and ziss is how you repay? By not punching out on break?")[169] It wasn't all fun and games, though. Andrew Crosby and J. Alexander produced *Damn Nation,* an all-adrenaline military thriller whose protagonists try to save a cure in a vampire-conquered America; in Steve Niles and Ben Templesmith's *30 Days of Night,* a high-concept grindhouse piece set at the top of the world, vampires flock to a city where the sun never rises; and Scott Snyder and Sean Murphy's *The Wake* elevates the Creature from the Black Lagoon to a full-fledged postapocalyptic action-adventure.[170]

Action and adventure, the beating heart of some of comics' greatest successes, underwent its own introspection—sometimes evoked in Le Carré-esque grim and grit, as in Greg Rucka's thoroughly satisfying *Queen & Country,* a British invasion in reverse, complete with level-headed and utterly competent female protagonist—but a surprising number of series are, metaphorically, *about* the insistence that there's life in these old genres yet. Examples include *The Highwaymen*'s tale of James Bond types who should be several decades past their prime, but aren't; *Welcome to Tranquility*'s retirement community superheroes who've still got life in them; and *Black Hammer*'s DC and Marvel analogues stuck in stasis,

wondering whether they'll be able to return to their homes and, meta-phorically, to creative vitality.[171]

Action and adventure are also hallmarks of high fantasy, which con-tinued to thrive in works like Linda Medley's lushly drawn, narratively engrossing *Castle Waiting*.[172] Begun as a Sleeping Beauty story, it soon expands to become a meditation on difference, becoming, and transfor-mation; its heroes are "bearded ladies" and human–animal hybrids. *Rat Queens* features a bearded lady, too: one of a profane, hilarious, hyper-violent, and occasionally pharmaceutically altered set of assassins who flip the script every which way and drink it under the table to boot.[173] More contemplatively, Tillie Walden's *The End of Summer* is a particularly precocious entry, the author having created it just out of high school. It's a deeply mature work, taking similar fairy-tale elements (the slumbering castle, the coming of seemingly eternal winter) to craft a story of familial loneliness.[174]

Similarly, the period's most successful SF invested character and wit into the space opera scrimshaws of the past. Brian K. Vaughan and Fiona Staples's *Saga* places Romeo and Juliet in space, attracting its fans and plau-dits, thanks as much, if not more, to its appealing characters and dialogue (and Staples's knockout art) as to its unfolding narrative. Vaughan and Cliff Chiang's *Paper Girls* does the same for time travel, looping the series' plucky namesakes in and out of the timestream, investing their adventures with emotional growth going beyond the delightful fractality.[175]

Not that dystopia doesn't make an appearance; anxious allegories included enviro-terrors, like the world of Grant Calof and Jeevan Kang's *H2O*, which has vanishingly little water, and Thomas Baehr's *The End Is Here*, which, strikingly, almost wordlessly, depicts an Antarctic penguin's survival struggle after nuclear war.[176] Greg Rucka and Michael Lark's *Lazarus* enlists genetic engineering and oligarchic dystopia for action-adventure stakes, while Jonathan Hickman and Nick Pitarra's largely insane versions of well-known scientists in his sidewise-in-time *Man-hattan Project* epitomize the comic's epigraph, a manifesto for a whole subgenre: "Science. Bad."[177]

SF comics, like other genres, resonated most when they forced us to recognize ourselves in them. Matt Madden's *Black Candy* adopted SF trappings, only to submerge them in a story about anxieties of consequence and adulthood: a sperm donor discovers his genetic material has been experimented on, and he must decide the fate of the resulting child. Eric Hobbs and Noel Tuazon's *The Broadcast*[178] uses Orson Welles's famous *War of the Worlds* hoax to suggest we are the greatest monsters we face, as fear and the unknown bring out our worst and our best. Conversely, we uncomfortably identify with the protagonist invaders who bring desire and death to an alien Eden in Sophie Goldstein's sinuous, sinister *House of Women*.[179]

Deconstructive impulses also flourished in the crime genre's continuing triumphant return. Without giving anything away, Andersen Gabrych and Brad Rader's *Fogtown* confronts the questions of sexuality and masculinity frequently central to noir novels; Greg Rucka and Matthew Southworth's *Stumptown*, with shamus Dexedrine Parios a low-key contrast to her name, interrogates genre conventions through gender. (The "private eye beaten up repeatedly" staple, for one, plays out discomfitingly differently.) And sometimes crime took second place to milieu, like the tale of Southern-fried murder and high school football in Jason Aaron and Jason Latour's *Southern Bastards*, or the survivalist compound in Brian Wood and Mack Chater's *Briggs Land*.[180] Sometimes, though, they just brilliantly play the classic notes, as in *Filthy Rich*, the tale of a washed-up athlete turned bodyguard for wild-child heiress ensnared in intrigue, lust, and murder, or are adaptations of classic prose works, like Darwyn Cooke's renderings of Richard Stark's Parker novels.[181]

Recent treatments of the Western have also done standout revisionist work, turning myths on their heads. Those '50s readers of Roy Rogers comics would practically be incapable of recognizing Jason Aaron and R. M. Guéra's *Scalped*, not just because of the rich and diverse (and by no means always positive) depictions of Native Americans, but because of its constant emphasis on history, both familial and national—everyone

in *Scalped* is wearily cynical about the state of play within and toward the reservations, dealing with it however they can.[182]

But possibly the most notable subversion occurred in the romance genre—perhaps the least successful at revitalization, as so many of its premises have been subject to searching criticism. It may say something that the highest-profile example infused the genre with the underground's explicit sensibilities: Alan Moore and Melinda Gebbie's *Lost Girls*, a Tijuana bible for the graphic novel era,[183] garnered controversy for its intertwining of sexuality and fantasy, featuring mythic characters like Dorothy Gale and Wendy Darling in sexually explicit incarnations. There were lighter touches, though. Ed Luce's *Wuvable Oaf* stories featured a variety of large, hirsute males looking bearishly, and often hilariously, for Mr. Right; Colleen Coover's quite frankly adorable *Small Favors*, featuring explicit lesbian activity with, among other things, an avatar of conscience named Nibbil; and Jess Fink's near-unclassifiable steampunk robo-pornstar *Chester 5000*.[184]

But the late-stage possibilities of the genre market allowed the most important freedom of all: the freedom to transcend genres, to mash them up. Scott Snyder, Stephen King, and Rafael Albuquerque's horror Western *American Vampire* used the vicissitudes of immortality to reflect on the curdling of various iterations of the American dream; Cullen Bunn and Brian Hurtt's *The Sixth Gun* worked those genres' different beats and pacings together like jazz rhythms.[185] Westerns are particularly good for mash-ups,[186] but other genres suit perfectly, too. Perhaps the best, Kelly Sue DeConnick and Valentine De Landro's SF-meets-women-in-prison *Bitch Planet*, uses genre tropes (including, as the narrative puts it, "the obligatory shower scene"), to show a world where femininity itself is penalized and subjugated, the most fully realized dystopian imagining since *The Handmaid's Tale*.[187] More frivolously, Jason Shiga's *Bookhunter* places hard-boiled detective tropes in the service of library police, and Kyle Starks's *Kill Them All* out-*Lethal Weapons Lethal Weapon* ("When are you going to stop being weirded out by how hard as hell I am?" asks the main character, revealing his automotive "carsenal").[188]

And then there are the unclassifiable icons, some feeling full-blown even from their surprising and off-kilter premises: John Layman and Rob Guillory's *Chew* manages to be both ridiculous and absorbing (Supernatural eating powers? A years-long mystery that resolves into a perfect absurd joke?); the "Jersey girl meets mock-Kirby Apokolips" winkfest of *Jersey Gods*; a couple who can stop time when they, ah, climax, and thus become *Sex Criminals*; a romp through a world in which gravity suddenly ceases to exist, everyone running the risk of suddenly flying up into space; a manga- and video-inspired blend where Scott Pilgrim fights Kim's evil ex-boyfriends, who turn into coins.[189]

Superheroes, that overmastering genre, contorted in varying directions. Some were expansions by older creative icons: Alan Moore's compendious desire to near-fannishly touch on a particular mythos's every element led to his own universes in creator-owned lines, fracturing every different trope, pushing panel and page nearly to their limits.[190] (Most innovative was *Promethea*, an attempt to weave together the feminine, mythic, magical, the transcendent; a combination of philosophy and cosmology, it was something more and less than comics.)[191] Mark Millar, among many others,[192] continued to focus on horrific aspects of the gods amok, starting with early British work featuring a Superman-type diabolic figure who masks in virtue.[193] In his gripping *Red Son*, an infant Superman lands in Stalin's Russia and, in Stalinistic fashion, takes over the world, matching Millar's other fantasias of what would happen if the bad guys actually won (occasioned, perhaps, by the type of primal catalytic incident critics love: a six-year-old Millar was told by his older brother all the superheroes "disappeared during this enormous battle and they've never been seen again").[194] He played it out with thinly disguised mainstream characters in *Wanted*, and actual Marvel intellectual property in *Old Man Logan*; there, Wolverine, the one hero left, is hobbled by his own cursed past. It became the basis for a movie, as did Millar's spin on another classic question: What happens when a totally powerless figure puts on long johns? The answer—he gets his ass kicked—became, reversed, the title of one of his biggest hits.[195]

Greg Rucka, Ed Brubaker, and Michael Lark's *Gotham Central* and Brian Michael Bendis and Michael Avon Oeming's *Powers* featured outsiders who understood how the mythological creatures that walk alongside them lead to a constant fight with relevancy, though *Gotham* is noir to *Powers'* mock-blasé tone. James Sturm "discovers" that the Fantastic Four are based on relatives, the Sturms; in his "true" account, the Four are broken-down, dysfunctional no-hopers, bouncing off one another like the "unstable molecules" of the book's title that, in FF canon, compose their uniforms. Brian Wood and Becky Cloonan's *Demo* told deeply characterized, moody black-and-white stories suggesting the damage, physical but primarily psychic, superpowers can wreak on those cursed to have them; Max Bemis and Jorge Coelho's *Polarity* was perhaps the most manifest statement of the metaphor, connecting the protagonist's bipolarity to his superpowers directly. The lost, lonely protagonist of Daniel Clowes's *The Death-Ray* is given enormous power in the form of the title object, but finds it largely untransformative. And the haunting *It's a Bird* shows a quasi-version of writer Steven T. Seagle struggling with the impossibility of writing, of grasping, Superman, considering his own hidden struggle with Huntington's.[196]

There were more satirical deconstructions. Garth Ennis and Darick Robertson's series *The Boys* "answers an old question, 'Who watches the Watchmen?' The Boys, of course, and they kick the living, fucking shit out of them to boot," and included extended piss-takes of both DC and Marvel heroes. Peter Milligan and Mike Allred would produce *X-Force: Famous, Mutant & Mortal*, about a young, commercially oriented team who cared more about merchandising than heroing.[197] Robert Kirkman and Ryan Ottley domesticated some of the energy of pastiche and of high-concept non sequitur and wrestled it into the form of what should have been a perfectly normal superhero book, but, as it turns out, wasn't: the long-running *Invincible* became one of the most enjoyable comics of the period. Getting in on the joke, DC pulled a reverse *Comix Book*, inviting alternative creators' own takes on canonical heroes, illustrating, once more, these characters' iconic, imaginative pull. *Bizarro World* featured

Peter Bagge, Kyle Baker, Eddie Campbell, Evan Dorkin, Ellen Forney, Tom Hart, and the Hernandez brothers, and that's just from the first third of the alphabet. Marvel followed suit with *Strange Tales*; it included Peter Bagge's "Megalomanical Spider-Man," in which Peter Parker "becomes a self-centered corporate hack, then a politically-charged recluse" à la Ditko.[198] Sometimes the comedy was cruder, caustic, even pornographic. Johnny Ryan's *The Comic Book Holocaust* was appropriately titled both in its desire to shock and its commitment to leave nothing untouched; its scorched-earth parodies of comics of every stripe might be the most scatological, pornographic, and consciously juvenile work out there, with the exception of his own *Prison Pit*, arguably the most disgustingly hilarious work of comics ever produced.[199]

—

IF THE ERA SAW REFINEMENTS, occasionally revolutions, in genre content, that didn't mean form was left behind. In 2006, Matt Madden's *99 Ways to Tell a Story: Exercises in Style* argued, "Rather than rehashing the eternal battle between form and content, style and substance, I hope this work questions those tired dichotomies and suggests a different model: form *as* content, and substance inseparable from style."[200] The dichotomies *are* tired, and Madden's right; but at the risk of reinforcing them, it's clear that readers attend to different comics in different ways, and in some, form and image dominate. Michael DeForge's monstrous, quasi-liquefied internal organs, which don't always remain internal, offer the overpowering image of *body*, in all its messiness and discomfitures;[201] Ray Fawkes's repeating nine-panel grid in *One Soul* depicts nine individuals from different times and places joining together physically and spiritually, through page layouts, repeating poetic themes, visual cues recurring from panel to panel, in a mystical unity difficult to render in any other medium.[202]

Formal and imagistic innovation flourished in more mainstream comics, too. Gerard Way and Gabriel Bá's *Umbrella Academy*—the name itself conjures Magritte-esque visions—brought together the subconscious substrate of superhero tropes in wild adventure: it's like what comic

books dream of.[203] Way, the lead singer for My Chemical Romance, would head DC's Young Animal line, which reimagined old characters (such as Eternity Girl and Shade, the Changing Girl) in ways that meshed surrealistic image with continuity concerns in ways as bold as Morrison did a generation earlier.[204] From the other Big Two company, Matt Fraction and David Aja's occasional detours into triumphant imagistic storytelling in Hawkeye, including issues rendered from the bubbled, connected thoughts of a dog, or silently after Hawkeye is temporarily deafened, allow us to wade into the overflowing complexity of wordless information.[205] Elsewhere, Jonathan Hickman's visually arresting combination of text and image in Pax Romana or The Nightly News[206] felt like comics had finally met Apple's Jony Ive and twenty-first-century design.[207]

Sometimes, formally innovative images spoke to the increasing audacity, and urgency, of exploring identity through the medium: What relation does the image, the representation of self and world, have to the thing itself? In Dash Shaw's novel of family dysfunction and allegiance, Bottomless Belly Button, he reminds readers of the medium's artifice, despite the story's realistic content, via the simple device of presenting one character unrepresentatively in contrast to all the others.[208] That process, of image surrounding being, found perfect metaphor in Paul Pope's Heavy Liquid. When, at story's end, the image becomes a second, blank, shadowy self, it stands in for the infinitely pliable possibilities of form's action on the page.[209] But this is not uncomplicated liberation. Eric Kostiuk Williams's Babybel Wax Bodysuit has figures composed of that waxy, shiny substance, flowing and disguising all at once. "Do you have any idea how long I've wanted / to peel off all this wax / and dig around through your insides?" the narrator asks. And, in several stories in Lilli Carré's remarkable Nine Ways to Disappear,[210] protagonists are literally consumed by images of their creation and discovery.

The conversation played itself out profoundly in the exploding subgenre of graphic medicine, in which formal and conceptual questions abounded. How, for example, could visual depiction of bipolar disorder reflect not only the multivalent self (in, say, movement from caricature to

more photorealistic representation) but the lenses through which others see the afflicted body? For that matter, how to portray illness itself in diagnosis? Treatment? Recovery?[211] And even *that* reinforces representing illness as predicated around pathology and recovery. What if it's a recurring, or incurable, condition? How could that cyclicality play out in comics?

Ellen Forney's *I Was Seven in '75* autobiographical strips appeared weekly in '90s alternative newspapers like Seattle's *Stranger*, not only bringing wistful and loving humor to her decidedly nontraditional upbringing (Nudist retreats! Partner-swapping parties! Babysitter thefts of parental marijuana!), but demonstrating a careful, anthropological, look at childhood anxieties, joys, and obsessions, rendered in a style so boisterous and energetic, it reminds you of a seven-year-old on a sugar rush.[212] Some of the material gained new depth and context when she shared her diagnosis of bipolar disorder in her graphic novel *Marbles*. There, Forney plays the roles of patient as historian (personal history, familial history, the disease's history); as educator, both to those with the illness and those wishing to learn more about it; even as identitarian, constructing an alternative or complementary genealogy focusing not only on genes but affiliative identity. *Marbles* focuses deeply on the relation between illness and art, and specifically what role this kind of illness plays in artistic genius, or, at least, the particularities of personal style.[213]

David Small, in the afterword to 2009's *Stitches*, his own powerful tale of graphic medicine, withholding parents, and personal self-discovery (the second graphic novel nominated for a National Book Award), notes with killing understatement, "If this had been [my mother's] story, not mine, her secret life as a lesbian would certainly have been examined more closely." But telling family stories via memoir can feel like historical obligation (Gusta Lemelman, in *Mendel's Daughter*, feels she needs to speak for other Holocaust survivors); historical corrective (Ann Marie Fleming, searching worldwide for traces of her magician great-grandfather, who had been written out of histories because he was Chinese); or family therapy (John Haugse's memoir of his father's "disappearance into Alz-

heimer's," expressed visually by the father's fading outline—metaphor in a generally realistic text).[214]

Parental loss frequently conditions the drive to graphic memoir, especially the whirling, impressionistic tendency of children to translate that loss into comprehensible image. The Obama years were, actuarially speaking, when many of the late-'60s cartoonists had aged or recently deceased parents, and some of the period's powerful artists produced accordingly powerful memoirs. Joyce Farmer's *Special Exits*, with its prosaic, unforgettable, quasi-autobiographical tale of aged parents' illness and slow decline, and their daughter's human, herculean efforts to care for them, remind us that the details of an ordinary life extraordinarily told are special indeed; its often sedate, ironic rhythms contrasted with famed *New Yorker* cartoonist Roz Chast's equally accomplished exploration of similar terrain in a neurotic, hyperanxious key, providing, in its own way, a genealogy to the figures portrayed in her other work.[215] Bill Griffith turned in a lesser-known, similarly powerful treatment of the mysteries of his parentage; like Bechdel, Griffith's journey to understand his mother's secret yearning for erotic satisfaction, romantic fulfillment, and cosmopolitan adventure leads him to question himself and his own genealogy—not biologically, but suggestively nonetheless.[216] But in all these cases, the graphic memoirist is at their best when sharing their life as well as their parents', enabling them to keep at least the partial detachment of an observer. Carol Tyler's monumental illustration of her father's World War II–era scrapbooks, and her relationship with her father, is in many ways the direct obverse of Spiegelman's: while his father talked constantly about his wartime experiences, Tyler's father's silence stands in for an absence, a lack of connection, that memoiristic activity seeks to bridge.[217]

Younger artists were doing it, too. Laurie Sandell's father—secretive, fictionalizing, confidence-manning—provides both trauma and inspiration: her memoir of loss, addiction, and recovery ends with her writing the graphic novel's first words. Perhaps the most gutting graphic memoir of loss ever published, though, features the bereaved parent rather

than the child: Tom Hart's *Rosalie Lightning* threatens to fracture under the weight of the artist's unimaginable loss of his two-year-old daughter, images in the books shattering and blearing into tears of ink.[218]

But the period's memoirs weren't only about what has been lost, but what was found: increasing freedom to embrace who you were, to live your truth, even if it didn't fit into fixed or traditional categories. In 2004, Phoebe Gloeckner had said, "There are a lot more cartoonists that are women now, but the basic flavor is male, and anything else has another adjective attached to it. . . . I'm not interested in being a female cartoonist. I'm not interested in being a female anything."[219] In the following years, her sentiment, while hardly achieved, has seemed increasingly within reach. Julia Wertz's hilarious, self-lacerating *Drinking at the Movies*[220] employs its cartoonish style to suggest a young woman not quite up to adulthood's rigors: which, to be fair, doesn't seem all it's cracked up to be. Wertz, despite her self-consciousness about her alcoholic tendencies, slovenly personal hygiene, and poor decision-making, never comes off as anything less than delightful, a Holly Golightly a little closer to dumpster diving. Conversely, when Laura Lee Gulledge's alter ego, Paige Turner (say the name out loud), says, "You can read me like a book," she means it: metaphor after metaphor for the imagined self comes alive on the Paige, Gulledge's illustrations constituting and reconstituting her self in ways that expertly prove how malleable, how impressionable, how powerful that self is.[221] Lauren Weinstein's *Girl Stories* talks about reconditioning her Barbie dolls (writing a letter to the manufacturer, then flagellating herself for being so superficial), attempting to negotiate the halls of her school and seem cool, but, as she portrays herself, well, *so* not. Her self-portrait of horror as her dad catches her kissing a boy is a master class in cringe comedy.[222]

Robert Kirby, introducing 2008's *Boy Trouble: Gay Boy Comics with a New Attitude*, looking back over fifteen years, notes that a group of previously "mostly twentysomething gay boy cartoonists working from the 'alternative' viewpoint . . . has now opened its collective, smoothly muscled arms to include artists of all genders and at all stages of life's rich

pageant . . . they just need to possess that certain *je ne sais quoi*."[223] The anthology *Juicy Mother 2*, asking, "What's the point of having queer cartoonists segregated in their own publication?" answers its own question: "Better parties. Actually, the whole queer-label issue is complicated by bookselling requirements. Books are rarely listed in multiple categories, so one must choose a genre like graphic novels, queer studies or literature. *Juicy Mother 2* is for 'Gender Pirates and Sexual Outlaws,' but I haven't found that section in the bookstore yet."[224] Nor, despite some recent efforts, has the "invisible orientation" of asexuality been fully represented (Jughead was so identified by Kevin Keller in 2016).[225] Dylan Edwards's *Transposes* focuses on the idea of sexuality as a dynamic thing (as in the dictionary definitions of *transpose*); Gina Kamentsky's comics take aim, with a dead-on satirical sense, at some of the mystification, and phobia, around transitioning. Julia Kaye's lovely diaristic strips chronicling her early time in transition present a path toward joyful acceptance, and delight, as she comes to terms with the person she always knew herself to be. And Eric Kostiuk Williams's *Hungry Bottom Comics* proudly presents not only the author's sexual orientation but his particular means of expressing that orientation, insisting, in swirling, panel-breaking images that refuse to conform to anything but the author's desire, that life, art, and performance are all the same.[226]

Such tales of identity can dwell entirely in the personal sphere. But they can also expand to embrace the sociological and anthropological aspects constructing, and constraining, identity: Maggie Thrash's wonderful *Honor Girl* is a coming-out story, yes, but, set in an all-girls camp in Kentucky in which "nothing had changed since 1922," it's also a story of alienation of other dimensions, in which details of female ritual, and the complexities of conforming with tradition—Christian, Southern, straight—are powerfully observed over a single summer.[227] And Percy Carey's account of a life lived in love of music and in drugs and violence, warm family, and toxic masculinity, provides viewers with anthropological insight into hip-hop's early years, and one person's attempt to come to personal reckoning with his past.[228]

And other artists expanded still further, to wrestle with the grand tradition that came before them.

Comics had long been used to illustrate classical mythologies and religious traditions. Surfer comix icon Rick Griffin illustrated a paraphrased Gospel of John in 1981; arch-creator of goony grotesqueries Basil Wolverton was an evangelical church elder who late in life illustrated the Bible for *The Plain Truth*, *Tomorrow's World*, and *The Good News*. Jack T. Chick long used comics to illustrate the power and possibility of the Rapture;[229] well-known superhero artist Michael Allred's faithful (in all senses) multivolume adaptation of *The Book of Mormon* showed how comics can be evangelical works of deep, abiding faith.[230] For some, like Chester Brown, adapting religious texts like the gospels expressed tensions between the faith-based circumstances of their own biography and their current personal beliefs;[231] for others, who considered these texts myth, their encounter is the struggle of talent and the individual tradition, like R. Crumb's 2009 adaptation of the Book of Genesis—an attempt, for this most gifted of caricaturists, to play it straight: "The most significant thing is actually illustrating everything that's in there. That's the most significant contribution I made," Crumb told the *Paris Review* in 2010[232] (though textual illustration is always an interpretation; Wolverton's visions of the Book of Revelation's Apocalyspe, straight out of the nuclear '50s, are still horifically hard to contemplate).

Some encounters came soberly draped in the lineaments of scholarly research—Eric Shanower's monumental Trojan War retelling includes glossary, map, genealogical chart, and bibliography.[233] Some attempted to lighten the historical and theological freight. Kyle Baker's retelling of the King David narrative combines cartoonish and comic styling with a sense of the palpable violence that must have suffused its first tellings, while Elijah Brubaker's expansive account of Jezebel, archenemy of the prophet Elijah, is filled with anachronistic language that simultaneously humanizes and satirizes the biblical narrative ("You stick to your guns, that's cool . . . I like you, Elijah," God tells him).[234] J. T. Waldman's illustration of the Book of Esther is designed as a liturgical aid (Jews read the

book as part of a holiday service), suggesting both the Oriental(ist) flavor of how Western readers envision the protagonists and the swirling currents of faith and chance that surround it.[235]

The Western canon continued to get attention far transcending the old *Classics Illustrated*; Eisner did work here, too, his adaptations of *Moby-Dick* and *Don Quixote* both, in very different ways, featuring his recurring theme of dreamers. Turning more toward nightmare, Peter Kuper has spent a career visiting and revisiting Kafka (whom Kuper compares to, and notes is contemporaneous with, Winsor McCay, though Kafka "never allowed his characters to enjoy the relief of awakening to normalcy from their disturbing dreams").[236] *Crazy Ex-Girlfriend* cocreator Aline Brosh McKenna and Ramón K. Pérez transposed *Jane Eyre* to the class-drenched steel-and-glass towers of twenty-first-century Manhattan; Ron Wimberly presented the figures of Verona tagging Long Island Rail Road trains in an updated *Romeo and Juliet* mixing Black vernacular with Elizabethan iambic pentameter.[237] And Seymour Chwast and Gary Panter produced very different adaptations of *The Divine Comedy*, whose structure and graphic imagery are made for graphics. "Don't try to pass a pop quiz based on a reading of this comic," Panter warns, "it won't work"—a reasonable manifesto for the field.[238]

Such works sometimes spoke, with greater or lesser directness, to contemporary matters. Gerry Duggan and Phil Noto's *The Infinite Horizon* transformed Homer's *Odyssey* into a long attempt to return from the American forever war; a collection of adaptations of flood myths post-Katrina showed the relevance of past to present.[239] But the commentary didn't have to derive from a change of venue; witness two recent adaptations of Joseph Conrad's *Heart of Darkness*, each with its own merits. David Zane Mairowitz and Catherine Anyango's version is restrained, replete with blurred images resembling old X-rays, appropriate for a fiction that flays the logic of empire to the core, getting to its heart without illuminating. Peter Kuper's, by contrast, has something of the malarial about it—the feverish, sweaty delirium that afflicts visitors to the land and stays with them. Both get to something essential about the original

material; both speak differently to questions of race and history that are an essential part of the current American conversation.[240]

Questions of authenticity and authority increasingly came to the fore. Matt Dembicki, a white man compiling a collection of Native American tales "in a sequential format" for the first time, took efforts to ensure his work was the product of Native American storytellers, navigating "significant historical baggage" and people "unsure of his intentions. . . . [T]he point wasn't to Westernize the stories for general consumption, but rather to provide an opportunity to experience authentic Native American stories, even if it sometimes meant clashing with Western vernacular."[241] Craig Thompson's *Habibi* dug deeply into the relationship between word, image, and icon in Islamic culture—beings are made of words in this text in a tradition Thompson posits to be no less in this vein than the first passage of John. And the manga-inspired visuals and rich brocades leaping off the page of the Alexanderesque tale *The Golden Vine* remind us not only of that conqueror's effort to unite East and West but of comics' similar attempts to embrace, and reckon with, Orientalism: a debate that raged around *Habibi*, with people wondering how exoticizing, how othering, Thompson's gaze was, and how (not if) that mattered.[242]

Here are two doubled tales, of statues and announcements, to try to summarize this moment. In October 2012, Harvey Pekar got a statue on the second floor of the Cleveland Heights–University Heights Public Library. (His widow, Joyce Brabner, raised $38,000 for it on Kickstarter.) Characteristically, the statue is shrugging. A word balloon next to the two-and-a-half-foot-tall statue reads, "Oy vey! What do you want from my life?" That same week, a life-size Superman statue was unveiled at Cleveland-Hopkins International Airport.[243] The real Pekar would probably have said that it figured.

What Pekar might have expected less were the two announcements toward the end of Obama's presidency, suggesting the beginning, and the end, of an age, all wrapped up together. In October 2015, the *New York Review of Books* launched New York Review Comics, an imprint publishing varied titles "united in their affirmation of the strange and wonderful

things that only comics can do."[244] And several months later, Marvel's list of relaunches made clear that, for the first time since the Marvel Age began, there would be no regular monthly Fantastic Four title, that Lee-Kirby primer of the strange and wonderful.[245] Cultivating the medium in careful, elite-approved gardens, while moving on, even if only symbolically, from mainstream anchors: the new century's first fifteen years had provided monumental growth and transformation.

EPILOGUE

For comics, elite approval seemed here to stay: Stan Lee's 2008 National Medal of Arts; Robert Williams's 2010 invitation to the Whitney Biennial; Alison Bechdel's 2014 MacArthur Fellowship and Roz Chast's 2015 National Book Critics Circle Award all served as nonexclusive proof. But comics weren't just for adults anymore. Gene Luen Yang's 2016 appointment as National Ambassador for Young People's Literature by the Library of Congress, the same year he received *his* MacArthur Fellowship, showed comics' aesthetic and moral irreproachability. So did the National Book Award nomination for *March*'s third volume in the Young People's Literature category that year, and Jarrett Krosoczka's, two years later, for graphic memoir *Hey, Kiddo*, about being raised by his grandparents in a milieu of parental addiction and abandonment. And two years after *that*, in January 2020, Jerry Craft's *New Kid* won the Newbery Medal for "the most distinguished American Children's Book published the previous year."[1]

But it wasn't just critical opinion; two comics figures bestrode the children's book markets like colossi. The five-hundred-thousand-copy first printing of Raina Telgemeier's 2016 *Ghosts* was the most ever for any graphic novel,[2] a record she beat with 2019's *Guts* and its million-

copy printing.[3] She was named Comics Industry Person of the Decade by widespread consensus in early 2020.[4] The only figure coming close was Dav Pilkey, of the illustrated Captain Underpants novels. A *five-million-copy* first printing of his graphic novel *Dog Man: Brawl of the Wild* was announced at the end of 2018; in 2019, *Dog Man* volumes accounted for one out of every six comics tracked by BookScan.[5] In 2019's last week, five of the ten best-selling books in the United States were comics, and Pilkey was named *Publishers Weekly*'s Person of the Year.[6] Sales of graphic novels for young readers were up 33 percent in 2018 alone; Scholastic had 40 percent of the comics trade market in 2019.[7]

The mainstream companies took notice. In 2018, DC president Diane Nelson, announcing lines aimed at middle grade and YA audiences, said, "The first comic books created decades ago were for kids, and as the business evolved and matured, it became more focused on adult readers. DC Ink and DC Zoom present an exciting new opportunity to . . . ensure beloved stories built around iconic characters like Superman, Batman and Wonder Woman are endeared as part of the fabric of childhood for years to come."[8] That same year, Marvel announced that IDW would publish comics featuring Marvel heroes for younger readers, aged eight to twelve. The idea that Marvel needed to outsource kids' comics, even to what it called a "most valued partner," was head-spinning to those familiar with comics history.[9] But those aware of recent controversies, like Marvel's sexualized variant cover of teenaged character Riri Williams, confirmed a sense that the company was far less focused on kids.[10]

Not that there's anything wrong with adult comics; the last years have seen some brilliant ones. Memoir has remained a standout genre. Tillie Walden's *Spinning* exquisitely translated her own history with ice skating to the slippery and sometimes treacherous negotiations of growing up, confronting her feelings about the costs of the avocation that threatens to overshadow an expression of her own identity. Neatly twining together personal history, graphic medicine, and educational platform, Lucy Knisley's powerful account of her difficult pregnancy and birth, *Kid Gloves*, not only continues her commitment to chronicling her life's progress,

but demystifies a critical time with her usual honesty and directness.[11] Thi Bui's memoir *The Best We Could Do*, a National Book Critics Circle Award finalist, shows, in retelling her parents' travails and her own, a new American coming to terms with a complex history in two countries intertwined by trauma and narrative about that same trauma.[12] Mira Jacob's *Good Talk*, by contrast, is about an American of color trying to raise her biracial son in a world awash in constant reminders of difference, including *bad* talk ranging from Trumpian nativist rhetoric to microaggressions from her familial and social circle.[13]

Brilliant fictions ran the gamut from realist mise-en-scène to imagistic explosion. The linked stories in Nick Drnaso's *Beverly* are master classes in showing the curdling of hopes and dreams: a married couple taking their children to their old romantic spot; a mother trying to bond with her daughter over watching a TV show; a man trying to connect with his masseuse. Drnaso illustrates precisely the crushing of the human spirit, with his colorful scalpel. (His follow-up, *Sabrina*, was nominated for a Booker Prize in 2018.) Rosemary Valero-O'Connell's fluid and atmospheric art illustrating Mariko Tamaki's tale of teenage romantic and erotic uncertainty and discovery makes *Laura Dean Keeps Breaking Up with Me*, for those who haven't been there in a while, a visceral visit to Planet Teenager.[14] In Carolyn Nowak's beautiful "Radishes," two down-to-earth schoolgirls encounter a market of enchantments; consuming the titular item creates the girls' temporary doppelgängers, and Nowak depicts their encounters with these other selves they could—may—be, in a fashion that says everything about the challenges and possibilities of contemporary girlhood.[15]

Emil Ferris, in the ostensible sketchbooks composing *My Favorite Thing Is Monsters*, allows everything from high art to '50s horror comics to Holocaust memoir as narrative and visual grist for the comic maker's mill, with an intensely satisfying result.[16] In Connor Willumsen's *Anti-Gone*, drug takers in a movie theater watch the world dissolve around them, on- and off-screen, plot devolving into image and impression;[17] D. J. Bryant's masterful story "Emordana, or, The Inflection of Nothing on the Visual

Cortex," hits the emotional truth of dreams, the deep sense in nonsense, all at once.[18] Jesse Jacobs's *Crawl Space*, bursting with rainbow color and coruscating, wavy form, resolves itself into the *Wizard of Oz* story of an attempted escape from drab teenage life into colorful abstraction.[19] And Box Brown's deep dive into the history of Tetris, a global history of dreamers and schemers, artists and businessmen, all centered around video-game building blocks that, like comics, exist somewhere between image and thing, shows how engrossing microhistory can be, and how clarifying the form can make it.

And yes, old genres and companies got their licks in, too. Creative teams on mainstream works like *Black Bolt* and *Mister Miracle* deformed, reframed, and defamiliarized superhero comics' classic type-scenes and poses.[20] If Roberto Aguirre-Sacasa and Robert Hack could expertly, if not unexpectedly, infuse Archie's Sabrina, the Teenage Witch with genuine New England horror bones, Tom King and Gabriel Walta invested Marvel's most prominent Frankenstein figure, the Vision, with a deep and abiding dread; the Synthezoid attempts to create a bride (and son, and daughter) of his own and lead a suburban life, and we know all along it will end in tears, and blood.[21]

More cheerfully, a plus-size superheroine emblematically named Faith delights in newly acquired powers, her winning personality reminding readers why we're here in the first place; while Chelsea Cain and Kate Niemczyk's *Mockingbird* lives up to the first half of her name, subverting the genre's over-the-top masculine heroics with a wink and a bo staff. Both beaten only (because she is, after all, unbeatable—it's in her name) by the magnificent, magnificently funny Unbeatable Squirrel Girl.[22]

There were other straightforward and well-executed genre pleasures, like Jeff Lemire's orphans-on-a-starship *Sentient*; Marjorie Liu's high-fantasy *Monstress*, with its rich mythos and Sana Takeda's lush art; and James Tynion IV and Werther Dell'Edera's self-explanatory *Something Is Killing the Children*.[23] Alternative creators also continued to sup at the genre table: Daniel Clowes's tale of love, desperation, obsession, and time travel, *Patience*, evokes the same feelings of inescapable discomfort that

characterized his earlier work, which no amount of futuristic gewgaws can, or are meant to, hide.[24] Emily Carroll's *When I Arrived at the Castle*, a study of desire and death rendered in black and red, gets to the heart of the vampire's lure: the desire to be submerged in oblivion and simultaneously become part of, and get to the bottom of, the story.[25]

But the story, in recent years, was ripped less from the (not-so-)funny pages than from the headlines.

Garry Trudeau had been mocking Donald Trump for decades, amassing enough strips in the process for his syndicate to release a book of them before the 2016 election.[26] "He wasn't a parody exactly; he was really more like a natural born toon. . . . Who knew he would catch on like this?" Trudeau said in August 2016. "[D]rawing Trump is a journey. . . . You just have to keep after it." And the journey to the election of the most polarizing president since the Civil War was interwoven with comics in ways small and large: from *Dilbert's* Scott Adams expressing early support (predicting Trump's nomination as early as August 2015, claiming his eventual victory would stem from his skills as "a master persuader")[27] to the fact that Mike Pence had been an actual cartoonist, for his law school newspaper,[28] to his Treasury secretary, Steven Mnuchin, having been a producer of X-Men movies. More consequential than Trudeau's or Pence's drawings was how cartoon frog Pepe, who was created in 2005 for the comic *Boys Club* and "acted out the dumb, laid-back stoner culture of post-college bros," became an alt-right symbol, making appearances in pro-Trump materials by way of 4chan and Reddit, much to creator Matt Furie's chagrin.[29] On a September 2016 earnings call, Barnes & Noble CEO Leonard Riggio, reporting the previous quarter's 6.1 percent decline in sales, said, "[T]he retail environment . . . is one of the worst I have ever experienced in the 50 years I have been in this industry." He blamed, in part, people staying home and watching election coverage.[30]

Maybe that was part of the problem, but people were looking at other things on their screens, too. ComiXology went unlimited in 2016, announcing a Netflix-like subscription plan for $5.99 a month; Marvel, which had tried its own version, would join on in mid-2017. Netflix bought

Mark Millar's Millarworld whole in summer 2017, part of a general strategy to sign creators with multiple shows in them; that same month, Robert Kirkman got a two-year production deal at Amazon.[31] As part of the Millar deal, Netflix agreed to publish comics, the newest media cart driving the comics horse.[32] DC countered with their DC Universe the next year, combining digital comics, DC streaming movies, and TV shows.[33]

DC's early-twenty-first-century movie work hadn't managed to reach the commercial, or critical, heights of Marvel Studios, 2008's *The Dark Knight* the notable exception. But its move into television with more secondary characters, spearheaded by Greg Berlanti–produced CW Network shows like *Arrow*, yielded profits and fan enthusiasm. Marvel followed with a Netflix deal in 2013 and occasional ABC synergy, also employing comparatively minor characters like Iron Fist, Luke Cage, and Jessica Jones, suggesting even such low-profile "properties" (as the industry might call them) could be hugely profitable. Look at *Guardians of the Galaxy*, after all: who'd ever heard of *them*?[34]

Such was comics in the age of Peak TV, with its emphasis on serialized ongoing narrative, allowing complex plotting (enabled by home recording technologies that allowed replay, review, and binge-watching, along with internet recapping), an explosion of channels willing to feature niche fare, wider ranges of character, and an eager appetite for already established and storyboarded IP. A godsend for the comics adaptation industry, in other words, which was recently epitomized by a show whose characters could get killed at any time and did lots of unsympathetic things, and was defiantly unending. AMC's *The Walking Dead*, one of the most popular shows in the history of non- or post-network television, wasn't the first comic book adaptation, but it opened the floodgates—and in many ways set the template for how to think about them.

Its many successes have been predicated on production design, character acting, and world building. By its 2010 premiere, the changed contours of the TV landscape moved the goalposts substantially in terms of graphic presentation and ideological offensiveness. Earlier TV shows, even early-twenty-first-century ones like 2001's *Smallville*, focused largely

on being teen- or family-friendly; but *Dead* and others firmly embraced TV's, and comics', image as an adult medium as well.

More characters brought to the screen meant more casting controversies, born of industry-wide attempts (insufficient, but there) to reach increasingly diverse demographics. When it was rumored that the biracial actress Zendaya would play the character of Mary Jane, Spider-Man's long-term love interest (and eventual wife) in 2017's *Spider-Man: Homecoming*, for example, director James Gunn addressed the issue: "For me, if a character's primary attribute—the thing that makes them iconic—is the color of their skin, or their hair color, frankly, that character is shallow and sucks. . . . [I]f we're going to continue to make movies based on the almost all white heroes and supporting characters from the comics of the last century, we're going to have to get used to them being more reflective of our diverse present world."[35]

That reflection materialized in another characteristic of two of the Trump era's most influential comic book movies: the centering of previously present marginalized or minority characters. *Wonder Woman* came out in June 2017, after a famously difficult development process.[36] Soon after, Scott Derrickson's tweet of a little girl in a WW costume in intense discussion with the film's star, Gal Gadot, at Comic-Con received 194,000 likes. "These movies matter," his caption read, and the world agreed.[37] Eight months after *Wonder Woman*, in February 2018, it was *Black Panther*'s turn.

From the Panther's first appearance in an earlier Marvel movie, it was "a prideful moment for fans who never see themselves represented in films like this," said producer Nate Moore in a 2016 interview, while the movie was still in production. But general audiences "are more progressive than we give them credit for," he continued. "You look at *Fast and Furious* [series] and no one's like, 'Um, hold on a second! There are a lot of minorities in there!' Nobody cares. They came for the cars. Audiences . . . want to be excited about going to the theater. . . . There's a trust that we're going to try to give them a really cool story and something they haven't seen before."[38]

Moore was right, of course. *Black Panther* garnered both critical raves and commercial success; the first comic book movie to be nominated for Best Picture, grossing over $1.3 billion internationally, over half in America alone.[39] Wakanda's fictionality "gave [director] Ryan Coogler free rein to create a country in the subjunctive mode: *what if . . . ?*" He "mingled myriad cultures, fashions, geographies"; Wakanda's "black sand is more than a cool visual effect and a gorgeous syncretic aesthetic—it expresses an ethos," wrote one critic. "I cannot think of a better metaphor than black sand for a diaspora, a word that comes from a 'scattering' yet has come to signify unity and solidarity."[40] Which allowed for a remarkably wide and unifying identification, of resonance, in a community often infrequently offered such resonant symbols: the "Wakanda salute," arms crossed against a chest in an X, spread from movie stars to sports figures to little kids, feeling an allegiance and solidarity, an invented but felt genealogy, at a time when Donald Trump was calling African nations "shithole countries."[41] Wakanda contested the point strongly, with its brilliant Afro-futuristic SF design:[42] the dazzling visual imagination of Coogler and his production team managed to meet the gauntlet thrown down by Kirby and others. It was a movie that gave the same giddy gifts of sight that the best comics did.

Diverse representation in comic *books* was also frequently politically framed in this polarized, politicized era, even as creators sometimes framed it more broadly: Roxane Gay, writing Marvel's *World of Wakanda*, wrote she was "excited to be writing black women, and black queer women, into the Marvel canon, but I am even more excited to tell a damn good super hero story."[43] The year Gay's trade collection came out, Marvel's senior vice president of sales and marketing, David Gabriel, said, "We heard . . . people didn't want any more diversity. . . . We saw the sales of any character that was diverse, any character that was new, our female characters, anything that was not a core Marvel character, people were turning their nose up against."[44] He later walked back the comments somewhat and redoubled the company's commitment to diversity,[45] but the comments bit deep nevertheless. (The irony being, as one writer put it, while "a recent

push for diversity has been blamed for weak print sales . . . the company's decades-old business practices are the true culprit.")[46]

Controversies over appropriateness, and authority, of representation continued.[47] Reviewing a cisgendered male's comic featuring a trans heroine, trans creator Magdalene Visaggio wrote, "There's a distinction between *telling a story with a transgender person in it* and *telling a trans story.* The former is the purview of any writer. . . . But the other? Well, the other is not. . . . Communicating essential parts of the trans experience is not the purview of a cis writer."[48] A high-profile case of telling other people's stories occurred when people learned in 2017 that newly hired Marvel editor in chief C. B. Cebulski had posed as Japanese writer Akira Yoshida for comic book companies, including Marvel, thirteen years before; notwithstanding Cebulski's significant experience with Japanese culture and long residence in Japan, "Yoshida" created "Japanese characters, locations, and themes that, if it had been Cebulski, would be problematic. That comes with allegations of appropriation, yellowface, and playing up an authenticity that wasn't there," one reporter wrote.[49] When, in the wake of George Floyd's tragic death and the Black Lives Matter protests, corporations tweeted out support, the proof, as many pointed out, would be in the hiring and support of diverse executives and creators.[50]

The questions of diversity and representation, unsurprisingly, were sometimes most powerfully played out in recent comics via allegory. Rich Tommaso's *She Wolf* used the werewolf curse to explore burgeoning female sexuality and individuality, as did Chelsea Cain and Kate Niemczyk's *Man-Eaters*, a dazzlingly designed tale of outlawed menstruation and were-panthers.[51] Zander Cannon's *Kaijumax*, whose tale of an island prison for Japanese monster types puts the *Oz* in *Godzilla*,[52] was considered for its racial subtext. Ezra Clayton Daniels and Ben Passmore's *BTTM FDRS* dispenses with subtext in its horror story about an apartment building in a gentrifying area, an arena for socioeconomic and racial tension.[53] One of the most surprisingly successful, enmeshed in comics and American history, is *Exit Stage Left: The Snagglepuss Chronicles*,[54] in which the Hanna-Barbera children's TV character is placed into

the McCarthy hearings, a playwright blackmailed because of his and his friend Huckleberry Hound's sexuality. Mark Russell and Mike Feehan well understand the triple meaning of the word *pink* at that time, and play on it to speak about performance as powerfully as Bechdel. America is the enemy, too, in Brian K. Vaughan and Steve Skroce's *We Stand on Guard*, about brutal, imperialist invaders despoiling and devastating Canada for its water; and in Scott Snyder, Charles Soule, Giuseppe Camuncoli, and Daniele Orlandini's *Undiscovered Country*, where America seals itself off to become a land of monstrous symbols, and more than symbols.[55]

That hostile American face turned up as the third card in our movie deck; it was, of course, a Joker. Todd Phillips's film about the early days of Batman's nemesis, *Taxi Driver* in a clown suit, garnered eleven Oscar nominations, including comics' second Best Picture nomination, and also grossed over a billion dollars. Much ink was spilled over potential resonances with the toxic stew of resentment and grievance that characterized performance and violence among white males in the Trump era (and what does the Joker do if not act out?). And, unfortunately, the real world, staggering uneasily between virtual and in person, real and costumed, had its share of echoes.

Back in May 2017, at Phoenix Comicon, a man had been apprehended with "two loaded rifles, a handgun, knives, and other weaponry"; if his threatening Facebook posts hadn't been flagged and police alerted, it's hard to know what would have happened. Conventions began to show heightened concern about "weapon"-toting cosplayers and replica sword and gun dealers.[56] But there were other types of violence in the comics world as well, continuing, and exacerbating, a long and shameful history.[57] "With Trump's election and the resulting surge in alt-right and conservative boldness," online harassment, particularly aimed at women creators and editors, metastasized, frequently following the playbook of video game–focused Gamergate, begun in 2014. Zainab Akhtar shut down the well-respected comics criticism website *Comics & Cola* in 2016 because of "toxic culture" and other people's "racism and sexism and bigotry."[58] "I'm amazed at the cruelty comics brings out in people," Chelsea

Cain tweeted in October 2016, before (temporarily) deleting her account.[59] In July 2017, Marvel assistant editor Heather Antos had the audacity to post a selfie of herself and other female editors having milkshakes, a tribute to recently deceased comics trailblazer/Marvel den mother/milkshake lover Flo Steinberg. Antos and the Marvel Milkshake Crew were called "'fake geek girls,' 'social justice warriors,' and 'tumblr-virtue signalers,' the sort of people who were ruining the comics industry by their very presence." Many of those subjected to these Comicsgaters' attentions were doxed and received "specific death threats."[60] Writer Chuck Wendig was abruptly fired by Marvel after tweeting opposition to Brett Kavanaugh's Supreme Court candidacy; at least some of the social media outrage that surely inflected the decision came via Comicsgate-related internet cutouts or sock puppets.[61] And the drumbeat of accounts of sexual harassment, assault, and "grooming" offline, by figures of authority ensconced in, rather than marginal to, the world of comics, continued through the presidency of a man credibly accused of many incidents of sexual assault and the birth of the #McToo movement.[62]

Much of this occurred in a miasma of rearguard Trumpian ressentiment, standing athwart a changing comics scene and yelling stop. And storied legacy institutions of the comics world *were* changing. In early 2016, *Playboy* announced it would no longer accept cartoon submissions.[63] Bob Mankoff left *The New Yorker* after twenty years as the cartoon editor ("huge news for refrigerators everywhere," wrote one blogger); simultaneously, the Cartoon Bank's revenues to artists had slowed to a trickle.[64] The *Village Voice*, a home for independently minded cartoonists since Feiffer's '50s, went digital-only in summer 2017. In summer 2019, DC announced the Vertigo imprint would be shuttered the following January, after twenty-six years;[65] that same summer, *The Walking Dead* finally ended—suddenly, and largely unexpectedly. ("The harder I tried to come up with new places to go, the clearer it was to me that this is what this story needed," Kirkman said. "It needed to end.")[66] And still that same summer, *Mad* magazine announced it was shutting down.

For some, there was even a sense that comics history itself was at

stake; new attitudes were re-evaluating, some would say toppling, old icons. Back in 2012, Thomas Nast failed to make the New Jersey Hall of Fame for the third year in a row, due to "outrage . . . because of his anti-Irish and anti-Catholic cartoons."[67] In summer 2018, DC canceled a planned hardcover reprint of the Captain Marvel "Monster Society of Evil" run from the '40s because of its racist depictions of Asians and Blacks, which were—and perhaps this may be the point—quite common for their time.[68] But Nast, and even the comics' Golden Age, was arguably ancient history, not living memory.

That same year, the Massachusetts Independent Comics Expo changed the name of its so-called Crumb Room; while recognizing Robert Crumb's "singular importance to the development of independent and alternative comics . . . and the quality and brilliance of much of his work," they felt "the great value of Crumb's radical and inventive freedom of expression is, we acknowledge, seriously problematic because of the pain and harm caused by perpetuating images of racial stereotypes and sexual violence."[69] Crumb's legacy was increasingly up for grabs as a monumentally influential figure in comics history or (depending on one's perspective) a purveyor of uncomfortable truths, a dismissable racist, or a satirical trafficker in racist, misogynist, and anti-Semitic imagery so persuasive that white supremacists, misunderstanding his satire (or understanding it and not caring), reprinted his work.

And then there was the virus.

It started in the United States in February 2020, with word of printer delays in Chinese plants; Iron Circus Comics announced that titles for winter and spring 2020 would have their release dates pushed off.[70] By early March, the convention cancellations had begun rolling in: Emerald City, WonderCon, Toronto, and then, by the end of April, Comic-Con—for the first time in fifty years. Instead of preparing for the convention, the San Diego Convention Center was pressed into duty as a homeless shelter.[71] (Iron Circus decided to run a stay-at-home PajamaCon 2020, one of the first of many forthcoming virtual conventions.) Comics retailers, for whom virus-related shutdowns and shelter-in-place orders threatened

to be extinction events (as for many other small businesses), began try-
ing mail order and pickup options, with customers largely stepping up
and staying faithful, within the ambit of their own economic troubles.[72]
There were comics-related livestreaming events; relief efforts for retailers,
including creators' auctions of original art; and other attempts at creating
and supporting communities.

In late March, Diamond, after first announcing it would provide aid
to retailers,[73] announced it would stop shipping new product after April 1,
and later announced cash flow problems; it wouldn't be able to pay vendors
at all for a week, and would defer large percentages of its payments there-
after.[74] This seems to have exacerbated already-extant discussions at DC
about moving away from the distributor's monopoly, perhaps especially
given concerns about Diamond's general financial health and liquidity.[75]
Within ten weeks, DC had ended its twenty-five-year relationship with
Diamond;[76] retailers greeted the process with shock, hostility, and deri-
sion.[77] One industry analyst wrote, "Realistically, how much of the retail
market is well-positioned to adjust to this right now? 10%? 20%? . . . [Per-
haps] all this will force the immediate adoption of changes [for stores,
publishers, and creators alike] that have been 20–25 years delayed by iner-
tia and monopoly. . . . But honestly, all that's like telling passengers on
the Titanic that now is a good time to develop strong swimming skills."[78]

A hint of what the future might include: as of early May 2020, as this
epilogue was being written, Marvel made selected issues digital-only. DC
followed with an announcement that *Supergirl* and *The Terrifics* would be
serialized only in digital form. Barnes & Noble, already suffering reverses
before the pandemic, laid off its graphic novel buyer of twenty years'
standing.[79] And that spoke volumes about the shape of the comics mar-
ket to come.

Or did it? Can we know for sure?

One of the most prominent modern-day cases of comics' original
sin—creators' rights to control their work—involved Alan Moore and
Dave Gibbons, who had been given to understand they would receive the
Watchmen rights when the book went out of print. Given that it didn't,

this never happened, but there was general consensus that DC president Paul Levitz had lived up to the spirit of the deal, vetoing anyone else's use of the characters from the series (with the exception of the 2009 movie adaptation), DC's legal rights to them notwithstanding. After Levitz's departure, that informal ban was rescinded, and in 2012, DC produced a series of comic book prequels, *Before Watchmen*, to significant criticism.[80] Moore, who'd broken off all contact with DC, told the *New York Times*, "I tend to take this latest development as a kind of eager confirmation that they are still apparently dependent on ideas that I had 25 years ago."[81]

Critical exhaustion, looking backward rather than forward. A dry well. And yet, the HBO adaptation/sequel/reimagination, appearing in the months before the death of George Floyd but long after searing cell phone videos of police brutality and violence had made their way onto the internet, was a meditation on America, race, violence, toxic masculinity, and the role of the imagination in rethinking what America might have been or could be. All in a series whose leading actor is Black, female, a police officer, and a superhero: it was a shock, a success, and, in its own way, a challenge.

Which is to say that when comics were, and are, and will be, considered all at once—the way Moore and Gibbons's character Dr. Manhattan sees the world, and we historians, to a more limited extent, do with the stories that we tell—here's, perhaps, what we see: A medium that has waxed and waned in its centrality to American life and consumership. Americans of all ages reading *Little Orphan Annie* and *Dick Tracy*, and millions of parents snuggled with their kids over a volume of Raina Telgemeier. Comic book stores struggling to keep their doors open and iPad apps doing numbers beyond anyone's imagination. The uneasy dance that comics performs, and has performed, with other media—the threat of television and movies as alternative entertainment, the fertile opportunities for reimagination provided by radio and podcast. The low barriers to entry the internet afforded cartoonists. Comic strip artists being feted by presidents and graphic novelists winning "genius" grants and comics publishers facing Congressional committees and cartoonists exhibited

at the Library of Congress. We see radical feminists and conservative jingoists and racist caricaturists and liberal satirists, and their characters: some who look like us and some who don't, some who look more like us than ever and some we flinch from because they speak to who, as a society, we wish we'd never been.

We see the great genres' beating hearts, tales of worlds that never were and that might be, worlds of fear and worlds of love, and worlds that seem a lot like ours but are somehow clearer, truer. We see how those worlds are so often in conversation with those that came before: and how that inheritance can be a gift, and it can be a burden. And we are surprised, always, at how what seems to be a dead end—because of technology, because of politics, because of the economy—continues to find life, in different formats, in different stories, taken up by different champions.

And we can only come to the same ineluctable conclusion about comics that Dr. Manhattan does, in the comic, about life itself: that nothing ever ends.

Comics' story is right in the middle of its run.

And so, we look forward to the next issue, the next trade, the next novel, the next voice, the next picture. And we hope to find those myths, those stories, those images, that enchant and educate and inspire.

ACKNOWLEDGMENTS

I could tell the story of my life through comics, I suppose: the yellowing piles of my uncle's Silver Age comics I plowed through as a young boy at my grandparents' house in Charleston, South Carolina; the obsessive Marvel collecting of my adolescence; reading *Maus* to tatters at my Jewish high school when it first came out in book form; leaving the crossovers and continuity snarls behind for college and then returning, with shock, delight, and absorption, to *Sandman*, *Preacher*, and the Vertigo titles in graduate school; giving a paper on Will Eisner at a conference on American Jewish literature as an assistant professor and never looking back; coming full circle as I watch my children read those same tales of Spiders and Bats alongside Dav Pilkey's and Raina Telgemeier's stories of Dog Men and Guts and Smiles.

But those are stories of books, and not people; and the journey—especially the journey of this book—is about an extraordinary group of people who require extraordinary thanks.

First, I have to thank Matt Weiland, my editor at Norton. When I proposed the book, I didn't have to elaborate, justify, or explain: he just said yes, and that yes—that enthusiasm and graciousness—has extended throughout the book's whole composition. (To say nothing

of his editorial acumen, which is, I can tell you, justly renowned.) I'm hugely grateful, as well, to the entire team at Norton who has worked with him, and me, on this book. Zarina Patwa, Lilly Gellman, and Huneeya Siddiqui provided valuable editorial assistance. Sarahmay Wilkinson's artistic direction—and inspiration—have led to Jon Gray's knockout cover. Lloyd Davis took on this mountain of a manuscript and tamed its wildnesses with brilliant discipline and disciplined brilliance. Thank you all.

As tends to be the case with books, this book involved reading many others; and this would have been impossible without the indefatigable efforts of the Columbia University libraries, whose staff members displayed remarkable cheer when they saw me walking up to the circulation desk with another two dozen or so of the many, many books this project entailed. I'd like to thank them by name: Insaf Ali, Mayra Alvarez, Christopher Babilaa, Joanna Barrett, Isacio Cedeno, Benny Figueroa, Dorian Hernández, Renata Johnson, Andrea Jordan, Tara Key, Evelyn Lopez, Jennifer Loubriel, Gustavo Martínez-Flores, Erica Moore, Rose Octolene, Catherine Parker-Thomas, Nikhil Raguram, Inji Ruiz, Robin Sanchez, Marcheinzy Valme, Arjay Velasco, Theodore White, and especially Dylan Rosenlieb. The reason so many of those books were there in the first place is because of Columbia's curator for comics and cartoons—and force of nature—Karen Green. I've been grateful to have her as a resource, guide, and friend.

I was fortunate beyond measure to have the research assistance of Tiffany Eloisa Babb on this project. All teachers learn from their students; I've learned more from Tiffany than from most, and look forward to learning much more as she goes on to what I know will be a spectacular career, in this and other related fields.

A huge note of thanks to those friends and experts who read through the entire draft manuscript and gave incredibly thorough and useful suggestions, corrections, kibitzes, and critiques: Danny Fingeroth, Paul Levitz, Tahneer Oksman, and Kim O'Connor. It goes without saying that any inaccuracies or just plain errors are the responsibility of the author alone.

I'd like to extend a particular note of gratitude, and affection, for Paul, my team teacher in Columbia's course on the American comic for the past decade or so, for the many insights, stories, and nuggets of advice (not all comics-related) over long talks, not infrequently over deli. Long may they continue. I'd also like to thank Peter Kuper and Jeff Newelt for their encouragement and suggestions.

My agent, Dan Conaway, knows how highly I think of him, how much I value his advice and his friendship. But it's possible that you don't. So let me shout it from the rooftops: this man knows how to make a book the best version of itself and, at least in this case, an author the best version of himself in print. Thank you, man, as always. My thanks also to Andrea Vedder and Lauren Carsley at Writers House for their assistance.

This book was completed during the COVID-19 pandemic, a time when, among much else, one appreciates, in new and profound ways, the sustaining and remarkable gifts of family, especially if you're lucky enough to have a family like mine. My parents, Eddie and Cheryl Dauber, are generous and kind in ways I cannot begin to express here; I can only hope they know how much I love, care, respect, and have learned from them. My in-laws, Bob and Sherry Pomerantz, are loving, caring, dedicated, and hospitable; I'm deeply grateful to have them in my life. My siblings—Noah, Andrew, and Sara Dauber, and Rachel Pomerantz—are constantly supportive presences, and have brought their own love of comics (or kindly quizzical skepticism of same) to these years; both are deeply appreciated.

My children, Eli, Ezra, and Talia, not only get me up in the day (thankfully, generally a little later than just a year or two ago) but fill those days with meaning and delight. Spending time with them, seeing them spend time with one another, telling stories about Leaf Man, Super-Talia, and the almost-correctly pronounced DC heroine "Wonder Melon"—a gift beyond measure. Thank you. One day you'll all be old enough to read this.

It would be cliché, I know, to refer to my wife Miri as a superhero. And, I think, inaccurate, since the kind of grace, power, intelligence, kind-

ness, and beauty she displays comes not from an easy narrative device like a distant planet or a radioactive bite, but from the effort and care that she takes to cherish her family, not least her husband, every single day. This is ordinary heroism, and far more magnificent for that. I am in love, more and more with every passing year.

NOTES

In citing works in the notes, short titles or author names have generally been used. Works frequently cited have been identified by the following abbreviations.

 AAW *America at War: The Best of DC War Comics*, ed. Michael Uslan (DC, 1979)
 ACA1 *Superman: The Action Comics Archives*, vol. 1 (DC, 1997)
 ACA2 *Superman: The Action Comics Archives*, vol. 2 (DC, 1998)
 ACA3 *Superman: The Action Comics Archives*, vol. 3 (DC, 1998)
 AEH2 *Marvel Masterworks: Atlas Era Heroes*, vol. 2 (Marvel, 2008)
 AETA1 *Marvel Masterworks: Atlas Era Tales to Astonish!*, vol. 1 (Marvel, 2006)
 AmSp2 *American Splendor* no. 2 (1977)
 AmSp4 *American Splendor* no. 4 (1979)
 AmSp7 *American Splendor* no. 7 (1982)
 ASCA1 *All Star Comics Archives*, vol. 1 (DC, 1991)
 ASCA2 *All Star Comics Archives*, vol. 2 (DC, 1992)
 ASCA3 *All Star Comics Archives*, vol. 3 (DC, 1997)
 ASCA4 *All Star Comics Archives*, vol. 4 (DC, 1998)
 ASCA6 *All Star Comics Archives*, vol. 6 (DC, 2000)
 BA1 *Batman Archives*, vol. 1 (DC, 1990)
 BA2 *Batman Archives*, vol. 2 (DC, 1991)
 BA3 *Batman Archives*, vol. 3 (DC, 1994)
 BA5 *Batman Archives*, vol. 5 (DC, 2001)
 BA6 *Batman Archives*, vol. 6 (DC, 2005)
 BA7 *Batman Archives*, vol. 7 (DC, 2007)
 BA8 *Batman Archives*, vol. 8 (DC, 2012)
 BACC *The Best American Comics Criticism*, ed. Ben Schwartz (Fantagraphics, 2010)
 BCA1 *Black Canary Archives*, vol. 1 (DC, 2001)
 BKYC *Marvel Masterworks: Atlas Era Black Knight/Yellow Claw* (Marvel, 2009)
 BWC Brian Walker, *The Comics: The Complete Collection* (Abrams ComicArts, 2011)
 CBB *The Comic-Book Book*, ed. Don Thompson and Dick Lupoff (Rainbow Books, 1973)
 CCA1 *Comic Cavalcade Archives*, vol. 1 (DC, 2005)
 CCC1 *The Complete Crumb Comics*, vol. 1, *The Early Years of Bitter Struggle* (Fantagraphics, 1987)
 CCC4 *The Complete Crumb Comics*, vol. 4, *Mr. Sixties!* (Fantagraphics, 1989)
 CCG Roger Sabin, *Comics, Comix, and Graphic Novels* (Phaidon Press, 1996)

CWC1 *The Complete Wimmen's Comix*, vol. 1 (Fantagraphics, 2016)
CWC2 *The Complete Wimmen's Comix*, vol. 2 (Fantagraphics, 2016)
DKA4 *Batman: The Dark Knight Archives*, vol. 4 (DC, 2003)
DL *The Complete Dirty Laundry Comics* (Last Gasp, 1992)
EAA1 *Enemy Ace Archives*, vol. 1 (DC, 2002)
FWO1 *Jack Kirby's Fourth World Omnibus*, vol. 1 (DC, 2007)
GAGLA1 *The Golden Age Green Lantern Archives*, vol. 1 (DC, 1999)
GAHT1 *Marvel Masterworks: Golden Age Human Torch*, vol. 1 (Marvel, 2005)
GAMC1 *The Golden Age of Marvel Comics*, vol. 1 (Marvel, 1997)
GAMC2 *The Golden Age of Marvel Comics*, vol. 2 (Marvel, 1999)
GASA1 *The Golden Age Starman Archives*, vol. 1 (DC, 2000)
GBS *The Greatest Batman Stories Ever Told* (DC, 1988)
GBW *Gothic Blimp Works*
GLGA2 *Green Lantern/Green Arrow*, vol. 2 (DC, 2004)
GSS *The Greatest Superman Stories Ever Told* (DC, 1987)
HDO *Howard the Duck Omnibus* (Marvel, 2008)
IJCA *International Journal of Comic Art*
JGNC *Journal of Graphic Novels and Comics*
JLAA1 *Justice League of America Archives*, vol. 1 (DC, 1992)
JLAA3 *Justice League of America Archives*, vol. 3 (DC, 1994)
JLAA8 *Justice League of America Archives*, vol. 8 (DC, 2003)
JPC *Journal of Popular Culture*
JRC Jerry Robinson, *The Comics: An Illustrated History of Comic Strip Art, 1895–2010* (Dark Horse, 2011)
LDC Les Daniels, *Comix: A History of Comic Books in America* (Bonanza Books, 1971)
LSH9 *Legion of Super-Heroes Archives*, vol. 9 (DC, 1999)
MMDS1 *Marvel Masterworks: Dr. Strange*, vol. 1 (Marvel, 2010)
MMX1 *Marvel Masterworks: The X-Men* (Marvel, 2002)
MOT Gerard Jones, *Men of Tomorrow: Geeks, Gangsters, and the Birth of the Comic Book* (Basic Books, 2004)
NYT *New York Times*
PC Randy Duncan and Matthew J. Smith, *The Power of Comics* (Continuum, 2009)
PMA1 *Plastic Man Archives*, vol. 1 (DC, 1998)
S1 Jim Steranko, *The Steranko History of Comics*, vol. 1 (Supergraphics, 1970)
S2 Jim Steranko, *The Steranko History of Comics*, vol. 2 (Supergraphics, 1972)
SA1 *Superman Archives*, vol. 1 (DC, 1989)
SA3 *Superman Archives*, vol. 3 (DC, 1991)
SA4 *Superman Archives*, vol. 4 (DC, 1994)
SA5 *Superman Archives*, vol. 5 (DC, 2000)
SA7 *Superman Archives*, vol. 7 (DC, 2006)
ShA1 *The Shazam! Archives*, vol. 1 (DC, 1992)
ShA2 *The Shazam! Archives*, vol. 2 (DC, 1999)
ShA3 *The Shazam! Archives*, vol. 3 (DC, 2002)
SLRise Jordan Raphael and Tom Spurgeon, *Stan Lee and the Rise and Fall of the American Comic Book* (Chicago Review Press, 2003)
SRA1 *Sgt. Rock Archives*, vol. 1 (DC, 2002)
TCJ *The Comics Journal*
TTA1 *The Silver Age Teen Titans Archives*, vol. 1 (DC, 2003)
UC Scott McCloud, *Understanding Comics: The Invisible Art* (HarperPerennial, 1993)
VMF1 *Vault of Mindless Fellowship* no. 1 (September 1972)
VMF2 *Vault of Mindless Fellowship* no. 2 (December 1972)
WWA1 *Wonder Woman Archives*, vol. 1 (DC, 1998)

Introduction: Birth of a Medium

1. See Albert Bigelow Paine, *Th. Nast: His Period and His Pictures* (Harper & Bros., 1904; repr. Peter Smith, 1967), 5–13.

2. See Scott McCloud, *Understanding Comics* (Kitchen Sink Press, 1993), 10–15; Jesper Nielsen and Søren Wichmann, "America's First Comics?," in *Comics & Culture: Analytical and Theoretical Approaches to Comics*, ed. Anne Magnussen and Hans-Christian Christiansen (Museum Tusculanum Press, 2000), 60–77; Laurence Grove, *Comics in French: The European Bande Dessineé in Context* (Berghahn, 2010), 59–86; Gideon Nisbet, "An Ancient Greek Graphic Novel," in *Classics and Comics*, ed. George Kovacs and C. W. Marshall (Oxford University Press, 2011), 27–42; Adam L. Kern, "The *Kibyōshi*: Japan's Eighteenth-Century Comicbook for Adults," *IJCA* 9, no. 1 (Spring 2007): 3–32.

3. Will Eisner, *Comics and Sequential Art*, rev. ed. (W. W. Norton, 2008; Poorhouse Press, 1985); for a judicious examination, see Bart Beaty, *Comics Versus Art* (University of Toronto Press, 2012), 27–44, quote 37; Hannah Miodrag, *Comics and Language: Reimagining Critical Discourse on the Form* (University Press of Mississippi, 2013), passim. The ne plus ultra of formal comics analysis is Paul Karasik and Mark Newgarden, *How to Read Nancy: The Elements of Comics in Three Easy Panels* (Fantagraphics, 2017).

4. See David Kunzle, *The Early Comic Strip: Narrative Strips and Picture Stories in the European Broadsheet from c. 1450 to 1825* (University of California Press, 1973, hereafter Kunzle, *Early*), passim.

5. The same illustration sometimes circulated at different events. See Kunzle, *Early*, 11–28, 37, 162–186, 197–199; Francis S. Betten, "The Cartoon in Luther's Warfare Against the Church," *Catholic Historical Review* 11, no. 2 (1925): 252–264, esp. 254, 260; Roger Sabin, *Comics, Comix, and Graphic Novels* (Phaidon Press, 1996, hereafter *CCG*), 11–12.

6. Roger Sabin, *Adult Comics: An Introduction* (Routledge, 1993), 14; Mike Kidson, "William Hogarth: Printing Techniques and Comics," *IJCA* 1, no. 1 (1999): 76–89.

7. Kunzle, *Early*, 299; Clark Kinnaird, "Cavalcade of the Funnies," in *The Funnies: An American Idiom*, ed. David Manning White and Roger H. Abel (Collier-Macmillan, 1963), 88–96, 88.

8. Quoted in Kunzle, *Early*, 298; compare Kidson, "William Hogarth," 81, and Kunzle, *Early*, 307; Matthew Surridge, "Hack's Progress, or Hogarth's Harlot and the Establishment of Creators' Rights," *TCJ* no. 236 (August 2001): 19.

9. See Randall P. Harrison, *Cartoon: Communication to the Quick* (Sage Publications, 1981), 74–75; Patricia Vansummeren, "From 'Mannekensblad' to Comic Strip," in *Forging a New Medium: The Comic Strip in the Nineteenth Century*, ed. Pascal Lefèvre and Charles Dierick (VUB University Press, 1998, hereafter *Forging*), 39–48; Kunzle, *Early*, 357–386.

10. Kinnaird, 89. First appearance in the *Pennsylvania Gazette* on May 9, 1754; recirculated around the Stamp Act Crisis and the early Revolutionary War. Franklin was also the Americas' first public figure *attacked* via cartoon, for his stance in a Pennsylvania election. See William Ray Heitzmann, "The Political Cartoon as Teaching Device," in *Teaching Political Science* 6 (1979): 166–184, and William Murrell, "Rise and Fall of Cartoon Symbols," *American Scholar* 4, no. 3 (1935): 306–315. Revere's cartoon, "The Bloody Massacre," appeared on March 28, 1770.

11. David Kunzle, *The History of the Comic Strip: The Nineteenth Century* (University of California Press, 1990, hereafter Kunzle, *History*), 6, 28–71; Kunzle, *Father of the Comic Strip: Rodolphe Töpffer* (University Press of Mississippi, 2007, hereafter Kunzle, *Father*); Thierry Groensteen, "Töpffer, the Originator of the Modern Comic Strip," in *Forging*, 107–114.

12. Quotes from Daniel Raeburn, *Chris Ware* (Yale University Press, 2004), 8, and Randy Duncan and Matthew J. Smith, *The Power of Comics* (Continuum, 2009, hereafter *PC*), 25; Kunzle, *Father*, 115–119.

13. See *Rodolphe Töpffer: The Complete Comic Strips*, ed. David Kunzle (University Press of Mississippi, 2007); on post-Töpffer nineteenth-century European comics, see *Forging*, notably 27–36.

14. Quote Reinhold Reitberger and Wolfgang Fuchs, *Comics: Anatomy of a Mass Medium* (Little, Brown, 1971), 17; Thierry Smolderen, *The Origins of Comics* (University Press of Mississippi, 2014), 62.

15. *CCG*, 12.

16. See George Perry and Alan Aldridge, *The Penguin Book of Comics: A Slight History* (Penguin, 1967), 9; Stephen Becker, *Comic Art in America* (Simon & Schuster, 1959), 2; Kunzle, *History*, 18–27, quote 22.

17. Harrison, 80; Maurice Horn, "What Is Comic Art?" in *75 Years of the Comics* (Boston Book & Art, 1971), 7–16, 7.

18. Commercial lithography began in America in 1822; all previous cartoons were engraved, etched, or cut on wood, copper, or steel. See Kinnaird, 89, and Jerry Robinson, *The Comics: An Illustrated History of Comic Strip Art, 1895–2010* (Dark Horse, 2011, hereafter *JRC*), 39; *Cartoon America*, ed. Harry Katz (Abrams, 2006), 35, 49.
19. "How We Poison Our Children," *NYT*, May 13, 1858. See also Paine, 18.
20. Paine, 34, 46–47, 82.
21. Quotes here from Paine, 69, 91, 98–99, 106, and Murrell, 307.
22. See Paine, 6, 84; Murrell, 310–314; Heitzmann.
23. Harrison, 14; Paine, 11; Murrell, 312; Robert C. Harvey, *Children of the Yellow Kid: The Evolution of the American Comic Strip* (Frye Art Museum, 1998, hereafter Harvey, *Children*), 135, 138; quote Ben Sargent, "Editorial Cartoons," in *The Education of a Comics Artist*, Michael Dooley and Steven Heller, eds. (Allworth Press, 2005), 15–16, 15.
24. See Martin Barker, *Comics: Ideology, Power, and the Critics* (Manchester University Press, 1989), 205–210.
25. Paine, 121.
26. Ryan Fleming, "News and Rumors on All of the TV Shows Based on Comics in the Works (There's a Lot)," *Dead Beats Panel*, June 19, 2017, http://www.deadbeatspanel.com/tv-shows -based-on-comics; "Domestic Box Office for 2018," *Box Office Mojo by IMDbPro*, https://www .boxofficemojo.com/yearly/chart/?yr=2018. The remaining two films were *Jurassic World: Fallen Kingdom* and *Mission: Impossible—Fallout*. *Comic-Con: 40 Years of Artists, Writers, Fans & Friends* (Chronicle Books, 2009), passim.
27. See Matthew Pustz, *Comic Book Culture: Fanboys and True Believers* (University Press of Mississippi, 1999), x.

Chapter 1: The Rise and Rise of the Comic Strip

1. Harvey, *Children*, 68; Brian Walker, *The Comics: The Complete Collection* (Abrams Comic-Arts, 2011, hereafter *BWC*), 10, 21; "New York City's Long List of Defunct Newspapers," *Ephemeral New York*, July 28, 2009, https://ephemeralnewyork.wordpress.com/2009/07/28/ new-york-citys-long-list-of-defunct-newspapers.
2. The *New York Evening Telegram*, in 1867, was the first American daily to use cartoons regularly; six years later, the *New York Daily Graphic* featured cartoons by Frederick B. Opper and A. B. Frost, creator of Br'er Rabbit, who used the term *comics* for various magazine stories he published. *BWC*, 10; *A. B. Frost: An Anthology* (Fantagraphics, 2003), 5–7.
3. See Richard Samuel West, "Laughing in German: A Short History of *Puck, Illustrirtes Humoristiches Wochenblatt* (1876–1898)," *Inks* 3, no. 1 (February 1996): 16–23.
4. Also frequently mentioned as pivotal in that election is Walt McDougall's *Belshazzar's Feast*, in the October 30, 1884, *New York World*; Becker, 2.
5. See Ian Gordon, *Comic Strips and Consumer Culture, 1890–1945* (Smithsonian Institution Press, 1998), 17, 174; *CCG*, 15; Richard Marschall, "The History of the Comic Strip, Part One," *TCJ* no. 57 (Summer 1980): 134–139; Marschall, "*Judge* Magazine—The Breeding Ground of Pictorial Humor," *TCJ* no. 60 (November 1980): 87–92; Harlen Makemson, "Private Vice and Public Virtue: Political Cartoons as 'Opprobrious Discourse' Against Grover Cleveland in the 1884 Election Campaign," *IJCA* 6, no. 2 (Fall 2004): 90–117.
6. Quoted in S. L. Harrison, "The Editorial Art of Edmund Duffy," *Inks* 1, no. 3 (November 1994): 18–29, 18.
7. Mort Gerberg, *Cartooning: The Art and the Business* (Morrow, 1989), 48–50; David Kunzle, "Precursors in American Weeklies to the American Newspaper Comic Strip," in *Forging*, 172; Gordon, 60–61; Fredrik Strömberg, *Black Images in the Comics: A Visual History* (Fantagraphics, 2003), 29–30.
8. *JRC*, 15–16; Coulton Waugh, *The Comics* (Macmillan, 1947), 6.
9. See Harrison, 85–86; Robert C. Harvey, *The Art of the Funnies: An Aesthetic History* (University Press of Mississippi, 1994), 4; Becker, 5; Ron Goulart, *The Funnies: 100 Years of American Comic Strips* (Adams, 1995, hereafter Goulart, *100 Years*), 1; Les Daniels, *Comix: A History of Comic Books in America* (Bonanza Books, 1971; hereafter *LDC*), 2; *JRC*, 15–16; *BWC*, 10; *Cartoon America*, 54; David R. Spencer, "The Press and the Spanish American War Political Cartoons of the Yellow Journalism Age," *IJCA* 9, no. 1 (Spring 2007): 262–263.

10. Becker, 7; Goulart, *100 Years*, 3; *LDC*, 2; *BWC*, 7; *JRC*, 16; Harvey, *Children*, 17; Bill Blackbeard, "The Yellow Kid, the Yellow Decade," in R. F. *Outcault's The Yellow Kid: A Centennial Celebration of the Kid Who Started the Comics* (Kitchen Sink Press, 1995), 23.

11. See Richard Marschall, *America's Great Comic-Strip Artists* (Abbeville Press, 1989, hereafter Marschall, *America's*), 24, 27.

12. Marschall, *America's*, 20.

13. *BWC*, 30; *JRC*, 16–17; Blackbeard, "Yellow Decade," 32; Goulart, *100 Years*, 2–3.

14. Cited in *BWC*, 30, and Waugh, 8; see also *LDC*, 2, and *JRC* 18; Blackbeard, "Yellow Decade," 17–136, 19.

15. Richard Marschall, "Shibboleths," *TCJ* no. 68 (November 1981): 83; Blackbeard, "Yellow Decade," 30–34; Goulart, *100 Years*, 4.

16. On the historical record, see Mark D. Winchester, "Hully Gee, It's a WAR!!! The Yellow Kid and the Coining of 'Yellow Journalism,'" *Inks* 2, no. 3 (November 1995): 22–37; see also Blackbeard, "Yellow Decade," 56, 59. Notably, the Kid was often thought to be Chinese; Outcault actually corrected the misapprehension in a strip; see Gordon, 29–31.

17. N. C. Christopher Couch, "The Yellow Kid and the Comics Page," in *The Language of Comics: Word and Image*, ed. Robin Varnum and Christina T. Gibbons (University Press of Mississippi, 2001), 60–74, 66–70; *BWC*, 8–11; Waugh, 2; *JRC*, 20.

18. Perry and Aldridge, 12; Harvey, *Children*, 20; *BWC*, 8–12, 46; Blackbeard, "Yellow Decade," 70–71; *JRC*, 18; Donald Phelps, *Reading the Funnies* (Fantagraphics, 2001), 219–229; Becker, 3; Paul Gravett, "The Cartoonist's Progress: The Inventors of Comics in Great Britain," in *Forging*, 81–103, 90.

19. Quoted in *BWC*, 13.

20. Lisa Heffernan Weil, "'A Good Line of Advertising'" (master's thesis, University of Missouri-Columbia, 2007), 104–107, quote 106, from *The Youth's Companion*, October 19, 1900; see also *BWC*, 53. The strip was 1903's *Brownie Clown of Brownie Town*.

21. *Truth* magazine, June 1894. See *BWC*, 7, 11; *JRC* 16–17; Blackbeard, "Yellow Decade," 25–28.

22. Trina Robbins and Catherine Yronwode, *Women and the Comics* (Eclipse Books, 1985), 7–15; on cuteness and comics' rise, compare Smolderen, 108.

23. See Jared Gardner, *Projections: Comics and the History of Twenty-First-Century Storytelling* (Stanford University Press, 2012, hereafter "Gardner"), 12; *JRC*, 21; Gordon, 4–7.

24. Quotes Outcault, "How the Yellow Kid Was Born" (*New York World*, May 1, 1898), quoted in *BWC*, 14; Gordon, 51–53; see Harvey, *Children*, 16; Goulart, *100 Years*, 15; *BWC*, 30; Harrison, 87; Reitberger and Fuchs, 15.

25. Waugh, 9; Goulart, *100 Years*, 14; Marschall, *America's*, 32.

26. *Life*, March 12, 1896, and February 13, 1896; quoted in Blackbeard, "Yellow Decade," 41; Sabin, *Adult*, 137.

27. Harvey, *Children*, 6; *JRC*, 26–27; *BWC*, 11; quote *New York World*, October 17, 1896, via Becker, 14; Allan Holtz, "Introduction," in *Frederick Burr Hopper's Happy Hooligan*, ed. Jeffrey Lindenblatt (NBM, 2008), 11.

28. Harvey, *Children*, 18; "George Benjamin Luks: The 'Other' Yellow Kid Artist (But So Much More)," *Hogan's Alley* no. 13 (2005): 112ff.

29. Mark D. Winchester, "Litigation and Early Comic Strips: The Lawsuits of Outcault, Dirks, and Fisher," *Inks* 2, no. 2 (May 1995): 16–25, 20, 25n17; *JRC*, 27; Richard Marschall, "Speculation and Integration in Slumberland," in Winsor McCay, *The Complete Little Nemo in Slumberland*, vol. 5, *1911–1912* (Fantagraphics, 1991), 7–22, 14–16. Outcault wrote the Library of Congress the month before the *Humorist* appeared to copyright "this little character . . . the Yellow Dugan Kid," whose "costume however is always yellow, his ears are large he has but two teeth and is distinctly different from everything else"; quoted Blackbeard, "Yellow Decade," 49.

30. Whether publicly known or not: Tige, Mrs. Brown, and girlfriend Mary Jane were modeled on Outcault's dog, wife, and daughter, for example, presumably unknown by most readers. *BWC* 25; Winchester, "Litigation," 21–22.

31. Kunzle, "Precursors," in *Forging*, 159–185, 160; Charlie Scheips, "W. R. Hearst and Comic Art: How the Art of the Comics Became Art," in *The Comics: Popeye to Pop Art*, ed. Anthony T. Mazzola (Hearst Fine Arts, 2012), 6; *JRC*, 43; Goulart, *100 Years*, 6; Kunzle, *History*, 231–283, esp. 244–250; Marschall, *America's*, 42–43; *BWC*, 10, 36.

32. See *JRC*, 18; *BWC*, 36; Waugh, 11; Robbins and Yronwode, 7; Goulart, *100 Years*, 16; Arthur Asa Berger, *The Comic-Stripped American* (Penguin, 1974), 36–37; and Lara Saguisag's excellent *Incorrigibles and Innocents: Constructing Childhood and Citizenship in Progressive Era Comics* (Rutgers University Press, 2019).

33. Waugh, 14; *BWC*, 21.

34. Scheips, 6; Waugh, 27; *LDC*, 4; Harvey, *Funnies*, 7, 67–69; Gordon, 38–41; Becker, 21, 27; *BWC*, 22; *JRC*, 61; Martin Sheridan, *Comics and Their Creators: Life Stories of American Cartoonists* (Hale, Cushman, & Flint, 1942), 16, 20–21, 24; Goulart, *100 Years*, 11.

35. Quotes from Gardner, 17, *BWC*, 22–23, Winchester, "Litigation," 23.

36. Quotes from Alan Fried, "Lyonel Feininger," *Inks* 3, no. 3 (November 1996): 12–23, 14; David Hajdu, *The Ten-Cent Plague* (Farrar, Straus & Giroux, 2008), 12; Harvey, *Children*, 10.

37. Roy L. McCardell, "Opper, Outcault, and Company," *Everybody's Magazine*, 1905, reprinted in *Inks* 2, no. 2 (May 1995): 3–15, 15 (emphasis mine).

38. See *BWC*, 12, 42; *JRC*, 50; Becker, 19; Waugh, 18; Gardner, 13–15; Holtz, "Introduction," 7; Mark McKinney, "After You, My Dear Fake Frenchmen: Frederick Burr Hopper's *Alphonse and Gaston*—and Leon!," *Inks* 1, no. 2 (Summer 2017): 143–164, esp. 151, 155–156.

39. In *Charlie Chaplin's Comic Papers*; M. Thomas Inge, *Comics as Culture* (University of Mississippi Press, 1990), 61.

40. Jackie Cooper, who played strip character Skippy in the movie adaptation, snagged a 1931 Best Actor nomination. See Goulart, *100 Years*, 13; Inge, *Culture*, 143; Ron Goulart, *Over Fifty Years of American Comic Books* (Publications International, 1991, hereafter Goulart, *Fifty*), 68–69; Leonard Maltin, "Introduction: Our Gang," in *Walt Kelly's Our Gang* (Fantagraphics, 2006), 4; Bill Blackbeard, introduction to Gus Mager, *Sherlocko the Monk: 1910–1912* (Hyperion Press, 1977).

41. Wiley Lee Umphlett, *Mythmakers of the American Dream* (Cornwall Books, 1983), 79–81; Ron Goulart, *The Adventurous Decade* (Arlington House, 1975, hereafter Goulart, *Adventurous*), 14–20; Don and Maggie Thompson, "Wheelan Pictures, Ink., Presents," in Ed Wheelan, *Minute Movies: A Complete Compilation, 1927–1928* (Hyperion Press, 1977), v–xii.

42. A new "actor," Paul Vogue, received intense unsympathetic reader reaction in 1927 ("and by intense we don't mean maybe"). The audience was asked to give him a chance; several weeks later, Vogue appeared on station WMMS to tell fans "how deeply I appreciate your wonderful letters of encouragement." Wheelan, 76, 102, 120; Sheridan, 139; Jared Gardner, "Ed Wheelan's *Minute Movies*," *TCJ* no. 289 (April 2008): 114–120.

43. Earlier, *Little Sammy Sneeze* began a year before *Little Nemo*; by each strip's end, Sammy's sneeze lays waste to all about him. See, generally, Scott Bukatman, *The Poetics of Slumberland* (University of California Press, 2012), esp. 50–68, 89–92, 100–105.

44. Quote Gardner, 41; see Fried, 16–17; *BWC*, 28; Richard Marschall, "Perchance to Dream," in Winsor McCay, *The Complete Little Nemo in Slumberland*, vol. 1, *1905–1907* (Fantagraphics, 1989), 10, 14. Marschall, *America's*, 77; Umphlett, 86; Inge, *Culture*, 30. McCay's pliable creations also figured in his vaudevillian chalktalk act and massive contributions to animation; Harvey, *Funnies*, 28, 31.

45. Richard Marschall, "Leitmotifs and Farewells: Leaving Slumberland but Staying Put," in Winsor McCay, *The Complete Little Nemo in Slumberland*, vol. 4, *1910–1911* (Fantagraphics, 1990), 5–14, 5; Gardner, 40–42; Harrison, 89; Bill Blackbeard, introduction, *The Comic Strip Art of Lyonel Feininger* (Fantagraphics, 2007).

46. Nemo's bedding suggests upper-middle-classdom, in line with the *Herald*'s slightly more upscale readership, compared to the *World*'s and *Journal*'s immigrant readers—another possible factor in the strip's failure to resonate. Marschall, "Perchance," 5–14, 5; Richard Marschall, "Realism and Surrealism: The Expanding Horizons of Winsor McCay," in Winsor McCay, *The Complete Little Nemo in Slumberland*, vol. 2, *1907–1908* (Fantagraphics, 1989), 5–14, 9; note Barker, *Ideology, Power*, esp. 97–105.

47. Umphlett, 89.

48. *Little Nemo*, December 24, 1905; December 31, 1905; January 7, 1906; July 15, 1906.

49. Cited Waugh, 25.

50. See Waugh, 28; *BWC*, 28–29; Gardner, 42; *JRC*, 73.

51. It was canceled in 1983. *JRC*, 69; *BWC*, 29; *LDC*, 4; Umphlett, 77.

52. *BWC*, 28–29; Harvey, *Children*, 26; Sheridan, 76–78.

53. Technically, Clare Briggs was the first, with *A. Piker Clerk* in the *Chicago American* in 1904, but it lacked *Mutt and Jeff*'s success. (Publisher Hearst may have thought it too vulgar.) Waugh, 27; Harvey, *Funnies*, 36; Allan Holtz, "The Daily Show," *Hogan's Alley* no. 12 (2004): 67.

54. Maurice Horn, *Sex in the Comics* (Chelsea House, 1985), 16, 18.

55. Sheridan, 45; Waugh, 47; Harvey, *Funnies*, 49; Reitberger and Fuchs, 38; R. C. Harvey, "A Short Look at a Long Run," *TCJ* no. 112 (October 1986): 47; R. C. Harvey, "Another History of Comics Book," *TCJ* no. 274 (February 2006): 191.

56. See Harvey, *Funnies*, 92–94; R. C. Harvey, "The Captain and the Comics," *Inks* 2, no. 3 (November 1995): 38–57.

57. He'd renounced his family money, earning his living from dairy farming and dramatics, with three produced Broadway plays.

58. Harvey, *Children*, 76; Harvey, "Captain," 43–44, quote 44; *JRC*, 108; Gardner, 47.

59. See *Will Eisner's Shop Talk* (Dark Horse, 2001), 115–116.

60. Harvey, *Funnies*, 11, 60, 62; Harvey, *Children*, 69; Harvey, "Captain," 42, 46; Gardner, 51–55, 60; Waugh, 81; *JRC*, 113; Sheridan, 102.

61. Mort Walker, *Backstage at the Strips* (Mason/Charter, 1975), 2; Goulart, *Adventurous*, 22; Harvey, *Funnies*, 39; Sheridan, 102.

62. Quote Reitberger and Fuchs, 48; Sheena Wagstaff, "Comic Iconoclasm," in *Comic Iconoclasm: An Exhibition Organised by the Institute of Contemporary Art* (Institute of Contemporary Arts, 1987), 10; Miodrag, 17–40.

63. Gilbert Seldes, "The Krazy Kat That Walks by Himself," repr. in White and Abel, 131–141, 131–132; Cummings's essay in *Krazy Kat & the Art of George Herriman*, ed. Craig Yoe (Abrams ComicArts, 2011); Joseph Witek, "Comics Criticism in the United States: A Brief Historical Survey," *IJCA* 1, no. 1 (Spring/Summer, 1999): 4–16, 13; Waugh, 59–60; Harvey, *Funnies*, 172; Sheridan, 64–65; Inge, *Culture*, 41, 49; Quote Marschall, *America's*, 111.

64. Sheridan, 64–65.

65. M. Thomas Inge, "Was *Krazy Kat* Black? The Racial Identity of George Herriman," *Inks* 3, no. 2 (May 1996): 2–9; Gordon, 62–67, 76–79; Strömberg, 49. Perhaps the definitive treatment of the subject is now Michael Tisserand, *Krazy: George Herriman, a Life in Black and White* (Harper, 2016); see esp. 153–154.

66. Scheips, 2; *The Smithsonian Collection of Newspaper Comics*, ed. Bill Blackbeard and Martin Williams (Smithsonian Institution Press, 1977, hereafter *Smithsonian Newspaper*), 81; Waugh, 61–62. Hearst, similarly, liked *Prince Valiant* so much, he ensured it ran at original full-page size in his papers long after others cut it to half-size.

67. Quote Bill Blackbeard, "Dreamscape: The Scattered Masterpiece of Winsor McCay," in Winsor McCay, *The Complete Little Nemo in Slumberland*, vol. 6, *1913–1914* (Fantagraphics, 1993), 5–9, 5; *BWC*, 36.

68. R. C. Harvey, *Cartoons of the Roaring Twenties*, vol. 1, *1921–1923* (Fantagraphics, 1991), 16. Between 1920 and 1929, GNP went from $74 billion to $104 billion; a skilled laborer's buying power increased 50 percent between 1913 and 1927; *BWC*, 114; see Berger, 76.

69. See R. C. Harvey, "Introduction," *Cartoons of the Roaring Twenties*, vol. 1, *1921–1923*: 5–8, 5; quote Harvey, "Introduction," *Cartoons of the Roaring Twenties*, vol. 2, *1923–1925* (Fantagraphics, 1991), 5–9, 7; *Cartoon America*, 156; Robbins and Yronwode, 12–13, 19, 22; Trina Robbins, *The Brinkley Girls* (Fantagraphics, 2009), 9.

70. Harvey, *Roaring Twenties*, 1:42; Horn, *Sex*, 27; *75 Years*, 45; Waugh, 101, 133, 136; Harvey, *Funnies*, 97; *JRC*, 83; Gordon, 118; Sheridan, 179–186.

71. Sheridan, 195.

72. Judith O'Sullivan, *The Art of the Comic Strip* (University of Maryland Art Gallery, 1971), 13.

73. Neé *Positive Polly*, appearing in 1912, its title changed a year later; see Waugh, 40, and Moira Davison Reynolds, *Comic Strip Artists in American Newspapers, 1945–1980* (McFarland, 2003), 16.

74. See Art Spiegelman, "Polyphonic Polly: Hot and Sweet," in Cliff Sterrett, *The Complete Color Polly & Her Pals*, vol. 1 (Remco, 1990), 5–6, 5; R. C. Harvey, "A Pretty Girl Is Like a Malady," *TCJ* no. 147 (December 1991): 85–90; quotes Sheridan, 82, and *Smithsonian Newspaper*, 79.

75. Brian Walker, "Made of Pen and Ink, She Can Win You in a Wink," in Max Fleischer, *The Definitive Betty Boop: The Classic Comic Strip Collection* (Titan, 2015); *Betty Boop* strip, July 28, 1934.

76. See Sheridan, 172–173, and Karasik and Newgarden, 46–49, 58–59.

77. In *Nancy and Sluggo* (Whitman, 1946), n.p.

78. Now known, if at all, for its refrain, where Annie mentions "the Gobble 'uns 'at gits you 'ef you Don't— Watch— Out!" See Bruce Smith, *The History of Little Orphan Annie* (Ballantine, 1982, hereafter B. Smith, *Annie*), 3–4, 8–9, quotes 3–4; Harrison, 36; Goulart, *Adventurous*, 140–141; Waugh, 83.

79. Sheridan, 69–70; Waugh, 84; Marschall, *America's*, 166.

80. "Right on the Button" (1925), repr. in *Little Orphan Annie and Little Orphan Annie in Cosmic City* (Dover, 1974), 72.

81. On September 27, 1924; B. Smith, *Annie*, 12.

82. B. Smith, *Annie*, 24–27; "The Picket," October 19, 1932; see also "Reward," October 22, 1932; Robert H. Abel, "One Shade of Gray," in White and Abel, 113–127, 115.

83. Quotes B. Smith, *Annie*, 35, 63.

84. See Dale Luciano, "Suckers and Survivors," *TCJ* no. 98 (May 1985): 46; Franklin Rosemont, "Ernest Riebe and Mr. Block," in *Mr. Block: Twenty-Four IWW Cartoons* (Charles H. Kerr, 1984), 5; Harvey, "Captain and the Comics," 50; Harvey, *Children of the Yellow Kid*, 138.

85. Sheridan, 56; Waugh, 94; Frank H. Willard, *Moon Mullins: Two Adventures* (Dover, 1976), 27.

86. Quotes strips from January 25, 1921, and February 15, 1921, in *Walt & Skeezix*, vol. 1, *1921–1922* (Drawn & Quarterly, 2005), *Walt & Skeezix*; Edward Barry, "Skeezix is Crowding 40!," *Chicago Sunday Tribune Magazine*, February 14, 1960; repr. *Drawn & Quarterly* 4 (2001), 97; Harvey, *Children*, 63; Gordon, 111; Sheridan, 52–53; Waugh, 95–96; *LDC*, 5; *JRC* 98, 105; Chris Ware's comments, inside back cover *Drawn & Quarterly* 3 (2000); Jeet Heer's introduction to *Walt & Skeezix*, vol. 1, *1921–1922*, 7; Phelps, *Reading*, 204–205.

87. Sheridan, 121–122.

88. Jim Steranko, *The Steranko History of Comics*, vol. 1 (Supergraphics, 1970, hereafter *S1*), 7; Marschall, *America's*, 227–229.

89. Reprinted in *The Complete Chester Gould's Dick Tracy*, vol. 1, *1931–1933* (IDW, 2006), n.p.

90. *S1*, 8; Harvey, *Sex*, 45; *Smithsonian Newspaper*, 131; quotes Goulart, *Adventurous*, 73–75.

91. Quoted Jay Maeder, *Dick Tracy: The Official Biography* (Plume, 1990), 31–32.

92. Rick Marschall, "No Longer Missing," in *Will Gould's Red Barry* (Fantagraphics, 1989), v–ix, quotes viii, ix. Davies played Tillie the Toiler in a movie; Perry and Aldridge, 232.

93. See *S1*, 14.

94. Maeder, *Tracy*, 56; Max Alan Collins, "Foreword," *Batman Archives*, vol. 2 (DC, 1991, hereafter *BA2*); "Roosevelt Puts Crime on the Spot," *True Detective*, quoted Vaz, 20.

95. See *LDC*, 7; *JRC*, 41, 196; Harvey, *Funnies*, 83; R. C. Harvey, "One Good Apple Proves a Barrel's Worth," *TCJ*, January 30, 2012, http://www.tcj.com/one-good-apple-proves-a-barrels-worth; "A Last Interview with Roy Crane About First Things," *TCJ* no. 203 (April 1998): 45–46. Easy may have been based on a Texas fraternity brother; see Michael H. Price, "The Man Who Was Easy," *ComicMix*, September 2, 2007, https://www.comicmix.com/2007/09/02/michael-h-price-the-man-who-was-easy.

96. See Robbins and Yronwode, 36; Allan Holtz, "The Quest for the First Adventure Strip," *Hogan's Alley* no. 10 (2002): 96–107.

97. Camille E. Cazedessus Jr., "Lords of the Jungle," in *The Comic-Book Book*, ed. Don Thompson and Dick Lupoff (Rainbow Books, 1973, hereafter, *CBB*), 256–289, 257, 260; Goulart, *Adventurous*, 46–47.

98. See *JRC*, 149–150; Waugh, 245; Harvey, *Funnies*, 119; Maurice Horn, "The Magic of Burne Hogarth," in Burne Hogarth, *Tarzan of the Apes* (Watson-Guptill, 1972), 14; *S1*, 7; Arn Saba, "Drawing upon History," *TCJ* no. 102 (September 1985): 62.

99. Quote Horn, "Magic," 5–28, 6; Thomas A. Pendleton, "Tarzan of the Papers," *JPC* 12, no. 4 (1979): 691–701, 694. When Foster left *Tarzan* to create *Prince Valiant*, another journey to the past (and another good editorial title change—from *Derek, Son of Thane*), he was again so committed to authenticity, he asked Hearst to postpone the start for eighteen months while he researched. *S1*, 13; Saba, 62; M. Reynolds, *1945–1980*, 42; Strömberg, 95.

100. From the August 1928 issue of *Amazing Stories*; see *LDC*, 7; *JRC*, 155; Waugh, 249; Goulart, *Adventurous*, 57; Mike Benton, *Science Fiction Comics: The Illustrated History* (Taylor Publishing, 1992), 9; Sheridan, 226–227; *S1*, 7.

101. As in *Tracy*, strip creators had outside consultants—here, Chicago University scientists. See Benton, *Science Fiction*, 10; Gordon, 82.
102. Quotes *JRC*, 157; Harvey, *Funnies*, 118; Dwight R. Decker, "Buck Rogers in the 20 4/5th Century," *TCJ* no. 48 (Summer 1979): 125–128, 126.
103. Quote Goulart, *Adventurous*, 57; see Umphlett, 94–95, and Berger, 98; *S1*, 9. Two slightly different SF perspectives: 1933's *Brick Bradford*, with flying time machine and visits to the Land of the Lost, and 1934's *Alley Oop*, to which, getting bored with the prehistoric setting in 1939, creator Vincent T. Hamlin introduced time travel, sending Oop and his romantic interest through history. See also Goulart, *Adventurous*, 60–62; Sheridan, 223; Harvey, *Children*, 62.
104. See Goulart, *Adventurous*, 124–131; Harvey, *Funnies*, 138, 144; quotes Sheridan, 157–158; Lawrence E. Mintz, "Fantasy, Formula, Realism, and Propaganda in Milton Caniff's Comic Strips," *JPC* 12, no. 4 (1979): 665.
105. Quoted in Goulart, *Adventurous*, 131; see *JRC*, 195. For Caniff's influences, including the female pirate Moon Shadow in the novel *Vampires of the China Coast*, see R. C. Harvey, "Origins of the Dragon Lady," *TCJ* no. 96 (March 1985): 38–40.
106. Goulart, *Adventurous*, 91; Harvey, *Funnies*, 101; *Red Barry*, 16; Quote Goulart, *Adventurous*, 87.
107. Goulart, *100 Years*, 10, 13; Strömberg, 53, 59, 65, 67, 69, 77, 79, 81; John Canemaker, *Felix: The Twisted Tale of the World's Most Famous Cat* (Pantheon, 1991), 27–39; Winsor McCay, *Daydreams and Nightmares: The Fantastic Visions of Winsor McCay* (Fantagraphics, 2005), 29.
108. Cited in *BWC*, 54; see Jeet Heer's judicious "Racism as a Stylistic Choice and Other Notes," *TCJ*, March 14, 2011, http://www.tcj.com/racism-as-a-stylistic-choice-and-other-notes.
109. Tim Jackson, *Pioneering Cartoonists of Color* (University Press of Mississippi, 2016), 9, 16, 20–23, 26, 31, 42; Strömberg, 109; Trina Robbins, "Hidden Treasure," *TCJ* no. 160 (July 1993): 48–49; Harvey, *Children*, 68; Harvey, *Accidental Ambassador Gordo: The Comic Strip Art of Gus Arriola* (University Press of Mississippi, 2000), 2–4; "Gus Arriola," *TCJ* no. 229 (December 2000): 81–82. *JRC*, 352–353; *Cartoon America*, 252–253 (Harrington 1952 cartoon from 253); Samuel Joyner, "My Life as an African-American Cartoonist," *TCJ* no. 150 (May 1992): 102–107; Nancy Goldstein, *Jackie Ormes: The First African American Woman Cartoonist* (University of Michigan, 2008), quote 4.
110. Quotes Richard Marschall, "Al Capp," *TCJ* no. 54 (March 1980): 45–53, 45; *JRC*, 200; Sheridan, 136; M. Thomas Inge, "Li'l Abner, Snuffy, and Friends: The Appalachian South and the U.S. Comic Strip," in *Comics and the U.S. South*, ed. Brannon Costello and Qiana J. Whitted (University Press of Mississippi, 2012), 3–28.
111. Expelled from the National Cartoonists Society, Fisher would commit suicide. M. Walker, *Backstage*, 96. See also Michael Schumacher and Denis Kitchen, *Al Capp: A Life to the Contrary* (Bloomsbury, 2013), 58–74, 88–91, 151–154, 178–180.
112. Sheridan, 134; Waugh, 202; *JRC*, 202.
113. The hundred-dollar prize was won by Mrs. Beatrice Barken, of Cleveland, for "Cookie." Dean Young and Rick Marschall, *Blondie & Dagwood's America* (Harper & Row, 1981), 22–24, 27–28; *JRC*, 162.
114. Paul Buhle, *From the Lower East Side to Hollywood: Jews in American Popular Culture* (Verso, 2004), 92–94; Paul Buhle, *Jews and American Comics* (New Press, 2008), 19–22; Eddy Portnoy, "Follow My Nose: Self-Caricature in Cartoons of the Yiddish Press," *IJCA* 6, no. 2 (Fall 2004): 285–303.
115. See Waugh, 65; Becker, 38; Buhle, *Lower*, 93. Hershfield replaced *Desmond* with *Dauntless Durham of the U.S.A.*, the character of Desmond revived as a bad guy: Harry Hershfield, *Dauntless Durham of the U.S.A., The Complete Strip, 1913–1914* (Hyperion Press, 1977), 3.
116. See Sheridan, 33; Waugh, 65; *JRC*, 74; Becker, 39; Harry Hershfield, *Abie the Agent: 1914–1915* (Hyperion Press, 1977), 45; Phelps, *Reading*, 66–67.
117. Quote *Lower*, 95; *Lower* 94, 97; Craig Yoe, "Laughs by the Gross!," in *The Complete Milt Gross*, ed. Craig Yoe (IDW, 2009), 11–14; Ari Y. Kelman, "Introduction," *Is Diss a System?: A Milt Gross Reader* (New York University Press, 2010), 1–54.
118. See Sheridan, 113–114; Harvey, *Funnies*, 95; Waugh, 54, 74–79; "Introduction," White and Abel, 19; H. T. Webster, *The Best of H. T. Webster* (Simon and Schuster, 1953), esp. 9–13; Bob Dunn, *Knock-Knock, Featuring Enoch Knox* (Dell, 1936); "Newswatch," *TCJ* no. 127 (March 1989): 24.

119. Rube Goldberg, *The Best of Rube Goldberg*, comp. Charles Keller (Prentice-Hall, 1979). He also created Mike and Ike, an Irishman and a Jew who "look alike," a "model of humane ethnic détente." Buhle, *Lower*, 97; Adam Gopnik, "The Goldberg Variations," in *The Art of Rube Goldberg* (Abrams ComicArts, 2013), 16–19.

120. Quoted in *S1*, 11.

121. Richard Reynolds, *Super Heroes: A Modern Mythology* (University Press of Mississippi, 1994), 26–38; "Will Eisner Interview," *TCJ* no. 46 (May 1979): 34–46, 37; Peter Coogan, *Superhero: The Secret Origins of a Genre* (MonkeyBrain, 2006), 190–191.

122. Bill Blackbeard, "The First (Arf, Arf) Superhero of Them All," in *All in Color for a Dime*, ed. Dick Lupoff and Don Thompson (Arlington House, 1970, hereafter *All in Color*), 96–123; Harvey, *Funnies*, 162; Coogan, *Superhero*, 165.

123. Alan Gowans, *Popeye and the American Dream* (American Life, 1983), 37, 59; Sheridan, 212.

124. Strips from May and June of 1929 reprinted in E. C. Segar's *Popeye* (Fantagraphics, 2006), 45–50; Sheridan, 218; Inge, xvii; Gowans, 38; Blackbeard, "First (Arf, Arf)," 118.

Chapter 2: Comic Books Explode (in Every Sense)

1. Bill Blackbeard, "Reprint Follies I: The Pale Pink Kid," *Funnyworld* no. 22: 40–41, quote 41; Mike Benton, *The Comic Book in America* (Taylor Publishing, 1989, hereafter Benton, *Comic Book*), 14; Ron Goulart, *Comic Book Culture* (Collectors Press, 2000), 4; R. C. Harvey, "More Firsts than the Garden of Eden," *TCJ* no. 189 (August 1996): 114–115.

2. Although one 1917 collection was indeed called *Comic Book*. Perry and Aldridge, 155; John L. Goldwater, *Americana in Four Colors: A Decade of Self-Regulation by the Comics Magazine Industry* (Comics Magazine Association of America, 1964), 19; *S1*, 13; Goulart, *Culture*, 6–11; *CCG*, 25; Greg S. McCue with Clive Bloom, *Dark Knights: The New Comics in Context* (Pluto Press, 1993), 13; Benton, *Comic Book*, 14.

3. Gardner, 64; *PC*, 26–27; McCue, 13; ad reprinted in *Ron Goulart's Great History of Comic Books* (Contemporary Books, 1986, hereafter Goulart, *Great*), 2.

4. An apparent predecessor to *The Funnies* as an all-original comic book: R. F. Outcault's 1906 *Drawing Book*, featuring Buster Brown. "Historian Finds Original Comic Book from 1906," *TCJ* no. 154 (November 1992): 13.

5. Hajdu, 21; Reitberger and Fuchs, 18; *CCG*, 35; Perry and Aldridge, 155; Gardner, 28–29; *LDC*, 10; Ted White, "The Spawn of M. C. Gaines," in *All in Color*, 20–43. Quote Benton, *Comic Book*, 15.

6. Grant Geissman, *Collectibly Mad* (Kitchen Sink, 1995), 19; Bradford W. Wright, *Comic Book Nation: The Transformation of Youth Culture in America* (Johns Hopkins University Press, 2001, hereafter B. Wright, *Nation*), 3.

7. Martha Reidelbach, *Completely Mad: A History of the Comic Book and Magazine* (MJF, 1997), 5; "William Gaines," *TCJ* no. 81 (May 1983), 54.

8. Benton, *Comic Book*, 17; Goulart, *Fifty*, 20.

9. Quote McCue, 14.

10. It's said he accused senior officers of Prussianism, leading to army countercharges; the family disputes this. Goulart, *Great*, 55; Hajdu, 20; Kitchen's notes to Will Eisner, *The Dreamer* (W. W. Norton, 2008; 1986), 51; Tom DeHaven, *Our Hero: Superman on Earth* (Yale University Press, 2010), 45–47.

11. Quotes *S1*, 19, 21; see also *S1*, 16–17; Goulart, *Great*, 97; Anthony Tollin, "Shades of the Shadow," in Howard Chaykin, *The Shadow: Blood & Judgment* (Dynamite Entertainment, 2012), 3–4, 3.

12. *S1*, 3, 7; *BWC*, 115.

13. B. Smith, *Annie*, 42.

14. Hajdu, 19; Goulart, *Great*, 57, 65–66; Goulart, *Fifty*, 44; Les Daniels, *DC Comics: Sixty Years of the World's Favorite Comic Book Heroes* (Little, Brown, 1995), 16.

15. Quote Frank Jacobs, *The Mad World of William M. Gaines* (Lyle Stuart, 1972), 55; Reidelbach, 5–6; Benton, *Comic Book*, 18.

16. See Gerard Jones, *Men of Tomorrow: Geeks, Gangsters, and the Birth of the Comic Book* (Basic Books, 2004, hereafter *MOT*), 43–46; Spiegelman's introduction to Bob Adelman, *Tijuana Bibles: Art and Wit in America's Forbidden Funnies, 1930s–1950s* (Simon & Schuster, 1997).

17. An actual line, from *Dumb Dora: Rod Gets Taken Again*, a work published ca. 1925, ostensibly by the Cuban Publishing Company of Havana.
18. Adelman, 6. They also often featured Hollywood royalty, like Clara "Blow" and Jimmy Durante, with a particular use for his schnozzola.
19. See, for example, Adelman, 21, 41.
20. Nicky Wright, *The Classic Era of American Comics* (Contemporary Books, 2000, hereafter N. Wright, *Classic*), 23–25. *MOT*, 59–62, 88–97.
21. *PC*, 30–31; Goldwater, *Americana in Four Colors*, 20; Ron Goulart, "Comic Book Noir," in Lee Server et al., *The Big Book of Noir* (Carroll & Graf, 1998), 338; Goulart, *Great*, 76.
22. Partial list from *S1*, 27.
23. Jules Feiffer, *The Great Comic Book Heroes* (Dial Press, 1965, hereafter Feiffer, *Heroes*), 14; quotes from Goulart, *Great*, 77–78.
24. Ray Mescallado, "That Yellow Bastard," *TCJ* no. 219 (January 2000): 129–130.
25. Goulart, *Fifty*, 76.
26. *Action Comics* no. 1 (June 1938), reprinted in *Superman: The Action Comics Archives*, vol. 1 (DC, 1997, hereafter *ACA1*), 11.
27. Quotes Dick Lupoff, "The Big Red Cheese," in *All in Color*, 78–79; *S1*, 35–37; *MOT*, 24, 29–32, 37, 80–84; compare *Harvey Pekar's Cleveland* (Top Shelf, 2012), 29–40.
28. Quoted Eric Leif Davin, *Pioneers of Wonder: Conversations with the Founders of Science Fiction* (Prometheus Books, 1999), 106; *The Smithsonian Book of Comic-Book Comics*, ed. Michael Barrier and Martin Williams (Smithsonian Institution Press, 1981, hereafter *Smithsonian Comic*), 10.
29. Gardner, 97; Hajdu, 16; Daniels, *DC*, 21; *S1*, 37.
30. Quoted Goulart, *Great*, 84–85.
31. Quotes *S1*, 39, and Mike Gold, "The Roots of Magic," in *The Greatest Golden Age Stories Ever Told* (DC, 1990), 12; McCue, 15; Goulart, *Great*, 59; Daniels, *DC*, 15–17; Benton, *Comic Book*, 19; *MOT*, 37–38, 119–120.
32. Hajdu, 28–29; Michael Uslan, "Foreword," *Superman: The Action Comics Archives*, vol. 3 (DC, 1998, hereafter *ACA3*); *MOT*, 121–124.
33. Quote *MOT*, 102.
34. "Sheldon Mayer Interview," *TCJ* no. 148 (February 1992): 96; *Action Comics* no. 10 (March 1939), repr. in *ACA1*, 55, 69; F. Jacobs, 54–58; Hajdu, 33.
35. For best animated short; it lost to a Mickey Mouse cartoon. Jim Korkis, "The 'Lost' Fleischer Superman Cartoon," *Hogan's Alley* no. 10 (2002): 14–20, 14–16; Gordon, 132; Jim Steranko, "Foreword," in *Superman Archives*, vol. 1 (DC, 1989, hereafter *SA1*), 5; Roger Stern, "Introduction," *Superman: The Sunday Classics, 1939–1943* (DC, 1998), xiv; Goulart, *Great*, 89; *Action Comics* no. 20 (January 1940), repr. in *ACA1*, 222.
36. "Introduction," White and Abel, *An American Idiom*, 22.
37. *Action Comics* no. 32 (January 1941); Paul Kupperberg, "Foreword," *Superman: The Action Comics Archives*, vol. 2 (DC, 1998, hereafter *ACA2*); *SA1*, 180–192, 182.
38. Goulart, *Fifty*, 83; Gordon, 135.
39. McCue, 22–24; Rick Marschall, "Foreword," *Batman Archives*, vol. 1 (DC, 1990, hereafter *BA1*); T. White, "Spawn," 37; Mike Gold, "Our Darkest Night," in *The Greatest Batman Stories Ever Told* (DC, 1988, hereafter *GBS*), 12–16, 12; Goulart, *Fifty*, 88; *MOT*, 149–150; "Jerry Robinson Interview," *TCJ* no. 271 (October 2005): 79–86. Almost simultaneous with Batman's premiere, the almost identical character the Black Bat appeared in July 1939's *Black Book Detective* (a proposed lawsuit against DC never materialized); see Vaz, 23. For the strong, now generally recognized claim for Finger's far greater creative contribution than was acknowledged for decades (largely by Kane), see Alan J. Porter, "The Dubious Origins of the Batman," in *Batman Unauthorized*, ed. Dennis O'Neil (BenBella Books, 2008), 85–98.
40. McCue, 25; Goulart, *Great*, 112–125, 142; quote Goulart, *Fifty*, 122–123. For a lovely selection, see *Supermen!: The First Wave of Comic Book Heroes, 1936–1941* (Fantagraphics, 2009).
41. Peter L. Myer, "Introduction," *Plastic Man Archives*, vol. 1 (DC, 1998, hereafter *PMA1*); *Police Comics* no. 1 (August 1941), repr. in *PMA1*, 16; Don Thompson, "The Rehabilitation of Eel O'Brian," in *CBB*, 18–35; Ron Goulart, *Focus On: Jack Cole* (Fantagraphics, 1986), 55–61.
42. *Greatest Golden Age*, 79–90.

43. See Paul Karasik, "I Shall Destroy, You Shall Die!," in Fletcher Hanks, *Turn Loose Our Death Rays and Kill Them All!: The Complete Works of Fletcher Hanks* (Fantagraphics, 2016), xi, 274.
44. Hanks, *Death Rays*, 6, 31, 44–50, 232.
45. Bob Ingersoll, "The Cheese Stands Accused! A Look at the Superman/Captain Marvel Litigation," *Alter Ego* no. 3 (Winter 2000): 20–23. Eisner's retrospective account of his testimony in the case is somewhat self-exculpating; see Eisner, *Dreamer*, 42, and Ken Quattro, "DC vs. Victor Fox: The Testimony of Will Eisner," *The Comics Detective*, July 1, 2010, http://thecomicsdetective.blogspot.com/2010/07/dc-vs-victor-fox-testimony-of-will.html, for transcripts showing Eisner's testimony differing from his later recollections. Joe and Jim Simon, in *Comic Book Makers* (Crestwood/II Publications, 1990), 35, back up Eisner.
46. *The Golden Age Green Lantern Archives*, vol. 1 (DC, 1999, hereafter *GAGLA1*), 15.
47. Dick O'Donnell, "It's Magic," in *CBB*, 168–169; *All-American Comics* no. 16 (July 1940), repr. in *GAGLA1*, 9. More prosaically, Marty Nodell's idea for the Green Lantern came from a subway trainman waving a green lantern to show that the tracks were clear: "Preface," *GAGLA1*.
48. Reitberger and Fuchs, 69.
49. "His Skin and His Garments Commence to Fade Away Until—Only a Skeleton Remains!," *More Fun Comics* no. 53 (March 1940), in *The Golden Age Spectre Archives*, vol. 1 (DC, 2003), 26.
50. Michael Uslan and Robert Klein, "Foreword," *Comic Cavalcade Archives*, vol. 1 (DC, 2005, hereafter *CCA1*). Liebowitz felt comics had greater potential, while Donenfeld felt four magazines were enough; so, Liebowitz started All-American with Gaines. The All-American line was temporarily spun off from DC, later reabsorbed. For readerly clarity, I generally refer to "DC" even when the company was actually called National Periodical Publications. See Daniels, *DC*, 48.
51. Hour-Man's "strength-giving Miraclo" lasts for, well, you guessed it. *All Star Comics* no. 3, repr. in *All Star Comics Archives*, vol. 1 (DC, 1991, hereafter *ASCA1*), 11; Jim Harmon, "A Swell Bunch of Guys," in *All in Color*, 170–197, 173.
52. DeHaven, 55.
53. *Action Comics* no. 1 (June 1938), repr. in *ACA1*, 17. One model for Lois was Joanne Carter, who served as a Shuster model; later, after meeting the duo again at a New York costume ball, she married Siegel; Daniels, *DC*, 25; *Superman* no. 10 (May/June 1944), repr. in *Superman Archives*, vol. 3 (DC, 1991), 127; *Superman Archives*, vol. 7 (DC, 2006, hereafter *SA7*), 179, 182.
54. *Batman* no. 1 (Spring 1940), repr. in *Batman: The Dark Knight Archives*, vol. 1 (DC, 1992), 49.
55. Lillian S. Robinson, *Wonder Women: Myths and Superheroes* (Routledge, 2004), 45; Jill Lepore, *The Secret History of Wonder Woman* (Knopf, 2014), passim; quotes from Juanita Coulson, "Of (Super)human Bondage," in *CBB*, 230, and Robert Greenberger, *Wonder Woman: Amazon, Hero, Icon* (DC, 2010), 17–18.
56. *All-Star Comics* no. 8 (December 1941/January 1942), repr. in *All Star Comics Archives*, vol. 2 (DC, 1992, hereafter *ASCA2*), 129, 131; *Greatest Golden Age*, 234, 236; Jerry G. Bails, "Foreword," *ASCA2*; Robinson, 27–32, 58.
57. Although see Mayer's comments in *CCG*, 88, and "Sheldon Mayer Interview," 95. See *Greatest Golden Age*, 235; "School for Spies," *Sensation Comics* no. 4 (April 1942), repr. in *Wonder Woman Archives*, vol. 1 (DC, 1998, hereafter *WWA1*), 68–69; Coulson 234, 236; Daniels, *DC*, 61.
58. Goulart, *Adventurous*, 180; Robbins and Yronwode, 45; Trina Robbins, "Miss Fury and the Very Personal Universe of Tarpé Mills," in Tarpé Mills, *Miss Fury: Sensational Sundays 1944–1949*, ed. Trina Robbins (IDW, 2011), 7–18, 11; Robbins, in "Tarpé Mills and Miss Fury," in Mills, *Miss Fury* (Pure Imagination, 2007), notes that *Miss Fury* debuted eight months before *Wonder Woman*.
59. *All-Star Comics* nos. 11–13 (June/July, August/September, October/November 1942); Wonder Woman quote in *All Star Comics Archives*, vol. 3 (DC, 1997, hereafter *ASCA3*), 181; Roy Thomas, "This Means War!," in *ASCA3*; Don Thompson, "Foreword," *ASCA1*.
60. Miles Beller and Jerry Leibowitz, *Hey Skinny!: Great Advertisements from the Golden Age of Comic Books* (Chronicle Books, 1995), 14, 18, 39, 71.
61. Richard Ellington, "Me to Your Leader Take," in *All in Color*, 44–64; Ron Goulart, *Good Girl Art* (Hermes Press, 2006).
62. Which, as the name implies, was packed with lots of material. Jumbo sizewise, too: packaged by Eisner and Iger for a British publisher, they were first oversized due to British require-

ments, but soon assumed regular size. Michael H. Price, "Ectoplasmic Spasmochasm with the Elusive and Enigmatic Drew Murdoch," *Ghosts and Girls of Fiction House*, ed. Michael H. Price (IDW, 2015), 11, 13; Craig Yoe, "50 Shades of 4 Colors," in *Ghosts and Girls*, 3–7.

63. William M. Savage, *Comic Books and America, 1945–1954* (University of Oklahoma Press, 1990), 76.

64. Quotes Ellington, "Me to Your," 55; Benton, *Science Fiction*, 28–29; Davin, 103, 105, 107.

65. Adam Philips, "Archie Comics in Review," *TCJ* no. 99 (June 1985): 71; Trina Robbins, *From Girls to Grrrlz: A History of Female Comics from Teens to Zines* (Chronicle Books, 1999), 8; Reitberger and Fuchs, 42; Archie was also based on "radio teenager" Henry Aldrich.

66. Sherm Cohen, "Dan Gordon: A Brush with Greatness," *TCJ* no. 291 (July 2008): 147–161, 148.

67. Goulart, *Fifty*, 59; quote Adelman, 7; Robinson, 51–55; John Benson, "An Interview with Will Eisner," *witzend* no. 6 (1969): 209–215, 209; *MOT*, 134–141; Eisner, *Dreamer*, 21.

68. Quotes B. Wright, *Nation*, 15; Simon and Simon, 33; Andelman, 73.

69. Jerry Bails, "Foreword," *Golden Age Green Lantern Archives*, vol. 2 (DC, 2002); *CCA1*, 43–48, 141–146; "Tracy's Influence," *Batman: The Sunday Classics, 1943–1946* (Sterling, 2007), 208; the Penguin's description from his first appearance in *Detective Comics* no. 58, repr. in *BA2*, 107; two-parter observation owed to Mark Hamill, "Introduction," in *Batman: Featuring Two-Face and the Riddler* (DC, 1995); *S1*, 48; *Detective Comics* no. 66, repr. in *BA2*, 218–231, 226; N. C. Christopher Couch, *Jerry Robinson: Ambassador of Comics* (Abrams ComicArts, 2010), 41–46.

70. Burnley, "Foreword," *The Golden Age Starman Archives*, vol. 1 (DC, 2000, hereafter *GASA1*); Smith, *Annie*, 43; R. C. Harvey, "Foreword," *Batman: The World's Finest Comics Archives*, vol. 1 (DC, 2002); Harvey, "How Much Did Batman Knock-Off Dick Tracy?," *TCJ* no. 214 (July 1999): 109–111.

71. Simon and Kirby ran one, too; "Shop Talk," in *The Who's Who of American Comic Books*, vol. 4, ed. Jerry Bails and Hames Ware (Jerry Bails, 1976), 335–336; quote Goulart, *Great*, 90.

72. *Superman* no. 25, *SA7*, 38–39; "Foreword," *GASA1*.

73. J. Robinson, "Foreword"; *S1*, 47; Benton, *Comic Book*, 30; Goulart, *Culture*, 111; *MOT*, 188–189; Karasik, "I Shall Destroy," v–xiii, ix; Kirby quote: Michael Vance, *Forbidden Adventures: The History of the American Comics Group* (Greenwood Press, 1996), 17; Couch, 72–76.

74. Greg Theakston, "Lou Fine Rediscovered," in *Lou Fine Comics* (Pure Imagination, 1991); *Special Edition Series: The Ray & Black Condor* (Special Edition Reprints, 1974); Steven Brower, *From Shadow to Light: The Life and Art of Mort Meskin* (Fantagraphics, 2010), 26–36; *BA1*, 8, 66–67; *ASCA1*, 14.

75. Roy Thomas, "Foreword," *Batman: The Dark Knight Archives*, vol. 8 (DC, 2012); Porter, 89n5; "Batman Versus the Vampire," *Detective Comics* no. 31 (September 1939), repr. in *GBS*, 17–36; *S1*, 47.

76. Gardner, 73–75; Gordon, *Superman* no. 1, repr. in *SA1*, 33–55; *Superman* no. 3, repr. in *SA1*, 11; *ACA1*, 11; G. Legman, *Love & Death: A Study in Censorship* (Hacker Art Books, 1963, 1949), 39–40.

77. *Batman* no. 7 (October/November 1941), quoted Vaz, 4–5.

78. *Flash Comics* no. 6 (June 1940), repr. in *Golden Age Flash Archives*, vol. 1 (DC, 1999), 90; McCue, 35.

79. *Whiz Comics* no. 21 (September 1941), repr. in *The Shazam! Archives*, vol. 3 (DC, 2002, hereafter *ShA3*), 160.

80. Story first published in a January 1940 black-and-white "ashcan edition" to secure copyright and gauge newspaper distributor interest. C. C. Beck, "The Captain's Chief," *Alter Ego* no. 2 (Fall 1999): 44–48, 44; "From Soup to Nuts," *Alter Ego* no. 4 (Spring 2000): 42–47, 42; *Shop Talk*, 55; Goulart, *Great*, 159; N. Wright, *Classic*, 52–54; Lupoff, "Foreword"; Goulart, *Culture*, 78; R. C. Harvey, "Captain Marvel, The Big Red Rip-Off," *TCJ* no. 215 (August 1999): 117.

81. "Captain Marvel Scores Again!," *Whiz Comics* no. 5, *The Shazam! Archives*, vol. 1 (DC, 1992, hereafter *ShA1*), 79, 83; *Captain Marvel Adventures* no. 3 (Fall 1941), repr. in *ShA3*, 125; Michael Uslan, "Foreword," *ShA3*.

82. *Batman* no. 5 (Spring 1941), repr. *Batman: The Dark Knight Archives*, vol. 2 (DC, 1997), 50; Reitberger and Fuchs, 84–85.

83. *Adventure Comics* no. 61 (April 1941), repr. in *GASA1*, 13; *Adventure Comics* no. 68 (November 1941), repr. in *GASA1*, 104; *Adventure Comics* no. 69 (December 1941), repr. in *GASA1*, 114; *Adventure Comics* no. 70 (January 1942), repr. in *GASA1*, 131.

84. Captain Marvel's nemesis, Sivana, was modeled on a druggist Beck knew. Steranko—in *History of Comics*, vol. 2 (Supergraphics, 1972), 17—gives a figure of 1.384 million for the January 1946 issue; "Captain's Chief," 46; *Shop Talk*, 66; Ingersoll, "Cheese," 23; Lupoff, "Red Cheese," 76–80; Will Jacobs and Gerard Jones, *The Comic Book Heroes: From the Silver Age to the Present* (Crown Publishers, 1985), 21.

85. "Nationwide" ended up a misnomer: it was in twenty papers at its height, with a combined circulation of five million (still far greater than any comic book). Bob Andelman, *Will Eisner: A Spirited Life* (M Press, 2005), 57, 102; Paul Levitz, *Will Eisner: Champion of the Graphic Novel* (Abrams ComicArts, 2015), 31–35. For fractious Eisner–Iger correspondence, see Andelman, 66–69; compare "Newswatch," *TCJ* no. 139 (December 1990): 15; Benson, "Eisner," 209–215, 209.

86. Benson, "Eisner," 212.

87. See Feiffer, *Heroes*, 34; Jerry Robinson, "Foreword," *Batman Archives* 3 (DC, 1994, hereafter *BA3*); *S1*, 47; Robinson, "The Boys of Gotham," in *Zap! Pow! Bam! The Superhero: The Golden Age of Comic Books, 1938–1950* (William Breman Jewish Heritage Museum, 2004), 33. The "Man of Tomorrow" name came from association with the equally forward-looking 1939 World's Fair: see *MOT*, 147. On Caniff, see *S1*, 11; Harvey, *Funnies*, 148; John Carlin, "Masters of American Comics," in *Masters of American Comics* (Hammer Museum, 2005), 84–85.

88. Eisner, "The Spirit: How It Came to Be," in *Will Eisner's The Spirit Archives*, vol. 1 (DC, 2000), 7.

89. "Will Eisner Interview," 49; "How It Came to Be," 9; *Shop Talk*, 90.

90. Quotes Maggie Thompson, "Blue Suit, Blue Mask, Blue Gloves—And No Socks," *CBB*, 135; Feiffer, *Heroes*, 36; Edward Whatley, "'In the Crooked Shadows of Wildwood Cemetery': Will Eisner's *The Spirit* and the Gothic Tradition," *IJCA* 9, no. 1 (Spring 2007): 558. Another example: "The Killer," originally December 8, 1946, republished in Will Eisner, *The Best of the Spirit* (DC, 2005), 51–58, 55.

91. Befitting Eisner's sensibility, the encounters often contained comic elements, channeling Preston Sturges: Umphlett, 107; Goulart, *Adventurous*, 177.

92. Reprinted in Will Eisner, *The Spirit: Femmes Fatales* (DC, 2008), 81.

93. Elain Madge Ard, "Factual Knowledge of Value Found in the Comic Strips," (master's thesis, Texas State College for Women, 1942), 102.

94. "The Tale of the Dictator's Return," June 22, 1941; see Levitz, *Eisner*, 38–46 for reprinted tale and discussion.

95. Quotes from Feiffer, *Heroes*, 35; Hajdu, 49; Lee's introduction, in Danny Fingeroth, *Disguised as Clark Kent: Jews, Comics, and the Creation of the Superhero* (Continuum, 2007), 9; see Buhle, *Jews and American Comics*. The most persuasive case for the affirmative is Fingeroth, *Disguised*.

96. Michael Chabon, *The Amazing Adventures of Kavalier & Clay* (Random House, 2000), 585.

97. Fingeroth, *Disguised*, 45; Robinson, "The Ultimate Fantasy," in *Zap! Pow! Bam!*, 12.

98. Will Eisner and Frank Miller, *Eisner/Miller* (Dark Horse, 2005), 211; he does add that they brought "their 2,000-year-old history of storytelling" with them. Arie Kaplan, *From Krakow to Krypton: Jews and Comic Books* (Jewish Publication Society, 2008), 28–29.

99. Eisner, *Dreamer*, 28.

100. For one such formative experience for Eisner, see Levitz, *Eisner*, 14.

101. See, for example, Ebony's first appearance (June 9, 1940); *Spirit Archives*, 1:28.

102. See Benson, "Eisner," 215; M. Thompson, "Blue Suit," 118–143, 131; "Will Eisner Interview—Conclusion," 47; *Whiz Comics* no. 12 (January 1941), repr. in *ShA1*, 168; Lupoff, "Red Cheese," 66–95, 70.

103. See Jackson, *Pioneering*, 6–7. Eisner would update Ebony to a non-caricatured character in the '60s.

104. Maeder, *Tracy*, 7; Hajdu, 55.

105. Greg Stump, "Archetypal Ad Spoke to Generations of 97-Pound Weaklings," *TCJ* no. 218 (December 1999): 21.

106. "Interview with Jack Kirby," *TCJ* no. 134 (February 1990, hereafter Kirby Interview *TCJ*): 60. See his autobiographical 1983 "Street Code," reprinted in *Streetwise: Autobiographical Stories by Comic Book Professionals* (TwoMorrows, 2000), 14–23. The double-page spread on pp. 18–19, pulsating with power and vibrancy, is a kind of *Call It Sleep* of comics.

107. Simon and Simon, 47; Kirby quotes from *Shop Talk*, 193–205; *S1*, 52–53; *New Nostalgia Journal* 27 (1976): 17.

108. Joe Simon and Jack Kirby, *Blue Bolt* (Verotik, 1998); the *Lone Ranger*–esque strip was called "Lightnin' and the Lone Rider." Goulart, *Great*, 11; R. C. Harvey, "Foreword," *The Shazam! Archives*, vol. 2 (DC, 1999, hereafter *ShA2*); Simon, *Makers* 52; quotes Goulart, *Fifty*, 117; B. Wright, *Nation*, 36.

109. Simon and Kirby, *Captain America: The Classic Years*, vol. 1 (Marvel, 1998), n.p.; Francis MacDonnell, *Insidious Foes: The Axis Fifth Column and the American Home Front* (Oxford University Press, 1995), 49, 62–63, 71.

110. Quote from *Superman* no. 15 (March/April 1942), repr. in *Superman Archives*, vol. 4 (DC, 1994, hereafter *SA4*), 133; *Superman* no. 18, repr. in *Superman Archives*, vol. 5 (DC, 2000), 62–74; MacDonnell, 134; *Spirit Archives*, 1:169–179; *Action Comics* no. 36 (May 1941), repr. in *ACA2*, 218–231; *Greatest Superman Stories Ever Told* (DC, 1987, hereafter *GSS*), 12–13.

111. In another story, putting the lie to overstated boasts of racial superiority, Superman beats "Dukalian" athletes handily at their own games: *ACA2*, 28; *Superman* no. 15, repr. in *SA4*, 145–146, 156–157; *Superman* no. 10 (May/June 1941), repr. in *Superman Archives*, vol. 3 (DC, 1991, hereafter *SA3*), 125.

112. Gold, "Roots," 10–13, 11; Benton, *Comic Book*, 32.

113. The title soon changed to *Marvel Mystery Comics*, a big hit under whatever name: Les Daniels, *Marvel: Five Fabulous Decades of the World's Greatest Comics* (Abrams, 1991), 17–23; Roy Thomas, "Marvel's First Timely Heroes," in *The Golden Age of Marvel Comics*, vol. 1 (Marvel, 1997, hereafter *GAMC1*), 4–8; Thomas, "Introduction," *Golden Age Marvel Comics* (Marvel, 2011), vi–viii, vi; Goulart, *Great*, 99. Goodman's company (actually, *companies*: a web of sub-companies published each title for financial and liability reasons) was variously known over the decades as Timely, Atlas, and Marvel: Blake Bell, *Fire & Water: The Sub-Mariner and the Birth of Marvel Comics* (Fantagraphics, 2010), 63; Sean Howe, *Marvel Comics: The Untold Story* (HarperPerennial, 2012), 9–15.

114. Kevin J. Wetmore, Jr., "'The Amazing Adventures of Superbard': Shakespeare in Comics and Graphic Novels," in Jennifer Hulbert et al., *Shakespeare and Youth Culture* (Palgrave Macmillan, 2006), 171–198, 181.

115. *Marvel Mystery Comics* no. 1 (October 1939), repr. in *Golden Age of Marvel Comics*, vol. 2 (Marvel, 1999, hereafter *GAMC2*), 6–21; Bell, 53–54.

116. "The Sub-Mariner," *Marvel Comics* no. 1 (October 1939); *Marvel Mystery Comics* no. 6 (April 1940), repr. in *GAMC2*, 87–96; *LDC*, 136; *S1*, 59; Fingeroth, *Disguised*, 59; Bell, 10.

117. *Marvel Mystery Comics* no. 17 (March 1941).

118. Daniels, *Marvel*, 33, 36; *Shop Talk*, 212; Howe, 19.

119. "Captain America Foils the Traitor's Revenge," in *Captain America Comics* no. 3 (May 1941); Daniels, *Marvel*, 41; Simon, *Makers*, 54; *S1*, 52; Goulart, *Great*, 134, 157; Goulart, *Fifty*, 104.

120. *Detective Comics* no. 38 (April 1940); Jerry Robinson quote: *S1*, 47; Robinson drew the costume from a memory of N. C. Wyeth's Robin Hood illustrations: J. Robinson, "The Ultimate Fantasy," 16; *Superman* no. 13, repr. in *SA4*, 40.

121. Quoted Daniels, *Marvel*, 36; Simon and Simon, 50; *Captain America Comics* no. 1 (March 1941), repr. in *GAMC2*, 57–64.

122. Kirby also drew on personal experiences with the "benevolent youth organization" the Boys Brotherhood Republic: Charles Hatfield, *Hand of Fire: The Comics Art of Jack Kirby* (University Press of Mississippi, 2012), 5.

123. The similar Newsboy Legion was made up of orphans who helped the Guardian fight crime: *Shop Talk*, 212; *S1*, 55; Gold, "Roots," 11; quote Don Thompson, "Ok, Axis, Here We Come!," in *All in Color*, 124–146, 139; Tom Fagan, "One on All and All on One," in *All in Color*, 148–168, 158; Dick Lupoff, "The Propwash Patrol Flies Again," in *CBB*, 185; Goulart, *Great*, 181; Andelman, 62; Jim Steranko, *The Steranko History of Comics*, vol. 2 (Supergraphics, 1972, hereafter *S2*), 53ff.; Sheng-Mei Ma, "The Nine Lives of *Blackhawk*'s Oriental: Chop Chop, Wu Cheng, and Weng Chan," *IJCA* 3, no. 1 (Spring 2001): 120–148.

124. *All-Winners Comics* no. 4 (Spring 1942), repr. in *Marvel Masterworks: Golden Age All-Winners*, vol. 1 (Marvel, 2005), 207; B. Wright, *Nation*, 45; D. Thompson, "Axis," 126; Benton, *Comic Book*, 33; "The Cobra Ring of Death," *Captain America Comics* no. 22 (January 1943), art by Syd Shores, repr. in *GAMC1*, 75–92; see also Jack Cole's stereotypical 1940 character the

Claw, story reprinted in *Supermen!*, 138–154; Michael Goodrum, *Superheroes and American Self-Image: From War to Watergate* (Ashgate, 2016), 24–25; Nathan Vernon Madison, *Anti-Foreign Imagery in American Pulps and Comic Books* (McFarland, 2013), 114–121, 128–133.

125. Drew Friedman, *More Heroes of the Comics* (Fantagraphics, 2016), plate 45.

126. Rocco Versaci, *This Book Contains Graphic Language: Comics as Literature* (Continuum, 2007), 153.

127. *Whiz Comics* no. 25 (December 1941), *Shazam! Archives*, vol. 4 (DC, 2004), 157.

128. "The Sub-Mariner Smashes a Nazi Uprising!," *Marvel Mystery Comics* no. 26 (December 1941), repr. in *GAMC2*, 81–92; D. Thompson, "Axis," 126.

129. *Police Comics* no. 15 (January 1943), repr. in *PMA1*, 144–145; *Police Comics* no. 18 (April 1943), repr. in *PMA1*, 191; Savage, 11; *Superman* no. 22 (May/June 1943), repr. in *Superman Archives*, vol. 6 (DC, 2003), 75–76; *ShA1*, 160–161; "The Case of the Hollow Men," *All Winners Comics* no. 1 (Summer 1941), repr. in *GAMC2*, 123–135; *Human Torch Comics* no. 3 (Winter 1940), in *Marvel Masterworks: Golden Age Human Torch*, vol. 1 (Marvel, 2005, hereafter *GAHT1*), 97.

130. Reprinted in Adelman, 129–131, who suggests that philosemitic remarks and some Yiddish suggest Jewish authorship.

131. *All-Star Comics* no. 11 (June/July, 1942), in *ASCA3*, 10–66, 66; R. C. Harvey, "Foreword," *Seven Soldiers of Victory Archives*, vol. 1 (DC, 2005). The teaming-up decision slightly preceded the war, but took new meaning after Pearl Harbor.

132. Matthew J. Smith, "The Tyranny of the Melting Pot Metaphor: Wonder Woman as the Americanized Immigrant," in *Comics & Ideology*, ed. Matthew P. McAllister, Edward H. Sewell Jr. and Ian Gordon (Peter Lang, 2001), 129–150. See *Wonder Woman Archives*, vol. 2 (DC, 2000), 136–137.

133. Waugh, 219–220, 226, 275; Sheridan, 126, 142, 151; Goulart, *Adventurous*, 196; Russell Keaton, *The Aviation Art of Russell Keaton* (Kitchen Sink, 1995); *Scorchy Smith and the Art of Noel Sickles*, ed. Dean Mullaney (IDW, 2008), 42–43; Dick Lupoff, "The Propwash Patrol," in *CBB*, 62–86, 66, 68; "Noel Sickles Interview," *TCJ* no. 242 (April 2002): 34–48; quote Bob Levin, "The Mark of Tyrone Power," *TCJ* no. 262 (September 2004): 96.

134. Waugh, 55; Maeder, 80; B. Smith, *Annie*, 48; Frank King, *Skeezix Goes to War* (Whitman, 1944), 332–334; "Generally Speaking," *TCJ* no. 114 (February 1987): 53; *BWC*, 290; Todd DePastino, *Bill Mauldin: A Life Up Front* (W. W. Norton, 2008), 64, 151–152, 157, 207–208.

135. Joe Simon, "Introduction," *The Best of Simon and Kirby* (Titan, 2009), 7; *Shop Talk*, 214–216; Kirby Interview *TCJ*, 68; David Culbert, "'A Quick, Delightful Gink': Eric Knight at the Walt Disney Studio," *Funnyworld* no. 19: 13–17; Waugh, 165; "Will Elder Interview," *TCJ* no. 177 (May 1995): 106; "Charles Schulz Interview," *TCJ* no. 200 (December 1997): 19; "Saul Steinberg Dies at 84," *TCJ* no. 213 (June 1999): 35–36.

136. *BWC*, 291.

137. Quote Ard, "Factual," 94; Roy Thomas, "Foreword," *Superman: The Action Comics Archives*, vol. 5 (DC, 2007); Craig Shutt, "Eisner's Military Strips," *Hogan's Alley* no. 11 (2003): 47; Andelman, 80–85.

138. She also suggested the name Minnie, possibly recalling characters named Mickey and Minnie Mouse in a 1921 *Good Housekeeping* kids' fiction series written by Raggedy Ann and Andy's creator: Bill Blackbeard, "Mickey Mouse and the Phantom Artist," in *CBB*, 36–60.

139. *Smithsonian Comic*, 128; *CCG*, 35; Art Spiegelman and Françoise Mouly, *The Toon Treasury of Classic Children's Comics* (Abrams ComicArts, 2009) 85–159. Wolverton's stationery read, "Producer of Preposterous Pictures of Peculiar People": Ron Goulart, "Basil Wolverton," *TCJ*, August 2, 2012, http://www.tcj.com/basil-wolverton.

140. *Smithsonian Comic*, 115; Basil Wolverton, *GJDRKZLXCBWQ Comics* (Glenn Bray, 1973); Goulart, *Culture*, 149; Goulart, *Fifty*, 136, 140–152; Hajdu, 36; Ron Goulart, "The Second Banana Superheroes," in *All in Color*, 252; Umphlett, 102.

141. Joe Desris, "A History of the 1940s Batman Newspaper Strips, Part 3," in *Batman: The Dailies*, vol. 3, *1945–1946* (Kitchen Sink Press, 1991), 18; Harvey, *Children*, 124–125; B. Wright, *Nation*, 31; Gordon, 85–86, 89.

142. Figures Patrick Parsons, "Batman and His Audience: The Dialectic of Culture," in *The Many Lives of the Batman: Critical Approaches to a Superhero and His Media*, ed. Roberta E. Pearson and William Uricchio (Routledge, 1991), 65–89, 68; Waugh, 334; Benton, *Comic Book*, 35; Gordon, 139–140; N. Wright, *Classic*, 101–102; *MOT*, 213. Milton Caniff's *Male Call*, printed

in *Stars and Stripes*, featured flirtatious, "curvaceous bundle of camaraderie" Miss Lace. Tame by today's standards, it caused Caniff some wartime trouble from guardians of public morality: Mintz, "Fantasy, Formula, Realism," *JPC* 12, no. 4 (1979): 653–680, 660–661; quote Harvey, *Children*, 94.

143. Robbins and Yronwode, 50–64; Goulart, *Culture*, 72–73.

144. Original strips are reprinted in *America at War: The Best of DC War Comics*, ed. Michael Uslan (DC, 1979, hereafter *AAW*), 43–46; *All Star Comics Archives*, vol. 4 (DC, 1998, hereafter *ASCA4*), 67.

145. *ASCA4*, 78, 120.

146. Uslan, "Foreword," *ACA3*; "Defender of Democracy," *Superman* no. 13 (November/December 1941), *SA4*, 15; covers: *Superman* no. 12 (September/October 1941) and *Superman* no. 29 (July/August 1944); "America's fighting men" quote in *Superman Archives*, vol. 8 (DC, 2010), 185.

147. Even more uncharacteristically, a wartime cover shows a smiling Batman operating and firing a machine gun, Robin serving as loader. *Detective Comics* no. 78 (August 1943) in *BA3*, 103–116; *Batman* no. 15 (February/March 1943); *Batman: The Dark Knight Archives*, vol. 4 (DC, 2003, hereafter *DKA4*), 115.

148. *World's Finest Comics* no. 11 (Fall 1943), repr. in *Superman: The World's Finest Comics Archives*, vol. 1 (DC, 2004), 173; *Superman* no. 18 (September/October 1942); *Action Comics* no. 58 (March 1943), repr. in *Superman: The Action Comics Archives*, vol. 4 (DC, 2005), 78; *Batman* no. 12 (August/September 1942), repr. in *Batman: The Dark Knight Archives*, vol. 3 (DC, 2000), 210; *All Star Comics* no. 24 (Spring 1945), repr. in *All Star Comics Archives*, vol. 6 (DC, 2000, hereafter *ASCA6*), 21; Desris, in *Batman: The Dailies*, 3:8; Thomas, "This Means War!," in *ASCA3*.

149. B. Smith, *Annie*, 49–50, quote 49; Jay Macder, "Al Capp: Treasury Man," *Hogan's Alley* no. 12 (2004): 106. For many *Nancy* war-related gags, see Ernie Bushmiller, *Nancy Is Happy* (Fantagraphics, 2011), passim.

150. *Action Comics* no. 14 (July 1939), *ACA1*, 138.

151. Thomas, "Foreword," *All Star Comics Archives*, vol. 11 (DC, 2005).

152. *Superman Archives*, vol. 2 (DC, 1990), 26; *ASCA3*, 238.

153. *Captain America Comics* no. 6 (September 1941), repr. in *Captain America: The Classic Years*, vol. 2 (Marvel, 2000).

154. *All Star Comics* no. 4 (March/April 1941), repr. in *ASCA1*, 77; Hanks, 290, 299.

155. Thomas Andrae, "From Menace to Messiah: The History and Historicity of Superman," in *American Media and Mass Culture: Left Perspectives*, ed. Donald Lazere (University of California Press, 1987), 127–131; *MOT*, 218–219.

156. From a longer list in John A. Lent, "The Comics Debates Internationally," in *Pulp Demons: International Dimensions of the Postwar Anti-Comics Campaign*, ed. John A. Lent (Fairleigh Dickinson University Press, 1999), 9–41, 11.

157. Quoted in William S. Gray, "Educational News and Editorial Comment: Issues Relating to the Comics," *Elementary School Journal* 42, no. 9 (May 1942): 641–644, 641–642; Amy Kiste Nyberg, *Seal of Approval: The History of the Comics Code* (University Press of Mississippi, 1998), 4; Mike Benton, *Horror Comics: The Illustrated History* (Taylor Publishing, 1991), 39; Hajdu, 45.

158. Harriet E. Lee, "Discrimination in Reading," *English Journal* 31, no. 9 (November 1942): 677–679, 677; Nyberg, *Seal*, 9–11; Sheridan, 234–235.

159. Howard E. Wilson, "Cartoons as an Aid in the Teaching of History," *School Review* 36, no. 3 (1928): 192–198, 193.

160. Quoted Nyberg, *Seal*, 15. On this special issue, see Bart Beaty, "Fredric Wertham Faces His Critics: Contextualizing the Postwar Comics Debate," *IJCA* 3, no. 2 (Fall 2001): 202–221, 203–210.

161. Nyberg, *Seal*, 7; quote Waugh, 346; Goulart, *Great*, 200–202; Goulart, *Fifty*, 202–203; Goodrum, 48; Les Daniels, *The Golden Age of DC Comics: 365 Days* (DC, 2004), "January 17"; *Government Issue: Comics for the People, 1940s to 2000s*, ed. Richard Graham (Abrams Comic-Arts, 2012).

162. Ard, "Factual," 37–42, 44–48, 62; Bert Hansen, *Picturing Medical Progress from Pasteur to Polio: A History of Mass Media and Popular Attitudes in America* (Rutgers University Press, 2009), 171–206; on *Texas History Movies*, see Jack Jackson's review in *TCJ* no. 119 (January 1988): 97–102; *Superman* no. 2 (1939), *SA1*, 92.

163. Ard, "Factual," 91; "The Art of the Comic Magazine," *Elementary English Review* 19, no. 5 (May 1942): 168–170, 169.

164. Michael Sawyer, "Albert Lewis Kanter and the Classics: The Man Behind the Gilberton Company," *JPC* 20, no. 4 (Spring 1987): 1–18, 1, 2, 7; Martin Barker and Roger Sabin, *The Lasting of the Mohicans: History of an American Myth* (University Press of Mississippi, 1995), 149; Bart Beaty, "Featuring Stories by the World's Greatest Authors," *IJCA* 1, no. 1 (Spring/ Summer 1999): 122–139, 129, 131; Goulart, *Great*, 207.

165. Ard, "Factual," 106, 114; quote Kathryn S. Tautfest Wilson, "Educational Values of the Comic Strip" (master's thesis, University of Southern California, 1941), 111.

166. Quotes Hajdu, 81, and Geoffrey Wagner, *Parade of Pleasure: A Study of Popular Iconography in the USA* (Library Publishers, 1955), 87; Ong, "The Comics and the Super State," repr. in *The Superhero Reader*, ed. Charles Hatfield, Jeet Heer, and Kent Worcester (University Press of Mississippi, 2013), 34–45.

167. Abel and White, "Introduction," 4.

168. Benton, *Comic Book*, 37; *LDC*, 62; Reitberger and Fuchs, 139; quote Waugh, 347; Joseph Witek, *Comic Books as History: The Narrative Art of Jack Jackson, Art Spiegelman, and Harvey Pekar* (University Press of Mississippi, 1989), 13.

169. Quoted Jacobs, *Mad World*, 60.

170. Jacobs, *Mad World*, 58–59. Donenfeld bought Gaines out for $500,000 in 1945 (after tax); Donenfeld had split his All-American share with his accountant, Jack Liebowitz, so Gaines got a new partner. Liebowitz pressed for more advertising; Gaines decided to cash out.

171. See T. White, "Spawn," 35.

172. "The Two Futures!," *Batman* no. 15 (February/March 1943), repr. in *DKA4*, 142–154, 151, 154. Goodrum, 31–32.

173. "THIS IS OUR ENEMY!," *All Star Comics* no. 24, repr. in *ASCA6*, 52, 11; Roy Thomas, "Foreword."

174. In *All Star Comics* no. 27 (Winter 1945), *ASCA6*, 139ff. A similar Justice League of America story appears a generation later, in "The Case of the Disabled Justice League!," *Justice League of America* no. 36 (June 1965), in *Justice League of America Archives*, vol. 5 (DC, 1999), 137–162. JLA members, themselves temporary disabled (Green Lantern stutters; Superman is blind, etc.), see "an opportunity to turn this into a valuable object lesson to those handicapped youngsters watching us" (145). "By watching us, they'll learn to depend on themselves, not on others," says Green Arrow (146). See also *JRC*, 223.

175. Quotes "Introduction: Comic Strips and American Culture," in White and Abel, 1–35, 2; Gardner, 73; Pustz 27.

176. *Whiz Comics* no. 15 (March 2, 1941); Roy Thomas, "Captain Billy's Whiz Gang!," in *All in Color*, 231; Benton, *Comic Book*, 43.

Chapter 3: Who's Afraid of the Comic Book?

1. Waugh, 334.

2. All reprinted in *Young Romance: The Best of Simon & Kirby's Romance Comics*, vol. 1 (Fantagraphics, 2012); see Michael Barson, *Agonizing Love: The Golden Era of Romance Comics* (HarperCollins, 2011), 10–12.

3. Michelle Nolan, *Love on the Racks: A History of American Romance Comics* (McFarland & Co, 2008), 29–85.

4. *Shop Talk*, 203–204; Robbins, *Brinkley Girls*, 36, 50–54; Maurice Horn, *Sex*, 71; *CCG*, 90; Daniels, *Marvel*, 58; quote *Saddle Romances* no. 9. The last romance comic standing, *Young Love*, stopped in 1977; see "Newswatch," *TCJ* no. 33 (April 1977): 4.

5. Hubert H. Crawford, *Crawford's Encyclopedia of Comic Books* (Jonathan David, 1978), 7; Waugh, 235–236; *S1*, 29; Savage, 67; *Batman* no. 21 (February/March 1944); Benton, *Comic Book*, 43; Raymond E. White, *King of the Cowboys, Queen of the West: Roy Rogers and Dale Evans* (University of Wisconsin Press, 2005), 67–68; *PC*, 37; Michael Uslan, "Foreword," *Batman Archives*, vol. 8 (DC, 2012, hereafter *BA8*); Dean Mullaney and Bruce Canwell, *Genius, Isolated: The Life and Art of Alex Toth* (IDW, 2011), 54–60; Jackson, *Pioneering*, 101.

6. White, *King*, 77, 83–84.

7. Jack Shadoian, "Yuh Got Pecos! Doggone, Belle, Yuh're as Good as Two Men!," *JPC* 12, no. 4 (1979): 721–736 (quotes 724, 727, 729); White, *King*, 80–81.

8. F. Jacobs, 60; D. Thompson, "Spawn," 303; Hajdu, 90; "William Gaines," 56; quote Reidelbach, 10.

9. Quoted Reidelbach, 184.

10. D. Thompson, "Spawn," 303; *LDC*, 62; Gardner, 98; *PC*, 38. The deposit was $2,000: F. Jacobs, 73.

11. *Modern Love* no. 8 (August/September 1949); see Reidelbach, 13.

12. Grant Geissman, *Foul Play!: The Art and Artists of the Notorious 1950s E.C. Comics* (Harper-Design, 2005), 21ff.

13. *A Moon, a Girl . . . Romance* no. 9 (September/October 1949), repr. in *A Moon, a Girl . . . Romance* (Gemstone, 1995).

14. *Saddle Romances* no. 9 (November/December 1949); *A Moon, a Girl . . . Romance* no. 12 (March/April 1950).

15. *A Moon, a Girl . . . Romance* no. 10 (November/December 1949); F. Jacobs, 73.

16. Simon and Simon, 125.

17. Quotes *A Moon, A Girl . . . Romance*, nos. 9–12 (September/October and November/December 1949, January/February and March/April 1950), repr. in *A Moon, A Girl . . . Romance* (Gemstone, 1995).

18. Savage, 22, 52–53; John Springhall, *Youth, Popular Culture, and Moral Panics: Penny Gaffs to Gangsta-Rap, 1830–1996* (Macmillan, 1998), 129; *Saddle Romances* no. 10 (January/February, 1950); Bill Mason, notes to *A Moon, A Girl . . . Romance* (Gemstone, 1995); John Benson, "No Fear of Heartache," in Dana Dutch, *Romance Without Tears* (Fantagraphics, 2003).

19. Bruce Lenthall, "Outside the Panel—Race in America's Popular Imagination: Comic Strips Before and After World War II," *Journal of American Studies* 32, no. 1 (1998): 39–61.

20. Reitberger and Fuchs, 151; Benson, *Confessions*, 101–102; Jackson, *Pioneering*, 80; Friedman, *More Heroes*, plate 30.

21. Robbins, *Brinkley Girls*, 15–42.

22. Reitberger and Fuchs, 43; Savage, 79; Craig Shutt, "Little Lulu, Big Media Star," *Hogan's Alley* no. 15 (2007): 32–43; *Smithsonian Comic*, 149–151.

23. See Robbins and Yronwode, 39–41; Harvey, "Captain," 55. M. Reynolds, in *Comic Strip Artists*, 100–101, gives some credit to Patterson's editorial assistant, Mollie Slott, who suggested changing the main character from a "bandit to a newspaper reporter."

24. Quotes R. C. Harvey, "More Sexism in Comics," *TCJ* no. 104 (January 1986): 33. A slightly different account appears in Robbins and Yronwode, 78.

25. Mike Barrier, "Starting Out in the Comics: Carl Barks Becomes 'The Duck Man,'" *Funnyworld* no. 22: 14; Barrier, "The Duck Man," in *CBB*, 206–225.

26. *Carl Barks: Conversations*, ed. Donald Ault (University Press of Mississippi, 2003), 10. He first left North America in the mid-'90s; see *Carl Barks: Conversations*, 173.

27. Quote and argument Dwight R. Decker, "Carl Barks: The Good Duck Artist," *TCJ* no. 73 (July 1982): 60.

28. See *Carl Barks: Conversations*, 67.

29. Ariel Dorfman and Armand Mattelart, *How to Read Donald Duck: Imperialist Ideology in the Disney Comic* (International General, 1975), quote 95; compare Harold E. Hinds Jr. and Charles M. Tatum, *Not Just for Children: The Mexican Comic Book in the Late 1960s and 1970s* (Greenwood Press, 1992), esp. 222–231; Anne Rubinstein, *Bad Language, Naked Ladies, and Other Threats to the Nation: A Political History of Comic Books in Mexico* (Duke University Press, 1998), 44–45; essays in John A. Lent, *Cartooning in Latin America* (Hampton Press, 2005); "Mickey in Cairo, Ramsîs in Paris," in Allen Douglas and Fedwa Malti-Douglas, *Arab Comic Strips: Politics of an Emerging Mass Culture* (Indiana University Press, 1994), esp. 9–15; Simone Castaldi, *Drawn and Dangerous: Italian Comics of the 1970s and 1980s* (University Press of Mississippi, 2010), 6, 24.

30. See Mort Walker's similar, though less ideologically inflected, point in his *Lexicon of Comicana* (iUniverse, 2000), 11.

31. K. Wilson, "Educational Values," 2–3; Barrier, "Duck Man," 217–220; Gary Groth, "Barks in Boston," *TCJ* no. 32 (1976): 25; Reidelbach, 42; *Carl Barks: Conversations*, 44. For a Barksian

critique of capitalism, or, at least, a farcical treatment, see "Tralla La," in *Toon Treasury*, 252–273.

32. Blackbeard, "Mickey," 52; Barrier, "Duck Man," 215. That said, Barks's stories sometimes employed harsh fate to keep matters exactly as they were, Donald, Gander, and Scrooge always in their places: "Barks's Darkening Vision," *Walt Disney's Comics and Stories*, vol. 2 (Another Rainbow, 1983), 289ff.

33. Brett Dakin, "Leverett Gleason," *Harvard Magazine*, May/June 2011, https://harvardmagazine.com/2011/05/leverett-gleason.

34. Goulart, *Fifty*, 34; Lupoff, "Propwash Again," 190; quote Goulart, "Noir," 340; Hajdu, 57–60; *MOT*, 187–194.

35. *Crime Does Not Pay* no. 22 (July 1942), repr. in *Crime Does Not Pay Archives* (Dark Horse, 2012), 10.

36. Quote Goulart, *Fifty*, 193; see *LDC*, 17; Goulart, "Noir," 341; Hajdu, 63, 87. They were even selling normally pulped defective copies, leading to a sell-through rate of over 100 percent, according to the publisher: Denis Kitchen, "Biro & Wood: Partners in Crime," in *Blackjacked and Pistol-Whipped: A Crime Does Not Pay Primer* (Dark Horse, 2011), 10.

37. *Detective Comics* no. 108 (February 1946), in *Batman Archives*, vol. 5 (DC, 2001, hereafter *BA5*), 78.

38. Wagner, *Parade*, 77–78; Benton, *Crime*, 39, 41, 49; Benton, *Comic Book*, 44–45; Goulart, *Fifty*, 200; Jean-Paul Gabilliet, *Of Comics and Men: A Cultural History of American Comic Books* (University Press of Mississippi, 2010), 37; quote Goulart, "Noir," 342.

39. Quotes Hajdu, 69, 64; see also 67; Benton, *Crime*, 26–28; *Scorchy Smith*, 35; *Drawing Power: A Compendium of Cartoon Advertising*, ed. Rick Marschall and Warren Bernard (Fantagraphics, 2011), 120–122. For his first appearance in November 1942, complete with skull eyeballs, see *Crime Does Not Pay Archives*, 1:146.

40. The comparative size of the title's words changed over the run: Kitchen, "Biro & Wood," 19.

41. Reprinted in *The Mammoth Book of Best Crime Comics*, ed. Paul Gravett (Running Press, 2008), 94–107; see also 394. On misogyny here, women as "cheap sex objects, fodder for male sadistic urges, or scheming murderous gold-diggers," see B. Wright, *Nation*, 83, and N. Wright, *Classic*, 148–150, along with, for example, the 1948 story "Machine-Gun Kelly: A Bully Who Would Kill at the Drop of a Hat—Was Meek as a Lamb When the Shrill Voice of His Wife Gave a Command!," repr. in *Blackjacked*, 199–207.

42. Hajdu, 70; Pustz, 31; Benton, *Crime*, 41.

43. *LDC*, 62. See essay in *The Crypt of Terror/Tales From the Crypt*, vol. 1 (Gemstone, 1979), n.p.

44. In the 1950s, capitalizing on EC's New Trend, it was renamed *Ghost Comics*; see Benton, *Horror*, 10; Price, "Ectoplasmic," 8–20; Thomas, "Timely," 7.

45. *Captain America Comics* no. 2 (April 1941): 4; D. Thompson, "Axis," 138; Price, "Ectoplasmic," 16; Goulart, *Great*, 255; Goulart, *Fifty*, 173.

46. Benton, *Horror*, 7, 21; "The Transcripts, 1972 EC Comics Convention," in *Squa Tront* no. 7 (1977): 23.

47. Quote Benton, *Horror*, 22–23; Vault-Keeper: "Curiosity Killed . . . ," in *Tales from the Crypt* no. 36 (June/July 1953).

48. *LDC*, 62, 64; D. Thompson, "Spawn," 298; *Tales from the Crypt* no. 36 (June/July 1953); "Crypt-Keeper's Corner," in *Tales from the Crypt* no. 37 (August/September 1953) and no. 44 (October/November 1954).

49. See Lupoff, "Propwash," 75; *Tales from the Crypt*, 23; Benton, *Horror*, 22; Reidelbach, 24; *Collectibly Mad*, 27.

50. See *Tales from the Crypt*, no. 39 (December 1953/January 1954).

51. *Tales from the Crypt*, nos. 29 (April/May 1952), 32 (October/November 1952), and 36 (June/July 1953); see Springhall, 128–129; Savage, 81; Benton, *Horror*, 30; B. Wright, *Nation*, 147, shrewdly points out the class differentiation between here and the blue-collar crime of *Crime Does Not Pay*.

52. *Tales from the Crypt* no. 24 (June/July 1951); *Tales from the Crypt* no. 26, (October/November 1951); "Cold War," *Tales from the Crypt* no. 43 (August/September 1954); "Reflection of Death!," *Tales from the Crypt* no. 23 (April/May 1951); see "Mirror, Mirror, on the Wall!," in *Tales from the Crypt* no. 34 (February/March 1953); Don G. Smith, *H. P. Lovecraft in Popular Culture* (McFarland, 2006), 137–145.

53. Quotes Springhall, 129; Bhob Stewart, "Dark Pagentry [sic]: A Nostalgic Introduction," in *Those Were the Terrible, Shocking, Sensational, Appalling, Forbidden . . . but Simply Wonderful Horror Comics of the 1950s* (Nostalgia Press, 1971), n.p.; F. Jacobs, 83; *Collectibly Mad*, 25. For Severin's own (slight) demurral, see Dewey Cassell, *Marie Severin: The Mirthful Mistress of Comics* (TwoMorrows, 2012), 26; on Severin, see also Robbins and Yronwode, 103, and *Collectibly Mad*, 239–240; for capsule sketches of women involved in Silver and Bronze Age mainstream comics, see *Girl Comics*, ed. Jeanine Schaefer (Marvel, 2010); see also Friedman, *More Heroes*, plate 12.

54. See, for example, *Human Torch Comics* no. 2 (Fall 1940), repr. in *GAHT1*, 32–33; *Forbidden Adventures*, 41–42; quote *Tales from the Crypt* no. 29 (April/May 1952).

55. "Transcripts," 37; *Weird Science* no. 21 (September/October 1953); *Tales from the Crypt* no. 34 (February/March 1953); compare Pustz, 39; *LDC*, 65–66; D. Thompson, "Spawn," 304, 307–308; "Introduction," *Ray Bradbury Chronicles*, vol. 1 (Bantam Spectra, 1992), 4; "William Gaines," 60; F. Jacobs, 80; Bradbury's 1952 letter repr. in *Collectibly Mad*, 27.

56. Denis Kitchen and Paul Buhle, *The Art of Harvey Kurtzman* (AbramsComicArts, 2009), esp. 60–62; Witek, *Comic Books as History*, 47; De Fuccio's comments in "Transcripts," 32; "Blood and Thunder," *TCJ* no. 218 (December 1999): 4.

57. Kurtzman: "An Interview with the Man Who Brought Truth to the Comics: Harvey Kurtzman," *TCJ* no. 67 (October 1981): 68–99, 78–79; B. Wright, *Nation*, 114; Savage, 51–57; Witek, *Comic Books as History*, 40; "Transcripts," 31; Versaci, 150–173. A revisionist view: Ng Suat Tong, "EC Comics and the Chimera of Memory," *TCJ* no. 250 (February 2003): 121–122. Not everyone was so glum: Beetle Bailey reported for duty in 1951; see March 13, 1951, strip repr. in Mort Walker, *Beetle Bailey: The First Years, 1950–1952* (Checker Book Publishing Group, 2008), 70.

58. Both letters printed in Don Thompson, "The Spawn of the Son of M. C. Gaines," in *CBB*, 290–316, 292–293.

59. Sending Gaines fifty dollars for printing them, which he and Feldstein spent at the Moroccan Village nightclub: "William Gaines," 57.

60. *Mysterious Adventures* no. 15 (August 1953), repr. in Benton, *Horror*, 35, quote 37; Benton, *Horror*, 5, 36–37, 48, quote 36. For great non-EC examples, see *Four Color Fear*, ed. Greg Sadowski (Fantagraphics, 2011).

61. Legman quotes 38, 40, 42, 44–45.

62. Quotes Gardner, 76; Hajdu, 45–46, 92; Nyberg, 31–33; *Superman* no. 12, in *SA3*, 236.

63. Discussion from Nyberg, *Seal*, 19–20, 85–97, quote 19; Hajdu, 88; Gardner, 77.

64. "The Plight of a Nation," reprinted *All Star Comics Archives*, vol. 9 (DC, 2003), 48–84, 62.

65. Quote Hajdu, 65; Benton, *Crime*, 25; *MOT*, 194; *Blackjacked*, 62.

66. Quote Charles S. Rhyne, *Comic Books—Municipal Control of Sale and Distribution: A Preliminary Study* (National Institute of Municipal Law Officers, 1948), 3; Nyberg, *Seal*, 23–30; Hajdu, 93–94.

67. Quotes Rhyne, 4, 9; Nyberg, *Seal*, 38–39; Hajdu, 96.

68. Quotes Rhyne, 5, 12, 13.

69. Quotes Rhyne, 5, 9.

70. See Martin Barker, "Fredric Wertham—The Sad Case of the Unhappy Humanist," and James E. Reibman, "Fredric Wertham: A Social Psychologist Characterizes Crime Comic Books and Media Violence as Public Health Issues," in *Pulp Demons*, 215–233, 234–268, Freud quote 240, Marshall quote 248; James Reibman, "Fredric Wertham, Spiegelman's *Maus*, and Representations of the Holocaust," in *The Graphic Novel*, ed. Jan Baetens (Leuven University Press, 2001), 26–27; Beaty, *Wertham*, passim, esp. 88–94.

71. "William Gaines," 73.

72. Beaty, *Wertham*, 27–30; "The Comic Books . . . Very Funny!": quoted in Benton, *Horror*, 41; the article was later reprinted in *Reader's Digest*.

73. Benton, *Horror*, 52; Nyberg, *Seal*, 32, 106–107; Edward L. Feder, *Comic Book Regulation* (Bureau of Public Administration, 1955), 15; "Leverett Gleason."

74. Feder, 16; Nyberg, *Seal*, 35–37; D. Thompson, "Spawn," 312; *MOT*, 241.

75. Quote *LDC*, 10; Benton, *Horror*, 39, 41; B. Wright, *Nation*, 86; Reidelbach, 17; Nyberg, *Seal*, 42–49; B. Wright, *Nation*, 104–106.

76. Martin Barker, *A Haunt of Fears: The Strange History of the British Horror Comics Campaign* (Pluto Press, 1984), 59.

77. On Wertham's almost Manichean sense of art, see Barker, "Wertham," 224–226; compare Beaty, *Wertham*, 33, 48ff., 142–143.
78. See Barker, *Haunt*, 60–70; Springhall, 125; Daniel Patanella, "The Persuasive Techniques and Psychological Validity of *Seduction of the Innocent*," *IJCA* 1, no. 2 (1999): 76–85; Maren Williams, "Researcher Proves Wertham Fabricated Evidence Against Comics," Comic Book Legal Defense Fund website, February 13, 2013, http://cbldf.org/2013/02/researcher-proves -wertham-fabricated-evidence-against-comics.
79. Yoe, "50 Shades," 7.
80. Fredric Wertham, *Seduction of the Innocent* (Rinehart, 1954), 189–190; Glen Weldon, "A Brief History of Dick," *Slate*, April 3, 2016.
81. Benton, *Horror*, 42.
82. Barker, *Haunt*, 67; Wertham, 193.
83. Josette Frank, *Comics, Radio, Movies—and Children* (Public Affairs Committee, 1949), 3, 6, 10, 12; Dr. Benjamin Spock took a similar tone in the first edition of *The Common Sense Book of Baby and Child Care* (Duell, Sloan and Pearce, 1946); see B. Wright, *Nation*, 89.
84. Quote *Tor Archives*, vol. 2 (DC, 2002), 93.
85. Wertham, 397; compare D. Thompson, "Spawn," 308–309.
86. Quote Nyberg, 54.
87. Quote Feder, 1; Benton, *Comic Book*, 51–53; Nyberg, 53, 56; Gabilliet, 30.
88. Quote Reibman, "Wertham: A Social Psychologist," 254.
89. For a nuanced reading of the story—"The Whipping," in *Shock SuspenStories* no. 13 (February/March 1954)—see Nyberg, *Seal*, 63–73. Jones, in *MOT*, 274, argues plausibly that Jewish industry creators were infuriated by Wertham seemingly calling them Nazis. Fascinating, given that Wertham's research partner, Dr. Hilde L. Mosse, was a German-Jewish refugee whose family press empire had run anti-fascist cartoons. See Leonard Rifas, "'Especially Dr. Hilde L. Mosse': Wertham's Research Collaborator," *IJCA* 8, no. 1 (Spring 2006): 17–18.
90. For their statement, see R. C. Harvey, "Fact and Fiction with the Old Caviler in Clay Feet," *TCJ* no. 248 (November 2002): 111–112.
91. Benton, *Horror*, 45; Charles Addams, *The World of Charles Addams* (Knopf, 1991); Hank Ketcham, *The Merchant of Dennis the Menace* (Fantagraphics, 2005), 25; see also *BWC*, 408, 446; Reitberger and Fuchs, 136; R. C. Harvey, "Milton Caniff, Steve Canyon, and the Fair Sex," *TCJ*, July 19, 2012, http://www.tcj.com/milton-caniff-steve-canyon-and-the-fair-sex.
92. "William Gaines" 72–73.
93. Quotes F. Jacobs, 106–107.
94. Cited F. Jacobs, 108–109.
95. "William Gaines" 73; Benton, *Horror*, 46; Nyberg, *Seal*, 63.
96. Quotes F. Jacobs, 105; see also Nyberg, 74–75.
97. *Tales from the Crypt* no. 45 (December 1954/January 1955), selections.
98. Nyberg, *Seal*, 120–121; Benton, *Horror*, 47; Springhall, 139.
99. Nyberg, *Seal*, 79–83; Reidelbach, 30; Barker, *Ideology, Power*, 14; Patrick Rosenkranz, "Comix on the Continent," *Funnyworld* no. 16: 29–33, 32; Reitberger and Fuchs, 67.
100. Quoted Perry and Aldridge, 160.
101. Benton, *Horror*, 49; Feder, 17; Gardner, 103; Nyberg, 109–112. The Comics Magazine Association of America incorporated on September 7, 1954.
102. All quotes from *Code for the Comics Magazine Industry* (CMAA, 1954).
103. Goldwater, 27–29; Nyberg, 114ff.
104. Quotes Feder, 18; Nyberg, 114; Benton, *Horror*, 51; D. Thompson, "Eel," 31.
105. Josette Frank, *Comics, TV, Radio, Movies: What Do They Offer Children?*, rev. ed. (Public Affairs Committee, 1955), 3; American Civil Liberties Union, *Censorship of Comic Books: A Statement in Opposition on Civil Liberties Grounds* (ACLU, 1955), 2–9. See also Feder; *LDC*, 87; Beaty, *Wertham*, 127.
106. Wolfgang Saxon, "Helen Honig Mayer, Who Led Dell Publishing, Dies at 95," *NYT*, April 24, 2003. Ironically, Dell produced some of the post-Code era's scariest horror comics: 1962's *Ghost Stories* and *Tales from the Tomb*. Benton, *Horror*, 55; Feder, 16; Nyberg, 116–117.
107. Sawyer, 4, 9.
108. *Tales from the Crypt* no. 46 (February/March 1955).

109. Eric A. Holmes, "Solidification, Hidden Guilts, and 'The Prude': EC's Agitative Rhetoric Continued," *IJCA* 7, no. 2 (Fall 2005): 262–272.

110. *M.D.* no. 1 (April/May 1955); on *Psychoanalysis*, see "EC on the Couch," *TCJ* no. 133 (December 1989), esp. 60–61; on *Extra!* (on journalism), see Tom Brislin, "Extra! The Comic Book Journalist Survives the Censors of 1955," *Journalism History* 21, no. 3 (Fall 1995): 123–130.

111. *Valor* no. 1 (March/April 1955), inside back cover; "The Punch Bowl," *Impact* no. 1 (March/April 1955).

112. In the '50s, Belsen, not Auschwitz, was the leading American metonym for the camps; possibly because English-speaking soldiers, here the British, liberated Belsen, while Auschwitz was liberated by the Russians.

113. See Martin Jukovsky, "Master Race and the Holocaust," *Impact* (Russ Cochran, 1988); "Al Feldstein," *TCJ* no. 225 (July 2000): 71–72.

114. On the authorship of "Master Race," see "An Interview with Al Feldstein," *Squa Tront* 9 (1983): 3–9, 9; John Benson, "Letter to the Editor," *TCJ* no. 70 (Winter 1982): 21; and the 1972 Feldstein interview reprinted in *Impact*; *Collectibly Mad*, 228.

115. *Impact* no. 1 (1988), 27; John Benson on "Master Race," in *Impact* no. 1; "Krigstein: A Eulogy by Art Spiegelman," *TCJ* no. 134 (February 1990): 13; John Benson, David Kasakove, and Art Spiegelman, "An Examination of 'Master Race,'" in *A Comics Studies Reader*, ed. Jeet Heer and Kent Worcester (University Press of Mississippi, 2009), 288–305.

116. D. Thompson, "Spawn," 312; Ted White, "History of Comics Fandom," *TCJ* no. 240 (January 2002): 117.

117. F. Jacobs, 114; Qiana Witted, *EC Comics: Race, Shock, and Social Protest* (Rutgers University Press, 2019), 104–132.

118. D. Thompson, "Spawn," 314–315; interview with Gaines, Feldstein, and Severin in "Transcripts," 21–44, 23.

119. See Gaines's comments in "Censorship in Comics," 98–99; John Benson in *Valor* (Russ Cochran, 1988), n.p.; James B. Twitchell, *Preposterous Violence: Fables of Aggression in Modern Culture* (Oxford University Press, 1989), 136–137; *Collectibly Mad*, 40.

120. "Lucky Luke" in *Squa Tront* 7 (1977): 19–34; "William Gaines," 60; Daniels, *Marvel*, 66; Kurtzman's late-'40s work collected in *Kurtzman Komix* (Kitchen Sink, 1976); Reidelbach, 20.

121. *Mad* no. 3 (January/February 1953).

122. Reidelbach, 157; Goulart, *Comic Book Culture*, 149; Grant Geissman, "When Better Drawrigns Are Drawrn," in Bhob Stewart and J. Michael Catron, *The Life and Legend of Wallace Wood*, vol. 1 (Fantagraphics, 2017), 147.

123. On *Mad*'s Yiddish(y) language and "chicken fact" joke cramming, see Al Jaffee's comments in Leah Garrett, "Al Jaffee Explains How *Mad* Magazine Made American Humor Jewish," *Forward,* February 21, 2016.

124. F. Jacobs, 192; *LDC*, 68–69; *Will Elder: The Mad Playboy of Art* (Fantagraphics, 2003), 96–111.

125. Vasallo, "Maneely"; *Best of Simon and Kirby*, 222–224; Craig Yoe, "Welcome to the Madhouse!," in *The Best of Archie's Madhouse*, ed. Craig Yoe (IDW, 2011), 15–26. Elder's version reprinted in *Collectibly Mad*, 161–167; *Elder*, 114–120.

126. Bill Spicer, "Interview with Lyle Stuart," *Squa Tront* 12 (2007): 51; F. Jacobs, 101.

127. Quote "Censorship in Comics," *TCJ* no. 77 (November 1982): 91. See also *Collectibly Mad*, 45–46; F. Jacobs, 117–118.

128. Quote *LDC*, 92; *Art of Harvey Kurtzman*, 77; card reprinted in *Collectibly Mad*, 38.

Chapter 4: From Censorship to Camp

1. N. Wright, *Classic*, 86.

2. Quoted Larry Rodman, "Reality Check: Violence in the Media," *TCJ* no. 133 (December 1989): 9–10; Gary Groth, "57 Years in the Making . . . ," *TCJ* no. 190 (September 1996): 4.

3. Goldwater, 7, 8, 13; Savage, 100; Benton, *Comic Book*, 55.

4. Beaty, *Wertham*, 104.

5. Nyberg, 125–126; Lupoff, "Propwash Again," 174–205, 175; *PC*, 40; *S2*, 63–79; Parsons, "Batman and His Audience," 72; Goulart, *Great*, 12; Mike Friedrich, "The Crisis in Comics" (special section), *TCJ* no. 199 (October 1997): 16.

6. Dave Blanchard, "Comics in the Comics," *Hogans Alley* no. 13 (2005): 92–95; Goulart, *Fifty*,

223–224; Kubert, "Foreword," *Tor Archives*, vol. 1 (DC, 2001); Kubert interview in John Benson, *Confessions, Romances, Secrets and Temptations* (Fantagraphics, 2007), 41–43. About fifty 3D comics were produced; see Dale Luciano, "Planes and Existence," *TCJ* no. 99 (June 1985): 48; Joe Kubert, "Introduction," in *Amazing 3-D Comics!*, ed. Craig Yoe (IDW, 2011), writes that their first red and green lenses were adapted from lollipop wrappers.

7. By 1971, that number rose to 2.15 million. F. Jacobs, 118; Reidelbach, 188; Reitberger and Fuchs, 218.

8. See Wagstaff, "Comic Iconoclasm," 7–18; Gabilliet, 63; Dan Graham, "Untitled," in *Comic Iconoclasm*, 66–68; John Benson, "No Fear of Heartache," in Dutch, *Romance Without Tears*; David Deitcher, "Wild History," in *Comic Iconoclasm*, 82–87; Friedman, *More Heroes*, 67; Beaty, *Versus*, 55 69; compare also Kirk Varnedoe and Adam Gopnik, *High & Low: Modern Art and Popular Culture* (Museum of Modern Art, 1990), esp. 197–208.

9. Nick Meglin, "Introduction," *Mad's "Original Idiots": Jack Davis* (Mad Books, 2015), 4–6; David Shayne, "Introduction," *MADvertising: A MAD Look at 50 Years of MADison Avenue* (Watson Guptill, 2005), 12–15; Dick DeBartolo, *Good Days and Mad* (Thunder's Mouth Press, 1994) 100; "Will Elder Interview," *TCJ* no. 254 (July 03): 94–95.

10. *Collectibly Mad*, 122ff., 139; Dick Voll, "The Spaghetti and Meatball School of Design," *TCJ* no. 102 (September 1985): 88; F. Jacobs, 209; Reidelbach, 140; "Kurtzman," *TCJ* no. 91 (July 1984): 108; "Al Feldstein Interview," *TCJ* no. 177 (May 1995): 85–86.

11. F. Jacobs, 211; Reidelbach, 146; Reitberger and Fuchs, 152.

12. Quote *LDC*, 93; Feiffer, *Sick, Sick, Sick: A Guide to Non-Confident Living* (McGraw-Hill, 1958).

13. See *Feiffer: The Collected Works*, vol. 2, *Munro* (Fantagraphics, 1989).

14. "Introduction," White and Abel, 3, 7; *BWC*, 352; *JRC*, 229–230; Perry and Aldridge, 99; Harvey, *Funnies*, 193; Reitberger and Fuchs, 49.

15. Martin Jezer, "Quo Peanuts?," in White and Abel, 167–176, 168–169. Schulz's title (and much else important to *Peanuts*) came from his first regular strip: Sparky's *Li'l Folks* appeared in the *St. Paul Pioneer Press* from June 1947 to January 1950. See Charles M. Schulz, *Li'l Beginnings* (Charles M. Schulz Museum and Research Center, 2003), esp. editor Derrick Bang's introduction.

16. See *The Peanuts Papers*, ed. Andrew Blauner (Library of America, 2019), especially essays by Gopnik, Ware, and Boxer; Harvey, *Funnies*, 211–213; *JRC*, 251; quote M. Reynolds, *1945–1980*, 151; *Charles M. Schulz: Conversations*, ed. M. Thomas Inge (University Press of Mississippi, 2000), 6, 20; "Charles Schulz Interview," 20–21; Brian Walker, *Doonesbury and the Art of* G. B. *Trudeau* (Yale University Press, 2010), 5; R. C. Harvey, "The Pagliacci Bit," *TCJ* no. 290 (May 2008): 85–87, quote 86; Trudeau quote: *Schulz: Conversations*, 271.

17. John Benson, "The E.C. Fanzines, Part One: The Gelatin Years," *Squa Tront* no. 5 (1974): 39–46; Harry Warner Jr., *A Wealth of Fable* (SCIFI Press, 1992), 234. Some EC fanzines hovered between magazine and comic, like Dennis Cunningham's 1965 *Weirdom*: Bill Schelly, *The Golden Age of Comic Fandom* (Hamster Press, 1999), 17–20.

18. See Gardner, 114–116, quote 114; Mark James Estren, *A History of Underground Comics* (Ronin, 2012), 43–46; Pahls, "Right Up to the Edge," viii–ix; Robert Crumb, *The R. Crumb Coffee Table Art Book* (Little, Brown, 1997), 35; Jared Gardner, "Before the Underground: Jay Lynch, Art Spiegelman, Skip Williamson, and the Fanzine Culture of the Early 1960s," *Inks* 1, no. 1 (Spring 2017), 75–99.

19. Jacobs, 19, 120–121, 143, 164, quotes 34, 120, 170. For more tales of Gaines, see DeBartolo, *Good Days and Mad*; compare also Bill Schelly, *Harvey Kurtzman: The Man Who Created Mad and Revolutionized Humor in America* (Fantagraphics, 2015), 330–337.

20. "Man Who Brought Truth," 87; "Harvey Kurtzman Interview: 1965," *TCJ* no. 153 (October 1992): 52–53; Kitchen, "Origins," 203; *Art of Harvey Kurtzman*, 121.

21. Quote F. Jacobs, 123; see also 125; *LDC*, 94–95; *Art of Harvey Kurtzman*, 125–129; John Benson and Gary Groth, "Introduction," *Humbug: Book One* (Fantagraphics, 2009), viii–xv.

22. Reprinted by Kitchen Sink Press in 1988; see *Art of Harvey Kurtzman*, 151–153.

23. See Schelly, *Golden*, 130, and Levitz, *Eisner*, 139–141; Eddie Campbell, "A Graphic Novelist's Manifesto," in *TCJ* no. 263 (October/November 2004): 169.

24. For a useful overview of the vexedness, see Annalisa Di Liddo, *Alan Moore: Comics as Performance, Fiction as Scalpel* (University Press of Mississippi, 2009), 15–20; quote David A. Beronä, "Picture Stories: Eric Drooker and the Tradition of Woodcut Novels," *Inks* 2,

no. 1 (1995): 2–11, 4; see also David A. Beronä, *Wordless Books: The Original Graphic Novels* (Abrams, 2008) for a useful anthology and overview.

25. Otto Nückel, *Destiny: A Novel in Pictures* (Farrar & Rinehart, 1930; repr. Dover, 2007); Lynd Ward, *Storyteller Without Words* (Abrams, 1974), 11, 21, 192; Beronä, "Picture Stories," 6; Gross, *He Done Her Wrong: The Great American Novel* (Fantagraphics, 2005); Sheridan, 87–88; Yoe, "Laughs by the Gross!," 21.

26. Published by New York's Coward-McCann in 1930.

27. Quoted David A Beronä, "A Season of Silent Novels," *TCJ* no. 208 (November 1998): 99.

28. Tito Patri and Georges Ray, "Introduction," *White Collar* (Dover, 2016).

29. Dennis O'Neil, "Foreword," *Justice League of America Archives*, vol. 8 (DC, 2003, hereafter *JLAA8*).

30. Leslie Waller, "Afterword: The Graphic Novel—and How It Grew," in *It Rhymes with Lust* (1949; Dark Horse, 2007), 129, 132; Drake later wrote extensively for DC and Marvel, as well as the movie *50,000 B.C.*; see Goulart, *Fifty*, 167.

31. Don Freeman, best known for the children's book *Corduroy*, struck a similar note; his wordless graphic novel *Skitzy: The Story of Floyd W. Skitzafroid*, self-published in 1955 (reissued by Drawn & Quarterly in 2008), literally divided a man between his uptown, uptight self and a bohemian, downtown-artist existence.

32. Satirizing, among others, jungle comics in a decolonizing age ("Listen, T*rz*n . . . Africa is awakening!") and American teenagerdom (the Archie Comics kids escorting Beaver to a Roman orgy earned a lawsuit). The suit was settled, giving Archie ownership over the comic; it prohibited republication. See *Goodman Beaver*, passim; Kitchen, "Origins," 205; Schreiner, "Gnawing," 9–11.

33. *Penthouse* produced its own, often raunchier versions, *Oh, Wicked Wanda* and *Sweet Chastity*: Denis Kitchen, "The Origins of Little Annie Fanny," in Harvey Kurtzman and Will Elder, *Playboy's Little Annie Fanny*, vol. 1, *1962–1970* (Dark Horse, 2000), 203–211, 206–209; Harvey, *Sex*, 93; "Will Elder Interview," 116.

34. See Gardner, 115–116; *LDC*, 92, 96; Kurtzman, in "Man Who Brought Truth," 93; "A Conversation with Harvey Kurtzman and Harry Chester," *Squa Tront* no. 12 (2007): 36–46, 41–42, 44; Terry Gilliam's comments in *TCJ* no. 153 (October 1992): 71; "Terry Gilliam," *TCJ* no. 182 (November 1995): 65; Kitchen, "Origins," 208; "Harvey Kurtzman Tribute," *TCJ* no. 157 (March 1993): 14; *Art of Harvey Kurtzman*, 168–170; Gloria Steinem, "Wonder Woman," repr. in *The Superhero Reader*, 203–210.

35. *Captain America Comics* no. 76 (May 1954), repr. in *Marvel Masterworks: Atlas Era Heroes*, vol. 2 (Marvel, 2008, hereafter *AEH2*), 77; *Men's Adventures* no. 27 (May 1954), repr. in *AEH2*, 18; *Fighting American* quote in Joe Simon and Jack Kirby, *Fighting American* (Titan, 2011); Kirby Interview *TCJ*, 76.

36. Blake Bell, *"I Have to Live With This Guy!"* (TwoMorrows, 2002), 27; *MOT*, 307.

37. *Detective Comics* no. 114 (August 1946), repr. in *BA5*, 149–160; *Detective Comics* no. 124 (June 1947), repr. in *Batman Archives*, vol. 6 (DC, 2005, hereafter *BA6*), 64–76; "Crimes in Reverse," *Detective Comics* no. 128 (October 1947), repr. in *BA6*, 117–129, quote 118; "The Rebus Crimes!," *Detective Comics* no. 137 (July 1948), repr. in *Batman Archives*, vol. 7 (DC, 2007, hereafter *BA7*), 20–32; "Crimes Puzzle Contest!," *Detective Comics* no. 142 (December 1948), in *BA7*, 83–95, 93.

38. In "Wonder Woman Comes to America," *Sensation Comics* no. 1 (January 1942), repr. in *WWA1*, 20. She receives an invitation from Hollywood to get into the movies later that year; "America's Guardian Angel," *Sensation Comics* no. 12 (December 1942), *WWA1*, 229, 239.

39. *ShA2*, 139; Daniels, *Marvel*, 53; Chip Kidd, *Shazam: The Golden Age of the World's Mightiest Mortal* (Abrams ComicArts, 2010); Daniels, *DC*, 108–111; Jacobs and Jones, 3, 22; *S1*, 41. There was also a "charming, quaint, and completely bonkers" aborted kids' TV pilot, *The Adventures of Superpup*, with characters played by "diminutive actors wearing fiberglass dog masks" with names like Bark Bent: Daniels, *DC*, 198.

40. Davin, 107; Benton, *Science Fiction*, 21–22; Jacobs and Jones, 74; *MOT*, 131–132; Julius Schwartz, *Man of Two Worlds: My Life in Science Fiction and Comics* (HarperEntertainment, 2000), 13, 28–34, 58–59; Mark Waid, "Foreword," *Superman: Man of Tomorrow Archives*, vol. 1 (DC, 2004).

41. Michael Uslan, "Introduction," *GSS*; "Foreword," *ACA3*; Reitberger and Fuchs, 106; Goulart,

Great, 89; Korkis, 16. The first account of Krypton's destruction, along with Jor-L and Lora (as they were then known), appeared in the newspaper strips: Goulart, *Fifty,* 78.

42. *Lois Lane* no. 19 (August 1960). See *DC's Greatest Imaginary Stories,* vol. 1 (DC, 2005), 26, and Craig Shutt's introduction.

43. Jacobs and Jones, 22–24; "The Origin of Batman!," *Batman* no. 47 (June/July 1948), repr. in *GBS,* 66–78; *MOT,* 287–289.

44. Daniels, *DC,* 88; "How Luthor Met Superboy," *Adventure Comics* no. 271 (April 1960), repr. in *Superman vs. Lex Luthor* (DC, 2006), 30–42.

45. See Anthony R. Mills, *American Theology, Superhero Comics, and Cinema: The Marvel of Stan Lee and the Revolution of a Genre* (Routledge, 2014), 40–42; Benton, *Science Fiction,* 64–67; "Joe Shuster . . . Forever Up, Up, and Away," *TCJ* no. 153 (October 1992): 20; Jacobs and Jones, 10–13, 29, 42.

46. "The Menace of the Dragonfly Raiders!," in *The Brave and the Bold* no. 42 (June/July 1962), repr. in *The Hawkman Archives,* vol. 1 (DC, 2000), 90–114, 93.

47. Wagner, 88; *Showcase* no. 7 (March/April 1957), repr. in *Challengers of the Unknown Archives,* vol. 1 (DC, 2003), 39.

48. Jacobs and Jones, 15, 29–30, 83.

49. Jacobs and Jones, 41; Gambaccini, "Foreword," *Justice League of America Archives,* vol. 1 (DC, 1992, hereafter *JLAA1*); Schwartz, *Two Worlds,* 95.

50. In *Justice League of America* no. 4 (May/June 1961), repr. in *JLAA1,* 195; James Kakalios, *The Physics of Superheroes* (Gotham, 2005), 12–16.

51. Mike W. Barr, *Silver Age Sci-Fi Companion* (TwoMorrows, 2007), 19.

52. See, for example, *Mysteries in Space: The Best of DC Science Fiction Comics,* ed. Michael Uslan (Fireside, 1980), 213. Metamorpho was introduced in 1964–1965; quote *The Brave and the Bold* no. 57 (December 1964/January 1965), repr. in *Showcase Presents: Metamorpho* (DC, 2005), 29. This, in addition to "institutional pages" appearing in DC comics between 1950 and 1967 about "issues as diverse as racial tolerance, consideration for neighbors, and the joys of public libraries": Jacobs and Jones, 28.

53. See, for example, "The Seaman and the Spyglass!," *The Atom* no. 9, (October/November 1963), repr. in *The Atom Archives,* vol. 2 (DC, 2003), 103.

54. See, for example, *All Flash Comics* no. 1 (Summer 1941), repr. in *The Golden Age Flash Archives,* vol. 2 (DC, 2005), 67–68; Roy Thomas, "Foreword," *All Star Comics Archives,* vol 11 (DC, 2005).

55. Tollin, "Shades of the Shadow," 4; Jacobs and Jones, 34–35; Eisner, *Comics and Sequential Art,* 149; Schwartz, *Two Worlds,* 169–171.

56. "The Globe-Trotter of Crime!," *Detective Comics* no. 160 (June 1950), repr. in *BA8,* 87; *Batman: The Sunday Classics, 1943–1946* (Sterling, 2007), 7; "Batman Meets Bat-Mite," *Detective Comics* no. 267 (May 1959), repr. in *Batman in the Fifties* (DC, 2002), 90.

57. *Detective Comics* no. 165 (November 1950), in *BA8,* 141; *Detective Comics* no. 132 (February 1948), repr. in *BA6,* 170–182, 178; Robert Greenberger, "Endnotes," *GBS,* 344–347, 346; Jacobs and Jones, 30–31.

58. On the Spirit in outer space, courtesy of Feiffer and Wood, see *Woodwork: Wallace Wood 1927–1981,* ed. Frédéric Manzano (IDW, 2012), 86–89.

59. "Foreword," *Supergirl Archives,* vol. 1 (DC, 2001); Coulson, 226–255, 250–252. On Canary, who began as a love interest for Johnny Thunder (a Captain Marvel parody who doesn't know his own magic word) and graduated to her own feature, see *365 Days,* "August 6"; *Flash Comics* no. 86 (August 1947), repr. in *Black Canary Archives,* vol. 1 (DC, 2001, hereafter *BCA1*), 7; and *Flash Comics* no. 92 (February 1948), repr. in *BCA1,* 44; "The Insect Queen of Smallville," *Superboy* no. 124 (October 1965).

60. "Birth of the Atom!," *Showcase* no. 34 (September/October 1961), repr. in *Atom Archives,* vol. 1 (DC, 2001), 13; *Showcase* no. 22 (September/October 1959), repr. in *Green Lantern Archives,* vol. 1 (DC, 1993), 28–29; "The Secret Life of Star Sapphire!," *Green Lantern* no. 16 (October 1962), repr. in *Green Lantern Archives,* vol. 3 (DC, 2001), 60–74, 64, 68, 73.

61. Jacobs and Jones, 56; L. Robinson, *Wonder Women,* 78–79.

62. Reprinted in *Mysteries in Space,* 84–91, quotes 85, 90, 91.

63. Roy Thomas, "Introduction," in *Marvel Masterworks: Atlas Era Black Knight/Yellow Claw* (Marvel, 2009, hereafter *BKYC*), n.p.; Stan Lee and Joe Maneely, "The Menace of Modred the

Evil!," *Black Knight* no. 1 (May 1955); on Maneely, who "was to Atlas [in the 1950s] what Jack Kirby would be to Marvel in the 1960s," see Michael J. Vassallo, "Joe Maneely: Adventure Comics," in *BKYC*. The Rawhide Kid, Lee said, was their "first attempt to get away from one-shot stories and start creating a hero we could turn into a successful series": "Introduction," *Marvel Masterworks: Rawhide Kid*, vol. 1 (Marvel, 2006); Daniels, *Marvel*, 58.

64. See "Gil Kane Interview," *TCJ* no. 186 (April 1996): 59.

65. Quoted Fingeroth, *Disguised*, 93; B. Wright, *Nation*, 201; Jacobs and Jones, 48; Daniels, *Marvel*, 78–81; Jordan Raphael and Tom Spurgeon, *Stan Lee and the Rise and Fall of the American Comic Book* (Chicago Review Press, 2003, hereafter *SLRise*), 61; Bell, 90.

66. See Dave Blanchard, "Everybody Loves a Mystery Comic," *Hogan's Alley* no. 19 (2013): 76–80; *365 Days*, "June 3"; quotes Kirby Interview TCJ, 80; *Shop Talk* 208–209.

67. Daniels, *DC*, 67; Daniels, *DC*, 82–83; Savage, 17–18, quote 18; Ferenc Morton Szasz, *Atomic Comics: Cartoonists Confront the Nuclear World* (University of Nevada, 2012), esp. part 2.

68. Davin, 107; "The Rise of the Atomic Knights!," in *Strange Adventures* no. 117 (June 1960), repr. in *Mysteries in Space*, 166–181, 166; "The Cavemen of New York!," *Strange Adventures* no. 123 (December 1960), repr. in *The Atomic Knights* (DC, 2010), 44 (see also 62, 147).

69. Quoted Savage, 19; see Jacobs and Jones, 16.

70. Greg Theakston, "The Road to Spider-Man," in *The Steve Ditko Reader* (Pure Imagination, 2002); Robert Michael "Bobb" Cotter, *The Great Monster Magazines* (McFarland, 2008), 33; Larry Lieber (writer), "I Was a Decoy for Pildorr, the Plunderer from Outer Space!," *Strange Tales* no. 94 (March 1962), repr. in *Marvel Visionaries: Jack Kirby* (Marvel, 2004), 52; Benton, *Horror*, 57.

71. For the often simple twists, see, for example, "I Journeyed Back to the 20th Century!," *Tales to Astonish!* no. 3 (May 1959), "I Dared Defy the Floating Head!," *Tales to Astonish!* no. 8 (March 1960), and "I Saw Droom, the Living Lizard!," *Tales to Astonish!* no. 9 (May 1960), all repr. in *Marvel Masterworks: Atlas Era Tales to Astonish!*, vol. 1 (Marvel, 2006, hereafter *AETA1*); see Cotter, 17; Kirby Interview *TCJ*, 79.

72. Quoted Daniels, *DC*, 131; *SLRise*, 77; Jacobs and Jones, 53; "The Creature That Couldn't Die!," in *Showcase* no. 24 (January/February 1960), repr. in *The Green Lantern Archives*, vol. 1 (DC, 1993), 89.

73. Quoted Jacobs and Jones, 51. Gotham, of course, based on New York City: early visitors remark, "The top of the State Building. Is it really 102 stories high?" and "I've always dreamed of shopping in a Fifth Avenue store." *Detective Comics* no. 53, repr. in *BA2*, 36–49, 37, 42.

74. Quoted *PC*, 46.

75. After writing this, I discovered Jonathan Lethem's similar points in *Give Our Regards to the Atom Smashers!: Writers on Comics*, ed. Sean Howe (Pantheon, 2004), 11. Compare Tom Crippen's very smart "Stan," *TCJ* no. 288 (February 2008): 167–177.

76. See *SLRise*, 91.

77. One person who knew them both said, "Actually, they don't disagree that much, although their terminologies sometimes cause confusion": Mark Evanier, "The Business of Comics," *TCJ* no. 112 (October 1986): 69; quotes Jacobs and Jones, 120; Daniels, *Marvel*, 99.

78. *Shop Talk*, 220–221. Or, more bluntly: "It wasn't possible for Stan Lee to come up with new things—or old things for that matter. . . . Stan Lee is essentially an office worker, OK?": Kirby Interview *TCJ*, 81.

79. *Tales of Suspense* no. 85 (January 1967)—the fight between Captain America and Batroc; Howe, 64; a judicious overview in Hatfield, *Hand of Fire*, 85–98.

80. *Shop Talk*, 217–219; Fingeroth, *Disguised*, 97; Reed Tucker, *Slugfest: Inside the Epic 50-Year Battle Between Marvel and DC* (Sphere, 2017), 19.

81. Compare Lee's deposition, reproduced in "Marvel Worldwide, Inc. et al. v. Kirby et al.— Stan Lee speaks," *20th Century Danny Boy*, March 6, 2011, https://ohdannyboy.blogspot .com/2011/03/marvel-worldwide-inc-et-al-v-kirby-et.html. See also his comments in *Stan Lee's How to Write Comics* (Watson-Guptill, 2011), 83.

82. Quote from Donald F. Glut, "Frankenstein Meets the Comics," in *CBB*, 89–117, 114; "I Spent Midnight with the Thing on Bald Mountain!," *Tales to Astonish!* no. 7 (January 1960), repr. in *AETA1*, 177–181; "I Live Again!," *Tales to Astonish!* no. 8 (March 1960), 189–193.

83. "Interview: Jack Kirby (part 1)," *New Nostalgia Journal* no. 30 (November 1976): 22; Daniels, *Marvel*, 89.

84. Lee, "Introduction," in *Marvel Masterworks: The X-Men* (Marvel, 2002, hereafter *MMX1*), quote 10; *X-Men* no. 2 (November 1963), *MMX1*, 37.
85. Scott Bukatman, "X-Bodies: The Torment of the Mutant Superhero," in *Matters of Gravity: Special Effects and Supermen in the 20th Century* (Duke University Press, 2003), 48–78.
86. Jacobs and Jones, 109; "Bob Haney Interview," *TCJ* no. 278 (October 2006): 172; "Foreword," *Doom Patrol Archives*, vol. 1 (DC, 2002).
87. José Alaniz, "Supercrip: Disability and the Marvel Silver Age Superhero," *IJCA* 6, no. 22 (Fall 2004): 304–324, esp. 311; Alaniz, *Death, Disability, and the Superhero* (University Press of Mississippi, 2014), esp. 35–41.
88. Kirby lurked in the background here, too: he and Simon had come up with a late-'50s character, the Fly, originally called Spider-man, then Silver Spider. Kirby claimed he brought the idea to Lee; Lee was more noncommittal: Joe Simon et al., *The Adventures of the Fly* (Red Circle Productions, 2004), and Kirby's account in *Shop Talk*, 217. For Ditko's response, see Steve Ditko, *The Avenging World* (Robin Snyder and Steve Ditko, 2002), 57–60; for Simon's judicious accounting, see Simon and Simon, 191–204; compare also Florentino Flórez, *Ditko Unleashed!* (IDW, 2016), 64–69. For a public version in the Mighty Marvel manner, filled with cracks about Lee's corniness, obsessiveness, and (yes) his inspiration for Spider-Man, see "How Stan Lee and Steve Ditko Created Spider-Man!," in *Spider-Man Annual* no. 1 (1964). See also Andrew Hultkrans's essay in *Atom Smasher*, esp. 218–219; Daniels, *Marvel*, 130; Howe, 53–54, 81.
89. *LDC*, 138; Daniels, *Marvel*, 95.
90. *Ditko Unleashed!*, 13; Bill Randall, "Ditko's Hands: An Appreciation," in *TCJ* no. 258 (February 2004): 91–93.
91. *Amazing Spider-Man* no. 15 (August 1964), repr. in *Marvel Masterworks: The Amazing Spider-Man*, vol. 2 (Marvel, 2002), 103.
92. *Amazing Spider-Man* no. 9 (February 1964); Jacobs and Jones, 62.
93. Similar points can be made about the Legion's Shrinking Violet and Phantom Girl.
94. Robinson, 90–94; Coulson, 253; Jacobs and Jones, 45; "The Invasion of the Lava Men!," *Avengers* no. 5 (May 1964).
95. Ted White states that the 1940s *Blue Bolt* had letters pages; see "History of Comics Fandom, Part Five," *TCJ* no. 234 (June 2001): 107.
96. *Justice League of America* no. 16 (December 1962), repr. in *Justice League of America Archives*, vol. 3 (DC, 1994, hereafter *JLAA3*), 60; Gambaccini, "Foreword," *JLAA1* (DC, 1992); see Pustz, 166; Jacobs and Jones, 25, 68–69; *Slugfest*, 36; on Bails and Thomas's fandom, see Schelly, *Golden*, 28–35, and Schwartz, *Two Worlds*, 105 (Schwartz used pseudonyms to print even more letters by the duo).
97. Reprinted in *Fantastic Four Omnibus*, vol. 1 (Marvel, 2005), 77; see Pustz, 167; quote Daniels, *Marvel*, 105; Jacobs and Jones, 71.
98. B. Wright, *Nation*, 223; Pustz, 54–55; *SLRise*, 96, 103; the ranks created by future comics writer and historian Mark Evanier.
99. See Stan Lee, "Introduction," Daniels, *Marvel*, 9–10; *Strange Tales* no. 138 (November 1965), in *Marvel Masterworks: Dr. Strange*, vol. 1 (Marvel, 2010, hereafter *MMDS1*), 240; *SLRise*, 4; Coogan, 92.
100. Daniels, *Marvel*, 68; *SLRise*, 53–55.
101. See, for example, "Kamen's Kalamity!," in *Tales from the Crypt* no. 31 (August/September 1952).
102. Reprinted from the *Stanford Chaparral* ca. 1966 in "Neato Vintage College Mag Marvel Ad," *Batfatty*, October 23, 2006, https://batfatty.livejournal.com/57421.html; Howe, 88; *Slugfest*, 23, 28.
103. Quotes D. Thompson, "Axis," 146; Goulart, *Great*, 287; Perry and Aldridge, 161. See also Benton, *Comic Book*, 63–67; Daniels, *Marvel*, 139; B. Wright, *Nation*, 230; Leo Partible, "Superheroes in Film and Pop Culture," *Gospel*, 229–254, 233; *Collected Jack Kirby Collector*, vol. 1 (TwoMorrows, 2004), 88.
104. The wedding also showcased Marvel's change in annuals to event-driven extravaganzas, rather than the earlier DC model of collecting stories. Richard Bruning, "Afterword," in *The Batman Annuals*, vol. 1 (DC, 2009), 260.
105. Quotes *LDC*, 139–140; Scott Edelman, "Stan Lee Was My Co-Pilot," *TCJ* no. 99 (June 1985): 93.

106. "The Coming of the Avengers!," *Avengers* no. 1 (September 1963), repr. in *Marvel Master-works: The Avengers*, vol. 1 (Marvel, 2002); see also Lee's introduction; Jacobs and Jones, 113.

107. Mike Carlin, "Foreword," *Superman Archives*, vol. 5 (DC, 2000, hereafter *SA5*); story is from *Superman* no. 17 (July/August 1942).

108. Lupoff, "Red Cheese," 89; Paul Gravett, *Graphic Novels: Everything You Need to Know* (Aurum, 2005), 74; *S2*, 18–19; "The Last Days of Superman," *Superman* no. 156 (October 1962), in *Superman in the Sixties* (DC, 1999), 89.

109. Jacobs and Jones, 95, 122.

110. Julius Schwartz, "Foreword," *The Greatest Team-Up Stories Ever Told* (DC, 1989), 6–9, 8; see *Crisis on Multiple Earths: The Team-Ups*, vol. 1 (DC, 2005), 13.

111. Cazedessus, 287–288; D. Thompson, "Axis," 139.

112. *Tales of Suspense*, nos. 63 (March 1965) and 72 (December 1965). In 1976, Kirby said the FF "was a revolution in the sense that it was Now." "Interview: Jack Kirby (part 1)," *New Nostalgia Journal* no. 30 (November 1976): 21–22, 22.

113. *Fantastic Four*, nos. 44–60 (November 1965–March 1967).

114. Lenthall, 53–57.

115. Ron Evry, "Activists!," *TCJ* no. 178 (July 1995): 48; James Romberger, "Big Apple Con Report," *Beat*, April 16, 2018, https://www.comicsbeat.com/big-apple-con-report-finally-revealed-the-artist-of-the-martin-luther-king-jr-comic.

116. R. C. Harvey, "Rambling Around the Reubens," *TCJ* no. 254 (July 2003): 32.

117. See, for example, Jackson, *Pioneering*, 91. Cited in *BWC*, 493; see also Reitberger and Fuchs, 244; Harvey, *Children*, 147; *JRC*, 283; Reitberger and Fuchs, 147; see "Dismantler of Black Stereotypes," *TCJ* no. 158 (April 1993): 24; "What's the Color of Your Blood?," *Our Army at War* no. 160 (November 1965), repr. in *AAW*, 149–163.

118. B. Wright, *Nation*, 219.

119. Compare Hatfield, *Hand of Fire*, 145–146, on Kirby's "technological sublime"; Goodrum, 122–124.

120. His first appearance is in *Fantastic Four* no. 52, cover-dated July 1966. See *Black Panther: Panther's Rage* (Marvel, 2016) for reprint; for "Coal Tiger" reference, see 128. Kirby: "I came up with the Black Panther because I realized I had no Blacks in my strip. I'd never drawn a Black. I needed a Black. I suddenly discovered I had a lot of Black readers. My first friend was a Black! . . . And here I am a leading cartoonist and I wasn't doing a Black." (Kirby Interview *TCJ*, 85). See also Howe, 85.

121. On Griffin, see Patrick Rosenkranz, *Rebel Visions: The Underground Comix Revolution, 1963–1975* (Fantagraphics, 2002), 10–11.

122. Quote Gerber, 220; Jacobs and Jones, 147; Donald Palumbo, "Science Fiction in Comic Books: Science Fiction Colonizes a Fantasy Medium," in C. W. Sullivan III, *Young Adult Science Fiction* (Greenwood Press, 1999), 161–182; "Return to the Nightmare World!," *Strange Tales* no. 116, repr. in *MMDS1*, 24; Jean-Paul Gabilliet, "Cultural and Mythical Aspects of a Superhero: The Silver Surfer, 1968–1970," *JPC* 28, no. 2 (1994): 203–213.

123. *Ditko Unleashed!*, 124–133; Zack Kruse, "Overwhelmed by a Cloak of Darkness: Steve Ditko's Dark Karma and Cosmic Inner Space," *Inks* 1, no. 3 (Fall 2017): 267–287.

124. Paul Davies, *Exactly 12¢ and Other Convictions* (ECW Press, 1994), 25; Dyer, in *Atom Smash-ers*, 41; *Steranko: Graphic Narrative* (Winnipeg Art Gallery, 1978), 2–4, quote 4; Steranko, in "The First Rule: There Are No Rules," in *Education of a Comics Artist*, 67–72, 70.

125. Reprinted in *Nick Fury, Agent of S.H.I.E.L.D.* (Marvel, 2000), 62, 97.

126. *Nick Fury, Agent of S.H.I.E.L.D.* (Marvel, 2000), 125; see Jacobs and Jones, 111–112, 144–146; *LDC*, 141; *Nick Fury, Agent of S.H.I.E.L.D.* (Marvel, 1990), 27.

127. Matthew J. Costello, *Secret Identity Crisis: Comic Books and the Unmasking of Cold War Amer-ica* (Continuum, 2009), esp. 12–14, 60–72.

128. *Tales of Suspense* no. 39 (March 1963), repr. in *Marvel Masterworks: The Invincible Iron Man* (Marvel, 2010), 2; Jacobs and Jones, 90; Leonard Rifas, "Cold War Comics," *IJCA* 2, no. 1 (Spring 2000): 3–32, 17–19; John Donovan, "Cold War in Comics," in Julian C. Chambliss et al., *Ages of Heroes, Eras of Men: Superheroes and the American Experience* (Cambridge Schol-ars, 2013), 58–75.

129. Howe, 38.

130. "Stan the Man Raps with Marvel Maniacs at James Madison University," *TCJ* no. 42 (1978):

44–55, 47; Mark Evanier, "Introduction," *Jack Kirby's OMAC: One Man Army Corps* (DC, 2008).

131. Robert Klein and Michael Uslan, "Foreword," *T.H.U.N.D.E.R. Agents Archives*, vol. 1 (DC, 2002); see *Spy vs. Spy: The Complete Casebook* (Watson-Guptill, 2001), 6–11, 30.

132. Richard E. Hughes and Ogden Whitney, *Herbie Archives*, vol. 1 (Dark Horse, 2008).

133. *LDC*, 139; quote Daniels, *DC*, 138.

134. Andy Medhurst, "Batman, Deviance, and Camp," in *Many Lives of the Batman*, 158; Adam West, "Introduction," *Batman in the Sixties* (DC, 1999); Vaz, 88–89, quote 89.

135. Quotes Lynn Spigel and Henry Jenkins, "Same Bat Channel, Different Bat Times: Mass Culture and Popular Memory," in *Many Lives of the Batman*, 117–148, 120, 123.

136. From "Batman's New Look," *Batman in the Sixties*; *Batman* no. 164 (June 1964), in *Batman: The Dynamic Duo Archives*, vol. 1 (DC, 2003), 30; Benton, *Comic Book*, 69.

137. Jake Black, "Flop of Steel," *IJCA* 7, no. 1 (Spring 2005): 546–552.

138. *Brave and the Bold* no. 54 (June/July 1964), repr. in *The Silver Age Teen Titans Archives*, vol. 1 (DC, 2003, hereafter *TTA1*), 11; *Showcase* no. 59 (November/December 1965), in *TTA1*, 61.

139. *Justice League of America* no. 1 (November/December 1960), repr. in *JLAA1*, 121; "The Negative-Crisis on Earths One-Two!," *Justice League of America* no. 56 (September 1967), *Justice League of America Archives*, vol. 7 (DC, 2001), 144; *Blackhawk* no. 228 (January 1967); quote Jacobs and Jones, 105; Goulart, *Fifty*, 265.

140. Shooter quote Jacobs and Jones, 85; Howe, 174–177; "One of Us Is a Traitor!," *Adventure Comics* no. 346 (July 1966), repr. in *Legion of Super-Heroes Archives*, vol. 5 (DC, 1994), 128; "The Outcast Super-Heroes!," *Adventure Comics* no. 350 (November 1966), repr. in *Legion of Super-Heroes Archives*, vol. 6 (DC, 1996), 29; "The Hapless Hero," *Action Comics* no. 381 (October 1969), repr. in *Legion of Super-Heroes Archives*, vol. 9 (DC, 1999, hereafter *LSH9*), 134–145; "Brainiac 5's Secret Weakness!," *Superboy* no. 204 (September/October 1974), repr. in *Legion of Super-Heroes Archives*, vol. 11 (DC, 2001), 44–51.

141. Alvin Schwartz, "Foreword," *Batman: The Dark Knight Archives*, vol. 6 (DC, 2009); Vaz, 94; Bill Boichel, "Batman: Commodity as Myth," in *Many Lives of the Batman*, 4–17, 15; cover is of *Batman* no. 183 (August 1966).

142. Goulart, *Great*, 290; Schwartz, *Two Worlds*, 119–120; quote Matthew Paul McAllister, "Cultural Argument and Organizational Constraint in the Comic Book Industry," *Journal of Communication* 40, no. 1 (1990): 55–71, 62–63; Reitberger and Fuchs, 54.

143. "Mass Culture and Popular Memory," 130; Bell, 126. The book's commissioning editor was E. L. Doctorow. "Feiffer Ends," *TCJ* no. 224 (June 2000): 15.

144. Feiffer, *Heroes*, 185. The first fanzine focused entirely on comics was Malcolm Willits and Jim Bradley's *Comic Collectors' News*, in October 1947; there were many "double fans" (of SF and comics), and some fanzines reflected both. See Pustz, 30.

Chapter 5: Comix with an X

1. Compare Berger, *Comic-Stripped American*, 217; Estren, 195–197. Shelton had already graduated: see Patrick Rosenkranz, *Rebel Visions: The Underground Comix Revolution, 1963–1975* (Fantagraphics, 2002), 19–20.

2. The early *Wonder Wart-Hog* (1961–1963) is collected in *(Not Only) The Best of Wonder Wart-Hog*, 3 vols.; this is from vol. 2, p. 4.

3. *Wonder Wart-Hog* no. 1 (Winter 1967), 16.

4. Frank Stack, *The New Adventures of Jesus: The Second Coming* (Fantagraphics, 2006), 19.

5. He'd first published them in a fanzine, *The*; Gilbert Shelton, "Introduction," in *New Adventures*, 9; Stack, "Some Notes on the Origins of My Jesus Cartoons," *New Adventures*, 11–16; Gardner, 116–117.

6. Jaxon, *God Nose* (Rip Off Press, 1971), 8; Stanley Wiater and Stephen R. Bissette, *Comic Book Rebels: Conversations with the Creators of the New Comics* (Donald I. Fine, 1993), 33.

7. He's literally, as the piece's title indicates, "My Son, the Folksinger": *God Nose*, 11–18. After writing this, I saw Gary Groth's identical comparison in "Tejano Cartoonist: An Interview with Jack Jackson," *TCJ* no. 61 (Winter 1980–1981): 100–111, 101; *God Nose*, 2, 5, 11. Wonder Wart-Hog also addressed civil rights; visiting the ghetto, he beats himself up for being part of the problem: "Wonder Wart-Hog Visits the Ghetto," *Wonder Wart-Hog* no. 1 (1967), 40.

"Jack Jackson's Long Ride Comes to an End," *TCJ* no. 278 (October 2006): 22; "A Tribute to Jaxon," *TCJ* no. 278 (October 2006): 34.

8. Robert Crumb, "The Straight Dope from R. Crumb," *TCJ* no. 121 (April 1988): 58, 60; *Coffee Table*, 48; *The Complete Crumb Comics*, vol. 4, *Mr. Sixties!* (Fantagraphics, 1989, hereafter *CCC4*), x. The head of the department of humorous cards, Tom Wilson, went on to create Ziggy; Mort Walker, for his part, put in time at Hallmark: *Mort Walker's Private Scrapbook* (Andrews McMeel, 2000), 35.

9. Crumb, "Twenty Years Later . . . ," in *R. Crumb's Head Comix: Twenty Years Later* (Fireside, 1988; Viking, 1968).

10. See Crumb, "Introduction," *R. Crumb's The Yum Yum Book* (Scrimshaw Press, 1975). His feeling weird started early, too: hit in the mouth with a rock at twelve, "all through my high school years I walked around with two front teeth missing": "Straight Dope," 55.

11. "A Note of Interest," *Joel Beck's Comics and Stories* (1977), 36; Trina Robbins, "Underground Pioneer Joel Beck Dies," *TCJ* no. 217 (November 1999): 27; Dan Donahue, "How I Went Underground," in *The Apex Treasury of Underground Comics* (Omnibus Press, 1974), 6–7, 6; Scott McCloud, *Understanding Comics: The Invisible Art* (HarperPerennial, 1993, hereafter *UC*), 13; *LDC*, 168; *CCC4*, x.

12. Geoff Dyer's essay in *Atom Smashers*, 39; *PC*, 52–53; Rosenkranz, 172; Edwin Pouncey, "The Black Eyed Boodle Will Knife Ya Tonight!: The Underground Art of Rory Hayes," in *Where Demented Wented: The Art and Comics of Rory Hayes* (Fantagraphics, 2008), 11.

13. Quoted in Gardner, 120.

14. Patrick Rosenkranz, "For Adult Intellectuals Only: A *Zap* Oral History," *The Complete Zap Comics*, vol. 5 (Fantagraphics, 2014), 885; "Meatball!," *Zap* no. 0, in *The Complete Zap Comix*, vol. 1 (Fantagraphics, 2014), 3–6, quote 6; J. Carlin, "Masters," 124.

15. *CCC4*, 54; *Complete Zap Comix*, 1:31–34.

16. *Yellow Dog Comix* no. 8, 7; "Mr. Natural Goes to a Meeting of the Minds," in *Apex Treasury*, 16–20; "Mr. Natural Meets God," *Head Comix*.

17. The first issue's original artwork seemingly disappeared; the second issue was released as the first, the original only released when Crumb inked over Xeroxes of his original drawings: Bob Levin, *Outlaws, Rebels, Freethinkers & Pirates* (Fantagraphics, 2005), 19–26; Donahue, 7; Rosenkranz, 68–72.

18. Crumb, "Twenty Years Later . . . ," quoted in Patrick Rosenkranz, "An Oral History," *witzend* no. 2 (1967), vii–xvi, vii; Bill Pearson, "Witzend, Beginning to End," *witzend*, vol. 1 (Fantagraphics, 2014), xv–xxiii, xvi; *witzend* no. 1 (1966), repr. in *witzend*, 1:2; *witzend* no. 3 (1967), repr. in *witzend*, 1: 82; *witzend*, no. 7 (1970), repr. in *witzend*, 1: 238, 242; see also Jacobs and Jones, 131; Ken Parille, "Steve Ditko—HA! / AH!—Laughing at Death," *TCJ*, August 25, 2011, http://www.tcj.com/steve-ditko-%E2%80%94-ha-ah-%E2%80%94-laughing-at-death; Kruse, "Ditko's Dark Karma."

19. "Adult Intellectuals," 893, 901; Dez Skinn, *Comix: The Underground Revolution* (Thunder's Mouth, 2004), 37; "Victor Moscoso Interview," *TCJ* no. 246 (September 2002): 60–61, 68; Pearson, "Beginning to End," xviii; Rosenkranz, 84–86.

20. *The Mythology of S. Clay Wilson*, vol. 1, *Pirates in the Heartland*, ed. Patrick Rosenkranz (Fantagraphics, 2014), 181; "The Skip Williamson Interview," *TCJ* no. 104 (January 1986), 52; "Before the Underground," 79–80; Marty Pahls, "Introduction," *The Best of Bijou Funnies* (Omnibus Press, 1974), 6–14, 6; *CCG*, 104; Dave Schreiner, *Kitchen Sink Press: The First 25 Years* (Kitchen Sink, 1994), 5; cover of *Mom's Homemade Comics* no. 2 (Winter 1969–1970); Spiegelman quote in Schreiner, *Kitchen*, 48; see also 15, 17—for less wholesome material, see issue no. 3; Charles Brownstein, "Who Is Denis Kitchen?," in *The Oddly Compelling Art of Denis Kitchen*, ed. Mike Richardson (Dark Horse, 2010), 11–48.

21. "Let's Be Honest," *Snarf* no. 2 (August 1972), 21; Kitchen, "The Underground Cartoonist," *Snarf* no. 4 (August 1976), 9.

22. "Rip Off Press," *TCJ* no. 92 (1984): 70, quote 71; Rosenkranz, 132.

23. Craig Yoe, *Secret Identity: The Fetish Art of Superman's Co-Creator Joe Shuster* (Abrams Comic-Arts, 2009), esp. 15–22, quotes 17, 161; "Joe Shuster," *TCJ* no. 153: 23; *MOT*, 200–202, 208, 247–250. Simon and Kirby had gotten a piece of *Captain America*, but this was less well known: Bell, 67. Marston got an even better deal on *Wonder Woman*, including a rights reversion clause and royalties in perpetuity.

24. See *Caniff: A Visual Biography*, ed. Dean Mullaney (IDW, 2011), 232–243.
25. "Interview: Denis Kitchen," *Vault of Mindless Fellowship* no. 2 (December 1972, hereafter *VMF2*), 7. See also *LDC*, 176; *UC*, 15.
26. "Bill Griffith Interview," *TCJ* no. 157 (March 1993): 68; "Staying Alive!," *TCJ* no. 92 (1984): 83.
27. See the Kitchen Sink T-shirt advertisement from Faith Concepts Inc., in *Smile* no. 3 (1972); Skinn, 132; *Pirates*, 194.
28. *Bogeyman Comics* no. 1 (1969), 3–6. Hayes, who died of a drug overdose at age thirty-four in 1983, pioneered a "naïve/primitive style" credited as an influence by Aline Kominsky-Crumb and Mark Beyer. See his obituary in "Newswatch," *TCJ* no. 87 (December 1983): 23; Pouncey, "Boodle," 7–17.
29. *Skull Comics* no. 1 (1970), 2.
30. *GBW* no. 6 (1969), 7; *GBW* no. 8 (1969), 14.
31. *Fantagor* no. 1 (1970), 2; *Grim Wit* no. 1 (1972).
32. See Reidelbach, 36, 187, Spain's comments in "Pioneers of Comix Panel," *TCJ* no. 251 (March 2003): 117, and "Carl Barks (1901–2000)," *TCJ* no. 227 (September 2000): 44; Estren, 38.
33. See, for example, Nancy Griffith, "Love on the Run," *Young Lust* no. 4 (1974), 2.
34. Bill Griffith, *Young Lust* no. 1 (1970), 3–7; compare also "They Called Our Young Love Porno-Graphic . . . But We Don't Care!," *Young Lust* no. 1 (1970), 20–27.
35. "Incest!," *Bizarre Sex* no. 1 (1972), 3–13.
36. Marty Pahls, "Right Up to the Edge," in *The Complete Crumb Comics*, vol. 1, *The Early Years of Bitter Struggle* (Fantagraphics, 1987, hereafter *CCC1*), vii.
37. Appearing as early as the mid-'60s for an intended "new obscene comic book" called *Fug* no. 1 (1965); see *The Complete Crumb Comics*, vol. 3, *Starring Fritz the Cat* (Fantagraphics, 1988), 100ff. A Fritzian figure appears as early as 1961 (in "Animal Town"), and by name as early as 1962, but these weren't published; see *CCC1*, 106, and *The Complete Crumb Comics*, vol. 2, *Some More Years of Bitter Struggle* (Fantagraphics, 1988), 13ff. See also Skinn, 84–85.
38. *Coffee Table*, 3; "Straight Dope," 56; *Head Comix*; Horn, *Sex*, 14; Otto Mesmer, *Nine Lives to Live* (Fantagraphics, 1996), 12, 48, 49–62, 83–85; Canemaker, *Felix*, 78–80.
39. The *Realist* also infamously published a piece about LBJ having sex with JFK's corpse: see Gardner, 122–123, *UC*, 13; Krassner, "In Praise of Offensive Cartoons," in *Education of a Comics Artist*, 8–14, 12–13, quote 11; Paul Krassner, "A Case History of the Disneyland Memorial Orgy Poster," *The Life and Legend of Wallace Wood*, vol. 2 (Fantagraphics, 2018), 37–43.
40. On O'Neill, the group surrounding him, the Air Pirates, and the legal proceedings, see Bob Levin, "The Pirate and the Mouse, Part Two," *TCJ* no. 239 (November 2001): 34–63, quote 43–44.
41. "O'Neill in the Dock," *Dan O'Neill's Comics and Stories* 2, no 1 (1975): 32, 34; Armstrong, "Feelin' Kinda Disney," *Mickey Rat* no. 2 (1972): 3–8, 7–8. Nazi and Disney imagery were sometimes mixed (a Rick Griffin inside back cover for *Zap* no. 3, "Gung Ho!," featured a Mickey Mouse character holding a Coke in one hand and a swastika in the other). Robert Williams, a slightly later *Zap* contributor with swastika-and-Nazi-eagle-sporting stationery imprinted with *Der Führer*, noted, "This was in the '60s. The general public hadn't adjusted to really filthy, liberal thinking completely."
42. Quoted in *Pirates in the Heartland*, 176.
43. As a University of Nebraska student, the story goes, he chased a professor up the halls with a pirate's cutlass; in ROTC medic training, "explicit movies about combat wounds" that he saw served him well in his later drawing: John Gary Brown's introduction to *Pirates in the Heartland*, 4–7, 5; *Pirates in the Heartland*, 68, 96–105; Skinn, 49; *S. Clay Wilson Portfolio Comix*; *Pirates in the Heartland*, 31; *Pirates in the Heartland*, 96–105.
44. Quoted in *Pirates in the Heartland*, 142; "Insect Angst," *Insect Fear* no. 2 (1970).
45. Shelton, *Feds 'n' Heads Comics* (1968).
46. See Shelton, "Freak Brothers History," in *The Complete Fabulous Furry Freak Brothers*, vol. 1 (Knockabout Comics, 2001, hereafter *Fabulous*). Stories appear in volume passim. The last, "Mexican Odyssey," was a long-ranging mid-'70s story, generally published one page a week in some of the remaining alternative newspapers.
47. "The Freaks Pull a Heist," in *Fabulous*; Skip Williamson, *The Scum Also Rises: An Anthology of Comic Art by Skip Williamson* (Fantagraphics, 1988), 31, 29; "Sappy Sammy Smoot Goes to a Rock Festival," *Hungry Chuck Biscuits and Stories* no. 1 (1971), 15–17, 17.

48. *Yellow Dog* no. 7 (1968), 4; *Breakdowns*, "Afterword."

49. *Coffee Table*, 77; see *Coffee Table*, 70, for a sketchbook page going from naturalistic drawing to one influenced by LSD; "Straight Dope," 69; "Adult Intellectuals," 927; Skinn, 34; Crumb, "Twenty Years Later . . ."

50. Quote Estren, 75; on Thompson, see Dan Nadel, *Art in Time* (Abrams ComicArts, 2010), 198.

51. "Moscoso Interview," 53. Compare the pure, surrealistic weirdness of 1971's *Armadillo Comics*, as if Dalí had really been into armored mammals. Doug Hansen's similar *Animal 8 Pager* (1974) features surprisingly placed seacows.

52. Rick Griffin, "Mystic Eyes," *Tales from the Tube* no. 1 (1973), 15–17; *Man from Utopia* (1972); "Remembering the Cosmic Visions of Rick Griffin," *TCJ* no. 145 (October 1991): 13; "Adult Intellectuals," 875–953, 876; Estren, 79; "Rick Griffin Interview," *TCJ* no. 257 (December 2003): 81. In 1973, Griffin published the EC-like surfing anthology *Tales from the Tube*; inside, Jesus rides a wave, along with alien robot surfers (or something).

53. Gore, *Up from the Deep* no. 1 (1971), 11–18.

54. "Wyatt Winghead: 52nd Century," *American Flyer Funnies* no. 2 (1972), 36; Dave Sheridan, "The Fun House," *Mother's Oats Comix* no. 2 (1971), 23–34, 23; R. Crumb, "Introduction," *Complete Zap* 5: 871.

55. Estren, 92, 206; Kim Deitch, "Introduction," in *Beyond the Pale!: Krazed Komics and Stories by Kim Deitch!* (Fantagraphics, 1989); Gardner, 118; "Kim Deitch Interview," 80.

56. *Heavy Tragi-Comics* no. 1 (1969), 2, 18–33.

57. *Moondog* no. 3 (1973), 27. Metzger, a cattle rancher's son, rhapsodized about the lifestyle of the road, preaching an idealistic, back-to-the-land sensibility. Compare "A Short Trip about Hitchhikin'," *Truckin* no. 1 (1972), 11–13; "George Metzger," *TCJ* no. 87 (December 1983): 79, 82.

58. "The Pipe and Dope Book," *Dr. Atomic* no. 4 (1976) and *Dr. Atomic's Marijuana Multiplier* (1974): "Isomerize your marijuana and hasheesh to increase its potency up to 5 or 6 times!" Dr. Atomic says on the front cover.

59. Dave Sheridan, "Slow Death Funnies," *Slow Death* no. 1 (1970), 18; examples of alien stories are James Osborne, "Routine," *Slow Death* no. 2 (1972), 19–24, and Michael T. Gilbert, "Balance," *Slow Death* no. 8 (1977), 23; *Yellow Dog* no. 15 (1969), 27–32; *Captain Guts* no. 1 (1969), 25; "The Wall," *San Francisco Comic Book* no. 2 (March/April 1970), 5–7. Even the Students for Democratic Society got into the mix with *Radical America Komiks*, an issue of their magazine *Radical America*, with contributions by Shelton (a Nick Fury parody) and Wilson.

60. See Skinn, 18. An early underground biker comic, George DiCaprio and R. Jaccoma's *Greaser Comics* (1971–1972) also looked back to the '50s, focusing on an underbelly of explicit sex and graphic violence.

61. *Apex Treasury*, 141; Spain, "Ultra-Violence," *San Francisco Comic Book* no. 4 (1973), 14, 23; "Adult Intellectuals," 899; "Spain Interview," *TCJ* no. 204 (May 1998): 69–72; Patrick Rosenkranz, "Spain Rodriguez: Still Cruisin' After All These Years," *TCJ*, April 26, 2012, http://www.tcj.com/spain-rodriguez-still-cruisin%E2%80%99-after-all-these-years.

62. "Spain Interview," 53–54. He also grabbed every *Fantastic Four* issue off the stands (73). Rosenkranz, 112–113.

63. *Trashman Lives!: The Collected Stories from 1968 to 1985* (Fantagraphics, 1989), 30, 22; Skinn, 50.

64. Compare Gilbert Shelton, "Believe It or Leave It!," in *Zap Comix* no. 5 (1970), repr. in *Complete Zap Comics*, vol. 2 (Fantagraphics, 2014), 237–238.

65. "Trina Robbins," 86.

66. Under the name Von; Jean-Paul Gabilliet, "Postface," in Vaughan Bodé, *Das Kampf* (Éditions aux forges de Vulcain, 2013; 1963), 51–65. Bodé was also, in his son's words, a bisexual and transvestite, part of his "hyper-persona": "The Mark Bodé Interview," *TCJ* no. 270 (August 2005): 125–126.

67. *Das Kampf*, 7, 9, 15, 33, 46.

68. Gabilliet, "Postface," 59–60.

69. There *are* references to American, German, and Russian soldiers, the Cold War, and World War II: Gabilliet, "Postface," 61.

70. See "Joe Kubert Interview," *TCJ* no. 172 (November 1994): 87.

71. Quote Reitberger and Fuchs, 93; Cooke, "Glanzman," xvi; Barker, *Ideology, Power*, 19. Similar

approaches appeared in Warren's *Blazing Combat* and Charlton's *Fightin' Army*: see "The Rock!," *G.I. Combat* no. 68 (January 1959), repr. in *Sgt. Rock Archives*, vol. 1 (DC, 2002, hereafter *SRA1*), 7–20; *Our Army at War* no. 83 (June 1959), repr. in *SRA1*, 68; *Our Army at War* no. 151 (February 1965), repr. in *Enemy Ace Archives*, vol. 1 (DC, 2002, hereafter *EAA1*); *Star-Spangled War Stories*, no. 139 (July 1968), repr. in *EAA1*, 125.

72. *Junkwaffel* no. 2 (1972), back cover. Lizard-men were a Bodé trademark, stemming from a high school joke that he resembled one, combined with his belief that lizards are the "basic man . . . a walking bundle of phallic symbolism and masturbatory violence." The alien aspect highlights his career as an SF illustrator: he won a Hugo in 1968. Bodé was also known for his erotic comics: Bodé, *Deadbone Erotica* (Bantam, 1971), 10; *Deadbone Erotica*, vol. 2 (Fantagraphics, 1988), front matter.

73. Stack, *New Adventures*, 67; see Stack, *New Adventures*, 158.

74. Compare Joseph Witek, "The Dream of Total War: The Limits of a Genre," *JPC* 30, no. 2 (Fall 1996): 37–46, esp. 41–42.

75. *GBW* no. 3 (1969), 4—compare similar phallic symbolization in Jim Gardner's "Only in America," *Yellow Dog* no. 20 (1971), 29–31; Paul Krassner, "Introduction," in Badajos, *Dick! The Nixon Era* (Head Imports, 1972), 5; *Commies from Mars* no. 1 (1973), 3–5. In David Geiser's 1971 *Uncle Sham*, "Spiri Duck and Dicky Mouse" visit the land of "bilk and money," an X-rated Nazi acid Wonderland, and serve as Tweedle Dee and Tweedle Dumb. "Let's Get Sick with Spiri and Dick," *Uncle Sham* no. 1 (1971), 3–11; see also Geiser, "The True Identity of King Dick," *Uncle Sham* no. 1 (1971), 2.

76. *Teen-Age Horizons of Shangrila* no. 2 (1972), 3–7, 5.

77. Quotes in "Adult Intellectuals," 900; *CCG*, 95.

78. *Complete Zap*, 1:55, 66.

79. *Coffee Table*, 109.

80. In *Who's Afraid of Robert Crumb?* (Musée de la bande dessinée, 1999), 15; *Despair* (1970), repr. in *The Complete Crumb Comics*, vol. 6, *On the Crest of a Wave* (Fantagraphics, 2013), 95. R. Fiore, "His Trouble with Women," *TCJ* no. 180 (September 1995): 33–38.

81. *Uncle Sham* no. 2 (1971), 20–23, quote 21.

82. *GBW* no. 6 (1969), 19–22.

83. Harvey, *Sex*, 29.

84. There were also *Snatch Comics* ("The Only High Grade Sex Comic!"; illustration from the first issue, published in October 1968, repr. in *CCC5*, 51), and *Cunt Comics* ("The Only Comic You Can Eat!"); Skinn, 60; *Snatch Comics Treasury* (Apex Joint Ventures, 2011).

85. "Exposing th' Younger Generation ta Some O' th' Facts of Life!," under the pseudonym J. O. Jackinov, speaks for itself: *Jiz Comics* no. 1 (1969), 2, 8, 31.

86. The cover of *Turned On Cuties* (1972) proclaimed, "Featuring . . . Nordic Nymphs, Sepia Sizzlers, The Girls of Juarez, Girls Girls Girls!," *Good Jive*: see "Stupid Stud," *Good Jive* no. 2 (1973), 10–16, and "A Guest," *Good Jive* no. 1 (1972), 3–9.

87. Gilbert Shelton, "Wonder Wart-Hog Breaks Up the Muthalode Smut Ring," *Zap Comix* no. 4 (1969), 181–185, quotes 182; Crumb sometimes signed some of his dirtier ones "R. Scum," "Crumbum," or "El Crummo"; Horn, *Sex*, 91; "Soupygoy," *Tales of Sex and Death* no. 1 (1971), 3–7; *GBW* no. 6 (1969), 5–6.

88. "Adult Intellectuals," 919; Spain, "The Sexist," *Young Lust* no. 7 (1990), 39–42, 42. Arguably also the ethos behind his "Big Bitch" comics, the big-bosomed heroine seems simultaneously to take no male prisoners and be constantly enslaved to male desire: see Spain, *She Comics: An Anthology* (Last Gasp, 1993).

89. *Bogeyman* no. 2 (1969); *Zap Comix* no. 5 (1970), repr. in *CCC5*: 110. Notably, Wilson, an alcoholic, was known to be verbally abusive to girlfriends: see Lorraine Chamberlain, "Introduction," *The Mythology of S. Clay Wilson*, vol. 3: *Belgian Lace from Hell*, ed. Patrick Rosenkranz (Fantagraphics, 2014), 7.

90. *Trashman Lives!*, 32–50, 35; Spain Rodríguez (as Algernon Backwash), "Mutiny on Stellar Craft Nimbus 3," *Mean Bitch Thrills* no. 5 (1971); *Apex Treasury*, 52–59, quotes 52, 59; *Apex Treasury*, 61. For Crumb's own (typically self-lacerating) embrace of the term *misogynist*, see "Robert Crumb Interview," *TCJ* no. 180 (September 1995): 124–126.

91. An exception to the underground rule: Shelton. Robbins: "Shelton is funny as hell and I have *never* seen a sexist cartoon by him"; quote Estren, 60.

92. Quotes Robbins and Yronwode, 6; "Newswatch," *TCJ* no. 94 (October 1984): 12–13.

93. "Trina, Queen of the Underground Cartoonists: An Interview," *JPC* 12, no. 4 (1979): 737–754, 741; "Kim Deitch," *TCJ* no. 123 (July 1988): 69. Robbins and Deitch announced the 1970 birth of their daughter "with a joint comic panel, which was published as a poster and also appeared in underground newspapers around the country": Estren, 96; Trina Robbins, "babes & women," in *The Complete Wimmen's Comix*, vol. 1 (Fantagraphics, 2016, hereafter *CWC1*), vii–xiii, vii; Robbins, *Brinkley Girls*, 86; "Trina Robbins," *TCJ* no. 223 (May 2000): 81–83. She'd also admired Kirby and Ditko.

94. Jams (although not called such) weren't an underground invention: Opper, Dirks, and Charles Schultze occasionally collaborated, each introducing their own characters to a strip; in "Kamen's Kalamity," Johnny Craig, Jack Davis, and Graham Ingels each appear, drawn by themselves, tormenting a voodoo doll that looks like Gaines; Becker, 19; *Those Were . . . the Terrible, Shocking . . .* ; *Pirates in the Heartland*, 183; Bruce Chrislip, "Jammin' the Toons," *TCJ* no. 165 (January 1994): 75–80.

95. "An Interview with Trina Robbins: The First Lady of Underground Comix," *TCJ* no. 53 (Winter 1980): 46–58, 48.

96. In *Gothic Blimp Works*, Robbins produced ongoing adventures of Panthea, a takeoff of "good girl" Fiction House jungle comics (which she characterized as featuring "strong, beautiful, competent heroines"), specifically Pantha, from postwar *Thrilling Comics*. A half-girl, half-lion mix, she rescues a lion from a zoo and rides on it, a liberator and her own Diana: *GBW* no. 3 (1969), 23; no. 5 (1969), 23; no. 6 (1969), 23; no. 7 (1969), 6–7; Goulart, *Good Girl Art*, 59; quote Price, "Ectoplasmic," 11.

97. Robbins, "God Paperdolls," *All Girl Thrills*, 11; Robbins, "babes," viii–ix.

98. On Kominsky-Crumb and "Goldie," see Hillary L. Chute, *Graphic Women: Life Narrative and Contemporary Comics* (Columbia University Press, 2010), 29–37, esp. Chute's precise characterization of Kominsky-Crumb's "hyperexaggerated expressionism" (29). See also Chute's foreword to Aline Kominsky-Crumb, *Love That Bunch* (Drawn & Quarterly, 2018).

99. *CWC1*, 39–43, quote 43; "Aline Kominsky-Crumb Interview," *TCJ* no. 139 (December 1990), 58 (hereafter AKC Interview); "Sandy Comes Out!," *CWC1*, 54–56; "All in a Day's Work" and "So, Ya Wanna Be an Artist," *CWC1*, 48–52, 99; "Trina Robbins," 86.

100. Robbins, "babes," x; *Wimmen's Comix* no. 2 (1973), inside front cover; in 1943, Marston put a similar "Wonder Woman for President" slogan on the cover—with the proviso it would happen in a thousand years; Greenberger, 106.

101. *Tits & Clits Comix* no. 1 (1972), 3–14, 8. "With Little Help from a Friend," *Tits & Clits Comix* no. 1 (1972), 16–17; Fonda Peters, "Vaginal Drip," *Tits & Clits Comix* no. 1 (1972), 18–23.

102. *Manhunt!* no. 1 (1973), 2; *Manhunt!* no. 2 (1974), 20; *Manhunt!* no. 2 (1974), 31–34, 31; Chin Lyvely, "Love Is . . . ," *Pandora's Box Comics* no. 1 (1973), 17; "Those Perfectly Permeable Peters Sisters," *Pandora's Box Comics* no. 1 (1973), 26; *As Naughty as She Wants to Be* (Fantagraphics, 1995), 63–66; Marrs, *The Further Fattening Adventures of Pudge, Girl Blimp* (Marrs-Books, 2016), 7—the original comic was published between 1973 and 1977; Skinn, 160.

103. Robbins, "Editorial," *Wet Satin* no. 2 (1978), 2.

104. Farmer would write about her own 1970 abortion in similar detail years later. "Joyce Farmer: Day Four," *TCJ*, May 12, 2011, http://www.tcj.com/joyce-farmer-day-four.

105. See selections in *Toon Treasury*, 61–67; Donald Phelps, "Rising Generations: The Unorthodox Kid Comics of Sheldon Mayer," *TCJ* no. 271 (October 2005): 63.

106. Bhob Stewart, "Ernie Bushmiller and Al Capp," *Potrzebie*, December 2, 2010, http://potrzebie .blogspot.com/2010/12/ernie-bushmiller-and-al-capp.html; for an autobiographical page Caniff drew for *Collier's* in 1948, see Bhob Stewart, *Potrzebie*, June 10, 2011, http://potrzebie .blogspot.com/2011/06/milton-caniff-drew-this.html.

107. Henry (Yoshitaka) Kiyama, *The Four Immigrants Manga: A Japanese Experience in San Francisco, 1904–1924* (Stone Bridge Press, 1998), with an invaluable introduction by Frederik Schodt: see introduction, 10–13; quote 79.

108. See Jon B. Cooke, "A Sailor's History: The Life and Art of Sam J. Glanzman," in Glanzman, *U.S.S. Stevens: The Collected Stories* (Dover, 2016), xi–xxvi, xii, 43, 65–68, 98–99, 104–105, 125–129, 206–210, 216–217, 232–233; *U.S.S. Stevens*, 125.

109. *Bijou Funnies*, 50–51; "When I Was Sixteen . . . 'Twas a Very Bad Year," *GBW* no. 3 (1969), 22.

110. "Justin Green," *TCJ* no. 104 (January 1986): 38.

111. *Binky Brown Meets the Holy Virgin Mary* (1972).
112. And Lutheran; Spiegelman points to Durer's influence on Green: "Symptoms," 5.
113. *Binky*, 9, 10, 11. He'd treated OCD earlier: in "First Command," the protagonist meets little Suzie counting license plates—"I made a deal with God that I can't go until I got 100 licenses . . . 'n' I always go for 110, 'cause th' doubles don't count!" "*God* doesn't like ya t'be *dirty*! Once I didn't take a bath so *he* made my cat get *run-over*!" *GBW* no. 5 (1969), 7.
114. *Binky*, 26, 30, 41.
115. Quoted Patrick Rosenkranz, "The ABCs of Autobio Comix," *TCJ*, March 6, 2011, http://www.tcj.com/the-abcs-of-auto-bio-comix-2; Hatfield, *Alternative Comics*, 134–137.
116. *CWC1*, 79; "Sweet Void of Youth with Binky Brown," *Sacred and Profane* (1976), 32–37, 32, 36. See "AKC Interview," 55; *Dangerous Drawings: Interviews with Comix and Graphix Artists*, ed. Andrea Juno (Juno Books, 1997), 10; Spiegelman, "Symptoms of Disorder/Signs of Genius," in Justin Green, *Justin Green's Binky Brown Sampler* (Last Gasp, 1995), 4–6, 4. S. Clay Wilson parodied Green's efforts, typically obscenely, in 1975's *Felch Cumics* [sic]: "The Felching Vampires Meet the Holy Virgin Mary," dedicated to Binky, contained lines like "Joseph escaped after the felching vampires had left. . . . The Virgin Mary finally regained her health enough to give rectal birth to the Christ child," accompanying images that must be seen to be believed.
117. Reprinted in *Pirates in the Heartland*, 150–157; *Apex Treasury*, 48–51, 48–49; *Zap Comix* no. 7 (March 1974), in *Complete Zap Comix*, 2:358–360; Bill Griffith, "Skeeter" Spiegelman, and Joe Schenkman, "Centerfold Manifesto," *Short Order Comix* no. 1 (1973), 18–19.
118. Green, *Super Soul Comix* no. 1 (1972), 3, 10; Schelly, *Golden*, 47; "Pioneering Underground Cartoonist Grass Green Passes Away at Age 63," *TCJ* no. 247 (October 2002): 32.
119. Patrick Rosenkranz, "Good Times and Bad: The Evolution of a Revolution," in Guy Colwell, *Inner City Romance* (Fantagraphics, 2015), vii–xv, vii, ix, xiii; Estren, 57; see esp. *Inner City Romance* no. 1 (1972), 29–30.
120. "Green," 43; see "Forward [sic]," *Show + Tell Comics* no. 2 (1973); *Binky Brown Sampler*, 8.
121. Reitberger and Fuchs, 52; *JRC*, 204; "Cartoonist Al Capp Exposed," *USA Today*, February 25, 2013; "Al Capp Is Fined $500 Plus Costs in Morals Charge," *NYT*, February 12, 1972; Schumacher and Kitchen, 207–241.
122. "Adult Intellectuals," 912.
123. Estren, 230; Crumb, "Joe Blow," *Zap Comix* no. 4 (1969), *Complete Zap Comix*, 1:169–174; prefigured in "The family that lays together stays together," *Snatch* no. 2 (January 1969); *CCC5*, 91.
124. "Adult Intellectuals," 913; *Pirates in the Heartland*, 186; Estren, 230–232, quote 232.
125. Quoted in Estren, 230. The chill affected creators, too: when two California shop owners were busted for *Tits & Clits*, it "so freak[ed] out Farmer and Chevely," they didn't publish another comic for two years: Robbins, "babes," xi; Shelton, "History."
126. *Joel Beck's Comics*, 6–11, quotes 9, 11.

Chapter 6: Convergences and Contracts

1. Lee letter: *Mom's Homemade Comics* no. 2 (1970); Bill Cross, "Interview: Denis Kitchen," *VMF2*, 4–7, 32, 5.
2. September 18, 1972, letter to Kitchen, repr. in *Best of Comix Book*, ed. Denis Kitchen (2013), 15; Kitchen, "Foreword," *Best of Comix Book*, 11; James Vance, "The Birth, Death, and Afterlife of *Comix Book*," *Best of Comix Book*, 12–32, esp. 14.
3. Elliot S! Maggin in Jayme Lynn Blaschke, *Voices of Vision: Creators of Science Fiction and Fantasy Speak* (University of Nebraska, 2005), 104.
4. Contemporaneously, a Black character appeared briefly in *Dennis the Menace*; another strip about growing up in the ghetto, *Butter and Boop*, started in Black newspapers in 1969, nationally syndicated in 1971. William Foster, "You Don't Know Jack(son)," in *Hogan's Alley* no. 19 (2013): 87. See also Strömberg, 139, 141; Harvey, *Children*, 149; *JRC*, 284; M. Walker, *Scrapbook*, 84; Maurice Horn, *Women in the Comics*, vol. 2 (Chelsea House, 2001), 166. Exchange between Schulz and Harriet Glickman repr. in Chip Kidd, *Only What's Necessary: Charles M. Schulz and the Art of Peanuts* (Abrams ComicArts, 2015), n.p.
5. "Mort Walker Interview," *TCJ* no. 297 (April 2009): 57.

6. M. Walker, *Scrapbook*, 85; Reitberger and Fuchs, 144.
7. Reitberger and Fuchs, 239; quote Jeffrey A. Brown, *Black Superheroes, Milestone Comics, and Their Fans* (University Press of Mississippi, 2001), 3. Of course, readers can *identify* across ethnicities or genders: compare Adilifu Nama, *Super Black: American Pop Culture and Black Superheroes* (University of Texas Press, 2011), 11–12.
8. Daniels, *Marvel*, 158; Coogan, *Superhero*, 46–47; Ruben-George Toyos, "Media Influence on Power Man," *TCJ* no. 41 (1978): 22–23; Nama, 36–39, 55; Howe, 144–146; Tracy L. Bealer, "'The Man Called Lucas': Luke Cage, Mass Incarceration, and the Stigma of Black Criminality," *Inks* 1, no. 2 (Summer 2017): 165–185; *Shang-Chi* became one of Marvel's most respected '70s comics; Jacobs and Jones, 232–236.
9. See *Jungle Action* no. 6 (September 1973), reprinted in *Black Panther Epic Collection*, vol. 1, *Panther's Rage* (Marvel, 2016), 60; Jacobs and Jones, 163; Ed Via, "McGregor: Ordeal and Triumph," *TCJ* no. 52 (December 1979): 23–25, 23; Abraham Riesman, "How an Untested Young Comics Writer Revolutionized Black Panther," *Vulture*, February 16, 2018, https://www.vulture.com/2018/02/don-mcgregor-panthers-rage-black-panther.html; Michael van Dyk, "What's Going On?: Black Identity in the Marvel Age," *IJCA* 8, no. 1 (Spring 2006): 476.
10. "Len Wein," *TCJ* no. 48 (Summer 79): 72–99, 74; see also "Marv Wolfman Trial," *TCJ* no. 236 (August 2001): 30.
11. Not least because, around 1966, they had finally asked DC administration for medical benefits and pension plan and been refused; see also Howe, 127.
12. O'Neil, "Foreword," *JLAA8*; "Divided—They Fall!," in *Justice League of America* no. 66 (November 1968), repr. in *JLAA8*, 133. On superheroes' mythic forebears, see Coogan, *Superhero*, 116–164; "Bullets," *TCJ* no. 242 (April 2002): 87.
13. See *SA7*, 103, 119ff., 190; B. Wright, *Nation*, 60–61.
14. Quotes Jacobs and Jones, 159; *Shop Talk*, 28; "In Each Man There Is a Demon," *Justice League of America* no. 75 (November 1969), in *Justice League of America Archives*, vol. 9 (DC, 2004), 124.
15. "Dennis O'Neil and Matt Fraction," *TCJ* no. 300 (November 2009): 151; compare Nama, 15–17.
16. O'Neil also worked on the revisionist Western *Bat Lash* (1968), which brought a kind of *Easy Rider*-dom to a comics genre staple; the character hated violence, loved nature, and had an ironic, occasionally absurd sense of humor ("Will He Save the West—Or Ruin It?" was the legend atop the cover); *Showcase: Bat Lash* (DC, 2009), esp. 7, 104, 141.
17. See *Green Lantern* no. 76 (April 1970), repr. in *Green Lantern/Green Arrow*, vol. 1 (DC, 2004), 32.
18. Quoted Jacobs and Jones, 160; *Green Lantern*, no. 81 (December 1970) quoted Pustz, 170; Thompson and Lupoff, "Introduction," 14; "Relevancy in Comics," *TCJ* no. 68 (November 1981): 57.
19. *Amazing Spider-Man* no. 78 (November 1969); compare Jacobs and Jones, 159; Green Lantern/Green Arrow, no. 87 (December 1971/January 1972), repr. in *Green Lantern/Green Arrow*, vol. 2 (DC, 2004, hereafter *GLGA2*), 106, 114; "The Hero Who Hated the Legion," "The Secret Villain the World Never Knew," and "This Legionnaire Is Condemned," in *Superboy* nos. 216, 218, and 222 (April, July, and December 1976), *Legion of Super-Heroes Archives*, vol. 12 (DC, 2003), 86–97, 123–139, 195–205; Nama, 17–19, 29.
20. Story repr. in *Superman in the Seventies* (DC, 2000), 135–148.
21. Tony Isabella, who had worked on Luke Cage, persuaded them to accept Black Lightning instead; Brown, *Milestone*, 24; Gary Groth, "Black Lightning Strikes Out!," *TCJ* no. 32 (January 1977): 12; *TCJ* no. 59 (October 1980): 17.
22. Chris Gage, "Can You Dig It?: The World of *Fast Willie Jackson*," *IJCA* 3, no.1 (Spring 2001): 203–209, 203.
23. See inside cover, *Blanga: Heroes of the Black Age* (Onli Studios, 2006); Carter Scholz, "Kane's Progress," *TCJ* no. 74 (August 1982): 38.
24. "Batgirl Breaks up the Dynamic Duo!," *Detective Comics* no. 369 (November 1967), repr. in *Batman in the Sixties* (DC, 1999); "Batman in the Sixties," introduction to *Batman in the Sixties*; on Supergirl's similarly changing wardrobe, see Ken Schenk, "Superman: A Popular Culture Messiah," in *The Gospel According to Superheroes: Religion and Pop Culture*, ed. B. J. Oropeza (Peter Lang, 2005), 33–48, 43; Mills, 32–34; Schwartz, *Two Worlds*, 124.

25. *Wonder Woman* no. 178 (September/October 1968), repr. in *Wonder Woman: The Greatest Stories Ever Told* (DC, 2007), 99; Cat Yronwode, "Sidekicks and Sun-Gods," *TCJ* no. 44 (1979): 23–25, 24; Coulson, 254; "The Canary and the Cat!," *Adventure Comics* nos. 418 and 419 (April and May 1972), repr. in *BCA1*, 212–227; "The Revolt of the Super-Pets!," *Adventure Comics* no. 364 (January 1968), repr. in *Legion of Super-Heroes Archives*, vol. 7 (DC, 1997); Greenberger, 170–172.

26. Trina Robbins, "No Man Is My Master: American Romance Comics of the 1970s and the Women's Liberation Movement," *IJCA* 4, vol. 1 (2002): 155; *Secret Identity Crisis*, 90–91.

27. Robbins and Yronwode, 106; Howe, 129–131.

28. Benton, *Comic Book*, 80; "An Interview with Marv Wolfman," *TCJ* no. 44 (1979): 34–51, 37; "Trina, Queen," 50. *Red Sonja*'s long-term creative talent, Frank Thorne, pushed off the book, went to Warren, and created the better-developed (in both senses) Ghita of Alizarr: Frank Thorne, *Ghita of Alizarr* (Catalan, 1986); "Frank Thorne Interview," *TCJ* no. 280 (January 2007): 60–61. In the mid-'80s, Marvel writer Martha Thomases introduced *Dakota North*, a sort of Duran Duran New Wave album cover come to life, featuring a kick-ass investigator who was also a fashion plate; despite ardent support, it was shuttered after five issues.

29. *Amazing Spider-Man* no. 96 (May 1971); McAllister, 63; B. Wright, *Nation*, 240; Goodrum, 168–175, quote 168.

30. "The Forbidden Fruit," *Action Comics* no. 378 (July 1969), repr. in *LSH9*, 104–113; *Green Lantern/Green Arrow* no. 86 (October/November 1971); *Shop Talk* 43, 30; *Green Lantern/Green Arrow* no. 85 (August/September 1971), repr. in *GLGA2*, 99–100.

31. Jacobs and Jones, 130, 137–139, 151; Benton, *Comic Book*, 72.

32. *The Amazing Transformations of Jimmy Olsen* (DC, 2007); Mark Evanier, "Afterword," *Jack Kirby's Fourth World Omnibus*, vol. 1 (DC, 2007, hereafter *FWO1*); "Carmine Infantino Interview," *TCJ* no. 191 (November 1996): 81, 84–85; Howe, 102–103, 107–108, 118–119; Hatfield, *Hand of Fire*, 179ff.

33. Jacobs and Jones, 179–182, quote 181; Morrison, "Introduction," *FWO1*; *Jack Kirby's The Forever People* (DC, 1999), esp. 8–9, 106–107, 116; compare Jonathan Lethem's comments in *Atom Smashers*, 6; Jacobs and Jones, 182–183; Hatfield, *Hand of Fire*, 233–234; Robert Greenberger, "Jack Kirby and the Eternals," in *Eternals by Jack Kirby* (Marvel, 2008); *Eternals* no. 1, repr. in *Eternals by Jack Kirby*, 22; see Mark Evanier, *Kirby: King of Comics* (Abrams, 2008), 215. Not all revolutions were thematic: Archie Goodwin and Walter Simonson's backup strip *Manhunter* broke new ground in visual sophistication and narrative continuity, winning Academy of Comic Book Arts awards in 1973 and 1974: Archie Goodwin, "Introduction," *Manhunter: The Special Edition* (DC, 1999).

34. Benton, *Horror*, 61–66, quote 66; *LDC*, 142; Cotter, 121–126; Jacobs and Jones, 174–178; see also Roy Thomas, "A $50 Misunderstanding," in *The Chronicles of Conan*, vol. 1 (Dark Horse, 2003).

35. Quote Reitberger and Fuchs, 74; "Mike Ploog Interview," *TCJ* no. 274 (February 2006): 95.

36. "Gene Colan," *TCJ* no. 231 (March 2001): 71–73; "Marv Wolfman Trial," 83; *Tomb of Dracula* no. 10, repr. in *Essential Tomb of Dracula*, vol. 1 (Marvel, 2004); Douglas Wolk, *Reading Comics: How Graphic Novels Work and What They Mean* (Da Capo Press, 2007), 317–328.

37. *Showcase Presents: House of Mystery* (DC, 2006).

38. Brian E. Cook, "The Rise and Fall of Richard Nixon and the Monsters from Marvel," *TCJ* no. 50 (October 1979): 76–79; *Secret Identity Crisis*, 90–119, quotes 99, 117; Cotter, passim; Benton, *Horror*, 68–75; Jacobs and Jones, 198–200, 218.

39. Some of this work, admittedly, was presented in black-and-white magazines like *Savage Tales* and *Savage Sword of Conan*, which were outside the Code by definition.

40. Reitberger and Fuchs, 240; Coogan, *Superhero*, 208.

41. "A Matter of Menace!," *Justice League of America* no. 69 (February 1969), *JLAA8*, 190; O'Neil quote: Sam Hamm, "Introduction," in O'Neil, *Batman: Tales of the Demon* (DC, 1991); Anthony Tollin, "Shades of the Shadow," 4; Dennis O'Neil, "Into the Shadow," *The Private Files of the Shadow* (DC, 1989), 5–9. O'Neil also took on Doc Savage: *Doc Savage: The Silver Pyramid* (DC, 2009), reprinting 1987–88 stories. "Don't the name Doc Savage mean anything any more?" one character bewails. Early Adams examples in *Batman: Illustrated by Neal Adams*, vol. 1 (DC, 2003), esp. "The Superman-Batman Revenge Squad," which originally

appeared in *World's Finest Comics* no. 175 (April 1968), 17–34; "Gil Kane Interview," 98. Dead-man created by Arnold Drake and Carmine Infantino.

42. Quote *Shop Talk*, 33; Levitz, *Eisner*, 112; "No Hope in Crime Alley," *Detective Comics* no. 457 (March 1976), repr. in *GBS*, 237–248.

43. Carl Barks's name first surfaced in the 1962 fanzine *Comic Art*. "Introduction," *Carl Barks: Conversations*, x; Schelly, *Golden Age*, 72–81; Bill Schelly, *Founders of Comic Fandom* (McFarland, 2010), passim.

44. Warner, *Wealth*, 235–236; Jerry Bails and Bill Spicer, "Introduction to Fandom," *Vault of Mindless Fellowship* no. 1 (1972, hereafter *VMF1*), 4–6, 5; Pustz, 183. Ironically, one of the fanzine's first historians was Fredric Wertham, whose 1973 *World of Fanzines*, "although criticized as superficial, incomplete, and misleading," was the only real work on the subject when he died in 1981: "Fredric Wertham Dead at Age 86," *TCJ* no. 69 (December 1981): 23.

45. *Shop Talk*, 286. Other claimants include a large get-together at Bails's house and events in Detroit and Chicago. Michael Uslan claims the first con was at the Broadway Central Hotel; see "Phil Seuling and the Early NY Comic Conventions," ICv2, April 23, 2008, https://icv2.com/articles/comics/view/12451/phil-seuling-early-ny-comic-conventions-part-1.

46. *Comic-Con*, 20–23; Thompson and Lupoff, "Introduction," 15.

47. F. Jacobs, 261; *Collectibly Mad*, 72.

48. "Captain America Joins . . . the Avengers!," *Avengers* no. 4 (March 1964); "The Mighty Avengers Meet the Masters of Evil!," *Avengers* no. 6 (July 1964); Darcy Sullivan, "Marvel Comics and the Kiddie Hustle," *TCJ* no. 152 (August 1992): 34; Perry and Aldridge, 169; Jacobs and Jones, 204–207; *Atom Smashers*, 10; Schelly, *Golden*, 89, 144–146.

49. Kitchen, "Foreword," 11; Daniels, *Marvel*, 155. Lee offered the editorship to Eisner, who turned it down: Andelman, 204; Howe, 91; *MOT*, 265.

50. Stan Lee, "Introduction," *Best of Comix Book*, 9; comic repr. on page 13.

51. The copyright grant took place over the course of the run; see Vance, 21; Kitchen, "Foreword," 11; *SLRise*, 144.

52. *Best of Comix Book*, 111 (the father is Plastic Man), 47–66; Vance, 21.

53. Letter by Kitchen in *Funnyworld* no. 16 (Winter 1974/1975): 3; see Vance, 18, 25–26; *Tales of Toad* no. 3 (1973), 36.

54. Art Spiegelman and Françoise Mouly, "Raw Nerves," in *Read Yourself Raw* (Pantheon, 1987); *Pirates in the Heartland*, 203; *Arcade* no. 1 (Spring 1975), 4; quote Vance, 30; *Dangerous Drawings*, 180; *Arcade* no. 2 (Summer 1975), 4; Noomin, *Twisted Sisters: A Collection of Bad Girl Art* (Penguin, 1991), 62, 63, 78; "Diane Noomin Interview," *TCJ* no. 162 (October 1993); "Art Spiegelman Interview," 94.

55. Harvey Kurtzman, *From Aargh! to Zap!* (Prentice-Hall, 1991); Don Thompson and Dick Lupoff, "Introduction," *CBB*, 9–17, 13. Kurtzman was challenged at the seminar about Little Annie Fanny's offensiveness to women, replying, "It's the first time somebody has said that to me." Quotes Estren, 39, 294; *Comic-Con*, 24, 52.

56. *PS Magazine: The Best of Preventive Maintenance Monthly* (Abrams, 2011); esp. 28, 47, 63. Institutions then producing educational comics included the Atomic Energy Commission, General Electric, the Department of Labor, the armed forces, and the Anti-Defamation League: Goldwater, 33; Sol M. Davidson, "The Funnies' Neglected Branch: Special Purpose Comics," *IJCA* 7, no. 2 (Fall 2005): 340–357. For Eisner's justifications for working for the army during Vietnam, see his comments reprinted in *TCJ* no. 267 (April/May 2005): 136; Eisner's introduction to *Last Day in Vietnam* (Dark Horse, 2000); R. Fiore, "A Year of Reading Comics," *TCJ* no. 275 (April 2006): 84–85.

57. Quote Wiater, 279; Gravett, *Graphic Novels*, 36; Andelman, 174, 184–189.

58. "The Neal Adams Panel," *VMF1*, 10–15, 18–22, 12; Skinn, 152–153; Vance, 32; Bob Levin, "How Michel Choquette (Almost) Assembled the Most Stupendous Comic Book in the World," *TCJ* no. 299 (August 2009): 40.

59. *Quack* no. 3 (1977).

60. Bill Cross, "Interview: Denis Kitchen," *VMF2*, 4–7, 32, 5; Mike Friedrich, "Star*Reach Productions," *Quack* no. 5 (1977), 2.

61. Marilyn Bethke, "An Introduction to Steve Gerber," in *TCJ* no. 41 (1978): 26–27; *Howard the Duck* no. 4 (July 1976), repr. in *Howard the Duck Omnibus* (Marvel, 2008, hereafter *HDO*), 136, Hulk quote: 226. Other comic characters had also run for president; *Mutt and Jeff* prac-

tically made it a habit, starting in 1908 against Taft: Harvey, *Children*, 138; "Introduction," White and Abel, 24.

62. Gerber, "Getting Down Again," *HDO*; "An Interview with Steve Gerber," *TCJ* no. 41 (1978): 28–44, 32. For a more saturnine contemporary reflection, see Jim Dawson, "Caught—In the Steve Gerber Trap!," *TCJ* no. 41 (1978): 19–20; *HDO*, 413–429.

63. See "The Beavers," *Quack* no. 3 (1977), 3–6; no. 5 (1977), 25–35, 25; Bell, 129.

64. "Good Aardvark Art," *TCJ* no. 52 (December 1979): 23–25, 23; "Reaching for the Stars with Mike Friedrich," *TCJ* no. 71 (March 1982): 85; Wiater, 102; "Dave and Deni Sim: II," *TCJ* no. 83 (1983): 60; *TCJ* no. 57 (Summer 1980): 18.

65. Quoted in *Jack Kirby Collector* no. 5 (May 1995), repr. in *Collected Jack Kirby Collector*, vol. 1 (TwoMorrows, 2004), 83.

66. Dave Sim, *High Society* (Aardvark-Vanaheim, 1986).

67. Wiater, 104; "Other Publishers," *TCJ* no. 54 (March 1980): 22; "Dave Sim," *TCJ* no. 100 (July 1985): 147; "Newswatch," *TCJ* no. 91 (July 1984): 11–12; *PB*, 42; "In the Company of Sim," *TCJ* no. 234 (June 2001): 10–11; Rich Kreiner, "Can *Cerebus* Survive Dave Sim?," *TCJ* no. 263 (October/November 2004): 101–102.

68. "Frank Thorne," 61–62; Richard and Wendy Pini, *Line of Beauty: The Art of Wendy Pini* (Flesk, 2017), 250–267.

69. "An Interview with Wendy and Richard Pini," *TCJ* no. 63 (Spring 1981): 127–151, 131, 134–135, 139, 143; see *Elfquest Archives*, vol. 1 (DC, 2003), 175–181, for examples.

70. Dwight R. Decker, "A Touch of Stardust," *TCJ* no. 42 (October 1978): 60–61.

71. See "The Last Survivor," *The First Kingdom*, vol. 1 (Titan, 2013); Bill Sherman, "The Kingdom and the Power of Jack Katz," *TCJ* no. 38 (February 1978): 51–52, 54–55, 51; Bob Levin, "Katz Feat," *TCJ* no. 206 (August 1998): 141–147.

72. On Starlin's metaphysical, metafictional imaginings, compare Howe, 140–144, 162–163.

73. *American Splendor* no. 2 (1977, hereafter *AmSp2*); "Harvey Pekar," *TCJ* no. 97 (April 1985): 46. Later, he did mention his near-photographic memory: see *The Quitter* (DC, 2005), n.p.

74. He'd had previous limited exposure in the undergrounds: see, for example, his self-explanatory "A Good Shit Is Best," with Willy Murphy in *Flamed-Out Funnies* no. 1 (1976), 20–21, the protagonist schooling his compatriots on life's *real* joy.

75. See "Hustlin' Sides," *AmSp2*, 41–45, illustrated by Crumb, with Pekar gently chided for "hustling" at work. "Winners never quit!" it ends, quasi-ironically.

76. Donald Phelps, "Word and Image," *TCJ* no. 97 (April 1985): 41–43; Pekar's letter in "Blood and Thunder," *TCJ* no. 133 (December 1989): 32; "The Young Crumb Story," illustrated by Crumb, in *American Splendor* no. 4 (1979, hereafter *AmSp4*), 3–9; quote Wiater, 135.

77. "A Mercifully Short Preface," *Bob and Harv's Comics* (Four Walls Eight Windows, 1996); Steve Monaco, "Splendor's Splendid, but Don't Bring Me Your Love," *TCJ* no. 91 (July 1984): 24; letter to the editor, *TCJ* no. 135 (April 1990): 37.

78. "Visualize, Actualize, Realize," *AmSp4*, 2; "Miracle Rabbis: A Doctor Gesundheit Story," *American Splendor* no. 7 (1982, hereafter *AmSp7*), 3–4. For important examples of Pekar's interaction toward Jewishness, see his early story "Don't Rain on My Parade," *Snarf* no. 6 (1976), 20–21; the Crumb-illustrated "Standing Behind Old Jewish Ladies in Supermarket Lines," *American Splendor* no. 3 (1978), 3–7; and "The Maggies (Oral History)," *AmSp7*, 5–6. See also Donald M. Fiene, "From Off the Streets of Cleveland: The Life and Work of Harvey Pekar," *TCJ* no. 97 (April 1985): 77.

79. *Harvey Pekar's American Splendor: Unsung Hero* (Dark Horse, 2003); Pekar, *Ego & Hubris* (Ballantine, 2006); "Harvey Pekar," 51.

80. See *CWC1*, 117–120, 121, 139–141; Garry Trudeau, *40: A Doonesbury Retrospective* (Andrews McMeel, 2010, hereafter *Doonesbury 40*), 324; Preiss, "Introduction," *One Year Affair* (Byron Preiss Visual Publications, 1976).

81. See *Star*Reach: Greatest Hits* (Star*Reach, 1979); Jacobs and Jones, 172–173; Bill Sherman, "Sympathy for the Groundlevel," *TCJ* no. 51 (November 1979): 70–75, 73; *Starfawn* (Pyramid, 1976); George Lucas, "Introduction," *Star Wars*, vol. 1 (Russ Cochran, 1991); Kim Thompson, "Marvel's Fouled Up Filmbook," *TCJ* no. 37 (December 1977): 26; Dan Raviv, *Comic Wars* (Broadway Books, 2002), 34; *HDO*, 538–555; Jim Korkis, "The Obscure Eisner," *TCJ* no. 59 (October 1980): 4; strips in *Checkered Demon* no. 3 (1979); Chaykin, *Conversations*, 219; Howe, 194.

82. It wasn't just SF: 1977 also saw a Gerber-written Marvel comic in which the rock band Kiss battled Dr. Doom. Its first printing sold out pre-publication and it entered a second printing of 100,000, aided by the story, perhaps even true, that the band members mixed their blood into the red ink as it went into the press. Alice Cooper appeared in his own EC-ish comic book in 1979: Julia Round, "Reconstructing Alice Cooper," *JGNC* 1, no. 2 (2010): 151–169; Cyriaque Lamar, "KISS v. Doctor Doom Is the Best and/or Worst Comic You'll Read Today," *Gizmodo*, December 11, 2010, https://io9.gizmodo.com/kiss-vs-doctor-doom-is-the-best-and -or-worst-comic-you-5711513; Howe, 192.

83. *Comic-Con*, 23; "Newswatch," *TCJ* no. 36 (August 1977): 5; Bill Sherman, "Cooped Up!," in *TCJ* no. 49 (September 1979): 37–38; *Alien: The Illustrated Story* (Heavy Metal Communications, 1979); "The Greatest: Neal Adams and *Superman vs. Muhammad Ali*," in *Comic Book Artist* 1, no. 1 (December 1999): 36–47, 38–39; "An Interview with Neal Adams," *TCJ* no. 43 (December 1978): 38–40; Levitz, *Eisner*, 161; *Superman vs. Muhammad Ali* (DC, 1978).

84. The second volume appeared in altered form a few years later: see Gary Groth's afterword in Gil Kane, *Blackmark: The Anniversary Edition* (Fantagraphics, 2002); "An Interview with Gil Kane," *TCJ* no. 38 (February 1978): 34–46, 37; "Gil Kane Interview," 86.

85. Umphlett, 19; Preiss, "Introduction," *Empire: A Visual Novel* (Berkley Windhover, 1978); Bob Toomey, "Vanishing Point," *TCJ* no. 45 (March 1979): 32–33; *TCJ* no. 48 (Summer 1979): 36–71, esp. 40–42; Byron Preiss, "Introduction," *Alfred Bester's The Stars My Destination: The Graphic Story Adaptation* (Epic Comics, 1992); see "The Illustrated Zelazny, Over-Priced and Over-Preissed," *TCJ* no. 44 (January 1979): 27–28, 28.

86. *TCJ* no. 42 (October 1978): 13.

87. Benson, "Eisner," 215; Yeh's author's note, dated June 24, 1977: "This *isn't* a comic book. . . . This is a *graphic fantasy* recorded by a cartoonist": *Even Cazco Gets the Blues* (Valentine Press/Fragments West, 1977). By 1980, he referred to *Blues* as "a contemporary graphic fantasy novel," "a long and trying 80 page graphic novel": "Introduction," *Cazco in China: A Transethnic Extravaganza* (Valentine Press/Fragments West, 1980). His influences included McCay, Kelly, Jack Cole, and Shelly Mayer: "Phil Yeh: Artist, Publisher, Dreamer," *TCJ* no. 87 (December 1983): 58.

88. Andrew J. Kunka, "*A Contract with God, The First Kingdom*, and the 'Graphic Novel': The Will Eisner/Jack Katz Letters," *Inks* 1, no. 1 (Spring 2017): 27–39.

89. *Shop Talk*, 26; "A Dream of Milk and Honey," *Imagine* no. 4 (1978), 3–18; *Imagine* no. 5 (April 1979), 2.

90. "Will Eisner," *TCJ* no. 100 (July 1985): 86; "Will Eisner Interview—Conclusion," *TCJ* no. 47 (July 1979): 43, 45; Eisner's comments in Dana Jennings, "Eisner in France," *TCJ* no. 89 (March 1984): 100; Andelman, 286–287.

91. "Winners & Losers: Harsh Memories from Will Eisner," *TCJ* no. 46 (May 79): 52–53, 52, 53; *Eisner/Miller*, 60; Andelman, 131; Levitz, *Eisner*, 113.

92. Tom Spurgeon and Michael Dean, *We Told You So: Comics as Art* (Fantagraphics, 2016), 47, 51.

93. *TCJ* no. 50 (October 1979): 44–45, 44; *TCJ* no. 51 (November 1979): 32–35, 37; Levitz, *Eisner*, 154.

94. See R. C. Harvey, "Bill Blackbeard, the Man Who Saved Comics, Dead at 84," *TCJ*, April 25, 2011, http://www.tcj.com/bill-blackbeard-1926-2011.

95. Bill Blackbeard and Martin Williams, "Introduction: The Comic Treasures of the American Newspaper Page," in *Smithsonian Newspaper*, 11–21, 12; Jules Feiffer, *Tantrum* (Knopf, 1979).

96. *SLRise*, 186; *Super Friends!* (DC, 2001), 11. Other examples: CBS's *New Adventures of Superman* (1966), *Superman/Aquaman Hour of Adventure* (1967), *Batman/Superman Hour* (1968); *Adventures of Batman* (1969), and NBC's Saturday morning cartoons *Spider-Man and His Amazing Friends* (1981) and *The Incredible Hulk* (1982), produced by the Marvel Productions company founded in 1980: Daniels, *DC*, 144–145; Jacobs and Jones, 214; Daniels, *Marvel*, 181–182.

97. Bill Mantlo, "Creating a New Series for Marvel: The Micronauts," *TCJ* no. 40 (June 1978): 24–25; "Newswatch," *TCJ* no. 46 (May 1979): 15; Dale Luciano, "Comics with a Message," *TCJ* no. 61 (Winter 1981): 69–72; Jonathan David Tankel and Keith Murphy, "Collecting Comic Books: A Study of the Fan and Curatorial Consumption," in *Theorizing Fandom: Fans, Subculture, and Identity*, ed. Cheryl Harris and Alison Alexander (Hampton Press, 1998), 55–68, 61; Goulart, *Great*, 304; Jean-Paul Gabilliet, *Of Comics and Men: A Cultural History of American Comic Books* (University Press of Mississippi, 2010), 79–80.

98. Daniels, *Marvel*, 176; Daniels, *DC*, 171; Kim Thompson, "Greenskin, Webhead, and the Boob Tube," *TCJ* no. 38 (February 1978): 56–57, 57; Newswatch, *TCJ* no. 32 (January 1977): 4; Newswatch, *TCJ* no. 38 (February 1978): 10; M. Keith Booker, *"May Contain Graphic Material": Comic Books, Graphic Novels, and Film* (Praeger, 2007), 7; Brian Cronin, *Was Superman a Spy?* (Plume, 2009), 123–124.

99. Gary Wright, "The Comic Book—A Forgotten Medium in the Classroom," *American Teacher* 33 (November 1979): 158–161.

Chapter 7: New Worlds

1. David Kunzle, "Introduction," in *Gustave Doré: Twelve Comic Strips*, ed. David Kunzle (University of Mississippi Press, 2015), 11–57, 11–13; Thierry Groensteen, "Gustave Doré's Comics," *IJCA* 2, no. 2 (Fall 2000): 111–120; Ann Miller, *Reading Bande Dessinée* (Intellect, 2007), 13–70.

2. For example, *Tintin in the Congo* (1930–31) was pulled from Borders bookstores in America in 2007; *PB*, 148–149; Mark McKinney, "Representations of History and Politics in French-Language Comics and Graphic Novels: An Introduction," in *History and Politics in French-Language Comics and Graphic Novels*, ed. Mark McKinney (University Press of Mississippi, 2008), 4; Hugo Frey, "Trapped in the Past: Anti-Semitism in Hergé's *Flight 714*," in McKinney, 27–43, esp. 27–31; Matthew Screech, *Masters of the Ninth Art: Bandes Dessinées and Franco-Belgian Identity* (Liverpool University Press, 2005), 38, 41; Mark McKinney, *The Colonial Heritage of French Comics* (Liverpool University Press, 2011), 3–4, 126–128.

3. Reitberger and Fuchs, 68; *PB*, 21; Screech, 6, 18; Anne Frank, *The Diary of a Young Girl: Definitive Edition* (Bantam, 1997), May 8, 1944, entry.

4. See Dorfman and Matellart, *How to Read Donald Duck*; Barker, *Ideology, Power*, 278–299; Dale Luciano, "Tintin's America," *TCJ* no. 66 (September 1981): 33–35, 34; "U.S. to Use Cartoon Books to Tell Asia Our Story," *NYT*, December 20, 1949.

5. Screech, 76; Dwight R. Decker, "Asterix: These Frenchmen Are Crazy!," *TCJ* no. 48 (February 1978): 21; Goscinny, *Asterix the Gaul* (1961, English trans. Brockhampton Press, 1969); *Asterix and the Goths* (1974, English trans. Brockhampton Press, 1974); Miller, *Reading*, 152–159.

6. *Two-Fisted Tales* no. 50 (November/December 1952); Bhob Stewart, "Screaming Metal," *TCJ* no. 94 (October 1984): 59; Screech, 17, quotes 77, 86.

7. After architecture, music, painting, sculpture, poetry, dance, cinema, and television: see Screech, *Masters of the Ninth Art*; Grove, *Comics in French*; Maurice Horn, "How It All Began; or, Present at the Creation," *IJCA* 4, no. 1 (2002): 15.

8. Screech, 114ff.; *PB*, 146, 152–154; Decker, "These Frenchmen," 20; Decker, "These Frenchmen," 20–22, 25–29, 20.

9. He started using it regularly in the early to mid-1970s; Screech, 100.

10. Other contemporary French-speaking SF comics were mostly variations on *Flash Gordon*: Screech, 95–97, 116, 126.

11. See Screech, 118–119, 124; "Interview with Gil Kane," 40; Carter Scholz, "Furriners," *TCJ* no. 119 (January 1988): 29; see *Is Man Good?* (Heavy Metal Communications, 1978) and *Arzach* (Marvel, 1987; originally 1974).

12. Editorial, *Heavy Metal*, May 1981: 6; "We're All Lunatics: The Heavy Metal Interview," in *TCJ* no. 49 (September 1979): 42–50, 44, 46.

13. See "Keiji Nakazawa," *TCJ* no. 256 (October 2003): 41–44, 50, and Hillary L. Chute, *Disaster Drawn: Visual Witness, Comics, and Documentary Form* (Belknap, 2016), esp. 112–128.

14. In Japan, it was promoted, surprisingly, "as a war comic, a 'ripping yarn', and . . . accompanied by advertisements for war toys—including, incredibly, American bombers"; Roger Sabin, *"Barefoot Gen* in the US and UK: Activist Comic, Graphic Novel, Manga," in *Reading Manga: Local and Global Perceptions of Japanese Comics*, ed. Jaqueline Berndt and Steffi Richter (Leipziger Universitätsverlag, 2006), 39–57, 41; "Undergrounds: Two New Books from Educomics," *TCJ* no. 54 (March 1980): 20; Dale Luciano, "Gen of Hiroshima: Two-Fisted Pacifism," *TCJ* no. 69 (December 1981): 40–43; Bill Sherman, "Dissent: Before the Bomb," *TCJ* no. 56 (June 1980): 78–79; "Newswatch," *TCJ* no. 71 (March 1982): 11; Art Spiegelman, "Barefoot Gen: Comics After the Bomb," in Keiji Nakazawa, *Barefoot Gen: A Cartoon Story of Hiroshima* (Last Gasp, 2003).

15. See Rifas, "Globalizing Comic Books from Below: How Manga Came to America," in *IJCA* 6, no. 2 (Fall 2004): 138–171.

16. John A. Lent, "Easy-Going Daddy, Kaptayn Barbell, and Unmad: American Influences Upon Asian Comics," *Inks* 2, no. 3 (November 1995): 58–72; Frederik L. Schodt, *Dreamland Japan: Writings on Modern Manga* (Stone Bridge Press, 1996), 34, 233–274; *PB*, 118; Jean-Marie Bouissou and N. C. Christopher Couch's articles in *Manga: An Anthology of Global and Cultural Perspectives*, ed. Toni Johnson-Woods (Continuum, 2010), 17–33, 204–220. Comics fans generally accept that the Disney movie *The Lion King* was, putting it carefully, at least *very strongly* influenced by Tezuka's 1950–1954 *Jungle Emperor*; for persuasive, judicious considerations, see *Dreamland Japan*, 268–274, and Fred Patten, *Watching Anime, Reading Manga* (Stone Bridge Press, 2004), 144–185.

17. *PB*, 92; *Dreamland Japan*, 61; Dani Cavallaro, *The Anime Art of Hayao Miyazaki* (McFarland, 2006), 15–16.

18. As did Rumiko Takahashi; see *PB*, 93–96; *Dreamland Japan*, 87–91.

19. See *Dreamland Japan*, 19.

20. *Lone Wolf and Cub*, vol. 1, *The Assassin's Road* (Dark Horse, 2000).

21. "An Interview with Jim Shooter," *TCJ* no. 60 (November 1980): 56–83, 70; Dwight R. Decker, "Frank Miller: An Interview," *TCJ* no. 70 (Winter 1982): 68, 76; Gary Groth, "Comics in 1981: Recycling the Old, Searching for the New," *TCJ* no. 71 (Winter 1982): 46.

22. "Frank Miller: An Interview," 71, 74, 77–79; R. C. Harvey, "McKenzie and Miller's Daredevil: Skillful Use of the Medium," *TCJ* no. 58 (September 1980): 92–94.

23. Jim Korkis, "The New Japanese Invasion," *TCJ* no. 51 (November 1979): 78–79; *Watching Anime*, 22–43; Tom DeFalco's comments in McCue, 96; Lee Marrs and Masaichi Mukaide, "The Awakening of Tamaki," *Imagine* no. 4 (November 1978), 27–38. Wendy Pini had been inspired by manga in her teens, a largely unheralded influence on *Elfquest: Line of Beauty*, 36–44.

24. Scott McCloud, "On the Threshhold of Adulthood," in *Zot! 1987–1991: The Complete Black and White Collection* (Harper, 2008), 9; Adam Philips, "Exotic Comics in a Faraway Land," *TCJ* no. 90 (June 1984): 59.

25. Daniels, *Marvel*, 168; Howe, 153.

26. Originally designed by Cockrum for the Legion; see Cockrum's "Foreword" to *Legion of Super-Heroes Archives*, vol. 10 (DC, 2000).

27. Claremont's Captain America also visited a Holocaust survivor; see *Captain America* no. 237 (September 1979); Isidoro Aizenberg, *American Cartoonists, Nazi Germany, and the Holocaust* (Queensborough Community College, Kupferberg Holocaust Research Center and Archives, 2009), 15–19; *Krakow to Krypton*, 122; Kathrin Bower, "Holocaust Avengers: From 'The Master Race' to Magneto," *IJCA* 6, no. 2 (Fall 2004): 189–192.

28. "Merry Christmas, X-Men—The Sentinels Have Returned!," *X-Men* no. 98 (April 1976).

29. Writer Michael Fleisher took a similar, less well-known tack contemporaneously, ending Western gunfighter Jonah Hex's story: murdered, stuffed, and put on display: Michael Catron, "The Blessed Life of Michael Fleisher," *TCJ* no. 56 (June 1980): 42–70, 43; McCue, 142.

30. "Chris Claremont Interview," *TCJ* no. 50 (October 1979): 49–69, 57, 63. Jean Grey's death occurs in *X-Men* no. 137 (September 1980). John Romita suggested that Gerry Conway received death threats after killing Gwen Stacy: "John Romita Jr. Draws Against Niece's Cancer Deadline," *TCJ* no. 245 (August 2002): 27; Howe, 228–229.

31. Daniels, *Marvel*, 166; Chris Claremont, "Introduction," *Best of Wolverine*, vol. 1 (Marvel, 2004); *Modern Masters*, vol. 7, *John Byrne* (TwoMorrows, 2006), 34; "Wolverine," 86.

32. "Wolverine," *TCJ* no. 78 (December 1982): 85; *X-Men* no. 118 (cover date February 1979).

33. Michelinie, "Heart of Iron, Feet of Clay," in *Iron Man: Demon in a Bottle* (Marvel, 2008); Brad Meltzer's essay in *Atom Smashers*, esp. 98; Dick Giordano in "Censorship in Comics," 92; *TCJ* no. 59 (October 1980): 54; *Slugfest*, 114.

34. Michael Dean, "Fine Young Cannibals," *TCJ* no. 277 (July 2006): 50; see also "The Origin of the Comics Direct Market," ICv2, November 8, 2004, https://icv2.com/articles/comics/view/5979/the-origin-comics-direct-market-part-1.

35. "Phil Seuling, Father of the Direct-Sales Comic-Book Market, Dies at Age of 50," *TCJ* no. 93 (September 1984): 13; Seuling, *Shop Talk*, 287; Schelly, *Golden*, 20–22, 37–38; *Slugfest*, 134–135.

36. *Shop Talk*, 289–290; "'Diamond' Symbol on Non-Returnable Marvel Comics to Prevent Dealer Fraud," *TCJ* no. 47 (July 1979): 8.

37. "Newswatch," *TCJ* no. 38 (February 1978): 7; Jacobs and Jones, 242–243; *Slugfest*, 136; Keith Dallas and John Wells, *Comic Book Implosion* (TwoMorrows, 2018).

38. Roy Thomas, "How Marv Wolfman and Co. Saved (a Bit of) the Golden Age," *Alter Ego* no. 2 (Fall 1999): 19–21, 19; *TCJ* no. 105 (February 1986): 72; "Jenette Kahn," *TCJ* no. 37 (1977): 54; "Marvel Hires Specialty Sales Manager," *TCJ* no. 54 (March 1980): 9; "The Direct-Sales Boom," *TCJ* no. 64 (July 1981): 7; See ad in *TCJ* no. 68 (November 1981): 19; Howe, 221–222.

39. "Reaching for the Stars," 83; Ted White, "It All Boils Down to the Editor," *TCJ* no. 83 (August 1983): 32, 44–45; Gary Groth, "What the Direct Sales Market Has Wrought, Part Two," *TCJ* no. 85 (October 1983): 9; Dale Stevens, *The Rocketeer: The Complete Adventures* (IDW, 2009); *Brush with Passion: The Art & Life of Dave Stevens*, ed. Arnie and Cathy Fenner (Underwood, 2008), 106–112; Carter Scholz, "Stupidities and Horrors, Cosmic and Otherwise," *TCJ* no. 70 (Winter 1982): 39; Mike Baron, "Foreword," *The Nexus Archives*, vol. 1 (Dark Horse, 2005); Wolk, 103; "Eclipse Magazine Premieres," *TCJ* no. 63 (Spring 1981): 24; Jim Wilson, "Reprise: Something Old, Something New," *TCJ* no. 105 (February 1986): 44; Max Allan Collins and Terry Beatty, *The Files of Ms. Tree*, vol. 1 (Renegade Press, 1984); Groth, "Jon Sable's 'Real People': Another Bundle of Trendy Cliches," *TCJ* no. 102 (September 1985): 7, 9.

40. R. Fiore, "The Rocky Road to Tanelorn: Moorcock in the Comics," *TCJ* no. 55 (April 1980): 28–30, 30. Chaykin turned a detailed Moorcock outline into a graphic novel of the Eternal Champion in *The Swords of Heaven, the Flowers of Hell* (Heavy Metal Communications, 1979); *Howard Chaykin's American Flagg!* (Image, 2008); R. C. Harvey, "Lookin' Good," *TCJ* no. 87 (December 1983): 53; *Atom Smashers*, 72–73; Carter Scholz, "Apostles of Junk," *TCJ* no. 109 (July 1986): 60; see *Howard Chaykin: Conversations* (University Press of Mississippi, 2011), esp. 46–49, 60–61.

41. Gary Groth's preface to Los Bros Hernandez, *Chelo's Burden* (Fantagraphics, 1989); "The Hernandez Bros. Interview," *TCJ* no. 126 (January 1989): 63–65; Groth, "Love, Rockets, and Thinking Artists," *TCJ* no. 67 (October 1981): 52; Todd Hignite, *The Art of Jaime Hernandez: The Secrets of Life and Death* (Abrams ComicArts, 2009), 37–38, 54; "Jaime and Gilbert Hernandez Interview," *TCJ* no. 178 (July 1995): 102–103.

42. Quotes Frederick Luis Aldama, *Spilling the Beans in Chicanolandia* (University of Texas Press, 2006), 121; Hignite 75, 77, 82, 145–147; Charles Hatfield, "Heartbreak Soup: The Interdependence of Theme and Form," *Inks* 4, no. 2 (May 1997), 2–17, 3; Jim Wilson, "Potential Wasted, Potential Achieved," *TCJ* no. 77 (November 1982): 65; Ana Merino, "The Bros. Hernandez: A Latin Presence in Alternative U.S. Comics," in *Redrawing the Nation: National Identity in Latino/a American Comics*, ed. Héctor Fernández L'Hoeste and Juan Poblete (Palgrave Macmillan, 2009), 251–269, 254–257.

43. *Mission District*, no. 1 (1980), n.p.

44. See, for example, Los Bros Hernandez, *Music for Mechanics* (Fantagraphics, 1994), 60.

45. Hatfield, 5; Wolk, 198–199. An excellent study of "Heartbreak Soup" is Hatfield, *Alternative Comics*, 68–107, esp. 70, 95. *Chelo's Burden*, 33, 67, 72–102; Jaime Hernandez, *The Education of Hopey Glass* (Fantagraphics, 2008). For a remarkable quasi-culmination, see Jaime Hernandez, *The Love Bunglers* (Fantagraphics, 2014).

46. *Comics as Art*, 87–91.

47. See, for example, William Messner-Loebs, *Journey: The Adventures of Wolverine MacAlistaire*, vol. 1 (IDW, 2008), 154–155, 310, 330, 148–149.

48. "Newswatch," *TCJ* no. 84 (September 1983): 13; see Simonson, *Thor Legends*, vol. 2, *Walter Simonson Book 2* (Marvel, 2003, material originally published 1984–1985), and *Thor Visionaries: Walter Simonson*, vol. 1 (Marvel, 2001, material originally published in *Thor* nos. 337–348); *Shop Talk*, 46.

49. See *Elric of Melnibone* (IDW, 2015); Kirby, *Silver Star* (Image, 2007); many iconic Batman stories by Englehart and Rogers appear in *Strange Apparitions* (DC, 1999); Ed Via, "Night of Fury," *TCJ* no. 44 (January 1979): 28–29, 28; Gary Groth, "Sabre's a Dull Blade," *TCJ* no. 44 (January 1979): 30–31, 30; McGregor, *Sabre: 30th Anniversary Edition* (Desperado, 2008); "Groundlevel," *TCJ* no. 45 (March 1979): 19; "Newswatch," *TCJ* no. 91 (July 1984): 12.

50. "Newswatch," *TCJ* no. 105 (February 1986): 20; *The Art of Al Williamson* (Blue Dolphin, 1983), 31, 54; *TCJ* no. 42 (October 1978): 22; "Gerber Sues Marvel over Rights to Duck," *TCJ*

no. 62 (March 1981): 11; "Moral Illiteracy," *TCJ* no. 99 (June 1985): 9; "Ploog & Kirby Quit Marvel over Contract Dispute," *TCJ* no. 44 (February 1979): 11; "Newswatch," *TCJ* no. 92 (August 1984): 8; see "Newswatch," *TCJ* no. 95 (February 1985): 8-9; "Newswatch," *TCJ* no. 100 (July 1985): 13; "Newswatch," *TCJ* no. 105 (February 1986): 20; "Newswatch," *TCJ* no. 111 (September 1986): 10; "Newswatch," *TCJ* no. 107 (April 1986): 9; Jacobs and Jones, 247; *SLRise*, 160, 162, 219-220.

51. "Newswatch," *TCJ* no. 69 (December 1981): 16-17; "Newswatch," *TCJ* no. 70 (Winter 1982): 10-11; "Newswatch," *TCJ* no. 87 (December 1983): 17; letter in *TCJ* no. 76 (October 1982): 35; "Joe Shuster," 24; *MOT*, 324-325; *Krakow to Krypton*, 48-49; "Superman Creator Jerry Siegel Dies at 81," *TCJ* no. 184 (February 1996): 36.

52. "Marvel to Publish *Heavy Metal* Type Book," *TCJ* no. 44 (January 1979): 12; "Rick Marschall on EPIC," *TCJ* no. 49 (September 1979): 10; "Odyssey: It Won't Be a Marvel Comic Book," *TCJ* no. 45 (March 1979): 11; "Odyssey Renamed Epic," *TCJ* no. 46 (May 1979): 12; "Magazine Line Reorganized; New Editor Hired," *TCJ* no. 50 (October 1979): 9; David Stallman's review in *TCJ* no. 54 (March 1980): 38-39.

53. "Marvel Focuses on Direct Sales," *TCJ* no. 59 (October 1980): 11; " 'Spectacular' Sales Prompt New Projects," *TCJ* no. 52 (December 1979): 7; Kim Thompson, "Death Warmed Over," *TCJ* no. 73 (July 1982): 50; "Newswatch," *TCJ* no. 74 (August 1982): 14; Ted White, "Just Another Marvel Comic," *TCJ* no. 76 (October 1982): 46; Walter Simonson and Gary Groth's comments in "Values in Comics," *TCJ* no. 99 (June 1985): 74.

54. *X-Men: God Loves, Man Kills* (Marvel, 2007; 1982); *The Raven Banner: A Tale of Asgard* (Marvel, 1985); *Me & Joe Priest* (Marvel, 1985); see Rick Veitch, "My Graphic Novel That Wasn't Really," in *Heartburst and Other Pleasures* (King Hell, 2008), n.p. Daniels, *DC*, 208; *Star Raiders* (DC, 1983); *Dracula: A Symphony in Moonlight and Nightmares* (Marvel, 1986); *Greenberg the Vampire* (Marvel, 1986).

55. "Newswatch," *TCJ* no. 79 (January 1983): 16.

56. "Newswatch," *TCJ* no. 82 (July 1983): 11; "Newswatch," *TCJ* no. 84 (September 1983): 10; "Newswatch," *TCJ* no. 80 (March 1983): 18; Don and Maggie Thompson, "Epic Beginnings," in Mike W. Barr and Brian Bolland, *Camelot 3000* (DC, 1988); Mike W. Barr, "Opening Knight," in *Camelot 3000*. Earlier DC character the Shining Knight was another Arthurian who spent centuries in suspended animation.

57. *Camelot 3000* no. 4 (March 1983), 15; no. 5 (April 1983), 3, 16; no. 7 (August 1983), 7; no. 12 (April 1985), 27-28. The contemporary *Defender* character Cloud was apparently "comics' first transsexual hero." Gene Phillips, "The Goldilocks School of Comics," *TCJ* no. 96 (March 1985): 49; Jason Tondro, *Superheroes of the Round Table* (McFarland, 2011), 172-176.

58. "Newswatch," *TCJ* no. 81 (May 1983): 12. One such early miniseries, 1983's *Sword of the Atom*, showcased the field's self-conceived greater maturity. Ray Palmer finds his Jean in another man's arms: "I stopped reading comic books years ago!" she says. "What makes you think I want to live in one?" *Sword of the Atom* (DC, 2007), 13.

59. "Miller Creates Title for DC," *TCJ* no. 72 (May 1982): 8; Miller and Mazzucchelli, *Daredevil: Born Again* (Marvel, 1987).

60. "Comics Code Rejects Daredevil Story," *TCJ* no. 57 (Summer 1980), quotes 8-9; "Newswatch," *TCJ* no. 68 (November 1981): 15; Ted White, "Reefer-Madness, Marvel Style," *TCJ* no. 77 (November 1982): 46-50. On shops, see Charles Hatfield, *Alternative Comics: An Emerging Literature* (University Press of Mississippi, 2005), 22-25; Lee Wochner, "Comics 1983: The Year in Review," *TCJ* no. 89 (March 1984): 62; "Newswatch," *TCJ* no. 100 (July 1985): 21; Daniels, *DC*, 178.

61. *Nuke* (McFarland, 1986); *Nuke II* (McFarland, 1990); *Dreadstar* no. 3 (March 1983), repr. in Jim Starlin, *Dreadstar Omnibus*, vol. 1 (Dynamite, 2014); *Generation Zero* (DC, 1991); *Booster Gold* no. 9 (October 1986), repr. in *Showcase Presents Booster Gold* (DC, 2008), 209.

62. Lucy R. Rippard, "Introduction," *World War 3 Illustrated, 1980-1988* (Fantagraphics, 1989), 4; "Peter Kuper Interview," *TCJ* no. 150 (May 1992): 70; formulation from Ted White, "Humor, History, Drugs, War, Music, Headaches, and Eyestrain," *TCJ* no. 81 (May 1983): 36; Avis Lang and Lü Xiuyuan's review of *WW3*, in *Inks* 1, no. 3 (November 1994): 41. Kuper worked as Chaykin's assistant around this time—*Howard Chaykin: Conversations* (University Press of Mississippi, 2011), 29-30.

63. *WW3 Illustrated* no. 2 (1981), 3-11; Peter Bagge, "Old Pals," *WW3 Illustrated* no. 1 (1980),

18–19; *WW3 Illustrated* no. 5 (1986), 13–17; "The *World War 3 Illustrated* Interview," *TCJ* no. 276 (June 2006): 174. R. Chévat and Dino's *The Ronnie Rat Show* (Ink Works, 1982), a satirical, hallucinatory, mash-up of Reagan and Disney, highlighted the sense of movified artificiality everyone felt around Reagan.

64. John Carlin, "Crossing the Line: The Profound and the Profane in Gary Panter's *Cola Madnes*," in *Cola Madnes* (Funny Garbage Press, 2001), 191–209, 207–208; Todd Hignite, *In the Studio: Visits with Contemporary Cartoonists* (Yale University Press, 2006), 81; Gary Panter, *Jimbo: Adventures in Paradise* (Pantheon, 1988); Dale Luciano, "Raw 3: Comix, Graphix, and Lost Faith in Nihilism," *TCJ* no. 68 (November 1981): 45; quote Panter, "Living for the Day," *TCJ* no. 100 (July 1985): 216.

65. Reprinted in 2000 by Water Row Press; Mark Beyer, *Amy and Jordan* (Pantheon, 2004), n.p.

66. Spiegelman, "Raw Nerves"; Spiegelman, *Breakdowns: Portrait of the Artist as a Young %@&*!*, rev. ed. (Pantheon, 2008; Bélier Press, 1977).

67. Early on, Zippy's a joke heartbreaker in a parodic true confession: "I gave my heart to a pinhead and he made a fool out of me!": *Real Pulp Comics* no. 1 (1971), 15–19. But he transcends that: *Zippy Stories* no. 1 (1977), 50; "Understanding Zippy," *Discovering Your Type Z Personality* (Fantagraphics, 2005), 8; see one of Griffith's most confessional Zippy works, "The Underground Cartoonists Retirement Center" and "Cast of Characters," *Zippy* no. 3 (1980), 34–42, esp. 37–39; introduction to *Griffith Observatory* (Fantagraphics, 1993), inside front cover.

68. Andrei Molotiu, "Introduction," in *Abstract Comics: The Anthology 1967–2009*, ed. Andrei Molotiu (Fantagraphics, 2009).

69. Koch and Lee hoped to jointly create a "peace comic" during Vietnam, but Lee found Koch's draft too "far out": David Lehman, "Introduction," Kenneth Koch, *The Art of the Possible: Comics Mainly Without Pictures* (Soft Skull Press, 2004).

70. *Zippy Stories* no. 1 (1977), 49; "Situation Comedy," *Mondo Snarfo* no. 1 (1978), 3–5, 4; J. Carlin, "Masters," 128; "Art Spiegelman Interview," *TCJ* no. 180 (September 1995): 76.

71. *Apex Treasury*, 63–65; quote John Benson, "Art Spiegelman: From Maus to Now," *TCJ* no. 40 (1978): 36–37, 37; *Breakdowns*, rev. ed.; *Legal Action Comics*, vol. 2 (Dirty Danny Legal Defense Fund, 2003), 30–31; "Newswatch," *TCJ* no. 43 (December 1978): 16; "Spiegelman and Mouly's 'Raw' Premieres," *TCJ* no. 58 (September 1980): 21; for the Topps work that helped support Spiegelman, see Spiegelman, "Wacky Days," in *Wacky Packages* (Abrams ComicArts, 2008), 6–8; Art Spiegelman, *MetaMaus* (Pantheon, 2011), 44–60, 111–114; "Art Spiegelman Interview," *TCJ* no. 180 (September 1995): 88–90; Spiegelman, "Garbage Pail Kids," *Slate*, March 31, 2012, http://www.slate.com/articles/arts/books/2012/03/art_spiegelman_tells_ the_story_of_garbage_pail_kids_.html.

72. Spiegelman, "Raw Nerves," *Raw* no. 1 (July 1980), no. 2 (December 1980), no. 5, (March 1983), and no. 6 (May 1984), respectively; Kurtzman, *From Aargh! to Zap!*, 92.

73. Jacques Tardi, "Manhattan," *Read Yourself Raw*, 11–18, 14; Screech, 128–153; compare also Tardi, *Roach Killer* (NBM, 1992).

74. "Raw 2 Scheduled for December Release," *TCJ* no. 61 (Winter 1980–1981): 27–28; "Newswatch," *TCJ* no. 64 (July 1981): 17; Jeet Heer, "Françoise Mouly: Underappreciated and Essential," *Sans Everything*, April 6, 2008, https://sanseverything.wordpress.com/2008/04/06/ francoise-mouly-underappreciated-and-essential.

75. "A Message from the Editor," *Weirdo* no. 1 (Spring 1981).

76. See *Weirdo* nos. 2–4, especially, for one with Kominsky-Crumb, "The Unfaithful Husband and la Malisima Tentadora!," in *Weirdo* no. 4 (1982); compare Bill Sherman, "Turning In on Yourself," *TCJ* no. 69 (December 1981): 104–105, 105.

77. In *Zap Comix* no. 10 (1982), repr. in *The Complete Zap Comix*, vol. 3: 505–514, quotes 505, 509, 514.

78. Aline Kominsky-Crumb and Robert Crumb, "Introduction," *The Complete Dirty Laundry Comics* (Last Gasp, 1992, hereafter *DL*), 3; "Let's Have a Little Talk" (1974), repr. in *DL*, 7; *DL*, 49, 4, 60, 69; "Aline Kominsky-Crumb Interview," *TCJ*, 61; Editors of *The Comics Journal*, *The Best Comics of the Decade* (Fantagraphics, 1990), 50–52; on *Dirty Laundry*, see *Graphic Women*, 51–55.

79. On Seda, see *Dori Stories* (Last Gasp, 1999), quote 52.

80. "The Nude Photography Class," *Weirdo* no. 4 (1982).

81. Quote *Who's Afraid*, 20; see Steve Monaco, "A Worthwhile (but Weird) Grab-Bag," *TCJ* no.

106 (March 1986): 29; Bagge, "Neat Stuff: An Introduction," *The Complete Neat Stuff*, vol. 1 (Fantagraphics, 2016), 7; *The Complete Neat Stuff*, vol. 2 (Fantagraphics, 2016), 15; *The Complete Neat Stuff*, 1:26, 39.

82. "True or False: Phoebe Gloeckner at Bluestockings," *TCJ* no. 245 (August 2002): 33; see also "Phoebe Gloeckner Interview," *TCJ* no. 261 (July 2004): 92, and *Graphic Women*, 61ff. Gloeckner was sexually abused by her mother's boyfriend as a teenager; see *Dangerous Drawings*, 150–151. Also notable were Mary Wilshire's pointed feminist comic strip *Unhomogenized Humor* and Dalison Darrow's furiously uncompromising image of a "nasty woman"; see *CWC1*, 302–304, 311–313, 319, 324–329.

83. "Mommie Dearest Bunch," in *Complete Wimmen's Comix*, vol. 2 (Fantagraphics, 2016, hereafter *CWC2*), 347–348; "Aline Kominsky-Crumb Interview," *TCJ* no. 139 (December 1990), 53; Mary Wilshire's "Multiple Choice," Leslie Ewing's "The Young and the Professional: The Life of the Lonesome Feminist Capitalist," Sharon Rudahl's "What Did You Learn Today?," Kathryn LeMieux's "Barbie at 30+," *CWC2*: 359–362, 367, 407–409, 418–419, 434–435; Leah Weaver, "The Feminine Condition: Cartoon Images of Women in *The New Yorker*," *Inks* 1, no. 3 (November 1994): 8–17, 15, 16.

84. Jay Kinney, "And Now for a Few Words from the Editor," *Anarchy Comics* no. 1 (1978), 2; "Two Generations of Weirdos," *TCJ* no. 106 (March 1986): 53.

85. Spiegelman, "Raw Nerves"; Peter Kuper, *Speechless* (Top Shelf Productions, 2001), 38; quote "Newswatch," *TCJ* no. 89 (March 1984): 14; Dale Luciano, "Newave Comics Survey," *TCJ* no. 96 (March 1985): 51–78, and subsequent issues.

86. Geerdes, "Newave Days," in *Newave!: The Underground Mini Comix of the 1980s*, ed. Michael Dowers (Fantagraphics, 2010), 154–162, 158.

87. Reprinted in Tobocman, *You Don't Have to Fuck People Over to Survive* (Soft Skull Press, 1999), 4, 6–7; "Peter Kuper Interview," 73; *WW3 Illustrated*, no. 3 (1984). This style was the hallmark of Tobocman's magnum opus, *War in the Neighborhood* (Autonomedia, 1999); Tobocman's work here is stark, strong, with hallmarks of political postering and iconic representation.

88. See Ben Katchor, *Cheap Novelties: The Pleasures of Urban Decay* (Penguin Books, 1991).

89. "Newswatch," *TCJ* no. 92 (August 1984): 18.

90. "Return of the Dark Knight," *TCJ* no. 101 (August 1985): 60.

91. "Master of Confusion," *TCJ* no. 77 (November 1982): 54; "Frank Miller: Return of the Dark Knight,", 59; Vaz, 176; *Vigilante* no. 4 (March 1984), repr. in Marv Wolfman, *Vigilante* vol. 1 (DC, 2017), 150.

92. "Newswatch," *TCJ* no. 112 (October 1986): 9. Miller professed himself to be a big fan of Steve Ditko's Mr. A. *Batman: The Dark Knight Returns* (DC, 1987), 61. Compare Tim Blackmore, "The Dark Knight of Democracy," *Journal of American Culture* 14, no. 1 (1991): 37–56.

93. DK 1:24. The vampire idea was played out more literally in a series of Doug Moench graphic novels. Tom Morris, "God, the Devil, and Matt Murdock," in *Superheroes and Philosophy: Truth, Justice, and the Socratic Way*, ed. Tom Morris and Matt Morris (Open Court, 2005), 45–61; "David Mazzucchelli Interview," *TCJ* no. 194 (March 1997): 49; Geoff Klock, *How to Read Superhero Comics and Why* (Continuum, 2002), 25–50.

94. Quote "Newswatch," *TCJ* no. 108 (May 1986): 14; "Newswatch," *TCJ* no. 109 (July 1986): 12; Eileen R. Meehan, "'Holy Commodity Fetish, Batman!': The Political Economy of a Commercial Intertext," in *The Many Lives of the Batman*, 53; *CCG*, 165.

95. First among equals: Golden Age superfan Roy Thomas. Thomas, "Introduction," *Infinity, Inc.: The Generations Saga* (DC, 2011), 4–5.

96. R. C. Harvey, "DC Is Dull Comics," *TCJ* no. 61: 113–123, 122.

97. "Newswatch," *TCJ* no. 67 (October 1981): 12; Kevin McConnell, "Mutants, Mutants, Everywhere!," *TCJ* no. 81 (May 1983): 46; McConnell, "The House of Second-Hand Ideas," *TCJ* no. 74 (August 1982): 6–7; "The Third Generation of X-Men," *TCJ* no. 74 (August 1982): 60; "Chris Claremont," *TCJ* no. 100 (July 1985): 80; see Avengers and Fantastic Four stories (from issues cover-dated January 1986) repr. in *Essential X-Factor*, vol. 1 (Marvel, 2005); Benton, *Comic Book*, 85; A. David Lewis, "Ever-Ending Battle," *IJCA* 8, no. 1 (Spring 2006): 163–173; Howe, 287.

98. "Newswatch," *TCJ* no. 85 (October 1983): 13–14; Daniels, *Marvel*, 197; "Marvel Super Heroes Secret Wars: The Toys!," in *Secret Wars* (Marvel, 2011). There were *Secret Wars* sunglasses, beach towels, watches, lunch boxes, and more.

99. Quote from Schwartz, *Two Worlds*, 88.

100. "Len Wein," *TCJ* no. 100 (July 1985): 163; "Funnybook Roulette," *TCJ* no. 112 (October 1986): 31–32.

101. "Newswatch," *TCJ* no. 104 (January 1986): 15; "DC Hires Clothes Designer for Comics Line," *TCJ* no. 77 (November 1982): 13; See Daniels, *DC*, 192.

102. Marv Wolfman, *Crisis on Infinite Earths* (DC, 1998); see "Crisis on Earth-One!," "Crisis on Earth-Two!," and "Crisis on Earth-Three!," *Justice League of America* no. 21–22 (August and September 1963), repr. in *JLAA3*, 171–222, and *Justice League of America* no. 29 (August 1964), repr. in *Justice League of America Archives*, vol. 4 (DC, 1998), 176; Heidi MacDonald, "Crises at Infinite Companies," *TCJ* no. 106 (March 1986): 35.

103. Marv Wolfman and George Pérez, *History of the DC Universe*, nos. 1 and 2 (1986); "Newswatch," *TCJ* no. 104 (January 1986): 14.

104. And doing away with her secret identity: Daniels, *DC*, 194.

105. *Batman: Year One* (DC, 1988); *Batman: Year Two* (DC, 2002); Dan Raspler, "An Ex-Assistant Editor Recalls Simpler Times," *Batman: Ten Nights of the Beast* (DC, 1994).

106. *Slugfest*, 157.

107. Roger Sabin, *Adult*, 28; *CCG*, 33; *True Brit*, ed. George Khoury (TwoMorrows, 2004), 4–29; Tim Pilcher and Brad Brooks, *The Essential Guide to World Comics* (Collins & Brown, 2005), 56–84.

108. Sabin, *Adult*, 47–49; Skinn, 54, 180–213; David Huxley, *Nasty Tales: Sex, Drugs, Rock 'N' Roll and Violence in the British Underground* (Critical Vision, 2001), 33–48, 96–100, 119–121; Bryan Talbot's 1975 *Brain Storm Comix* no. 1, its cover proclaiming "Journey into Delirium," starred a psychedelic alchemist whose fantastic trips mixed Kirbyesque figures and spacescapes with countercultural language: "Bryan Talbot Interview," *TCJ* no. 194 (March 1997): 91–92.

109. See *PB*, 75–76; one long arc, "The Cursed Earth," allegorizes the British reimposition on the decaying but still powerful American monolith; see "Night of the Vampire!" and "The Sleeper Awakes," originally published 1978, repr. in *Judge Dredd: The Complete Case Files 02* (Rebellion, 2010), n.p.; John Newsinger, *The Dredd Phenomenon: Comics and Contemporary Society* (Libertarian Education, 1999), esp. 9–16; Matthew T. Althouse, "Kevlar Armor, Heat-Seeking Bullets, and Social Order," in *Comics & Ideology*, 195–219; *CCG*, 138.

110. He worked at a skinyard and as a toilet cleaner at a local hotel: "Big Words: Alan Moore Interview," *TCJ* no. 138 (October 1990): 58, 63–65; Hy Bender, *The Sandman Companion* (DC, 1999), 8; George Khoury, *The Extraordinary Works of Alan Moore* (TwoMorrows, 2003), 18–20, 38, 44, quotes 20; "Alan Moore," *TCJ* no. 93 (September 1984): 77, 79, 84–85.

111. See, for example, *The Complete D. R. and Quinch* (Rebellion, 2010); *The Complete Future Shocks* (Rebellion, 2018); "'Marvel Revolution' in England," *TCJ* no. 45 (March 1979): 14; "Marvel U.K. Now Producing Own Strips," *TCJ* no. 47 (July 1979): 9; "Dez Skinn Leaves Marvel U.K.," *TCJ* no. 53 (March 1980): 15; Huxley 56–58.

112. Lupoff, "Propwash Again," 198–204; *S2*, 71; "DC's Swamp Thing to Star in Movie," *TCJ* no. 61 (Winter 1980–1981): 21; Len Wein, "Home Again, Home Again: An Introduction of Sorts," in Alan Moore, *Saga of the Swamp Thing, Book One* (DC, 2009), 6–8; Dick Giordano credited Levitz, saying, "Maybe it was Paul Levitz's idea, I forget whose it was, but Paul said, 'Look, we've run out of possibilities here, let's start looking elsewhere'": "Dick Giordano," *TCJ* no. 100 (July 1985): 107.

113. Compare Di Liddo, 46–47, 61.

114. Alan Moore, "Introduction," *Saga of the Swamp Thing*, (DC, 1987), v–xi, vii.

115. *Superman* no. 423 and *Action Comics* no. 583 (both September 1986), repr. in *DC Universe*, 164–214.

116. *Saga of the Swamp Thing* no. 21 (February 1984), repr. in *Saga of the Swamp Thing*, 49, 59.

117. Quotes *Extraordinary*, 95; Neil Gaiman, "Love and Death—An Overture," *Saga of the Swamp Thing, Book Two* (DC, 2009), 9–12, 12; "Comics Code Rejects Saga of Swamp Thing; Swamp Thing Rejects Code," *TCJ* no. 93 (September 1984): 12; "Rite of Spring," *Swamp Thing* no. 34 (March 1985).

118. Quote Benton, *Horror*, 79.

119. Moore, "Introduction," viii–ix.

120. DC bought the characters in 1983, Charlton went out of business in 1985; Moore quote *TCJ* no. 116 (July 1987): 80.

121. Mark Gruenwald, *Squadron Supreme Omnibus* (Marvel, 2010); Rob Rodi, "Super Fascists, Absolute Evil, and Wild, Wild Women," *TCJ* no. 109 (July 1986): 64–65. Contemporary with *Watchmen* was DC's more typical *Legends*; Reagan's proscription of superhero activity turns out to be due to Darkseid's plot: John Ostrander et al., *Legends: The Collection* (DC, 1993, original material 1986–87).

122. Wertham actually had a 1945 *New Republic* article called "Who Will Guard the Guardians." Were it anybody but Moore, I'd suspect they'd never heard of it.

123. Compare Rob Rodi, "Values and Vigilantes," *TCJ* no. 120 (March 1988): 37; Moore "defend[s] its structure to the ends of the Earth," "Big Words," 80; Groensteen, "Töpffer, the Originator," 99–100; Wolk, 237–238.

124. Original Ditko-drawn story of Captain Atom in *Space Adventures* no. 33 (March 1960), repr. in *The Action Heroes Archives*, vol. 1, *Captain Atom* (DC, 2004), 10–18, 18. Dell published *Doctor Solar, Man of the Atom*, in 1962; see Mark Evanier, "Introduction," *Doctor Solar* (Dark Horse, 2010). Around the same time, in 1984, Moore's sometime collaborator Rick Veitch also published a superhero story set against American–Russian nuclear tensions, *The One* (King Hell, 2003): "Rick Veitch Interview," *TCJ* no. 175 (March 1995): 66.

125. See also R. Reynolds, *Super Heroes*, 106.

126. Quotes *TCJ* no. 116 (July 1987): 85; Daniels, *DC*, 196.

127. "Newswatch," *TCJ* no. 113 (December 1986): 13–14. Moore cited Kurtzman's parodies as influential, similarly applying real-world logic to a superhero situation, only for dramatic, rather than satiric, purpose. See Alan Moore, "Revival and Revelation," in George Khoury, *Kimota!: The Miracleman Companion* (TwoMorrows, 2001), 11–12.

128. Collected in DeMatteis and Muth, *The Compleat Moonshadow* (DC, 1998); "Newswatch," *TCJ* no. 97 (April 1985): 16.

129. First appears in *Bizarre Sex* no. 9 (1981). The issue sold over sixty thousand copies: Schreiner, *Kitchen*, 56.

130. Bob Maddux, *Fantasy Explosion* (Regal Books, 1986), 61–62; "The Ratings Debate," *TCJ* no. 85 (October 1983): 17–21; "Newswatch," *TCJ* no. 92 (August 1984): 16.

131. "Newswatch," *TCJ* no. 102 (September 1985): 26; "Newswatch," *TCJ* no. 103 (November 1985): 13–14; James Vance, "Introduction," *The Complete Omaha the Cat Dancer*, vol. 1 (NBM, 2005); "Newswatch," *TCJ* no. 114 (February 1987): 13; "Newswatch," *TCJ* no. 120 (March 1988): 5; "Newswatch," *TCJ* no. 133 (December 1989): 13–14; "Newswatch," *TCJ* no. 126 (January 1989): 25; "Newswatch," *TCJ* no. 113 (December 1986): 18; "Newswatch," *TCJ* no. 114 (February 1987): 16–19.

132. Dale Luciano, "'Raw': Pataphysical Spirit and Graphic Possibilities," *TCJ* no. 64 (July 1981): 36–44, 39.

133. *MetaMaus*, 46.

134. Janice Morris, "Of Mice and Men: Collaboration, Postmemory, and Working Through in Art Spiegelman's *Maus: A Survivor's Tale*," in *Graphic History: Essays on Graphic Novels and/ as History*, ed. Richard Iadonisi (Cambridge Scholars Publishing, 2012), 6–36, 7; Michael G. Levine, "Necessary Stains: Art Spiegelman's *Maus* and the Bleeding of History," in *Considering Maus: Approaches to Art Spiegelman's "Survivor's Tale" of the Holocaust*, ed. Deborah R. Geis (University of Alabama Press, 2003), 63–104; *MetaMaus*, 35.

135. Witek, *Comic Books as History*, 115, 117. Spiegelman seemingly suggested the work was cathartic; in 1991, he said, "In many ways I have a better relationship with him than when he was alive": "Art Spiegelman Interview," *TCJ* no. 145 (October 1991), 98.

136. Morris 17–19; Spiegelman, *MetaMaus*, 23–24. On Vladek's taped voice, and the "odd disjunction between the quality of the voice and the inflection rendered in the panels," see Nancy K. Miller, "Cartoons of the Self," in Deborah R. Geis, ed., *Considering Maus*, 44–59, 55; John C. Anderson and Bradley Katz, "Read Only Memory: Maus and Its Marginalia on CD-ROM," in *Considering Maus*, 167–168. The Geis collection as a whole is an excellent overview.

137. Two excellent unpackings are Gene Kannenberg Jr., "'I Looked Just Like Rudolph Valentino': Identity and Representation in *Maus*," in *The Graphic Novel*, 79–89, and Hillary Chute, "History and Graphic Representation in *Maus*," in *Comics Studies Reader*, 340–362; see also *MetaMaus*, 28–32; Greg Cwiklik, "Art Spiegelman Re-Examines Comics," *TCJ* no. 240 (January 2002): 12. *Funny Aminals*, notably, was an anti-vivisectionist benefit comic: Richard

De Angelis, "Of Mice and Vermin: Animals as Absent Referent in Art Spiegelman's *Maus*," *IJCA* 7, no. 1 (Spring 2005): 238.

138. "Foreword," in Edmond-François Calvo and Victor Dancette, *The Beast Is Dead: II World War Among the Animals* (Abi Melzer, 1984; 1944), n.p.

139. Quotes Witek, *Comic Books as History*, 112; *TCJ* no. 116 (July 1987): 75.

140. Groth, "Slaughter on Greene Street," *TCJ* no. 74 (August 1982): 70; *Dangerous Drawings*, 10; Sue Vice, "'It's About Time': The Chronotope of the Holocaust in Art Spiegelman's *Maus*," in *The Graphic Novel*, 47–60, esp. 49–51; Dale Luciano, "Trapped by Life: Pathos and Humor Among Mice and Men," *TCJ* no. 113 (December 1986): 45; Andrew Loman, "'That Mouse's Shadow,'" in *The Rise of the American Comics Artist*, ed. Paul Williams and James Lyons (University Press of Mississippi, 2010), 210–233.

Chapter 8: Between Spandex and Seattle

1. Janwillem van de Wetering and Paul Kirchner, *Murder by Remote Control* (Ballantine, 1986); "Newswatch," *TCJ* no. 110 (August 1986): 15–16; "Newswatch," *TCJ* no. 112 (October 1986): 14.

2. Letter reprinted in Spiegelman, *Comix, Essays, Graphics and Scraps* (Raw Books, 1999), 16.

3. Kurt Eichenwald, "Grown-Ups Gather at the Comic Book Stand," *NYT*, September 30, 1987; Gerber, 220; "Introduction," Daniels, *DC*, 13; Robbins, "babes," xii.

4. Shirrel Rhoades, *Comic Books: How the Industry Works* (Peter Lang, 2008), 4–5, 16; "Kurt Busiek: The Mainstream," *TCJ* no. 188 (July 1996): 85; "News Watch Special: Rob and Todd," *TCJ* no. 195 (April 1997): 30; "Comics Sales Still Slipping," *TCJ* no. 203 (April 1998): 14.

5. Compare *Dream* (Pajama Rancher Books, 1995); *Flock of Dreamers: An Anthology of Dream Inspired Comics* (Kitchen Sink, 1997); Richard Gehr, "Higher than Hieroglycerine," *Snake Eyes* no. 2 (1992), inside front cover; R. Fiore, "Funnybook Roulette," *TCJ* no. 132 (November 1989): 46; *CCG*, 178; "Dan Clowes Interview," 84.

6. "Newswatch," *TCJ* no. 141 (April 1991): 25; "Industry Sales Records in 1993 Shadowed by Collapse of Spectacular Boom," *TCJ* no. 166 (February 1994): 27; Matthew P. McAllister, "Ownership Concentration in the U.S. Comic Book Industry," in *Comics & Ideology*, 15–38, 17, 20; Mila Bongco, *Reading Comics: Language, Culture, and the Concept of the Superhero in Comic Books* (Garland, 2000), 197; Howe, 324.

7. Russell Freund, "Make the Heroes Turtles," *TCJ* no. 98 (May 1985): 37; see also "Newswatch," *TCJ* no. 89 (March 1984): 15; Goulart *Fifty* 303; "Kevin Eastman," 43–44, 47; *Teenage Mutant Ninja Turtles: Ultimate Collection*, vol. 1 (IDW, 2011), 20.

8. Quote "Newswatch," *TCJ* no. 114 (February 1987): 26; "Newswatch," *TCJ* no. 115 (April 1987): 21; Gary Groth, "Black and White and Dead All Over," *TCJ* no. 116 (July 1987): 8; "Subversion Through Subtlety," *TCJ* no. 107 (April 1986): 96.

9. See comments in "Todd McFarlane Interview," *TCJ* no. 152 (August 1992): 46; quote Bongco, 185; Daniels, *Marvel*, 223–225; "Newswatch," *TCJ* no. 147 (December 1991): 13–14; *SLRise*, 235; "Newswatch," *TCJ* no. 170 (July 1994): 15; Mark Voger, *The Dark Age* (TwoMorrows, 2006), 124–132; Howe, 316–323, 330–331, 335–342.

10. *Deadpool Classic*, vol. 1 (Marvel, 2008); *Deathblow: Sinners and Saints* (WildStorm, 1999, originally published 1993–1995); Bongco, 191; "X-Bodies," 59; "Batman in a Bustier," *Forbes*, April 8, 1996; Brown, *Milestone*, 56; Jeffrey A. Brown, "Gender, Sexuality, and Toughness: The Bad Girls of Action Film and Comic Books," in Sherrie A. Inness, *Action Chicks: New Images of Tough Women in Popular Culture* (Palgrave Macmillan, 2004), 47–74, esp. 60–64; J. Scott Campbell, *Absolute Danger Girl* (WildStorm, 2003), from the late '90s; see *Gen13 #13 A, B, & C Collected Edition* (Image, 1997).

11. See Trina Robbins, "Comics for Women & Girls: Impossible Market or Untapped Riches?," *TCJ* no. 187 (May 1996): 11.

12. Wiater, 264; "Bye Bye Marvel; Here Comes Image," *TCJ* no. 148 (February 1992): 11–12, 12; "Newswatch," *TCJ* no. 151 (July 1992): 21; "Newswatch," *TCJ* no. 152 (August 1992): 7; for a longer history, see "The Image Story," *TCJ* no. 222 (April 2000): 11, Stewart quote 12; *TCJ* no. 223 (May 2000): 3, 5; *TCJ* no. 225 (July 2000): 8–11; *TCJ* no. 226 (August 2000): 14–20; Tankel and Murphy, 64–65; Beaty, *Versus*, 163–172.

13. Recriminations and lawsuits followed: "Newswatch," *TCJ* no. 161 (August 1993): 9; *SLRise*,

237, 243; "Comics Publishers Suffer Tough Summer," *TCJ* no. 172 (November 1994): 13; "Viva La Comix!," *TCJ* no. 173 (December 1994): 6; "Newswatch," *TCJ* no. 174 (February 1995): 22; "Now It Can Be Told: Image Lashes Back," *TCJ* no. 194 (March 1997): 16; *Oddly Compelling*, 47. For a partial list of closed companies, see "Pro/Con Politics," *TCJ* no. 178 (July 1995): 1.

14. On Kitchen Sink's finances, particularly its relationship with Kevin Eastman's Tundra, see, variously, "Steve Bissette Interview," *TCJ* no. 185 (March 1995): 49–59; "Kevin Eastman," *TCJ* no. 202 (March 1998): 60–99; Michael Dean, "Kitchen Sunk," *TCJ* no. 213 (June 1999): 13–26, Kitchen quote 19.

15. "State of the Industry—1996," *TCJ* no. 188 (July 1996): 36.

16. See Ray Mescallado, "Cheap Thrills, Essentially Yours," *TCJ* no. 193 (February 1997): 121; R. C. Harvey, "Milestones at Two Score and One," *TCJ* no. 200 (December 1997): 82.

17. Bart Beaty, "Pickle, Poot, and the *Cerebus* Effect," *TCJ* no. 207 (September 1998): 1.

18. Jerome Charyn, "A Note to the American Reader," *The Magician's Wife* (Catalan, 1987); "Newswatch," *TCJ* no. 117 (September 1987): 17; "Mad About the *Maus*," *TCJ* no. 147 (December 1991): 22.

19. "Newswatch," *TCJ* no. 116 (July 1987): 27.

20. *Slugfest*, 163; Daniels, *Marvel*, 202–203, 215; Sabin, *CCG*, 171; "Newswatch," *TCJ* no. 89 (March 1984): 8; "Marvelution: The Art of the Deal," *TCJ* no. 176 (April 1995): 14; Raviv, *Comic Wars*.

21. See *DC's Greatest Imaginary Stories*, 34–58; McAllister, "Ownership," 22; *Dark Age*, 89–93.

22. Compare Arnold T. Blumberg, "'The Night Gwen Stacy Died': The End of Innocence and the 'Last Gasp of the Silver Age,'" *IJCA* 8, no. 1 (Spring 2006): 203–204.

23. José Alaniz, "Death and the Superhero: The Silver Age and Beyond," *IJCA* 8, no. 1 (Spring 2006): 234.

24. Michael Dean, "Our Zombies, Ourselves," *TCJ* no. 289 (April 2008): 40.

25. "Newswatch," *TCJ* no. 174 (February 1995): 15; see also Tom Spurgeon, "How Diamond Works," *TCJ* no. 215 (August 1999): 30–39; "Is Diamond Necessary?," *TCJ* no. 222 (April 2000): 20–26; "Newswatch," *TCJ* no. 274 (February 2006): 21; *Slugfest*, 180–182.

26. "Department of Justice Investigates Comic Distribution Industry," *TCJ* no. 199 (October 1997): 9–12; "DOJ Drops Investigation of Diamond," *TCJ* no. 229 (December 2000): 8.

27. Pustz, 16–17; "Bud Plant Sells Out to Diamond: Diamond Achieves 40% Market Share," *TCJ* no. 124 (August 1988): 9; McAllister, "Ownership," 24–26, 31; Skinn, 45; *Comic Wars*, 176, 54.

28. Mark C. Rogers, "Licensing Farming and the Comic Book Industry," *IJCA* 1, no. 2 (1999): 132–142; Gordon, 169n2; Goulart, *Fifty*, 303; Wiater, 111–112, 115, 120; *Comic Wars*, 256–257; Rhoades, 9.

29. Michael Dean, "Image Gets a More Mainstream Makeover," *TCJ* no. 260 (May/June 2004): 10.

30. "Image Story—Part Four: An Accounting," *TCJ* no. 226 (August 2000): 16.

31. *CCG*, 167.

32. "Newswatch," *TCJ* no. 142 (June 1991): 23; Meehan, 47–65, 47, 55; McCue, 127.

33. Booker, 61–72; Sabin, *Adult*, 218.

34. See, for example, Dennis O'Neil et al., *Batman: The Movies* (DC, 1997).

35. See Kelley Puckett et al., *The Batman Adventures*, vol. 1 (DC, 1993).

36. *The Batman Strikes!*, vol. 3, *Duty Calls* (DC, 2007).

37. See Mark Evanier's comments in "The Business of Comics," 61–62; Jacobs and Jones, 188; "Carmine Infantino Interview," 85.

38. "Newswatch," *TCJ* no. 100 (July 1985): 29.

39. "San Diego Comic-Con 2000," *TCJ* no. 226 (August 2000): 23.

40. "San Diego Notebook 1998," *TCJ* no. 207 (September 1998): 19; "Big Deal," *TCJ* no. 216 (October 1999): 23; "Newswatch," *TCJ* no. 247 (October 2002): 28; "Newswatch," *TCJ* no. 263 (October/November 2004): 27; "Newswatch," *TCJ* no. 271 (October 2005): 29; "Newswatch," *TCJ* no. 278 (October 2006): 60.

41. "Evan Dorkin," *TCJ* no. 214 (July 1999): 80; "Pro/Con 3 Survives Turbulent Times," *TCJ* no. 177 (May 1995): 22; "Kevin Eastman," 48; "Meet Marvel's New Boss," *TCJ* no. 218 (December 1999): 7; "Kitchen Sunk," 16.

42. Kevin Tinsley, *Digital Prepress for Comic Books: The Definitive Desktop Production Guide* (Stickman Graphics, 1999), 9; Michael Saenz and Peter Gillis, *Shatter: The Revolutionary Graphic Novel* (Fawcett Columbine, 1988); "Comics Step Slowly into Computer Age," *TCJ* no. 140

(February 1991): 20; "Newswatch," *TCJ* no. 94 (October 1984): 25; Pepe Moreno, *Batman: Digital Justice* (DC, 1990); *Surfing the Conscious Nets* (Last Gasp, 1995); Anderson and Katz, 159–174; "Slowly Through This Little Tale," *TCJ* no. 173 (December 1994); 60–61; "Byte Me, Fan-Boy!," *TCJ* no. 188 (July 1996): 28–29.

43. See Clark Farmer, "Comic Book Color and the Digital Revolution," *IJCA* 8, no. 2 (Fall 2006), esp. 331, 339–340.

44. "Kyle Baker," *TCJ* no. 219 (January 2000): 56–57; "Graphic Novel Panels Discussion," *TCJ* no. 243 (May 2002): 43.

45. R. C. Harvey, "Comicopia," *TCJ* no. 183 (January 1996): 115; "Newswatch," *TCJ* no. 184 (February 1996): 47; "Newswatch," *TCJ* no. 187 (May 1996): 14; see also "Scott McCloud: Comics Future," *TCJ* no. 188 (July 1996): 76–83.

46. "Spain Interview," *TCJ* no. 206 (August 1998): 140; "Spain: Kicking and Screaming," *TCJ* no. 232 (April 2001): 92; "Newswatch," *TCJ* no. 206 (August 1998): 22; *TCJ* no. 207 (September 1998): 28; "Newswatch," *TCJ* no. 211 (April 1999): 9; "Chuck Rozanski's Amazon Adventure," *TCJ* no. 218 (December 1999): 10–11; "Web Dominates Comic Book Expo," *TCJ* no. 216 (October 1999): 25.

47. "Heavy Metal Madness?," *TCJ* no. 202 (March 1998): 7.

48. "Newswatch," *TCJ* no. 100 (July 1985): 29.

49. Ad reprinted in Daniel Wallace, *The Joker* (DC, 2011), 110; Dennis O'Neil, "Introduction," Marv Wolfman and George Perez, *Batman: A Lonely Place of Dying* (DC, 1990).

50. Jeremy Pinkham, "28.8 Panels Per Second: A Field Guide to Electronic Comics Culture," *TCJ* no. 213 (June 1999): 106.

51. Wolk, 66. In an echoing incident by an early internet evangelist, *Dilbert* asked readers in November 1993 to vote by email on whether Dilbert should whack Ratbert with a rolled-up newspaper. Ratbert noted the next day that "male [respondents] heavily favor" the whacking: Scott Adams, *Fugitive from the Cubicle Police* (Andrews and McMeel, 1996), 27.

52. For a female critic's view, Heidi MacDonald's title "You Guys Need to Get Laid" (*TCJ* no. 200 [December 1997]: 90–97), says it all.

53. Evan Dorkin's Eltingville comics display the type at its most navel-gazing, back-biting, and toxic: see "Evan Dorkin," 65–69; compare Dan Clowes's "The Death of Dan Pussey."

54. Scott Nesbitt, "Comics on CompuServe," *TCJ* no. 171 (September 1994): 94; Roger Sabin, "The Crisis in Modern American and British Comics, and the Possibilities of the Internet as a Solution," in *Comics & Culture*, 43–57.

55. Tom Spurgeon, "Martin Wagner Owes Me Fifty Bucks," *TCJ* no. 211 (April 1999): 2.

56. Quotes *Dangerous Drawings*, 10; Gardner, 141; Eisner's introduction to *The Dreamer*. Compare Groth, "Will Eisner: A Second Opinion," in *TCJ* no. 119 (January 1988): 3–7; Levitz, *Eisner*, 28.

57. See Eichhorn, *Real Stuff* (Swifty Morales Press, 2004); "Dennis Eichhorn Interview," *TCJ* no. 162 (October 1993): 85–86. For a contemporary (quasi-)autobiographical collection somewhere between Pekar and Eichhorn on the gonzo spectrum, see Michael Dougan, *Can't Tell You Anything and Other Stories* (Penguin, 1993).

58. "Appreciating Carl Barks," *TCJ* no. 83 (August 1983): 53; Dale Luciano, "American Gothic and Sardonic Horror," *TCJ* no. 66 (September 1981): 37–40, 37; *Dangerous Drawings*, 99; "Dan Clowes Interview," *TCJ* no. 154 (November 1992): 62, 64, 68; Hignite, 171–175.

59. "Dan Clowes Interview," 66; *Ghost World* (Fantagraphics, 1998).

60. On *Hate* as a generational text, see Pustz, 96–97. Band names include Unsupervised Existence and Slutburger; see *Buddy Does Seattle* (Fantagraphics, 2005), 58, 110, 167–171, quote 274–275. Christopher Irving, "Meet the Bagges," in *Peter Bagge: Comics Introspective* (Two-Morrows, 2007), 13, 61–66; R. Fiore, "Seattle Club Seattle," *TCJ* no. 172 (November 1994): 43–45.

61. See *The Complete Eightball* (Fantagraphics, 2015). Clowes's graphic novel *Wilson* uses gag strip rhythms, like the punch line in last panel, to deliver similar misanthropic punch; his contemporary *Caricature* visits concepts of image and self-presentation more profoundly.

62. Compare Gilbert Hernandez and Crumb's discussion in Gary Groth, "Robert Crumb—Live Online: The Interview That Didn't Happen," *TCJ*, October 31, 2011, http://www.tcj.com/crumb-and-groth-live-online/3.

63. "Dumb," *Zap Comix* no. 13 (1994), 643–652; "A Bitchin' Bod!," *Hup* no. 4, repr. in *Coffee*

Table, 231–243, 232–233; "Newswatch," *TCJ* no. 172 (November 1994): 35. The final, on-brand panel of *Zap* is Crumb smacking Aline's behind, saying, "I'll give you a zap on the tuckus!": Crumb, "I've Had It!," *Zap Comix* no. 14 (1998), repr. in *The Complete Zap Comix*, vol. 4 (Fantagraphics, 2014), 725–726, 726.

64. Brown, *I Never Liked You: A Comic-Strip Narrative* (Drawn & Quarterly, 2002); Seth, *It's a Good Life If You Don't Weaken* (Drawn & Quarterly, 2004). On Seth's mainstream childhood influences, see "Seth Interview," *TCJ* no. 193 (February 1997): 60–64; on his use of silence, 83; compare Daniel Marrone, *Forging the Past: Seth and the Art of Memory* (University Press of Mississippi, 2016), esp. 149–152.

65. Later, Matt casts doubt on *Fair Weather*'s narrative: "This doesn't *begin* to capture what my childhood was like. . . . I was a happy go lucky kid . . . not this miserable, little brat," claiming he was too lazy to draw the ending he'd planned. See *Spent* (Drawn & Quarterly, 2007); "Joe Matt Interview," *TCJ* no. 183 (January 1996): 68.

66. Fingerman, *Maximum Minimum Wage* (Image, 2013), 205. Years later, Fingerman returned to the characters; see *Minimum Wage*, vol. 1, *Focus on the Strange* (Image, 2014). Fingerman asked memoir's all-important question ("How liberating would it be to create a memoir of events yet to happen?"); given his pop culture–soaked imagination, the events involved postapocalyptic nuclear mutants: *Bob Fingerman's From the Ashes (A Speculative Memoir)* (IDW, 2010), front cover flap.

67. Lynda Barry, *One! Hundred! Demons!* (Sasquatch Books, 2002), 72; Barry, *The Fun House* (Perennial Library, 1987); see Susan E. Kirtley, *Lynda Barry: Childhood Through the Looking Glass* (University Press of Mississippi, 2012), 15–47, 148–178.

68. *Amputee Love* no. 1 (1975), inside front cover, later quote 19.

69. Al Davison, *The Spiral Cage* (Active Images/Astral Gypsy Press, 2003); *Our Cancer Year* (Thunder's Mouth Press, 1994—art by Frank Stack). Years before, Pekar and Gerry Shamway had chronicled another Pekar health scare; see "An Everyday Horror Story," *American Splendor* no. 5 (1980), 34–58; compare Elisabeth El Refaie, *Autobiographical Comics: Life Writing in Pictures* (University Press of Mississippi, 2012), esp. 66–68, 89–92.

70. Matthew P. McAllister, "Comic Books and AIDS," *JPC* 26 no. 2 (1992): 1–24, 4, 14–15.

71. In June of 1994, a DC editor died of AIDS, bringing it home to the company as well; *TCJ* no. 170 (August 1994): 32.

72. David Wojnarowicz, *Seven Miles a Second* (DC, 1996), quotes 56, 58.

73. Judd Winick, *Pedro and Me: Friendship, Loss, and What I Learned* (Henry Holt, 2000), 27.

74. Charles Burns, *Hard-Boiled Defective Stories* (Penguin, 1990) and *Skin Deep* (Fantagraphics, 2001); see "Charles Burns Interview," *TCJ* no. 148 (February 1992): 55, 65; Leon Hunt, "Popular Defective," *TCJ* no. 125 (October 1988): 50. Early single-panel cartoons running in the free Seattle monthly the *Rocket* were titled *Mutantis*: Hignite, 104, 110.

75. 1988's "Teen Plague" was published in *Raw* in 1989; Charles Burns, *Big Baby* (Fantagraphics, 2007), 41–62.

76. Burns, "Interview," 65.

77. Another clear influence, David Cronenberg's body horror, is visible in Burns's slightly later descendant Dave Cooper; see his *Ripple: A Predilection for Tina* (Fantagraphics, 2003) and "Dave Cooper Interview," *TCJ* no. 245 (August 2002): 92.

78. Compare, however, Goulart, *Adventurous Decade*, 135, and Edward H. Sewell Jr., "Queer Characters in Comic Strips," in *Comics & Ideology*, 251–274, 253.

79. Robbins, *Brinkley Girls*, 92; Skinn, 167; Justin Hall, ed., *No Straight Lines: Four Decades of Queer Comics* (Fantagraphics, 2012), 10–15; *CWC1*, 164–167, quote 167; "Roberta Gregory Interview," *TCJ* no. 168 (May 1994): 58, 60; *Dynamite Damsels* (1976), 2. Gregory created the unforgettable Bitchy Bitch and Bitchy Butch in the '90s. See *As Naughty as She Wants to Be!* (Fantagraphics, 1995), 19; Tyler Cohen, "Go Ahead and Bitch," *TCJ* no. 158 (April 1993): 11–13; *Bitchy Butch: World's Angriest Dyke!* (Fantagraphics, 1999).

80. Bell, 166; "Sexual Politics and Comic Art: An Interview with Howard Cruse," *TCJ* no. 111 (September 1986): 68; Wiater, 74, 76.

81. "Unfinished Pictures," *Bizarre Sex* no. 4 (1975), 14–17, quote 15; Howard Cruse, *The Other Sides of Howard Cruse* (Boom! Studios, 2012); "Gravy on Gay," *Barefootz Funnies* no. 2 (1976), 23–34, 23, 27–29; see *Cruse*, 91, and Cruse, *From Headrack to Claude: Collected Gay Comix* (Nifty Kitsch, 2009), 8–12.

82. Schreiner, *Kitchen*, 45; "Cruse to Edit Gay Comic Book," *TCJ* no. 53 (Winter 1980): 18; *TCJ* no. 59 (1980): 53; Bill Sherman, "Coming Out and Going Out," *TCJ* no. 62 (March 1981): 92–94, 92; Cruse quote *From Headrack*, 28.

83. *Best Comics of the Decade*, 81–85; Schreiner, *Kitchen*, 66; "Sexual Politics," 77; McAllister, "AIDS," 13; Cruse, *From Headrack*, 51, quotes 52.

84. Reprinted in *Doonesbury 40*, 105. He later died of AIDS, receiving an honorary square on the AIDS Memorial Quilt: B. Walker, *Doonesbury*, 78.

85. See Maxine P. Fisher, "Tender Balloons: An Interview with Tom Hachtman," *Funnyworld* no. 22: 34–39, quote 35; see *Fun City: Gertrude's Follies Come to Town* (Arbor House, 1985); previous collections included *Gertrude's Follies* and *Tom Hachtman's DoubleTakes*.

86. Howard Cruse, *Wendel All Together* (Olmstead, 2001); Tim Barela, *Domesticity Isn't Pretty: A Larry and Leonard Collection* (Palliard Press, 1993).

87. "Life Drawing," 51.

88. Alison Bechdel, "Introduction: On the Occasion of the Twentieth Anniversary of 'Dykes to Watch Out For,'" *Dykes and Sundry Other Carbon-Based Life-Forms to Watch Out For* (Alyson Books, 2003); "Alison Bechdel Interview," 116.

89. Alison Bechdel, *Dykes to Watch Out For* (Firebrand Books, 1986), back cover. The collection included the famous Bechdel Test (here called "The Rule," added "with thanks to Liz Wallace"): "I only go to a movie if it satisfies three basic requirements. One, it has to have at least two women in it. Who, Two, talk to each other about, Three, something besides a man. . . . Last movie I was able to see was *Alien* . . . the two women in it talk to each other about the monster."

90. "Alison Bechdel Interview," 117.

91. Alison Bechdel, *Dykes to Watch Out For: The Sequel* (McNaughton & Gunn, 1992), 16–17.

92. "Life Drawing," 44.

93. "Newswatch," *TCJ* no. 86 (November 1983): 16; Scholz, "Post-Modernist Spacemen," *TCJ* no. 98 (May 1985): 44; "Living," 220.

94. "Operation Friendship!," *Tales from the Crypt* no. 41 (April/May 1954); *Tales of the Closet* no. 2 (Fall 1987—Hetrick-Martin Institute for the Protection of Lesbian and Gay Youth).

95. See *Zot! 1987–1991*, 37, 55, 243, 261, 341, 367–368, 409, 417, 475ff., quotes 488, 493, 33.

96. Cotter, 19; "Timid," 31; Morris E. Franklin, "Coming Out in Comic Books: Letter Columns, Readers, and Gay and Lesbian Characters," in *Comics & Ideology*, 221–250; "Newswatch," *TCJ* no. 144 (September 1991): 18; R. Reynolds, *Super Heroes*, 79, 120–121; quote Frankin, "Coming Out," 233, from *Alpha Flight* no. 106 (March 1992); "The First Gay Superhero—Not," in *TCJ* no. 148 (February 1992): 12–13; *JRC*, 324.

97. See "Lynn Johnston," *TCJ* no. 217 (November 1999): 49–50.

98. *Jane's World, Collection 1* (Girl Twirl Comics, 2006), see esp. 45, 121, 366ff.; *Strangers in Paradise, Pocket Book 1* (Abstract Studio, 2004). Donna Barr's *Desert Peach* incorporated these questions into (quasi-)historical context, detailing the adventures of Nazi general Erwin Rommel's gay younger brother.

99. See "Viva La Comix!," *TCJ* no. 181 (October 1995): 5.

100. Howard Cruse, *Stuck Rubber Baby* (DC, 1995); Ray Mescallado, "Easy Comparisons," *TCJ* no. 182 (November 1995): 99–102; Ho Che Anderson, "Rings True," *TCJ* no. 182 (November 1995): 105; "Matters of Conscience: A Howard Cruse Interview," *TCJ* no. 182 (November 1995): 107, 112–113.

101. Ariel Schrag, *Definition* (SLG, 1997); *Potential* (SLG, 2000), esp. 3, 9, 124; see El Refaie, 157–158.

102. Diane DiMassa, *The Complete Hothead Paisan* (Cleis Press, 1999), 11, 85; Terry Sapp, *Adventures of Baby Dyke* no. 2 (1992).

103. "Alison Bechdel Interview," *TCJ* no. 179 (August 1995): 115.

104. *Hothead Paisan*, 374.

105. "Lesbo A Go-Go," in *Real Girl* no. 1, 18–21, 21. See also Robbins, *Brinkley Girls*, 114.

106. *CWC2*, 586.

107. Noomin, foreword to *Twisted Sisters*, 7; "Diane Noomin Interview," 72; *Dangerous Drawings*, 179; Nicole Rudick, "'I Felt Like I Didn't Have a Baby but at Least I'd Have a Book': A Diane Noomin Interview," *TCJ*, May 8, 2012, http://www.tcj.com/i-felt-like-i-didn%e2%80%99t-have-a-baby-but-at-least-i%e2%80%99d-have-a-book-a-diane-noomin-interview; *Goodnight*,

Irene: The Collected Stories of Irene Van de Kamp (Last Gasp, 2007); "Carol Lay," *TCJ* no. 213 (June 1999): 61.

108. Phoebe Gloeckner, "Magda Meets the Little Men in the Woods," in *Twisted Sisters*, 45–47; Debbie Drechsler, *Daddy's Girl* (Fantagraphics, 2008), 32; El Refaie, 146–147. Similarly, Penny Moran Van Horn's black-and-white, dark, scratched-out art hacks out the trauma of her religious upbringing, expressing movement from shadow to light: "A True Story: Catholic School," *CWC2*, 562–563; see also *The Librarian* (Fantagraphics, 1992).

109. "Debbie Drechsler Interview," *TCJ* no. 249 (December 2002): quotes 84, 98; see also her comments on 99–101.

110. See, for selections of Doucet's work besides Dirty Plotte, *Lift Your Leg, My Fish Is Dead!* (Drawn & Quarterly, 1993), *The Madame Paul Affair* (Drawn & Quarterly, 2000), and *Long Time Relationship* (Drawn & Quarterly, 2001). In this last, Doucet's imagination of the figures behind anonymous personal ads are simultaneously grotesque and empathetic, insisting that we contemplate their humanity in all its limitations as we shrink the infinitude of possibilities from the ad to what we see in front of us. Compare Anne Elizabeth Moore, *Sweet Little Cunt: The Graphic Work of Julie Doucet* (Uncivilized Books, 2018), esp. 40–67.

111. *Real Girl* no. 4 (1992), 5.

112. David Chelsea's contemporaneous *David Chelsea in Love* (Reed Graphica, 2003) is less physical, but depicts the artist as both naïf and player whose heart keeps getting stomped on but who simultaneously casually manipulates and instrumentalizes those around him. See also Rich Kreiner, "Just a Guy Trying to Get Laid," *TCJ* no. 147 (December 1991): 37; Ad, *TCJ* no. 162 (October 1993): 36.

113. Jones, inside front cover, *Girltalk* no. 1 (1995); see, notably, Ann Decker's "First Love," *Girltalk* no. 1 (1995), 8–11, and Vicky Rabinowicz's "Oh Fuck, I'm a Victim," *Girltalk* no. 2 (Fall 1995), 20–25; Robbins, *Brinkley Girls*, 118–119. That same year, *Twisted Sisters* published a second collection, featuring many repeat contributors: Noomin's own story, "Baby Talk," is a standout, wrestling with the decision of whether, and how, to represent her decision to have multiple abortions in comics form: *Twisted Sisters*, vol. 2, *Drawing the Line* (Kitchen Sink, 1995), 164–175.

114. Robbins, *Brinkley Girls*, 126.

115. See, for example, "Soundtrack" and "Permanent Damage," in Jessica Abel, *Soundtrack: Short Stories, 1989–1996* (Fantagraphics, 2001) 3, 9; *Mirror, Window* (Fantagraphics, 2004); see pages 17 and 38 in "As I Live and Breathe" and "Châiné," in *Mirror, Window*, 1–26, 27–52.

116. See "Newswatch," *TCJ* no. 145 (October 1991): 29.

117. *Danger Funnies* no. 1 (1993); *TCJ* no. 62: 15. A decade later, Tooks's major work, *Lucifer's Garden of Verses*, saw the Devil tempt and be tempted by the Black saint of Fever Street, Black Lily, combining poetry with grittier street prose; see *Lucifer's Garden of Verses*, vol. 1, *The Devil on Fever Street* (NBM, 2004).

118. Harrison, 37–38; Gary Groth, "Strategies of Self-Deception," *TCJ* no. 136 (July 1990): 8; "Spin Controlling Racist Comics," *TCJ* no. 134 (February 1990): 5; "Gasoline Alley Is Charged with Racism," *TCJ* no. 146 (November 1991): 27.

119. Ryder Windham, "Finish Line," *Floaters* no. 4 (December 1993).

120. "Can Breathed Be Taken Seriously?: The Creator of *Bloom County* Talks About Mixing Politics with Penguins," *TCJ* no. 125 (October 1988): 103.

121. *Steel* no. 1, collected in *Steel: The Forging of a Hero* (DC, 1997), 42; Nama, 92–98.

122. Quotes Brown, *Milestone*, 32, 158; Jeffrey Winbush, "The New Black Age of Comics," *TCJ* no. 160 (July 1993): 79–83; see also "DC Allied with Milestone Media," *TCJ* no. 153 (October 1992): 26–27.

123. See Daniels, *DC*, 232; Dwayne McDuffie, *Hardware: The Man in the Machine* (DC, 2010); Dwayne McDuffie, *Icon: A Hero's Welcome* (DC, 2009), 182–183.

124. Reprinted in McDuffie, *Icon: Mothership Connection* (DC, 2010), 238–239. Compare Brown, *Milestone*, 161–164.

125. Carey Monserrate, "Another Kind of Superhero," *Newsweek*, August 16, 1993, 58.

126. Brown, *Milestone*, 43, 46. Quote from Nabile Hage interview, *TCJ* no. 160 (July 1993): 42; "*Brotherman* vs. Social Apathy," *TCJ* no. 142 (June 1991): 18; "Sims Brothers Interview," *TCJ* no. 160 (July 1993): 93–102.

127. "The End of the Road for Milestone Comics," *TCJ* no. 192 (December 1996): 18–21.

128. In *El Gato Negro* no. 1 (October 1993).
129. *El Gato Negro* no. 4 (Summer 1997).
130. Mike Grell, *Green Arrow: The Longbow Hunters* (DC, 1989); Rob Rodi, "Prestige, Schmestige," *TCJ* no. 119 (January 1988): 33.
131. In the '90s, Sim alleged that feminists "are setting the political, economic, and moral agenda for the world at large, much to society's detriment," illuminating connections between ideology and product. See "The Story That Wasn't: 'Reads' and the Comics Industry"; *TCJ* no. 174 (February 1995): 112–117.
132. Bell, 146; Alan Moore, *Supreme: The Return* (Checker Book Publishing Group, 2003).
133. For a pull-no-punches take on *Identity Crisis*, see Wolk, 107–108; see also Steven Grant, "Misogyny Crisis," *TCJ* no. 265 (February 2005): 168–169, and "Gail Simone Interview," 74–75.
134. *Y: The Last Man*, vol. 6 (DC, 2005), 92–93. For a brilliant non-American perspective, see Dylan Horrocks, *Sam Zabel and the Magic Pen* (Fantagraphics, 2014), esp. 136–137; for Vaughan's own description of a germ of *Y* as "a sick nerd fantasy," see "Brian K. Vaughan," 49.
135. "Will Eisner Interviews Chris Claremont, Frank Miller, and Wendy Pini," *TCJ* no. 89 (March 1984): 94; "Fixations and Vexations: A Panel of Women Cartoonists," in *TCJ* no. 95 (February 1985): 89.
136. See "Manhunt" in *Birds of Prey*, vol. 1 (DC, 1999); Gail Simone, *You'll All Be Sorry!* (About Comics, 2008), 5–8, quote 16.
137. "Gail Simone Interview," *TCJ* no. 286 (November 2007): 72.
138. "Gail Simone Interview," 73.
139. Compare Carolyn Cocca, *Superwomen: Gender, Power, and Representation* (Bloomsbury, 2016), 57–85. A notable previous representation of disability was in 1980's *New Teen Titans*. Newly introduced Black hero Cyborg at first perceives his cybernetic alteration as a meaningful disability, but, in a successful early tale, his self-pity is transformed by his encounter with children with prostheses. "A Day in the Lives . . . ," *New Teen Titans* no. 8 (June 1981), repr. in *New Teen Titans Archives*, vol. 1 (DC, 1999), 228–229.
140. *Hero: Powers and Abilities* (DC, 2003); *Human Target* (DC, 2000, first published 1999); *Human Target: Living in Amerika* (DC, 2004).
141. *Planetary* no. 24 (March 2006), repr. in *Planetary*, vol. 4, *Spacetime Archaeology* (WildStorm, 2010); *Planetary* no. 10 (June 2000), in *Planetary*, vol. 2, *The Fourth Man* (WildStorm, 2001); compare Klock, 153ff., and Marc Singer, *Breaking the Frames: Populism and Prestige in Comics Studies* (University of Texas Press, 2018), 71–78.
142. Mike Gold, "Introduction," in Timothy Truman, *Hawkworld* (DC, 1991).
143. For example, 1989's Batman-meets-Jack-the-Ripper story *Gotham by Gaslight: An Alternative History of the Batman;* a 1992 Bat-Viking; a Victorian-age Wonder Woman. In a series of 1994 annuals, Batman became a corsair, Superman came to Earth in Revolutionary War–era England, and Steel became a slave in antebellum America.
144. See *DC Versus Marvel Comics* (DC and Marvel, 1996); *The Amalgam Age of Comics: The Marvel Comics Collection* (Marvel, 1996); *The Amalgam Age of Comics: The DC Comics Collection* (DC, 1996); *Tangent Comics* (DC, 2007); Kurt Busiek and George Pérez, *Avengers/JLA Compendium* (DC and Marvel, 2004), 19.
145. As, in its own way, was Alan Moore's *1963* (published in 1993); see Bongco, 195, and A. David Lewis, "The Secret, Untold Relationship of Biblical Midrash and Comic Book Retcon," *IJCA* 4, no. 2 (2002): 261ff., and "Kurt Busiek," *TCJ* no. 216 (October 1999): 57, 67–70.
146. *Starman* no. 3 (1994), 19–20, collected in *Starman: Sins of the Father* (DC, 1996).
147. One of *Astro City*'s most powerful stories is an empathic, emotional take on the "Lois Lane seeks Superman's secret identity" stories: Kurt Busiek, "Introduction," *Kurt Busiek's Astro City: Life in the Big City* (WildStorm, 1996), 7–10; Busiek, *Greetings from Astro City: Local Heroes* (WildStorm, 2005).
148. Quoted in "Newswatch," *TCJ* no. 198 (August 1997): 25.
149. Quotes "Furriners," 31; "Batman and the Twilight of the Idols," in *Many Lives of the Batman*, 33–46, 45; "Dick Giordano," *TCJ* no. 100 (July 1985): 107. Immediate predecessor Marv Wolfman's *Night Force* (see *Night Force: The Complete Collection* [DC, 2017]) didn't match the impact of *Swamp Thing* and *Sandman*. On Berger's hiring, after Levitz's desire for "someone from outside of comics who didn't have years of fandom behind them . . . who had read more than just comics," see "Vertigo Roundtable," *TCJ* no. 163 (November 1993): 48–49.

150. *Sandman Companion*, 105, 13; Paul Levitz, "Introduction," *Absolute Sandman*, vol. 1 (DC, 2006).

151. Neil Gaiman and Mike Matthews, "The Book of Judges," *Outrageous Tales from the New Testament* (Knockabout, 1987), 23; *Violent Cases* (Dark Horse, 2003); *Sandman Companion*, 20–22; Jacobs and Jones, 191; "Neil Gaiman Interview," *TCJ* no. 169 (July 1994): 56.

152. Neil Gaiman, *Black Orchid* (DC, 1991); *Neil Gaiman's Midnight Days* (DC, 1999); *Absolute Sandman* 1:546.

153. See C. W. Marshall, "The Furies, Wonder Woman, and Dream: Mythmaking in DC Comics," in *Classics and Comics*, 89–101.

154. Eddie Campbell's *Bacchus*, for example, in which a young Gaiman appears by name (vol. 9, *King Bacchus*), satirized as a young celebrity obsessed with image cultivation and stoking his fan base.

155. Compare Josh Heuman and Richard Burt, "Suggested for Mature Readers? Deconstructing Shakespearean Value in Comic Books," in *Shakespeare After Mass Media*, ed. Richard Burt (Palgrave Macmillan, 2002), 150–171.

156. *Absolute Sandman*, 1:546, 54; *Sandman Companion*, 10–11.

157. "Newswatch," *TCJ* no. 240 (January 2002): 9.

158. *Sandman Companion*, 49, quote 191; Warren Ellis, *From the Desk of Warren Ellis*, vol. 2 (Avatar Press, 2000), 32.

159. Alisa Kwitney, *Vertigo Visions* (DC, 2000), 41; *Sandman Companion*, 24, 240.

160. Quoted in McCue, *Dark Knights*, 3; see "Newswatch," *TCJ* no. 100 (July 1985): 20; "Newswatch," *TCJ* no. 117 (September 1987): 13; "Newswatch," *TCJ* no. 118 (December 1987): 23; see Sabin, *Adult*, 114; "Newswatch," *TCJ* no. 121 (April 1988): 6; "Newswatch," *TCJ* no. 125 (October 1988): 11; "Newswatch," *TCJ* no. 116 (July 1987): 15; *TCJ* no. 130 (July 1989): 126; "Newswatch," *TCJ* no. 175 (March 1995): 31.

161. "Neil Gaiman Testimony," *TCJ* no. 250 (February 2003): 20.

162. Only half true, it turned out; the *Sandman* title ended, but *Sandman* spawned an empire of its own: Mike Carey, *Sandman Presents: The Furies* (DC, 2002); Jill Thompson, *The Little Endless Storybook* (DC, 2004); Mike Carey, *Lucifer: Devil in the Gateway* (DC, 2001); *The Dreaming* (DC, 1998); Joseph McCabe, *Hanging Out with the Dream King* (Fantagraphics, 2004), 51; "Gaiman Interview," 80; *Sandman Companion*, 37, 234; Wiater, 190–191.

163. See Delano et al., *John Constantine, Hellblazer: Original Sins* (DC, 1992), description from Delano's introduction; "Alan Moore," *TCJ* no. 106 (March 1986): 42; Bryan Talbot, *The Naked Artist: Comic Book Legends* (Moonstone, 2007), 73–75.

164. *Books of Magic* no. 2 (January 1991), repr. in Gaiman, *The Books of Magic* (Vertigo, 1993); Wiater, 164.

165. Occasionally with knowledge gaps caught by their American collaborators: Gaiman's story "24 Hours" was originally set in an English pub; artist Mike Dringenberg explained Americans didn't have those, so they changed it to a diner. McCabe, *Hanging*, 80.

166. *True Faith* (Vertigo, 1997); "Garth Ennis," *TCJ* no. 207 (September 1998): 42, 65; see Sabin, *Adult*, 113, and Ennis's portrait of the Bible-inspired former serial killer whose newfound faith powers him across a postapocalyptic landscape in *Just a Pilgrim* (Dynamite, 2008).

167. Peter Milligan, Brett Ewins, and Jim McCarthy, *The Complete Bad Company* (Rebellion, 2011).

168. *Shade the Changing Man* no. 16 (October 1991), repr. in *Shade the Changing Man*, vol. 3, *Scream Time* (DC, 2010), 71, 75.

169. Morrison, "A Word from the Author," *Doom Patrol* no. 20, repr. in *Doom Patrol: Crawling from the Wreckage* (DC, 2004); Marc Singer, *Grant Morrison* (University Press of Mississippi, 2011), 52–63, 72–91.

170. Steven Zani, "It's a Jungle in Here: Animal Man, Continuity Issues, and the Authorial Death Drive," in *The Contemporary Comic Book Superhero*, ed. Angela Ndalianis (Routledge, 2009), 233–249; "Grant Morrison," *TCJ* no. 176 (April 1995): 55; "Peter Milligan," *TCJ* no. 206 (August 1998): 102.

171. Compare Alan Moore and Donald Simpson's *In Pictopia!*, first published in 1986 (in *Best Comics of the Decade*, 29–41).

172. *Animal Man*, vol. 3, *Deus ex Machina* (DC, 1991), 212.

173. *Animal Man*, 3:224. Morrison reached metafictional heights/depths in the later series *The Filth*, with lines like "We're surfacing through the page wall just ahead of the continuity breakers": *The Filth* (Vertigo/DC, 2004), 62.

174. "Abandoned Houses," *Swamp Thing* no. 33 (February 1985).

175. *Marvel 1602* (Marvel, 2006).

176. "Newswatch," *TCJ* no. 152 (August 1992): 13.

177. On modern-day comic book genres, see Nicolas Labarre, *Understanding Genres in Comics* (Palgrave Macmillan, 2020), esp. ch. 6.

178. *Planetary* no. 7 (January 2000), repr. in *Planetary*, vol. 2; "Cartoonist Charged in Florida Obscenity Case," *TCJ* no. 160 (July 1993): 10; "Two Florida Comic Shops Go on Trial," *TCJ* no. 165 (January 1994): 7; "Michael Diana Convicted," *TCJ* no. 168 (May 1994): 15; *Speechless*, 94ff.

179. From *Hellblazer* no. 80 (1994), repr. in Garth Ennis, *John Constantine, Hellblazer: Rake at the Gates of Hell* (DC, 1997), 75.

180. "Afterword," *Mike Mignola's Hellboy: Weird Tales*, vol. 1 (Dark Horse, 2003). Note the title's nod to pulp tradition; see "Mike Mignola Interview," *TCJ* no. 189 (August 1996): 66, 84.

181. The futuristic city has appealed from Metropolis on: besides *Transmetropolitan*, notable examples include Dean Motter's *Terminal City*, with mayors named Orwell and Huxley, and the *Nevermen's* steampunk setting: *Terminal City* (Vertigo/DC, 1997); Mike Russo, "Introduction," *Nevermen* (2001); Marc Singer, "Invisible Order: Time and Narrative," *IJCA* 1, no. 2 (1999): 29–40; "Grant Morrison," 75.

182. John Wagner and Vince Locke, *A History of Violence* (Vertigo, 1997); *Road to Perdition* (Paradox Press, 1998).

183. Both were reissued, slightly revised and updated, as part of DC's Jinxworld line in 2001.

184. *100 Bullets: First Shot, Last Call* (Vertigo/DC, 2000); David Lapham, *Stray Bullets: Über Alles Edition* (Image, 2014). On *Stray Bullets'* scattered temporal structure (and "graphic, blackly comic violence"), see Chris Brayshaw, "Cool Beans," *TCJ* no. 182 (November 1995), esp. 54; on *100 Bullets'* "realism," see the interview with the creative team in *TCJ* no. 228 (November 2000), esp. 96.

185. *Sin City: The Hard Goodbye* (Dark Horse, 2005).

186. "Frank Miller," 64–66, quote 64.

187. Sales would drop—in part, Murray believed, because of tensions between the commercial genre and his self-described aesthetic aims: Larry Hama, "Introduction," *The 'Nam*, vol. 1 (Marvel, 2009); "Generally Speaking," *TCJ* no. 114 (February 1987): 52; Andrew Dagilis, "Uncle Sugar vs. Uncle Charlie," *TCJ* no. 136 (July 1990): 62, 65, 72–73; Dagilis, "Casualties," *TCJ* no. 131 (September 1989): 32; Annette Matton, "From Realism to Superheroes in Marvel's *The 'Nam*," in *Comics & Ideology*, 151–176; Matton, "Reader Responses to Doug Murray's *The 'Nam*," *IJCA* 2, no. 1 (Spring 2000): 33–44, esp. 37–38.

188. Garth Ennis, *Unknown Soldier* (DC, 1998), 103, 106.

189. *U.S.: Uncle Sam* (DC, 1998).

190. See Miller and Gibbons, *Give Me Liberty: An American Dream* (Dell, 1990); "Afterword," *Martha Washington Goes to War* (Dark Horse, 1998).

191. *Stormwatch*, vol. 1 (DC, 2012, issues from 1996–1997); Warren Ellis, *Absolute Authority*, vol. 1 (DC, 2002, issues from 1999 to 2000); compare Klock, 135–136.

192. Andrew Helfer and Kyle Baker, *Justice, Inc.*, 2 vols. (DC, 1989); John Ostrander, *Suicide Squad: Trial by Fire* (DC, 2015); *The American* (Dark Horse, 2005); *American Century: Scars and Stripes* (Vertigo/DC, 2001).

193. Denis Kitchen, "An Introduction," *Consumer Comix* no. 1 (1975), 2; Schreiner, *Kitchen*, 39, 46. The three-legged frog in Rifas's 1976 *All-Atomic Comics* summed up the arguments against nuclear power; see also his *Energy Comics* (1980) and *Food Comix* (1980).

194. *CWC1*, 219–286. A notable antecedent: Nick Thorkelson's 1973 *Underhanded History of the USA* (originally published by *Radical America* magazine).

195. See "Larry Gonick," *TCJ* no. 224 (June 2000): 46–78. Still others appealed to the conspiratorial mindset: for example, Joel Andreas's fifty-two-page dive into the Rockefeller family (*The Incredible Rocky . . . vs. the Power of the People!* [1973] and Jay Kinney and Paul Mavrides's four-page "amazing pull-out total-world-conspiracy moebius flow-chart" in *Cover-Up Lowdown* [1977]), 25–28.

196. On "Nits," see Witek, *Comic Books as History*, 61–75, esp. 70–71.

197. *Comanche Moon* (1979); "Jack Jackson on His Work in the Underground," *TCJ* no. 75 (1982): 80–81; Witek, *Comic Books as History*, 75–84; Martha A. Sandweiss, "Redrawing the West: Jack Jackson's *Comanche Moon*," in *The Graphic Novel*, 115–130; "Jack Jackson's Long Ride," 24–25.

198. *Brought to Light* (Eclipse Books, 1989); Wiater, 140; "Newswatch," *TCJ* no. 125 (October 1988): 5.

199. *A Treasury of Victorian Murder* (NBM, 1987); *The Borden Tragedy* (NBM, 1997); *The Fatal Bullet* (NBM, 1999).

200. Ho Che Anderson, *King* (Fantagraphics, 2005); Robert Edison Sandford, "Love and Subjugation," *TCJ* no. 265 (February 2005): 42; Anne Rubinstein, "Testify," *TCJ* no. 165 (January 1994): 32.

201. Sturm, *The Golem's Mighty Swing* (Drawn & Quarterly, 2001); two additional graphic novellas complete Sturm's "American Trilogy": 1996's *The Revival* and 1998's *Hundreds of Feet Below Daylight*; in *Above and Below: Two Stories of the American Frontier* (Drawn & Quarterly, 2004).

202. *Kings in Disguise* (W. W. Norton, 2005 [1990]).

203. See "Shame and Loathing," *But I Like It* (Fantagraphics, 2006); *Notes from a Defeatist* (Fantagraphics, 2003); "Joe Sacco," *TCJ* no. 176 (April 1995): 90.

204. See Sacco's comments in Øyvind Vågnes, "A Conversation with Joe Sacco," *JGNC* 1, no. 2 (2010), esp. 200–203, and his comments on *Footnotes in Gaza*: Gary Groth, "Joe Sacco on Footnotes in Gaza," *TCJ*, June 6, 2011, http://www.tcj.com/tcj-301-joe-sacco-on-footnotes-in-gaza. Compare Benjamin Woo, "Reconsidering Comics Journalism: Information and Experience in Joe Sacco's *Palestine*," in *The Rise and Reason of Comics and Graphic Literature*, ed. Joyce Goggin and Dan Hassler-Forest (McFarland, 2010), 166–177, esp. 173–175, and the valuable essays in *The Comics of Joe Sacco: Journalism in a Visual World*, ed. Daniel Worden (University Press of Mississippi, 2015).

205. Joe Sacco, *Palestine: In the Gaza Strip* (Fantagraphics, 1996), 73, 75; *The Fixer* (Drawn & Quarterly, 2003); *Fax from Sarajevo: A Story of Survival* (Dark Horse, 1996). On witnessing, see 91, 183. On Sacco's "extrapolating from photographs," see "'Drawing from Life': An Interview with Joe Sacco," *IJCA* 4, no. 2 (2002): 27–28, quote 27, and Andrea A. Lunsford, "Critique, Caricature, and Compulsion in Joe Sacco's Comics Journalism," in Williams and Lyons, 68–88. Sacco quotes "Joe Sacco," 103, 107; Kent Worcester, "Provocative Pulp," *TCJ* no. 199 (October 1997): 53–54.

206. See Gene Deitch, *The Real-Great Adventures of Terrible Thompson!* (Fantagraphics, 2006).

207. Steve Anker, "Kim Deitch, An Appreciation," *Arcade* no. 7 (1976), 4.

208. See "Kim Deitch Interview," *TCJ* no. 292 (October 2008): 76–79.

209. *All Waldo Comics* (Fantagraphics, 1992), 7, 11, 12; see *A Shroud for Waldo* (Fantagraphics, 1992), 8; *The Boulevard of Broken Dreams* (Pantheon, 2002) and "Kim Deitch Interview," 128, 132; Gregory Cwiklik, "Where's Waldo?," *TCJ* no. 179 (August 1995): 32–36.

210. Woodring, *The Frank Book* (Fantagraphics, 2011); Roanne Bell and Mark Sinclair, *Pictures and Words: New Comic Art and Narrative Illustration* (Yale University Press, 2005), 36; "Screechy Peachy Is Screaming," *TCJ* no. 164 (December 1993): 44; "Jim Woodring Interview," *TCJ* no. 164 (December 1993): 60.

211. *Ed the Happy Clown* (Vortex Comics, 1992); see "M-mm Good," *TCJ* no. 107 (April 1986): 54; *Dangerous Drawings*, 135.

212. Neil Gaiman and Dave McKean, *Signal to Noise* (Dark Horse, 1992).

213. *Stray Toasters* (Epic Comics, 1988; Image, 2008).

214. Richard McGuire, "Here," *Raw* 2, no. 1 (1989); book-length expansion, *Here* (Pantheon, 2014).

215. *The Narrative Corpse: A Chain-Story by 69 Artists!* (Raw Books, 1995).

216. On the origin of twenty-four-hour comics, *24 Hour Comics*, ed. Scott McCloud (About Comics, 2004), i–vi.

217. "Eric Drooker Interview," *TCJ* no. 253 (June 2003): 85; David A. Beronä, "Picture Stories: Eric Drooker and the Tradition of Woodcut Novels," *Inks* 2, no. 1 (1995): 2–11; Peter Kuper, *The System* (DC, 1997).

218. *Slutburger Stories* (1990), introduction. One evocative cover shows her buried beneath a nude orgy, sighing, "I wanna go home and draw!!": *Slutburger Stories* no. 2 (1991).

219. The closest mainstream equivalent was Bill Sienkiewicz's illustration of Frank Miller's *Elektra: Assassin*, taking the fragmentation of traumatic violence to its ultimate textual and artistic level: Jim Dawson, "Blood and Irony," *TCJ* no. 115 (April 1987): 42; *Elektra: Assassin* (Marvel, 2012); Howe, 276.

220. *Dangerous Drawings*, 33, quote 45; Gene Kannenberg Jr., "The Comics of Chris Ware: Text, Image, and Visual Strategies," in *The Language of Comics*, 174–197, esp. 187, 191; Raeburn,

22, 50, 62; Scott A. Gilbert, "He Said to Tell You He Had a Real Good Time," *TCJ* no. 174 (February 1995): 47–48; "Chris Ware Gets His Own Comic," *TCJ* no. 164 (December 1993): 28; Brad Prager, "Modernism in the Contemporary Graphic Novel: Chris Ware and the Age of Mechanical Reproduction," *IJCA* 5, no. 1 (Spring 2003), esp. 207–209.

221. Ware, *Jimmy Corrigan: The Smartest Kid on Earth* (Pantheon, 2000); "Rusty Brown," *Acme Novelty Library* no. 16 (2005); see J. Carlin, "Masters," 158, and D. J. Dycus, *Chris Ware's Jimmy Corrigan* (Cambridge Scholars Publishing, 2012); "Chris Ware Interview," *TCJ* no. 200 (December 1997): 131, 145, 153–155; Ken Parille, "Bedlam and Baby: Parables of Creation in Jack Kirby and Chris Ware," *TCJ*, May 23, 2011, http://www.tcj.com/bedlam-and-baby -parables-of-creation-in-jack-kirby-and-chris-ware.

222. See Drew Friedman, *Any Similarity to Persons Living or Dead Is Purely Coincidental* (Fantagraphics, 1990), 21, 36; "Hester's Little Pearl: Red Letter Days," "RAS KOL," "Crypt of Bronte," all in Sikoryak's *Masterpiece Comics* (Drawn & Quarterly, 2009); stay for the faux-letter-column explanations. See discussion of this and the similarly virtuosic *The Seduction of Mike* in "R. Sikoryak Interview," *TCJ* no. 255 (September 2003): 97–99.

223. M. Thomas Inge, *Anything Can Happen in a Comic Strip: Centennial Reflections on an American Art Form* (Columbus: Ohio State University Libraries, 1995).

224. Elizabeth Weise, "Gary Larson Goes Wild," *USA Today*, November 22, 2006.

225. Compare David Carrier, *The Aesthetics of Comics* (Penn State University Press, 2000), 19ff.

226. Sam Henderson, *Humor Can Be Funny!* (Dodecaphonic Books, 1996); Dorkin, *Fun with Milk and Cheese* (Slave Labor Graphics, 2000); *Snake 'n' Bacon's Cartoon Cabaret* (HarperEntertainment, 2000).

227. *Sock Monkey* (Dark Horse, 2000); *Der Struwwelmaakies* (Fantagraphics, 2005); "Tony Millionaire," *TCJ* no. 215 (August 1999): 102; "The Depraved and Badly Behaved," *TCJ* no. 231 (March 2001): 26–28.

228. The *most* unclassifiable was *Reid Fleming, World's Toughest Milkman,* seemingly sprung from an *SCTV* sketch played by John Candy in a bald cap (although, as Fleming would shout at you, he's not bald; he just gets his hair cut that way): David Boswell, *Reid Fleming: World's Toughest Milkman*, vol. 1 (IDW, 2010); Bongco, 179.

229. See *DC Showcase Presents: Ambush Bug* (DC, 2009); "Funny Funnybooks," *TCJ* no. 102 (September 1985): 53; Bob Burden, *Flaming Carrot's Greatest Hits* (Dark Horse, 1998), esp. 9–37, 126–146; see also "Stop! In the Name of the Carrot!," *TCJ* no. 73 (July 1972): 43, and "Bob Burden Interview," *TCJ* no. 268 (July 2005): 122–123, 130–131.

230. See Don Simpson, *Megaton Man* (Kitchen Sink, 1990); Darcy Sullivan, "Biting the Fist That Feeds Them," *TCJ* no. 135 (April 1990): 53; "Newswatch," *TCJ* no. 104 (January 1986): 12; *The Complete Normalman* (Shadowline/Image, 2007), 32. Mentally deranged superhero the Tick was Megaton Man's best mid-'90s heir; Matt Feazell used superheroesque stick figures (Cynicalman, Antisocial Man, CuteGirl, the Incredibly Stupid Boy, etc.) to talk politics and tell self-proclaimed stupid jokes—see *The Tick Omnibus*, vol. 1 (New England Comics Press, 1997), *Ert!: Not Available Comics* (Caliber Press, 1995), and *The Amazing Cynicalman!* (Not Available Books, 2003).

231. Compare Matthew T. Jones, "Reflexivity in Comic Art," *IJCA* 7, no. 1 (Spring 2005): 270–286. All part of a long history of similar jokery; in a Golden Age story titled "Superman, Matinee Idol," Clark and Lois actually *watch* the Superman movie cartoons, to Clark's "acute embarrassment": *Superman* no. 19 (November 1942), *SA5*, 154, 155; compare Christopher Murray, "Superman vs. Imago: Superheroes, Lacan, and Mediated Identity," *IJCA* 4, no. 2 (2002): 186ff.

232. "Jeff Smith Interview," *TCJ* no. 173 (December 1994): 68. He also mentions *Dark Knight* (73); see his discussion of Tolkien in "Jeff Smith," *TCJ* no. 218 (December 1999): 112; also 114.

233. "Jeff Smith Interview," 86; "Tripping the Light Fantastic with Arn Saba," *TCJ* no. 99 (June 1985): 64–65; "Making the World Safe for Musical Comedy: An Appreciation," in *The Collected Neil the Horse* (Conundrum, 2017), 8–9; Collins, "The Backward," in *Collected Neil the Horse*, 352; Bob Levin, "Now You See Me," *TCJ* no. 255 (September 2003): 65; Wolk, 85.

234. In no small part, it was because the *Voice* wanted to drastically cut his pay: "Feiffer Ends," 14.

235. N'Gai Croal, "What's the Color of Funny?," *Newsweek*, July 5, 1999.

236. R. C. Harvey, "A Couple Chidings and Some New Lang Syne: The Year in Review," *TCJ* no. 250 (February 2003): 76.

237. David Astor, "Many Comics Getting On in Years," *Editor & Publisher* 125, no. 40 (October 3, 1992), 30.
238. *We Told You So*, 318–326; Tom Spurgeon, "Fort Thunder Forever," *TCJ* no. 256 (October 2003): 58–72, esp. 66. For an extensive overview of the Montreal scene, see "Blood and Thunder," *TCJ* no. 274 (February 2006): 7–14.
239. "Newswatch," *TCJ* no. 191 (November 1996): 20; *TCJ* no. 194 (March 1997): 23.
240. "Emerging Publishers Roundtable," *TCJ* no. 211 (April 1999): 49.
241. "Expo 2000," *TCJ* no. 228 (November 2000): 21.
242. "Newswatch," *TCJ* no. 192 (December 1996): 22.
243. "Academics Prepare to Analyze *Love and Rockets*," *TCJ* no. 184 (February 1996): 19; "Newswatch," *TCJ* no. 188 (July 1996): 8.
244. Ben Schwartz, "Introduction," in *The Best American Comics Criticism*, ed. Ben Schwartz (Fantagraphics Books, 2010, hereafter BACC), 10–21, 11.
245. See Chabon et al., *The Amazing Adventures of the Escapist*, vol. 1 (Dark Horse, 2004), 4–5, 25–30, 129–130; Jonathan Lethem, *Omega the Unknown* (Marvel, 2008); "Michael Chabon," *TCJ* no. 231 (March 2001): 90, 92; "Newswatch," *TCJ* no. 161 (August 1993): 28; "News," *TCJ* no. 163 (November 1993): 21; "School of Visual Arts," *TCJ* no. 178 (July 1995): 24; "Newswatch," *TCJ* no. 181 (October 1995): 25.
246. Quoted in Rick Moody, " 'Epileptic': Disorder in the House," *NYT*, January 23, 2005.
247. Quoted in Scott Bukatman, "Secret Identity Politics," in Ndalianis, 113–114.

Chapter 9: New Worlds (Reprise and Variation)

1. *9-11*, vol. 1, *Artists Respond* (Dark Horse, 2002), 15–18; *9-11*, 1:103, 43, *9-11*, vol. 2, *The World's Finest Comic Book Writers & Artists Tell Stories to Remember* (DC, 2002), 45; *Doonesbury* strip from December 21, 2001, repr. in *Doonesbury 40*, 537; compare Kuper and Levitz's comments in Martha H. Kennedy, "Early Creative Responses to 9-11 by Comic Artists," *IJCA* 5, vol. 1 (Spring 2003): 369–370.
2. *9-11*, 2:16; Stephan Packard, " 'Whose Side Are You On?': The Allegorization of 9/11 in Marvel's *Civil War*," in Véronique Bragard et al., *Portraying 9/11* (McFarland, 2011), 44–56, 46–47; Marc DiPaolo, *War, Politics, and Superheroes* (McFarland, 2011), 20–21; John Ney Rieber, *Captain America: The New Deal* (Marvel, 2010).
3. *Can't Get No* (Vertigo, 2006); "Joe Casey," *TCJ* no. 257 (December 2003): 115.
4. "A Novel Graphic," in *Education of a Comics Artist*, 110–113, 110; Fiore, *BACC*, 46; Art Spiegelman, "Small Bits of Infinity," *Potrzebie*, November 5, 2011, http://potrzebie.blogspot.com/2011/11/back-1960s-spiegelman-told-me-he-had.html.
5. See R. C. Harvey, "2001 in Remembrance and War," *TCJ* no. 240 (January 2002): 114.
6. Marvel's *Call of Duty: The Brotherhood* nos. 1–6 and *The Call of Duty: The Wagon* nos. 1–4 (both 2002–2003); Karl Zinsmeister, *Combat Zone: True Tales of GIs in Iraq* (Marvel, 2005); Michael Dean, "The New Patriotism," *TCJ* no. 276 (June 2006): 18.
7. Michael Dean, "9/11, Benefit Comics, and the Dog-Eat-Dog World of Good Samaritanism," *TCJ* no. 247 (October 2002): 9; see also Dean, "The New Patriotism: The Comics Industry and the War in Iraq," *TCJ* no. 275 (April 2006): 22–24.
8. See Moore's afterword in AiT/Planet Lar's *Giant Robot Warriors* (2003); *Ex Machina*, vol.1, *The First Hundred Days* (WildStorm/DC, 2005); *Pigs* (Image, 2012); *Pride of Baghdad* (Vertigo, 2006); *American Virgin: Head* (DC, 2007); Mark Millar, *Civil War* (Marvel, 2007); *Secret Identity Crisis*, 234–238.
9. See Matthew J. Costello, "Spandex Agonistes: Superhero Comics Confront the War on Terror," in *Portraying 9/11*, 30–43; *Secret Identity Crisis*, 214–219; Howe, 413–414.
10. Garth Ennis's *War Stories*, for example, includes bibliographies and suggestions for further reading: see esp. "Afterword," *War Stories*, vol. 1 (DC, 2004); *The Complete Battlefields*, vol. 1 (Dynamite, 2009). Like Kurtzman and Kanigher, Ennis also humanizes the enemy and glorifies war less: Kubert's *Dong Xoai, Vietnam 1965* (DC, 2010), inspired by actual events, contains several dozen pages of participant testimony.
11. *TCJ* no. 136 (July 1990): 88; *Refresh, Refresh* (First Second, 2009); *Finding Peace* (IDW, 2008); *The Other Side* (DC, 2007), 42; *Blindspot* (Henry Holt, 2007).
12. *Tribeca Sunset* (iBooks, 2005).

13. See Gene Weingarten, "Doonesbury's War," *Washington Post Magazine*, October 26, 2006.

14. Compare cutesy/romantic cartoonist/rocker Ben Snakepit: *Snake Pit 2007* (Microcosm, 2008). On the '90s indie rock comparison to '70s punk influence, see "A Conversation with Gilbert Hernandez and Craig Thompson," *TCJ* no. 258 (February 2004): 82.

15. *American Elf: The Collected Sketchbook Diaries of James Kochalka, Oct. 26, 1998, to Dec. 31, 2003* (Top Shelf, 2004), n.p.; "James Kochalka," *TCJ* no. 222 (April 2000): 64–65; Liz Prince, *Delayed Replays* (Top Shelf, 2008), 32—see also *Will You Still Love Me If I Wet the Bed?* (Top Shelf, 2005), esp. 16; Wolk, 205; "December 13, 2003," Vanessa Davis, *Spaniel Rage* (Buenaventura Press, 2005). Kochalka created a comics contretemps by insisting "craft is the enemy" in a 1996 letter to the *Comics Journal*: "Blood and Thunder," *TCJ* no. 189 (August 1996): 8; "State of Minicomics, Part Two," *TCJ* no. 189 (August 1996): 50. On diary comics, see Isaac Cates's "The Diary Comic" in *Graphic Subjects: Critical Essays on Autobiography and Graphic Novels*, ed. Michael A. Chaney (University of Wisconsin Press, 2011), 209–225.

16. Tom Spurgeon, "CR Sunday Interview: James Kochalka," *Comics Reporter*, November 23, 2008, https://www.comicsreporter.com/index.php/cr_sunday_interview_james_kochalka.

17. All four published by Top Shelf.

18. Moen, "Dyke," in *Dar: A Super Girly Top Secret Comic Diary* (Erika Moen, 2009), 88; Moen and Lucy Knisley, *Drawn to You* (Moen and Knisley, 2009), 6.

19. Davis, *Make Me a Woman* (Drawn & Quarterly, 2010); McNinch, *I Want Everything to Be Okay* (Tugboat Press, 2006); Bell, *Lucky* (Drawn & Quarterly, 2006). Jesse Reklaw depicts himself constantly speaking about his physical suffering, but claims to do otherwise in real life: Reklaw, "Introduction," *Ten Thousand Things to Do* (Jesse Reklaw, 2010); "I Hide Behind Anything I Can," in Brown, *Love Is a Peculiar Type of Thing* (Box Brown, 2009).

20. Contemporaneously, the long-running comic strip *Funky Winkerbean* featured a six-month breast cancer storyline; main character Lisa Moore evenutually succumbed. Lana Berkowitz, "Comic Strip Takes On Disease," *Houston Chronicle*, May 9, 2007, https://www.chron.com/life/article/Comic-strip-takes-on-disease-1826020.php; "Arts, Briefly," *NYT*, October 4, 2007.

21. *Mom's Cancer* (Abrams ComicArts, 2006); *Mammoir* (AuthorHouse, 2005); *Cancer Made Me a Shallower Person* (HarperCollins, 2006); *Cancer Vixen* (Knopf, 2006), 64, 121, 150, 205.

22. Thompson, *Blankets* (Top Shelf, 2005) 137, 306. For Thompson's credo, see 533; "Craig Thompson Interview," *TCJ* no. 268 (July 2005): 83–85, 103–105. A more surrealistic reckoning with heartland Christianity appears in Joshua W. Cotter's *Skyscrapers of the Midwest* (AdHouse, 2008).

23. *Blankets*, 391, 581–582.

24. Tom Crippen, "Puzzle Palace," *TCJ* no. 278 (October 2006): 154; see also Sean Wilsey, "The Things They Buried," *NYT*, June 18, 2006. "It's not capricious at all," Bechdel said of the book's structure—Tom Spurgeon, "CR Holiday Interview #1—Alison Bechdel," *Comics Reporter*, December 18, 2012, https://www.comicsreporter.com/index.php/briefings/blog_monthly/2012/12.

25. Compare Bechdel's comments about her "psychoanalytic way of thinking" in "Life Drawing: Alison Bechdel Interview," *TCJ* no. 282 (April 2007): 38; Ginia Bellafante, "Twenty Years Later, the Walls Still Talk," *NYT*, August 3, 2006.

26. See Julia Watson's excellent "Autographic Disclosures and Genealogies of Desire in Alison Bechdel's *Fun Home*," in *Graphic Subjects*, 123–152; *Graphic Women*, 175–217, esp. 200–203.

27. "Life Drawing," 48.

28. Joe Kubert, *Yossel, April 19, 1943* (iBooks, 2005; 2003). On *Yossel*, Kubert writes in the introduction, "It is a work of fiction, based on a nightmare that was fact. There's no question in my mind that what you are about to read could have happened."

29. Compare Paul Hornschemeier's strikingly personal false memoir, *Mother, Come Home* (Dark Horse, 2003): a boy's masked retreat into disguise, imagination, surreal representation, attempting to deal not only with his mother's death, but, even more profoundly, his father's inability to accept life without her.

30. John Porcellino, *Diary of a Mosquito Abatement Man* (La Mano, 2005); see also *Perfect Example* (Drawn & Quarterly, 2005). On Porcellino's aesthetics of sequential action, see "John Porcellino," *TCJ* no. 241 (February 2002): 58, 68; compare Porcellino, "Well-Drawn Funnies," in *King-Cat Classix* (Drawn & Quarterly, 2007), 89–90. For another ambivalent retrospective on early employment, complete with grotesque imagery, see Derf, *Trashed* (SLG, 2002).

31. Miss Lasko-Gross, *Escape from Special* (Fantagraphics, 2006); Alex Robinson, *Too Cool to Be Forgotten* (Top Shelf, 2008), quote 77.

32. Rocco Versaci, *This Book Contains Graphic Language: Comics as Literature* (Continuum, 2007), 8–9; Kent Worcester, "9/11 101," *TCJ* no. 279 (November 2006): 101–102; "Ernie Colon Interview," *TCJ* no. 285 (October 2007): 84–85.

33. H. M. van den Bogaert and George O'Connor, *Journey into Mohawk Country* (First Second, 2006).

34. Jay Hosler's *Sandwalk Adventures* (Active Synapse, 2003); see also his examination of bees' lives in *Clan Apis* (Active Synapse, 2007); "Jay Hosler Interview," *TCJ* no. 261 (July 2004): 59, 62–63, 69, quote 69; see also the illustrated Darwin's *Origin of Species*, with illustrations reminiscent of an Audubon book: Michael Keller, *Charles Darwin's On the Origin of Species* (Rodale, 2009).

35. On industry support for individual retailers, see "First Gulf Coast Retailer News," ICv2, September 1, 2005, https://icv2.com/articles/comics/view/7458/first-gulf-coast-retailer-news.

36. Josh Neufeld, *A.D.: New Orleans After the Deluge* (Pantheon, 2009); Mat Johnson, *Dark Rain* (Vertigo/DC, 2010).

37. Kyle Baker, *Nat Turner*, vol. 1 (Kyle Baker, 2006) and vol. 2 (Image, 2007); Michael A. Chaney, "Drawing on History in Recent African American Graphic Novels," *MELUS* 32, no. 3 (Fall 2007): 175–200, esp. 180–181, 188–189; and Consuela Francis, "Drawing the Unspeakable," in Costello and Whitted, 113–136; Jeremy Love, *Bayou*, vol. 1 (DC, 2009); Rob Vollmar and Pablo C. Callejo, *Bluesman*, vol. 1 (ComicsLit/NBM, 2006); Derek McCulloch and Shepherd Hendrix, *Stagger Lee* (Image, 2006); Emi Gennis's *Unknown Origins & Untimely Ends* (Hic & Hoc, 2013); see also Kate Polak, *Ethics in the Gutter: Empathy and Historical Fiction in Comics* (Ohio State University Press, 2017), 150–164.

38. Sacco, *Footnotes in Gaza* (Metropolitan, 2009), 9, 12, 124.

39. Works collected in Justin Green, *Musical Legends* (Last Gasp, 2003); Stephanie Gladden, Donna Barr, Roberta Gregory, and Linda Medley, "Rosalind Franklin," in *Dignifying Science: Stories About Women Scientists* (G.T. Labs, 1999), 49–78, 54; C. C. Colbert, *Booth* (First Second, 2010).

40. Tony Norman, "Ed Piskor's Graphic Novel Creates Sensation Among Genre's Fans," *Pittsburgh Post-Gazette*, June 22, 2009, https://www.post-gazette.com/ae/books/2009/06/22/Ed-Piskor-s-graphic-novel-creates-sensation-among-genre-s-fans/stories/200906220153.

41. *Wizzywig* (self-published, 2008); Ottaviani, *Suspended in Language: Niels Bohr's Life, Discoveries, and the Century He Shaped* (G.T. Labs, 2004), 145.

42. Jason Lutes and Nick Bertozzi, *Houdini: The Handcuff King* (Hyperion, 2007); Taylor Sarah Stewart, *Amelia Earhart: This Broad Ocean* (Disney Hyperion, 2010).

43. *No More Shaves* (Fantagraphics, 2003); *The Complete Jack Survives* (Buenaventura Press, 2009); *What's a Paintoonist?* (Fantagraphics, 2017), 27.

44. *Fishtown* (IDW, 2008); *Yummy* (Lee & Low, 2010); Jeff Jensen, *Green River Killer: A True Detective Story* (Dark Horse, 2011); Derf, *My Friend Dahmer* (Abrams, 2012), final page; "The Power of Old-Fashioned Storytelling," in *Education of a Comics Artist*, 121–123, 121.

45. See Josh Neufeld, *A Few Perfect Hours* (Alternative Comics, 2004); *Carnet de Voyage* (Top Shelf, 2006), 59; *How to Understand Israel in 60 Days or Less* (DC, 2010), 206; see Tahneer Oksman, *"How Come Boys Get to Keep Their Noses?": Women and Jewish American Identity in Contemporary Graphic Memoirs* (Columbia University Press, 2016), 167–220.

46. See, for example, Thomas, "Introduction," *Black Knight/Yellow Claw*; *Yellow Claw* no. 1 (October 1956); "Five Million Sleepwalkers!," *Yellow Claw* no. 4 (April 1957); Madison, 195–199; Ma, "Nine Lives of *Blackhawk*'s Oriental," 136.

47. Yang had explored the burden of representation in earlier graphic novels: see protagonist Gordon Yamamoto in *Animal Crackers* (SLG, 2010). For more narratological blurring, see his and Derek Kirk Kim's *The Eternal Smile* (First Second, 2009) and (as its name suggests) *Level Up* (First Second, 2011). Compare "Gene Luen Yang Interview," *TCJ* no. 284 (July 2007): 127–128.

48. In *Whirlwind Wonderland* (Tugboat Press, 2009), n.p.; compare Melinda L. de Jesús, "Liminality and Mestiza Consciousness in Lynda Barry's 'One Hundred Demons,'" *MELUS* 29, no. 1 (2004): 219–252. Quite differently, Mariko and Jillian Tamaki's *Skim* (Groundwood, 2008) focuses on eroticism and marginality (by ethnicity, orientation, body size, choice of interests), weaving it all together into sustained contemplation on loss and connection.

49. Jeff Yang, "Asian Pop: See You in the Funny Pages," *SFGate*, October 25, 2006, https://www.sfgate.com/entertainment/article/ASIAN-POP-See-you-in-the-funny-pages-2549008.php.

50. "Interview with Gene Luen Yang and Mark Siegel," ICv2, June 28, 2007, https://icv2.com/articles/comics/view/10833/interview-gene-luen-yang-mark-siegel.

51. "Newswatch," *TCJ* no. 275 (April 2006): 30; "Chris Ware at the Museum of Contemporary Art in Chicago," *TCJ* no. 278 (October 2006): 186; Michael Dean, "Best Foot Forward," *TCJ* no. 295 (January 2009): 6.

52. Chris Matz, "Supporting the Teaching of the Graphic Novel," in *Teaching the Graphic Novel*, ed. Stephen E. Tabachnik (Modern Language Association of America, 2009), 328; Wolk, 3; *Krakow to Krypton*, 208.

53. "Newswatch," *TCJ* no. 264 (December 2004): 43.

54. "Newswatch," *TCJ* no. 272 (November 2005): 32; Rich Kreiner, "All the Funnybook News That's Fit to Print," *TCJ* no. 274 (February 2006): 178–184; "Journal Datebook," *TCJ* no. 296 (February 2009): 10.

55. "James Sturm Interview," *TCJ* no. 251 (March 2003): 79. Predecessors included Randy Duncan and Peter Coogan's Comic Arts Conference, affiliated with SDCC and founded in 1992, and the late-'90s launch of the *International Journal of Comic Art*.

56. See Jeet Heer, "The Rise of Comics Scholarship: The Role of University Press of Mississippi," *Sans Everything*, August 2, 2008, https://sanseverything.wordpress.com/2008/08/02/the-rise-of-comics-scholarship-the-role-of-university-press-of-mississippi/#more-373; see also, for example, *Manga and Philosophy*, ed. Adam Barkman and Josef Steiff (Open Court, 2009), *X-Men and Philosophy* ed. William Irwin, Rebecca Housel, and Jeremy Wisnewski (Wiley, 2009), *Supervillains and Philosophy*, ed. Ben Dyer (Open Court, 2009), *Watchmen and Philosophy*, ed. William Irwin and Mark D. White (Wiley, 2009), *Transformers and Philosophy*, ed. John Shook and Liz Swan (Open Court, 2009); Hillary Chute and Marianne DeKoven, "Introduction: Graphic Narrative," *Modern Fiction Studies* 52, no. 4 (2006): 767–782; "Editor's Note," *World Literature Today* 81, no. 2 (March/April 2007): 5.

57. Randy Lander, "Adventures in Retailing: Feeding Frenzy," *Inside Joke Theatre*, March 8, 2007, http://insidejoketheatre.blogspot.com/2007/03/adventures-in-retailing-feeding-frenzy.html.

58. "Newswatch," *TCJ* no. 252 (May 2003): 24.

59. For details, see "CBLDF Takes Georgia Obscenity Case," ICv2, February 7, 2005, https://icv2.com/articles/comics/view/6395/cbldf-takes-georgia-obscenity-case.

60. Mary Ellen Hunt, "Free Comic Book Day," *SFGate*, May 3, 2012, https://www.sfgate.com/entertainment/article/Free-Comic-Book-Day-3530158.php.

61. "DC Adjusts Ordering Policies," ICv2, September 21, 2005, https://icv2.com/articles/comics/view/7552/dc-adjusts-ordering-policies.

62. Brian Hibbs, "Churn or Burn," *CBR*, July 18, 2008, https://www.cbr.com/262550-2.

63. "Increased Backlist Drives Diamond's Memphis Expansion," ICv2, September 29, 2005, https://icv2.com/articles/comics/view/7592/increased-backlist-drives-diamonds-memphis-expansion.

64. Tom Spurgeon, "Why We Should Be Worried That Diamond Comics Distributors Rejected PictureBox Inc.," *Comics Reporter*, June 30, 2006, https://www.comicsreporter.com/index.php/why_we_should_be_worried_that_diamond_comic_distributors_rejected_picturebo; Tom Spurgeon, "In Praise of Diamond: Distributor to Work with PictureBox Inc. After All," *Comics Reporter*, August 2, 2006, https://www.comicsreporter.com/index.php/in_praise_of_diamond_distributor_to_work_with_picturebox_after_all.

65. Tom Spurgeon, "Book Expo America 2003: By the Numbers," *TCJ* no. 254 (July 2003): 20, 22.

66. Dirk Deppey, "Opening Shot," *TCJ* no. 259 (April 2004): 3; "Newswatch," *TCJ* no. 262 (September 2004): 35.

67. Kai-Ming Cha, "Filling the Void," *TCJ* no. 269 (July 2005): 110; "Newswatch," *TCJ* no. 275 (April 2006): 35.

68. See conversation in "Dallas Middaugh Interview," *TCJ* no. 277 (July 2006): 255.

69. Tom Spurgeon, "Marvel: Singin' Songs a/b the Southland," *Comics Reporter*, March 3, 2005, https://www.comicsreporter.com/index.php/marvel_singin_songs_about_the_southland; Tom Spurgeon, "Dan Buckley: Make Mine Generalities," *Comics Reporter*, August 22, 2005, https://www.comicsreporter.com/index.php/dan_buckley_make_mine_generalities;

"Interview with Marvel Publisher Dan Buckley, Pt. 1," ICv2, November 27, 2006, https://icv2.com/articles/comics/view/9659/interview-marvel-publisher-dan-buckley-pt-1.

70. See "Newswatch," *TCJ* no. 263 (October/November 2004): 18–24; "Newswatch," *TCJ* no. 267 (April–May 2005): 45; "Newswatch," *TCJ* no. 270 (August 2005): 14–17; "Diana Schutz Interview," *TCJ* no. 277 (July 2006): 241.

71. Dirk Deppey, "Parting Shot," *TCJ* no. 277 (July 2006): 5; "Journal Datebook," *TCJ* no. 282 (April 2007): 32.

72. "Interview with DC CEO Paul Levitz 2006, Part 1," ICv2, August 21, 2006, https://icv2.com/articles/comics/view/9190/interview-dc-ceo-paul-levitz-2006-part-1.

73. "Newswatch," *TCJ* no. 252 (May 2003): 3; "Newswatch," *TCJ* no. 267 (April-May 2005): 46.

74. An instrumental figure: Byron Preiss, still experimenting with form decades later. "The Pull of the Graphic Novel," *TCJ* no. 268 (July 2005): 18.

75. "Scholatic [sic] Sells Half a Million Spongebob Cine-Manga," ICv2, December 17, 2004, https://icv2.com/articles/comics/view/6148/scholatic-sells-half-million-spongebob-cine-manga.

76. Art Spiegelman and Françoise Mouly, *Big Fat Little Lit* (Puffin, 2006), collecting material published between 2000 and 2003; see also Lara Saguisag, "*Raw* and *Little Lit*: Resisting and Redefining Children's Comics," in *Picturing Childhood: Youth in Transnational Comics*, ed. Mark Heimermann and Brittany Tullis (University of Texas Press, 2017), 128–147.

77. *Owly: The Way Home and the Bittersweet Summer* (Top Shelf, 2004); *Owly: Flying Lessons* (Top Shelf, 2005);

78. David Petersen, *Mouse Guard: Fall 1152* (Archaia Studios Press, 2007). More mature treatments in similar mien include Bryan J. L. Glass and Michael Avon Oeming, *Mice Templar: The Prophecy* (Image, 2008) and Evan Dorkin and Jill Thompson, *Beasts of Burden: Animal Rites* (Dark Horse, 2010).

79. Jordan Crane, *The Clouds Above* (Fantagraphics, 2005); Matthew Forsythe, *Ojingogo*, (Drawn & Quarterly, 2008); compare Kean Soo's *Jellaby* (Hyperion, 2008), where imaginary friends become real.

80. Lauren Mechling, "Alexa Kitchen Draws on Life's Experiences, No Matter How Few," *NYT*, July 23, 2006.

81. Ariel Schrag, *Stuck in the Middle* (Viking, 2007). Titles include "Snitch," "Anxiety," "Surviving Middle School," and "Never Go Home." Note also Heather Smith, "Judging a Book by Its Cover: Comics Swankified," *Bookslut*, June 2007, http://www.bookslut.com/features/2007_06_011209.php.

82. Greg Toppo, "Teachers Are Getting Graphic," *USA Today*, May 3, 2005. In 2013, Smith recalled a major library book distributor telling him there had been library demand for *Bone* by the late '90s; see Jeff Smith, quoted in *Jam*, https://yougoof.tumblr.com/post/52064065592/after-about-two-years-i-remember-baker-taylor.

83. "Graphic Lit: An Interview with Françoise Mouly," *Panels and Pixels*, April 9, 2008, http://panelsandpixels.blogspot.com/2008/04/graphic-lit-interview-with-francoise.html.

84. Heidi MacDonald, "How Graphic Novels Became the Hottest Section of the Library," *Publishers Weekly*, May 3, 2013, https://www.publishersweekly.com/pw/by-topic/industry-news/libraries/article/57093-how-graphic-novels-became-the-hottest-section-in-the-library.html.

85. See "CBDLF & ALA Office for Intellectual Freedom Speak Out in Defense of Comic Facing Removal from School Library," CBDLF website, December 12, 2011, http://cbldf.org/2011/12/cbldf-ala-office-for-intellectual-freedom-speak-out-in-defense-of-comic-facing-removal-from-school-library.

86. *CCG*, 231; *PB*, 115. David Mack's academic background, personal experiences, and creator-owned project produced the most thoroughgoing mid-'90s American engagement with Japanese culture: the visually arresting *Kabuki: Circle of Blood* (Image, 2010, first published 1994–1995).

87. See Cecilia D'Anastasio, "The Invisible Labor Economy Behind Pirated Japanese Comics," *Vice*, April 9, 2015, https://www.vice.com/en/article/4x3pwm/meet-the-scanlators.

88. "Comic Shops Fight for Share of Pokémon Profits," *TCJ* no. 214 (July 1999): 9–10.

89. Jemas quote in Robert Boyd, "On Second Thought, There Is a Need for Tenchi," *TCJ* no. 238 (October 2001): 98.

90. Compare Maia Tsurumi, "Gender Roles and Girls' Comics in Japan," in *Japan Pop!: Inside the*

World of Japanese Popular Culture, ed. Timothy J. Craig (M. E. Sharpe, 2000), 171–185, esp. 172; *PB*, 115; Wendy Goldberg, "The Manga Phenomenon in America," in Johnson-Woods, 281–296; Larsen in "Erik Larsen," *TCJ* no. 222 (April 2000): 55.

91. "Newswatch," *TCJ* no. 259 (April 2004): 5; "Newswatch," *TCJ* no. 276 (June 2006): 29; Casey Brienza, "Producing Comics Culture," *JGNC* 1, no. 2 (2010): 113–114.

92. "Manga Hits the Funny Pages," ICv2, November 8, 2005, https://icv2.com/articles/comics/view/7782/manga-hits-funny-pages.

93. Robin E. Brenner, *Understanding Manga and Anime* (Libraries Unlimited, 2007), xi; Boyd, "On Second Thought," 93–95; "Newswatch," *TCJ* no. 277 (July 2006): 28; "Graphic Novels Buck the Trend," ICv2, September 28, 2006, https://icv2.com/articles/comics/view/9390/graphic-novels-buck-trend.

94. "Journal Datebook," *TCJ* no. 280 (January 2007): 32; not counting "the hidden manga consumer," the library user or the in-store reader: "The Hidden Manga Consumer," ICv2, June 14, 2005, https://icv2.com/articles/comics/view/7049/the-hidden-manga-consumer.

95. Brian Hibbs quoted in Dirk Deppey, "She's Got Her Own Thing Now," *TCJ* no. 269 (July 2005): 13.

96. Compare Michael Dean, "A Tale of Two Manga Shops," *TCJ* no. 269 (July 2005): 28.

97. "Newswatch," *TCJ* no. 270 (August 2005): 26.

98. "DC SVP Karen Berger on Minx," ICv2, December 30, 2006, https://icv2.com/articles/comics/view/9697/dc-svp-karen-berger-minx; Andy Khouri, "DC Cancels Minx Young Adults Line," *CBR*, September 24, 2008, https://www.cbr.com/dc-cancels-minx-young-adults-line.

99. "Over 3,300 Graphic Novels Released in '07," ICv2, March 6, 2008, https://icv2.com/articles/comics/view/12186/over-3-300-graphic-novels-released-07.

100. "John Miller of Lost Realms Comics and Games on Online Competition," ICv2, August 6, 2007, https://icv2.com/articles/comics/view/11052/john-miller-lost-realms-comics-games-online-competition.

101. Shaenon Garrity, "The History of Webcomics," *TCJ*, July 15, 2011, http://www.tcj.com/the-history-of-webcomics.

102. Michael Dean, "Hear Him Roar," *TCJ* no. 232 (April 2001): 59; "A Silly Little Coat Hanger for Fart Jokes," *TCJ* no. 232 (April 2001): 81–82, 87.

103. "Newswatch," *TCJ* no. 264 (December 2004): 23–24; "Newswatch," *TCJ* no. 265 (February 2005): 29.

104. See Michael Dean, "Online Comics Journalism: Does It Exist?," *TCJ* no. 265 (February 2005): 21–24; "Part 9: The Report Card," *TCJ* no. 272 (November 2005): 22–28.

105. "Fighting Words," *TCJ* no. 266 (March 2005): 171; Tim O'Neil, "Arcadia," *TCJ* no. 281 (February 2007): 188.

106. Tom Spurgeon, "Finder Serial to Go On-Line," *Comics Reporter*, September 26, 2005, https://www.comicsreporter.com/index.php/finder_serial_to_go_on_line.

107. Tom Spurgeon, "The New Norm," *Comics Reporter*, January 7, 2005, https://www.comicsreporter.com/index.php/the_new_norm; Alison Bechdel, "Latest Episode, #486," *DTWOF: The Blog*, April 22, 2006, http://alisonbechdel.blogspot.com/2006/04/latest-episode-486.html (April 22, 2006).

108. Daniel D. Turner, "A Comic Strip That Takes Video Games Seriously (Almost)," *NYT*, December 16, 2004, https://www.nytimes.com/2004/12/16/technology/circuits/a-comic-strip-takes-video-games-seriously-almost.html. For a good description of the 2005 Expo, see "PAX05 Writeup," *Slashdot*, August 30, 2005, https://games.slashdot.org/story/05/08/30/138259/pax05-writeup; see also Dan Tochen, "Preshow Q&A: Penny Arcade's Robert Khoo," *Gamespot*, August 29, 2005, https://www.gamespot.com/articles/preshow-qanda-penny-arcades-robert-khoo/1100-6132103.

109. "Fighting Words," *TCJ* no. 268 (July 2005): 71; "Chris Onstad Interview," *TCJ* no. 277 (July 2006): 203, 207; "Fred Gallagher Interview," *TCJ* no. 277 (July 2006): 213.

110. Similar, though even less conventionally classifiable, is Kyle Starks's "hoboes fight the devil" *Rock Candy Mountain* (Image, 2017).

111. Ursula Vernon, *Digger* (Sofawolf Press, 2005); Jonathan Rosenberg, *Infinite Typewriters* (Ballantine, 2009).

112. David Malki, *Beards of Our Forefathers* (Dark Horse, 2008); David Malki, *Clever Tricks to Stave Off Death* (Dark Horse, 2009).

113. Nicholas Gurewitch, *The Trial of Colonel Sweeto and Other Stories* (Dark Horse, 2007); "Nicholas Gurewitch Interview," *TCJ* no. 298 (May 2009): 75; Nicole Lee, "XKCD Webcomic Turns Ten Years Old Today," *Engadget*, September 30, 2015.

114. Kate Beaton, *Hark! A Vagrant* (Drawn & Quarterly, 2011), 113–115; Dave Kellett, *Literature!: Unsuccessfully Competing Against TV Since 1953* (Small Fish, 2010).

115. "Journal Datebook," *TCJ* no. 294 (December 2008): 20; "Is the Main Character Missing? Maybe Not," *NYT*, June 2, 2008. In 2010, Jeff Ocean tried the same thing with Calvin minus Hobbes, but gave up because it was too "sad." Alan Gardner, "Calvin Minus Hobbes Strips Posted," *Daily Cartoonist*, June 9, 2010, http://www.dailycartoonist.com/index.php/2010/06/09/calvin-minus-hobbes-strips-posted. On *Garfield*'s brilliant use of negative space, see Michelle Ann Abate, "*Garfield* and Negative Space," *Inks* 1, vol. 3 (2017): 288–308.

116. *3anuts*, https://3eanuts.com.

117. *The Silent Penultimate Panel Watch*, http://penultimate-panel.blogspot.com.

118. Shaenon Garrity, "The Bossest Comics on Girlamatic," *TCJ*, August 12, 2011, http://www.tcj.com/the-bossest-comics-on-girlamatic.

119. Michael Dean, "LPC's Chapter 11 and Top Shelf's Near Death Experience," *TCJ* no. 243 (May 2002): 5. Fantagraphics underwent a similar process a year later; see "Newswatch," *TCJ* no. 254 (July 2003): 3.

120. See comments by Robert Kirkman in "Robert Kirkman Interview," *TCJ* no. 289 (April 2008): 61; Heidi MacDonald, "Did Yahoo Just Destroy the Future of Comics by Buying Tumblr?," *Beat*, May 20, 2013, https://www.comicsbeat.com/did-yahoo-just-destroy-the-future-of-comics-by-buying-tumblr.

121. Motoko Rich, "Crossover Dreams," *NYT*, December 13, 2007. On another such hybrid, *The Invention of Hugo Cabret*, see Tom Spurgeon, "All Hail the Comics-Prose Hybrid," *Comics Reporter*, January 24, 2008, https://www.comicsreporter.com/index.php/all_hail_the_comics_prose_hybrid; Dan Kois, "Kids' Lit Gets Graphic," *New York*, April 10, 2008.

122. "Wizard World Chicago Attracts 56k," ICv2, August 9, 2005, https://icv2.com/articles/comics/view/7350/wizard-world-chicago-attracts-56k; "Journal Datebook," *TCJ* no. 298 (May 2009): 12.

123. "Journal Datebook," *TCJ* no. 300 (November 2009): 16.

124. Tom Spurgeon, "Your 2007 San Diego Con Update," *Comics Reporter*, July 27, 2007, https://www.comicsreporter.com/index.php/your_2007_san_diego_con_update4.

125. "Voices from ICAF," *TCJ* no. 228 (November 2000): 28.

126. Pekar chronicled his typically ambivalent reactions to the business in *American Splendor: Our Movie Year* (Ballantine, 2004).

127. Tom Spurgeon, "The First Great American Pop Culture Con—50-Plus Thoughts on CCI 2008!," *Comics Reporter*, July 29, 2008, https://www.comicsreporter.com/index.php/the_first_great_american_pop_culture_con_50_thoughts_on_cci_2008.

128. "Brian Michael Bendis Interview," *TCJ* no. 266 (March 2005): 108–109; Bendis, *Fortune and Glory: A True Hollywood Comic Book Story* (Oni Press, 2000).

129. Frank Miller, *300* (Dark Horse, 1999); compare Emily Fairey, "Persians in Frank Miller's *300* and Greek Vase Painting," *Classics and Comics*, 159–172, and Tim Blackmore, "*300* and Two," *IJCA* 6, no. 2 (Fall 2004): 325–349; "Frank Miller," *TCJ* no. 209 (December 1998): 46; on the polite marginalization Miller encountered when visiting the *Daredevil* movie set, see "Man with Pen in Head," in *Autobiographix*, ed. Diana Schutz (Dark Horse, 2003), 5–10; *Comic-Con*, 154.

130. "The DVD Effect Materializes!," ICv2, August 28, 2005, https://icv2.com/articles/comics/view/7433/the-dvd-effect-materializes; "A Million Copies of 'Watchmen,'" ICv2, August 13, 2008, https://icv2.com/articles/comics/view/13085/a-million-copies-watchmen. Tom Spurgeon, "Heartfelt Disquisition on Personal Freedom Leveraged into Corporate $$$," *Comics Reporter*, March 30, 2006, https://www.comicsreporter.com/index.php/heartfelt_disquistion_on_personal_freedom_leveraged_into_big_corporate_buck.

131. "Larry Marder Interview," *TCJ* no. 201 (January 1998): 97.

132. "Excelsi-Sore!," *TCJ* no. 230 (February 2001): 10; "If This Be My Destiny," *TCJ* no. 232 (April 2001): 5–13, quote 10.

133. "Newswatch," *TCJ* no. 253 (June 2003): 19.

134. Tom Spurgeon, "Blah Blah Blah," *Comics Reporter*, January 27, 2005, https://www
 .comicsreporter.com/index.php/blah_blah_blah_012705.
135. "Marvel Licensing Continues to Grow," ICv2, April 17, 2006, https://icv2.com/articles/
 comics/view/8525/marvel-licensing-continues-grow.
136. Devin Leonard, "Marvel Goes Hollywood," *CNN Money*, May 23, 2007, https://money.cnn
 .com/magazines/fortune/fortune_archive/2007/05/28/100034246/index2.htm.
137. Julia Hanna, "Marvel's Superhero CEO," *Working Knowledge*, December 19, 2005, https://
 hbswk.hbs.edu/archive/marvel-s-superhero-ceo; Sean Howe, "Avengers Assemble!," *Slate*,
 September 28, 2012, https://slate.com/business/2012/09/marvel-comics-and-the-movies
 -the-business-story-behind-the-avengers.html.
138. David Stires, "The Spider-Man Trade," CNN Money, May 2, 2007, https://money.cnn
 .com/2007/05/01/news/companies/pluggedin_stires_spiderman.fortune; see also Rick
 Munarriz, "Big Blue Marvel," *Motley Fool*, June 26, 2007.
139. "Robert Downey Jr. to Portray Iron Man," ICv2, October 1, 2006, https://icv2.com/articles/
 comics/view/9395/robert-downey-jr-portray-iron-man; "A Lot Is Riding on 'Iron Man,' " ICv2,
 May 1, 2008, https://icv2.com/articles/comics/view/12492/a-lot-is-riding-iron-man.
140. David Locke, "Marvel Enterprises: The Movie's Just Started," *Seeking Alpha*, September 25,
 2008, https://seekingalpha.com/article/97317-marvel-enterprises-the-movies-just-started.
141. "Amazing Fantasy #15 Nets 227k," ICv2, October 22, 2007, https://icv2.com/articles/comics/
 view/11513/amazing-fantasy-15-nets-227k; " 'Action Comics' #1: $317,200," ICv2, March 14,
 2009, https://icv2.com/articles/comics/view/14508/action-comics-1-317-200.
142. "The Comic Book Is Back, in Luxe Coffee-Table Form," *NYT*, December 3, 2007.
143. "Walter Mosely's [sic] 'Maximum Fantastic Four,' " ICv2, October 16, 2005, https://icv2.com/
 articles/comics/view/7672/walter-moselys-maximum-fantastic-four.
144. "Joe Simon Appeals Captain America Copyright," *TCJ* no. 244 (June 2002): 14.
145. Compare "Superman Opens Can of Copyright Worms," *TCJ* no. 216 (October 1999): 15–17;
 "Is DC's Green Lantern Copyright Valuable?," *TCJ* no. 217 (November 1999): 13–14; "Joe
 Simon Claims Cap Copyright," *TCJ* no. 219 (January 2000): 8–10; "Girl Trouble at Archie,"
 TCJ no. 220 (February 2000): 5; "Newswatch," *TCJ* no. 224 (June 2000): 5; "Wolfman Loses
 Blade Suit," *TCJ* no. 229 (December 2000): 19; "Wolfman Appeals Blade Ruling," *TCJ* no.
 230 (February 2001): 7; "News in Brief," *TCJ* no. 254 (July 2003): 45.
146. Leslie Simmons, " 'Ghost Rider' Creator Sues over Copyright," Reuters, April 10, 2007,
 https://uk.reuters.com/article/uk-ghostrider/ghost-rider-creator-sues-over-copyright-idUK
 N1037146020070410?pageNumber=1.
147. "Ruling Gives Heirs a New Share of Superman Copyright," *NYT*, March 29, 2008.
148. "Newswatch," *TCJ* no. 249 (December 2002): 29; "Newswatch," *TCJ* no. 267 (April/May 2005):
 22–27; "Newswatch," *TCJ* no. 269 (July 2005): 22–26; Tom Spurgeon, "The Key to the Stan
 Lee Case, at Least for Me," *Comics Reporter*, January 23, 2005, https://www.comicsreporter
 .com/index.php/briefings/commentary/769.
149. Sean T. Collins, "Dan DiDio vs. Joe Quesada on 'Event Fatigue,' " *CBR*, November 30, 2009,
 https://www.cbr.com/dan-didio-vs-joe-quesada-on-event-fatigue; Brian Hibbs, "Chaos in
 the Multiverse," *CBR*, March 20, 2015, https://www.cbr.com/chaos-in-the-multiverse.
150. George Gene Gustines, "Recalibrating DC Heroes for a Grittier Century," *NYT*, October
 12, 2005.
151. Graeme McMillan, "You Won't Need a PhD in DC Comics to Understand New Weekly,"
 Gizmodo, February 11, 2008, https://io9.gizmodo.com/you-wont-need-a-phd-in-dc-comics-to
 -understand-new-week-354783; see also *Slugfest*, 246–248.
152. In Grant Morrison, *New X-Men Omnibus* (Marvel, 2016). See Dirk Deppey, "X-Men . . .
 Retreat!," *TCJ* no. 262 (September 2004): 46–50, and Jason Bainbridge, " 'Worlds Within
 Worlds': The Role of Superheroes in the DC and Marvel Universes," in Ndailanis, 75–76;
 Christopher Brayshaw, "Today's Finest Sermon to the Already Converted," *TCJ* no. 246 (Sep-
 tember 2002): 28.
153. Compare Henry Jenkins, " 'Just Men In Tights': Rewriting Silver Age Comics in an Era of
 Multiplicity," in Ndalianis, 16–43, 33–37.
154. Mark Waid, "Introduction," *All-Star Superman*, vol. 2 (DC, 2009); *Superman for All Seasons*
 (DC, 1999).
155. G. Willow Wilson, *Cairo* (Vertigo, 2007).

156. Lisa Wangsness, "Beneath the Veil" (page 2 of 2), Boston.com, June 20, 2010, http://archive
 .boston.com/bostonglobe/ideas/articles/2010/06/20/beneath_the_veil/?page=2.

157. See Kelley Puckett et al., *Batgirl: Silent Running* (DC, 2001).

158. See Paul Dini, *The Batman Adventures: Mad Love*, repr. in *Batman Adventures: Dangerous
 Dames and Demons* (DC, 2003); *Manhunter: Street Justice* (DC, 2005); *Catwoman: Her Sister's
 Keeper* (DC, 1991); see also Darwyn Cooke, *Selina's Big Score* (DC, 2002) and *Catwoman: Nine
 Lives of a Feline Fatale* (DC, 2004); Gladys Knight, *Female Action Heroes: A Guide to Women
 in Comics, Video Games, Film, and Television* (Greenwood, 2010), 29–41; J. Torres, *Teen Titans
 Spotlight: Wonder Girl* (DC, 2008); Terry Moore, *Echo: Moon Lake* (Abstract Studio, 2008).

159. *Plastic Man: On the Lam!*, vol. 1 (DC, 2004); *Why I Hate Saturn* (Vertigo, 1990).

160. David Mazzucchelli, *Asterios Polyp* (Pantheon, 2009); see Douglas Wolk's excellent *New York
 Times* review, "Shades of Meaning," July 23, 2009.

161. See Thierry Groensteen, *The System of Comics* (University Press of Mississippi, 2007), 50–
 53; Scott McCloud, *Making Comics* (HarperCollins, 2006), 138; Paul Hornschemeier, *The
 Collected Sequential* (AdHouse, 2004), 118–124, 212–217; Renée French, *Micrographica* (Top
 Shelf, 2007), quote inside cover flap; see also "Renée French Interview," *TCJ* no. 271 (October
 2005): 115, 121, 124.

162. Jason Shiga, *Meanwhile* (Amulet, 2010).

163. Lynda Barry, *What It Is* (Drawn & Quarterly, 2008), quotes 8, 19–20. On Barry's visual poet-
 ics, compare Özge Samanci, "Lynda Barry's Humor," *IJCA* 8, no. 2 (Fall 2006), esp. 185–187.

164. Anders Nilsen, *Monologues for Calculating the Density of Black Holes* (Fantagraphics, 2008),
 170; Jesse Jacobs, *Even the Giants* (AdHouse, 2010); Edie Fake, *Gaylord Phoenix* (Secret Acres,
 2010); Barry, *Picture This* (Drawn & Quarterly, 2010), 68–69.

165. Jennifer Daydreamer, *Oliver* (Top Shelf, 2003); Hope Larson, *Salamander Dream* (AdHouse,
 2005). For an excellent look at Larson, see Wolk, 214–219; on Daydreamer, see "Magic and
 Indescribable," *TCJ* no. 237 (September 2001): 56–60.

166. "Ron Regé Interview," *TCJ* no. 252 (May 2003): 61.

167. Ron Regé Jr., *Skibber Bee Bye* (Highwater Books, 2000); John Hankiewicz, *Asthma* (Spark-
 plug, 2006).

168. Ted Jouflas, *Filthy* (Fantagraphics, 1999); Josh Simmons, *House* (Fantagraphics, 2007); "Josh
 Simmons Interview," *TCJ* no. 291 (July 2008): 87–90; "Ted Jouflas," *TCJ* no. 229 (December
 2000), esp. 59, 62, 67.

169. Compare Charles Hatfield, "Are You Shrood to Nesheth Up?," *TCJ* no. 182 (November 1995):
 59–60; Chester Brown, *Underwater* (Drawn & Quarterly, 1994–1997).

170. Jay Stephens, *Oddville!* (Art Ick, 1996). Compare Stephens's *Atomic City Tales*, vol. 1 (Kitchen
 Sink, 1997), with its own dreamlike tether to traditional comic book narrative, and his
 parodic *Land of Nod Treasury* (Oni Press, 2001). See "For the Love of Nod," *TCJ* no. 179
 (August 1995): 43; Hans Rickheit, *Chloe* (Chrome Fetus Comics, 2002); see *TCJ* no. 249
 (December 2002): 40–41.

171. Kevin Huizenga, *Curses: Glenn Ganges Stories* (Drawn & Quarterly, 2006), 54–55. Compare
 "Kevin Huizenga Interview," *TCJ* no. 259 (April 2004): 83.

172. As precursor, see her powerful expressions of heartbreak and loss in *Girlhero*, which express
 themselves in fractured, imagistic panels, esp. *Girlhero* no. 2 (February 1994); Megan Kelso,
 The Squirrel Mother (Fantagraphics, 2006); see "The Comics of Megan Kelso," *TCJ* no. 193
 (February 1997): 41–43.

173. On the toybox metaphor, see Tondro, 12; see, variously, Bill Willingham's *Fables: Legends
 in Exile* (Vertigo/DC, 2002), *Jack of Fables: The (Nearly) Great Escape* (Vertigo/DC, 2007),
 Conor McCreery and Anthony Del Col, *Kill Shakespeare*, vol. 1 (IDW, 2010), *Rai* (Valiant,
 1993), *Crossing Midnight: Cut Here* (Vertigo/DC, 2007), *The Wicked + the Divine: The Faust
 Act* (Image, 2014), *Heck* (Top Shelf, 2013), Gareth Hinds, *Bearskin: A Grimm Tale* (Gareth
 Hinds, 1998). For more subversive examples, compare Elizabeth Genco, *Blue* (Desperado,
 2008), Richard Sala, *Delphine* (Fantagraphics, 2012), Emily Carroll, *Beneath the Dead Oak
 Tree* (Shortbox, 2018), Anna Bongiovanni, *Out of Hollow Water* (2D Cloud, 2013), Eleanor
 Davis, *How to Be Happy* (Fantagraphics, 2014); see also Karin Kukkonen, *Contemporary Com-
 ics Storytelling* (University of Nebraska Press, 2013), 51–86.

174. Andrew Vachss, *Hard Looks: Adapted Stories* (Dark Horse, 1996); *Graphic Classics: H. P. Lovecraft*
 (Eureka Productions, 2002); *The Nightmare Factory: Based on the Stories of Thomas Ligotti* (Fox

Atomic, 2007); *The Dark Tower: The Gunslinger* (Marvel, 2007); *At the Mountains of Madness* (Sterling, 2010).

175. *Paul Auster's City of Glass*, rev. ed. (Henry Holt, 2004; Avon, 1994); "Mazzucchelli Interview," *TCJ* no. 194 (March 1997): 65.

176. Compare Tomine's interview in *TCJ* no. 205 (June 1998): 68.

177. See "A Brief History of the Art Form Known as 'Hortisculpture'" and "Go Owls" in *Killing and Dying* (Drawn & Quarterly, 2015), 9–30, 45–72.

178. Adrian Tomine, *Shortcomings* (Drawn & Quarterly, 2007); see Tomine's interview: https://www.comicsreporter.com/index.php/briefings/blog_monthly/2007/07 (July 21, 2007). Compare Derek Kirk Kim's lovely 2003 novella *Same Difference*, another reflection on continued emotional immaturity: the book's title presumably refers to when outsiders view him and a friend as indistinguishably "Oriental" (Kim is Korean-American) and, when corrected, essentially respond "same difference," reminding how ethnicity, even when not the work's essential lens or catalyst, permeates the lived atmosphere. Gene Luen Yang, *American Born Chinese* (First Second, 2011), esp. 41–42. Kim expanded his canvas in *Good as Lily* (Minx, 2007); compare the valuable essays by Ruth Y. Hsu and Ralph Rodriguez in *Drawing New Color Lines: Transnational Asian American Graphic Narratives* (HKU Press, 2015), ed. Monica Chiu.

179. Noah Van Sciver, *Fante Bukowski* (Fantagraphics, 2015). Van Sciver's *Blammo*, beginning in 2007, frequently concerns the emotional and artistic wringer of making the comics themselves.

180. Adrian Tomine, *Sleepwalk and Other Stories* (Drawn & Quarterly, 2004), 23–24; Adrian Tomine, *Summer Blonde* (Drawn & Quarterly, 2002), 69–100; Gabrielle Bell, *Cecil and Jordan in New York: Stories* (Drawn & Quarterly, 2009), 45–78. See also Gabrielle Bell, *When I'm Old* (Alternative Comics, 2002).

181. Jason Lutes, *Berlin: City of Stones* (Drawn & Quarterly, 2001). His earlier *Jar of Fools*, about a failing magician trying to understand his dead brother's story and his own purpose, had more modest historical scope but equal depth of character.

182. Neil Kleid and Jake Allen, *Brownsville* (ComicsLit/NBM, 2006).

183. Adam Hines, *Duncan the Wonder Dog* (AdHouse, 2010).

Chapter 10: Endings, Beginnings

1. Barry Blitt, in *The New Yorker*, July 21, 2008; see "*The New Yorker*'s Obama," *Tom the Dancing Bug Blog*, July 14, 2008, https://gocomics.typepad.com/tomthedancingbugblog/2008/07/the-new-yorkers.html.

2. Tom Spurgeon, "President Obama Is the New Wolverine," *Comics Reporter*, February 13, 2009, https://www.comicsreporter.com/index.php/president_obama_is_the_new_wolverine.

3. See Tom Spurgeon, "Joe Gross on Douglas Wolk and Comics Pricing," *Comics Reporter*, September 13, 2010, https://www.comicsreporter.com/index.php/joe_gross_on_douglas_wolk_and_comics_pricing.

4. "Interview with Mike Richardson, Part 1," ICv2, October 15, 2008, https://icv2.com/articles/comics/view/13524/interview-mike-richardson-part-one.

5. Tom Spurgeon, "Updates on Kevin Huizenga Ending His Or Else Series, VVM Killing Its Cartoons," *Comics Reporter*, January 27, 2009, https://www.comicsreporter.com/index.php/updates_on_kevin_huizenga_ending_his_or_else_series_vvm_killing_its_cartoon; Tom Spurgeon, "Why Diamond's new Minimums Policy Is Wrong, and What They Should Do About It," *Comics Reporter*, February 8, 2009, https://www.comicsreporter.com/index.php/why_diamonds_new_minimums_policy_is_wrong_and_what_they_should_do_about_it.

6. Important predecessors included the late-'80s *Prime Cuts* and Kim Thompson's late-'90s *Zero Zero*; see *Comics as Art*, 194–195, and Tom Spurgeon, "Recommended: A Quick and (Mostly) Easy Kim Thompson Primer," *Comics Reporter*, June 22, 2013, https://www.comicsreporter.com/index.php/recommended_a_quick_and_easy_kim_thompson_primer.

7. "Top Cow Comics Available for Downloading," ICv2, March 28, 2007, https://icv2.com/articles/comics/view/10324/top-cow-comics-available-downloading.

8. "Marvel Expands Digital Exclusive Offerings," ICv2, October 16, 2008, https://icv2.com/

articles/comics/view/13538/marvel-expands-digital-exclusive-offerings; see also "Marvel Launches Original Webcomics," ICv2, September 17, 2008, https://icv2.com/articles/comics/view/13313/marvel-launches-original-webcomics; Tom Spurgeon, "Marvel Launches New On-Line Initiative," *Comics Reporter*, November 13, 2007, https://www.comicsreporter.com/index.php/marvel_launches_new_on_line_initiative.

9. See Tim O'Neil, "Meet the New Boss, Same as the Old Boss," *TCJ* no. 287 (January 2008): 176–181; "An Escape from the Slush Pile," *NYT*, July 9, 2007.

10. Andy Maxwell, "Marvel and DC Comics Join Forces to Target BitTorrent," *TorrentFreak*, November 22, 2007, https://torrentfreak.com/marvel-dc-comics-target-bittorrent-071122.

11. "The Comics Are Feeling the Pain of Print," *NYT*, December 26, 2008.

12. See "iPhone Marvels," ICv2, October 30, 2009, https://icv2.com/articles/comics/view/16148/iphone-marvels.

13. "NYCC: ICv2's Digital Conference in Depth," *CBR*, October 9, 2010, https://www.cbr.com/nycc-icv2s-digital-conference-in-depth.

14. Tom Spurgeon, "Bundled, Tossed, Untied and Stacked: A Publishing News Column," *Comics Reporter*, April 13, 2011, https://www.comicsreporter.com/index.php/bundled_tossed_untied_and_stacked041311.

15. Rich Johnston, ComiXology Release Terms of Use for Comic Store Websites, *Bleeding Cool*, August 19, 2011, https://bleedingcool.com/comics/recent-updates/comiXology-release-terms-of-use-for-comic-store-websites.

16. See Tom Spurgeon, "Go, Read: Censorship of Underground Comics App for iPhone Discussed by App Creator at Imprint," *Comics Reporter*, August 10, 2011, https://www.comicsreporter.com/index.php/go_read_censorship_of_underground_comics_app_for_iphone_discussed_by_app_cr; Kevin Melrose, "ComiXology Pulls 56 Digital Comics from iOS App," *CBR*, May 23, 2013, https://www.cbr.com/comixology-pulls-56-digital-comics-from-ios-app-updated.

17. Andrew Bayer, "Digital Comics Pricing," *4thLetter*, April 12, 2010, http://4thletter.net/2010/04/guest-post-andrew-bayer-on-digital-comics-pricing.

18. "Digital Comics Triple in 2011," ICv2, February 8, 2012.

19. "Interview with Ted Adams—Part 1," ICv2, May 9, 2012, https://icv2.com/articles/comics/view/22866/interview-with-ted-adams-part-1; "Image's Digital Sales Are a Double Digit Percentage," ICv2, May 15, 2012, https://icv2.com/articles/comics/view/22901/images-digital-sales-are-double-digit-percentage.

20. "Comic Store Expansion Programs," ICv2, October 23, 2012, https://icv2.com/articles/comics/view/24236/comic-store-expansion-programs.

21. Tom Spurgeon, "Assembled, Zipped, Transferred, and Downloaded: News from Digital," *Comics Reporter*, October 26, 2012, https://www.comicsreporter.com/index.php/assembled_zipped_transferred_and_downloaded102612.

22. Kevin Melrose, "ComiXology and Andrews McMeel Announce Digital-Distribution Deal," *CBR*, December 19, 2012, https://www.cbr.com/comixology-and-andrews-mcmeel-announce-digital-distribution-deal.

23. David Betancourt, "When Comics Crash the Internet," *Washington Post*, March 11, 2013.

24. "Digital Comics Sales Grow to $90 Million," ICv2, July 11, 2014, https://icv2.com/articles/comics/view/29068/digital-comics-sales-grow-90-million.

25. John Jackson Miller, "Overall Print Comics Market Topped $700 Million in 2012," *Comichron*, February 17, 2013, https://blog.comichron.com/2013/02/overall-print-comics-market-topped-700.html.

26. Andrew Wheeler, "ComiXology Passes 200 Million Downloads," *Comics Alliance*, September 26, 2013, https://comicsalliance.com/comixology-passes-200-million-downloads.

27. Tom Spurgeon, "I Have No Idea What I Think of This: PictureBox Seeks Pledged Support," *Comics Reporter*, May 7, 2009, https://www.comicsreporter.com/index.php/i_have_no_idea_what_i_think_of_this_picturebox_seeks_pledged_support.

28. Tom Spurgeon, "Kickstarter Facilitates Almost $1M for Comics Projects," *Comics Reporter*, April, 28, 2011, https://www.comicsreporter.com/index.php/kickstarter_facilitates_almost_1m_for_comics_projects.

29. Rich Burlew, "The Order of the Stick Reprint Drive," Kickstarter website, https://www.kickstarter.com/projects/599092525/the-order-of-the-stick-reprint-drive.

30. See Gary Tyrell, "She Is the Safest for Work," *Fleen*, February 27, 2012, http://fleen
.com/2012/02/27/she-is-the-safest-for-work.

31. Calvin Reid, "Publishing Campaigns Grow on Kickstarter," *Publishers Weekly*, May 16, 2014,
https://www.publishersweekly.com/pw/by-topic/industry-news/publisher-news/article
/62344-publishing-campaigns-grow-on-kickstarter.html.

32. Warren Ellis, "The Private Eye: Leaving Comics Publishers Behind," personal blog,
March 19, 2013, http://www.warrenellis.com/the-private-eye-leaving-comics-publishers
-behind. The comic implicates the medium directly; the futuristic noir tale is set in a
world where the internet is gone and unscrupulous types desire its restoration: *The Pri-
vate Eye* (Image, 2015).

33. Paul Tobin and Colleen Coover, *Bandette: Presto!* (Dark Horse, 2013).

34. Tom Spurgeon, "CR Comic-Con 2013 Interview: Allison Baker, Chris Roberson," *Comics
Reporter*, July 21, 2013, https://www.comicsreporter.com/index.php/cr_sunday_interview_
allison_baker_chris_roberson.

35. "Afterword," *A.D.*, 193.

36. For a remarkable example, see Michel Gagné's process comments in *Young Romance*, vol. 2
(Fantagraphics, 2014), 199.

37. "Spiegelman & Huizenga," *TCJ* no. 300 (November 2009): 29, 34. See also Tom Spurgeon,
"The Blind Man's Elephant in the Room," *Comics Reporter*, January 24, 2010, https://www
.comicsreporter.com/index.php/the_medium_that_shrank_from_view_but_grew_in_
every_other_way.

38. "ICv2 Interview: Berkeley Breathed," ICv2, September 16, 2009, https://icv2.com/articles/
comics/view/15842/icv2-interview-berkeley-breathed.

39. Jordan Weissmann, "The Decline of Newspapers Hits a Stunning Milestone," Slate, April
28, 2014, https://slate.com/business/2014/04/decline-of-newspapers-hits-a-milestone-print
-revenue-is-lowest-since-1950.html.

40. Richard Thompson, *The Complete Cul de Sac* (Andrews McMeel, 2014).

41. Alan Gardner, "Cartoon 'Sit-In' Scheduled for February 10," *Daily Cartoonist*, January 9,
2008, http://www.dailycartoonist.com/index.php/2008/01/09/cartoon-sit-in-scheduled-for
-february-10; "Sunday's Comic Strip Protest Round-Up," *Comics Reporter*, February 11, 2008,
https://www.comicsreporter.com/index.php/sundays_comic_strip_protest_round_up.

42. Tom Spurgeon, "E&P: Female Editorial Cartoonists Scarce," *Comics Reporter*, March 29, 2005,
https://www.comicsreporter.com/index.php/ep_female_editorial_cartoonists_scarce.

43. "Other Casualties," *Eye on Comics*, March 12, 2007, http://www.eyeoncomics.com/?p=117.

44. Stories collected in Michael Uslan, *Archie Marries . . .* (Abrams ComicArts, 2010). It's accom-
plished, cleverly, by walking up Riverdale's "Memory Lane" (previously only walked down)
into a yellow wood in which two roads diverge. On Uslan's familiarity with parallel universes,
see 180. See also *Archie: The Married Life* (Archie Comics, 2011).

45. Tom Spurgeon, "CR Sunday Interview: Jon Goldwater," *Comics Reporter*, June 12, 2011,
https://www.comicsreporter.com/index.php/resources/interviews/35165.

46. *Archie's Pal: Kevin Keller* (Archie Comics, 2012); Uslan, 177; Vanetta Rogers, "Archie, Meet
Kevin," *Newsarama*, April 22, 2010, https://www.newsarama.com/5161-archie-meet-kevin
-riverdale-s-new-gay-student.html.

47. John Parkin, "American Family Association Targets Kevin Keller Comics at Toys 'R' Us,"
CBR, February 29, 2012, https://www.cbr.com/american-family-association-targets-kevin
-keller-comics-at-toys-r-us-updated.

48. Amy Kiste Nyberg, "Comic Book Censorship in the United States," in *Pulp Demons*, 42–69, 60.

49. "Marvel Drops Comics Code," *TCJ* no. 234 (June 2001): 19.

50. R. C. Harvey, "John Goldwater, the Comics Code, and Archie," *TCJ*, July 28, 2011, http://www
.tcj.com/john-goldwater-the-comics-code-authority-and-archie.

51. As this transpired, Archie Comics was caught in a mounting legal tussle between dual CEOs,
restraining orders and allegations of bad behavior running rampant. Robin Finn, "The Battle
for a Comic-Book Empire That Archie Built," *NYT*, April 13, 2012.

52. Gail Simone, *The All-New Atom: My Life in Miniature* (DC, 2007); *White Tiger* (Marvel, 2007).
Araña (Marvel, 2005), back cover. For a comprehensive overview of Hispanic characters
in superhero comics, see Frederick Luis Aldama, *Latinx Superheroes in Mainstream Comics*
(University of Arizona Press, 2017), 7–89.

53. See, for example, Kelly Thompson, *Hawkeye: Masks* (Marvel, 2017); *Watson and Holmes: A Study in Black* (New Paradigm Studios, 2013).

54. Rob Lendrum, "Queering Super-Manhood: Superhero Masculinity, Camp and Public Relations as a Textual Framework," *IJCA* 7, no. 1 (Spring 2005): 289–290.

55. Tom Spurgeon, "Gay League on Marvel's GLBT Policy," *Comics Reporter*, August 15, 2006, https://www.comicsreporter.com/index.php/gay_league_on_marvels_glbt_policy. Several other gay characters Marvel had were tortured and killed in 2006, leading to some controversy. Tom Spurgeon, "Andy Mangels on Marvel's Recent Weirdness Regarding LGBT Characters," *Comics Reporter*, October 8, 2006, https://www.comicsreporter.com/index.php/andy_mangels_on_marvels_recent_weirdness_regarding_lgbt_characters.

56. Chris Sims, "The Racial Politics of Regressive Storytelling," *Comics Alliance*, May 6, 2010, https://comicsalliance.com/the-racial-politics-of-regressive-storytelling.

57. On *Ultimate Spider-Man*, see "Brian Michael Bendis," 118–120; for a part-Latino predecessor in the '90s *Spider-Man 2099*, see *Latinx Superheroes*, 37–40.

58. "Spider-Man Spins a New Secret Identity," *NYT*, August 2, 2011.

59. Albert Ching, "Miles Morales to Star in Bendis & Pichelli's 'Spider-Man' Post-'Secret Wars,'" *CBR*, June 20, 2015, https://www.cbr.com/miles-morales-to-star-in-bendis-pichellis-spider-man-post-secret-wars.

60. Alex Pappademas, "Northstar's Same-Sex Wedding and Comic Books' Uncomfortable History with Gay Heroes," *Grantland*, May 23, 2012, http://grantland.com/hollywood-prospectus/northstars-same-sex-wedding-and-comic-books-uncomfortable-history-with-gay-heroes.

61. Kevin Melrose, "Loki Will Be Bisexual, Occasionally a Woman in 'Agent of Asgard,'" *CBR*, October 24, 2013, https://www.cbr.com/loki-will-be-bisexual-occasionally-a-woman-in-agent-of-asgard.

62. James Whitbrook, "*Midnighter* Is the Best Portrayal of a Gay Superhero in Mainstream Comics," *Gizmodo*, July 1, 2015, https://i09.gizmodo.com/midnighter-is-the-best-portrayal-of-a-gay-superhero-in-1715225013.

63. Particularly evident in Steve Orlando's series *Midnighter and Apollo* (DC, 2017), and *Out* and *Hard*, whose titles show the close proximity between hard-edged masculinity and non-heteronormativity.

64. Tatiana Craine, "Ta-Nehisi Coates Discusses Race, Mental Health, and 'Underboob' at Comic Con," *Village Voice*, October 7, 2016, https://www.villagevoice.com/2016/10/07/ta-nehisi-coates-discusses-race-mental-health-and-underboob-at-comic-con.

65. See *Avengers: The Children's Crusade* (Marvel, 2012); Greg Rucka, *Batwoman: Elegy* (DC, 2010); Paul Petrovic, "Queer Resistance, Gender Performance, and 'Coming Out' of the Panel in Greg Rucka and J. H. Williams III's *Batwoman: Elegy*," *JGNC* 2, no. 1 (2011): 67–76.

66. Andrew Wheeler, "The Straightwashing of Hercules and How Marvel Keeps Failing LGBTQ Readers," *Comics Alliance*, August 3, 2015, https://comicsalliance.com/hercules-marvel-lgbtq. John Constantine had been revealed to be bisexual back in 2002: James Whitbrook, "The New Constantine Comic Is Way More Comfortable with His Bisexuality," *Gizmodo*, June 11, 2015, https://i09.gizmodo.com/the-new-constantine-comic-is-way-more-comfortable-with-1710643002.

67. Carolyn Cox, "Marvel Editor-In-Chief Axel Alonso 'Not Looking to Put Labels' on Obviously LGBTQ+ Characters," *Mary Sue*, November 2, 2015, https://www.themarysue.com/marvel-not-looking-for-labels.

68. "Interview with Marvel's David Gabriel—Part Two," ICv2, Febaruary 7, 2012, https://icv2.com/articles/comics/view/22092/interview-marvels-david-gabriel-part-2; for a statistical deep dive, see Walt Hickey, "Comic Books Are Still Made by Men, for Men and About Men," *FiveThirtyEight*, October 13, 2014, https://fivethirtyeight.com/features/women-in-comic-books.

69. Curtis M. Wong, "Original 'X-Men' Character Iceman Comes Out as Gay," *HuffPost*, April 21, 2015, https://www.huffpost.com/entry/iceman-bobbie-drake-gay-_n_7110308; see Gareth Schott, "From Fan Appropriation to Industry Re-Appropriation: The Sexual Identity of Comic Superheroes," *JGNC* 1, no. 1 (2010): 17–29.

70. Fred Chao's delightful *Johnny Hiro* ("Half Asian, All Hero") balances deadpan comedy and big-budget superhero silliness with an ethnic twist: when *rōnin* attack at a Lincoln Center

opera, the narrator wonders, "What if the performance was able to complete? [sic] Could that have opened opportunities for Asians in mainstream theater?" Fred Chao, *Johnny Hiro* (Tor, 2009), 106; Gene Luen Yang and Sonny Liew, *The Shadow Hero* (First Second, 2014), offers a just slightly less tongue-in-cheek dynamic.

71. Ta-Nehisi Coates, "And Now Let Us Praise Great Comic Books," *Atlantic*, October 17, 2008, https://www.theatlantic.com/entertainment/archive/2008/10/and-now-let-us-praise-great -comic-books/6064.

72. Closer to home is Aaron McGruder, Reginald Hudlin, and Kyle Baker's graphic novel *Birth of a Nation* (Three Rivers Press, 2004), in which East St. Louis, fed up with its citizens being ignored and abused, secedes: its title, reclaiming the phrase from D. W. Griffith's Klan-sympathetic retelling of Reconstruction, another shot across the bow for Black stories.

73. Rich Johnston, "This Year, the Eisners Quadrupled the Amount of Nominated Black Writers of Print Comics, in the Last Ten Years," *Bleeding Cool*, May 16, 2014, https://bleedingcool .com/comics/recent-updates/this-year-the-eisners-tripled-the-amount-of-nominated-black -writers-of-print-comics-ever.

74. Tom Ayres, "Women Still Under-Represented in Comics," *DigitalSpy*, November 22, 2010, https://www.digitalspy.com/comics/a289035/women-still-under-represented-in-comics; see also Tim Hanley, "Women & NB Creators at Marvel Comics, October 2010 Solicits—17 Creators on 16 Books," personal blog, September 30, 2020, https://thanley.wordpress.com/ tag/women-in-comics-statistics.

75. Laura Hudson, "Answering Dan Didio: The Problem with Having Only 1% Female Creators at Marvel Comics," *Comics Alliance*, July 28, 2011, https://comicsalliance.com/dc-dan-didio -female-creators.

76. DCE Editorial, "We Hear You," DCComics.com, July 29, 2011, https://www.dccomics.com/ blog/2011/07/29/we-hear-you.

77. Joseph Hughes, "Outrage Deferred: On the Lack of Black Writers in the Comic Book Indus-try," *Comics Alliance*, February 4, 2012, https://comicsalliance.com/black-writers-comic-book -industry.

78. Julian Lytle, Tumblr blog post, July 15, 2015, https://julianlytle.tumblr.com/post/124174 437987/can-you-explain-why-marvel-thinks-that-doing-hip. Jim Rugg and Brian Maruca similarly introduced an archetypal Blaxploitation figure into a wide variety of comics genres, tweaking both the former and the latter and, more seriously, questioning the representation of Blacks in the genres more generally. See *Afrodisiac* (AdHouse, 2009).

79. Allison Baker, "Image Expo and the Public Perception Problem," *CBR*, January 13, 2014, https://www.cbr.com/image-expo-and-the-public-perception-problem.

80. Laura Hudson, "The Big Sexy Problem with Superheroines and Their 'Liberated Sexual-ity,'" *Comics Alliance*, September 22, 2011, https://comicsalliance.com/starfire-catwoman -sex-superheroine.

81. See project managers' statements in *Womanthology: Heroic* (IDW, 2011), 6–8, and esp. Sim-one's contribution (90–94).

82. See Karen Healey, "When Fangirls Perform: The Gendered Fan Identity in Superhero Com-ics Fandom," in Ndalianis, 144ff.

83. Laura Hudson, "Marvel Editors Discuss Women in Comics and the Lack of Female-Led Titles," *Comics Alliance*, December 8, 2011, https://comicsalliance.com/marvel-women -comics-editors; "Former DC Comics Editor Janelle Asselin on Women, Comics and Mar-keting," *DC Women Kicking Ass* Tumblr blog, January 31, 2012, https://dcwomenkickingass .tumblr.com/post/16823331908/jasselin.

84. "Who Run the World?," *Kate or Die*, https://kateordie.tumblr.com/post/100085987982/who -run-the-world-yesterday-the-valkyries-hit.

85. Heidi MacDonald, "Graphic Novel Sales Hit $460 Million in 2014," *Publishers Weekly*, October 9, 2015, https://www.publishersweekly.com/pw/by-topic/industry-news/comics/ article/68308-graphic-novel-sales-hit-460-million-in-2014.html.

86. "'Fanboy' Makes It into Dictionary," ICv2, July 7, 2008, https://icv2.com/articles/comics/ view/12869/-fanboy-makes-it.

87. "Akira Adaptation Courts White Actors," *Racebending*, March 22, 2011, http://www .racebending.com/v4/featured/akira-adaptation-courts-white-actors.

88. "Len Wein," *TCJ* no. 100 (July 1985): 165.

89. Compare Deborah Elizabeth Whaley, "Black Cat Got Your Tongue?: Catwoman, Blackness, and the Alchemy of Postracialism," *JGNC* 2, no. 1 (2011): 3–23.

90. Gary Groth, "A Bill of Goods," *TCJ* no. 254 (July 2003): 61.

91. *Fanboy* (DC, 2001), quotes 141; Clowes, *Eightball* no. 14 (1994), 21ff., quote 24; *Wimbledon Green* (Drawn & Quarterly, 2005); *Mail Order Bride* (Fantagraphics, 2001).

92. *The Wicked + the Divine*, vol. 2, *Fandemonium* (Image, 2015).

93. Steve Sunu, "'Amazing Spider-Man' Writer Dan Slott Receives Death Threats via Social Media," *CBR*, December 18, 2012, https://www.cbr.com/amazing-spider-man-writer-dan -slott-receives-death-threats-via-social-media. Slott had previously attracted trolls' attentions for his Spider-Man work. Sean T. Collins, "Dan Slott Responds to Message-Board Insult with Well-Deserved F-Bomb," *CBR*, December 9, 2010, https://www.cbr.com/dan-slott-responds -to-message-board-insult-with-well-deserved-f-bomb.

94. Quoted Sean T. Collins, "Quote of the Day: Kate Beaton on Sexist 'Compliments," *CBR*, October 27, 2010, https://www.cbr.com/quote-of-the-day-kate-beaton-on-sexist-compliments.

95. This account is deeply indebted to Jay Edidin (as Rachel Edidin), "Why I'm Never Going Back to Penny Arcade Expo," *Wired*, September 5, 2013, https://www.wired.com/2013/09/penny -arcade-expo-dickwolves.

96. See, for example, "Two Sides of Julie the Ladies' Man," *TCJ* no. 259 (April 2004): 22.

97. Katherine Keller, "Sexual Harassment, Cons, and You," *Sequential Tart*, July 1, 2006, http:// www.sequentialtart.com/article.php?id=194.

98. Dave Trumbore, "San Diego Comic-Con 2011 Badges Sell Out in Less than a Day," *Collider*, February 6, 2011, https://collider.com/san-diego-comic-con-2011-badges-sell-out; Lori Weisberg, "Another Year, Another Comic-Con Sellout," *San Diego Union-Tribune*, March 15, 2014, https://www.sandiegouniontribune.com/business/tourism/sdut-comiccon-badges -sell-out-2014mar15-html; Lori Weisberg, "Comic-Con Badges Sell Out in Record Time," *San Diego Union-Tribune*, February 21, 2015, https://www.sandiegouniontribune.com/ business/tourism/sdut-comic-con-badges-sell-out-record-time-2015feb21-story.html; Kerry Dixon, "Parking for San Diego Comic-Con Moving to a Lottery Based System," *SDCC Unofficial Blog*, March 31, 2015, https://sdccblog.com/2015/03/parking-for-san-diego-comic-con -moving-to-a-lottery-based-system.

99. Lori Weisberg, "Gauging the Power of Comic-Con's Punch," *San Diego Union-Tribune*, June 24, 2010, https://www.sandiegouniontribune.com/sdut-how-much-money-does-comic-con -bring-san-diego-2010jun24-story.html.

100. Rob Salkowitz, "The Long Con," ICv2, February 25, 2014, https://icv2.com/articles/columns/ view/27960/the-long-con.

101. "Breaking Down the Comic-Con Walls," ICv2, June 26, 2009, https://icv2.com/articles/ comics/view/15243/breaking-down-comic-con-walls.

102. "Who Says San Diego Doesn't Matter?," ICv2, August 16, 2009, https://icv2.com/articles/ comics/view/15637/who-says-san-diego-doesnt-matter.

103. Tom Spurgeon, "Comic-Con 2010: A Final Report," *Comics Reporter*, July 28, 2010, https:// www.comicsreporter.com/index.php/comic_con_2010_a_final_report.

104. Kevin Melrose, "SDCC: MTV to Debut mtvU Fandom Awards at Comic-Con," *CBR*, June 6, 2014, https://www.cbr.com/sdcc-mtv-to-debut-mtvu-fandom-awards-at-comic-con.

105. Kevin Melrose, "Survey: More than Half of Emerald City Attendees Were Female," *CBR*, May 13, 2014, https://www.cbr.com/survey-more-than-half-of-emerald-city-attendees-were -female.

106. See *We Are Comics* Tumblr blog, https://wearecomics.tumblr.com.

107. Heidi MacDonald, "Two Conventions Forget What Year It Is with Questionable Promotions," *Beat*, March 10, 2014, https://www.comicsbeat.com/two-conventions-forget-what-year-it-is -with-questionable-promotions.

108. Heidi MacDonald, "New York Comic-Con 2013: Creepy Camera Crews, Arizona's Big Cans, and Harassment," *Beat*, October 15, 2013, https://www.comicsbeat.com/new-york-comic-con -2013-creepy-camera-crews-arizonas-big-cans-and-harassment.

109. See Noah Berlatsky, "How to Dismantle the Comic-Book Boys' Club," *Atlantic*, November 20, 2013, https://www.theatlantic.com/entertainment/archive/2013/11/how-to-dismantle -the-comic-books-boys-club/281694; Parkin, "Mark Millar, Others Team Up to Take Down Online Bully," *CBR*, September 2, 2012, https://www.cbr.com/mark-millar-others-team-up

-to-take-down-online-bully; "Let's Talk About Scott Lobdell," *Postcards from Space*, December 21, 2013, https://postcardsfromspace.tumblr.com/post/70661279423/lets-talk-about-scott-lobdell.

110. Tom Spurgeon, "MariNaomi Writes About Being Harassed During a Convention Panel; Harasser Scott Lobdell Apologizes," *Comics Reporter*, December 19, 2013, https://www.comicsreporter.com/index.php/marinaomi_writes_about_being_harassed_during_a_convention_panel_harasser_sc.

111. "A Serious Note," *Comics Oughta Be Fun!*, August 15, 2008, http://bullyscomics.blogspot.com/2008/08/serious-note.html.

112. Quoted in Carolyn Cox, "After Investigation Police Rule Alleged Comic-Con Assault an Accident," *Mary Sue*, July 31, 2014, https://www.themarysue.com/comic-con-cosplay-assault.

113. Heidi MacDonald, "San Diego Comic-Con Under Fire for Its Harassment Policy, or Lack Thereof," *Beat*, June 3, 2014, https://www.comicsbeat.com/san-diego-comic-con-under-fire-for-its-harassment-policy-or-lack-thereof.

114. Albert Ching, "Comic-Con Responds to Anti-Harassment Petition: 'Safety and Security Is a Major Concern,'" *CBR*, May 29, 2014, https://www.cbr.com/comic-con-responds-to-anti-harassment-petition-safety-and-security-is-a-major-concern.

115. Jude Terror, "Licensed DC Comics Shirts Congratulate Superman for Banging Wonder Woman, Prepare Young Women to Marry Batman," *Outhousers*, September 29, 2014, http://www.theouthousers.com/index.php/news/129154-licensed-dc-comics-shirts-congratulate-superman-for-banging-wonder-woman-prepare-young-women-to-marry-batman.html; Albert Ching, "'We Agree': DC Comics Responds to Sexist T-Shirt Criticism," *CBR*, September 30, 2014, https://www.cbr.com/we-agree-dc-comics-responds-to-sexist-t-shirt-criticism.

116. Tom Spurgeon, "CCI Volunteer Tweets in Strident, Aggressive Fashion Post-Ferguson Verdict; CCI Cuts Ties," *Comics Reporter*, November 24, 2014, https://www.comicsreporter.com/index.php/comic_con_international_volunteer_tweets_in_strident_aggressive_fashion_pos; see also Rich Johnston, "Bill Purcell vs. the Comic Book Internet over Ferguson," *Bleeding Cool*, November 25, 2014, https://bleedingcool.com/comics/bill-purcell-vs-the-comic-book-internet-over-ferguson.

117. "Out with the Old: Introducing the New CBR Community," *CBR*, April 30, 2014, https://www.cbr.com/out-with-the-old-introducing-the-new-cbr-community.

118. Janelle Masselin, "Enough Is Enough: Dark Horse's Scott Allie's Assaulting Behavior," *Graphic Policy*, October 1, 2015, https://graphicpolicy.com/2015/10/01/enough-is-enough-dark-horses-scott-allies-assaulting-behavior.

119. Powell had illustrated a previous civil rights–oriented graphic novel: Mark Long and Jim Demonakos's *The Silence of Our Friends: The Civil Rights Struggle Was Never Black and White* (Top Shelf, 2012).

120. Raina Telgemeier, "Beginnings," in *Friends of Lulu Presents Broad Appeal* (Friends of Lulu, 2003), 11–13, 13; Friends of Lulu was "a national, non-profit organization trying to get more women and girls involved in comics," founded in 1993; see Robbins, *Brinkley Girls*, 140–141, and the description of Laydeez do Comics in "Oh, That F Word!," in *Feminist Fables for the Twenty-First Century*, ed. Maureen Burdock (McFarland, 2015), xi; *Kristy's Great Idea* (Scholastic, 2006).

121. Quote *TCJ* no. 263 (October/November 2004): 177.

122. "Telgemeier's 'Sisters' Gets 200k Print Run," ICv2, May 22, 2014, https://icv2.com/articles/comics/view/28698/telgemeiers-sisters-gets-200k-print-run.

123. Jennifer Maloney, "The New Wave of Graphic Novels," *Wall Street Journal*, December 31, 2014, https://www.wsj.com/articles/the-new-wave-of-graphic-novels-1420048910.

124. See Raina Telgemeier, *Smile* (Scholastic, 2010), especially 56–57, 111. *Hereville*'s ancestor was Yankl Pinson's 1982 *Mendy and the Golem*, "an attempt to promote traditional Jewish values." "Publisher Releases Jewish Educational Comics," *TCJ* no. 76 (October 1982): 25; *Hereville* (Amulet, 2010); *Hazed* (Image, 2008). Compare also Victoria Jamieson's lovely *Roller Girl* (Dial Books, 2015).

125. Although sometimes, as in Jacob Chabot's hilarious Skullboy adventures, the failure at, say, world domination is its own reward. Jacob Chabot, *The Mighty Skullboy Army* (Dark Horse, 2008); Chris Schweizer, *Crogan's Vengeance* (Oni Press, 2008), 183; Noelle Stevenson and Grace Ellis, *Lumberjanes*, vol. 1 (Boom!, 2015).

126. Tom Siddell, *Gunnerkrigg Court* (Archaia, 2010); Kazu Kibuishi, *Amulet*, vol. 1 (Graphix, 2008); Ted Naifeh, *Courtney Crumrin and the Night Things* (Oni Press, 2002); Doug TenNapel, *Ghostopolis* (Scholastic, 2010); Vera Brosgol, *Anya's Ghost* (First Second, 2011).

127. Doug TenNapel, *Bad Island* (Scholastic, 2011), 218.

128. Nick Spencer, *Morning Glories Deluxe*, vol. 1 (Image, 2011).

129. See Dick Giordano's comments in McCue, 110, 114.

130. "Interview with Paul Levitz, Part 3," ICv2, August 18, 2008, https://icv2.com/articles/comics/view/13113/interview-paul-levitz-part-three.

131. "Brian K. Vaughan Interview," *TCJ* no. 295 (January 2009): 40–41.

132. Marvel's stock, previously as low as ninety-six cents, was acquired by Disney for $54 a share. Robert Reiss, "How Marvel Became a Business Superhero," *Forbes*, February 1, 2010; *Slugfest*, 231.

133. Ike Perlmutter was estimated to make $1.5 billion; see James Quinn, "Marvel Saviour Ike Perlmutter to Net $1.5bn Payout from Disney Sale," *Telegraph* (UK), September 1, 2009, https://www.telegraph.co.uk/finance/newsbysector/mediatechnologyandtelecoms/media/6123325/Marvel-saviour-Ike-Perlmutter-to-net-1.5bn-payout-from-Disney-sale.html. Others made large sums, too: see "Big Paydays for Marvel Brass," ICv2, November 20, 2009, https://icv2.com/articles/comics/view/16336/big-paydays-marvel-brass; Kevin Melrose, "DC Entertainment: What We Know So Far," *CBR*, September 10, 2009, https://www.cbr.com/dc-entertainment-what-we-know-so-far. Nelson had been responsible for the wildly successful marketing of the Harry Potter franchise.

134. DC press release quoted in "DC Comics Remains in NYC, DC Entertainment Moves to Burbank," *CBR*, September 21, 2010, https://www.cbr.com/dc-comics-remains-in-nyc-dc-entertainment-moves-to-burbank.

135. Dave Itzkoff, "Comics' 'Mother of the Weird Stuff' Is Moving On," *NYT*, May 29, 2013. Sam Costello, "Karen Berger and the End of the Beginning of the Graphic Novel," *Full Stop*, December 14, 2012, http://www.full-stop.net/2012/12/14/blog/sam-costello/karen-berger-and-the-end-of-the-beginning-of-the-graphic-novel.

136. Pamela McClintock, "From 'Iron Man 3' to 'Hangover III': The Profit Breakdown of May's Blockbusters," *Hollywood Reporter*, June 6, 2013, https://www.hollywoodreporter.com/news/iron-man-3-hangover-3-562666.

137. Gerry Conway, "Who Created Caitlin Snow on #TheFlash? According to @DCComics, Nobody," *Conway's Corner*, April 28, 2015, https://gerryconway.tumblr.com/post/117619743363/who-created-caitlin-snow-on-theflash-according; and the response to Conway in Milton Griepp, "Gerry Conway Apologies [sic] to DC Execs," ICv2, May 18, 2015, https://icv2.com/articles/news/view/31601/gerry-conway-apologies-dc-execs.

138. David Brothers, "The Ethical Rot Behind 'Before Watchmen' and 'The Avengers,'" *Comics Alliance*, April 18, 2012, https://comicsalliance.com/creator-rights-before-watchmen-avengers-moore-kirby.

139. Tom Spurgeon, "CR Holiday Interview #14—Dean Haspiel," *Comics Reporter*, January 2, 2013, https://www.comicsreporter.com/index.php/cr_holiday_interview_2_dean_haspiel.

140. "Top 300 Comics Actual—February 2014," ICv2, March 17, 2014, https://icv2.com/articles/comics/view/28148/top-300-comics-actual-february-2014.

141. Heidi MacDonald, "Being a Cartoonist by the Numbers . . . and the Numbers Are Ugly," *Beat*, June 17, 2015, https://www.comicsbeat.com/being-a-cartoonist-by-the-numbers-and-the-numbers-are-ugly; see also Martin Flanagan, Mike McKenny, and Andy Livingstone, *The Marvel Studios Phenomenon: Inside a Transmedia Universe* (Bloomsbury, 2016), 74.

142. "Marvel Owns Ghost Rider, Judge Says," ICv2, December 29, 2011, https://icv2.com/articles/comics/view/21823/marvel-owns-ghost-rider.

143. See Brookes Barnes and Michael Cieply, "A Supersized Custody Battle over Marvel Superheroes," *NYT*, March 20, 2010; Ted Johnson, "Marvel, Jack Kirby Heirs Settle Dispute over Superhero Rights," *Variety*, September 26, 2014, https://variety.com/2014/biz/news/marvel-jack-kirby-heirs-settle-dispute-over-superhero-rights-1201314563.

144. See, variously, "The Legal View: What the Shuster Ruling Means," *Beat*, October 18, 2012, https://www.comicsbeat.com/the-legal-view-what-the-shuster-ruling-means; Eriq Gardner, "Warner Bros. Wins Blockbuster Victory in Legal Battle for Superman," *Hollywood Reporter*, January 10, 2013, https://www.hollywoodreporter.com/thr-esq/warner-bros-wins

-blockbuster-victory-410871; Jeff Trexler, "Today's Superman Rulings Explained," *Beat*, January 10, 2013, https://www.comicsbeat.com/todays-superman-rulings-explained; Eriq Gardner, "Supreme Court Denies Review of Superman Rights," *Hollywood Reporter*, October 6, 2014, https://www.hollywoodreporter.com/thr-esq/supreme-court-denies-review -superman-738308.

145. Kevin Melrose, "Dave Gibbons' 'Watchmen' #1–3 Covers Sell for Nearly $217,000," *CBR*, https://www.cbr.com/dave-gibbons-watchmen-1-3-covers-sell-for-nearly-217000.

146. Ng Suat Tong, "A Poor Investment: Frank King's *Gasoline Alley*," *Hooded Utilitarian*, August 13, 2012, https://www.hoodedutilitarian.com/2012/08/a-poor-investment-frank-kings-gaso line-alley; John Parkin, "*Dark Knight Returns* Artwork Sells for Almost $450,000," *CBR*, May 6, 2011, https://www.cbr.com/dark-knight-returns-artwork-sells-for-almost-450000.

147. Michael Dean, "Who Owns the Man of Steel?," *TCJ*, July 17, 2013, http://www.tcj.com/who -owns-the-man-of-steel.

148. Jackson Miller, "The Print Age of *Wizard* Ends," *Comichron*, January 24, 2011, https://blog .comichron.com/2011/01/print-age-of-wizard-ends.html.

149. Michael Cavna, "Batman, Superman Comic Books Set Records for Sale Price," *Washington Post*, February 27, 2010, https://www.washingtonpost.com/wp-dyn/content/ article/2010/02/26/AR2010022605938.html.

150. Kevin Melrose, "Pristine Copy of 'Action Comics' #1 Sells for Record $3.2 Million," *CBR*, August 24, 2014, https://www.cbr.com/pristine-copy-of-action-comics-1-sells-for-record-3-2 -million.

151. Dave Itzkoff, "Modern Marvel," *NYT*, March 25, 2011. See also Tom Brevoort's comments in Sean T. Collins, "Synergy Assemble!," *CBR*, May 16, 2011, https://www.cbr.com/synergy -assemble-tom-brevoort-explains-how-marvels-movies-and-publishing-work-together. On "films lead[ing] policy," see *Marvel Studios*, 35–36.

152. See *Green Arrow: Quiver* (DC, 2002); Whedon's *The Long Way Home* (Dark Horse, 2007); Christos Gage, *Angel & Faith: Season Nine*, vol. 1 (Dark Horse, 2015). See also Richard George, "Hollywood Invades the Comic Book Industry," IGN.com, December, 1, 2006, https://www .ign.com/articles/2006/12/01/hollywood-invades-the-comic-book-industry, for a roundup.

153. "Newswatch," *TCJ* no. 274 (February 2006): 40.

154. Quoted in "Image Story—Part Four," 15, and comment there.

155. Which gained a market share of over 4 percent in the 2000s via a combination of licensed comics, originals, and classic reprints. See Tom Spurgeon, "CR Sunday Interview: Ted Adams," *Comics Reporter*, January 17, 2010, https://www.comicsreporter.com/index.php/ cr_sunday_interview_ted_adams.

156. Marvel's Icon was all or partly creator-owned, and its preceding Marvel Knights and Max lines (around the turn of this century), which allowed brand-name creators like Morrison, Ennis, and Bendis to have their more mature way with corporate creations, helped restore some of Marvel's sales in the early 2000s. "Image Gets a More Mainstream Makeover," TCJ no. 260 (May/June 2004): 12; "Newswatch," *TCJ* no. 261 (July 2004): 5; "X-Men . . . Retreat! Part 2," *TCJ* no. 263 (October/November 2004): 175.

157. Tom Spurgeon, "Robert Kirkman Becomes Image Partner," *Comics Reporter*, July 22, 2008, https://www.comicsreporter.com/index.php/robert_kirkman_becomes_image_partner.

158. " 'Walking Dead' Leave Stores Selling Out," ICv2, April 5, 2005, https://icv2.com/articles/ comics/view/6677/walking-dead-leave-stores.

159. "Estimates for 'The Walking Dead' #100 Over 300K," ICv2, June 19, 2012, https://icv2.com/ articles/comics/view/23168/estimates-the-walking-dead-100-over-300k.

160. See *Zombie Tales* (Boom!, 2007); *The Goon Library*, vol. 1 (Dark Horse, 2015); Phil Hester, *Antoine Sharpe Is the Atheist Incarnate* (Desperado, 2008); "All Zombies Attack," *Paper Theater* (Alternative Comics, 2001); *Rachel Rising: The Shadow of Death* (Abstract, 2011); *Revival* (Image, 2013); "Robert Kirkman Interview," 82. For the zombie's cousin the ghoul, see *Steve Niles Omnibus* (IDW, 2008).

161. Roberto Aguirre-Sacasa, *Afterlife with Archie: Escape from Riverdale* (Archie Comics, 2015).

162. "Nancy Drew and Hardy Boys with Vampires and Zombies," ICv2, June 17, 2010, https://icv2 .com/articles/comics/view/17727/nancy-drew-hardy-boys.

163. *Crossed* (Avatar, 2010). Given Ennis's famously combative approach toward organized religion, it's unsurprising the sign of the infected is a red cross on their face. A more explicitly

religious, but almost equally graphic, apocalyptic landscape appeared the same year in John Hicklenton's *100 Months: The End of All Things* (Cutting Edge Press, 2010). On Ennis and religion, see "Garth Ennis," 52.

164. Brian Ralph, *Daybreak*, vol. 1 (Bodega, 2006).

165. Joshua Williamson and Mike Henderson, *Nailbiter* (Image, 2014).

166. Cullen Bunn and Tyler Crook, *Harrow County*, vol. 1 (Dark Horse, 2015).

167. *Locke & Key* (IDW, 2008). A fine adaptation of a classic haunted house novel is Ian Edginton's *Richard Matheson's Hell House* (IDW, 2008).

168. Luna Brothers, *Girls* (Image, 2005). There's a more Branch Davidian, less supernatural vibe to the same small-town, closed-off approach in Joshua Hale Fialkov and Noel Tuazon's no less horrific *Elk's Run* (Villard, 2007).

169. See *Johnny the Homocidal Maniac: The Director's Cut* (SLG, 1997); Lee Adam Herold, *Always Remember to Bring the Scythe* (Keenspot, 2003). A more contemplative, even mystical, take on the hockey-mask vibe is John Brodowski's *Curio Cabinet* (Secret Acres, 2010). Richard Sala, *Peculia* (Fantagraphics, 2002); Joe Casey and Steve Parkhouse, *Milkman Murders* (Dark Horse, 2005). On Sala's self-described "fever dream" approach, influenced by Chester Gould and Mark Beyer, see "Richard Sala," *TCJ* no. 208 (November 1998): 64, 66, 76. Jessica Abel, *Life Sucks* (First Second, 2008), quote 26.

170. Andrew Crosby and J. Alexander, *Damn Nation* (Dark Horse, 2005); Steve Niles and Ben Templesmith, *30 Days of Night* (IDW, 2004); Scott Snyder and Sean Murphy, *The Wake* (DC, 2014).

171. Greg Rucka, *Queen & Country*, vol. 1 (Oni Press, 2007); Marc Bernardin, Adam Freeman, and Lee Garbett, *Highwaymen* (WildStorm, 2008); Gail Simone and Neil Googe, *Welcome to Tranquility* (WildStorm, 2008). The same dynamic is played for wrath in Warren Ellis and Cully Hammer's *Red* (WildStorm, 2009), and for noir in his and J. H. Williams III's *Desolation Jones* (WildStorm, 2006). Jeff Lemire, *Black Hammer* (Dark Horse, 2017).

172. Linda Medley, *Castle Waiting* (Fantagraphics, 2006), esp. 339.

173. Kurtis J. Wiebe and Roc Upchurch, *Rat Queens*, vol. 1 (Image, 2014). For other deconstructive takes, compare Chris Northrop and Jeff Stokely's *The Reason for Dragons* (Archaia, 2013) and Adam Smith and Matthew Fox's *The Long Walk to Valhalla* (Archaia, 2015).

174. Tillie Walden, *The End of Summer* (Avery Hill, 2015). Compare also Cathy Malkasian's *Percy Gloom* (Turnaround, 2007), whose protagonist's adventures are based on fearfulness of the surrounding world, everyday objects as death threats more profound than dragons or orcs.

175. Brian K. Vaughan and Fiona Staples, *Saga* (Image, 2012); Brian K. Vaughan and Cliff Chiang, *Paper Girls* (Image, 2016).

176. Grant Calof and Jeevan Kang, *H2O* (Dynamite, 2010); Thomas Baehr, *The End Is Here* (Activate, 2009). Both descendants of Stephen Murphy and Michael Zulli's *Puma Blues* (Mirage Studios, 1988), a polemic in which Zulli's majestic animals almost made the argument for themselves.

177. Compare also Warren Ellis's insane guides and navigators to worlds of shimmering myth in *Supreme: Blue Rose* (Image, 2015, with Tula Lotay), and *Anna Mercury*, vol. 1, *The Cutter* (Avatar, 2009, with Facundo Percio).

178. Matt Madden, *Black Candy* (Black Eye Books, 1998); Eric Hobbs and Noel Tuazon, *The Broadcast* (NBM, 2010). Compare Michael Cherkas and Larry Hancock's "science fiction mystery" *The Silent Invasion*, evoking classic '50s *Body Snatchers* paranoia (NBM, 1988), and their *Suburban Nightmares* (NBM, 1996), treading similar territory.

179. Sophie Goldstein, *House of Women* (Fantagraphics, 2017). For another subversive, gendered Goldstein spin on an SF trope (a dystopian look at fertility), see *The Oven* (AdHouse, 2015).

180. Andersen Gabrych and Brad Rader, *Fogtown* (Vertigo, 2010); Greg Rucka and Matthew Southworth, *Stumptown* (Oni, 2011); Jason Aaron and Jason Latour, *Southern Bastards* (Image, 2014); Brian Wood and Mack Chater, *Briggs Land: State of Grace* (Dark Horse, 2017).

181. Brian Azzarello and Victor Santos, *Filthy Rich* (Vertigo, 2009); Richard Stark, *Richard Stark's Parker: The Hunter* (IDW, 2009).

182. Jason Aaron and R. M. Guéra, *Scalped: Indian Country* (Vertigo/DC, 2007); Polak, *Ethics in the Gutter*, esp. 114–119. Compare also Sergio Aragonés, *Bat Lash: Guns and Roses* (DC, 2008), and Brian Azzarello and Marcelo Frusin, *Loveless: A Kin of Homecoming* (Vertigo/DC, 2007).

183. See Di Liddo, 144, and, more generally, 134–161. See also "Pornographer Laureate: An Interview with Alan Moore," *TCJ* no. 143 (July 1991) 118; *TCJ* no. 278 (October 2006): 136–143;

Kristian Williams, "Lost Girls," in *TCJ* no. 281 (February 2007): 54–55; "Melinda Gebbie Interview," *TCJ* no. 281 (February 2007): 57–75.

184. Ed Luce, *Wuvable Oaf* (Fantagraphics, 2015); Colleen Coover, *Small Favors: The Definitive Girly Porno Collection* (Limerence Press, 2017); Jess Fink, *Chester 5000* (Top Shelf, 2011).

185. Snyder, King, and Albuquerque, *American Vampire*, vol. 1 (Vertigo, 2010). Other highlights included Texan horror writer Joe R. Lansdale's take on the iconic DC Western hero Jonah Hex in *Jonah Hex: Two-Gun Mojo* (DC, 1994); Jeff Mariotte and master EC illustrator John Severin's *Desperadoes: Quiet of the Grave* (Homage, 2002); Rick Spears and Rob G's Western zombie *Dead West* (Gigantic Graphic Novels, 2005); Cullen Bunn and Brian Hurtt, *The Sixth Gun* (Oni, 2011).

186. Richard Moore has *Lord of the Rings* types turned train robbers and bounty hunters in *Far West* (NBM, 2001); Westerns meet SF (with an allegory for Native American mistreatment) in Andrew Foley and Fred Van Lente's *Cowboys & Aliens* (Platinum Studios, 2006).

187. Kelly Sue DeConnick and Valentine De Landro, *Bitch Planet* (Image, 2015).

188. Jason Shiga, *Bookhunter* (Sparkplug, 2007); Kyle Starks, *Kill Them All* (Oni, 2015).

189. An ancestor, perhaps: Paul Chadwick's Concrete, looking like a contemplative version of the Thing, but whose efforts to find a place for himself brought philosophical existentialism to the comic book hero. "Introduction," *Paul Chadwick's Concrete*, vol. 1 (Dark Horse, 2005), 4; see also "Paul Chadwick," *TCJ* no. 220 (February 2000): 50; Pustz, 174; John Layman and Rob Guillory, *Chew*, vol. 1, *Taster's Choice* (Image, 2009); Glen Brunswick and Dan McDaid, *Jersey Gods* (Image, 2009); Tom Spurgeon, "CR Sunday Interview: Glen Brunswick," *Comics Reporter*, May 2, 2010, https://www.comicsreporter.com/index.php/cr_sunday_interview_glen_brunswick; Matt Fraction and Chip Zdarsky, *Sex Criminals* (Image, 2014); Joe Henderson and Lee Garbett, *Skyward* (Image, 2019); Bryan Lee O'Malley, *Scott Pilgrim's Precious Little Life* (Oni Press, 2004).

190. See *Tomorrow Stories*, featuring a Tom Swiftian inventor, a '40s-style femme fatale/good girl, a '30s pulp hero type, and a '40s long johns American parody; and Neopolis, populated with new dozens, if not hundreds, of new(ish) super beings. Moore, *Tomorrow Stories*, vol. 1 (America's Best Comics, 2002), and *Top 10: The Forty-Niners* (America's Best Comics, 2005).

191. Alan Moore and J. H. Williams III, *Promethea: Collected Edition, Book 1* (America's Best Comics, 2000); Wolk, 245–251; Hannah Means-Shannon, "Seeing Double," *JGNC* 1, vol. 2 (2010): 93–104.

192. See J. Michael Straczynski and Gary Frank, *Supreme Power*, vol. 1 (Marvel, 2004); Howard Wong, Jim Valentino, Marco Rudy, and Manny Trembley's *After the Cape* (Image, 2007); Mark Waid and Peter Krause, *Irredeemable* (Boom!, 2009); John Arcudi and Peter Snejbjerg, *A God Somewhere* (WildStorm, 2010); *Injustice: Gods Among Us* (DC, 2013).

193. Mark Millar, Nigel Kitching, and Daniel Vallely, *The Saviour*, vol. 1 (Trident Comics, 1990). His and Peter Gross's *Chosen* (Dark Horse, 2005) has a seemingly simply structured mythic narrative: the miraculous birth and growth of the apparent Second Coming of Jesus, played out in a small-town American setting. It's not that simple.

194. Mark Millar, Dave Johnson, and Kilian Plunkett, *Superman: Red Son* (DC, 2004).

195. Millar's afterword to *Wanted* (Top Cow, 2007, art J. G. Jones); Mark Millar and Steven McNiven, *Old Man Logan* (Marvel, 2010). Mark Millar and John Romita Jr., *Kick-Ass* (Marvel, 2010).

196. "James Sturm Interview," 109; Jeff Nicholson's *Ultra Klutz*—begun as a loving mash-up of Japanese monster movies and Justice League of America parodies—deepened, over its on-and-off decade-long run, into a look at the wages of heroism and art, as Nicholson weighed the financial and personal costs of producing his independent comics; see Nicholson, "Blah Blah Blah: Reflections on the *Ultra Klutz* Process," in *Ultra Klutz: Book Two* (Colonia Press, 2003), esp. 349–354; Sturm, *The Fantastic Four: Unstable Molecules* (Marvel, 2003); Steven T. Seagle and Teddy Kristiansen, *It's a Bird* (Vertigo, 2004); Daniel Clowes, *The Death-Ray* (Drawn & Quarterly, 2011); Brian Wood and Becky Cloonan, *Demo* (AiT/Planet Lar, 2005); Max Bemis and Jorge Coelho, *Polarity* (Boom!, 2013).

197. Simon Pegg, "Introduction," *The Boys: The Name of the Game* (Dynamite, 2007); compare also Ennis and Amanda Conner's *The Pro* (Image, 2007).

198. *Bizarro World* (DC, 2005); Bagge, *Comics Introspective*, 75, 77. *Strange Tales* (Marvel, 2010); *Strange Tales II* (Marvel, 2011). Compare Michel Fiffe, "The Big Fusion," *The Factual Opin-*

ion, August 31, 2011, https://www.factualopinion.com/the_factual_opinion/2011/08/the
-big-fusion.html.

199. Johnny Ryan, *The Comic Book Holocaust* (Buenaventura Press, 2006); "Johnny Ryan Interview," *TCJ* no. 279 (November 2006): 77; Johnny Ryan, *Prison Pit* (Fantagraphics, 2009); Jesse Pearson, "The Johnny Ryan Interview," *TCJ*, September 23, 2011, http://www.tcj.com/the-johnny-ryan-interview/4.

200. "Introduction," Matt Madden, *99 Ways to Tell a Story* (Jonathan Cape, 2006); Tom Spurgeon, "A Short Interview with Matt Madden," *Comics Reporter*, January 6, 2006, https://www.comicsreporter.com/index.php/resources/interviews/3917.

201. Michael DeForge, *Very Casual* (Koyama, 2013).

202. Ray Fawkes, *One Soul* (Oni, 2011).

203. Gerard Way and Gabriel Bá, *The Umbrella Academy: Apocalypse Suite* (Dark Horse, 2008). See also Jeff Lemire and Travel Foreman, *Animal Man*, vol. 1, *The Hunt* (DC, 2012).

204. See Magdalene Visaggio and Sonny Liew, *Eternity Girl* (DC, 2018); Cecil Castellucci and Marley Zarcone, *Shade, the Changing Girl: Earth Girl Made Easy* (DC, 2017).

205. See *Hawkeye Omnibus* (Marvel, 2015). Other fascinating defamiliarizations appear in Joe Casey and Charlie Adlard's *Codeflesh* (AiT/Planet Lar, 2003), with its brilliant reuse of word balloons; Paul Tobin and Colleen Coover's *Gingerbread Girl* (Top Shelf, 2011), and its shifting narration between marginal characters; and Frank M. Young and David Lasky's *The Carter Family: Don't Forget This Song* (Abrams ComicArts, 2012), where the country songs' ideas are visually expressed in the singer's word balloons.

206. Jonathan Hickman, *Pax Romana* (Image, 2009); *The Nightly News* (Image, 2010).

207. Tom Spurgeon, "CR Sunday Interview: David Lasky and Frank M. Young," *Comics Reporter*, October 14, 2012, https://www.comicsreporter.com/index.php/cr_sunday_interview_david_lasky_and_frank_young.

208. Dash Shaw, *Bottomless Belly Button* (Fantagraphics, 2008); "Dash Shaw Interview," *TCJ* no. 296 (February 2009): 71.

209. Pope worked for Japan's largest manga publisher, Kodansha, between 1996 and 2000; see *Pulphope* (AdHouse, 2006), 70–79; Gregory Cwiklik, "Fast Fiction," *TCJ* no. 202 (March 1998), esp. 31–32.

210. Eric Kostiuk Wiliams, *Babybel Wux Bodysuit* (Retrofit, 2016); Lilli Carré, *Nine Ways to Disappear* (Little Otsu, 2009).

211. A fascinating formal example appears in the portrayal of Helen Keller's sensory deprivation in Joseph Lambert, *Annie Sullivan and the Trials of Helen Keller* (Hyperion, 2012).

212. Collected in Ellen Forney, *Monkey Food* (Fantagraphics, 1999).

213. Compare Madison Clell's *Cuckoo* (Green Door, 2002), by a sufferer of dissociative identity disorder, showing remarkably how differing visual effects (fonts, shadings, physical representations, the balance of abstraction and representationalism) can merge to express the different personalities participating in the story. Other cartoonists employ similar "lighter side of" mixed with "gloom and doom introspectivism," such as Colin Upton's *Diabetes Funnies* (self-published, 2008–2011) and Ken Dahl's *Monsters* (Secret Acres, 2009), whose ironic end suggests monstrosity's most important determinant is how one deals with disease-related moral questions, like who you tell about your STD.

214. David Small, *Stitches* (W. W. Norton, 2009); Gusta Lemelman, *Mendel's Daughter* (Free Press, 2006); Ann Marie Fleming, *The Magical Life of Long Tack Sam* (Riverhead, 2007); John Haugse, *Heavy Snow: My Father's Disappearance into Alzheimer's* (Health Communications, 1999).

215. Joyce Farmer, *Special Exits* (Fantagraphics, 2010); Roz Chast, *Can't We Talk About Something More Pleasant?* (Bloomsbury, 2014).

216. Bill Griffith, *Invisible Ink: My Mother's Secret Affair with a Famous Cartoonist* (Fantagraphics, 2015). An earlier autobiographical Griffith comic is "Daily Strip: The Agony, the Ecstasy, the Plumber in Rapid City," *Best Comics of the Decade*, 12–19.

217. Carol Tyler, *You'll Never Know, Book One: A Good and Decent Man* (Fantagraphics, 2009) and *You'll Never Know, Book Two: Collateral Damage* (Fantagraphics, 2010). In Michael Kupperman's *All the Answers* (Gallery 13, 2018), Kupperman, the son of perhaps the most famous "Quiz Kid," seeks to understand similar paternal distancing, his father finally incapable of providing the answer to this, of all questions.

218. Laurie Sandell, *The Impostor's Daughter* (Little, Brown, 2009); Tom Hart, *Rosalie Lightning* (St. Martin's Press, 2015). Hart was best known earlier for more irascible curmudgeons; compare *Tom Hart's Banks Eubanks* (Top Shelf, 1999) and *Collected Hutch Owen*, vol. 1 (Top Shelf, 2000), esp. "Hutch Owen's Working Hard," 51–53.

219. "Phoebe Gloeckner Interview," *TCJ* no. 261 (July 2004): 104.

220. Julia Wertz, *Drinking at the Movies* (Koyama, 2015).

221. Laura Lee Gulledge, *Page by Paige* (Amulet, 2011).

222. Lauren Weinstein, *Girl Stories* (Henry Holt, 2006); 9, 15–16, 122, 169.

223. Robert Kirby, *Boy Trouble: Gay Boy Comics with a New Attitude* (Green Candy Press, 2008).

224. Jennifer Camper, "Come Here Often?," in *Juicy Mother 2* (Manic D Press, 2007), 7.

225. See Nicholas E. Miller, "Asexuality and Its Discontents: Making the 'Invisible Orientation' Visible in Comics," *Inks* 1, no. 3 (2017): 354–376, esp. 361–364, which speaks to a long-standing tradition of reading Jughead as gay.

226. Dylan Edwards, *Transposes* (Northwest Press, 2012); Eric Kostiuk Williams, *Collected Hungry Bottom Comics* (Colour Code, 2014); *No Straight Lines*, 191–194; Julia Kaye, *Super Late Bloomer* (Andrews McMeel, 2018). For a similar account of transitioning, see Erin Nations, *Gumballs* (Top Shelf, 2018).

227. Maggie Thrash, *Honor Girl* (Candlewick Press, 2015). For a knowing look at a masculine analogue in a scouting camp, suffused with BO, braggadocio, and sexual anxiety, compare Mike Dawson's *Troop 142* (Secret Acres, 2011).

228. Percy Carey, *Sentences: The Life of M. F. Grimm* (Vertigo, 2007).

229. See *TCJ* no. 69 (December 1981): 48; *TCJ* no. 102 (September 1985): 89; Basil Wolverton, *The Wolverton Bible* (Fantagraphics, 2009); Crumb, "Introduction," *The Book of Genesis, Illustrated* (W. W. Norton, 2009); Horn, "What Is Comic Art?," 15; Jack T. Chick, *Chaos* (Chick Publications, 2003); Cat Yronwode, "Blackhawks for Christ," *TCJ* no. 50 (1979): 30–32; Mark Barnette, "From the Other Side of the Tracts," *TCJ* no. 145 (October 1991): 89.

230. See Michael Allred, *The Golden Plates: The Book of Mormon in Pictures and Word* (AAA Pop, 2004).

231. See Ng Suat Tong, "Chester Brown's Gospels," *TCJ* no. 261 (July 2004): 31–37.

232. Ted Widmer, "R. Crumb: The Art of Comics, No. 1," *Paris Review*, Summer 2010, https://www.theparisreview.org/interviews/6017/the-art-of-comics-no-1-r-crumb.

233. See Eric Shanower, *Age of Bronze: A Thousand Ships* (Image, 2001); *Age of Bronze 2: Sacrifice* (Image, 2004); "Eric Shanower Interview," *TCJ* no. 265 (February 2005): 149.

234. Kyle Baker, *King David* (Vertigo/DC, 2002); Elijah Brubaker, *The Story of Jezebel* (Uncivilized Books, 2017), 19.

235. See J. T. Waldman, *Megillat Esther* (Jewish Publication Society, 2005).

236. *Moby Dick by Herman Melville, Retold by Will Eisner* (NBM, 1998); Eisner, *The Last Knight: An Introduction to Don Quixote* (NBM, 2000); "Introduction," *The Metamorphosis* (Crown, 2003); see also Peter Kuper, *Give It Up! and Other Short Stories* (Comics Lit, 1995).

237. Aline Brosh McKenna and Ramón K. Pérez, *Jane* (Archaia, 2017); Ron Wimberly, *King of Cats* (DC, 2012).

238. Seymour Chwast, *Dante's Divine Comedy* (Bloomsbury, 2010); Gary Panter, *Jimbo's Inferno* (Fantagraphics, 2006); Chwast's *Homer: The Odyssey* (Bloomsbury, 2012), following the example of the *Tempest* adaptation *Forbidden Planet*, drenches Odysseus's wandering in '50s-style science fiction accoutrements; see "Gary Panter Interview," *TCJ* 250 (February 2003), esp. 250–251.

239. Gerry Duggan and Phil Noto, *The Infinite Horizon* (Image, 2012); MP Mann and A. David Lewis, *Some New Kind of Slaughter* (Archaia, 2007).

240. Joseph Conrad, *Heart of Darkness*, adapted by David Zane Mairowitz, art by Catherine Anyango (Self Made Hero, 2010); *Joseph Conrad's Heart of Darkness*, adapted by Peter Kuper (W. W. Norton, 2019).

241. Matt Dembicki, "From the Editor," *Trickster: Native American Tales* (Fulcrum, 2010), 225.

242. Craig Thompson, *Habibi* (Pantheon, 2011)—see, for example, 182, 405. Jai Sen, *The Golden Vine* (Shoto Press, 2003).

243. Tom Breckenridge, "Harvey Pekar Statue Unveiled at Library Is Tribute to the Late Graphic Novelist from Cleveland," Cleveland.com, October 15, 2012, https://www.cleveland.com/metro/2012/10/statue_of_harvey_pekar_unveile.html.

244. Nicole Bunge, "NYRB Launches Comic Imprint," ICv2, October 22, 2015, https://icv2.com/articles/news/view/32867/nyrb-launches-comic-imprint,

245. Compare Bob Temuka, "Good Night, Mr. Fantastic," *Tearoom of Despair*, December 1, 2015, http://tearoomofdespair.blogspot.com/2015/12/good-night-mr-fantastic.html.

Epilogue

1. Torsten Adair, "Jerry Craft's *New Kid* Wins Newbery & King Awards as Numerous Graphic Novels Are Honored by Librarians," *Beat*, January 27, 2020, https://www.comicsbeat.com/jerry-crafts-new-kid-wins-newbery-and-king-awards; Jarrett J. Krosoczka, *Hey, Kiddo* (Scholastic, 2018).

2. Heidi MacDonald, "Raina Telgemeier's 'Ghosts' Has a 500,000-Copy First Printing," *Beat*, June 30, 2016; https://www.comicsbeat.com/raina-telgemeiers-ghosts-has-a-500000-copy-first-printing.

3. "Raina's New Book Will Have a Million Copies," *Comics Worth Reading*, October 8, 2018, https://comicsworthreading.com/2018/10/08/rainas-new-book-will-have-a-million-copies.

4. Heidi MacDonald, "Raina Telgemeier: The Comics Industry Person of the Decade," *Beat*, Jaanuary 7, 2020, https://www.comicsbeat.com/raina-telgemeier-the-comics-industry-person-of-the-decade.

5. "Scholastic Announces 5 Million Copy First Printing for Dav Pilkey's Dog Man," Stockhouse.com, December 11, 2018, https://stockhouse.com/news/press-releases/2018/12/11/scholastic-announces-5-million-copy-first-printing-for-dav-pilkey-s-dog-man; Brian Hibbs, "Tilting at Windmills #281—Looking at BookScan: 2019," *Beat*, July 7, 2020, https://www.comicsbeat.com/bookscan-2019-analysis.

6. Heidi MacDonald, "Last Week, Five of the Top Ten Best Selling Books in the US Were Comics," *Beat*, December 31, 2019, https://www.comicsbeat.com/best-selling-books-comics.

7. Oliver Sava, "Do DC's Graphic Novels for Young Readers Get a Passing Grade?," *AV Club*, August 31, 2019, https://aux.avclub.com/do-dc-s-graphic-novels-for-young-readers-get-a-passing-1837743857; Hibbs, "Looking at BookScan."

8. Graeme McMillan, "DC Unveils Graphic Novel Lines," *Hollywood Reporter*, February 5, 2018, https://www.hollywoodreporter.com/heat-vision/dc-unveils-new-graphic-novel-lines-young-adult-middle-grade-audiences-1081584. At the end of 2019, the lines would be renamed DC Books for Young Readers.

9. Steve Foxe, "IDW to Publish Original Marvel Comics for Young Readers," *Paste*, July 17, 2018.

10. Teresa Jusino, "Dear Marvel: Stop Sexualizing Female Teenage Characters Like Riri Williams. Love, Everyone," *Mary Sue*, October 19, 2016, https://www.themarysue.com/riri-williams-stop-sexualizing-teen-girls-in-comics; James Whitbrook, "Artist Draws New *Invincible Iron Man* Variant Art," *Gizmodo*, November 9, 2016, https://io9.gizmodo.com/artist-draws-new-variant-invincible-iron-man-art-to-rep-1788754291.

11. Lucy Knisley, *Kid Gloves* (First Second, 2019).

12. For a slightly earlier comparand, see Miriam Katin, *Letting It Go* (Drawn & Quarterly, 2013); *Documenting Trauma in Comics*, ed. Dominic Davies and Candida Rifkind (Palgrave Macmillan, 2020).

13. Mira Jacob, *Good Talk* (One World, 2019).

14. Nick Drnaso, *Beverly* (Drawn & Quarterly, 2016); Mariko Tamaki, *Laura Dean Keeps Breaking Up with Me* (First Second, 2019). A delightful, more fantastic take is Jen Wang, *The Prince and the Dressmaker* (First Second, 2018).

15. Carolyn Nowak, "Radishes," in *Girl Town* (Top Shelf, 2018), 25–46.

16. Emil Ferris, *My Favorite Thing Is Monsters* (Fantagraphics, 2018).

17. Connor Willumsen, *Anti-Gone* (Koyama, 2017).

18. D. J. Bryant, *Unreal City* (Fantagraphics, 2017), 37–58.

19. Jesse Jacobs, *Crawl Space* (Koyama, 2017).

20. *Black Bolt: Home Free* (Marvel, 2018); *Mister Miracle* (DC, 2019).

21. Roberto Aguirre-Sacasa and Robert Hack, *The Chilling Adventures of Sabrina: Occult Edition* (Archie Comics, 2019); Tom King and Gabriel Walta, *The Vision*, vol. 1 (Marvel, 2016).

22. Jody Houser, Francis Portela, and Marguerite Sauvage, *Faith: Hollywood and Vine* (Valiant,

2016); Chelsea Cain and Kate Niemczyk, *Mockingbird* (Marvel, 2016); Ryan North and Erica Henderson, *Unbeatable Squirrel Girl* (Marvel, 2015).

23. Jeff Lemire, *Sentient* (TKO, 2019); Marjorie Liu and Sana Takeda, *Monstress* (Image, 2019); James Tynion IV and Werther Dell'Edera, *Something Is Killing the Children* (Boom!, 2020).

24. Daniel Clowes, *Patience* (Fantagraphics, 2016).

25. Emily Carroll, *When I Arrived at the Castle* (Koyama, 2019); see also Bobby Curnow and Simon Gane, *Ghost Tree* (IDW, 2019).

26. Michael Cavna, "How *Doonesbury* Predicted Donald Trump's Presidential Run 29 Years Ago," *Washington Post*, June 23, 2016; *Yuge!: 30 Years of Doonesbury on Trump* (Andrews McMeel, 2016).

27. Zach Weissmueller, "As Trump Coasts to the Nomination, Remember That the Cartoonist Behind Dilbert Saw It All Coming," *Reason*, May 7, 2016. Later, Adams endorsed Hillary Clinton, afraid of assassination by Clinton supporters: Travis Gettys, "'Dilbert' Cartoonist Scott Adams Thinks He'll Be Assassinated If He Doesn't Endorse Clinton," *Raw Story*, June 6, 2016, https://www.rawstory.com/2016/06/dilbert-cartoonist-scott-adams-thinks-hell-be-assassinated-if-he-doesnt-endorse-clinton.

28. Annie Garau, "Mike Pence Used to Draw Cartoons," *Esquire*, August 25, 2016, https://www.esquire.com/news-politics/news/a47983/mike-pence-cartoons-trump.

29. Matt Miller, "The Creator of Pepe the Frog is Voting for Hillary," *Esquire*, September 28, 2016, https://www.esquire.com/news-politics/news/a49057/pepe-frog-creator-voting-hillary. Furie eventually took legal action: see Sam Barsanti, "Pepe the Frog Creator Is Not Fucking Around, Takes Legal Action Against the 'Alt-Right,'" *AV Club*, September 18, 2017, https://www.avclub.com/pepe-the-frog-creator-stops-fucking-around-takes-legal-1818519749; Eriq Garner, "Pepe the Frog Artist Suing InfoWars for Copyright Infringement," *Hollywood Reporter*, March 6, 2018, https://www.hollywoodreporter.com/thr-esq/pepe-frog-artist-suing-infowars-copyright-infringement-1092233.

30. Milton Griepp, "B&N Sees 'Terrible' Retail Environment," ICv2, September 9, 2016, https://icv2.com/articles/news/view/35465/b-n-sees-terrible-retail-environment.

31. Heidi MacDonald, "Robert Kirkman Moving Over to Amazon with 2-Year Production Deal," *Beat*, August 11, 2017, https://www.comicsbeat.com/robert-kirkman-moving-over-to-amazon-with-2-year-production-deal.

32. Abraham Riesman, "Netflix Announces Its First Comic Book," *Vulture*, November 7, 2017, https://www.vulture.com/2017/11/netflix-comics-millar-coipel-magic-order.html.

33. Brett White, "New ComiXology Unlimited Service," *CBR*, May 24, 2016, https://www.cbr.com/new-comixology-unlimited-service-lets-you-read-as-much-as-you-want; Gregory Schmidt, "Comic Book Publishers, Faced with Flagging Sales, Look to Streaming," *NYT*, July 22, 2018.

34. See *Marvel Studios*, 137–157.

35. Quoted in Carly Lane, "James Gunn Addresses the *Spider-Man: Homecoming* Casting Backlash," *Mary Sue*, August 20, 2016, https://www.themarysue.com/james-gunn-spider-man-homecoming-backlash.

36. See Jeffrey A. Brown, *Dangerous Curves: Action Heroines, Gender, Fetishism, and Popular Culture* (University of Mississippi, 2011), 233–235.

37. Scott Derrickson, Twitter post, July 22, 2017, 6:59 p.m., https://twitter.com/scottderrickson/status/888896290737631234.

38. Kelley L. Carter, "The Man Who Put Marvel in the Black," *Undefeated*, May 17, 2016, https://theundefeated.com/features/marvel-nate-moore-black-panther.

39. "Black Panther 2018," *Box Office Mojo*, https://www.boxofficemojo.com/title/tt1825683/?ref_=bo_se_1_1.

40. Namwali Serpell, "Black Panther: Choose Your Weapons," *NYR Daily*, February 22, 2018, https://www.nybooks.com/daily/2018/02/22/black-panther-choose-your-weapons.

41. See Kashmira Gander, "Is the Black Panther 'Wakanda Salute' Becoming a Symbol of Black Pride?," *Newsweek*, March 13, 2018.

42. Compare Alex Fitzpatrick, "It's Not Just *Black Panther*. Afrofuturism Is Having a Moment," *Time*, April 20, 2018.

43. *Black Panther: World of Wakanda* (Marvel, 2017).

44. Milton Griepp, "Marvel's David Gabriel on the 2016 Market Shift," ICv2, March 31, 2017, https://icv2.com/articles/news/view/37152/marvels-david-gabriel-2016-market-shift.

45. Tim Adams, "Marvel Exec Clarifies Comments That 'People Didn't Want Any More Diversity," *CBR*, April 1, 2017, https://www.cbr.com/marvel-sales-diversity.

46. Asher Elbein, "The Real Reason for Marvel Comics' Woes," *Atlantic*, May 24, 2017, https://www.theatlantic.com/entertainment/archive/2017/05/the-real-reasons-for-marvel-comics-woes/527127. In February 2017, only one ongoing superhero title sold over fifty thousand copies. Brian Hibbs, "Marvel Comics and the Deck Chairs of the Titanic," *Beat*, August 1, 2017, https://www.comicsbeat.com/tilting-at-windmills-261-marvel-comics-and-the-deck-chairs-of-the-titanic.

47. For two others, see the account of Peter David's controversial statements in "NYCC '16: Anti-Romani Statements Made At X-Men LGBTQ Panel," *Beat*, October 7, 2016, https://www.comicsbeat.com/nycc-16-anti-romani-statements-made-at-x-men-lgbtq-panel, and an artist's inserting allegedly anti-Semitic and Islamist imagery in *X-Men Gold*—see Marykate Jasper, "Marvel Will Remove Artwork, Discipline Artist for Controversial Political References in *X-Men Gold* #1," April 9, 2017, https://www.themarysue.com/x-men-gold-indonesia-politics-art. Milton Griepp, "Marvel Cashiers 'X-Men Gold' Artist," ICv2, April 12, 2017, https://icv2.com/articles/news/view/37246/marvel-cashiers-x-men-gold-artist.

48. "Magdalene Visaggio on the Problem of Cis Creators Writing Trans Narratives," *Paste*, September 9, 2016, https://www.pastemagazine.com/comics/magdalene-visaggio/the-problem-of-cis-creators-writing-trans-narratives.

49. Rich Johnston, "New Marvel Comics EIC C. B. Cebulski Admits He Wrote as 'Akira Yoshida' 13 Years Ago," *Bleeding Cool*, November 28, 2017, https://bleedingcool.com/comics/marvel-eic-c-b-cebulski-akira-yoshida. See also Asher Elbein, "The Secret Identity of Marvel Comics' Editor," *Atlantic*, December 17, 2017, https://www.theatlantic.com/entertainment/archive/2017/12/the-secret-identity-of-marvel-comics-editor/547829.

50. Various comic shops were attacked in some of the rioting. Heidi MacDonald, "Kibbles 'n' Bits 6/1/2020: #BlackLivesMatter," *Beat*, June 1, 2020, https://www.comicsbeat.com/kibbles-n-bits-6-1-2020-blacklivesmatter.

51. *She Wolf*, vol. 1 (Image, 2016), quote issue no. 2; *Man-Eaters* (Image, 2019).

52. Zander Cannon, *Kaijumax: Season One, Terror and Respect* (Oni, 2016).

53. Mark Peters, "One of the Best Examinations of Race in Comics Is a Bonkers Comic About a Prison for Giant Monsters," *Salon*, August 28, 2017, https://www.salon.com/test/2017/08/28/one-of-the-best-examinations-of-race-in-comics-is-a-bonkers-comic-about-a-prison-for-giant-monsters; Ezra Clayton Daniels and Ben Passmore, *BTTM FDRS* (Fantagraphics, 2019); see also Passmore, "As Way of . . . Introduction," *Your Black Friend and Other Strangers* (Silver Sprocket, 2018).

54. *Exit Stage Left: The Snagglepuss Chronicles* (DC, 2018). Russell's earlier work recasting *The Flintstones* for contemporary audiences (DC, 2017) provided a brilliant series of satirical just-so stories about how institutions arise and acquire the heft of, well, bedrock.

55. Brian K. Vaughan and Steve Skroce, *We Stand on Guard* (Image, 2016); Scott Snyder, Charles Soule, and Giuseppe Camuncoli's *Undiscovered Country* (Image, 2020).

56. Heidi MacDonald, "Staying Safe at Comic-Con 2017," *Publishers Weekly*, July 7, 2017, https://www.publishersweekly.com/pw/by-topic/industry-news/comics/article/74196-staying-safe-at-san-diego-comic-con-2017.html.

57. Todd Martens, "Creators, Fans, and Death Threats," *Los Angeles Times*, July 25, 2016.

58. Tom Spurgeon, "Assembled Extra: Zainab Akhtar to Shutter Comics & Cola," *Comics Reporter*, March 16, 2016, https://www.comicsreporter.com/index.php/assembled_extra_zainab_akhtar_to_shutter_comics_cola, and Kim O'Connor's account of toxicity in comics criticism in "Don't Be a Dick," *Comics & Cola*, March 16, 2016, http://www.comicsandcola.com/2016/03/dont-be-dick-tips-and-tricks-for-how-to.html.

59. Chelsea Cain, Twitter post, October 26, 2016, 1:19 a.m., https://twitter.com/ChelseaCain/status/791147254174408704; see also Kim O'Connor, "Marvel, Please Stop Fanning the Flames of Your Troll Problem," *Shallow Brigade*, October 27, 2016, https://amazingcavalieri.blogspot.com/2016/10/marvel-please-stop-fanning-flames-of.html.

60. Quotes from Asher Elbein's excellent account, "Comicsgate: How an Anti-Diversity Harassment Campaign in Comics Got Ugly—and Profitable," *Daily Beast*, April 2, 2018, https://www.thedailybeast.com/comicsgate-how-an-anti-diversity-harassment-campaign-in-comics-got-uglyand-profitable.

61. Anthony Breznican, "Star Wars Author Chuck Wendig Says Marvel Fired Him over Political Tweets," *Entertainment Weekly*, October 12, 2018, https://ew.com/books/2018/10/12/star-wars-author-chuck-wendig-marvel-comics-fired-political-tweets.; Bethany Lacina, Twitter post, October 15, 2018, 4:09 p.m., https://twitter.com/bethany_lacina/status/105192814 5069268995.

62. See, for example, the discussions of individual cases in Jude Terror, "DC Restructures Vertigo," *Outhousers*, April 21, 2016, http://www.theouthousers.com/index.php/news/135141-dc-restructures-vertigo-fires-shelly-bond-provokes-naming-of-open-secret-sexual-harasser-in-upper-management.html; Albert Ching, "DC Addresses Harassment Issues," *CBR*, May 13, 2016, https://www.cbr.com/dc-entertainment-addresses-harassment-issues-plans-to-review-and-expand-policies; Rich Johnston, "When Diane Nelson Spoke to Katie Jones About Sexual Assault," *Bleeding Cool*, June 7, 2016, https://bleedingcool.com/comics/when-diane-nelson-spoke-to-katie-jones-about-sexual-harassment; "I'm Tired of Performing Trauma: Five Cartoonists on #MeToo," *Nib*, October 27, 2017, https://thenib.com/response-metoo; Jessica Testa, Tyler Kingkade, and Jay Edidin, "The Dark Side of DC Comics," *Buzzfeed News*, November 10, 2017, https://www.buzzfeednews.com/article/jtes/dc-comics-editor-eddie-berganza-sexual-harassment; Cynthia Naugle, "X, My Experience with My Abuser," personal blog, December 9, 2018, http://cynthianaugle.blogspot.com/2018/12/x.html; Jay Edidin, Twitter thread, December 10, 2018, 11:03 p.m., https://twitter.com/NotLasers/status/1072341025685934082; Sam Thielman, "Women Speak Out About Warren Ellis," *Guardian*, July 13, 2020; Heidi MacDonald, "Creative Team Quits After *Border Town* Writer Accused of Sexual Misconduct," *Beat*, December 13, 2018, https://www.comicsbeat.com/creative-team-quits-after-border-town-writer-accused-of-sexual-misconduct; Christopher Chiu-Tabet, "Cameron Stewart Accused of Grooming Teenagers," *Multiversity Comics*, June 16, 2020, http://www.multiversitycomics.com/news/cameron-stewart-allegations; Luke Cornelius, "Warren Ellis Accused of Sexual Coercion," *Multiversity Comics*, June 17, 2020, http://www.multiversitycomics.com/news/warren-ellis-allegations; for Ellis's statement in response, see Heidi MacDonald, "Warren Ellis Releases Statement Addressing Sexual Misconduct Accusations," *Beat*, June 18, 2020, https://www.comicsbeat.com/warren-ellis-releases-statement-addressing-sexual-misconduct-accusations; Nicole Asbury, "Lawrence Comic Book Writer Banned from KU," *Kansas City Star*, August 4, 2019, https://www.kansascity.com/news/local/crime/article232789272.html; Joe Grunenwald, "Charles Brownstein Officially Out at the CBLDF," *Beat*, June 22, 2020, https://www.comicsbeat.com/Charles-brownstein-officially-out-at-the-cbldf; Deanna Destito, "Vault Drops Myke Cole's New Book," *Beat*, June 25, 2020, https://www.comicsbeat.com/vault-drops-myke-cole-hundred-wolves-misconduct-accusations; Heidi MacDonald, "Dark Horse, Mignola, and Richardson Release Statements," *Beat*, June 26, 2020, https://www.comicsbeat.com/dark-horse-scott-allie-misconduct; Joe Grunenwald, "New Allegations Against Scott Lobdell Surface," *Beat*, June 30, 2020, https://www.comicsbeat.com/scott-lobdell-harassment-allegations.

63. Susan Karlin, "The Playboy Revamp Continues," *Fast Company*, March 7, 2016, https://www.fastcompany.com/3057521/the-playboy-revamp-continues-how-the-magazine-is-redrawing-its-cartoon-lines-too.

64. Jennifer Schuessler, "A Cartoonist Savors His Favorite Art for the *New Yorker*," *NYT*, March 7, 2017; Seth Simons, "How Condé Nast Put the Squeeze on New Yorker Cartoonists," *Paste*, September 6, 2017, https://www.pastemagazine.com/comedy/the-new-yorker/how-conde-nast-put-the-squeeze-on-new-yorker-carto.

65. James Whitbrook, "DC Comics Just Killed Its Vertigo Imprint," *Gizmodo*, June 21, 2019, https://io9.gizmodo.com/dc-comics-just-killed-its-vertigo-imprint-1835249469.

66. Quoted Clark Collis, "The *Walking Dead* Comic Unexpectedly Ending with Latest Issue," *Entertainment Weekly*, July 2, 2019, https://ew.com/books/2019/07/02/the-walking-dead-comic-ends-robert-kirkman. Another blow to the comic shops; as recently as 2016, one industry critic estimated the *Walking Dead*'s "annual market share as high as 2.5 percent of the total comic shop market by itself." Calvin Reid, "Sales of Walking Dead Graphic Novels Higher than Ever," *Publishers Weekly*, November 4, 2016, https://www.publishersweekly.com/pw/by-topic/industry-news/comics/article/71961-sales-of-walking-dead-graphic-novels-higher-than-ever.html; David Harper, "The House of the 'Walking Dead'," *Ringer*,

February 1, 2017, https://www.theringer.com/2017/2/1/16041010/image-comics-25-year-anniversary-the-walking-dead-e4774b7bffcd#.86y2c71eb.

67. "Cartoonist Thomas Nast Misses Cut for N.J. Hall of Fame," NJ.com, January 29, 2012, https://www.nj.com/njv_auditor/2012/01/cartoonist_thomas_nast_misses.html.

68. Brandon Staley, "DC Cancels Shazam! The Monster Society of Evil Reprint," CBR, August 1, 2018, https://www.cbr.com/dc-shazam-monster-society-of-evil-canceled.

69. "MICE Is Retiring the Name of the Crumb Room," Massachusetts Independent Comics Expo website, March 26, 2018, http://www.micexpo.org/2018/crumb-room. Compare also the description of Ben Passmore's speech in Brian Doherty, "Cancel Culture Comes from Counterculture Comics," Reason, August 2019.

70. Quoted in Heidi MacDonald, "Coronavirus-Related Printing Delays Are Affecting Comics Releases," Beat, February 20, 2020, https://www.comicsbeat.com/coronavirus-related-printing-delays-are-affecting-comics-releases.

71. Heidi MacDonald, "A Very Different Look for the San Diego Convention Center," Beat, June 16, 2020, https://www.comicsbeat.com/a-very-different-look-for-the-san-diego-convention-center-homeless-shelter.

72. Heidi MacDonald, "Comix Experience Announces Mail Order and Pick-Up Options," Beat, March 17, 2020, https://www.comicsbeat.com/comix-experience-announces-mail-order-and-pick-up-options; Heidi MacDonald, "Comics Retailers React to Diamond Ceasing Shipments of New Comics," Beat, March 24, 2020, https://www.comicsbeat.com/comics-retailers-react-to-diamond-ceasing-shipments-of-new-comics.

73. Heidi MacDonald, "Diamond Allows Stores to Put Accounts on Hold and Muls Changes to Free Comic Book Day," Beat, March 18, 2020, https://www.comicsbeat.com/developing-diamond-allows-stores-to-put-accounts-on-hold-and-mulls-changes-to-free-comic-book-day.

74. Heidi MacDonald, "Diamond Experiences Cash Flow Problems and Will Not Be Paying Vendors This Week," Beat, March 31, 2020, https://www.comicsbeat.com/diamond-experiences-cash-flow-problems-and-will-not-be-paying-vendors-this-week; Heidi MacDonald, "Diamond Announces Payment Schedule to Publishers," Beat, April 6, 2020, https://www.comicsbeat.com/diamond-announces-payment-schedule-to-publishers.

75. Heidi MacDonald, "End of an Era: The Comics Industry Reacts to the DC Diamond Split," Beat, June 6, 2020: https://www.comicsbeat.com/dc-diamond-split.

76. Heidi MacDonald, "DC Pulls Out of Diamond," Beat, June 5, 2020, https://www.comicsbeat.com/breaking-dc-pulls-out-of-diamond-will-use-lunar-and-ucs-for-periodical-distribution.

77. Heidi MacDonald, "DC Announces Return to Shipping Comics for 4/27 with Alternative Distributors," Beat, April 17, 2020, https://www.comicsbeat.com/shocker-dc-announces-return-to-shipping-comics-for-4-27-with-alternative-distributors; Heidi MacDonald, "Retailers Have Poor Reaction to DC's New Distribution Plan," Beat, April 20, 2020, https://www.comicsbeat.com/retailers-react-to-dcs-new-distribution-plan.

78. Rob Salkowitz, "Is the Comic Shop Apocalypse at Hand?," ICv2, June 8, 2020, https://icv2.com/articles/columns/view/45875/is-comic-shop-apocalypse-hand-hope-vs-fear.

79. Joe Grunenwald, "Marvel Going Digital-Only with Select Single Issues," Beat, May 6, 2020, https://www.comicsbeat.com/marvel-going-digital-only-with-select-single-issues; Brandon Schatz and Danica LeBlanc, "The Coronavirus Journal," Beat, May 25, 2020, https://www.comicsbeat.com/the-coronavirus-journal-the-death-rebirth-of-print-single-issues; Heidi MacDonald, "Graphic Novel Buyer James Killen Laid Off at Barnes & Noble," Beat, June 25, 2020, https://www.comicsbeat.com/graphic-novel-buyer-james-killen-laid-off-at-barnes-noble; Rich Johnston, "Who The F*ck Is Jim Killen?," Beat, July 3, 2020, https://www.comicsbeat.com/who-is-jim-killen.

80. Along with another series several years later, Doomsday Clock, considered a Watchmen sequel.

81. Dave Itzkoff, "DC Plans Prequels to Watchmen Series," NYT, February 1, 2012; see Adrian Simmons, "Immortality, Truth-Telling and Snow Witches: Heroic Fantasy Quarterly 47," Black Gate, February 6, 2012, https://www.blackgate.com/2012/02/06/ill-look-down-and-whisper-no-before-watchmen.

INDEX

Aardvark-Vanaheim, 244
Aaron, Jason, 360, 417–18
Abbott and Costello, 140
ABC, 112, 178, 254
Abel, Jessica, 326, 415
Abie the Agent, 35–36
Abortion Eve, 213–14
"Abortion Rights," 325–26
"abstract comics," 278
"Acacia," 368–69
Ace Drummond, 78
Ace Hole, 291
"Ace Hole, Midget Detective,"
 279
Aces High, 130
Ace the Bat-Hound (charac-
 ter), 156
ACG, 271
Achewood, 376, 377
Ackerman, Forrest, 152
Action Comics, 47, 49, 50, 85,
 92, 94, 150, 381, 412
Action Detective, 46
A.D., 394
Adams, Douglas, 334
Adams, Neal, 227, 231, 234–
 35, 241, 249, 270, 271,
 302, 338
Adams, Scott, 435
Adam Strange (character), 154
Addams, Charles, 122
addiction, portrayal of, 230–31

Adlard, Charlie, 413
"Adolf Hitler Funnies," 204
adult readership, 92–93
Advance Comics Special Batlist,
 307–8
Adventure magazine, 43
Adventures into the Unknown,
 105
Adventures of Baby Dyke, 323
Adventures of Bob Hope, The
 (TV show), 140
*Adventures of Dean Martin
 and Jerry Lewis, The* (TV
 show), 140
Adventures of Jesus, The,
 183–84
Adventures of Kathlyn, The, 18
*Adventures of Lethem & Cha-
 bon, The,* 356
*Adventures of Obadiah Old-
 buck, The,* xiv
*Adventures of Phoebe Zeit-
 Geist,* 207
Adventures of Superman (TV
 show), 152
advertising, 6, 22, 41–42,
 44, 141
"Advice from Adrienne," 97
Advocate, 320
Africa, 30
Afterlife with Archie, 414
Agnew, Spiro, 143

Aguirre-Sacasa, Roberto, 434
AIDS, 316–17, 320, 341
Aim toothpaste, 253
Airboy, 102
Air Pirate Funnies, 195
Aja, David, 422
Akhtar, Zainab, 440
Akira, 373, 401
Alan Armstrong (character),
 91
Alan Scott (character), 53
Alay-Opp (Gropper), 147
Albert, Prince, xv
Albuquerque, Rafael, 418
Alec Holland (character), 293
Alexander, J., 415
Alexandra DeWitt (character),
 330
Alfie Twidgett (character), 76
Alfred (character), 180
Alfred E. Neuman (character),
 136, 141
Alias, 384
Alice in Wonderland (Carroll),
 xv
Alien, 249
Aliens, 308
Ali Muhammad, 249
Allen, Jake, 389
Allen, Woody, 150
Alley Oop, 140
All Girl Thrills, 211

All in the Family (TV show), 282

All-Negro Comics, 99

Allred, Michael, 420, 427

All Star Comics, 53–56, 83, 94

All-Star Superman, 383

All Star Western, 94

All-Story, 30

All-True Crime Cases, 103

Alphonse (character), 13

alternative bookstores, 191–92

Always Remember to Bring the Scythe, 415

Alyn, Kirk, 236

Amazing Adult Fantasy, 165

Amazing Adventures of Kavalier & Clay, The (Chabon), 68, 355–56, 369

Amazing Fantasy, 160, 165, 381

Amazing Man (character), 52

Amazing Spider-Man, The (comic), 171, 225, 231, 250, 390, 402, 412

Amazing Stories, 30–31

Amazon, 310, 375, 393, 436

Ambush Bug (character), 352

AMC, 436

American, The, 345

American Academy of Arts and Letters, 355

American Academy of Arts and Sciences, 369

American Avenger, 75

American Book Award, 355

American Bookseller magazine, 304

American Booksellers Association, 304

American Born Chinese, 368, 369, 388, 408

American Century, 345

American Civil Liberties Union, 128

American Culture Association, 355

AmericanElf.com, 376

American Enterprise, 358

American exceptionalism, 285

American Family Association, 396

American Flagg!, 267, 291, 345

American Greeting Card Company, 184

American Humorist, 8

American Library Association, 373

American News, 139

"American Scream, The," 339

American Splendor, 246–48, 300, 373, 378

American Vampire, 418

American Virgin, 359

American Visuals Corporation, 240

"Amok Time," 308–9, 310

Amos Hokum, 33

Amputee Love, 315–16

Amsterdam News, 33

Amulet, 408

Anarchy Comics, 283

ANC, 158

Anderson, Ho Che, 346

Anderson, Murphy, 154

And Her Name Was Maud, 13

André Chavard (character), 76

Andrews McMeel (publisher), 392

And Sam Laughed, 32

Andy (character), 320

Andy Gump (character), 19

Angel, the (character), 73

Angel and the Ape, 168

Angel Child, The, 9

Angelfire, 374

Angelfood McSpade (character), 205

Angelpuss (character), 59

Angels in America (play), 316

Angoulême, 304

Ania, 329

animal comics, 33

Animal Man (character), 339–40

animal rights activism, 339–40

animated cartoons, 50–51, 151–52, 253

Ann Arbor, Mich., 118

Anne Bonny (character), 345

anthologies, 73, 164, 233, 250, 277, 279, 282, 283, 301, 316, 324, 339, 341, 354, 357, 366, 369, 373, 391, 395, 426

Anthony, Susan B., 56

anti-communism, 151, 176, 177

Anti-Defamation League, 36

Anti-Gone, 433

anti-Semitism, xii, 2, 7, 69, 131–32, 257

antitrust, 139, 158

Ant-Man and the Wasp (film), xix

Antos, Heather, 441

Anyango, Catherine, 428

Anya's Ghost, 408–9

Any Easy Intimacy, 361

Aparo, Jim, 290

Apex Novelties, 207

Apple, 392

Aquaman (character), 152, 155

Aquaman (film), xix

Arad, Avi, 306–7, 380

Aragonés, Sergio, 270, 311

Araña (character), 396–97

Arcade, 239, 240, 278, 348

Archie, 72, 93, 97, 268, 382

Archie Andrews (character), 58, 179, 395

Archie Comics, 58–59, 99, 316, 393, 395–96, 434

Archie's Madhouse, 136

Archive Editions, 304

Argosy All-Story Weekly, 30

Argosy magazine, 43

Argus McFiendy (character), 101

Arkansas, 131

Arkham Asylum, 330

Arlington, Gary, 186, 192

Armstrong, Robert, 195–96

Arnold, Everett "Busy," 52, 60

Arriola, Gus, 33–34

Arrow, 436

art, comics in, 140–41

Artbabe, 326

Arzach, 259

Asian Americans, xviii

Asian characters, 95, 225, 442; *see also* Orientalism

Associated Press, 257

Association of Comics Magazine Publishers (ACMP), 117

Astaire, Fred, 73

Asterios Polyp (character), 385

Astérix, 257–58

Astoria (character), 330

Astounding, 152

Astounding Stories, 44

Astro Boy, 260

Astro City, 334

Atlantic, 11, 300

Atlas (publisher), 158, 159, 160, 171; *see also* Timely Publications

Atom, the (character), 53, 54, 85, 154–57, 226, 396

Atom-Age Combat, 159–60

Atomic Age, 160

atomic bomb, 53

Atomic Knights, 159
atomic power, 159–60,
 259–60
Atomic War!, 159
Atom Man (character), 159
Auburn, N.Y., 118
audience community, creation
 of, 167
Aunt Harriet (character), 180
Auster, Paul, 388
Austin, Terry, 263
Australia, 257
Authentic Police Cases, 103
autobiographical comics, 35,
 59, 143, 148, 211, 214–18,
 238, 245, 246, 250–52,
 260, 279, 281, 299, 312,
 315–16, 323, 325–26,
 360–61, 364, 405–7, 423
automobile, 22, 41
Autry, Gene, 94
Avengelyne (character), 303
Avenger, the (character), 345
Avengers, The (comic), 164,
 169–70, 225, 229
Avengers, The (film), 410–12
Avengers: Endgame, 410
Avengers: Infinity War (film),
 xix
Ayuyang, Rina, 368–69
Aztec of the City, 329
Azzarello, Brian, 343

Bá, Gabriel, 421–22
Babybel Wax Bodysuit, 422
Baby-Sitters Club, 372, 407
Bacall, Lauren, 67
Backderf, Derf, 367
Badajos, Ed, 204
Badger, 267
"bad girl phenomenon," 303
Bad Island, 409
Baehr, Thomas, 416
Baez, Joan, 219–20
Bagge, Peter, 276–77, 282,
 313, 354, 415, 421
Bails, Jerry, 235–36
Baker, George, 79
Baker, Kyle, 310, 365, 385,
 421, 427
Baker, Matt, 148
Ballantine Books, 146, 149
Baltimore, Md., 87
Baltimore Sun, 23
Barbara Gordon (character),
 332
Barbarella, 207

Barbier, Gilles, 306
Barefoot Gen, 259–60, 407
Barefootz, 239, 319
Barela, Tim, 320
Barker, Clive, 341
Barks, Carl, 101–2, 195, 243
Barnaby, 100
Barnes & Noble, 371, 394,
 435, 443
Barney Baxter, 79
Barney Google, 36, 40, 79
Barnum, P. T., xv
Baron, Mike, 267
Baroness von Gunther (char-
 acter), 56
Barry, Lynda, 315, 385
Barry, Red, 32
Barry, Sy, 173
Barry Allen (character), 154,
 171, 289
baseball, 346–47
"Baseball Is Ruining Our
 Children," 139
Bat, The, 51
Bat-Ape (character), 156
"Bat Boy and Rubin," 135
Batgirl (character), 157, 229,
 332, 383–84
Bat-Girl (character), *see* Batgirl
 (character)
Batman, 253, 289; *see also*
 Dark Knight, The
Batman (character), 55, 57,
 60–64, 75, 76, 84, 90,
 94, 102–3, 119, 150–51,
 153, 155–56, 177–80, 193,
 226, 229, 234–36, 270,
 285–87, 294, 311, 330,
 332, 343, 351, 374, 381,
 398, 405, 412, 432, 440
Batman (comic), 111, 151, 179,
 224, 289–91
Batman (1989 film), 305,
 307–8
Batman (TV show), 178–81, 253
Batman: Digital Justice, 309
Batman: The Animated Series,
 253, 308
Batman: Year One, 290
Batman Adventures, 308, 384
Batman Begins, 378
Batman Chronicles, The, 381
Batman Returns (film), 401
*Batman Strikes, The! Duty
 Calls*, 308
Bat Masterson (TV show), 140
Bat-Mite (character), 156

Batmobile, 179
"Bats in My Belfry!," 107
Battle Cry, 110
Batwoman, 229, 398
Bayeux Tapestry, xii
Bayou, 365
BD *(bande dessinée)*, 257–58,
 393
B.D. (character), 357, 360
Beach Blanket Bingo (film),
 162
Beaser, Herbert, 123
Beatles, the, 162, 175, 178
Beaton, Kate, 377, 402
Beautiful Babs, 22, 34
Bechdel, Alison, 312, 320–23,
 331, 363–64, 376, 424,
 431, 440
Beck, C. C., 63–64
Beck, Joel, 186, 204, 222
Beetle Bailey, 209, 224
Before Watchmen, 444
Belgium, 256, 257
Belinda Berkeley, 209–10
Bell, Gabrielle, 361–62, 388
Bell Syndicate, 49
Bemis, Max, 420
Bendis, Brian Michael, 343,
 379, 384, 397, 420
Berger, Karen, 334, 335, 338,
 340–41, 375, 410–11
Berkeley, Calif., 186, 241,
 283–84
Berkeley Barb, 186
Berlanti, Greg, 436
Berle, Milton, 140
Berlin, 388–89
Berlin, Irving, 141, 195
Berlin Wall, 176
Berman, Shelley, 143
Bernard, Laura, 314
Bernhard, Arthur, 104
Berry, Halle, 401
Bertozzi, Nick, 366–67
Bester, Alfred, 58, 152
Best We Could Do, The, 433
Better Homes and Gardens,
 138–39
Betty (character), 395–96
Betty Boop (character), 23, 45
Betty Cooper (character), 58
Beverly, 433
Beyer, Mark, 277
Beylie, Claude, 258
biblical themes and imagery,
 68, 89–90, 335, 427–28
Bierce, Ambrose, 67

Big Boy (character), 29
Big Chief Wahoo, 94
Big City Publishing, 329
Biggers, Earl Derr, 32
Bijou Funnies, 189, 190
Bilal, Enki, 259
"Bill of Rights for Comics
 Creators, A," 338
Billy Batson (character),
 63–64, 69–70
"Billy Comes Out," 319–20
"Billy Goes Out," 320
Binder, Jack, 60
Binder, Otto, 58, 152, 226
Binghamton, N.Y., 117
Binky Brown, 214–17, 219,
 315, 366
Birds of Prey, 331–32
Biro, Charles, 102, 103, 108,
 113, 117
Bissette, Steve, 292, 341
Bitch Planet, 418
Bixby, Bill, 254
Bizarre, 213
Bizarre Sex, 194, 212, 319
Bizarro (character), 293
Bizarro World, 420–21
Black Age of Comics Conven-
 tion, 229
Black Americans, 116
 as artists and cartoonists,
 218–19, 224, 228–29,
 329, 395, 399–400
 as characters, 69–70,
 94, 172–74, 224–28,
 233, 247, 327–28, 344,
 365–67, 383, 397–98,
 437–38
 stereotyped depiction of,
 xviii, 2, 33, 76, 98–99,
 119, 133, 442
"black-and-white" boom, 302
Black Bolt, 434
Black Canary (character), 157,
 229, 330, 331
Black Candy, 417
Black Comic Book, 224
Black Condor (character), 61
Black Flag, 268
Black Hammer, 415–16
Blackhawks, 76, 156, 179
Black Hole, xix, 317–18
Black Knight, 158
Black Lightning (character),
 228
Black Like Me (Griffin), 228
Black Lives Matter, 439

Blackmark, 249
Black Orchid, 335
Black Owned Communica-
 tions Alliance, 225
Black-owned newspapers, 33,
 94, 172, 173
Black Panther (film and char-
 acter), xix, 172, 224, 225,
 263, 395, 399, 438
Blade (film), 308
Blade, the vampire hunter
 (character), 233
Blair, Barry, 326
Blankets, 362–63, 367
Blasé, 144
Blaxploitation, 225, 262, 328
Blindspot, 360
Blitt, Barry, 390
Bloch, Robert, 152
Block, Embee Rudolph, Jr., 40
Block v. City of Chicago, 115
Blonde Phantom (character),
 91
Blondie, 34–35, 80, 93, 224
Blondie (character), 326, 354
Bloom County, 327, 394
Blue Bolt, 71
Bluesman, 365–66
Bobbitt, Lorena, 325
Bobby Drake (character), 399
Bocage, Angela, 324
Bodé, Vaughn, 202–3, 291
Bogeyman Comics, 192
Bohr, Niels, 366
Boiled Angel, 341
Bolívar, Simón, 87
bondage, 119
Bone, 353, 373
book burnings, 117–18
Booker Prize, 433
Book Expo, 371
Bookhunter, 418
Book of Hours (Masereel), 146
Book of Mormon, The, 427
Book of Raziel, 199
Books of Blood, 341
bookstores, 191–92, 220, 252,
 255, 262, 283, 287, 304,
 306, 318, 337, 371–75,
 391, 394
"Books Worth Reading,"
 112–13
Boondocks, The, 354, 358
Booster Gold (character), 276
Booth, 366
Borders (bookstore), 394
Boston, Mass., 84

Boston Globe, 383
Boston Herald, 12–15
Boston Massacre, xiv
Bottomless Belly Button, 422
Bourke-White, Margaret, 131
Bowery Boys, 76
Box Brown (character), 361–
 62, 434
Boy Commandos, 76
Boys, The, 420
Boys Club, 435
*Boy Trouble: Gay Boy Comics
 with a New Attitude,*
 425–26
Brabner, Joyce, 429
Bradbury, Ray, 31, 109, 152,
 236
Braddock, Paige, 323
Brad Nelson (character), 47
Bradshaw, Annette, 22
Brady, Pat, 353–54
Brainiac 5 (character), 180
Brand, Michelle, 210
Brand, Roger, 193
Brando, Marlon, 162, 201
Breakdowns, 278–79
Breathed, Berke, 327, 394
Brenda Starr, 100, 224, 394
Bressler, Simone, 248
Briggs Land, 417
"Bringing Back Father," 135
Bringing Up Father, 17, 20, 40
Bring On the Bad Guys, 250
"Bring Us Together," 204
Brinkley, Nell, 22
Brinkley Girl, 22
British comics, 337–39
Broadcast, The, 417
broadsheets, xii–xiii
Bronzie, 224
Brooklyn, N.Y., 59, 73, 76,
 361, 397
Brooks, Mel, 183
Brosgol, Vera, 408–9
Brotherman, 329
Brother Power, 231
Brown, Chester, 314, 349,
 387, 427
Brown, Jeffrey, 361
Brown, John Mason, 112
"Brownie's Ride, The" (Cox), 6
Brownsville, 389
Brown v. Board of Education,
 116
Brubaker, Ed, 343
Bruce, Lenny, 134, 136, 143,
 183, 240

Bruce Wayne (character), 62, 84, 180, 285–86
Bryant, D. J., 433–34
BTTM FDRS, 439
Bubnis, Bernie, 236
Buck Rogers (comic and character), 29–31, 51, 53, 71, 72, 75–77, 109, 152, 172, 257
Buck Vinson (character), 159
Buck Wild (character), 328
Bucky Barnes (character), 177
Bucky Bug (character), 100
Buddy (character), 339–40
Buddy Bradley (character), 313, 415
Buell, Marjorie Henderson, 100
Buffalo Belle (character), 95
Buffy the Vampire Slayer, 309, 412
Bughouse, 135
Bugs Bunny, 81, 195
Bui, Thi, 433
Bumsteads, the, 35
Bungleton Green, 33
Bungleton Green (character), 172
Bunn, Cullen, 414, 418
Burbank, Calif., 410
Burden, Bob, 352
Bureau of Naval Intelligence, 78
Burgos, Carl, 73
Burnley, Jack, 60
Burns, Charles, 317–18
Burrito!, 329
Burroughs, William, 240
Burrows, Jacen, 414
Burton, Tim, 307
Busch, Wilhelm, 8–9
Bush, George H. W., 328
Bushmiller, Ernie, 23, 351
Busiek, Kurt, 301, 333–34
Buster Brown, 7–9, 40
Byrne, John, 263, 289, 302, 353
Byrne, Olive, 56
Byrnes, Loy, 79

Cadence Industries, 237
Caesar, Sid, 134
Cagney, James, 29
Cahan, Abraham, 251
Cain, Chelsea, 434, 439–41
Cairo, 383
California, 199–200, 268–69

California State University, Long Beach, 251
Calkins, Dick, 29, 31
"Calling All Cars," 49
Calling All Girls, 87
Call It Sleep (Roth), 251
Call of Duty, 358
Calof, Grant, 416
Calvin and Hobbes, 351–52, 394
Calvo, Edmond-François, 298
Camelot 3000, 274
Camera Fiend (character), 85
camp, 178–81, 234
Campbell, Eddie, 341, 421
Campbell, John, 28
Campbell Soup, 253–54
Campbell Soup Kids, 6
Camuncoli, Giuseppe, 440
Camus, Albert, 144, 353
Canada, 118
Canada Dry, 41
Cancer Made Me a Shallower Person, 362
cancer memoirs, 362
Cancer Vixen, 362
Caniff, Milton, 31–32, 60, 66, 71, 78, 79, 84, 100, 104, 122, 150, 191
cannibalism, 111
Cannon, Zander, 439
Can't Get No, 358
Capital Comics, 267
capitalism, 24, 102, 149, 189–90, 200, 257, 283, 358
Capone, Al, 27, 29
Capote, Truman, 103
Capp, Al, 34, 81, 84, 100, 112, 141, 173, 214, 219–20
Capra, Frank, 80
Cap Stubbs and Tippie, 23
Captain America (comic and character), 70–77, 93, 99, 105, 151, 152, 169, 171–72, 177, 225, 233, 253–54, 345, 358, 370
Captain America Comics, 74–76, 105
Captain America's Weird Tales, 105
Captain Atom (character), 295
Captain Billy's Whiz-Bang, 63
Captain Easy (character), 30
Captain Future (character), 152
Captain Guts: America's Savior!, 204–5

Captain Marvel Adventures (comic and character), 63–65, 71, 77, 135, 152, 201, 235–37, 272, 294, 296, 400
"Captain Marvel and the Monster Society of Evil" (movie serial), 170
Captain Marvel Jr. (character), 77, 138
Captain Midnight, 60
Captain Nazi (character), 77
Captain Pureheart (character), 179
Captain Thunder (character), 63
Captain Underpants (character), 432
Carew, Kate, 9
Carey, Mike, 341
Carey, Percy, 426
Carlson, George, 81
Carol Corps, 400
Carpenter, John Alden, 20
Carré, Lilli, 422
Carroll, Emily, 435
Carter, Lynda, 254
Cartoon Bank, 441
Cartoon History of Surfing, The, 174
Cartoon History of the Universe, The, 345
Cartoonists Guild, 326
cartoons
 animated, 50–51, 151–52, 253
 origin of term, xv
Casali, Kim, 213
Case, Jonathan, 367
Casey, Joe, 415
Caspar Milquetoast (character), 36
Cassaday, John, 332–33
Cassandra Cain (character), 383–84
Castle Waiting, 416
Caston, Rodney, 376
Castro, Fidel, 177
Catechetical Guild, 89
Catholic Church, xii, 89, 118, 214–16
Catholic League, 126
Catholic World, 89
Cathy, 230, 358, 394
Catmull, Ben, 414
Catwoman (character), 55, 60, 290, 331, 384
Catwoman: The Movie, 401

C. Auguste Dupin (character), 37
Cazco (character), 251
CD-ROM, 309, 310, 376
Cebulski, C. B., 439
Céline, Louis-Ferdinand, 353
censorship, 115, 117, 121–23, 125–26, 128–30, 133, 136, 139, 209, 222, 330, 392; *see also* Comics Code
Cerebus (comic and character), 243–44, 250, 267, 269, 304, 330, 338, 377
Cerebus Effect, 304
Chabon, Michael, 68, 355–56, 407
Chadwick, Paul, 357
Challengers of the Unknown, 155, 161
Chamber of Chills, 111, 233
Chambers, Robert, 5
Chameleon Boy (character), 180
Champion (horse), 94
Chandler, 250
Chaplin, Charlie, 13, 147
characters, readers' emotional attachment to, 19
Chariots of the Gods? (film), 232
Charles, Prince, 141
Charles Atlas ads, 70–71
Charlie, What Are You Up To?, 35
Charlie Brown (character), 144
Charlie Chan (character), 32, 47
Charlie Chaplin's Comic Capers, 37
Charlton Comics, 99, 159, 231, 294
Charyn, Jerome, 304
Chast, Roz, 424, 431
Chater, Mack, 417
Chaykin, Howard, 245, 249, 250, 267–68, 345
Checkered Demon (character), 196, 249
Chesler, Harry "A," 59
Chester 5000, 418
Chevli, Lyn, 212, 213–14
Chew, 419
Chiang, Cliff, 416
Chicago, Ill., 36, 45, 86, 178, 189, 229, 367, 369, 378
Chicago American, 40

Chicago Comicon, 303
Chicago Daily News, 35, 78, 86
Chicago Democratic Convention (1968), 189
Chicago Gay Life, 321
Chicago Inter-Ocean, 3–4
Chicago Mirror, 189
Chicago Tribune, 17–19
Chick, Jack T., 427
Children's Book Committee, 86
"Child's Play," 275
Child Study Association of America, 86, 112
Chinese immigrants, xvii, 4
Chisholm Kid, The, 94
Chivington, John, 346
Chloe, 387
Chop Chop (character), 76
Chris Rhodes (character), 318
Churchill, Winston, 87, 125
Chute, Hillary, 298
Chwast, Seymour, 428
Circus, The (film), 147
Citizen Kane (film), 7, 8, 66
City of Glass, 388
Civilian Justice, 359
civil liberalism, 83–84
civil rights, 228–29
civil rights movement, 172–74
Civil War, 359, 371, 381
Civil War, American, xvi–xvii, 3, 10
Claremont, Chris, 261, 263–65, 301–2
Clarke, Arthur C., 152
Clark Kent (character), 48, 55, 60–61, 68, 72, 83, 84, 85, 153, 154, 170, 254
Classic Comics, 105
"Classic Condensed Comic Classics," 331
"Classics Crucified," 240
Classics Illustrated, 88, 129
Claws of the Cat, The, 230
Cleese, John, 150
Cleveland, Grover, 2
Cleveland, Ohio, 47, 184, 185, 247, 429
Clock, the (character), 52
Cloonan, Becky, 359, 420
Clouds Above, The, 372
Clowes, Daniel, 312–14, 355, 369, 378, 420, 434–35
Clumsy, 361
CNN, 397
Coates, Ta-Nehisi, 399

Cockrum, Dave, 262
Code for the Comics Magazine Industry, 125; *see also* Comics Code
"Cody Starbuck," 245
Coelho, Jorge, 420
Colan, Gene, 233
Colbert, C. C., 366
Colden, Kevin, 367
Cold War, 176, 177, 285, 295
Cole, Jack, 52, 104
Coleridge, Samuel Taylor, 73
collectors, xix, 236, 289, 305, 412
Collector's Item Classics, 237
Collier's, 112
Collins, Katherine, 353
Collins, Max Allan, 267
Colón, Ernie, 224, 365
Colonial America, xiii–xiv
colonialism, 30, 37, 58, 173, 256–58, 269, 345, 399
color printing, 3, 5, 45
Colossus (character), 263
Columbia University, 168, 221, 278
Comanche Moon, 346
Combat Zone, 358
Comedian, the (character), 295–96
Come Out Comix, 318
Comic Book Holocaust, The, 421
Comic Book Price Guide, 236
comic books
 defining, 39
 hardcover, 40
 numbering of, 40, 96
 two-page text pieces in, 96
Comic Collector's News, The, 144
Comic-Con International, 378; *see also* New York Comic-Con; San Diego Comic-Con
Comic Monthly, 40–41
Comicon.com, 310
comics
 adult readership of, 92–93
 continuity concept in, 25
 criticisms of, 86–87, 112–30
 "family-friendly," 11
 first daily, 16–17
 horizontal layout of, 16
 online, 310, 331, 354, 356, 375–77, 391, 394
 origin of term, xiii
 prices of, 121, 266, 390–91

sequential layout of, xi–
xii, 9
symbolic shorthand in,
xvi–xvii
3-D, 140
women as readers of,
92–93
*Comics, Radio, Movies—and
Children* (pamphlet),
120
Comics and Animation
Forum, 311–12
Comics Arts Festival, 378
Comics Code, 125–33, 136–39,
151, 159, 160, 188,
193–94, 219, 230–34,
237, 238, 272, 274, 275,
293–94, 318, 330–31,
341, 356
Comics Code Authority,
127–28, 365, 396
Comics & Cola, 440
Comics.com, 392
comics conventions, 236,
378, 402–3, 440; see also
specific conventions
Comicsgate, 440–41
comic shops, 60–61
Comics Journal, 252, 269,
288, 371
Comics Magazine Association
of America, 125–26,
129, 139
Comics Magazine Company,
46
comics readership, 301
comic strips, 125–26
comic supplements, first, 3
Comix Book, 238–39, 241,
272, 420
ComiXology, 392–93, 400,
435
Comix Syndicate, 191
Comix World, 284
Commissioner Gordon (char-
acter), 62–63, 332
Committee for Women Car-
toonists, 100
Common Lives/Lesbian Lives,
321
communism, 124, 148, 151,
159, 176, 177, 257
community decency cam-
paigns, 118
"community standards," 221
compensation of writers and
artists, 49–50

Complete EC Checklist, The,
144
Complete Maus, The, 309
Compost Comics, 200
CompuServe, 311–12
Conan Doyle, Arthur, 232
Conan the Barbarian, 234,
237, 244
Condé Nast, 237
Confessions of a Nazi Spy
(film), 72
Congressional Joint Commit-
tee on Printing, 125
Congressional Record, 79
Connie Rodd (character),
240–41
Conrad, Joseph, 428
ConsciousNet, 309
Constantine, 378
Constantine, John, 338,
341–42
Consumer Comix, 345
contests, reader, 18
Continental Features Syndi-
cate, 33
continuity concept, 25
Contract with God, A, 251–53,
312
Coogler, Ryan, 438
Cooke, Darwyn, 383, 417
Cookie O'Toole (character), 59
Coover, Colleen, 393, 418
copperplate engravings, xiii
copyright, xiii, 8, 9, 43,
49–50, 52, 65, 189, 191,
195, 270
Corben, Richard, 193
Corporate Crime Comics, 345
Cosby, Nate, 359
Cosmic Stories, 47
Cosmo, the Phantom of Dis-
guise, 47
Countdown, 382
Countess Valentina Allegra
de Fontaine (character),
176
court cases, see lawsuits and
court cases
Courtney Crumrin (charac-
ter), 408
Cousin Eerie (character), 232
Covenant with God, 252
Cowan, Denys, 327–28
Cowboy Love, 94
Cox, Palmer, 6
Coyote, 270
Cracked, 135

Craft, Jerry, 431
Craig, Johnny, 108
Crandall, Reed, 76
Crane, Jordan, 372
Crane, Roy, 30, 32
Craven, Wes, 292
Crawl Space, 434
Crazy, 135
"Crazy Bitches," 213
Crazy Ex-Girlfriend, 428
"creator summits," 338
Creature from the Black Lagoon
(film), 160, 415
Creepy magazine, 232
Crepax, Guido, 259
Crestwood (publisher), 93
Crick, Francis, 366
Crime and Punishment (Dosto-
evsky), 351
Crimebuster, 102
crime comics, xii–xiii, 27–28,
43, 46, 92, 96–97, 102–7,
111–26, 128–30, 132–34,
220, 230, 232, 257, 342–
43, 345, 417; see also true
crime; *specific comics*
Crime Detective Cases, 103
Crime Does Not Pay, 102–3,
103–4, 113, 117, 220
Crime Must Pay the Penalty, 103
Crime Patrol, 104
Crimes by Women, 103
Crime Smasher, 92
Crime SuspenStories, 111
Crimson Avenger, the (char-
acter), 51, 78
Crimson Dynamo, the (char-
acter), 176
Crisis, 339, 340
Crisis on Infinite Earths,
289–90
Crook, Tyler, 414
Crosby, Andrew, 415
Crosby, David, 209
Crossed, 414
Crossley, Dave, 184
cross-promotion, 54, 253–54
Cruikshank, George, xv
Crumb, Charles, 144, 195
Crumb, Dana, 188
Crumb, Robert, 144, 150,
184–88, 190, 192, 193,
195–99, 205–8, 211, 213,
220, 239–41, 247, 258,
268, 278, 280–83, 291,
298, 313, 314, 350, 373,
378, 427, 442

Crumb, Sandra, 211
Cruse, Howard, 239, 318–20, 323
Cryll (character), 155
Crypt-Keeper (character), 106, 108, 134, 193
Crypt of Terror, 104, 117
Crystal City, Tex., 37
Cuba, 177
Cul de Sac, 394
Cummings, E. E., 20
Cuneo, Peter, 307, 380
Cupples & Leon, 40
Curt Vile (pseudonym), 291–92
CW Network, 436
"Cycle of an Artist," 282
Cyclops Comics, 199, 291

Dada, 20
Daddy Warbucks (character), 24–25, 79
Dagwood (character), 35, 93
Dahmer, Jeffrey, 367
Daily Planet (fictional newspaper), 75
Daily Star, 153
Daily Worker, 25, 124
Daisy Mae (character), 34, 51
Dakota Universe, 328
Dallas, Tex., 88
Damn Nation, 415
Dancette, Victor, 298
Danger Funnies, 326, 327
Danger Girl (character), 303
Daniels, Ezra Clayton, 439
Danny the Dreamer, 15
Dan O'Neill's Comics and Stories, 195
Daredevil, 261–62, 275, 287
Daredevil (character), 164, 261, 269–70
Daring Confessions, 94
Dark Age, 330, 332, 333
Dark Horse Comics, 308, 342, 372, 375, 390–92, 399, 413
Dark Hotel, 310
Dark Knight, the (character), 75
Dark Knight, The (comic and film adaptations), 285–87, 290, 294, 330, 341, 343, 381, 412, 436
Dark Laughter, 33
Dark Phoenix (character), 264
Dark Rain, 365

Darkseid (character), 232, 249
Darling, Wendy, 418
Darnall, Steve, 344
Darrow, Clarence, 116
Darwin, Charles, 365
Das Kampf, 202–3
Dateline: Danger, 173
Date with Patsy, A, 99
Daumier, Honoré, xiii, 256
David Boring, 355
Davies, Marion, 28
Davis, Jack, 108, 141, 145
Davis, Jim, 377
Davis, Vanessa, 361
Davison, Al, 316
Day After, The (TV movie), 285
"Day at the Circuits," 279
Daybreak, 414
Daydreamer, Jennifer, 386
Dazzler, 266
DC Entertainment, 46–47, 49, 52, 53, 55, 60, 62, 63, 65, 75, 78, 80–84, 87, 90, 94, 108, 110, 112, 117, 135, 138, 140, 152, 154–61, 164, 167, 168, 170–73, 179–80, 190–91, 203, 225–33, 236–37, 246, 252–54, 262, 265–66, 271, 273–75, 285–94, 297, 301, 304–6, 308–11, 316, 323, 327–28, 331–35, 337–38, 340–41, 344, 352–54, 370–72, 374, 375, 379, 382–84, 391–92, 396, 399–400, 405, 409–11, 415–16, 420, 422, 432, 436, 441–44
DC: The New Frontier, 383
DC Universe, 436
D-Day, 80
Dead End Kids, 76
Deadly Class, 409
Deadman, 234–35
Deadpool, 303
Deadpool 2 (film), xix
Dead Stories, 277
Dean, James, 162
Deathblow (character), 303
"Death of Speedy Ortiz, The," 269
Death-Ray, The, 420
Debs, Eugene V., 17
DeCarlo, Dan, 228, 268, 382
DeConnick, Kelly Sue, 418

Deep Throat (film), 221
Defender, The, 75
Definitive X-Men Erotica Archive, The, 311
DeForge, Michael, 421
De Fuccio, Jerry, 110
Deitch, Gene, 142, 238, 348
Deitch, Kim, 200, 209, 348
Delacorte, George, 41, 45
De Landro, Valentine, 418
Delany, Samuel R., 250
del Fuego, Rojelio, 268–69
Dell Comics, 214
Dell'Edera, Werther, 434
Dell Publishing Company, 41, 42, 45, 57, 72, 129
Del Rey, 374
DeMatteis, J. M., 273, 296
Dembicki, Matt, 429
Demented Pervert Comix, 201–2
Demo, 420
Democratic Party, xvii, 2, 189
Demon Knight (film), 341
"De Night in de Front from Chreesmas," 136
Dennis the Menace, 122, 268
Denny Colt (character), 65
Denver Post, 374
Deren, Maya, 339
Derrickson, Scott, 437
Deseret News, 11
Desperate Desmond, 35
Destiny, 146
Destroyer Duck (character), 270
Detective Action, 46
Detective Comics, 46–47, 49, 75, 76, 94, 236, 412
Detective Picture Stories, 46
Detroit, Mich., 118, 186, 220
Detroit News, 374
Deutsch, Barry, 407–8
Devil Bat, The (film), 105
"Devil's Lonely Day, The," 385
Devlin, Tom, 354
Dewey, Thomas, 118, 143
Dexedrine Parios (character), 417
Dial H for Hero, 332
Diamond, 297, 306, 370–71, 391, 392, 443
"Diamond Pendant, The" (Maupassant), 131
Diana, Michael, 341
Diana Dane (character), 330
Diary of a Mosquito Abatement Man, 364

Diary of Anne Frank, The, 131
Diary of a Wimpy Kid, 378
Dick, Philip K., 90
Dickens, Charles, xv
Dick Grayson (character), 234, 311
Dickinson, Emily, 377
Dick Tracy (comic and character), 26–29, 31, 37, 45, 51, 55, 60, 64, 79, 102, 140, 267, 354, 444
DiDi Glitz (character), 240
DiDio, Dan, 399
Digger, 377
Diggle, Andy, 341, 359
digital piracy, 374
digital technology, 309–10
Dilbert, 315, 377, 392, 435
Dille, John Flint, 31
Dillingham's American Authors Library, 39
Dillon, Steve, 339
DiMassa, Diane, 323, 326
Dinah Lance (character), 330
Dirigible of Doom, 62
Dirks, Rudolph, 9, 52
Dirty Harry (film), 291
Dirty Plotte, 325
Disch, Thomas, 342
"Discover America," 204
Disney, Lillian, 81
Disney, Walt, 45, 81, 100–101, 194, 195; *see also* Walt Disney
District 9 (film), 403
Ditko, Steve, 159, 162, 165, 174–75, 231, 268, 339, 348, 380, 409
Divine Comedy, The (Dante), 428
divorce, 11, 98
Doc Savage (character), 43, 47, 237
Doctor Gesundheit (character), 247
Dodson, Bert, 276
Dog Man: Brawl of the Wild, 432
domestic politics, 233
"Domination of Wonder Woman, The," 311
Dominguez, Olga, 329
Dominguez, Richard, 329
Donald Duck (comic and character), 45, 80, 100–102
Don Blake (character), 164

Donenfeld, Harry, 46, 49, 50, 52, 190, 288–89
Don Quixote (Cervantes), 428
"Don't Get Around Much Anymore," 279
Don Winslow of the Navy, 78, 88
Doom Patrol, 164–65
Doomsday, 305
Doonesbury, 143, 248, 276, 320, 321, 354, 357, 360
Doré, Gustave, 256
Dorgan, Tad, 36
Dorkin, Evan, 309, 352, 421
Doubleday, 372
Double Detective, 46
Double Impact (character), 303
Doucet, Julie, 325, 354
Dove, the (character), 231
Downey, Robert, Jr., 380–81
Doyle, Thomas F., 89
Dozier, William, 177–78
Dr. Atomic (character), 200
Dr. Death (character), 111
Dr. Doom (character), 358
Dr. Fate (character), 54
Dr. Manhattan (character), 295, 444, 445
Dr. Mid-Nite (character), 83
"Dr. Occult," 49
Dr. Seuss' The Grinch (film), xix
Dr. Strange (character), 167, 170, 174–75
Dr. Strangelove (film), 268
Dracula (character), 237
Dracula: A Symphony in Moonlight and Nightmares, 273
Dracula Lives!, 232
Dragon Ball, 374
Dragon Lady (character), 32
Drake, Arnold, 148, 164
Drake Waller (pseudonym), 148
Drawing Is Easy! (Except When It's Hard), 372–73
"Drawn and Quartered!," 107
Drawn & Quarterly, 354, 371, 372
Drayton, Grace, 6
Dreadstar, 276
Dreamer, The, 312
Dream of the Rarebit Fiend, 14–15

Drechsler, Debbie, 325
Drew Murdoch (character), 105
Drinking at the Movies, 425
Drinky Crow (character), 352
Drnaso, Nick, 433
Drooker, Eric, 350
Drucker, Mort, 268
drug abuse, portrayal of, 230–31; *see also* LSD; marijuana
Druillet, Philippe, 259
Drusilla, Wonder Girl (character), 254
Duchamp, Marcel, 353
Dugan, Mickey, 4–6
Duggan, Gary, 428
Dumb Dora, 22, 34
Dumm, Edwina, 23
Duncan the Wonder Dog, 389
Dune (film), 248
Dunn, Bob, 36
Dupuis, Charles, 256
Dupuis, Jean, 256
Dutch, Dana, 98
Dykes to Watch Out For, 320–21
Dynamite, 266
Dynamite Daniels, 318
dystopias, 31, 275–76, 416, 418

"Earth Stories," 322
Eastern Color Printing Company, 41, 42, 102
Eastman, Kevin, 301–2
Eastman Kodak, 6
East Side Book Store, 221
East Village Other (EVO), 186, 200, 201, 214, 219
Easy Rider (film), 169, 192, 201, 227
Ebony, 224
Ebony White (character), 69
EC (publisher), 96–97, 105–11, 122, 124–25, 129–36, 141, 144, 158, 160, 166–68, 181, 182, 188, 193, 195, 196, 201, 232, 236, 249, 258, 262, 271, 291–92, 294, 296, 312–13, 335, 342–44, 415
"EC Confidential," 108
EC Fan Addict Convention, 236
EC Fan Bulletin, 144
Echo, 384

Eclipse, 270
economy, 22
Ed, Carl, 25
Edison, Thomas, 4
Ed the Happy Clown (character), 349
Educational Alliance, 71
educational comics, 88
Educational Comics Inc., 90, 96, 110–11; see also EC
Educomics, 259–60
Edwards, Dylan, 426
Eerie, 232
Egypt, 257
Egypt, Ancient, 53
Eh!, 135
Eichhorn, Dennis P., 312
Eichler, Glenn, 366
Eightball, 313, 314
Eisenhower, Dwight, 295
Eisner, Will, 52, 58–60, 65–72, 76, 81, 109, 150, 156, 175, 240–42, 249–53, 260, 262, 269, 270, 291, 312, 337, 363–64, 372, 379, 393, 428
Eisner Award, 362, 377, 379, 393, 399, 407
El Borbah (character), 317
Elder, Will, 80, 136, 141, 145, 149, 177
Electrical World, 4
Electric Company, The, 253
Electro (character), 171
Elektra (character), 262
Elfquest, 245, 250, 267
El Gato Negro, 329
Elliott, Mama Cass, 209
Ellis, Warren, 332–33, 342
Ellsworth, Whitney, 60, 81
Elongated Man (character), 330
Elric, 242, 270
Elseworlds, 333
Emerald City Comic Con, 378, 404, 405, 442
Emerson, Ralph Waldo, 7
"Emordana," 433–34
Empire, 250
Empire Strikes Back, The, 309
Encino, Calif., 220
Encyclopedia Britannica, 101
End Is Here, The, 416
End of Summer, The, 416
End of the Fucking World, The, 409
Engelberg, Miriam, 362

Engelhart, Steve, 270
England, xiii–xv, 76; see also Great Britain
engravings, xiii–xv
Enid Coleslaw (character), 313–14
Ennis, Garth, 338–39, 341, 344, 414, 420
Entertaining Comics, 96; see also EC
environmentalism, 200
Epic Illustrated, 272, 273
Erik Killmonger (character), 225
Escape from Special, 364–65
escapism, 29
Esquire, 177
Esquire Features, 49
"Essay on Physiognomy" (Töpffer), xiv
Eternals, The, 232
Evanier, Mark, 311
Evans, Dale, 94
Evans, Orrin Cromwell, 99
Eve, 148
Even the Giants, 386
Everett, Bill, 73
Evergreen Review, 207
Everybody's Magazine, 12
Every Girl Is the End of the World for Me, 361
Ev'ry Month magazine, 6
Exciting Romances, 94
Exit Stage Left: The Snagglepuss Chronicles, 439–40
Ex Machina, 358–59
exoticism, 30
explicit and pornographic material, 34, 45–46, 57–58, 206–7, 213, 296, 315, 316
Eye of the Beholder, 355

Fabulous Furry Freak Brothers, 192, 197
Fairbanks, Douglas, 51
Fair Weather, 315
"fake mags," 194
Falcon, the (character), 225
Falk, Lee, 36–37
Falwell, Jerry, 277
Family Circle, 55
Family Circus, The, 321
"family-friendly" comics, 11
Famous Detective, 46
Famous Funnies, 42, 140

Famous Monsters of Filmland, 150, 160
Fanboy, 311
Fanfare, 144
Fantagor (character), 193
Fantagraphics, 269, 304, 348, 371, 372
Fantasia (film), 143
Fantastic Four (comic and characters), 161–74, 176, 180, 198, 250, 333, 381, 395, 399, 420
fantasy and fantasy comics, 244–46, 387, 416, 418
Fantasy and Science Fiction, 152
Fantasy Comics, 144
Fante Bukowski, 388
fanzines, 47–48, 144, 150, 152, 154, 181, 188, 189, 235, 252, 261–62, 291, 292
Farmer, Joyce, 212–14, 424
Farnon, Tristan A., 376
Farrar, Straus and Giroux, 372
Far Side, The, 351–52
fascism, 70, 89, 147, 201, 203, 286, 294, 344, 359, 389
Fast Action Detective, 46
Fast Willie Jackson, 228
Fatale (character), 303
Fat Freddy (character), 197
"Father and Son, 1972," 204
Father Knows Best, 98, 221
Fausta the Nazi Wonder Woman, 254
Fawcett Publications, 63, 65, 70, 82, 92, 99, 111, 117, 236
Fawkes, Ray, 421
Fax from Sarajevo, 347–48
Fearless Vampire Killers, The (film), 273
Fear of Flying (Jong), 194
Federal Bureau of Investigation (FBI), 28, 95, 212, 379
Federal Express, 308
"Federal Men," 49
Feds 'n' Heads, 189, 197
Feehan, Mike, 440
Feiffer, Jules, 67, 68, 142–43, 181, 182, 253, 348, 353, 355, 441
Feige, Kevin, 412
Feininger, Lyonel, 15, 23
Feldstein, Al, 97–98, 105, 108–10, 131–34, 145, 342

"Felix," 388
Felix the Cat, 33, 195
feminism, 55, 211–12, 229
Feminisms, 22
Femme Force, 229
femmes fatales, 67, 240
Ferrigno, Lou, 254
Ferris (character), 157
Ferris, Emil, 433
Ferris Aircraft, 157
Festival of Comic Art, 310
Fiction House, 57–59, 82, 148
Fiction Illustrated, 248
Fiery Mask, the (character), 73
Fies, Brian, 362
Fifth Estate, 186
52, 371
Fighting American, 151
Fighting Leathernecks, 110
Fighting Yank (character), 75
Fillmore Grinchbottom (character), 204–5
film and film adaptations,
 13–14, 29, 30, 65–66,
 76, 80, 115, 258; see also
 specific films
Filthy, 386
Filthy Rich, 417
Fin, the (character), 73
Final Crisis, 382
Finder, 376
Finding Peace, 360
Finger, Bill, 51, 60, 62, 156, 226
Fingerman, Bob, 315
Fing Fang Four, 391
Fink, Jess, 418
Finkelstein, Max, 73
Fire: A Spy Grahic Novel, 343
First Amendment, 128
First Comics, 267
First Golden Book of God,
 The, 183
First Kingdom, The, 245, 251
Fisher, Bud, 16, 19, 34, 36
Fisher, Ham, 34
Fishtown, 367
Five Card Nancy (character),
 349
Fixer, The, 347
Flakey Foont (character),
 188, 314
Flame, the (character), 51
Flaming Carrot, 352
Flapper Fanny, 22
Flash, The, 308, 322
Flash, the (character), 53, 54,
 63, 82, 154, 171, 289

Flash Gordon, 31, 51, 60, 155,
 245
"Flashlight Gordon," 207
"Flash of Two Worlds," 171
Flattop (character), 29
Fleener, Mary, 350
Fleischer Studios, 23, 50–51,
 71, 148, 151, 153
Fleming, Ann Marie, 423
Flip, 135
Flood!, 350
Floyd, George, 439, 444
Floyd, Pretty Boy, 29
Flyin' Jenny, 78
Flynn, Errol, 75
Foglio, Kaja, 376
Foglio, Phil, 376
Fogtown, 417
folk elements (folklore, folk-
 tales), 199, 247, 269,
 304, 311, 336, 365, 366,
 368, 372, 387–88, 408
Fonda, Peter, 169
Fontaine, Jane, 177
Foo, 144
Foolbert Sturgeon (pseud-
 onym), 184
FOOM, 167
For a Night of Love, 94
For Better or for Worse, 322, 323
Forbidden Love, 94
Ford, Henry, 25
Ford, John, 258
Forever People, 232
Forney, Ellen, 421, 423
Forsman, Charles, 409
Forsythe, Matthew, 372
Fortress of Solitude (Lethem),
 355
Fort Thunder Collective, 354
Foster, Harold "Hal," 29,
 30, 172
4chan, 435
Four Methods of Flush Riveting
 (film), 80
Four Students Comic, The, 214
"Fourth Ward Brownies,
 The," 6
Fourth World, 232
Fox, Gardner, 155–56, 171, 226
Fox, Victor, 104
Fox, Vincent, 52, 59
Foxy Grandpa, 12–13, 40
Fraction, Matt, 422
France and French comics,
 76, 256–58, 298, 322
Frank (character), 349

Frank, Anne, 131, 257
Frank, Josette, 112–13, 120
Frank Castle (character), 286
Frankenstein (Shelley), 105
Frank Leslie's Budget of Fun, xv
Frank Leslie's Illustrated News-
 paper (Leslie's Weekly), xv
Franklin (character), 224
Franklin, Benjamin, xiii–xiv, 5
Franklin, Rosalind, 366
Frank Merriwell's School Days,
 29
Frank Redrum (character), 29
Frannie Frightenedfaun
 (character), 207
Frazetta, Frank, 271
Free Comic Book Day, 370
Freelance, 267
Free Speech Movement, 186
Freewheelin' Frank (charac-
 ter), 197
French, Renée, 369, 385
Frenzy, 135
Freud, Sigmund, 15, 116
Frezno Funnies, 221–22
Friday Foster, 224
Friedman, Drew, 351
Friedrich, Gary, 382, 411
Friedrich, Max, 241–42
Friends (TV show), 315
Fritzi Ritz, 23
Fritz the Cat, 194–95
From Hell, 341
Frontline Combat, 109
Front Page, 105
"Fuck Books," 45, 206
"Full Hands, Empty Heart,"
 228
Fu Manchu (character), 32, 225
Fun Home, xix, 363–64, 365,
 369
Fun House, The, 315
Funnies, The, 41
Funnies Inc., 73
Funnies on Parade, 41
funny animal comics, 81
Funny Aminals, 279
Funny Pages, The, 369
Fun with Milk and Cheese, 352
Furie, Matt, 435
Fussell, Tucky, 362
Futurians, 44
FYOVs, 311

Gable, Clark, 48
Gabriel, David, 438–39
Gabrych, Anderson, 417

Gadot, Gal, 437
Gaiman, Neil, 293, 334–38,
 340, 349, 374
Gaines, Bill, 95–98, 104–5,
 108–11, 116, 117, 122–24,
 129–36, 141, 144–46,
 195, 271, 342
Gaines, Maxwell Charles
 (M. C. "Max"), 41–42, 45,
 49, 53, 55, 72, 89–90, 95
Galactic Federation, 133
Galactus (character), 174, 391
Galaxy, 152
Gale, Dorothy, 418
Gale Allen and her Girl
 Squadron, 58
Gallagher, Fred, 376
Gallup, George H., 87
Gallus Coon, The, 32
Gamergate, 440
Ganzfeld, The, 391
Garfield, 377, 392
Gasoline Alley, 26, 32–33, 45,
 51, 79, 170
Gaston (character), 13
Gay, Roxane, 438
gay comics, 316–17; see also
 LGBTQ+ comics and
 readers
Gay Comix, 319–20
Gay Community News, 321
Gaydos, Michael, 384
Gay Ghost, the (character), 52
Gaylord Phoenix, 386
Geary, Rick, 346
Gebbie, Melinda, 248, 418
Geek, the (character), 231
Geeks for CONsent, 405
Geerdes, Clay, 283–84
Geezer (character), 61
Geiser, Dave, 201–2, 206,
 216, 218, 251
Gellar, Sarah Michelle, 309
Gen13, 303, 373
gender diversity, 395, 402
General Thunderbolt Ross
 (character), 164
Generation Z, 397
Generation Zero, 276
Genjii: The Conjurers' Maga-
 zine, 175
Gen of Hiroshima, 259–60
Gentleman's Agreement (film),
 132
GeoCities, 374
Georgia, 329
Geppi, Steve, 297, 306

Gerber, Steve, 242–43, 246,
 270
Gerhard Schnobble (charac-
 ter), 67
German-American Bund, 71
German Expressionism, 66
Gernsback, Hugo, 28, 44
Gertrude's Follies, 320
Get Lost, 135
"Ghost Gallery," 105
Ghostopolis, 408
Ghost Rider (character), 411
Ghost Rider (film), 233
Ghosts, 431
Ghost Stories, 105
Ghost World, xix, 313–14, 378,
 388
Ghoul Tales, 232
GhouLunatics, 105–6, 108,
 167, 193, 351
G.I. Bill, 148
G.I. Combat, 203
G.I. Comics, 80
G.I. Joe, 110, 307
"G.I. Shmoe," 135
Giamatti, Paul, 378
Giant Robot Warriors, 359
Gibbons, Dave, 295–96, 310,
 344, 443, 444
Gibson, Walter Brown, 43
"Gift of the Magi, The"
 (O. Henry), 67
Gilbert, Michael T., 251
Gilberton (publisher), 129
Gillen, Kieron, 402
Gilliam, Terry, 150
Gillray, James, xiii
Gilman, Charlotte Perkins,
 5, 56
Gimpel Benish (character), 35
Giordano, Dick, 235, 289, 294
Giraud, Jean, 258; see also
 Moebius
Girl-A-Matic, 400
Girl Comics, 395
Girl Genius, 376
girlie magazines, 46
Girls, 414–15
Girl Stories, 425
"girl strips," 22–23, 34
Girltalk, 326
Give Me Liberty, 344
Give Me Liberty! A Revised
 History of the American
 Revolution, 345
Gizmodo, 382
GLAAD, 322

Gladiator (Wylie), 47
Gladstone Gander (character),
 101
Glanzman, Sam, 246
Gleason, Lev, 102–4, 117
Glenn Ganges (character), 387
Gloeckner, Phoebe, 282–83,
 325, 425
Gloomy Gus (character), 13
Glover, Donald, 397
Goddard, Morrill, 3, 4, 8
Godfather, The (film), 341
God Nose (Snot Reel), 184
"God Paper Dolls," 211
Gods' Man (Ward), 147
Goethe, Johann Wolfgang
 von, xiv
Goetz, Bernie, 286
Going Steady with Peggy, 97
Goldberg, Rube, 36
Golden Age of comics, 63,
 154, 170, 172, 237, 304,
 335, 381
Golden Vine, The, 429
"Goldie: A Neurotic Woman,"
 211, 216
Goldstein, Sophie, 417
Goldwater, John L., 139
Goldwater, Jon, 395, 396
Golem's Mighty Swing, The,
 346–47
Gomgatz (character), 35
Gonick, Larry, 345
"good girl art," 57–58, 82
"good girl" comics, 119
"good guy" stereotypes, 76–77
Good Jive Comix, 207
Goodman, Martin, 73, 75–76,
 81, 93, 149, 158, 160–61,
 165, 237
Goodman Beaver (character),
 149
Goodman Brown (character),
 149
Good News, The, 427
Good Talk, 433
Goodwin, Archie, 249, 276
Goon, The, 413
Gordo, 33–34
Gorer, Geoffrey, 90–91
Goscinny, René, 258
Gotham (fictional city),
 62–63, 286
Gotham Central, 420
Gothic Blimp Works, 186
Gould, Chester, 26–29, 267
Gould, Jay, 3

Gould, Will, 26
Goya, Francisco, xiii
Grandma Duck (character), 100
Grant, Ulysses S., xvi
Grant Gardner (character), 152
graphic docudrama, 346
graphic novels, 146–49, 250–52, 272–73, 300, 304, 330, 342, 372–75, 405–7, 418, 423–24, 432
Gray, Harold, 24–25
Gray, Thomas, xiii
Great Asia Comic Strip Study Society, 89
Great Britain, 89, 125, 274, 291
Great Comic Book Heroes, The (Feiffer), 181
Great Depression, 24–25, 28–29, 35, 38, 43, 47, 59, 69, 147
Greatest Generation, 79, 91, 177, 204, 246
Great Recession, 390
Great War, see World War I
Greece, ancient, xii
Greek mythology, 64
Green, Jason, 310
Green, Justin, 207, 214–18, 238, 240, 246, 315, 366
Green, Richard "Grass," 194, 207, 218–19
Green Arrow, 412
Green Arrow (character), 152, 226, 227, 229, 231
Greenberger, David, 367
Greenberg the Vampire, 273
Green Goblin (character), 306
Green Lantern, 226–27, 243
Green Lantern (character), 53, 54, 154, 155, 157, 161, 171, 179, 226–28, 330, 333
Green Mask, the (character), 52
Gregory, Roberta, 213, 318
Gregory Gallant (character), 315
Grell, Mike, 246, 267, 330
Grell, Sharon, 246
Griffin, John Howard, 228
Griffin, Rick, 174, 186, 189, 199, 201, 202, 259, 348, 427
Griffith, Bill, 193–94, 239, 278–80, 424
Griffith, Nancy, 194

Grim Wit, 193
Groening, Matt, 283–84
Groo the Wanderer, 270
Gropper, William, 147
Gross, Milt, 36, 136, 147, 148, 240
Groth, Gary, 252
Groyser Kundes, Der, 35
Gruskin, Ed, 82
Guardian, 355
Guardians of the Galaxy (comic and characters), 246, 436
Guardians of the Galaxy (film), 411
Guéra, R. M., 417–18
Guernica, 386
Guerra, Pia, 331
Guess Who's Coming to Dinner (film), 174
Guevara, Che, 177
Guggenheim Fellowship, 300
Guillory, Rob, 419
Gulf Comic Weekly, The, 41
Gulf Oil, 41
Gulledge, Laura Lee, 425
Gumps, The, 18–19, 21, 24
Gunfighter, 96, 104
Gunnerkrigg Court, 408
Gunsmoke (TV show), 140
Gurewitch, Nicholas, 377
Guts, 431–32
Gwen Stacy (character), 306
Gyro Gearloose (character), 101

Habibi, 429
Hachtman, Tom, 320
Hack, Robert, 434
Hugo, Nubile, 328–29
Haight-Ashbury (San Francisco), 186, 188, 196
Hairbreadth Harry, 14, 32
Hajdu, David, 103
Hal Jordan (character), 154, 157, 227
Hamilton, Edmond, 58, 152, 155
Hand, August, 52
Hand, Learned, 65
Haney, Bob, 164
Hank, 90
Hankiewicz, John, 386
Hanks, Fletcher, 52, 85
Hansen, Doug, 221–22
"Hapless Hero, The," 180
Happiness Is a Warm Puppy, 202–3

Happy Hooligan, 13, 216
hardbound editions, 304
Hardware, 328
"Hard Work and No Fun," 216
Hardy Boys, 375, 414
Haring, Keith, 386
Hark! A Vagrant!, 402
Harkham, Sammy, 391
Harlem (New York City), 397
Harlequin romances, 375
Harley Quinn (character), 384
Harlot's Progress (Hogarth), xiii
Harold Teen, 25, 36, 58, 63
Harper, Fletcher, xvi
Harper's Weekly, xvi, xvii, 1
Harrington, Ollie, 33
Harrison, Benjamin, 2
Harrow County, 414
Harry Block (character), 345
Harry N. Abrams (publisher), 378
Harry Osborn (character), 230
Harry Potter (character), 408
Hart, Tom, 421, 425
Harvard Club, 55
Harvard University, 73
Harvey (publisher), 111, 140
Harvey Award, 377
Harvey Kurtzman's Jungle Book, 146
Harvey Pekar (character), 246–48
Haspiel, Dean, 411
Hassler, Alfred, 173
"Hate," 131
Hate Comics, 313
Haugse, John, 422–31
Haunt of Fear, The, 104, 130
Haunt of Horror, 232
Haverhill, Mass., 58
"Hawaiian Getaway," 388
Hawk, the (character), 231
Hawkeye (character), 397, 422
Hawkman (character), 54, 83, 155, 171, 364
Hawks, Howard, 258
Hawthorne, Nathaniel, 149
Hayes, Rory, 192–93
Hays, Ethel, 22
Hays Code, 110
Hazed, 408
HBO, 444
"headlight comics," 57–58
Headline Comics, 103
Headquarters Detective: True Cases from the Police Blotter, 118

Headrack (character), 319
Heap, the (character), 292
Hearst, William Randolph,
 7–10, 16–17, 21, 22,
 27–28, 40, 45, 195
Hearst syndicate, 10–11, 14,
 16, 27; *see also* King
 Features Syndicate
Heartburst, 273
Heart of Darkness (Conrad), 428
Heath, Russ, 140
Heavy Liquid, 422
Heavy Metal comics, 259,
 272, 310
Heck, Don, 162
He Done It Wrong (Gross), 147
Hefner, Hugh, 145, 149, 178,
 188, 190
Heinlein, Robert, 155, 211
Held, John, Jr., 22
Hellblazer, 341
Hellspawn (character), 327
Help!, 150, 183–85, 240
Hembeck, Fred, 352
Hemingway, Ernest, 38
Henderson, Mike, 414
Henrickson, Robert, 121–22
Henry, O., 67
Henry Holt (publisher), 372
Herbie Popnecker (character),
 177
Hercules, 398
"Here," 349
Hereville, 407–8
Hergé, 256–57
Herland, 56
Hernandez, Gilbert ("Beto"),
 313, 339
Hernandez, Jaime, 369
Hernandez, Mario, 269
Hernandez brothers, *see* Los
 Bros Hernandez
Heroes World, 306
Hero Initiative, 411
Herold, Lee Adam, 415
Herriman, George, 20–21, 23
Hersey, John, 131
Hershfield, Harry, 35–36
"Hester's Little Pearl," 351
heterosexual marriage, depic-
 tion of, 98
Hey, Kiddo, 431
"Hey Look!," 134
Hi and Lois, 211
Hickman, Jonathan, 416, 422
*Highlights of American His-
 tory*, 88

Highsmith, Patricia, 76
"High Society," 243–44
Highwater Books, 354
Highwayman, The, 415
Hill, Joe, 25, 414
Hillman (publisher), 93
Hillsdale, Mich., 118
Hines, Adam, 389
hippies, 186, 195, 197, 199–
 200, 219, 231, 251
Hiroshima, 259–60
His Name Is . . . Savage, 249
Hispanics and Hispanic
 comics, 268–69, 329,
 396–97
History of the DC Universe,
 289
History of Violence, A, 342
*Hitchhiker's Guide to the Gal-
 axy* (Adams), 334
Hitler, Adolf, 67–68, 70, 72,
 77, 78, 83, 122, 204, 352
Hobbs, Eric, 417
Hobie Brown (character), 225
Hogan's Alley, 4–6, 8, 14
Hogarth, Burne, 30
Hogarth, William, xiii, 146
Hokusai, 260
Holden Caulfield (character),
 162
Holkins, Jerry, 376
Holland, Debbie, 248
Hollywood, 35, 62, 113, 247,
 307, 351
Holmes, Sherlock, 28
Holocaust, 131, 251, 263, 279,
 297–99, 301, 364, 423
Holocaust (TV miniseries),
 297–98
Home Grown Funnies, 192
Homeless Hector, 35
Homer, 245, 428
homosexuality and homoerot-
 icism, 119, 229; *see also*
 LGBTQ+ comics and
 readers
Hong Kong Cholly (charac-
 ter), 32
Honor Girl, 426
Hoover, J. Edgar, 28, 102, 128
Hope, Bob, 140
Hopper, Frances, 83
"Hoppers," 269
Hoppy the Marvel Bunny
 (character), 82
Hopwood, Avery, 51
Hornschemeier, Paul, 385

Horrilor (character), 193
horror and horror comics, 92,
 104–9, 111–13, 121–26,
 129–30, 132, 134, 144,
 159, 160, 192–93, 232–
 33, 236, 257, 292, 294,
 334, 341–43, 348, 351,
 387, 413–14, 418, 433
Horror Stories, 105
Horror Tales, 232
Horror Writers of America,
 355
Horton (character), 73
Hosler, Jay, 365
Hot Dog (character), 414
Hothead Paisan, 323, 324, 326
Hotsky Trotski (character), 151
Hot Wire, 321
Houdini: The Handcuff King,
 366–67
Houghton Mifflin (publisher),
 369
Hourman (character), 54
House of Mystery, 159, 233, 334
House of Secrets, 233
House of Women, 417
House Un-American Activi-
 ties Committee, 117
Howard, Robert, 233–34
Howard Crankwood (pseud-
 onym), 207
Howard the Duck, 242–43,
 246, 249, 355–56
Howard the Duck (character),
 270
Howdy Doody Show, The (TV
 show), 143
"How Green Was My Alley,"
 107
How to Draw Funny Pictures
 (Matthews), 33
H2O, 416
Hubbell, Virginia, 103
"Huey and Eldridge," 206
Hugo Award, 376
Huizenga, Kevin, 387, 391
Hulk, the (character), 163–64,
 168, 170, 242
Hulk, The (comic), 291, 319
Hulk, The (TV show), 254
Human Target, 332
Human Torch, the (charac-
 ter), 73, 74, 76, 151, 161
Humbug, 145–46, 188
humor, 167
Hunchback of Notre Dame, The
 (Hugo), 105

Hungry Bottom Comics, 426
Huntress (character), 331
Hurricane Katrina, 365
Hurtt, Brian, 418
Hydrogen Bomb and Biochemical Warfare Funnies, 203–4
Hyme Putz Presents You Nazi Man, 78

Icahn, Carl, 307
Iceman (character), 399
Ice Storm, The (Moody), 355
I Ching (character), 229
Icon (character), 328, 329
Identity Crisis, 330–31
IDW, 392, 413, 432
Iger, Jerry, 59, 65, 71
Ignatz Awards, 375
Ignatz Mouse (character), 20
Illinois, 17
Illustrated Harlan Ellison, 250
Illustrated News, xv
I Love You, 94
Image Comics, 302, 303, 348, 373, 374, 390, 399, 413
Image Expo, 400
immigrants, xvii, 1–2, 7, 9, 13, 17
Impact, 131
imperialism, 101, 257, 440
In Cold Blood (Capote), 103
Incredible Mr. Limpet, The (film), 268
Incredibles 2 (film), xix
Incredible Science Fiction, 132
Incredible Shrinking Man, The, 155
Independent News, 46
India, 257
Indianapolis, Ind., 118
"Indian Love Call," 97
Indonesia, 257
Industrial Worker, 25
I Never Liked You, 314
Infantino, Carmine, 231
Inferior Man (character), 82
Infinite Horizon, The, 428
Infinite Typewriters, 377
Ingels, "Ghastly" Graham, 108
inner-city locales, 228–29, 291
Inner City Romance, 219
Inner Sanctum (radio program), 105
Insect Fear, 197

Insect Queen (character), 157
Inspector Javert (character), 52
International Comics, 104
International Crime Patrol, 104
internet, 375–76, 378, 402, 405, 444
In the Night Kitchen (Sendak), 372
Invaders, The, 237
Invasion of the Saucer Men (film), 160
Invisible Kid, the (character), 161
Invisibles, The, 342
Invisible Woman, the (character), 352
Iran-Contra scandal, 345, 346
Iraq, 359
Irish Americans, xviii, 2
Iron Circus Comics, 442
Iron Fist (character), 225, 436
Iron Man (character), 164, 175
Iron Man (film), 409
Iron Man 3 (film), 411
Irons, Greg, 200–201, 204
Irving Forbush (character), 136
isolationism, 25, 70, 72
issue numbering, comic-book, 96
It Ain't Me Babe, 209–11, 214
Italy, 257
It Really Happened, 87
It Rhymes with Lust, 148, 149
It's a Bird, 420
It's a Bird, It's a Plane, It's Superman (play), 179
It's a Good Life If You Don't Weaken, 314–15
"It's a Woman's World," 158
It's Love, 94
Itto Ogami (character), 261
iTunes, 392
Iva Crustycrotch Presents Betty Boop in Flesh, 45
Ivory soap, 6
"I Was a Teen-age . . . Hippie!," 199–200
I Was Seven in '75, 423
IWW, 201

Jack Carter (character), 341
Jack Lockwill's Adventures, 29
Jack Russell (character), 233
Jackson, Andrew, xvii

Jackson, Jack "Jaxon," 184, 190, 345–46
Jack the Ripper, 341
Jacob, Mira, 433
Jacobs, Jesse, 386, 434
Jacobs, Ken, 279
Jacobson, Sid, 224, 365
Jacquet, Lloyd, 60
Jaffee, Al, 81, 82, 145
James Bond (character), 175, 176, 178, 249, 415
James Sturm (character), 420
Jane Eyre (Brontë), 428
Jane Grey (character), 306
Jane's World, 323
Jan Haasan (character), 76
Jantze, Michael, 376
Jantze, Nicole, 376
Japan and Japanese comics, xii, 89, 256, 259–62, 264, 275, 322, 343, 374, 439; *see also* manga
Japanese characters, 76–78, 214–15
Jap-Buster Johnson, 76
Jason Todd (character), 311
J.C. Penney, 307
Jean Dupuis (publisher), 256
Jean Grey (character), 263–64, 288
Jean Loring (character), 157
Jefferson Worthington Sandervilt (character), 76
Jemas, Bill, 374
Jenny Sparks (character), 344
Jensen, Jeff, 367
Jericho (character), 225–26
"Jerry Mack," 320
Jersey Gods, 419
Jessica Jones (character), 384, 436
Jesus, xii, 183–84, 203
Jew Gangster, 364
Jews and Judaism, xii, 35–36, 68–70, 83, 131–32, 184, 251, 263, 273, 284, 346–47, 364, 389, 407–8; *see also* anti-Semitism
Jiggs, 140
"Jiggs and Maggie," 17, 93, 135
Jimbo, 277, 285
Jimmy Corrigan, xix, 350–51, 355–56
Jimmy Olsen (character), 75, 191, 293
Jimmy Olsen (comic), 231

Jimmy Wells (character), 37
Jingle Jangle Comics, 81
Jiz Comics, 207
Joanie (character), 320
Joanie Caucus (character), 248
"Joe Blow," 220–21
Joe Chill (character), 153
Joe Dope (character), 240
Joe Palooka, 25, 34, 91
Johansson, Scarlett, 401
John Bull's Progress (Gillray), xiii
John Donkey, xv
John Henry Irons (character), 327
Johnny the Homicidal Maniac, 415
Johns, Jasper, 140
Johnson, Crockett, 100
Johnson, Kenneth, 254
Johnson, Lyndon, 177
Johnson, Mat, 365
Johnson, Tor, 351
John Stewart (character), 227
Johnston, Lynn, 322
John Wanamaker (brand), 41
Join, or Die, xiii–xiv
Joker, the (character), 60, 151, 235, 287, 309, 311, 332, 381, 440
Joker Comics, 81
Jolly Bean Eaters, The, 33
Jolly Joker, xv
Jones, Sabrina, 325–26
Jong, Erica, 194, 281–82
Jon Sable, 267
Jor-El (character), 69
Josie and the Pussycats, 382
Josie and the Pussycats (characters), 396
Jouflas, Ted, 386
Journal of Educational Sociology, 87
"Journal of Occurrences, The," 10
Journal of Popular Culture, 252
Journal Pour Rire, 256
Journey, 269
Journey into Mystery, 159, 160
Joyce, James, 20
Judge, 2, 3, 9
Judge Dredd, 291, 292
"Judgment Day!," 132–33
Jughead (character), 58
Juicy Mother 2, 426
Julius Caesar, 73

Julius Schwartz (character), 352
Jumbo Comics, 58, 105
Jungle Action, 225
Jungle Book, 149
jungle comics, 57–58, 73, 119, 127, 173, 225
Junior Justice Society, 85, 113
Justice Battalion, 78
Justice Inc., 344–45
Justice League of America (comics and characters), 155, 160–61, 166, 171, 179, 226, 227, 234, 330–31, 335, 344
Justice Society of America (comics and characters), 54, 57, 65, 74, 78, 90, 94, 99, 113, 155, 169, 171
juvenile delinquency, 113–16, 118, 121–22, 125, 128–30
J. Wellington Wimpy (character), 45

Kafka, Franz, 428
Kahn, Jenette, 266, 272, 289
Kaijumax, 439
Kakutani, Michiko, 300
Kalesniko, Mark, 401
Kamala Khan (character), 399, 400
Kamen, Jack, 108
Kamentsky, Gina, 426
Kane, Bob, 51, 60
Kane, Gil, 154, 249, 250, 259
Kang, Jeevan, 416
Kanigher, Robert "Bob," 157, 203
Kanter, Albert, 88
Karasik, Paul, 388
Karloff, Boris, 53
Katchor, Ben, 284, 355
Kate Bishop (character), 397
Katy Keene (character), 99
Katy Keene Glamour, 99
Katy Keene 3-D, 99
Katz, Jack, 245, 251
Katzenjammer Kids, 9–10, 12–14, 21
Kaufman, Irving R., 142
Kavalier (character), 68, 355–56
Kavanaugh, Brett, 441
Kaye, Julia, 426
Ka-Zar (character), 73
K-Bar Kate (character), 95
Keaton, Russell, 78

Keenan, Joseph, 29
Kefauver, Estes, 121, 123–24
Keller, Katherine, 403
Kellett, Dave, 377
Kelly, Walt, 122, 143
Kelso, Megan, 387
Kennedy, Howard W., 118
Kennedy, Jackie, 178
Kennedy, John F., 177, 203
Kent Lark (character), 207
Kent State shootings, 220
Ketcham, Hank, 122
Kevin Keller (character), 396, 398, 426
Kibuishi, Kazu, 408
Kickstarter, 393, 400, 429
Kid Colt (character), 94
Kidder, Margot, 254
Kid Eternity (character), 52
Kid Gloves, 432–33
Kid Miracleman (character), 330
Kid Sister, The, 23
Kieth, Sam, 308
Killers, The, 342
Killing Joke, The, 332
Kill Them All, 418
Kin-Der-Kids, The, 15
King, 346
King, Frank, 26
King, Martin Luther, Jr., 172–73
King, Stephen, 107, 387, 415, 418
King, Tom, 434
King Comics, 45
Kingdom Come, 333
King Features Syndicate, 10–11, 19, 21–23, 45, 80, 101, 257, 376
King in Yellow, The (Chambers), 5
Kings in Disguise, 347
Kinney, Jay, 193, 283
Kinney, Jeff, 378
Kinney Corporation, 237
Kinney Shoes, 41
Kinsey Report, 98
Kirby, Jack, 61, 70–71, 74, 76, 80, 93, 97, 103, 136, 151, 155, 159–65, 168, 169, 171–74, 177, 186, 224, 231–32, 236, 243, 249, 263, 267, 268, 270–71, 291, 302, 338, 342, 348, 352, 355, 369, 380, 382, 409, 411, 430, 438
Kirby, Robert, 425–26
Kirchner, Paul, 300

Kirkman, Robert, xix, 306, 413, 420, 436, 441
Kitchen, Alexa, 372–73
Kitchen, Denis, 189–92, 194, 199–200, 213, 223–25, 238–41, 297, 303–4, 345, 372
Kitchen Sink Comics, 303–4, 307
Kitty Pryde (character), 263
Kiyama, Henry, 214
Klaw (character), 173
Kleid, Neil, 389
Klein, Calvin, 99
Knisley, Lucy, 432–33
knock-knock jokes, 36
Knox, Frank, 78
Knuckles (character), 76
Koch, Kenneth, 278
Kochalka, James, 360–61, 376
KOF, 167
Koike, Kazuo, 261
Kojima, Goseki, 261
Kominsky, Aline, 211, 216, 218, 246, 251, 281, 283, 324, 350
Koppy McFad (character), 82
Korean War, 110, 203
Kornbluth, C. M., 90
Krahulik, Mike, 376, 402
Kramer's Ergot, 391
Krassner, Paul, 195, 239–40
Krazy Kat, 20–21, 257
Krazy Komics, 81
Krigstein. Bernard, 131–32
Kristy's Great Idea, 407
Krosoczka, Jarrett, 431
Kruppcards, 319
Krupp Comics, 213, 319
Krypton and kryptonite, 83, 152, 153, 171, 228, 274, 293, 327
Kubert, Joe, 120, 203, 347–48, 364
Ku Klux Klan, xvii
Kundera, Milan, 388
Kuper, Peter, 276–77, 284, 350, 355, 357, 428
Kupperman, Michael, 352
Kurosawa, Akira, 265
Kurtzman, Harvey, 109–10, 117, 134–37, 141, 144–46, 149–50, 177, 183–85, 188, 236, 240, 258, 280, 313, 359–60
Kuttner, Henry, 58
Kyle, Richard, 146

Ladies' Home Journal, 12, 119
Lady Death (character), 303
Lady Luck (character), 65
Lady Rawhide (character), 303
LaGuardia, Fiorello, 71
Lana Lang (character), 157, 293
Lang, Fritz, 66
Lang, Howard, 113
Lansing, Ill., 296–97
Lapham, David, 343
Lark, Michael, 416, 420
Larsen, Erik, 374, 390
Larson, Gary, 351–52
Larson, Hope, 386
Lash, Batton, 354
Last Airbender, The, 401
Last Gasp Ecofunnies, 211, 213, 282
Latimer, Dean, 186
Latinx characters, 396–97; see also Hispanics and Hispanic comics
Latour, Jason, 417
Laura Dean Keeps Breaking Up with Me, 433
Lawrence, Jennifer, 401
LA Weekly, 300
lawsuits and court cases, 65, 270, 296–97, 381–82, 411–12; see also Supreme Court
Lay, Carol, 325
Layman, John, 419
Layton, Bob, 265
League for the Improvement of the Children's Comic Supplement, 12
League of Nations, 72
Lear, Norman, 282
Leary, Timothy, 175, 239–40, 309
L'Echo des savanes, 258
Ledger, Heath, 381
Lee, Bruce, 225
Lee, Cinqué, 327
Lee, Harriet E., 86–87
Lee, Jim, 302
Lee, Pinky, 140
Lee, Spike, 327
Lee, Stan, 68, 75, 81, 93, 99, 134–36, 151, 158–72, 174–77, 191, 223–24, 226, 229–31, 237–41, 243, 250, 263, 270, 272, 278, 305–6, 355, 379–80, 382, 409, 430, 431

Leer, 135
Lefty Louie, 25
"Legendary Dope Famine of '69, The," 197
Legion of Super-Heroes, 155, 179–80, 228, 246
Legman, Gershon, 62, 112
Leipzig Academy, 147
LeisureTown.com, 376
Le Journal de Mickey, 257
Lemelman, Gusta, 423
Lemire, Jeff, 434
Lena the Hyena, 81
Lenny of Laredo, 186, 222
"Lenore Goldberg and Her Girl Commandos," 208–9
Leonard and Larry (characters), 320
lesbian comics (lesbian characters), 211, 318, 320–23, 321, 397, 418, 423; see also LGBTQ+ comics and readers
Lesbian Contradiction, 321
Leslie, Frank, xi, xiv, xv, 13
"Lester Gass, the Midnight Misogynist," 208
Lethem, Jonathan, 237, 355–56
letter columns, 166–67
Letterman, David, 247
Lev Gleason Publications, 102
Levitz, Paul, 252, 357, 372, 409–10, 444
Lewis, Jerry, 140
Lewis, John, 405–7
Lex Luthor (character), 154, 191
LGBTQ+ comics and readers, 316–24, 361, 398, 425–26, 439
Liberty Belle (character), 75
libraries, 87, 121, 373
Library of Classic American Comic Strips, 253
Library of Congress, 355, 431
Licensing Company of America, The, 180
Lichtenstein, Roy, 140
Lieber, Stanley, see Lee, Stan
Liebowitz, Jack, 46, 160–61
Liefeld, Rob, 301–3
Lieutenant Blueberry (character), 258
Lieutenant Flap (character), 224
Life magazine, 2, 7, 9, 22, 34, 81, 131, 178

Life Sucks, 415
Lights Out (radio program), 105
Ligotti, Thomas, 387
Like a Velvet Glove Cast in Iron, 313
Li'l Abner, 34, 91
Li'l Bad Wolf (character), 100
Li'l Folks, 143
Lilies of the Field (film), 174
Liliuokalani, Queen, 345
Lincoln, Abraham, xvi
Lindelof, Damon, 412
Lindsay, John, 231
Linkin Park, 403
linocuts, 147–48
lithography, xiii
Little Annie Fanny, 149–50
Little Bears, 6
Little Firefly (character), 97
Little Jimmy, 40
Little Lotta, 140
Little Lulu, 100, 140, 210, 351
Little Nemo, 277, 348
Little Nemo in Slumberland, 14–16, 18, 32
Little Orphan Annie, 24–25, 44, 45, 149, 298, 394, 444
Little Orphan Annie (character), 72, 354
Little Orphan Annie's Junior Commandos, 84
"Little Orphan Melvin," 135
Little Red Songbook, 25
Liu, Marjorie, 434
Lloyd, David, 379
Lloyd Llewellyn (character), 313
Locke & Key, 414
Lockheed Aircraft, 80
Loco, 135
Loeb, Jeph, 383
Logan's Run (film), 248
Lois and Clark (TV show), 308
Lois Lamebrain (character), 207
Lois Lane (character), 54–55, 100, 135, 153, 166, 170, 191, 228, 254, 289, 330
Lois Lane, Girl Reporter, 55
Loki (character), 398
Lomax, Don, 360
"Lonely One, The," 131
Lone Ranger, 71, 94, 134
"Lone Stranger!," 134
Lone Wolf and Cub, 261

"Long Distance," 388
Lookin' Fine, 228–29
Look magazine, 72
Looney Tunes and Merrie Melodies, 81, 141
Lord of Death, the (character), 77
Los Angeles, Calif., 209
Los Angeles County, 118–19
Los Angeles Free Press, 186
Los Angeles Times, 374, 410
Los Bros Hernandez, 268–69, 355, 421
Losers, The, 359
Lost Girls, 418
Loubert, Deni, 244
Louis Philippe, King, xiii
Love, Jeremy, 365
Love and Rockets, xix, 269, 291, 323
Love and Romance, 94
Lovecraft, H. P., 53, 152, 342, 387
"Love Glut," 94
love interests, xviii, 127, 157, 263
"Love Story to End All Love Stories, The," 96
Love Trails, 94
Lower East Side (New York City), 70–71, 162, 350
Lowlife: Seedy Existential Stories of Real Life, 343
LSD, 175, 198–99
Lucas, George, 248–49
Lucasfilm, 403
Luce, Ed, 418
Lucky, 361
Lucky Fights It Through, 134
Luke Cage (character), 233, 328, 436
Luke Hanley (character), 95
Lulu: The Life of the Party, 45
Lumberjanes, 408
Lumet, Sidney, 132
Luna Brothers, 414–15
Lupoff, Dick, 235
Lutes, Jason, 366–67, 388–89
Luther, Martin, xii
Lyn (character), 316
Lynch, Jay, 189

Maakies, 352
MacDonald, Heidi, 404
MacGruder, Aaron, 354
MacMurray, Fred, 63
Madden, Matt, 417, 421

Maddux, Bob, 297
Made in the U.S.A., 125
Madhouse, 135
Mad magazine, 80, 82, 134–37, 139–42, 144–46, 149, 177, 178, 182–83, 188, 189, 193, 195, 213, 232, 268, 281, 282, 291, 441
Mager, Gus, 13
"Magic and Loss," 333
Magician's Wife, The, 304
Magic School Bus, 362
Magic Whistle, The, 352
Magneto (character), 263
"Magneto and Titanium Man" (song), 169
Magnolia Petroleum Company, 88
Mail Order Bride, 401
mail privileges, 96
Mairowitz, David Zane, 428
Maisel, David, 380
Major Liberty, 75
Malcolm-10 (character), 229
Malki, David, 377
Mammoir, 362
Manara, Milo, 259
Mandarin, the (character), 176
Mandrake the Magician, 33, 36–37
Man-Eaters, 439
Man from U.N.C.L.E., The (TV show), 175
manga, 260–62, 265, 343, 373–76, 391, 401, 419, 429
Manhattan Project, 416
Manhunt!, 211–13
Manhunter, 384
Man in Black (character), 105
Mankoff, Bob, 441
Mann, Thomas, 116, 146
mannekensbladen, xiii
"Man of Bronze, The," 43
Mansfield, J. Carroll, 88
Man-Thing (character), 292
Mantlo, Bill, 253, 411
Mapleleaf (character), 322
Marbles, 423
March, xix, 431
Marchetto, Marisa Acocella, 362
"Marching Marvin," 186
Marder, Larry, 353
"Marge's Little Lulu," 100
marijuana, 197, 198, 200, 221, 423

Marjorie Morningstar (Wouk), 251
Mark Moonrider (character), 249
Marks, Steven, 221
Marla Drake (character), 57
marriage, depiction of, 98
Marriage A-la-Mode (Hogarth), xiii
"Marriage à la Mode," 158
Marrs, Lee, 211, 213, 238, 271
Marschall, Richard, 272
Marshall, Thurgood, 116
Marston, Elizabeth, 55
Marston, William Moulton, 55–58, 157–58
Martha Kent (character), 153
Martha Washington (character), 344
Martian Manhunter, the (character), 155
Martin, Dean, 140
Martin, Marcos, 393
Martinek, Frank V., 78
Martin Luther King and the Montgomery Story, 172–73
Marvel Characters Group, 307
Marvel Chillers, 232–33
Marvel Cinematic Universe, 409
Marvel Comics, 73
Marvel Comics (publisher), 110, 136, 162–63, 165, 167–78, 180, 186, 223–33, 237–39, 241–43, 245, 246, 249, 253–54, 261–66, 270–73, 285, 287–92, 301–7, 310, 322, 323, 326, 333, 338, 340, 344, 352, 355–56, 358–59, 370, 371, 373–74, 376, 379–82, 384, 391–92, 395–400, 409–12, 415–16, 419–21, 430, 432, 434–39, 441–43
Marvelman, 296
Marvel Masterworks, 304
"Marvel Method," 162–63
Marvel Mystery Comics, 74, 99, 105
Marvel Pop Art Productions, 175
Marvels, 333–34
Marvels Channel: Monsters, Myths and Marvels, 391
Marvel Science Stories, 73

Marvel Studios, 412, 436
Marvel Superheroes, The, 253
Marvel Super Heroes Secret Wars, 288
Marvel Swimsuit Special, 323
Marvel Tales, 105
Marvel Zombies, 305, 306
Marvin, Lee, 338
Marx, Groucho, 244
Marx Brothers, 13
Mary Gold (character), 19
Mary Jane (character), 7, 437
Mary Jane Watson (character), 166, 305
Mary Kennedy (character), 104
Mary Marvel (character), 238
Mary Worth, 29
Masereel, Frans, 146, 147, 350
Masked Marvel, the (character), 51
Masked Meanie (character), 183
Masked Raider, the (character), 73
Massachusetts, 136
Massachusetts Independent Comics Expo, 442
Master of Kung Fu, 225
"Master Race," 131–32
Matheson, Richard, 154–55, 164
Matt, Joe, 315
Matthews, E. C., 33
Matt Murdock (character), 164–65, 169
Maud, Zuni, 35
Mauldin, Bill, 79–80
Maupassant, Guy de, 131
Maupin, Armistead, 321
Maurer, Norm, 120
Maus, 260, 279, 297–300, 315, 322, 329, 369, 388
Maverick (TV show), 140
Mavrides, Paul, 310
Max and Moritz (characters), 8–9
Maxx, The, 308
Mayans, xii
Mayer, Sheldon "Shelly," 45, 49, 50, 53–54, 56, 96, 214
Mazzucchelli, David, 290, 385, 388
McCarthy, Joseph, 143, 440
McCartney, Paul, 169
McCay, Winsor, 14–15, 23, 52, 150, 348, 428

McCloud, Scott, 262, 310, 322, 338, 349–50, 407
McClure Syndicate, 10–11, 45
McCool, Ben, 359
McDuffie, Dwayne, 327–28, 395
McFarlane, Todd, 302, 303, 307, 327, 412
McGregor, Don, 225, 226, 270
McGruder, Aaron, 358
McGuire, Richard, 349
McKean, Dave, 330, 335, 337, 349
McKelvie, Jamie, 402
McKenna, Aline Brosh, 428
McManus, George, 17, 19, 40, 240
McNeil, Carla Speed, 376
McNinch, Carrie, 362
McSnurtle the Turtle (character), 82
McWilliams, Alden Spurr, 173
M.D., 130
Mean Bitch Thrills, 208
Me & Joe Priest, 273
Meanwhile, 385
Medley, Linda, 416
"Meet the Squiffles," 77
Mega City One, 291
"Megalomaniacal Spider-Man," 421
Megatokyo, 376
Megaton Man, 352
Méliès, George, 348
Meltzer, Brad, 331
Melvin (character), 134, 141
Mencken, H. L., 2
Mendel's Daughter, 423
Mendes, Barbara "Willy," 186, 210
Mendoza, Paul, 397
Men in Black (film), 308
"Menses Is the Massage!, The," 212
merchandising, 6–7, 51, 180, 192, 253–54, 288, 307–8
Merely Margy, 22
Meshes of the Afternoon, 339
Meskin, Mort, 61, 94
Mesmer, Otto, 195
Messick, Dale, 100, 224
Messmer, Otto, 33
Messner-Loebs, William, 269
Métal Hurlant, 259
Metamorpho (character), 156

#MeToo movement, 441
Metropolis (fictional city) 66
Metzger, George, 200
MGM, 102, 128
Miami Vice (TV show), 267
Michael Malice (character), 247
Michel, Albin, 296–97
Michelinie, David, 265
Michigan Paper, 186
Mickey Mouse, 89
Mickey Mouse (character), 33, 81, 100, 195, 349
Mickey Mouse Magazine, 45, 81
Mickey Rat, 195–96
Micrographica, 385
Micronauts, 253, 307
Mighty Mouse, 140
Mignola, Mike, 342
Milady Sepia, 33
Mile High Comics, 310
Miles Morales (character), 397–98
Milestone, 328–29, 395
Military Comics, 76
Milkman Murders, The, 415
Milko-Malt, 41
Millar, Mark, 419, 436
Millarworld, 436
Miller (character), 131
Miller, Arthur, 116, 331
Miller, Frank, 261–62, 264, 265, 268–70, 273–75, 280, 285–87, 290, 296–97, 334, 343, 344, 379
Miller v. California, 221, 296
Millie the Model (character), 99
Milligan, Peter, 339, 420
Millionaire, Tony, 352
Mills, Tarpé, 56–57
Ming the Merciless of Mongo (character), 31
Minimum Wage, 315
Minnie Mouse (character), 45
minority characters, *see* nonwhite characters
Minute Movies, 14, 33, 60
Minx, 375
Miracleman, 330
Mirror, Window, 326
Mischievous Twins, The, 9
misogyny, 185, 208, 230, 244, 442
Miss America Comics, 75, 99
Miss Buxley (character), 209

Miss Fury, 56–57
Mission District, The, 268–69
Miss Lasko-Gross (character), 364–65
"Miss Lulu Moppet," 207–8
Mister Miracle, 434
Mitchell, Elvis, 369
Mitchell, Joni, 209
Mitchell Hundred (character), 359
Mitchum, Robert, 342
MLJ Comics, 58–59, 72, 75, 99; *see also* Archie Comics
MMMS, 167
Mnuchin, Steve, 435
Mobfire, 341
Mobile Comics Network, 376
mobile platforms, 392
Moby-Dick (Melville), 428
Mockingbird, 434
Modern Language Association, 252–53
Modern Love, 94, 96
"Modern Romance, A," 318
Moebius (pseudonym of Jean Giraud), 258–59, 275, 291
Moen, Erika, 361
Moench, Doug, 265
Moiseiwitsch, Carel, 386
Mole, the (character), 29
Mome, 391
Mom's Cancer, 362
Mom's Homemade Comics, 223, 240
Mondo Snarfo: Surrealistic Comix, 278
Monologues for Calculating the Density of Black Holes, 385–86
Monroe, Randall, 377
monster pictures, 160
Monsters Unleashed, 232
Monstress, 434
Montana, Bob, 58
Montreal, Que., 354
Monty Python's Flying Circus, 150
Moody, Rick, 355
Moon, a Girl . . . Romance, A, 96, 97
Moondog, 200
Moon Knight, 265, 266
Moon Mullins, 26, 32
Moonshadow, 296
Moorcock, Michael, 242, 270

Moore, Alan, 152, 291–97, 310, 330, 332, 335, 336, 337, 338, 340, 341, 346, 369, 418, 419, 443, 444
Moore, Nate, 437–38
Moore, Stuart, 359
Moore, Terry, 323, 384, 414
Moore, Tony, 413
morals and morality, xii–xiii, xviii, 9, 11–12, 23, 55, 86, 88–89, 95, 107, 109, 110, 118, 123–27, 130, 133, 138–40, 188–89, 257, 258, 276, 286–87, 297, 346, 347, 408, 431
"Morbid Sense of Humor" (Crumb), 206
Morbius, the Living Vampire, 233
More Fun, 44, 49
Moreno, Pepe, 276
Morgan, Henry, 141
Moriarty, Dave, 190
Moriarty, Jerry, 367
Mormons, 11
Morning Glories, 409
Morning Journal, 7, 8, 10, 11
Morrison, Grant, 232, 330, 339–40, 342, 383, 422
Mortal Kombat, 309
Moscoso, Victor, 186, 189, 198–99, 259, 348
Mosley, Walter, 381
motion, representation of, 30
Motley Food, 380
Mouly, Françoise, 278–80, 299, 372, 373
Mount Prospect, Ill., 118
Mouse Guard: Fall 1152, 372
Moustafa, Ibrahim, 377
movable type, xii
movies, xviii–xix
movie serials, 152, 170, 180
Mr. A (character), 188–89
Mr. Block, 25
Mr. Coffee Nerves (character), 104
Mr. Crime (character), 103–4
Mr. Jack, 195
Mr. Miracle (character), 232
Mr. Mxyzptlk (character), 151, 293
Mr. Mystic (character), 65
Mr. Natural (character), 187–88, 197, 314
Mr. Terrific (character), 63

"Mr. Toad and the Great Underground Comic Book Crisis," 239
Ms. magazine, 212
Ms. Marvel, 399
Ms. Marvel (character), 230
Ms. Tree (character), 267
MTV, 267, 317
Muhammad, Elijah, 249
Mumbles (character), 29
Mummy, The (film), 53
municipal codes, 115
Munro, 142, 348
Muradov, Roman, 386
Murder, Incorporated, 104
"Murder, Morphine and Me," 104
Murder by Remote Control, 300
Murphy, Charles F., 127–28, 133, 138–39
Murphy, Sean, 415
Murphy, Willy, 204
Murray, Doug, 343–44
Murrow, Edward R., 143
Musical Mose, 21
Muslim characters, 399
Mussolini, Benito, 89
mutants, 164, 401
Mutants, the (characters), 287
Muth, Jon J., 273, 296
Mutt and Jeff, 16, 19, 20, 33, 40, 60
My Chemical Romance, 422
My Date, 93
My Favorite Thing Is Monsters, 433
My Friend Irma, 99
My Love Story, 94
My Private Life, 94
Myra (character), 155
Mysta of the Moon (character), 58
mystery comics, 74, 99, 105, 159
Mystery in Space, 158

Naifeh, Ted, 408
Nailbiter, 414
Nakazawa, Keiji, 259
'Nam, The, 344
Namor (character), 73–74, 77, 151
Nancy, 23–24, 351
Nancy Drew (character), 375, 414
Nancy Hale (pseudonym), 97

Naps of Polly Sleepyhead, The, 15
Nard 'n' Pat, 189
Narrative Corpse, 349
Naruto, 374
Nast, Sarah, xviii
Nast, Thomas, xi, xiv–xviii, xx, 1, 2, 442
Nasty Tales, 291
National Allied Publications (National Periodical Publishers), 42, 44
National Association of Comics Art Educators, 369
National Association of Newspaper Circulation Managers, 11
National Book Award, 369, 406, 423, 431
National Cartoonists Society, 84, 100, 172, 326
National Geographic, 101
National Institute of Municipal Law Officers, 114
National Institutes of Health, 230
National Lampoon, 241, 248, 346
National Office of Decent Literature, 118
Native Americans (Native American characters), 79–80, 95, 97, 269, 270, 346, 353, 417–18, 429
Nativity in Black: A Tribute to Black Sabbath, 341
Nat Turner, 365
Nazis (Nazi characters), 67–68, 70, 72, 74, 76–77, 89, 90, 93, 116, 132, 159, 176, 257, 279, 298
NBC Nightly News, 289
NBM, 304, 375
Neat Stuff, 282
Nebula Award, 268
necrophilia, 111
Negro Heroes, 87
Neil the Horse, 353
Nellie the Nurse (character), 99
Nelson, Diane, 410, 432
Neri, G., 367
Nervous Breakdown, 268
Netflix, 435–36
Netherlands, 76

Neufeld, Josh, 365, 394
Neutralist, the (character), 189
Neven (character), 347
New Adventures of Batman, The, 289
New Age, 186
New Case Files, 414
New Comics, 44, 49
New Deal, 25
New Fun comics, 44
New Gods, 232
New Kid, 431
Newlyweds, The, 17
New Mutants, The, 288
New Orleans A.D., 365
Newsboy Legion, 76
New School, 66
Newsday, 124
Newsdealer magazine, 94
newspaper buying, 7
newspaper comics, 143
Newspaper Comics Council, 125–26
Newspaper Enterprises Association, 22
newspapers (newspaper industry), 1–3, 7–8, 10–12, 18, 32–35, 37, 44, 48, 50, 102, 125, 143, 172–73, 320, 355, 394–95
newsprint, 274
newsstands, 28, 42, 96, 114, 125, 192, 219
News Syndicate Company, 80
New Teen Titans, 265
New Trend, 111
New Wave, 291
New York American, 17, 21
New York Bookshop, 221
New York City, xiv, xvi, xvii, 1, 7, 18, 41, 43, 44, 71, 127–28, 136, 186, 221, 236, 238, 271, 285, 286, 350, 378, 428
New York Comic-Con, 404
New York Daily Graphic, 3
New York Daily News, 18, 27, 100
New Yorker, The, 80, 110–11, 122, 183, 253, 283, 322, 354, 369, 390, 441
New York Graphic, 45
New York Herald, 3, 10
New York Review of Books, 300, 429–30
New York's Daily Graphic, 3

New York Society for the Suppression of Vice, 46
New York State, 118, 119, 190, 221, 382
New York Stock Exchange, 307
New York Times, 124, 136, 236, 242, 249, 300–301, 355, 365, 369, 373, 376, 378, 392, 407, 410, 444
New York World, 3–5, 7–8, 10–11, 21
Nexus (character), 267
Nibsy the Newsboy in Funny Fairyland, 15
Nickelodeon, 380
Nick Fury (character), 175–76
Nick Fury, Agent of S.H.I.E.L.D., 175–76, 229
Niemczyk, Kate, 434, 439
"Night Before Christmas, The," 136
Night Breed, 341
Nightcrawler (character), 263
Nightingale, Florence, 56
Nightly News, The, 422
Night Nurse, 230
Nights of Horror, 191
Niles, Steve, 415
Nilsen, Anders, 385–86
9/11 Commission Report, 365, 374
Nineteenth Amendment, 23
99 Ways to Tell a Story: Exercises in Style, 421
Nine Ways to Disappear, 422
Nite Owl (character), 294–96
"Nits Make Lice," 346
Nixon, Richard, 143, 204
Nog (character), 229
non-white characters, xviii, 31, 33–34, 77, 98–99, 327, 395
Noomin, Diane, 240, 324–25
Norm (character), 352
Norm, The, 376
"Normal," 322
Normalman, 352
Norris, Chuck, 225, 345
Norse mythology, 244, 270
North, Oliver, 345
North, Sterling, 86
Northstar (character), 323, 398
nostalgia, 181, 235–37, 240, 333, 334, 354
Nostalgia Journal, 252

Nostalgia Press, 236
Nostradamus, 52
Noto, Phil, 428
Novgorodoff, Danica, 360
Novick, Ira, 140
Nowak, Carolyn, 433
Nowlan, Philip, 29
Nückel, Otto, 146, 147
nuclear war, 276, 286
Nuke, 276
Nursing Home, 306
Nuts!, 135
"Nutsboy," 208

Obama, Barack, 369, 390–92, 394, 405–7, 424, 429
O'Brian, Patrick, 352
O'Brien, Conan, 403
obscenity, 115, 117, 126, 183, 184, 219–22, 221, 291, 296–97, 341; see also explicit and pornographic material
"Occurrence at Owl Creek Bridge, An" (Bierce), 67
O'Connor, George, 365
Octi-Ape (character), 156
Oddville!, 387
O'Donoghue, Michael, 207
Odyssey (Homer), 428
Oeming, Michael Avon, 420
Official Handbook of the Marvel Universe, The, 288
Offissa Bull Pupp (character), 20
offset printing, 144, 318
Ojingogo, 372
"Old Bible Keeper," 335
Old Man Logan, 419
"Old Pals," 276–77
Old Witch (character), 104
Ol' Hot, 33
Oliver, 386
Oliver Queen (character), 180
Oliver's Adventures, 29
Omaha the Cat Dancer, 296
Omega the Unknown, 356
100 Bullets, 343
One! Hundred! Demons!, 315
O'Neil, Dennis, 226–29, 234, 237, 252, 275, 311
O'Neill, Dan, 195
O'Neill, Rose, 6
"One Million Mouths," 386
One Soul, 421
Ong, Walter, 89

Onli, Turtel, 229
online comics, 310, 331, 354, 356, 375–77, 391, 394
Onli Studios, 229
Onstad, Chris, 376, 377
On Stage, 172
Opper, Frederick, 13
Optic Nerve, 388
Oracle (character), 332
"Organization Man in the Grey Flannel Executive Suite, The," 149
Orientalism, xviii, 31–32, 37, 47, 53, 76, 367–69, 429
Origins, 237
Orlandini, Daniele, 440
Orlando, Joe, 132–33
Orlando, Steve, 398
Ormes, Jackie, 33
Orr, Martha, 29
Oswald the Rabbit, 44
Other Side, The, 360
Ottley, Ryan, 420
Ottovani, Jim, 366
Our Army at War, 110, 203
Our Fighting Forces, 203
Outcault, Richard Felton, 4–8, 141
"Outlaws," 345
Outlook, 12
Out of the Past, 342
Out Our Way, 27
Ovaltine, 60
Overkill, 261–62
Overstreet, Bob, 236
Owl stories, 372
Oxnard, Calif., 268

Pacific Comics, 267, 270
Pacific Northwest, 354
Page, Bettie, 267
Pageant magazine, 136–37
Pahls, Marty, 144
Paige Turner (character), 425
PajamaCon 2020, 442
Palestine, 347, 355
Palmer, Ray, 396
Pandora's Box Comics, 213
panels, sequential layout of, xii, 9, 260
Panel Syndicate, 393
Panic, 136
Panter, Gary, 277, 428
Pantheon, 297, 355
"Panther's Rage," 225
paper (paper supply), 41, 82, 84, 274, 303–4

paperback books, 80, 148, 290, 304, 337, 379
Papercutz, 414
Paper Girls, 416
Paper Theater, 414
Paramount, 50–51
Parent, Dan, 396
Parents' Magazine, 87
Paris Review, 369, 427
Parker, Bill, 63
Parker, Cynthia Ann, 346
Parker, Quanah, 346
Parker Brothers, 253
Parkhouse, Steve, 415
parody, parodies, xv, 60–61, 81–82, 106, 134–35, 141–42, 149, 151, 188, 193–94, 202, 204–7, 213, 218, 243–44, 249, 270, 281, 282, 317, 328, 351, 352, 421
Passionale of Christ and Anti-Christ, The (woodcuts), xii
Passionate Journey, 146
Passmore, Ben, 439
Patience, 434–35
Patri, Giacomo Giuseppe, 147–48
Patriot, The, 75
patriotism, 71–72, 75, 78, 82, 85, 177, 204–5, 227, 359
Patsy Walker, 99, 166
Patterson (publisher), 70, 100
Patterson, Joseph Medill, 17–18, 21–27, 31
Patton, George, 80
Pawnbroker, The (film), 132
PAX, 402
Pax Romana, 422
PBS, 253
Peach Fuzz, 374
Peale, Norman Vincent, 89
Peanuts, 143–44, 180, 224, 268, 353, 358, 377, 392
Pearl Harbor, attack on, 79
Peckinpah, Sam, 262
Peculia, 415
pedophilia, 119
Pekar, Harvey, 246–48, 276, 300, 312, 316, 367, 378, 429
Pekar, Joyce, 316
Pence, Mike, 435
Penguin, the (character), 60, 372
Penny Arcade, 376, 402

Penny Arcade Expo, 376
Peoria, Ill., 185
Pep Comics, 58, 72
Pepito (character), 33
Perelman, Ron, 305, 307
Pérez, George, 265, 270, 286, 289–90
Pérez, Ramón K., 428
Perfect Film and Chemical Corporation, 237
Perker, M. K., 383
Perlmutter, Isaac "Ike," 307, 380
Perlow, Brandon, 397
Perry Bible Fellowship, The, 377
Peter Gunn (TV show), 149
Peter Parker (character), 161, 166, 230, 234, 305–6, 397
Peter Porker (character), 352
Petersen, David, 372
Petunia Pig (character), 210
Peyton Place (TV show), 178
Pfeiffer, Michelle, 401
Phantom, The, 37, 257
Phantom, the (character), 43, 65
Phantom Stranger, the (character), 335
Philadelphia, Pa., xv, 10, 99, 367
Philadelphia Gay News, 321
Phil Hardy, 27
Phillips, Todd, 440
Phillips' Tooth Paste, 41–42
Phineas (character), 197
Phoenix Comicon, 440
phone books, 244, 269, 304
photography, 4
Pichelli, Sara, 397
Pickford, Mary, 24
Picnic Ruined, 386
Pictopia, 301
pictorial love stories, 148
Picture Stories from American History, 90
Picture Stories from Science, 90
Picture Stories from the Bible, 89, 136
Picture Stories from World History, 90
Pied Piper (character), 322
Pigs, 359
Pildorr (character), 160
Pilkey, Dav, 432
Pilote, 257

Pineapple, 329
Pines, Ned, 87
Pini, Richard, 244–46
Pini, Wendy, 244–46, 272
Pinocchio (character), 204
Pinocchio (film), 143, 260
Pioneer Picture Stories, 87
Piracy, 130, 196–97
Piskor, Ed., 366
Pitarra, Nick, 416
Pittsburgh, Pa., 94
Pittsburgh Courier, 94
Plain Truth, The, 427
Planetary, 332–33
Planet Comics, 57, 58
Plastic Man, 104, 128, 384–85
Plastic Man (character), 52, 77, 161, 237
Playboy, The, 314
Playboy magazine, 141, 145, 149–50, 181, 441
Playboy Mansion, 178
"Playboy Philosophy," 138
Playground Association of America, 11
"Plot Thickens, The," 278
Pocahontas, 345
Pocket Books (publisher), 250
podcasts, 412, 444
Poe, Edgar Allan, 37, 232
Pogo, 143
Poison Ivan (character), 151
Poitier, Sidney, 174
Pokémon, 374
Polanski, Roman, 273
Polarity, 420
political comics, 25, 143, 204, 349
Polly and Her Pals, 23, 40
"Poopeye," 135
Pop Art, 178
Pope, Paul, 422
Popeye (character), 37–38, 140, 257
Popular Comics, 45
Popular Culture Association, 355
Porcellino, John, 364
Pore Lil Mose, 32
Porky Pig (character), 81, 210
pornography, *see* explicit and pornographic material
Portland, Ore., 378
Portman, Natalie, 379
postage and postal regulations, 96, 160, 166–67
Potter, Greg, 273

Powell, Bob, 105, 111
Powell, Colin, 224
Powell, Eric, 413
Powerhouse Pepper (character), 81–82
Power Man (character), 225
Powers, 420
Pow-Wow Smith (character), 94
Prankster, the (character), 151
Preacher, 273, 338–39
Predator, 308
Preiss, Byron, 248–50
Prelude to a Million Years (Ward), 147
Presley, Elvis, 138
Prez (character), 231
Pride of Baghdad, 359
Prince, Harold, 178
Prince, Liz, 361
Prince Valiant, 51, 172
"Prince Violent," 135
printing, xii–xiv, 1, 3, 41, 144, 190, 192, 270
Print Mint, 192, 221, 283
"Prisoner of the Hell Planet," 238, 279
Prison Pit, 421
Private Eye, The, 393
Prix Alfred, 304
Procter & Gamble, 41
Professor Artefact McArchives (character), 101
Professor Emirc (character), 29
Professor Reinstein (character), 71–72
Professor Smalley (character), 47
"Profit, The," 186
Prohías, Antonio, 177
Prohibition, 41, 45
Promethea, 419
propaganda, 69, 131
Pro Rata (character), 242
Providence, R.I., 354
Prowler, the (character), 225
Proxmire, William, 224
prozines, 188
"Prude, The," 130
Pruneface (character), 29
P.S. magazine, 240–41
psychoanalysis, 15, 119
Psycho Comics, 312–13
Publishers Weekly, 374, 432
Puck, 2, 3, 9, 39
Pudge, Girl Blimp, 213

Pulitzer, Albert, 7
Pulitzer, Joseph, 2–4, 7–8, 10
Pulitzer Prize, 68, 300, 322, 355
Pullman porters, 33
pulp periodicals, 28–29, 43–46, 57, 58, 63, 73, 234
Punch, xv, 2, 39
Punisher, the (character), 286
punk, 268, 276–77, 282, 339
Purvis, Leland, 366
Puzo, Mario, 254
Pyle, Kevin C., 360

Quack!, 242–43
Quality Comics, 52, 59
Queen & Country, 415
Quesada, Joe, 412
Quincy, 224

Race & Reality, 314
Rachel Rising, 414
racism and racial stereotypes, xviii, 2, 21, 32–34, 58, 69–70, 76–77, 83, 98–99, 116, 119, 122, 127, 133, 173, 205–6, 225, 230, 256–57, 279, 326–27, 345–46, 365–66, 368–69, 383, 442
Rader, Brad, 417
radio, 41, 43–44, 50, 102, 105, 112, 159, 310, 444
Radio Shack, 253
"Radio Squad," 49
"Radishes," 433
Raisins, 224
Ralph, Brian, 414
Randall, Ron, 273
Random House, 375
Rangeland Love, 94
Ranma 1/2, 374
"Raskol," 351
Rat Queens, 416
Raven Banner, The: A Tale of Asgard, 273
Raw, 280, 283–84, 285, 297, 348, 349
Raw Books and Graphics, 279–80
Rawhide (TV show), 140, 158
Rawhide Kid, 158
Rawhide Kid, the (character), 397
"Raw War Comics," 203–4
Ray, Man, 66
Ray, the (character), 61

Ray Finch's 17th Annual Review of Turned On Cuties, 207
ray guns, 31, 51
Raymond, Alex, 31, 60, 71, 249
Ray Palmer (character), 157
Razor (character), 303
R. Crumb's Comics and Stories, 195
Reader's Digest, 112, 120
Reagan, Ronald, 276, 349
Real Fact, 87
Real Girl, 324
Real Heroes, 87
realism, 30, 32
Realist magazine, 195
Real Life Comics, 87
Real World, The: San Diego (TV show), 317
Red Barbarian, the (character), 176
Red Barry, 27–28
Red Bee (character), 52
Red Circle, 267
Red Cross, 88
Reddit, 435
Red Ryder, 94
Red Skull (character), 105
Red Son, 419
Red Sonja (character), 234
Reed Richards (character), 169, 176
Reese, Ralph, 248
Reeve, Christopher, 254
Reeves, Keanu, 378
Refresh, Refresh, 360
Regé, Ron, Jr., 386
Rehr, Henrik, 360
"Reign of the Superman," 154
religion, xii, 11, 83, 89, 113, 117, 126, 127, 136, 164, 184, 216, 243, 273, 287, 339, 362–63, 368, 399, 427; *see also* biblical themes and imagery; Catholic Church
Rembrandt, 52
Remi, Georges, 256–57
Republican Party, xvii, 2, 17, 328–29
Republic serials, 152, 180
Resnik, Benton, 173
Revealing Romances, 94
Revere, Paul, xiv, 5
Revival, 414
RFO, 167
Rhoda Trail (character), 95

Richards, Terry, 211–13
Richardson, Mike, 390–91
Richie Rich, 140
Rickheit, Hans, 387
Rick Starr (character), 155
Riddler, the (character), 151
Riebe, Ernest, 25
Rifas, Leonard, 259–60, 345
Riggio, Leonard, 435
Riis, Jacob, 4
Riley, James Whitcomb, 24
Riley and Huey (characters), 354
Rime of the Ancient Mariner, The (Coleridge), 73
Rinehart, Mary Roberts, 51
Riot, 135
Riot Grrrl movement, 326
Rip Off Press, 190, 191
Ripper, 326
Riri Williams (character), 432
Rise of David Levinsky, The (Cahan), 251
Risso, Eduardo, 343
Road to Perdition, The, 342–43
Robbins, Trina, 202, 209–11, 213, 230, 238, 239, 301, 357
Robert Scum (character), 207
Robertson, Darick, 342, 420
Robin (character), 55, 75, 76, 84, 90, 94, 103, 119, 156, 178–80, 229, 234, 311
Robin Hood (character), 75
Robinson, Alex, 365
Robinson, Edward G., 29
Robinson, James, 333
Robinson, Jerry, 51, 60, 61, 66
Rocket (character), 328
Rod Brown of the Rocket Rangers (TV show), 177
Roddenberry, Gene, 308, 310
Rodriguez, Gabriel, 414
Rodríguez, Manuel "Spain," 201, 205, 208, 239–40, 291, 310
Rodriguez, Robbi, 408
Rogers, Marshall, 270
Rogers, Roy, 94, 95, 417
Rohmer, Sax, 32
Rolling Stone, 192
Rollins (character), 247
romance (romance comics), xiv, 93–99, 106, 193–94, 218, 228, 263, 325, 375, 397, 418

Romance Trail, 94
romantic interests, xviii, 127, 157, 263
Romberger, James, 316–17
Rome, ancient, xii
Romeo and Juliet (Shakespeare), 428
Romero, George, 413
Romita, John, 151
Rom the Spaceknight, 253
Rōnin, 273–76
Rooney, Mickey, 87
Roosevelt, Franklin Delano, 25, 28, 62, 71, 77
"Roped-In!," 107
Rorschach (character), 294
Rosalie Lightning, 425
Roscoe Moscow, 291
Rose Is Rose, 353–54
Rosenberg, Jonathan, 377
Rosie the Riveter, 82–83, 98
Ross, Alex, 333, 344
Roth, Henry, 251
Rowan & Martin's Laugh-In (TV show), 178
Royal Air Force, 79
Royal Society of the Arts, xv
royalties, 43, 93, 109, 189, 191, 237, 270, 271, 302, 376
Rubenstein, Raeanne, 198
Rucka, Greg, 415, 416, 417, 420
Rumrich spy case, 72
Runson, N. J., 117–18
Runton, Andy, 372
Ruscha, Ed, 140
Russell, Mark, 440
Ryan, Johnny, 421

Saalburg, Charles W., 3–4
Sable, Mark, 408
sabotage, 72
Sabre, 270
Sabrina, 433
Sabrina the Teenage Witch (character), 136, 414, 434
Sacco, Joe, 347–48, 355, 366
"Sacrifice," 357
Saddle Justice, 96
Saddle Romances, 94, 96–98
Sadie Hawkins Day, 34
sadomasochism, 119
Sad Sack, 79, 140
Safe Area Gorazde, 347
"Safe Sex," 320

"safety crusades," 88
Saga, 416
Sahl, Mort, 143
St. John, Nathan, 360
St. John Publications, 148
St. Louis, Mo., 2, 3, 17
St. Louis Post-Dispatch, 3, 10
St. Nicholas Magazine, 6
Saiz, Jesús, 384
Sala, Richard, 415
Salamander Dream, 386
Salon, 310
Saloon, 218, 251
Salt Lake City, Utah, 11
Salt Lake Tribune, 27
San Creek Massacre, 346
Sandell, Laurie, 424
San Diego, Calif., 236, 346, 378, 403, 442
San Diego Comic-Con, xix, 236, 240, 309, 399, 403–5, 437
Sandman, the (character), 51, 54, 335, 340
Sandman (comic), xix, 316, 335–38, 340, 348, 354–55
Sandy (character), 44
San Francisco, Calif., 185, 200, 209, 214
San Francisco Chronicle, 16, 147
San Francisco Comic Book Company, 186
San Francisco Examiner, 6, 314
Santa Claus (character), xvii, 15, 136
Sapp, Terry, 323
Sarah Glidden (character), 367–68
Sarajevo, 347–48
Sartre, Jean-Paul, 144
satire, xv, 25, 36, 96–97, 110, 124, 142, 144, 150, 151, 183, 184, 197, 201–2, 206, 213, 222, 240, 244, 256, 267, 276, 314, 315, 320, 339, 351, 377, 420, 426, 427, 442, 445
Saturday Evening Post, 11–12, 48, 100
Saturday Mindfuckee Funnies, 240
Saturday Review of Literature, 116, 139
Saunders, John, 173
Savage Dragon, 374, 390
Savio, Mario, 186

Saxon, John, 225
Scalped, 417–18
"scanlation," 373–74
Scarface (character), 29
Scarlet Letter, The (Hawthorne), 351
Scheiman, Martin, 136
Schenker, Don, 221
Schiff, Jack, 81, 156
Schindler's List (film), 298
Scholastic (publisher), 372, 432
Schomburg, Alex, 76
Schrag, Ariel, 323, 373
Schultze, Carl, 12–13
Schulz, Charles, 80, 143, 180, 202–3, 213, 224, 377
Schutz, Diana, 157, 371
Schwartz, Julius, 152, 154–56, 166, 168, 171, 179, 231
Schweizer, Chris, 408
Science Fiction (fanzine), 47
science fiction (SF), 28, 31, 44, 47–48, 53, 57, 58, 90, 106, 109, 132–33, 144, 152–56, 159, 164, 170–71, 204, 207, 227, 234–36, 244, 248–49, 258–59, 267–68, 275–76, 291–92, 342, 416–18, 438
scientific romance, 28, 31
Scott Summers (character), 263
Screen Gems, 160
Screen Thrills Illustrated, 150
Scribbly Jibbet (character), 214
Scrooge McDuck (character), 101–2
Seagle, Steven T., 359, 420
Seattle, Wash., 354, 367, 378, 423
Seattle Post-Intelligencer, 374
Sebela, Christopher, 377
second-class postage, 96
"secret identities," 37
Secrets of Sinister House, 233
Seda, Dori, 282–83
Seduction of the Innocent (Wertham), 118, 120
See It Now (TV program), 143
Seeley, Tim, 414
Segar, Elzie Crisler, 37
Seldes, Gilbert, 20
"Self-Abuse," 214
Senate Subcommittee on Juvenile Delinquency, 121–26

Sendak, Maurice, 372
Sennett, Mack, 13
Sentient, 434
Sentinels of Liberty, 85
September 11 attacks, 357–60
Sequential, 385
Sequential Tart, 403
"Seth" (cartoonist), 369, 401
Seth (character), 315
Seuling, Phil, 236, 265–66
Seven Lively Arts (Seldes), 20
Seven Miles a Second, 316
Seven Soldiers of Victory (character), 78
Seventeen Comics from an Unpleasant Age, 373
Severin, Marie, 108
sex and sexuality, 23, 27, 34, 62, 112, 115, 118–19, 127, 135, 138, 176, 193–96, 200, 206–13, 215, 218–20, 229, 245, 248, 268, 272, 274, 293, 296, 303, 312, 314, 316–21, 331, 345, 361, 363, 368, 384, 386, 388, 396, 398, 402–4, 417–19, 426, 439
Sex Criminals, 419
sexism, 33, 100, 158, 176, 208–11, 229, 402, 405, 440
sexual abuse and assault, 200, 282–83, 325, 326, 404, 405, 441, 442
sexual harassment, 202, 402–4
sexualization, 290, 331, 400, 432
SF, *see* science fiction
Sgt. Fury and His Howling Commandos, 175
Sgt. Pepper's Lonely Hearts Club Band, 175
Sgt. Rock and Easy Company, 203
Shade the Changing Man (character), 339
Shadow, the (character), 29, 38, 43–44, 51, 102, 237
Shadow (comic), 60, 62, 234
Shadow of No Towers, 358
Shaft (character), 225
Shakespeare, William, 73, 428
Shang-Chi, 265
Shanna the She-Devil, 230
Shanower, Eric, 427
Shatter, 309

Shaw, Dash, 422
Shazam (character), 237
Shearer, Ted, 224
Sheena, Queen of the Jungle (character), 58, 82, 238
She Hulk (character), 353
Sheldon.com, 377
Shelley, Mary, 232
Shelton, Gilbert, 182–84, 190, 192, 197, 201, 203, 207, 213, 240, 291, 345
Shenanigan Kids, The, 21
Sheridan, Dave, 199, 200
Sherlocko the Monk, 13
Sherman, Allan, 184
She Wolf, 439
Shield, the (character), 72
Shiga, Jason, 385, 418
Shining Knight (character), 78
Shmoo (character), 141
Shock SuspenStories, 131
Shooter, Jim, 179–80, 226, 261, 264, 272, 288
Shortcomings, 388
Short Order Comix, 216
Shoulders (character), 29
Showcase, 154, 274
Showcase editions, 304
Shuster, Joe, 47–51, 60–62, 66, 72, 75, 83, 190–91, 271, 272, 355, 382, 412
Sick, 136
Sickles, Noel, 78–79, 104
Siddell, Tom, 408
sidekicks, 15, 69, 75–77, 119, 177, 179, 231, 328
Siegel, Herbie, 46
Siegel, Jerry, 47–51, 60, 62, 66, 69, 70, 72, 75, 83, 152, 154, 190–91, 271–72, 355, 382, 412
Sienkiewicz, Bill, 265, 346, 349, 389
Signal to Noise, 349
Signet (publisher), 146
Sikoryak, R., 351, 358
Silent Penultimate Panel Watch, The, 377
Silver (horse), 94
Silver Age of comics, 154, 304, 322, 376, 381, 383
Silver Star, 270
Silver Streak Comics, 102
Silver Surfer, 172, 174, 186, 244
Sim, Dave, 243–46, 304, 330, 338

Simek, Artie, 238
Simon, Joe, 59–60, 70, 71, 75–76, 93, 103, 136, 151, 231, 382
Simone, Gail, 330–32
Simonson, Walter, 249, 270
Simpson, Don, 352
Simpsons, The (TV show), 194, 296, 308, 369
Sin City, 343, 379
Sinnott, Joe, 168
"Situation Comedy," 278
Sixth Gun, The, 418
Skeeter Grant (character), 216
Skeezix (character), 26, 79, 91
Skibber Bee Bye, 386
Skinn, Dez, 292
Skippy (radio show), 41–42
Skroce, Steve, 440
Skull Comics, 193
Skull Valley, 94
Slam Bradley (character), 47, 49
Slott, Dan, 402
Slow Death, 200
Slug (character), 58
Sluggo (character), 23
Small, David, 423
Small Change, 84
Small Favors, 418
Small Fry, 84
Small Press Expo (SPX), 354
Smallville (TV show), 436–37
Smash, 266
Smile, 407, 408
Smith, Clark Ashton, 234
Smith, Jeff, 353, 373
Smith, Kevin, 412
Smith, Sidney, 18–20, 24
Smithsonian Collection of Newspaper Comics, 253
Snafu, 135–36
Snake Eyes, 301
Snapper Carr (character), 179
Snappy Sammy Smoot (character), 197
Snarf, 189–90, 241
Snidely Whiplash (character), xviii
Snooks and Snicks, 9
Snow White (film), 143
Snuffy Smith (character), 79
Snyder, Scott, 418, 440
social consciousness, 227–31
socialism, 17–18, 24
socialist realism, 148
Sock Monkey, 352

Soho Weekly News, 320
Solar Sales Service, 152
Solo: A Star Wars Story (film), xix
Something Is Killing the Children, 434
Somnambulo, 329
Song Without Words (Ward), 147
Son of Frankenstein (film), 105
Son of Origins, 237, 250
Son of Satan, 233
Son-O'-God (character), 241
Soul Brother American (character), 218–19
Soule, Charles, 440
Soupygoy (character), 207
Source, the (character), 249
South by Southwest, 392
Southern Bastards, 417
South Korea, 257
Southworth, Matthew, 417
Spacemen magazine, 150
Space Museum, 155
space race, 154
Space Ranger, 155
Spain (country), xiii, xvii
Spain (pseudonym), see Rodríguez, Manuel "Spain"
Spawn, 303, 327
Special Exits, 424
Spectacular Spider-Ham, the (character), 353
Spectre, the (character), 54
speech balloons, first, 5
Speed Jaxon (character), 172
Speed Saunders (character), 46
Speedy (character), 231
Spider, The (character), 43
Spider-Man (character), 165, 169, 177, 225, 230, 253, 254, 286, 288, 302, 307–8, 380, 381, 397, 421, 437; see also Amazing Spider-Man, The (comic)
Spider-Man (film), 370, 381, 397
Spider-Man: Homecoming, 437
Spider-Man: The Animated Series, 308
Spider-Woman (character), 230
Spiegelman, Art, 132, 144, 150, 188–90, 198, 218, 238–40, 251, 253, 260,

277–80, 291, 297–301, 310, 312, 349, 358, 360, 369, 372, 388, 394, 424
Spiegelman, Vladek, 297–98
Spillane, Mickey, 343
Spirit, The, 65–70, 251, 309, 337
Spirit, the (character), 156, 241
Spirou, 256, 257
Sponge Bob SquarePants, 372
sponsorships, 41–42, 60
Spooky the Tuff Little Ghost, 140
Sport Comics, 57
Springer, Frank, 207
Spunkie, 79
Spurgeon, Tom, 391, 401, 403, 404
Spy Smasher (character), 91
"Spy vs. Spy," 177
Squadron Supreme, 294
Squeak the Mouse, 296–97
Squirrel Mother, The, 387
Stack, Frank, 183–84
Stagger Lee, 366
Stalin, Joseph, 72, 419
Stallone, Sylvester, 345
Stan Bragg (character), 168
Stan Lee Media, 379
Stanley, John, 100
"Stan's Soapbox," 167
Stapledon, Olaf, 245
Staples, Fiona, 416
"Starchie," 135
Stardust Sixth Column, 85
Stardust the Super Wizard, 52
Starfawn, 248
Starfire (character), 401
Star Jaws, 249
Stark, Richard, 417
Starks, Kyle, 418
Stark Terror, 232
Starlin, Jim, 245–46, 272, 276, 290
Starman (character), 64, 333
Staros, Chris, 354
Star Raiders, 273
Star*Reach, 242, 243, 245, 267
Stars and Stripes, 224
Star Sapphire (character), 157
Star-Spangled Kid (character), 75
Star-Spangled War Stories, 110, 203

Startling Stories, 152
Star Trek (TV show), 248, 252, 308, 310
Star Wars (film series), 248–49, 252, 308–9
"Statement of NO Policy," 188
Staton, Joe, 357
Steamboat Bill (character), 70
Steamboat Willie, 81
steampunk, 418
Stein, Gertrude, 320
Steinbeck, John, 38
Steinberg, Flo, 441
Steinberg, Saul, 80
Steinem, Gloria, 150
Stephens, Jay, 387
Steranko, Jim, 175–76, 249
Sterrett, Cliff, 23
Steve Canyon, 191
Steve Dallas (character), 327
Stevens, Dave, 267
Stevenson, Robert Louis, 111, 138–39
Steve Rogers (character), 70, 152, 383
Stewart, Cameron, 360
Stiles, Steve, 204
Stitches (Small), 423
stock market crash, 37
Stoker, Bram, 233
Storm (character), 263, 395
Storms, Patricia, 356
"story arc," 290
Story of Superman, The, 144
Strange Adventures, 155
"Strange Costumes of Batman!, The," 156
Stranger in a Strange Land (Heinlein), 211
Strangers in Paradise, 323
Strange Story, 105
Strange Tales, 160, 421
Stray Bullets, 343
Stray Toasters, 349
Streaky (character), 229
"Streamlined Rustlers, The," 94
Street & Smith, 57, 87
Street & Smith's Detective Story Hour, 43
Stripesy (character), 75
Strips Aids U.S.A., 316
Stuart, Lyle, 136
Stuck Rubber Baby, 323
Stuffed!, 366
Stumptown, 417
Stumptown comics convention (Portland), 378

Sturgeon, Theodore, 58
Sturm, James, 346–47, 369
Sub-Mariner (character), 73–74, 77, 151, 171
subscription services, 376
suburbanization, 139–40
Sue Dibny (character), 330–31
Sue Storm (character), 166, 169
Sullivan, Vincent, 49
Sunday papers (Sunday funnies), 3, 8, 10, 12, 41, 65
Sunshine Girl, 200
Superblack, 224
Superboy (character), 153–54, 157
Superduperman (character), 135, 207
Super Friends, 253
Supergirl (character), 157, 166, 180, 289, 384
Supergirl (comic), 443
superheroes, 332–34, 384–85, 413, 419–21, 434; *see also specific superheroes and superhero teams*
and American exceptionalism, 285
Big Two's, 379–80
Black, 225, 228, 327
camp, 179
as complex characters, 168–71
criticisms of, 62, 89, 286, 331
decline of, in postwar years, 91, 92, 99, 150–51, 194
effect of alternative comics on depiction of, xix, 290
fan fiction about, 357–58
as fascists, 294
female, 55, 209, 331–32
first, 37–38, 49, 52–54
gay, 398
Hispanic, 329
humanizing of, 226–27, 359, 415
as Jews, 68
for juvenile audiences, 253
kid, 63
and letter columns, 166
and monsters, 160
parodies of, 81–82, 135, 306
as progressive liberals, 83–84
sidekicks of, 75

underground, 241, 352
vulnerability of, 64
during World War II, 83
Superman (character), 47–52, 54–55, 57, 60–65, 68, 70, 72, 75, 77, 78, 83–89, 94, 112, 140, 144, 150–55, 159, 161, 170–71, 180, 190–91, 215, 226, 227, 246, 249, 254, 257, 271–72, 293, 305, 327, 328, 330, 333, 357–58, 370, 381–83, 398, 412, 419, 420, 429, 432
Superman (comic), 50, 51, 54, 60–62, 72, 77, 81, 82, 85, 87, 88, 111–13, 151, 152, 214, 289, 293, 313
Superman (film), 236, 254, 271–72
Superman (1940s animated cartoon), 50–51, 151
Superman (radio serial), 50, 310
Superman for All Seasons, 383
Superman from the '30s to the '70s, 191
Superman Workbook, The, 87
Supersnipe, 82
Super Soul Comix, 218–19
Supreme, 330
Supreme Court, 17, 115, 116, 118, 122, 195, 220, 296, 411–12, 441
Surfing Funnies, The, 174
surrealism, xix, 14, 278, 306, 339, 348, 349, 352, 386, 387, 422
Sustah Girl (character), 229
Sutton, Joyce, 212
Svankmajer, Jan, 339
Swamp Thing, 292–94, 310, 334, 335, 337, 338, 341, 413
Swan, Curt, 293
Sweden, 257
Sweethearts, 94
Swinnerton, James, 6, 32, 195
Swiss Family Robinson, 29
Switzerland, 256
sword and sorcery, 233–34
syndication, 10–11, 19, 21, 22
Synthezoid, the (character), 434
System, The, 350

Taboo, 341
Tailspin Tommy, 29
Takeda, Sana, 434
Tales from the Crypt, 104, 111, 130, 193
Tales of Sex and Death, 193
Tales of Suspense, 160
Tales of the Beanworld, 353
Tales of the City, 321
Tales of the Closet, 322
Tales of the Zombie, 232
Tales to Astonish, 160
Tamaki, Mariko, 433
Tammany Hall, xvi, xvii
Tantrum, 253
Tapley, Mel, 173
Tapping the Vein, 341
Tarantino, Quentin, 339
Tardi, Jacques, 280, 284
Tarzan, 29–31, 58, 237, 245, 257
T'Challa (character), 173–74
"Team Comics," 401
Teeka Tok (character), 326–27
Teena, 100
Teenage Mutant Ninja Turtles, 301–2
teen culture, 113
Teen Titans, 179, 225–26
television, xix, 140, 160, 253–54, 285, 436–37
Telgemeier, Raina, 372, 407, 408, 431–32, 444
Temple, Shirley, 87
Templesmith, Ben, 415
TenNapel, Doug, 408, 409
Tenniel, John, xv
Terminator, 308
Terrifics, The, 443
Terror Tales, 105, 232
Terry, Hilda, 100
Terry and the Pirates, 31–32, 45, 60, 66, 79, 80, 191
Tessie the Typist (character), 99
Tess Tracy (character), 354
Tess Truehart (character), 27
Tetris, 434
Texas Hippies March on the Capitol, The (film), 197
Texas History Movies, 88, 345
Texas Ranger, 182–84
Texas Rangers, 329
text pieces, two-page, 96, 166–67
Tezuka, Osamu, 260–61
Thailand, 257

thalidomide, 164
Thanos (character), 246
Thimble Theatre, 37
Thing, the (character), 163
"Thing in the Room, The," 192–93
Third Eye Bookstore (Encino, Calif.), 220
30 Days of Night, 415
Thirty Years' War, xii
This Is Your Enemy, 131
This Magazine Is Haunted, 111
Thomas, Roy, 234, 237, 262, 270
Thomas Edison Award, 129
Thompson, Craig, 362–63, 367, 429
Thompson, John, 199
Thompson, Richard, 394
Thor (character), 164, 170, 398
Thor (comic), 270
Thoreau, Henry David, 7
Thrash, Maggie, 426
3anuts, 377
3-D comics, 140
300 (film), 379
Three Musketeers, The, 88
Three Stooges, the, 140
Thrilling Wonder Stories, 152
T.H.U.N.D.E.R. Agents, 177
Tijuana bibles, 45, 59, 77–78, 207, 240, 418
Tillie the Toiler, 40, 63
Tim Drake (character), 311
Timely Publications, 73, 76, 81, 91, 93, 94, 99, 105, 108, 140, 149, 151, 156, 158, 160, 171
Time magazine, 185–86, 191, 369
Time Traveller, 152
Time Warner, 381, 410–11
Timid Soul, 36
Ting Ling Kids, The, 4, 6
Tip Top Comics, 45
"Tirade Funnies," 210
Tits & Clits Comix, 212–13
"To Be Continued," 18
Tobin, Paul, 393
Tobocman, Seth, 276, 284
Todd, Fred, 190
Todd, Larry, 200
Toklas, Alice B., 320
Tokyopop, 374, 391
Tolkien, J. R. R., 231, 245, 353
Tom and Jerry (characters), 140

Tomine, Adrian, 388
Tommasso, Rich, 439
Tomorrow's World, 427
Tony Stark (character), 164, 176, 233, 265
Too Cool to Be Forgotten, 365
Tooks, Lance, 326
Toon Books, 372, 373
Top Cow, 391
Töpffer, Rodolphe, xiv, 256
Topix Comics, 89
Top Shelf, 354, 371, 376
Topsy-Turvy Comics, 59
Tor, 120
Torch, the, *see* Human Torch, the (character)
Torchy Brown, 33
Toro (character), 76
Toronto, Ont., 378, 442
Torpey, Frank, 73
To Sir, with Love (film), 174
Toth, Alex, 94, 267
Totleben, John, 292, 330, 341
Tower Records, 283
Town Meeting of the Air, 112
Toy Biz, 306–7
Toyman, the (character), 151
toys, comics-related, 288
Toys "R" Us, 396
trademarks, 189, 195, 230
Trail Blazers, 87
transgender people, 439
Transmetropolitan, 342
Transposes, 426
Trashman (character), 208, 219
Trashman (comic), 201
Treasure Island (Stevenson), 138–39
Tribeca Sunset, 360
Tribit, Inez T., 9
"Tribute to Dr. Strange, A" (rock concert), 186
Trigger (horse), 94
Triple Detective, 46
Trojan War, 427
Trudeau, Garry, 143, 248, 320, 360, 435
True Comics, 87
true crime, 102–4, 367
True Crime Comics, 104
True Faith, 339
Trump, 145
Trump, Donald, 406, 433, 435, 438, 441
Truth, 383
Truth, Sojourner, 56

Tsayt, 35
Tuazon, Noel, 417
Tubman, Harriet, 345
Tumblr, 404
Turner, Morrie, 173, 224
Turner, Ron, 211, 213
Tuskegee, Ala., 383
Tuskegee Airmen, 173
Tweed, "Boss" Bill, xvii
"28th Street", 387
Twisted Sisters, 325
Two-Face (character), 60
Two-Fisted Tales, 109, 110
Two-Fisted Zombies, 193
"Two Futures," The, 90
Two-Gun Kid, the (charac-
 ter), 94
2000 AD, 291, 339
Tyler, Carol, 424
Tyler, Joel, 221
Tynion, James, IV, 434
Tyroc (character), 228

Ultimate Spider-Man, 397, 409
Ultimate Wolverine vs. Hulk, 412
Ulysses (Joyce), 20, 220
Umbrella Academy, 421–22
Unbeatable Squirrel Girl
 (character), 434
Uncle Bim (character), 18
Uncle Creepy (character), 232
Uncle Sam (character), xvii,
 74, 75, 344
Uncle Scrooge (character), 101
Uncle Sham, 206
Uncle Tom's Cabin (Stowe), xvi
underground comics, 174,
 183–209, 212–24, 229,
 230, 232, 238–42, 245–
 47, 258, 265, 270, 271,
 283–84, 291, 309, 312,
 316, 318–20, 324, 349,
 378, 392, 418
Underground Press Syndi-
 cate, 186
Underwater, 387
Undiscovered Country, 440
unions, 25
United Cartoon Workers of
 America, 201
United Features, 45, 49
United Feature Syndicate, 392
United Kingdom Comic Art
 Convention, 334
United Nations, 344
Universal Press Syndicate,
 230

Universal Studios, 160, 232
University of California,
 Berkeley, 248
University of Geneva, xiv
University of Texas, Austin,
 182, 183, 197, 202
University of Wisconsin, Eau
 Claire, 220
*Unknown Origins & Untimely
 Ends*, 366
Unlikely, 361
Unsane, 135
urbanization, 1, 22
U.S. Justice Department, 139,
 306
U.S. Postal Service, 96
U.S. State Department, 257
U.S. Treasury Department, 80
U.S.A. Comics, 76
USA Is Ready, 72

Valentino, Jim, 352
Valerie (character), 396
Valero-O'Connell, Rosemary,
 433
Valkyrie (character), 229
Valkyries, 400
Valley of the Zombies (film),
 105
Valor, 130, 158
Vampirella, 232
Vampirella (character), 193
Vampire's Ghost, The (film),
 105
Vampire Tales, 232
Vance, James, 347
Vancouver Post, 374
Van Sciver, Noah, 388
Van Von Hunter, 374
Varhayt, 35
Varley, John, 342
Varley, Lynn, 275
Vasquez, Jhonen, 415
vaudeville, 2, 11, 16
Vaughan, Brian K., 331,
 358–59, 393, 409–10,
 416, 440
Vault-Keeper (character), 104,
 105, 107
Vault of Horror, The, 104
Veitch, Rick, 193, 273, 310,
 358, 375
Veitch, Tom, 193
Velvet Underground, 280
Venom (film), xix
Verheiden, Mark, 345
Vernon, Ursula, 377

Veronica Lodge (character),
 58, 395
Vertical, 374
Vertigo, 316, 340–42, 345,
 410, 413, 441
Vess, Charles, 273
V for Vendetta, 379
Viacom, 380
Victoria, Queen, xv
victory gardens, 84
video games, 273, 309, 440
Vietnam, 257
Vietnam Journal, 360
Vietnam War, 176, 202, 203,
 219, 233, 234, 285, 286,
 343–46, 360
Vigilante, 94
Vigilante, the (character), 286
vigilantism, 286
Vigus, Robert, 88
Village Voice, The, 142, 353, 441
violence in comics, 27–28,
 86, 112, 114–15, 118, 126,
 129, 132, 138–39, 193,
 196–99, 207–9, 229,
 249, 261–62, 272, 273,
 284, 302, 323, 330–31,
 335, 342–43, 349, 352,
 384, 427, 440, 442, 444
Violent Cases, 335
Visaggio, Magdalene, 439
Vision, the (character), 73, 434
visual novels, 250–51
Viz, 374
Vogue (character), 303
von Bernewitz, Fred, 144
von Vogt, A. E., 236

Waich, Graig, 359
Waid, Mark, 333
Wakanda, 173–74, 225, 399,
 438
Wake, The, 415
Walden, Tillie, 416
Waldenbooks, 304–5
Waldman, J. T., 427–28
Waldman, Myron, 148
Waldo (character), 348
Walker, Drake, 148
Walker, Mort, 209, 224
Walking Dead, The (comic),
 413, 441
Walking Dead, The (TV show),
 xix, 436–37
*Walking with the Wind: A
 Memoir of the Movement*,
 405–7

Wall, The (Hersey), 131
Wallace, George, 206
Wallant, Edward Lewis, 132
Waller, Leslie, 148
Waller, Reed, 296
Walsh, Dan, 377
Walta, Gabriel, 434
Walt Disney, 80, 143, 257, 260, 298, 308, 380, 410–11
Walt Disney's Comics and Stories, 81, 82, 100–102, 139
Walt Wallet (character), 26
Waltz, Tom, 360
Wanted, 419
Wanted Comics, 103
War Action, 110
War Adventures, 110
War Against Crime, 104
war bonds, 84
war comics, 57, 76–80, 109–10, 140, 203–4, 215, 343
War Comics, 57
Ward, Chris, 350–51, 355, 369
Ward, Lynn, 146–47, 250
War Fury, 110
War Heroes, 110
Warhol, Andy, 140, 178
Warlock, 245–46
Warlord, 246, 330
Warner Bros. Entertainment, 410
Warner Bros. Picture Group, 410
Warner Brothers, 54, 71, 81, 237, 380, 410
WarnerMedia, 410
Warner Communications, 266
Warnock, Brett, 354
Warnock, Julie, 425
War of the Worlds (radio broadcast), 417
War on Crime, 28
War on Terror, 359
Warren, James, 150, 160
Warren Forbisher (character), 130
Warren Publications, 232
Warrior, 292
Warsaw ghetto, 131, 364
Washington Post, 242
Washington Tubbs II, 30
Wasp, the (character), 166, 170
Watchmen, xix, 285, 294–96, 330, 334, 341, 369, 379, 420, 443–44
Watergate, 233

Watson, James, 366
Watson and Holmes, 397
Watterson, Bill, 351–52
Watts riots, 220
Waugh, Coulton, 90
Way, Gerard, 421–22
Wayne, John, 95, 338
Wayne Manor, 178, 180, 234
We Are Comics Tumblr page, 404
Webster, Harold T., 36
Weekly Boys' Jump, 261
Weekly Comic Book, 65
Wee Pals, 173, 224
Wee Willie Winkie's World, 15
"We Fellow Travelers," 238
Wein, Len, 225, 226, 228, 262, 264, 289, 292, 332
Weinstein, Lauren, 425
Weird Fantasy, 109
Weirdo, 281, 314
Weird Science, 108, 109
Weird Science-Fantasy, 132
Weird Tales, 105
Weisinger, Mort, 94, 138–39, 152, 166, 291
Welcome to Tranquility, 415
Welles, Orson, 7, 8, 43, 417
Wellman, Manly Wade, 58
Wells, H. G., 245
Welz, Larry, 198, 204–5
Wendel Trupstock (character), 320
Wendig, Chuck, 441
Werewolf by Night, 233
Wertham, Fredric, 115–22, 118, 126–30, 131, 181, 229, 257, 398
Wertz, Julie, 425
West, Adam, 178
We Stand On Guard, 440
West Coast movement, 186
"West Coast style," 302–3
Western comics, 31, 94–96, 140, 149, 258–59, 417–18, 428, 429
Wet Satin, 213
Wetering, Janwillem van de, 300
Whack, 135
What If series, 333
What It Is: The Formless Thing Which Gives Things Form, 385
"What Parents Don't Know About Comic Books," 119
Wheatena, 41

Whedon, Joss, 412
Wheelan, Ed, 14
Wheeler-Nicholson, Major Malcolm, 42–46, 49, 50
"When Dinosaurs Ruled the Earth," 276
"When Dreams Collide," 199
When Fangirls Attack, 400
When I Arrived at the Castle, 435
"When the Goddam Jews Take Over America," 314
"When the Niggers Take Over America," 314
Whistler, The (radio program), 105
White, Ted, 144
White Boy, 94
White Collar (Patti), 148
"Whiteman," 187, 205
"white savior" narratives, 58
Whitewash Jones (character), 76
Whitman-Dell Animal Comics, 81
Whitney Museum, 116
Whiz Comics, 91
Who Framed Roger Rabbit? (film), 308
Why I Hate Saturn, 385
Why We Fight films, 80
Wicked + the Divine, The, 402
Wikipedia, 265
Wild, 135
Wildenberg, Harry, 41, 102, 117
Wildest Western magazine, 150
Wild One, The (film), 201
Will Eisner's The Spirit, 309
Williams, Eric Kostiuk, 422
Williams, Robert, 309, 431
426
Williamson, Al, 249, 271
Williamson, Joshua, 414
Williamson, Skip, 189, 197
Willie and Joe, 79–80
Willumsen, Connor, 433
Wilson, G. Willow, 383, 399
Wilson, S. Clay, 196–97, 201, 207, 208, 220, 238, 240, 249, 291, 325
Wilson, Woodrow, 20, 21
Wilson and Company, xiv
Wimberly, Ron, 428
Wimbledon Green, 369, 401
Wimmen's Comix, 211–12, 248, 282, 315, 318, 324, 345
Windsor-Smith, Barry, 234
Winger, Debra, 254

Wings, Mary, 318
Wings Comics, 79
Winick, Judd, 317
Winnie Winkle the Breadwin-
ner, 22–23
Winters v. New York, 118
Wisconsin, 345
Witchblade (character), 303
Witches' Tales, 232
witzend, 188–89
Wizard, 303, 412
Wizard World, 378
Wizzywig, 366
W. L. Evans School of Car-
tooning, 26
Wojnarowicz, David, 316
Wolfman, Marv, 225, 226,
228, 233, 265, 286,
381–82
Wolverine (character), 264–65
Wolverton, Basil, 81, 135, 141,
282, 427
Womanthology, 400
women, 22–23
 as artists and writers, 82–83,
 100, 103, 108, 248
 Code restrictions on ren-
 dering of, 127
 as comic protagonists,
 54–59, 209–10, 229–30,
 264, 331–32, 345
 in crime comics, 157–58
 in Stan Lee's work, 166
 as readers of comics,
 92–93, 400
 violence against, 112, 208;
 see also misogyny
 in Western comics, 95
Women in Refrigerators, 330
Women Kicking Ass, 400
Women of Marvel, 400
women's comics, 210–13
women's history, 345
women's liberation, 209–10
Wonder Comics, 52
WonderCon, 442
Wonder Girl (character), 384
Wonder Man, 52, 59, 65
Wondermark.com, 377
Wonder Wart-Hog, 182–83,
197, 207
Wonder Woman (character),
54–58, 64, 72, 78, 84,
119–20, 150–52, 155,
178, 212, 226, 289–90,
333, 432
Wonder Woman (comics
series), 119, 157–58, 229

Wonder Woman (film), 437
Wonder Woman and Friends,
311
"Wonder Woman in Slave
Training," 311
Wonder Woman Meets Baron-
ess von Gunther, 254
"Wonder Women of History,"
158
Wood, Bob, 108, 113
Wood, Brian, 417, 420
Wood, Wally, 135, 141, 177,
188, 195
Woodring, Jim, 348–49
Woolfolk, Dorothy, 83
Woolworth's, 42
"Word to You Feminist
Women, A," 209
Workman, John, 259
World Color Syndicate, 11
World Fantasy Award, 354–55
World of Krypton, 274
World of Wakanda, 438
World Science Fiction Con-
vention, 308–9
World's Finest, 84
World War I, 18, 20, 24, 63,
78, 348
World War II, 32, 67–68,
70–72, 76–87, 89, 110,
131, 148, 175, 176, 214–
15, 237, 339, 344, 424
World War 3 Illustrated, 276,
283–85, 350
Worley, Kate, 296
Wouk, Herman, 251
Wright, Rebecka, 324
Wrightson, Berni, 292
Wunable Oaf, 418
W. W. Norton (publisher), 372
"Wyatt Winghead," 198
Wylie, Philip, 47

Xero, 235
X-Factor, 288
X-Force, 302
X-Force: Famous, Mutant &
Mortal, 420
xkcd, 377
X-Man: The Animated Series, 308
X-Men (comics series), 164,
262–68, 272, 288,
289, 302, 322, 353,
399, 411
X-Men (film series), 370, 380,
382, 401, 435
X-Men: God Loves, Man Kills,
273

X-ray vision, 83, 207
XYZ, 192

Y: The Last Man, 273, 331
Yale University, 17
Yang, Gene Luen, 368, 431
Yankee Doodle, xv
Yankee Notion, xv
Yeh, Phil, 251
Yellow Dog, 189
Yellow Kid, the (character),
4–9, 13, 39–41
Yellow Kid in McFadden's Flats,
The, 8, 39
"Yellow Wallpaper, The," 5
Yiddish and Yiddishisms, 35,
36, 136, 147, 364
Yokums, the (characters), 34
Yoshida, Akira, 439
Yossel, April 19, 1943, 364
Young, Muran, "Chic,"
34–35
Young Allies, 76
Young Avengers, 398
Youngblood, 303
"Young Dan Pussey," 314
Young Lust, 193–94, 216
Young Romance, 93, 97
"Your Name Is Frankenstein,"
163
Youth Against Legal Terrorism,
201
"You've Been Good All Day
Fifi," 207
Yummy, 367
Yummy Fur, 349

Zamarons, 157
Zamora, Pedro, 317
Zane, Billy, 341
Zany, 135
Zap Comix, 187–89, 192,
196–99, 201, 205, 207,
209, 210, 220, 277,
281, 314
Zendaya, 437
Zinmeister, Karl, 358
Zippy, 373
Zippy the Pinhead (character),
278, 352
zombies, 77, 105, 108, 193, 232,
305, 306, 387, 413–14
"Zone Card," 310
Zoot (character), 59
Zorro (character), 29, 51
Zot!, 322, 338
Zuda (imprint), 391
Zwigoff, Terry, 378